American Quilts in the Modern Age, 1870–1940

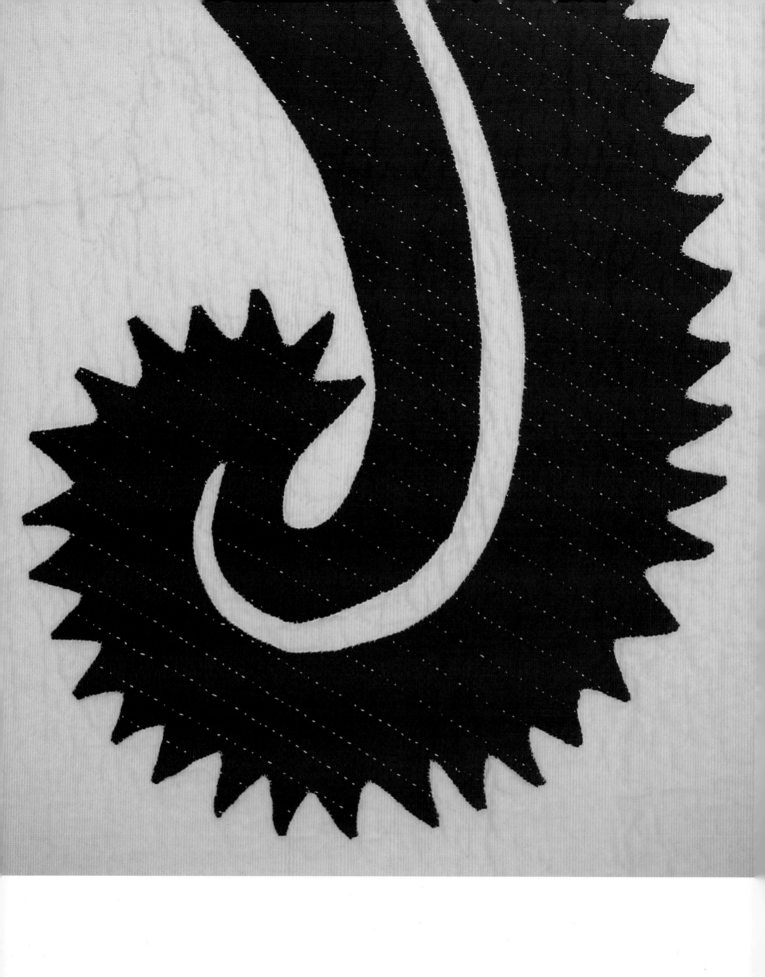

American Quilts in the Modern Age, 1870–1940

The International Quilt Study Center Collections

EDITED BY MARIN F. HANSON AND PATRICIA COX CREWS

University of Nebraska Press ▪ Lincoln and London

∞

Portions of the introduction appear in a different
form in Marin F. Hanson, "Modern, Yet Anti-Modern:
Two Sides of Late-Nineteenth- and Early-Twentieth-
Century Quiltmaking," in *Uncoverings 2008*, ed.
Laurel Horton, 105–35 (Lincoln NE: American Quilt
Study Group, 2008).

Published with the assistance of The Getty Foundation.

| MM | Publication of this book also has been
aided by a grant from the Millard Meiss
Publication Fund of the College Art Association.

Library of Congress Cataloging-in-Publication Data

American quilts in the modern age, 1870–1940 :
the International Quilt Study Center collections /
edited by Marin F. Hanson and Patricia Cox Crews.
 p. cm.
Includes bibliographical references and index.
ISBN 978-0-8032-2054-6 (cloth : alkaline paper)
1. Quilts—United States—Catalogs. 2. Quilts—
Nebraska—Lincoln—Catalogs. 3. University
of Nebraska—Lincoln. International Quilt Study
Center—Catalogs. I. Hanson, Marin F. II. Crews,
Patricia Cox.
NK9112.A56 2009
746.460973'09034—dc22 2008031253

DESIGNED AND SET IN SCALA BY A. SHAHAN
PRINTED IN CHINA

Contents

Preface vi

Acknowledgments xi

Introduction: American Quilts in the Modern Age, 1870–1940 1
 Marin F. Hanson

1 American Adaptation: Block-Style Quilts 19
 Barbara Brackman and Marin F. Hanson

2 Building on a Foundation: Log Cabin Quilts 89
 Patricia Cox Crews, Carolyn Ducey,
 Marin F. Hanson, and Jonathan Gregory

3 Regularly Irregular: Crazy Quilts 127
 Beverly Gordon and Marin F. Hanson

4 Simple and Complex: Allover-Style Quilts 179
 Laurel Horton

5 Perfecting the Past: Colonial Revival Quilts 227
 Virginia Gunn

6 Repackaging Tradition: Pattern and Kit Quilts 305
 Merikay Waldvogel, Deborah Rake,
 and Marin F. Hanson

7 Innovation and Imagination: One-of-a-Kind and Niche Quilts 383
 Jonathan Holstein, Merikay Waldvogel,
 and Marin F. Hanson

Notes 447

Glossary 463

Selected Bibliography 467

Contributors 469

Index 471

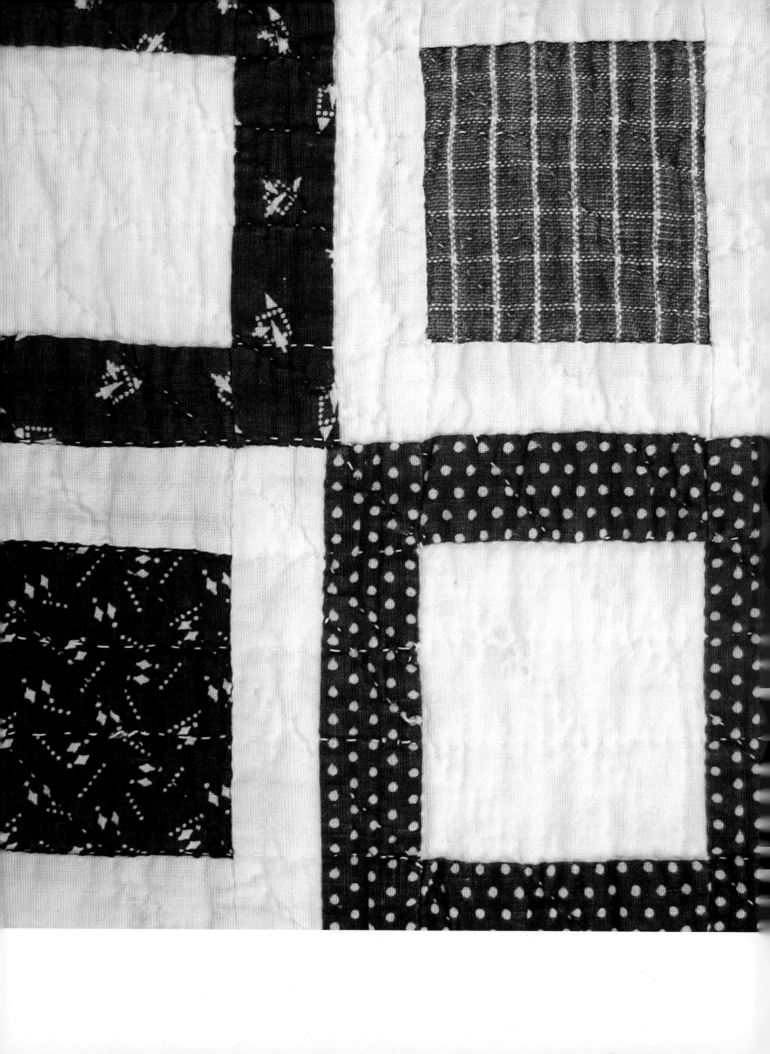

Preface

The International Quilt Study Center & Museum at the University of Nebraska–Lincoln houses one of the most important and largest publicly owned quilt collections in the world. The Center's collections (at the time of this writing) comprise more than 2,300 quilts, representing over twenty countries, with some examples dating back to the early 1700s. Its collections include outstanding early examples of British and European quiltmaking traditions, classic American quilts, as well as contemporary art quilts and international examples representing folk traditions worldwide.

In 2004, the Center embarked on a long-term cataloguing project that will eventually result in the publication of a multivolume, comprehensive catalog of its collections. The project in turn will provide greater collections access for scholars and quilt enthusiasts, help preserve the collections, and promote new research in the field of quilt studies. The first step in this multistep project, to research and photograph all of the Center's quilts made in the United States between roughly 1870 and 1940, was funded by a grant from The Getty Foundation of Los Angeles. It should be noted that this volume does not include Amish, Mennonite, or African American quilts, as these will be featured in future publications. Future cataloguing projects will also explore quilts from other eras, cultural groups, and geographical origins.

The Getty Foundation–funded project began in spring 2004 and encompassed nearly six hundred quilts. The size of this sample is significant; very few public institutions, if any, have this many quilts from this era in their collections. The Center's staff and a host of visiting scholars (all contributors to this volume) examined the quilts to gather different types of information: stylistic format, iconography, and construction techniques as well as a host of technical data, including fiber content, fabric construction, thread structure, and dyeing and printing techniques used in component fabrics.

Because the Center's collections are dynamic, completing the research for this volume was a challenge.

Quilts are added to the collections continually as the Acquisitions Committee locates better examples of quilt styles already represented in the collections or finds outstanding examples representing gaps in the existing collections. Eventually, we simply had to set an arbitrary cutoff date. We decided to limit the quilts included in this volume to those acquired by the Center from its inception in 1997 through the end of 2005, plus a select few from 2006—ones that were such good examples of a particular style that we could not resist including them.

One of the first steps in the project was to group the quilts into categories to examine them in an organized fashion and compare them to one another more easily. The Center's database, created in 2002 especially for the Center to fit the specific needs of its quilt collections, was utilized for the initial grouping process. After examining the quilts in person, some shifts were made based on details that couldn't necessarily be gleaned from the database. The categories we settled on were pieced, block-style; pieced, allover-style; Log Cabin; Crazy; kits and patterns; Colonial Revival; and one-of-a-kind and niche. The pieced, block-style quilts comprised about 25 percent of the collections, and the remaining categories all fell between 9 and 16 percent.

Certainly, the categories were not absolute, and some quilts could have been classified in different ways; for instance, several of the quilts placed in the Colonial Revival section were block-style quilts made from either a kit or a pattern. In addition, the one-of-a-kind and niche group was, to a certain extent, a catchall category. Within it, however, there were many quilts that coalesced into subcategories, such as Hawaiian appliqué, Sears, Roebuck and Co. Century of Progress National Quilt Contest entries, redwork, and tobacco premium quilts. Therefore, although there was a certain amount of fluidity between the categories, we were able to easily place most quilts in an appropriate group.

It was noteworthy, if not unexpected, that aside from those quilts classified as one-of-a-kind and niche,

the majority of the pieces (88 percent) fit into one of a limited number of specific categories. The past twenty-five years of quilt scholarship, especially the analysis performed on state quilt documentation project data, has identified the most popular quilt styles of the era between the Civil War and World War II. The fact that Crazy quilts and Log Cabins were extremely popular in the last quarter of the nineteenth century and kits and patterns were a trend in the 1920s and 1930s is well known. Yet the reconfirmation of the pervasiveness of these quilt styles was an important starting point for our research.

Categorizing was not an end in itself, however. More important, it was a framework around which we were able to reconsider individual quilts and how they related to one another to form a set of group characteristics, and to form ideas about what the prevalence of these categories indicated about the larger cultural milieu in which the quilts were made.

Each chapter features from seven to seventeen full catalog entries dedicated to a single quilt. Some of the quilts were chosen to represent the typical elements of their style. Others demonstrate the range within each of these categories. At the end of each chapter, the remaining quilts from each category are presented in groupings. Rather than solely categorizing them by their pattern, date range, or color scheme, we've also in some cases identified a distinct theme that brings the quilts together in an interesting way.

The full catalog captions include basic information (pattern name, quiltmaker name, location made, probable date, dimensions, predominant fiber types, and number of quilting stitches per inch [QSPI] if hand-quilted) for each quilt. If the quilt was titled by the maker or collector, the title is indicated in italics. If it is a conventional pattern name (e.g., Nine Patch or Feathered Star), or if we have named it, it is in plain text. The captions for the groupings in the galleries at the end of each chapter are abbreviated (QSPI have been omitted, and if a maker's name is not included, the reader may assume that the attribution is unknown). We've also included the museum accession number for every quilt, including the quilts in the galleries; these numbers can be used to look up the quilts on our online database at www.quiltstudy.org. Since the majority of quilts in this volume are from the Ardis and Robert James Collection (accession numbers 1997.007) and the Jonathan Holstein Collection (ac-

cession numbers 2003.003), we have not included their collection names in the galleries. The names of all other donors or collections are credited, however.

The Center's staff and consulting scholars analyzed each quilt in terms of stylistic format, iconography, and construction techniques. Additionally, selected fabrics in many quilts underwent detailed technical examination, including fiber microscopy, stereoscopic analysis of fabric construction, structural analyses of threads, and identification of dyeing and printing techniques.

In addition to a thorough physical and stylistic examination of each quilt, we also pursued documentary evidence related to each quiltmaker—when the maker is known. Members of the staff, consulting specialists, or students in the Textile History/Quilt Studies Graduate Program in the University of Nebraska–Lincoln Department of Textiles, Clothing, and Design conducted genealogical research to corroborate information supplied by donors or dealers. This information was examined by the scholars for consideration and incorporation into the overall historical analysis and interpretation of each quilt.

Many of the quilts are without solid provenance because most of the collectors from whom the Center acquired most of its quilts assembled their collections primarily by purchase from dealers. Sometimes the dealer supplied them with information about where a quilt was found and who made it and when, but more often the dealer was able to provide only the location where the quilt was found. Because the American people have always been a mobile population, we cannot be sure that a quilt was made in the state where it was found. Consequently, we very conservatively assigned place of origin for each quilt in this catalog.

If we have only a dealer's note as to where a quilt was found and no other supporting clues or documentation, we designated its place of origin as "possibly" made in the state where the dealer or collector noted the quilt was found. If object-based research revealed supporting information, such as stylistic clues within the quilt itself, we designated its place of origin as "probably" having been made in that state. Occasionally, a quilt entered the collection without a dealer's or collector's note on its provenance. In those instances, we designated it as probably made in the United States, or the eastern or southern United States if sufficient stylistic evidence warranted a regional denotation.

For most of the quilts pictured herein, we do not know with any degree of certainty when they were made. Once again, the estimated date provided by the dealer or collector was our starting point. We sought additional clues, both stylistic and technical, to corroborate or refute those dates. Clues such as overall style, fabrications, colors, printed patterns, and sewing techniques were examined and analyzed to help place each quilt within the overall framework of American textile history.

We most often chose to give a date range for the probable date of manufacture, generally a range of at least two decades. Occasionally, the quiltmaker inscribed a date, which we assumed to be the date the quilt was completed, although we realize it may have commemorated some other significant date in the life of the maker or the intended recipient. We used "circa" in several different situations. One was to designate a probable year that a quilt was made based on the provenance that accompanied it. Another was when we knew the earliest date the quilt could have been made based on evidence contained within the quilt itself, such as a fabric commemorating a specific event such as a World's Fair. Yet another instance was when we knew the probable date a quilt pattern or kit was first made available. We realize that commemorative fabrics were often set aside only to be incorporated into a quilt years later and that quilts were sometimes made many years after their patterns first appeared. But the "circa" date is a starting point, one that is sometimes expanded into a range of years depending on other evidence, such as the quilt's fabric styles.

The fiber content is also given for each quilt. In the full entries, the predominant fiber is listed first, followed by other fibers if present. Visual inspection provided the initial basis for this information. Microscopic analyses of fibers were performed subsequently whenever selected fabrics used in a quilt did not appear to be of the predominant fiber type and/or whenever the estimated date of a quilt fell just before or during the period when a new manufactured fiber was introduced commercially in the United States. Fiber analyses often provided the determinant clue in estimating the probable date.

The number of quilting stitches per inch (QSPI) is given for each quilt with hand quilting. We counted the number of stitches in at least three places. When it varied, we listed the range rather than the average, because the former is much more telling than the latter.

Remaining true to models for object-based scholarship, the research focused on the examination and interpretation of each quilt. The contributing scholars integrated the outcomes of the technical analyses into their catalog entries, using the information to give a fuller picture of the quilt's history and its maker's possible motivations and working methods. We believe that this project marks the first time that in-depth, thorough technical analyses performed on each quilt are featured in this manner. We hope that the analysis and documentation provided for each catalog entry, coupled with thoughtful description and discussion, will help strengthen scholarship in the burgeoning field of quilt studies.

■ **The Editors**

Acknowledgments

Many persons have contributed to the research, writing, and publication of this book. First we wish to acknowledge The Getty Foundation of Los Angeles; without the Foundation's generous financial support, this project would not have been possible.

We are grateful to the contributors who examined each quilt, wrote cogent catalog entries, and responded thoughtfully (and generally cheerfully) to our numerous comments and requests for additional information, clarification, or supporting documentation. Special thanks to those contributors who helped Marin Hanson with the compiling and writing of the grouped entries at the end of each chapter: Barbara Brackman, Jonathan Gregory, Virginia Gunn, and Deborah Rake. We also thank Connie Chunn, Virginia Gunn, Linda Pumphrey, and Merikay Waldvogel for lending us items from their ephemera collections and doing so on short notice.

We are especially indebted to Jonathan Gregory and Jonathan Holstein for their editorial assistance. Jonathan Gregory deserves special mention for his tireless work at inputting and tracking editorial changes and for his determined efforts to make the endnotes as accurate and informative as humanly possible. Jonathan Holstein generously agreed to read an early version of the manuscript. His astute comments and suggestions from an art historical perspective helped amplify that important dimension for many entries.

Other International Quilt Study Center & Museum staff members gave their time and expertise as well. Nao Nomura performed all the microscopic analyses to determine or confirm fiber content of the multitude of fabrics included in the quilts for this volume. In addition, she oversaw the data-gathering process, examining many of the quilts and compiling the information for our technical summaries. Janet Price expertly managed the photography of more than four hundred quilts. Melissa Slaton and Valerie Davis served as editorial and research assistants and helped compile the glossary.

Melissa Stewart Jurgena completed genealogical research on most of the quiltmakers for whom we had a name. In the process, she uncovered information that helped corroborate many details about the quilts' makers, origins, and dates of production.

A host of volunteers and graduate students assisted in a variety of ways, but particularly in the process of getting each quilt out of storage for systematic examination and returning it, refolded and interleaved with tissue, to its respective archival box.

David Kostelnik and John Nollendorfs contributed their expertise and patience during the photography process.

We are grateful to have at the International Quilt Study Center & Museum the two principal collections that we drew on for this volume, the Ardis and Robert James Collection and the Jonathan Holstein Collection. The James Collection represents more than 60 percent of the quilts in this volume, and the Holstein Collection comprises over 25 percent. We are especially grateful to Robert and Ardis James, whose vision and generosity led to the establishment of the International Quilt Study Center at the University of Nebraska–Lincoln in 1997 and whose continuing support has allowed the Center and its collections to grow.

The University of Nebraska Press publication team was a pleasure to work with. Our thanks to Associate Director Ladette Randolph, editor Ann Baker, designer Andrea Shahan, and copyeditor Judith Hoover.

Finally, we would like to express our appreciation to the University of Nebraska–Lincoln, Department of Textiles, Clothing, and Design, College of Education and Human Sciences, and Institute for Agriculture and Natural Resources for their institutional support.

American Quilts in the Modern Age, 1870–1940

FIG 00-1. Rising Sun, *detail* (see plate 1-69).

FIG 00-2. Stars, *detail* (see plate 1-20).

American Quilts in the Modern Age, 1870–1940

The period between the Civil War and World War II was a time of tumultuous change in America. Rapid technological advances forced American society to quickly adapt to industrial life. While industrialization in pre–Civil War America had mainly been a localized process, after the war it spread rapidly, causing urban centers to expand and factories to be placed in closer proximity to everyday Americans. Certainly, technological progress led to the improvement of some people's lives, creating more evenly distributed wealth and leisure time. Yet industrialization's detrimental side effects—child labor, corporate monopolies, worker riots, polluted waterways, and the spread of urban slums, among others—were increasingly evident. In addition, massive immigration, increasing urbanization, and vastly improved transportation systems forced Americans to quickly and repeatedly adjust to an increasingly fast-paced, multiethnic, and multiclass society. For many Americans, the rapid conversion to modern industrial life produced a sense of displacement and unease.

There were many different responses to the pervasive apprehension in post–Civil War America. Many felt nostalgia for a simpler, pre-industrial time, lamenting the passing of old traditions and folkways and longing for the seemingly uncomplicated lives of their forebears. Others disenchanted with modern life found moral and aesthetic inspiration in non-Western, premodern cultures. Many people felt that, in the words of the historian Harvey Green, "by looking backward . . . they might save the future."[1] These antimodern sentiments led to such cultural phenomena as the Aesthetic Movement and the Colonial Revival, both of which had a profound impact on American decorative arts.

Quiltmaking reflected both the industrial modernization and the antimodern tensions of American culture. In the first half of the nineteenth century, quiltmaking was largely practiced by women who could afford to buy fabric specifically for quilts. After the Civil War, fabric and sewing implements became more plentiful and affordable, transforming quiltmaking into a democratic pastime performed by women from a range of economic backgrounds. In addition to the increased availability of sewing materials, other developments contributed to the expansion of quiltmaking. Women's magazines, which frequently fueled quilting fads, greatly increased their circulations in the last quarter of the nineteenth century. Savvy businesses and periodicals perceived a market for quiltmaking aids and began offering instructions, patterns, templates, and eventually kits to a seemingly insatiable audience. Due to these influences, by the 1930s the practitioners, processes, and aesthetics of quiltmaking had been modernized. Early in the period to which this catalog is devoted, quilts also, ironically, reflected the influence of Anti-Modernism, the Aesthetic Movement, and Colonial Revival aversion to industrialization and these movements' romanticization of past eras and foreign cultures. Quilts, always reflections of the times in which they are created, help us understand this era of ambivalence, when America was struggling to come to terms with what it meant to be a modern, industrialized nation.

ANTI-MODERNISM AND AMERICAN QUILTS

During the 1880s, on both sides of the Atlantic, one begins to sense a restive desire for a freshening of the cultural atmosphere. Haltingly, half-consciously, Europeans and Americans alike began to recognize that the triumph of modern culture had not produced greater autonomy (which was the official claim) but rather had promoted a spreading sense of moral impotence and spiritual sterility—a feeling that life had become not only overcivilized but also curiously unreal.[2]

The Civil War was a turning point in America's development as a nation; it marked the time when America transformed from a largely agrarian society to an in-

FIG 00-3. Tile quilt, *detail* (see plate 3-41).
FIG 00-4. Whig Rose, *detail* (see plate 5-40).

dustrial society. The North's overwhelmingly greater capacity to manufacture war-related goods proved to be one of the keys to the South's defeat, and many in the American elite and growing bourgeoisie saw the victory of the Union as proof that material progress was implicitly beneficial to the nation and its inhabitants. By the 1880s, however, doubts were forming about this paradigm, leading to what the historian T. J. Jackson Lears calls a "crisis of cultural authority."[3] In the public sphere, the chaos and corruption of the Reconstruction period and the class and ethnic conflicts of the postwar industrial boom (sometimes called the "second industrial revolution") led to a desire for new moral standards. In the private sphere, the Victorian family model, with its strict and sometimes repressively delineated roles, also began to be questioned as nascent feminists and religious liberals rejected traditional authority models. Some Americans began to view modern progress as problematic at best, spiritually bankrupt at worst, the means by which "authentic" experience was lost. This sense of loss, in turn, led to what the art historian Lynda Jessup describes as "a longing for the types of physical or spiritual experience embodied in utopian futures and imagined pasts."[4]

Anti-Modernism, one response to this cultural crisis, was strongly manifested in the literary and visual arts, including the decorative arts. Both the Aesthetic

Movement, dominant during the 1870s and 1880s, and the Colonial Revival, strongest from the 1890s through the 1930s, shared anti-industrial, antimodern roots and attempted to answer the question of how to mitigate the negative impact of industrialization on society. But whereas the Aesthetic Movement chose fantasy and alternative realities for inspiration, the Colonial Revival found it in a simplified and romanticized national history.

As the nation's rural roots and customs faded, followers of the Aesthetic Movement argued that the rapidly modernizing America was becoming uglier—both in a literal, visual sense, from the environmentally harmful byproducts of industrialization, and in a socioeconomic sense, from degraded working conditions and labor unrest. By making everyday life, especially the home, more beautiful, they believed they could regain the quality of life that had existed before industrialization. Advocates of the movement, which had its roots in 1860s antiestablishment England, placed an emphasis on the appreciation of "true" (that is, sincere, refined) beauty, often represented by romanticized depictions of past decorative styles, such as Gothic, or exotic artwork, such as Japanese or Moorish.

In its attempt to instill artistic principles into everyday life, leaders of the Aesthetic Movement encouraged women to decorate and enliven their domes-

tic surroundings. The Victorian notion of "separate spheres" held that women were responsible for maintaining the home as a safe haven, a refuge from the male-dominated, business-oriented public sphere. Part of that responsibility included such virtuous pursuits as home decoration and fancywork. Fancywork, or the making of decorative objects, was a vital component of the beautification of the home, an activity that in turn enhanced the domestic sphere's moral character. Not only did fancywork make the home more pleasant, but it had the appeal of being handmade, not mass-manufactured by a lifeless machine. To our twenty-first-century eyes, Victorian fancywork may look like fussy busywork, but Beverly Gordon, a textile historian and a contributor to this volume, counters that "women who engaged in fancywork were fulfilling or accommodating their obligation to create a moral and edifying home, but at the same time were, at least symbolically, creating a different and less constrained reality."[5] Through fancywork, women could simultaneously fulfill their responsibility as the ideal Victorian woman and engage in the aesthetic pursuit of creating escapist fantasies through home decoration.

The hallmark fancywork object of the Aesthetic era, and the focus of chapter 3, was the Crazy quilt. It consisted of oddly shaped, asymmetrically arranged, and elaborately embroidered pieces of silk. Crazy quilts were created as artistic statements, not as functional bed coverings, and most often were displayed draped on parlor furniture, on piano tops, at the foot of a bed, or in the popular "Turkish corners" of the day—nooks and small rooms decorated in a lavish, Oriental style. Although most quilt historians believe the Crazy quilt was a spontaneous grassroots phenomenon, they unanimously point to two primary sources of inspiration: English needlework and Japanese decorative arts.[6]

The Royal School of Art Needlework in London, also known as the South Kensington School, introduced America to a new, more sophisticated style of embroidery at its popular 1876 Philadelphia Centennial Exposition display. Instead of counting and sewing stitches in grids, as with the previously fashionable Berlin needlework, the new Kensington method used free-form satin stitches to "paint" pictures on fabric. The South Kensington School's curriculum was inspired by the revival of medieval English crewelwork that William Morris, the well-known textile designer, initiated as early as the 1850s. The display in Philadelphia featured embroidered curtains and screens with medieval- and Oriental-inspired motifs, all of which garnered a great deal of positive attention from the American press and other Exposition observers.[7] The freedom that the Kensington method allowed for creating unique imagery was considered highly artistic and corresponded with the Aesthetic Movement's emphasis on individual expression.

FIG 00-5. Crazy quilt, *detail* (see plate 3-25).
FIG 00-6. Crazy quilt, *detail* (see plate 3-15).

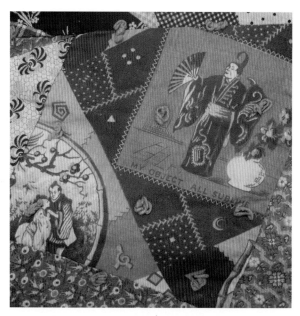

FIG 00-7. Crazy quilt, *detail*, imagery from *The Mikado* (see plate 3-47).

FIG 00-8. Crazy/Log Cabin quilt, *detail* (see plate 3-5).

Although the expressive and elaborate embroidery may have been of English origin, the Crazy quilt format was likely inspired by Japanese design; scholars point to objects such as Japanese silk screens, crazed-glaze pottery, and marquetry sewing boxes as possible sources.[8] The 1854 Treaty of Kanagawa had opened Japan to the West after hundreds of years of isolation, but although European artists such as Edgar Degas and Edouard Manet had been inspired by Japanese prints as early as the 1860s, artwork and products from that nation did not become commonplace in the United States until many years later. Indeed, it was the Centennial Exposition that introduced Japan to its widest audience yet; the Japanese Pavilion was one of the most popular attractions at a fair that drew nearly 10 million visitors.[9] Japan participated in a number of other World's Fairs, including the 1862 London exhibition and those in Paris in 1867 and 1889, also contributing to Western awareness of Japanese decorative arts. The enormously popular 1885 Gilbert and Sullivan operetta *The Mikado* also encouraged fascination with Japanese culture. All over the country, "Mikado clubs" were formed, holding Japanese-themed dances and other social activities for young people. Additionally, the widespread presence of Japanese novelty stores in major U.S. cities furthered the public's appreciation of decorating in the Japanese style.[10] These stores, popular from the 1880s through the ear-

ly twentieth century, sold "exotic" goods not only from Japan, but from China and India as well. The Asian art and objects purchased at these stores were viewed as natural yet sophisticated, ornate yet sincere, and exotic yet morally uplifting—a mix of contradictory characteristics typical of the Aesthetic Movement, which reflected the inconsistencies inherent in this era of rapid societal and cultural change.

Although the Crazy quilt was likely inspired by foreign design sources, some of the techniques and aesthetics that went into making Crazy quilts were already familiar to American quiltmakers. Log Cabin quilts, popular at least since the 1860s, were constructed on a foundation fabric rather than by seaming edges of fabric together, just as Crazy quilts were made. (See chapter 2 for a full discussion of Log Cabin quilts.) Indeed, crossover between Log Cabin quilts and Crazy quilts frequently occurred, with single quilts mixing the two styles or with Log Cabin quilts echoing Crazy quilts in their silk fabrics and elaborate embellishment (see Plate 3-5). Additionally, the intricate embroidery found on Crazy quilts, though now executed in a less rigid fashion than in earlier embroidery styles, would have been easy for American women to accomplish; decorative needlework was a part of middle-class Victorian women's daily activities. The saturated abundance of the Crazy quilt was not new either. Beginning in the 1850s, women's magazines printed directions

FIG 00-9. Crazy quilt, *detail* (see plate 3-5?).

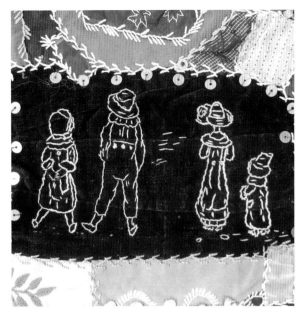

FIG 00-10. Crazy quilt, *detail*, Kate Greenaway–style figures (see plate 3-19).

for making silk patchwork, often called "silk mosaic work" or "mosaic patchwork."[11] Based on an earlier, British technique of piecing together thousands of small pieces of cotton, usually in hexagonal shapes, these midcentury silk versions heralded the dawn of a new, lavish aesthetic. These homegrown precursors certainly hastened American women's adoption of the Crazy quilt in the late 1870s.

Women's magazines quickly picked up on the grassroots Crazy quilt fashion and began promoting it in the early 1880s, at first simply describing the technique and later relating the origins of its name. One magazine stated, "When the present favorite style of quilt was introduced it was called the Japanese, but the national sense of humor has been too keen, and the Japanese is now generally known as the 'crazy' quilt."[12] Stories published in these magazines also gave clues to Crazy quilts' popularity. In one story, a woman explains that she loves Crazy work because "it sets all rules at defiance. . . . I do so detest anything with a pattern to be followed, and where you have to count."[13] The free-form nature of the Crazy quilt was one of its main attractions in a society frequently bound by rigid rules of behavior, dress, and decoration.

Also appealing was the wide variety of imagery typically found in a Crazy quilt. All the influences of the era came into play in embellishing its surface, echoing a society that embraced all the decorative styles in the world. Japanese motifs such as fans, cranes, butterflies, and swallows frequently appeared, as did characters and scenes from *The Mikado*. Intricately embroidered flowers, insects, animals, and fruits represented an idealized natural world where one could escape the gray regimentation of industrialization. Kate Greenaway characters and other children's book or fairy tale figures implied a carefree, innocent childhood, in keeping with the precepts of the cult of domesticity, the Victorian idealization of home life. These quilt images created a fanciful vision, a "fairyland" (as contributor Beverly Gordon calls it) that assisted the artistic goal of transforming "the contained, utilitarian Victorian house into a foreign, exotic dream."[14]

Although silk Crazy quilts continued to be made into the 1890s, the fad faded fairly quickly in fashionable circles. Articles denigrating the Crazy style appeared by 1885. As one commentator succinctly stated, "The fault of the crazy quilts is their craziness."[15] Another detractor protested, "One sees a dozen glaring, bizarre affairs in which never ending 'fights' are going on between warring colors and clashing shades, while tints that have been 'killed outright' lie scattered all about."[16] Stories relating the nefarious means that women used to get free silk samples, both from relatives (cutting the lining from Father's best overcoat) and from manufacturers (creating a fictional business in order to request samples from a silk producer), also

FIG 00-11. Wool Crazy quilt, *detail* (see plate 3-35).

frequently appeared in women's magazines.[17] By the early 1890s the national tide had turned against the Crazy quilt, and "old-fashioned" patchwork came back into style. Alternatives to Crazy quilts were offered, and, ironically, the older, mosaic style of patchwork was encouraged by tastemakers. One author voiced the opinion that "if you must do silk patch-work, make a mosaic of your bits, not a huge night-mare of them."[18] Cotton mosaic-style quilts became popular again as well and are the focus of chapter 4.

Crazy quilts lived on well into the twentieth century, but after the 1890s they were rarely made in the high-fashion, silk style. As early as 1884, tastemakers encouraged the use of fabrics other than silk in Crazy quilts, and in the 1890s and the early twentieth century most were made in cottons and wools by women in nonmetropolitan areas.[19] But at its height of popularity, the silk Crazy quilt had been the quiltmaker's consummate aesthetic creation. In its embrace of the Japanese artistic sensibility, its illogical, haphazard format, and its overly elaborated sensuousness, the Crazy quilt embodied the expressive individualism and antimodern sentiments of the Aesthetic Movement.

The Colonial Revival, the focus of chapter 5, was another movement born out of fears of industrial progress. It reacted against the eclecticism of the Aesthetic Movement, moving away from the lavish, foreign-inspired decoration of the 1870s and 1880s. Unlike the Aesthetic Movement, which began in England, the Colonial Revival was a purely American phenomenon, an idealized reconception of the country's colonial past. In reality, it sometimes looked for inspiration only as far back as the first half of the nineteenth century. As the material culture scholar Ken Ames explains, "colonial" actually meant pre-Victorian and "can be seen as a code word for . . . anti- or nonmodern."[20] The Colonial Revival style was developed from American architecture and furnishing designs ranging anywhere from true colonial times to the mid-nineteenth century. Though it is often noted that Colonial Revival objects were frequently historically inaccurate, more important at the time was the psychologically soothing effect the style purportedly had on what was then called "neurasthenia," a general nervousness that arose among those living in industrialized societies. The perceived benefits of the style paralleled those of the contemporaneous Arts and Crafts style. Both were based on design principles that rejected the exotic, ornate, and visually rich qualities of the Aesthetic Movement. Tastemakers now advocated designs that were natural, simple, streamlined, and "honest"—without artifice, in other words. In addition to being less complicated, and therefore supposedly less stressful to the senses, the Colonial style reminded Americans of their glorious republican roots, evoking the notion of the simple, industrious, and noble character of their ancestors.

It is difficult to assign a beginning date for the Colonial Revival period. Some historians feel it had roots in the patriotic atmosphere surrounding the American Centennial; others point to the "colonial kitchens" of the Civil War era at northern fundraising fairs, which featured tableau-style colonial costumery. Many historians cite the 1893 Columbian Exposition's emphasis on Classical and Colonial architecture in its exposition and state buildings as the genesis of the movement.[21] In any case, admiration for America's colonial and pioneer past stemmed from a desire to lessen the impact of current social realities by emulating the past. "Associationism," the idea that home decoration in the style of an earlier era would grant the inhabitants the desirable character traits of that period, became a commonly held belief.[22] By decorating in a past style, social, political, and economic unrest could be mitigated, or at least more easily ignored. Indeed, the historian Harvey Green notes that

the "mania for antiques began in earnest at the end of the 1880s, about the time shifts in immigration patterns and economic conditions caused many Americans to fear for the future of civilization."[23]

Discerning the moment at which Colonial Revival quilts began to appear is equally difficult. Unlike such crafts as cabinetry and silversmithing, ordinarily performed by relatively small numbers of highly trained men, quilts were made by many thousands of women, and as some styles of quilts were abandoned in some areas, they remained popular in others. There were also differences in the quilts made by urban and rural women. For instance, as noted previously, Crazy quilts continued to be made by rural women well after their peak of urban popularity in the 1880s. In addition, some styles seemed to enjoy frequent recurrences. The hexagon mosaic patchwork quilt, for instance, appeared in slightly different guises throughout the nineteenth century and was often referred to later as "the old style of patchwork" or patchwork "after the fashion of our grandmothers," suggesting that mosaic quilts might have been precursors to Colonial Revival quilts.[24] Because the Colonial Revival brought

back quilt styles that were popular only a few decades earlier at most, there is no clear time line as to when the influence of the Colonial Revival began to affect quiltmaking.

By reviewing women's magazines of the day, however, one can chart the return to fashion of patchwork quilts after the fading of the Crazy quilt fad. Articles in the early 1890s frequently refer to the revival of "old-fashioned" patchwork quilts. One contributor to *Arthur's Home Magazine* wrote in August 1890, "I am not a bit afraid to declare that I like to make patchwork; it isn't because it is now a fashionable occupation, either." She reveals the influence of Colonial Revival sentiments when, in making suggestions for finishing a quilt, she says, "Be sure to invite in the dear old ladies who used to go to quiltings in their young days, but who somehow feel that the bustle and hurry of nowadays has left them quite behind."[25] Reflecting the era's anxiety over the fast pace of modern life, the writer encourages readers to look to previous generations for inspiration and comfort.

Women's magazines begin to refer to specifically "colonial" and not just "old-fashioned" needlework in

FIG 00-12. Eagle, *detail* (see plate 5-33).

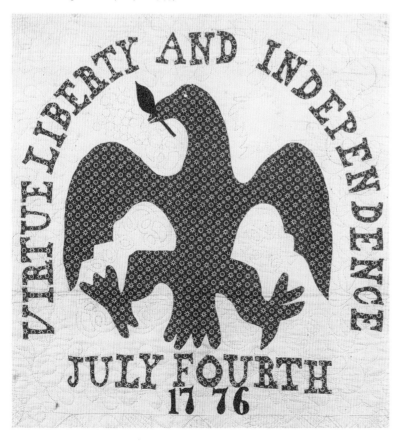

FIG 00-13. Hexagons, *detail* (see plate 4-41).

FIG 00-14. Triple Irish Chain, *detail* (see plate 5-26).

the mid-1890s. The author of one 1895 article wrote, "Of the many styles that afford a generous amount and great variety of pretty designs for embroidery work the Colonial is one of the most attractive, owing, in a great measure, to its dainty simplicity."[26] Eight years later, a *Ladies' Home Journal* article made a clear connection between the Colonial Revival and quilts: "The pieced cotton quilt, which has not been a possible bed-covering within the memory of the woman of to-day, has now become a most modish dressing for beds. The re-appearance of the furniture of our forbears has quite naturally brought about a rehabilitation of the long-despised coverlets with which bridal chests were once so well plenished, and the modern housewife, casting a keen glance quiltward, has discovered that nothing, save perhaps the old hand-woven bedspread, so effectively drapes a mahogany four-poster as one of these gay quilts."[27] This passage illustrates clearly the forces that encouraged the reappearance of earlier quilt styles that had been de rigueur prior to the Civil War.

Geometric quilts constructed from hundreds of small squares or triangles returned to popularity around the beginning of the twentieth century, like-ly because of their similarity to the "old hand-woven bedspreads" mentioned in the *Ladies' Home Journal* article. One of these, the Irish Chain quilt, first ap-peared around the second quarter of the nineteenth century, usually in calicoes and glazed chintzes, but

returned to popularity during the Colonial Revival. Indeed, one variation on the Irish Chain pattern was renamed Burgoyne Surrounded, after England's de-feated Revolutionary War general, in order to attach a distinctly colonial quality to the pattern. Other mid-nineteenth-century pieced patterns were revived as well, such as Star of Bethlehem, Baskets, and Feath-ered Star.

Many of the Colonial Revival versions of these ear-lier patterns were completed in red-and-white or blue-and-white color schemes. There were several reasons for the popularity of two-color quilts. First, the style was compatible with turn-of-the-century, progressive ideas of simplicity and streamlined aesthetics. The Progressive movement of the late nineteenth and ear-ly twentieth centuries was a rationalist approach to solving the problems of industrialization, urbaniza-tion, and immigration, and, like the Colonial Revival, "rejected life-styles and aesthetics of the last quarter of the nineteenth century in preference to earlier, less complicated, pre-industrial ones as ways of overcom-ing the negative aspects of modern life."[28] Second, two-color quilts evoked a connection to early Ameri-can coverlets, which most often were woven in red and white or blue and white. Finally, a number of the new synthetic dyes were not reliably colorfast at this time, and so, in the words of one patchwork pattern author, "Care must be taken to select only the colors

FIG 00-15. Burgoyne Surrounded, *detail* (see plate 5-18).

FIG 00-17.
Whig Rose
variation, *detail*
(see plate 5-6).

FIG 00-18.
Princess Feather,
detail (see plate
5-63).

FIG 00-16. Pine Tree, *detail* (see plate 5-29).

that will stand repeated visits to the laundry. . . . Turkey red is always safe, and there is also a blue cotton . . . that is effective and safe to use."[29]

Mid-nineteenth-century red-and-green appliqué quilts also returned as an inspiration during the Colonial Revival. The red-and-green appliqué style, at its peak of popularity between 1845 and 1875, never truly disappeared but, like many other patchwork patterns, was largely overshadowed by Crazy quilts in the 1880s. A new wave of these quilts appeared around the beginning of the twentieth century and remained common well into the century. Appliqué patterns such as Whig Rose and Princess Feather became popular again, decades after being considered the height of mid-nineteenth-century fashion. Other mid-nineteenth-century quilt designs, such as the four-block format, also made a comeback.

Distinct differences existed between the mid-nineteenth-century originals and the Colonial Revival imitators. Many of these discrepancies resulted from the fact that the later quilts were made at a time when technological advances had begun to change the methods with which quilts were made and the materials

from which they were constructed. Even from the beginning of each movement, however, both Aesthetic- and Colonial-style quilts were affected by technological change. Quilts during the Aesthetic Movement were influenced mainly in the way they were constructed; Colonial Revival quilts, on the other hand, and all quilts of the first half of the twentieth century, were more deeply affected by the realities and ideals of modernity.

QUILTMAKING EMBRACES MODERNITY

Although the Aesthetic Movement and the Colonial Revival were rooted in a mistrust of industrialization, quilts of the modern age were irrevocably altered by it. Rapid advances in technology during the second half of the nineteenth century led to new quiltmaking techniques and materials. The development of sewing machines, new dyes, and mail-order services meant quilts could be more quickly made and a wider variety of materials more easily obtained. Though the Crazy quilt was influenced by foreign design sources and fantastical imagery, and the Colonial Revival quilt

FIG 00-19. President's Wreath, *detail*, machine quilting
(see plate 5-42).

style attempted to imitate an earlier American aesthetic, both styles were in fact the products of a quickly changing and modernizing world.

The most obvious of the technological changes that affected quiltmaking was the introduction of the home sewing machine. Equally important were the innovative marketing techniques that helped the machine become a standard item in many American households. Isaac Singer and his partner, Edward Clark, through a novel installment payment plan and trade-in option, made the sewing machine affordable to the majority of Americans by the turn of the century. As early as the mid-1850s, women's magazines praised the benefits of the sewing machine, which had first been introduced during the 1840s. In 1855, the editors of *Godey's Lady's Book and Magazine* stated, "No woman of the least enterprise or spirit will long submit to sit stitching from dawn till dark, at a garment which could be better done in forty minutes" with a sewing machine.[30] The author of an 1863 article in *Arthur's Home Magazine* saw beyond the practical uses of the sewing machine to its potential as an agent for moral and social change. The author felt that because it would grant upper- and middle-class women more time for helping and educating the lower class-

es, "many of those evils, which are now the fruit of ignorance, and early initiation into the hard places of life, will be banished."[31] In an 1868 article in the *New England Farmer*, however, the writer cautioned that "all cannot afford the more expensive kinds [of sewing machine]; and the cheap ones are, really, worse than none."[32]

Despite early misgivings about the quality of some sewing machines, by the 1890s manufacturers were producing and selling great numbers of new sewing machine models and auxiliary devices that they marketed to women through advertisements in women's magazines. One sewing machine manufacturer, the Free Sewing Machine Company of Chicago, appealed to women's modern sensibilities and to their desire to compete with their husbands in keeping up with the latest technological developments: "Think of it! And all this in the year 1909 when husbands have automobiles, automatic adding machines, automatic locking desks, automatic threshers, automatic reapers, etc., etc.—you, Mrs. Housewife, are compelled to be satisfied to sew for your husband and family with a sewing machine that hasn't been improved to speak of for the last 25 years!"[33] In 1893, the Bolgiano Water Motor Company of Baltimore offered a motor, apparently powered by the running water from a faucet, that could drive all sorts of domestic devices, including sewing machines, fans, churns, and washing machines.[34] Seventeen years later, the Bissell Motor Company announced, "Sewing Machine Treadmill Abolished!" in an advertisement for their electric sewing machine motor.[35] Other companies advertised such sewing machine accessories as needle threaders, seam rippers, and buttonhole attachments. Although quilting with a sewing machine only ever reached novelty status (only eleven of the quilts in this volume display machine quilting),[36] manufacturers attempted to market quilting attachments to quiltmakers. In 1890, Henry T. Davis of New York City offered a quilting attachment with which "one lady will be able to make a large, six-pound comforter within less than one hour on her own sewing machine, and also conveniently do all kinds of quilting, such as coat linings, dress skirts, cloaks, etc."[37] And for those women who were particularly loyal to their favorite magazine, they could order an official *Ladies' Home Journal* sewing machine, made by "one of the most reliable Sewing Machine manufacturers in the United States," whose name was

withheld so as not to compete with the company's regular sales agents.[38]

Women responded to the onslaught of advertising and began using sewing machines in great numbers to construct, if not to quilt, their quilts. An analysis of the International Quilt Study Center (IQSC) collections reveal the quick adoption of sewing machines by post–Civil War quiltmakers. Of the quilts that fall into the 1865–1900 time period, about 40 percent have some kind of machine stitching. The quilts made between 1901 and 1940 fall in the 60 percent range. It is not surprising that 80 percent of Colonial Revival quilts, which were made from the late 1800s well into the 1940s, display machine stitching. What is remarkable, however, is that 73 percent of Crazy quilts, with their emphasis on handwork, have some amount of machine stitching on them.[39]

One would expect that Log Cabin quilts would also contain a large amount of machine stitching, since foundation piecing can easily and quickly be performed on a machine. But the blocks in over 80 percent of IQSC Log Cabin quilts were sewn entirely by hand.[40] Perhaps quiltmakers who enjoyed handwork—those who were more traditional and less likely to adopt new technologies—were particularly drawn to the Log Cabin pattern. Another possibility becomes apparent through close examination of the quilts themselves. At least thirteen Log Cabin quilts in the Center's collection were made with large numbers of "logs" cut from fabrics on the bias rather than along their natural perpendicular grain. Frequently, this technique appears to be used for visual effect; fabrics with a stripe or plaid are transformed into dynamic diagonal designs, often giving a "barber pole" appearance. Piecing fabrics on the bias is best achieved by hand, whereby careful manipulation can keep the fabric from shifting too severely, which is a danger when working against the grain.

Machine stitching is quite apparent in areas of Log Cabin quilts other than the blocks, however. Often, a machine was used to sew the blocks together and add the binding, and of all the quilts that are not simply a top, nearly 60 percent have backings that were stitched together by machine.

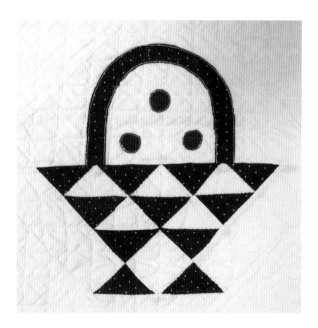

FIG 00-20. Baskets, *detail*, machine-appliquéd handle (see plate 5-82).

FIG 00-21. Log Cabin, *detail*, bias cut logs (see plate 2-62).

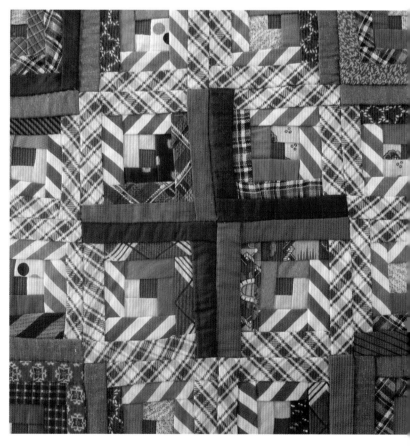

The increased use of the sewing machine in quilt-making coincided with the rising popularity of the pieced, block-style quilt, a type more fully addressed in chapter 1. In the first half of the nineteenth century, appliqué quilts, either in a center-medallion or album format, were more common than pieced, block-style quilts. They also served as signs of status and wealth since their creation necessitated that whole pieces of fabric be selectively cut apart to produce individualized motifs. Sewing machines made block-style quilts a more efficient format because the long seams connecting the individual blocks could be done quickly by machine. They also made the tedious task of attaching borders faster, which may have contributed to the popularity of using multiple borders to frame a quilt (almost one-quarter of the quilts in this volume have more than one border).

Although it was certainly easier and faster to make a quilt with a sewing machine, quality often suffered. Frequently, women were not proficient enough with their machines to sew the small pieces of fabric together precisely, resulting in quilts that would not lie flat. Appliquéing with a sewing machine was difficult and often produced frayed edges and clumsy shapes. When it came to quilting, hand sewing was still preferred (despite the various quilting attachments being offered

to quiltmakers), but the quilting around the beginning of the twentieth century is often sparser and less accomplished than that of earlier times. In addition, women with inferior hand-quilting skills often had to mark their quilting designs with pencil lines, many of which are still visible and detract from the beauty of the quilt. The widespread use of the sewing machine around the turn of the twentieth century, when many quiltmakers' machine-sewing skills were still developing, could be said to have temporarily lowered the overall quality and aesthetics of American quilts.

Advances in synthetic dye production also radically changed the dyeing and printing processes for fabrics used in quilts. Although the first synthetic dye was discovered in 1856, it was not until the late 1860s, when scientists developed processes for the production of synthetic alizarin—the primary colorant in natural madder root—that fabric coloration was greatly affected. The madder style—a combination of oranges, reds, chocolate browns, and blacks—popular since the 1850s, remained prevalent into the 1870s, coinciding with the Aesthetic Movement's interest in Oriental rugs, Kashmir shawls, and other exotic textiles. In 1894 indigo was synthesized, and by the early 1900s a process for easily manufacturing indigo was perfected; its naturally occurring counterpart was very soon replaced.[41] The turn-of-the-century Progressive preference for clean, spare design was helped along by the wide commercial availability of synthetically dyed fabrics and yarns in blue and red, many of which were both washfast and lightfast. Two-color quilts, including those in the Colonial style and redwork style (red embroidery on a white ground frequently made into fundraising or commemorative quilts) were some of the most popular in the years immediately preceding and following 1900.

Some synthetic dyes, however, were not as colorfast as the Turkey reds and indigos. One dye in particular, invented in 1884 and called Congo red, had notoriously poor wash- and lightfastness, fading to a peachy tan. One quilt in the Center's collections, a Hands All Around pattern from around 1900, shows what could happen when a quiltmaker mixed different red fabrics in one quilt: the stunning red-and-white color scheme is marred by two pieces of peach-colored fabric dyed with Congo red or another equally undependable formulation. Many synthetic green dyes from the last quarter of the nineteenth century were equally unreli-

FIG 00-22. Center Diamond, *detail* (see plate 5-81).

FIG 00-23. Album, Signature, *detail* (see plate 7-54).

FIG 00-24. Hands All Around, *detail*, synthetic red dye faded to peach.

FIG 00-25. Rose, *detail*, synthetic green dye beginning to fade to khaki (see plate 5-37).

able, often fading to tan. Consequently, some turn-of-the-century Colonial Revival red-and-green appliqué quilts—those whose reds have withstood the test of time—have become red and khaki.[42] In fact, sixteen of ninety-three quilts categorized as Colonial Revival quilts, or 17 percent, exhibit this phenomenon, and 11 percent of all quilts in the circa 1880–1910 range have a green fabric that has faded to khaki.

By the 1920s and 1930s, a shift in color palette had occurred. Although lighter colored woven chambrays had been common for utility clothing since around the turn of the century and made their way into scrappy quilts, the quiltmaking palette generally did not include pastel solids and prints until the late 1920s.[43] Due to the English blockade of Germany at the beginning of World War I and the subsequent entrance of the United States into the war, American dye companies were forced to develop new dye chemicals, almost all of which had previously been obtained from Germany. Because of the initial dye shortage, fashions during the war were designed using lighter colors and whites. But after the war, American chemical companies used their newly developed dye knowledge to create novel colors; indeed, by 1923 the Textile Color Card Association of America featured more than eighty colors on a standard color card.[44] Some of these were bright tertiary colors (a primary mixed with a secondary color) and tints (colors made lighter with the addition of white). When Colonial Revival appliqué patterns were refashioned with these vivid new pinks, periwinkles, and Nile greens (a grayed green that was particularly popular in the 1930s), they looked markedly different from their red-and-green appliqué precursors of eighty years earlier.

FIG 00-26. Crazy quilt, *detail*, manufactured embroidered decal (see plate 3-7).

FIG 00-27. Crazy quilt, *detail*, printed silk patch (see plate 3-7).

Developments in communication and transportation also greatly affected quiltmaking in the decades before and after the beginning of the twentieth century. Railroad track was added across the United States at a rate of four thousand miles per year between 1860 and 1910.[45] Mail-order catalogs, whose business was made possible by this transportation boom, ensured that even the most geographically isolated women could obtain quiltmaking instructions, fabrics, notions, and even sewing machines, as did the U.S. Postal Service's inauguration of rural free delivery. Department stores, catering to urban customers, offered the same variety of sewing-related merchandise as mail-order catalogs.

Magazines, newspapers, and pattern companies were able to print greater quantities of their publications and distribute them and their products more quickly. Many of these sources offered quiltmaking patterns and advice, which meant that to a certain extent quilts became more standardized. Even Crazy quilts, paragons of irregularity and spontaneity, be-

gan to look alike because embroidery and appliqué patterns, embroidered decals, silk scrap bundles, and even patterns for cutting and placing the pieces of fabric became commonplace. To be sure, women still made highly original quilts, creating their own patterns and adding individual touches to existing ones, but for many it was simpler to send away for a pattern than adapt one from an existing quilt or invent a new one. The ultimate progression of this trend led to the 1930s and 1940s fashion for quilt patterns and kits. With these, a quiltmaker could pay a minimal amount for basic pattern instructions, or she could pay a much more substantial sum to receive all of the materials and instructions needed to make an entire quilt—no individual decisions necessary.

Thanks to women's magazines and such firms as the Ladies Art Company of St. Louis, which began publishing pattern catalogs in 1889, patchwork and appliqué patterns became widely available in the late nineteenth century.[46] By the 1920s, the quilt pattern and kit business had developed into a vast industry

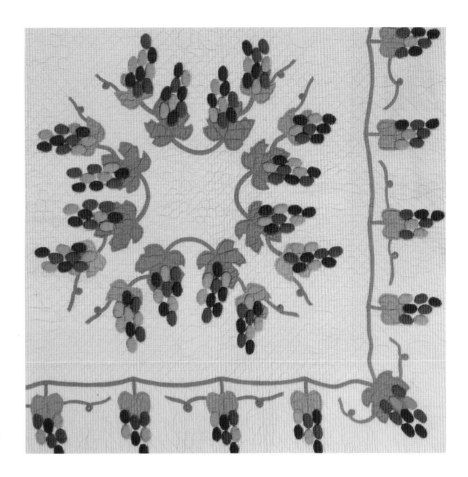

FIG OO-28. Grapes and Vines, Marie Webster pattern, *detail* (see plate 6-28).

FIG OO-29. Wild Ducks, Mountain Mist pattern, *detail* (see plate 6-60).

aimed at helping women with every aspect of designing, preparing, constructing, and finishing quilts. (See chapter 6 for more on kit and pattern quilts.) Quilt patterns eventually were offered not only by individual designers such as Marie Webster, a pioneer of and one of the foremost designers in the kit and pattern industry, but by virtually every major newspaper and women's magazine in the country, as well as by quilt batting companies and needlework catalogs. Transfer patterns, which allowed a quiltmaker to apply a pattern outline to fabric with a hot iron, and perforated quilting patterns, which could be marked with a special stamping wax, also contributed to the transformation of quiltmaking into an up-to-date, modern pastime.[47] And while quilt patterns provided the outline for the quilt's design, leaving fabric choices up to the maker, quilt kit companies took advantage of die-cutting technologies to supply quiltmakers with precut fabrics, ready to be pieced or appliquéd into a quilt top.

None of these ventures would have been successful if quiltmakers had not purchased quiltmaking aids in huge numbers. All of the nineteenth- and twentieth-century technological developments that quiltmakers enthusiastically adopted, from the sewing machine to new fabric colors to mass-produced quilt patterns and kits, changed the way quilts were made and the way they looked. The quilt pattern and kit phenomenon of the 1920–1940 period provides evidence that women and, by inference, American society had truly acclimated to the modernized world. Instead of rejecting the "cookie-cutter" aesthetic and construction method of machine-produced quilt kits, as their grandmothers would have done during the Crazy quilt fad, they embraced it as a sign of modernity and progressivism.

As chapter 7 explores, however, there were many quiltmakers who retained their own unique perspectives on quilt design throughout this era of increasing mechanization and standardization. One-of-a-kind and niche quilts, such as Hawaiian appliqué, yo-yo, and tobacco premium quilts, prove that individuals and subgroups enjoyed creating their own quilt variations, distinct from those made from carefully followed directions and materials lists.

Mavericks and subgroups aside, the style that remained the most popular for quilts well into the 1940s was, paradoxically, the colonial. The modern, streamlined aesthetic of the Arts and Crafts and the Progressive movements was adopted wholeheartedly but was frequently applied to nostalgic, Colonial Revival motifs. Jacobean-inspired embroidery was reinterpreted in stylized appliqué patterns; spinning wheels became common embroidery motifs; and the "colonial lady"—an appliquéd woman in antebellum, not colonial, attire—became one of the most popular quilt and needlework designs of the era. Capitalizing on the ongoing strength of the Colonial Revival fashion, companies and publications continued through the 1940s to produce patterns and kits that appealed to people's desire for history, heritage, and quaintness.

American quilts made between 1870 and 1940 are reflections of their era. As the United States transformed into a modern, industrialized nation, so, too, did quiltmaking become a modern, progressive art form. New tools, techniques, and materials allowed quiltmakers to make quilts more efficiently and to quickly adapt to the changing fashions of the day. These inventions and innovations contributed to the growth of quiltmaking from a pastime of the few to one of the most popular hobbies in America. The continuum from 1870s Crazy quilts, many of which were made with

FIG 00-30. Hawaiian Appliqué, *detail* (see plate 7-18).
FIG 00-31. Colonial Lady, *detail* (see plate 5-10).

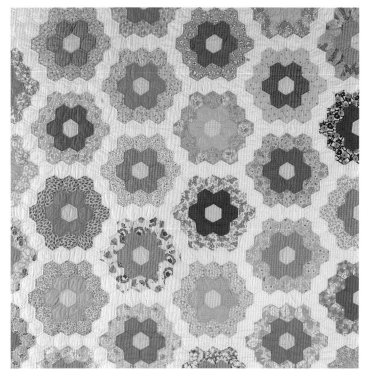

FIG 00-32. Hexagons (1860–1880), *detail* (see plate 4-32).

FIG 00-33. Grandmother's Flower Garden (dated 1931–1934), *detail* (see plate 6-8).

prebundled silk scraps following prescribed embroidery patterns, to 1930s kit quilts, many of which came with precut fabrics and premarked backgrounds, mirrors the swift changes happening in quiltmaking, and in America at large.

The rapid modernization of the nation, while leading to huge economic and industrial growth, also produced social unrest, a faster pace of life, and an increasingly urban landscape. An Anti-Modernist outlook, most clearly seen in the Aesthetic Movement and the Colonial Revival, was one response to these quick and unsettling changes. Quilts, like the decorative arts in general, were affected by these movements, being made in styles that exhibited the gilded, escapist fashion of the Aesthetic Movement and the simple, traditional look of the Colonial Revival. Although the technological advances and antimodern sentiments that simultaneously shaped American quiltmaking may seem to contradict one another, they actually embody the paradoxes inherent in the process of becoming a modern nation. *American Quilts in the Modern Age* presents a body of quilts that reflect both the continuity and change that were hallmarks of the 1870–1940 era.

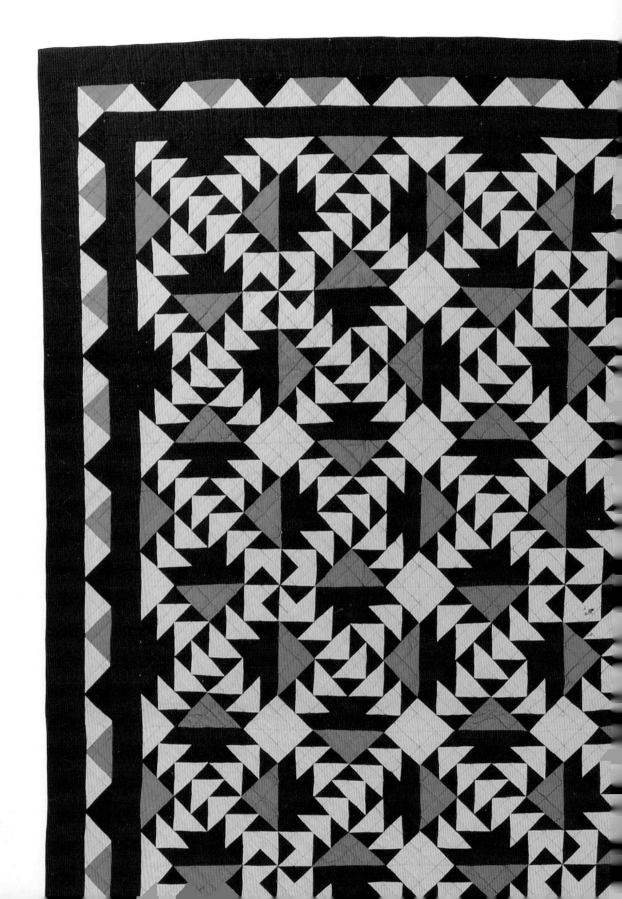

American Adaptation *Block-Style Quilts*

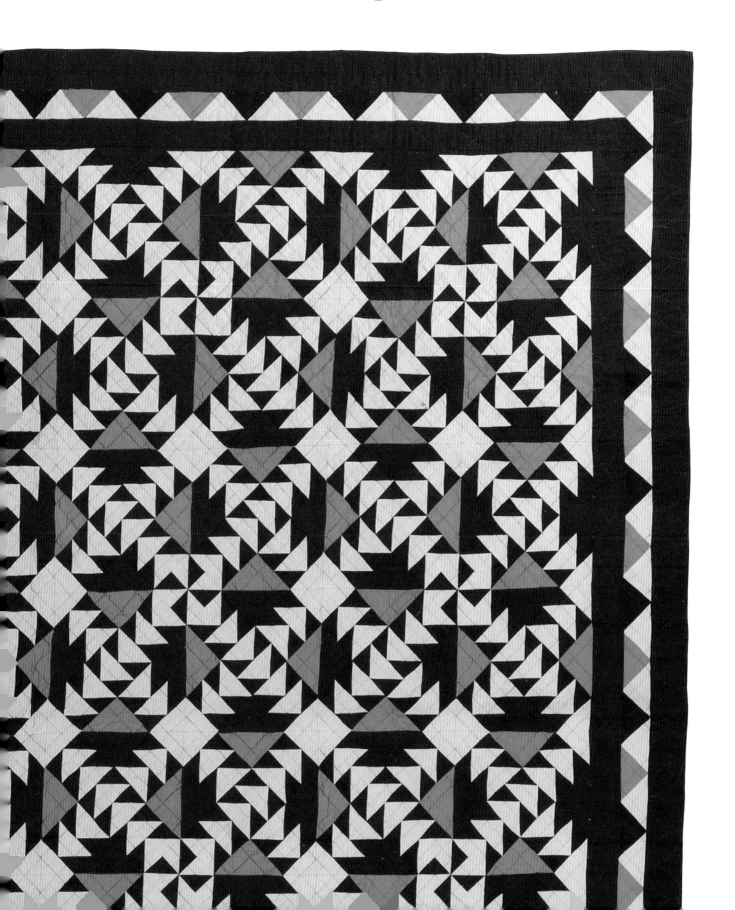

The American quiltmaker has left an extraordinary design legacy in the pieced quilt, creating a remarkable diversity within a relatively narrow structure, the gridded square. From 1865 to 1940 women exercised endless invention in filling that grid.

After the Civil War, the pieced block format dominated quilt design as subtleties of fine quilting and elaborate appliqué fell out of favor. New fashions in fabric and pattern appeared, and as the pieced quilt's complexity increased, simpler prints came to rule the fabric scrap bag. Earlier quiltmakers might have incorporated large-scale chintzes into their designs, but women working after the Civil War narrowed their view of appropriate fabrics, favoring the small-scale figured designs generally known as calicoes. If the old unwritten rules dictated that complex fabrics should be pieced into simple patterns, the new rules reversed the emphasis, to simple fabric and complex pattern.

Technological developments, especially new synthetic dyes, provided many new colors, some with excellent colorfastness properties and some with notoriously poor washfastness and lightfastness. As greens became unreliable in the 1890s, fewer women chose to use them. When more colorfast green dyes became available after World War I, green became the new craze. By the 1930s, pastels and bright colors were the standards, giving quilts of the 1930s a very different appearance from those at the beginning of the century.

Fads crested with the mania for Log Cabin quilts, followed by a rage for Crazy quilts, the vogue for the pieced block format, and later the Double Wedding Rings and Flower Gardens of the 1930s. Rather than narrowing their focus to a few designs, Americans showed a passion for miscellany.

Trends in piecework included a fascination with smaller pieces and a variety of calicoes. Whereas earlier quiltmakers took pride in the size of their quilting stitches, women working in the 1870s and 1880s valued different aspects of quiltmaking. New styles included postage stamp quilts pieced of inch-square patches and Charm quilts containing, ideally, 999 different prints. Some women, such as Martha Haggard, carried the concept to extremes. Her quilt includes an inscription boasting, "This quilt contains 62,948 separate pieces."[1]

Pictorial blocks with trees pieced of triangles and abstracted baskets, cabins, and "wild geese" also captured quiltmakers' imaginations. Another trend, possibly inspired by the fashion for the Log Cabin quilt, was an increase in patterns plotted to create secondary

FIG 1-1. Feathered Star, *detail* (SEE PLATE 1-64)

FIG 1-2. Around the World, *detail* (SEE PLATE 1-92)

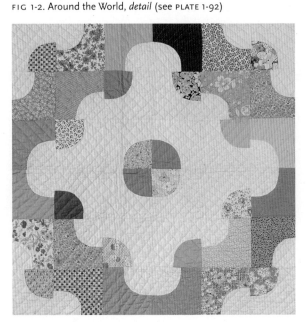

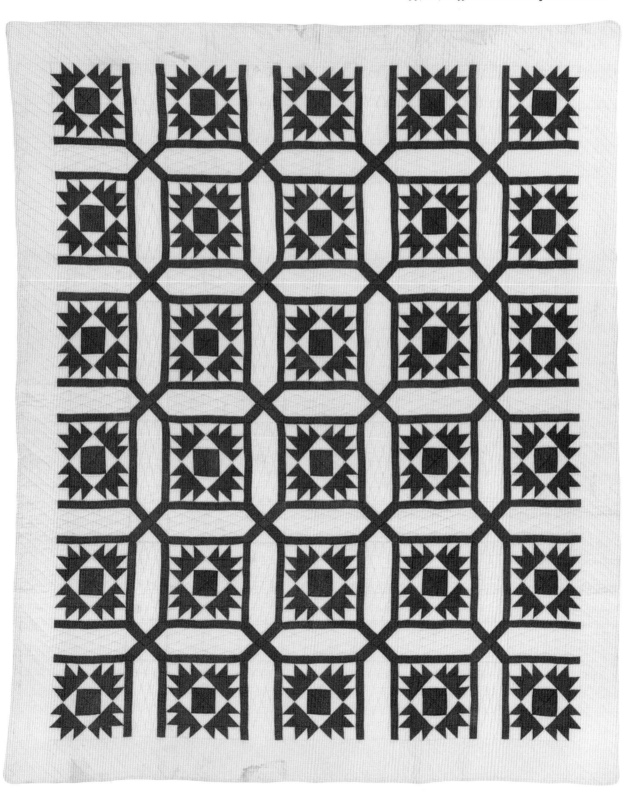

PLATE 1-1. Union Square.
Maker unknown
Possibly made in Cass County, Michigan, 1875–1895.
Cottons, 77.5" x 63.5". QSPI: 10–11.
1997.007.0053. *Ardis and Robert James Collection.*

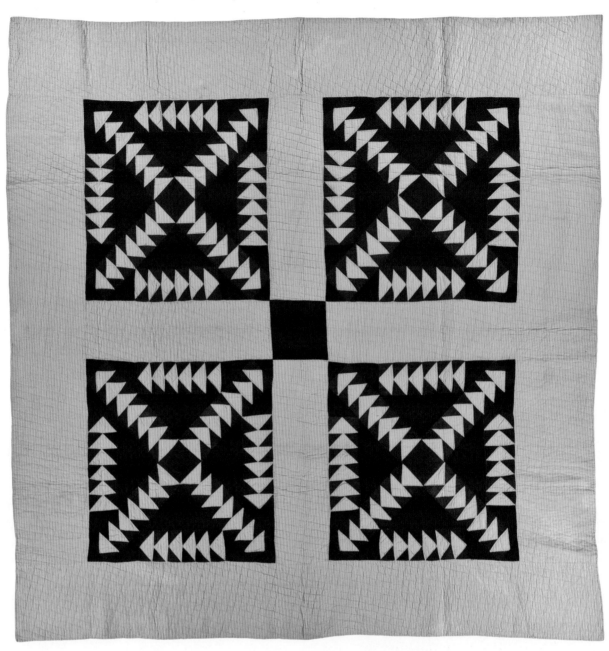

designs when blocks were set side by side, as opposed to being separated by sashing or setting blocks (see, for example, plates 1-49 to 1-58). Complex designs such as pineapples pieced of small strips, Drunkard's Paths with interlocking trails of quarter-circles, and Ocean Waves of tiny triangles required high-contrast shading to highlight pattern illusions. The emphasis on light versus dark geometries encouraged a reliance on light-colored shirting prints, a clothing fashion that became a standard in quilts through World War I. In the 1920s, plain white cottons became the staple neutral, and contrast declined in importance as quiltmakers explored the subtleties of a paler palette.

Throughout these years, as fashions in color, fabric,

and pattern peaked and declined, the most important change was the transition of the quilt pattern from a folk art to a commercial industry. At the beginning of the period, patterns were generally shared as folk arts are, through direct transmission from artist to artist. Before the age of the printed pattern, quiltmakers copied designs from a quilt rather than a piece of paper. The women in the Goschenhoppen region of Pennsylvania continued to use that method well into the twentieth century, explaining, "You need one to make one."[2]

Women often stored and traded patterns as quilt blocks. Thirteen-year-old Julia Hall was part of the network of pattern transmission when she wrote her cousin in 1855, "I am peacing [sic] a quilt. I will send you a block."[3]

We also find some early evidence of paper designs. In 1835, Phoebe George Bradford of Wilmington, Delaware, wrote about her purchases at the Christmastime fair held at St. Andrew's Church, "I bought . . . a pattern card for patchwork."[4] Her card, probably hand-drawn by an enterprising needlewoman, is the kind of disposable item that hasn't survived in appreciable quantities.[5] More durable were published patterns initiated in the United States during the early 1830s with illustrations for a simple "hexagon" or "honeycomb" design.[6]

Over the next fifty years, periodicals occasionally printed designs. A comparison of midcentury quilts to the few patterns in print reveals a weak relationship. Printed sources were rarely an inspiration to the quiltmakers or a reflection of their art. The magazines generally focused on piecework, ignoring the appliqué that was so popular through the end of the Civil War. They printed patterns for mosaic-style construction using template paper piecing rather than the block-style design favored by American seamstresses, and they often recommended silk fabric rather than cottons. The editors, by presenting English piecework preferences and ignoring vernacular design characteristics, hoped to elevate readers' taste—with little success, if the quilts that survive offer any evidence.

During the 1880s, magazines increased references to quilts, promoting patterns such as the fan, the Crazy quilt, and outline-embroidered designs. In the 1890s, the number of quilt patterns appearing in print increased significantly, and, most important, these designs began to reflect everyday patchwork quilts,

FIG 1-3. Shooting Star, *detail* (see plate 1-59).

which were largely pieced-block designs made of cotton. The emphasis was no longer on technique and refined fashion but on pattern diversity.

Several developments in trade and technology led to the increase in pattern features. Innovations included cheaper wood pulp paper for newsprint and the invention of linotype printing, which mechanized hand-set type. The federal government subsidized periodicals for a news-hungry nation of farmers by providing inexpensive postage and free delivery to rural mailboxes. Special-interest publications thrived, particularly in the areas of agriculture and women's interests. In 1870, ninety farm periodicals competed; the number doubled over the next decade.[7]

Looking for inexpensive content, publishers developed contests for fiction and encouraged reader exchanges for household hints and recipes to fill the columns between the advertisements. Women's magazines and farm periodicals also asked readers to mail their favorite quilt designs to be shared with others.

The mainstream press today might disdain the inexpensive magazines with their amateur journalists and advertisements for patent medicines, but these periodicals provided a creative outlet for writers delighted to see their poetry in print. They also served

as a clearinghouse for housekeeping and needlework information, taking pattern sharing out of the local community and into the national.

As offset lithography and photographic reproductions replaced elaborate wood engravings, illustrations increased, leading to another increase in pattern features around the turn of the century. Rather than describing a needlework technique, the paper or magazine could illustrate the block and perhaps print a pattern name and minimal color or setting suggestions. The quilt designs did not include full-size pattern pieces but a sketch or photograph representing the finished block. The editors assumed that patchwork was a basic skill and readers could easily draft their own patterns.

Quilt patterns were such a popular feature that some periodicals offered them as premiums for subscriptions. *Comfort*, America's most popular magazine between 1892 and 1905, based an empire on the idea of rewarding readers who helped develop their subscription list. The publisher, William Gannett, always savvy about trends, saw the nationwide craze for Crazy patchwork and began buying small remnants from a necktie factory. At their kitchen table in Augusta, Maine, his wife, Sadie, packaged the remnants for a premium called "Sadie's Silken Shower of Satin Samples." Women were glad to mail in their friends' addresses, trading subscription lists for free fabric. After the Crazy quilt fashion waned, *Comfort* sent packets of quilt patterns and kits, a practice copied by other inexpensive magazines trying to match Gannett's success.[8]

At about the same time, other entrepreneurs realized that women would be willing to mail in coins for the patterns. In the early 1890s, the Modern Art Company of New Haven, Connecticut, advertised three patterns for a dime, a dozen for a quarter. In 1895, H. M. Brockstedt of St. Louis offered 272 different quilt patterns at three for a quarter. Brockstedt's Ladies Art Company soon printed a catalog of four hundred designs, each with a name and a number. This catalog, which has been reprinted into the present day, offers the first index of popular pieced and appliqué patterns.

Pattern historians assume that in return for her dime the quiltmaker received an envelope with three small, scaled-down pattern cards, hand-colored at Brockstedt's kitchen table by his children. At some point, publishers realized the competitive advantages

in selling a full-size pattern. The quilt historian Wilene Smith has identified an early full-size diagram available from *Hearth & Home* magazine in April 1895. Readers who mailed three two-cent stamps received a twelve-inch sketch of the block. Subscribers could collect new patterns by reading the magazine. Those who wanted drafting help could order the larger diagram.[9]

During the 1910s, more pattern catalogs, including Clara Stone's from Boston and Joseph Doyle's from Chicago, added to the quiltmaker's repertoire. Quiltmakers might order a card or a diagram, but most undoubtedly saw these catalogs as idea workbooks. The catalog itself sold for a dime.

The combination of a pictured block and a mail-order pattern (either a single sheet or a bound booklet) became the standard periodical format in the first decades of the century. The field widened when mainstream city newspapers began to offer patterns. In 1916, Ruby Short McKim, who designed quilt patterns that appeared in many newspapers during the 1920s, collaborated with the children's author Thornton Burgess to produce a series of quilt patterns in the *Kansas City Star*. The Bedtime Quilt featured embroidered animals from Burgess's stories outlined in a cubist-influenced style. A few years later McKim's modernistic quilt blocks began appearing in other papers. The Bedtime Quilt is thought to be the first syndicated pattern series, an idea that became big business in the 1930s, when hundreds of newspapers carried some type of pattern column.[10]

The mail-order pattern formats generally improved over the years, with many offering seam allowances, stitching instructions, and an occasional yardage table for a full-size quilt. Despite the attempts by artists like McKim to introduce modern aesthetics, the majority of the pattern columns featured traditional patterns based on ideas introduced in the nineteenth century.

The quilts described in this chapter tell the story of pieced block design between 1865 and 1940. The quilt pattern industry continues to influence quilt styles, but publications do not dictate all design. Then, as now, we find patterns that seem to be one of a kind, designs handed around in small communities, and popular ideas ignored by the industry. The quilts testify to the persistence of the folk tradition in the age of the printed pattern.

■ **Barbara Brackman**

DESIGNS FOR PATCH WORK QUILTS

By Jane Benson

THE time was when patchwork quilts represented merely the odds and ends of the piece bag, when, from the remnants left over from frock or apron, squares and cubes were cut to keep the housewife busy, to teach the little girls to sew, and to make the outside of a quilt, which, after completion, would add to the stock of winter bed coverings. But nowadays the patchwork quilt is most often made from material specially bought for the purpose, and usually only one color and white are used. A pretty fashion is to have a square centre block of white containing an initial or monogram worked in red, and to surround this with diagonal-shaped pieces of alternate red and white until a larger square is formed. A quilt made after this fashion might have a lining of Turkey red cotton or white if preferred.

The designs for patchwork quilts given on this page may be made from patches of either silk or cotton, tiny pieces of either of these materials being just the things required for these patchwork quilts. When either of the latter care must be taken to select only the colors that will stand repeated visits to the laundry. Turkey red is always safe, and there is also a blue cotton, which may almost be called Delft in color, that is effective and safe to use.

LARGE STAR PATTERN

THE large star given in the accompanying illustration may be made by sewing neatly together four small blocks of colored silk or cotton three and a half inches square, to form one large block. Between the corners on each side sew four blocks made of the color used and white, put together diagonally. Join the corner blocks to the side blocks, so that the white and colored angles may alternate, and finish with a plain block at each corner. When finished the block will form a star similar to the one shown

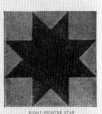

in illustration. Blocks made after this pattern form, with alternate blocks of white, the strip for very pretty patchwork quilts.

EIGHT-POINTED STAR

CUT eight diamond-shaped pieces of colored material each measuring two and a half inches on all four sides; sew neatly together into the form of a star, then add a sufficient number of white pieces to transform the star into a square, and make up with alternate blocks of white into strips; sew the strips neatly together and make up with an interlining of white cotton batting.

A SMALLER STAR

THE design for a small star pattern is very attractive when made in Turkey red and white, the star being entirely of the red, and the pieces forming the square of white. This design is effective when the patches are made of silk.

A good size for the centre of the plain block pattern patch is three inches; the rectangular patches at the sides should be three inches in length and one and a half in width. The squares at the corners must, of course, be of a size to make the patch a complete square. This block patch is made up with alternating blocks of white, and made up with a lining of the solid color.

A very effective pattern is made from squares and angles, as shown in design, of alternate colors. A quilt made after this pattern should be made up with alternating blocks of white.

The appliqué daisy patch makes a most effective quilt. The background may be either of white or yellow; if of white the design is appliquéd in yellow; if of yellow, in white. The blocks should be eight inches square, the centre of each being ornamented by a six-petaled daisy five and a half inches in size. The daisy is appliquéd to the patch with buttonhole stitching of yellow wash silk. The centre is ornamented with

long lines of yellow silk in Kensington stitch. In following any of these designs pieces of any kind of colored cotton may be used. The general effect will not be so good, but the quilt will be just as comfortable when extra bed coverings are in demand.

Patchwork quilts are very useful. The comforters which are nearly always given as extra bed covering do not wash satisfactorily, and blankets soon thicken and shrink if constantly washed. Neither of these objections applies to the patchwork quilt.

FINISHING THE QUILT

WHEN the patches are all complete and sewed together into strips of the required length the strips should be sewed neatly together to the desired width. Two layers of white wadding should then be tacked on the inner side, and over them a lining of exactly the same size; then all three must be very carefully and closely basted together. It will then be ready for the hands of the quilter, who, after quilting, will bind and hand it over all ready for use. Well-made patchwork quilts are very serviceable; they are easily laundered, and

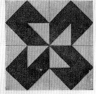

comfortable to sleep under, besides being reminiscent of pleasant moments spent in putting the pretty patches together.

SILK OR OTHER QUILTS

SILK quilts are very much in favor at the present time. The pretty wash silks in flowered or plain patterns for both inner and outer side are used with an interlining of white cotton batting quilted in place. A ruffle of the silk is the usual finish.

A pretty bedspread, which will probably be more ornamental than useful, however, may be made from four-inch-wide strips of silk or satin of one color, connected by strips of lace insertion two inches wide; the whole lined with silk of a solid color and finished with a lace ruffle. Linen bedspreads embroidered in a conventional pattern, with monogram in the centre, also make most effective bed coverings.

For the nursery nothing in the quilt line is as popular as the cheesecloth comforter in white, pale pink, pale blue or yellow. These little comforters are often tufted with baby ribbon and are also finished with a ruffle. Many mothers, however, prefer the little white Marseilles quilts, which come in many patterns. Yet many other mothers who live in the country, and many thrifty ones who live elsewhere, spend their leisure moments in fashioning from little pieces of print very acceptable quilts

for either cradle or crib. These quilts are inexpensive, and where there is a home fortunate enough to have a succession of babies to need bed coverings these little quilts serve a purpose that no bought one can, for the little stars, cubes and triangles form the baby's first glimpse at shape and color, and may be made the very first step in its education.

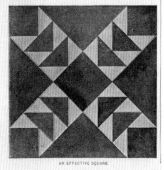

FIG 1-4. Appliqué design from the hand-drawn "Collection of Paterns [sic] for Mary Dallarmi, 1861." *Gift of Joanna S. Rose.*

FIG 1-5. "Designs for Patch Work Quilts," *Ladies' Home Journal,* November 1896.

FIG 1-6. Ladies Art Company pattern catalog, 1922. Courtesy of Connie Chunn Collection.

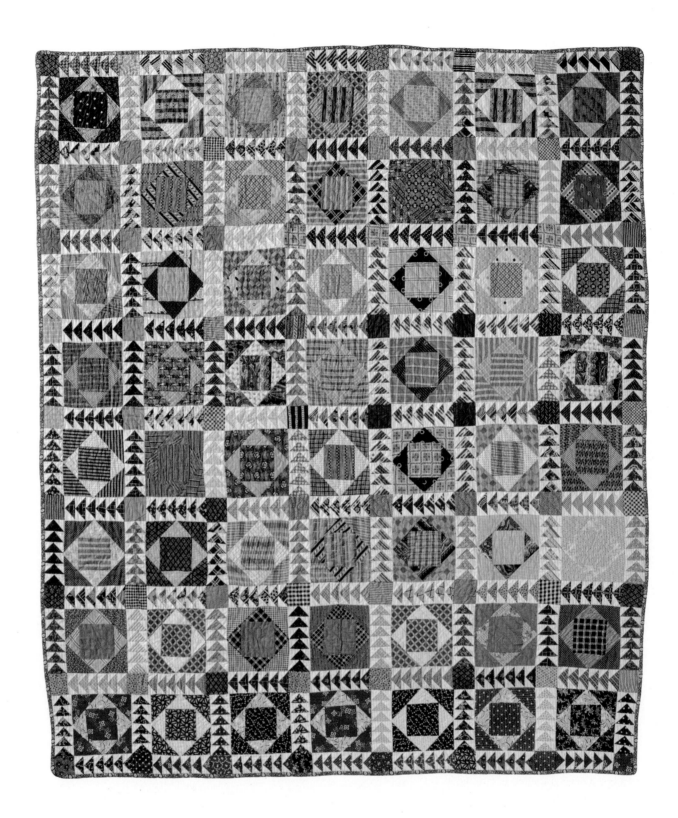

PLATE 1-3. Square in a Square.
Maker/location unknown, 1870–1910.
Cottons, 68" x 80.5". QSPI: 8.
1997.007.0051. *Ardis and Robert James Collection.*

Close examination of all of the individual components of a quilt can reveal much about its age, its maker, and about the processes undertaken to complete it. Even though we don't know who made this Square in a Square quilt (plate 1-3) or where it was made, by inspecting every aspect of its materials and techniques we can infer quite a bit about its history.

Most of the fabrics date from 1860 to 1890. Many of them are madder-style prints, which feature colors ranging from dark, chocolate brown to reddish orange to pink. These colors were produced using alizarin, extracted from natural madder root or synthesized from coal tar, in combination with various mordants, to create different hues. As in this quilt, madder-style colors were often used in prints featuring paisleys, stripes, and cartouches, designs intended to imitate the colors and motifs found in exotic Asian textiles such as Kashmir shawls and Oriental rugs. In addition to the typical 1860–1890 fabrics, there are a limited number of Prussian blue (a mineral colorant with a bright, vibrant blue distinct from indigo's deeper navy) and brown prints that point to an 1830–1860 date. Looking solely at this group of fabrics, therefore, it would appear that the quilt top was pieced during the 1860s, 1870s, or 1880s, using a few earlier fabrics.

Another group of fabrics tells a different story, however. Indeed, the bottom row of blocks clearly betrays its later, early twentieth-century origins. Many of the fabrics feature bright, almost neon green, pink, and yellow figures on solid black backgrounds. This type of print, often mistaken today for a modern one because it is so vibrant and eccentric, is a defining style of the 1890–1925 era.[11] A maroon discharge print and a polka-dot indigo print, both of which are a single color with a white figure, also point to the early twentieth century, as these prints were cheap to produce and therefore popular.[12] Finally, a beautiful, twining lily print reveals the influence of early twentieth-century Art Nouveau. Our conception of this quilt has been changed, therefore, by examining its bottom row of blocks. We can now theorize that the top seven rows were created prior to 1890, remained unfinished as a top for many years, and were added to around 1900, perhaps to make the quilt longer to fit a particular bed.

Turning to construction techniques, we find further evidence for this theory. The top seven rows were sewn entirely by hand, whereas the bottom row was pieced by machine and attached to the upper section by machine. In addition, the backing fabrics were pieced together by machine, and the binding fabric, a circa 1900, finely engraved black-on-white print commonly known as a "mourning print," was applied to the top by machine and whipstitched to the back by hand. Although a sewing machine would have been available to the maker of the 1860–1890 portion of the quilt (sewing machines were sold to home sewers beginning in the 1850s), she may not have been able to afford one or simply preferred sewing by hand. There is no way to know if the same person also made the bottom row, but if she did, she was able to either purchase or borrow a sewing machine and overcame her objection to using one.

Quilt tops and individual blocks often were abandoned after completion to be picked up years or decades later and finally assembled into a whole quilt. However, such obvious combinations of older and newer blocks within a quilt, as seen here, are not common, though they are extremely helpful in reminding us that quiltmaking is often an ongoing process.

■ **Marin F. Hanson**

FIG 1-7. Square in a Square, *detail*. 1860s–1880s fabrics in top row, 1890s–1910s in bottom row.

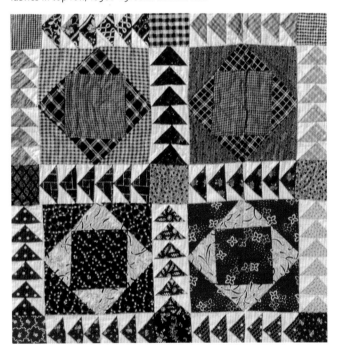

This neat and orderly Wreath of Stars quilt (plate 1-4) is one of a pair. The other, in which the maker set the blocks a bit differently, is inscribed "1873, Alice S. Bennett, Waverly, NY." The quilts share many of the same fabrics and quilting patterns and were purchased at the same time from a single dealer. The pattern, a six-sided block featuring six stars with six points, looks much like a rather common design published a few decades later as Seven Stars or Seven Sisters. The major difference is Alice's omission of the seventh star in the center. The name Wreath of Stars was bestowed by the collector Jonathan Holstein. Although it is not traditional, the name describes the distinctive pattern well.

Alice was only fourteen years old when she inscribed her name on her quilt. The 1880 census finds her a young woman of twenty-one, living with her parents, grandmother, and older brother in the town of Barton, near Waverly, New York, along the border with Pennsylvania. Her father, Stephen Bennett, is listed as a druggist, she a "clerk in a store." Nearby lives Adolph K. Gore, also "a clerk in a store." Alice and Adolph married soon after the census. Their only child, M. Elting Gore, became a chiropractor in East Orange, New Jersey, and left no children, one reason this pair of quilts became available in the antique market.

Alice made her quilts at the height of what was called the "Calico Craze," a celebration of America's domestic fabrics rather than the imported French and English silks, Irish linens, or English floral chintzes that were the basis of high fashion. After Civil War scarcities, the inexpensive cottons printed in the New England mills became the staple for pieced quilts and calico became popular for attire worn to social events that were an alternative to fancy dress balls. For example, a Calico Carnival held to raise funds to repair the community hall was described in a clipping from a Chester County, Pennsylvania, newspaper: "According to invitations many of the ladies were attired in calico while the gentlemen looked rather sporty with calico ties." In 1877, the Young Men's Social Club of Lawrence, Kansas, sent invitations to the "first Calico Ball of the season," printed on actual cotton swatches. The German immigrants in Atchison, Kansas, organized a Calico Neck Tie Party in 1887, a matchmaking event where "the ladies wore calico dresses, each depositing with the door-keeper a tie made out of the

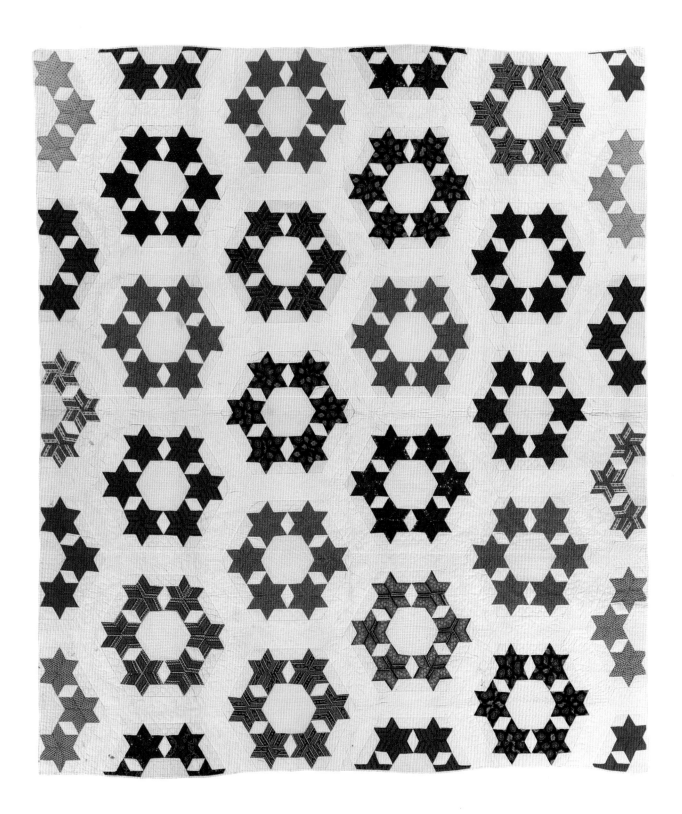

PLATE 1-4. Wreath of Stars.
Made by Alice S. Bennett Gore (1859–1931).
Waverly, Tioga County, New York, dated 1873.
Cottons, 84.5" x 73". QSPI: 7-8.
2003.003.0322. *Jonathan Holstein Collection.*

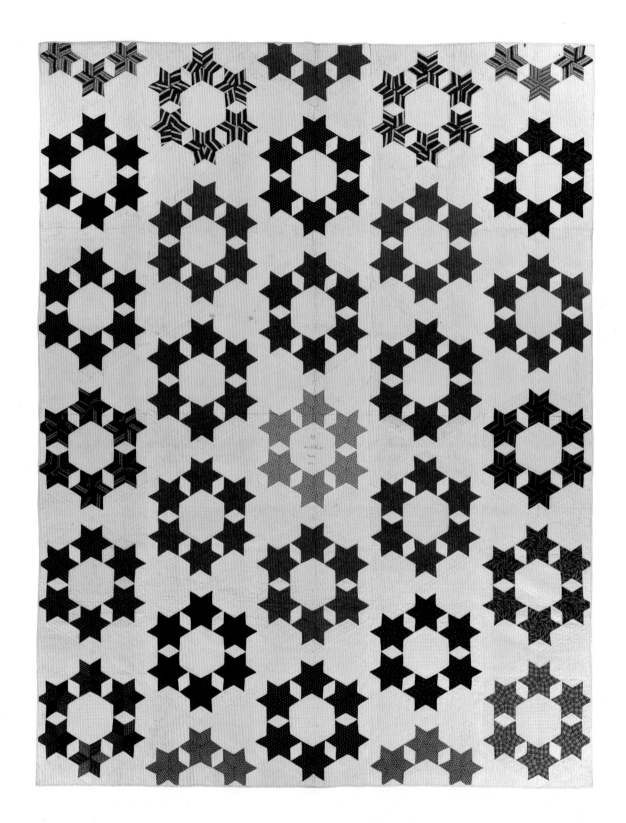

PLATE 1-5. Wreath of Stars.
Made by Alice S. Bennett Gore (1859–1931).
Waverly, Tioga County, New York, dated 1873.
Cottons, 84.5" x 73". QPSI: 7-8.
2003.003.0321. *Jonathan Holstein Collection.*

FIG 1-8. Wreath of Stars, *detail*.

same material as their dress, which was drawn by one of the gentlemen, and the two were united for the evening."[13]

Cotton was not only fashionable but affordable, as prices dropped dramatically from Civil War highs of $10.00 or $20.00 per yard. In 1872 the first catalog from Montgomery Ward featured cotton prints at twelve yards for $1.00. A rural dry goods dealer advertised similar prices, "owing to the hard time and scarcity of money . . . best prints 8$^1/_3$ cents per yard."[14] Cotton prints costing less than a dime per yard were common throughout the country as the Industrial Revolution matured and efficient roller printing completely replaced labor-intensive woodblock and copperplate printing methods. Postwar competition between U.S. and foreign manufacturers increased as tariffs disappeared. Southern mills sprang up, hoping to add industry to the southern economic system. New synthetic dyes were in production, especially for silks and woolens. Cottons continued to be printed with the old reliable root- and mineral-derived dyes in color combinations that were light and washfast and

efficient and inexpensive to produce until the mid-1870s, when synthetic alizarin, with its advantages in purity and consistency, was widely adopted commercially.[15] Madder-style prints declined in popularity by the early 1880s, when many new brightly colored synthetic dyes appeared on the U.S. market.

Alice's quilts serve as scrapbooks documenting the decade's stylish prints for quilts and clothing. The greens and yellows, although common in quilts, were not popular for garments, but the double pink prints were the standard fabric for girls' dresses, the kind of clothing that Alice at fourteen was outgrowing. The stripes and figured prints in madder-style browns were the staple for women's wear at home.

Fitting a hexagonal block into a rectangular quilt presents design problems that Alice resolved by cutting the blocks. The yellow-orange half-block on the left has a twin on the right. Each striped half-block has a match on the other side. The elongated hexagons of plain white between the blocks left Alice a place for fancy quilting, which she filled with a feathered vine.

■ **Barbara Brackman**

This graceful Broken Dishes quilt (plate 1-6) with wide sashes framing blocks on point is a classic exercise in the use of formal geometry. The pattern, pieced of simple squares and triangles, was popular with quiltmakers at the beginning of the twentieth century, but somehow escaped the notice of household hint columns and commercial pattern writers until 1930, when *Needlecraft Magazine* named it Broken Dishes. In 1938 the *Kansas City Star* gave it the name Chinese Block.[16] By then the design was out of fashion. It is as rare in Depression-era pastel prints as it is common in the blacks, indigo blues, and light shirting prints of this example.

A century later we have no idea what the women who used this block called the design. We do know that women gave names to their quilt designs, particularly at the time this quilt was made. Before the age of the printed pattern we have some evidence of the importance of pattern names in wills and letters, in the fiction of the time, in needlework instruction booklets, and sometimes actually inscribed on the quilt. In 1847 the newspaper *National Era* referred to a Midnight Star pattern.[17] Elizabeth Range Miller's quilt, listed in her husband, Jacob's, 1857 will, was made "of the pattern known and called 'Rose of Sharon.'" A mid-

nineteenth-century design that we might call Princess Feather today is inscribed "Kossuth's Feather" in appliqué on the quilt, a reference to a Hungarian rebel of fleeting fame.[18]

In the 1890s, as periodicals began to include more quilt patterns, names took on increasing importance. Early competition among magazines trying to interest readers and mail-order catalogs vying for customers encouraged variety in pattern names. In October 1899, the Ladies Art Company advertised their catalog in *Home Needlework Magazine:* "Every quilter should have our book of 400 designs, containing the prettiest, queerest, scarcest and most grotesque patterns from old log cabin to star and puzzle designs."[19] It's unlikely that a pattern's geometry made it grotesque or queer; more likely names like Hearts and Gizzards, Drunkard's Path, Bat's Wing, or Spider's Den added to the pattern's appeal.

The wide selection of patterns available in print gave quiltmakers hundreds upon hundreds of options, but many of these designs were more likely to have been clipped and pasted into a scrapbook rather than stitched into a quilt or even a single block for a sampler. Quiltmakers around the country tended to favor a relatively small number of designs, the classic nine-patch and four-patch variations such as Shoofly and Monkey Wrench, Bear's Paw and Churn Dash, simple stars, Irish Chains, and a few novel designs such as Ocean Waves, Drunkard's Path, and Bow Tie. This quilt's design, though never as common as the pieced Schoolhouse or т quilts, seems to have enjoyed a flurry of popularity.

The 1938 name Chinese Block probably refers to the pattern's complexity, a form of Chinese puzzle. It is enough of a puzzle that the maker made an error in piecing a block at the center left. Quilt lovers like to speculate that such pattern mistakes, most likely accidental, are deliberate attempts to disrupt design regularity. One common version of the tale behind an error, which is sometimes called a "vanity block" or "humility block," is that it is proof to the gods that one is far from perfect. Similar stories have been passed on in numerous cultures as a fear of the Evil Eye. The oldest may be the Greek myth of Arachne, a mortal who challenged the goddess Athena to a weaving contest and won, only to be condemned to weave forever as a spider.

■ **Barbara Brackman**

FIG 1-9. Broken Dishes, *detail*, "humility block."

PLATE 1-6. Broken Dishes.
Maker unknown.
Possibly made in New York, 1880–1900.
Cottons, 71.5" x 82". QSPI: 5.
1997.007.0030. *Ardis and Robert James Collection.*

PLATE 1-7. Broken Circle.
Maker unknown.
Possibly made in Pennsylvania or Maryland, 1880–1900.
Cottons, 79" x 83.5". QSPI: 6-7.
2003.003.0153. *Jonathan Holstein Collection.*

n this Broken Circle (plate 1-7) we have a quilt masterful in its use of color and pattern, with small triangles of white flickering across a background of red. The block, essentially a fan design, has long been a challenge to the expert piecer. When the block is sashed with complex-pieced or appliquéd strips, it is known today as New York Beauty or Rocky Mountain, but this simpler version, a block isolated by broad blue bars, was called Broken Circle or Suspension Bridge in the 1933 Ladies Art Company catalog.

The quilting theme is double lines. The quilter has echoed some of the patches twice and doubled the diagonal parallel lines in the sashing and border. A triple sash border provides a neat frame for the intricate blocks.

White fabric is common in cotton quilts for both practical and aesthetic reasons. Because the dyeing and printing steps are omitted and chemical bleaching is a relatively simple process, plain white generally costs less than prints. It serves as an effective neutral, a foil for the complexities of the chintzes and calicoes that dominate American quilt design. White also gives the quilter an area to show off the subtleties of her quilting stitches. But here the quiltmaker has used the white as a color rather than as a neutral.

The fabric selection, in colors that appear so modern to our eyes, may actually be viewed as a conservative choice. The red, green, yellow, and blue palette echoes old-fashioned taste at a time when high-style brown calico prints and increasingly available indigo blues and black novelty prints were creating new styles in mainstream quilt design. Quiltmakers in more conservative communities, such as the separatist groups of Germanic ethnicity, especially those living in southeastern Pennsylvania, were reluctant to accept change, holding on to more traditional color palettes. The old-fashioned bright colors appear often in quilts of the Mennonites and other Anabaptists, as well as in the quilts of what were called the "Gay Dutch," the Germans of Lutheran and Reformed Protestant religions.

At the beginning of the twentieth century, seamstresses in these separatist communities located in Ohio, southern New York, and Pennsylvania supported a small but profitable fabric industry centering on the continuing production of earlier print styles. The nostalgic prints of stereotypical small figures on yellow, red, and green grounds were often called "oil calico."

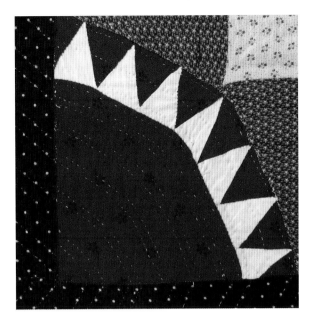

FIG 1-10. Broken Circle, *detail.*

The 1895 Montgomery Ward catalog advertised "Oil prints, green ground, yellow and black small figures; canary with red and black small figure; red ground with yellow and black figure. Per yard .06."[20] A 1900 edition of the *Sugarcreek Budget,* a national newspaper with Amish and Mennonite subscribers, published an advertisement for Garver Brothers Drygoods that listed sateens, muslin, large sheets of cotton wadding, and "Cocheco oil colors," which probably meant nostalgic prints from the Cocheco Printworks of Dover, New Hampshire. Seamstresses were familiar with those words through midcentury, when Louise Fowler Roote, the editor of *Capper's Weekly,* told her mainstream readers in 1933 to buy paler colors for their quilts, avoiding "brilliant red and green oil calico."[21]

To the experienced eye many of these oil calicoes are poor imitations of the mid-nineteenth-century Turkey reds and other prints. The figures are rather minimally drawn, the colors are limited, and the same designs were reprinted over and over. The efforts by dyers to find faster ways to produce oil calicoes were not always successful, as evidenced by the fading here in sashing and block.[22] Yet this community of quiltmakers, working within a restricted palette and using only a narrow range of fabrics, was able to create a multitude of splendid quilts, of which this piece is a stunning example.

■ **Barbara Brackman**

Although pieced in a common pattern of everyday cottons, this carefully planned Dutchman's Reel quilt (plate 1-8) is an uncommon work of art. We often look at successful folk art as a happy accident, but it is apparent here that the maker had a goal in mind as she expertly arranged her blocks to achieve a harmonious whole, with layers of depth and a central focus.

This quilt, among the others featured in Jonathan Holstein's 1974 book *The Pieced Quilt*, revealed fresh possibilities in patchwork to those new to quiltmaking. Those who took up the craft in the 1970s, nearly a century after this quilt was made, saw in it a license to look beyond the block. The maker's decision to strategically place the lighter and darker blocks in order to create a secondary, overall pattern (in this case, a large x) opened the door to a new way of looking at the field of pattern. Rather than repeating the fabrics block by block, one could color the whole quilt as a single, cohesive composition.

Like the Broken Circle quilt, the color scheme and paired strip borders, as well as the blocks on point, indicate a quiltmaker working within the confines of the Germanic aesthetic.[23] The influences of German folk arts are also apparent in the pieced design, which might look too much like a swastika for our society's bitter memories of World War II. Germanic design conventions have long been common in American quilt pattern design, particularly in appliqué design, with its flattened roses and triple blooms in reds and greens. The influence is also obvious in pieced designs, with their four-way symmetries. In a four-way symmetry, one fourth of the quilt block rotates and repeats, a design convention as familiar to American quiltmakers today as it was to Bavarian stencil painters in earlier generations. Whirling crosses, or *hexfeiss,* as they are called in Pennsylvania German, are also traditional quilting designs.[24]

This particular pattern has a variety of names in different publications. The *Ohio Farmer* in 1898 called it Dutchman's Reel at a time when "Dutchman" was American slang for a German or Deutsch-speaking man. In 1929, Ruth Finley called it Flyfoot in her book *Old Patchwork Quilts and the Women Who Made Them.* (She noted that the word was a vernacular adaptation of the similarly spelled "fylfot," a design element similar in appearance to the swastika, or a Greek cross with arms at forty-five-degree angles. The fylfot had been a staple image in English heraldry as well as in other cultures.)

The cottons reflect the common clothing fabrics of the time: shirtings in white with small figures, the nostalgic chrome yellow prints so popular with Pennsylvanians, and, in particular, a double pink to enliven the whole palette. A double pink is defined as a printed cotton with two or more shades of pink in the figure. Double pinks often include white figures, too, through specks of cotton fabric left uncolored. If much of the white background is visible, the pink is pale. With three or four shades of pink and little visible white, as in the double pinks of this quilt, the fabric is quite vivid.

Double pink is the term textile printers used. The Cocheco Printworks in 1886 referred to sample card swatches as "double pink," and a French technical manual described it as *rose double* in 1846. Printers also called the prints by the number of shades, such as three reds or four pinks. Today quilt historians tend to use the name double pink for all these closely related pink prints, whether two shades or five. Other contemporary descriptors are cinnamon pink, strawberry pink, and bubblegum pink.

The customers who bought the fabric over a hundred years ago used a variety of names. We find "old rose" and "rose pink" in the popular press. Other

FIG 1-11. Dutchman's Reel, *detail.*

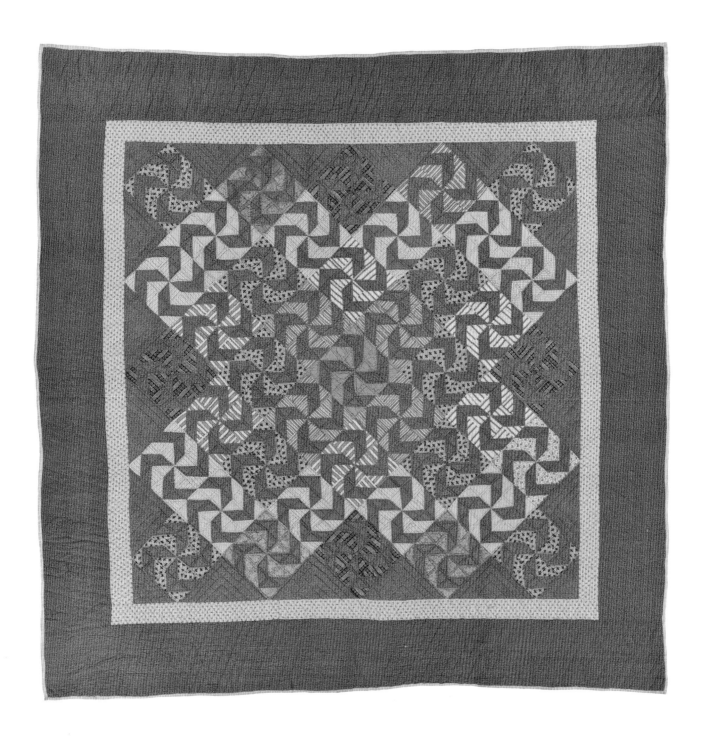

names are "seaweed pink," because the figures resemble coral and algae, and "Merrimack pink," because the mills in the Merrimack River valley of New England printed the fabric for so long.

The quilting here is typical late nineteenth-century utility quilting, a combination of parallel lines formed into diagonals, grids, and chevrons.

■ **Barbara Brackman**

PLATE 1-8. Dutchman's Reel.
Maker unknown.
Probably made in Pennsylvania, 1880–1900.
Cottons, 66.5" x 66". QSPI: 6.
2003.003.0182. *Jonathan Holstein Collection.*

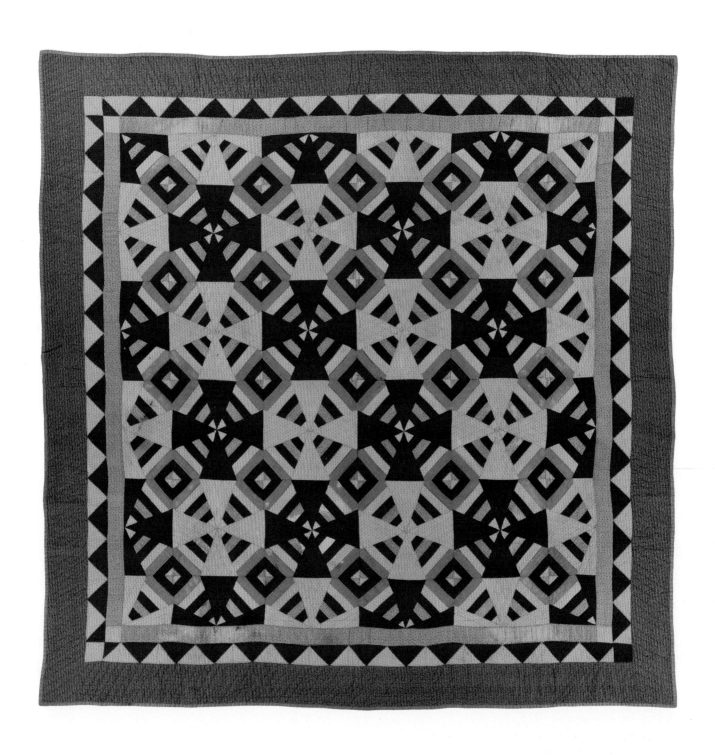

PLATE 1-9. Spider Web.
Maker unknown.
Probably made in Pennsylvania, 1890–1910.
Cottons, 82" x 81.5". QSPI: 5-7.
2003.003.0189. *Jonathan Holstein Collection.*

Working within a limited primary palette, the maker of this Spider Web quilt (plate 1-9) created a masterpiece, one of the type of quilt that joins shapes, assembled first in blocks, to create large-scale, optically active surfaces. The pattern is a variation of one known as Spider Web or Kaleidoscope, but the overall effect is far more visually striking than the usual scrap versions.

While the block construction method facilitated the design of pieced quilts, such successful results required sophisticated manipulations of color and shape. Analysis of the seams in the blocks indicates a grid of sixteen full blocks framed by a ring of sixteen half-blocks along the periwinkle border. The blocks are shaded in counterchange fashion, with the darker Turkey red alternating with lighter chrome yellow blocks. The calicoes include a double pink print for the border and two varieties of the light blue that was so popular in southeastern Pennsylvania at the beginning of the twentieth century. Like the lively double pinks composed of several shades of a single hue, these double blue calicoes were inexpensive to print. The blue dye is possibly a mineral dye, Prussian blue, liable to fade when washed with a strong alkali soap. The blues here are spotting to white, and one piece has completely lost its color.

Double blue prints in a periwinkle or blue-violet shade were particularly popular for clothing for men, women, and children, and thus with quiltmakers, in the 1870s and 1880s. When fashion moved on to darker and grayer indigo blues in the 1890s, the bright double blues disappeared from patchwork quilts everywhere but in southeastern Pennsylvania. In certain small areas, where quiltmakers were likely to piece saturated colors side by side without using a shirting print or plain white as a neutral, they relied on that blue-violet to complement the chrome yellows, chrome oranges, double pinks, and Turkey reds. Some even seemed to view the blue-violet as a neutral shade, and we find it used as background for late nineteenth-century appliqué, a vision that quiltmakers in other places did not share.

The blue is so common in southeastern Pennsylvania that collectors today call it Lancaster blue, after the county home of some of the more graphic quilts. Apparently, fabric mills, willing to cater to a small but loyal customer base, continued to print double blue

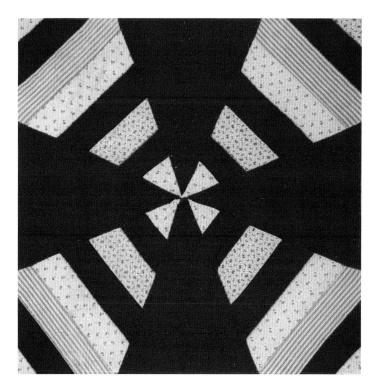

FIG 1-12. Spider Web, block.

yardage for the dry goods stores there long after fashion elsewhere had changed.

Another strong clue to a Pennsylvania origin lies in the quilt's backing, pieced of eleven long strips of pink, green, and yellow calicoes. Strip quilts and strip backs had once been popular with mainstream American quiltmakers, but after the Civil War the strip format, never a major setting style, was completely replaced by a focus on the block grid. Again, the exception is southeastern Pennsylvania, where strip backs and some strip settings for quilt tops continued into the twentieth century.

A triple border of two plain strips and one pieced of triangles is similar to the border on Viola's Wild Goose Chase quilt (plate 1-16). Although acquired by different collectors from different sources, these two quilts share an affinity that suggests a common regional origin. More than just a striking palette and skillful pattern manipulation, the makers of these quilts exhibit an uncommon design expertise.

■ **Barbara Brackman**

The formal rhythms in this Square in a Square quilt (plate 1-10) derive from two different but closely related blocks that create complex secondary designs when they are combined. The visual effect of such light and dark interlocking geometric forms is often, as here, one of grids that advance and recede as the quilt is observed. The eye catches one pattern only to lose it to another. The blocks, which are set on point, on a diagonal, are assembled stacks of squares. The more complicated pattern block is a square inside a square times five. The gradually larger series of triangles gave the maker an opportunity to show off a fine collection of oil calicoes, the small prints so popular with quiltmakers in the decades around 1900. She began in the center with a dark blue and progressed through a red square, a yellow, and a double pink and finished the blocks with either a green or blue-green fabric. The simpler setting block, a blue-green print pieced into a Turkey red square, adds a layer of depth to the design and a unifying grid to the composition. The published pattern names, a bit prosaic, are Scrap and Triangle Design. Quiltmakers might call them both variations on the Square-in-a-Square construction.

The quilting is in a variety of patterns, including chevrons and a grid with a simple geometric design based on heart shapes. The border is quilted with a triple cable pattern; such interlacing curved lines were especially popular in Pennsylvania with many different ethnic groups after 1850.

The quiltmaker used two different but very similar versions of a green calico that arguably qualifies as the most common print fabric found in American quilts. The folklorist Jeannette Lasansky, analyzing the findings of a quilt documentation project in central Pennsylvania, observed that the green print existed over a sixty- to seventy-year period, noting a quilt inscribed "1857" as well as many examples made up into the 1920s. Lasansky wrote, "The minute changes exhibited in similar looking fabrics were phenomenal."[25]

A version of the oil calicoes marketed by late nineteenth-century fabric mills, this stereotypical green print was classified by some Pennsylvanians as a "quilting calico." The historian Nancy Roan recalled that her mother used those words to describe inexpensive cottons manufactured specifically for quilts. They were not as colorfast and they did not wear as well as dress calicoes. It may be that a good deal of the yardage in the bright greens and chrome yellows here, which were popular for quilts but not for clothing, were considered quilting fabrics over a number of generations. Roan found mention of quilting calicoes in store ledgers dating to 1833 and 1848. Ellice Ronsheim, researching for the Ohio Quilt Project, found an advertisement in the *Cleveland Herald* in 1849 that distinguished between dress prints and quilt prints. After descriptions of several dress fabrics, a separate line offered "Green and Yellow Prints for Quilts."[26]

The maker assembled this quilt completely by machine. We could find no evidence of hand stitch-

FIG 1-13. Square in a Square, pattern block.

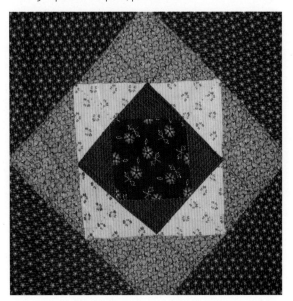

FIG 1-14. Square in a Square, setting block.

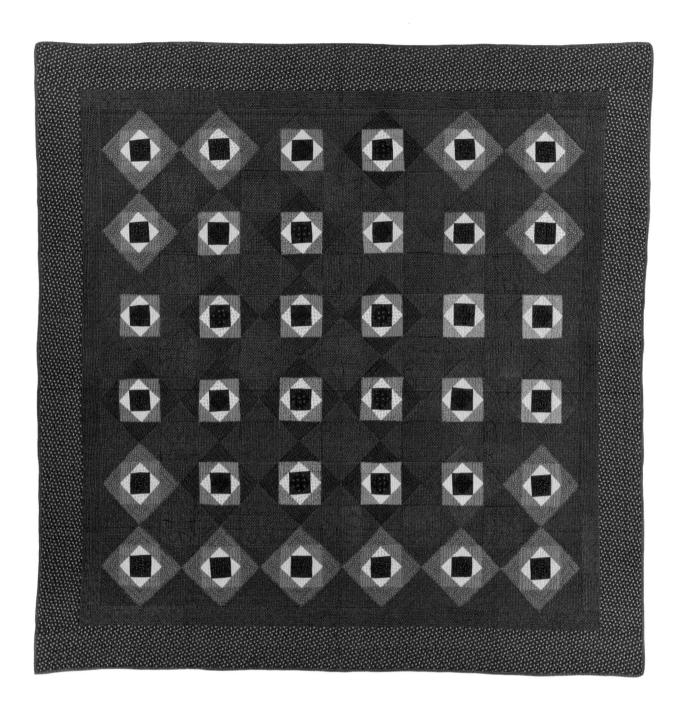

ing in the patchwork or setting seams. A good many quilts made at the turn of the twentieth century include both hand-sewn and machine-sewn seams. Most seamstresses persisted in hand-piecing the patchwork blocks and used the machine for the long seams in settings and borders. The facility afforded by sewing machines appears to have affected the overall look of some quilts through the addition of plain strip borders, single, double (as in this example), or triple strips being a rather weak clue to a quilt made after 1870.

■ **Barbara Brackman**

PLATE 1-10. Square in a Square.
Maker unknown.
Possibly made in Pennsylvania, 1890–1910.
Cottons, 79.5" x 79". QSPI: 9-10.
2003.003.0298. *Jonathan Holstein Collection.*

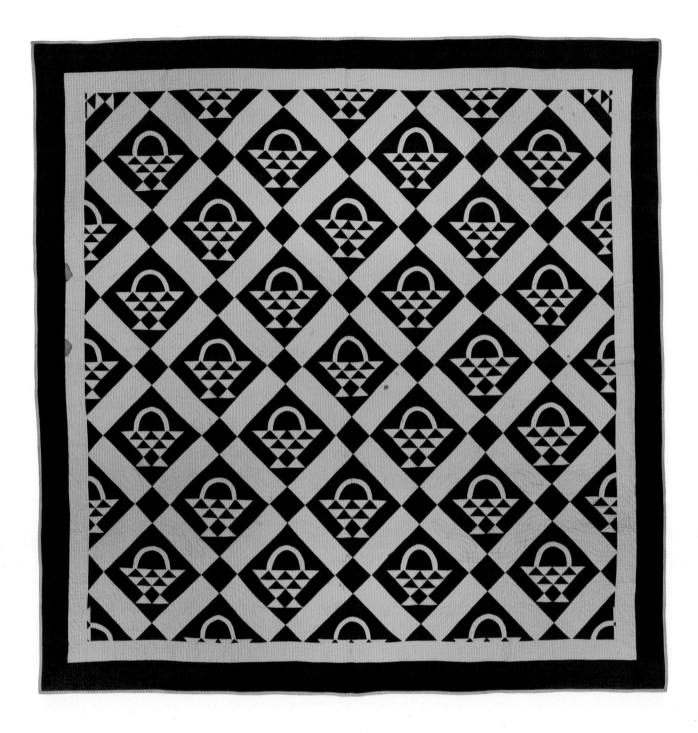

PLATE 1-11. Baskets.
Maker unknown.
Probably made in Pennsylvania, 1890–1910.
Cottons, 95.5" x 95". QSPI: 8.
2003.003.0345. *Jonathan Holstein Collection.*

Such exceptionally graphic quilts as this Baskets (plate 1-11) often have a simplified color and design format. Here, the maker chose a rather unusual two-color palette of solid madder brown punctuated by vivid chrome yellow baskets. It is also unusual in that the maker reversed a quilt design convention by laying light baskets atop a dark background. The quilt's style—flat areas of contrasting color, bold ge-

ometry, and rhythmic repetition of the abstract baskets—appeals to a generation of collectors raised to appreciate Modernism. Yet the quiltmaker was likely a woman without interest in new trends, someone considered old-fashioned in her dress and conservative in her habits and religion. Though we know nothing factual about the life of its maker, the quilt's style gives us a few clues as to where she lived and her probable religious affiliation.

Quilts like this one, with a vivid palette, multiple borders, contrasting binding, and pieced blocks separated by plain sashing and set into a diagonal grid, are characteristic of the work of women of German ancestry and Anabaptist Protestant faith. The quilt scholar Ricky Clark notes that the style was a favorite among people she describes as "Germanic Sectarians," conservative Protestant communities that set themselves apart from mainstream culture. The Amish and Mennonites are the best-known of these American sects, who generally call themselves Brethren.[27]

Clark was writing about Ohio quiltmakers, but the sectarian communities and this characteristic style were found in a broader region; the style was particularly popular in Pennsylvania (where the quilt was collected) from about 1850 to 1950, and also in states farther west, where emigrating Amish and Mennonites maintained traditional ways. This quilt features the standard wide outer border with a narrow inner border typical of many Amish and Mennonite quilts, a format idea that has become the favored border style among mainstream quiltmakers working at the turn of the twenty-first century. The notion of adding a contrasting binding, an echo of a color used in the central field, is also popular with today's quiltmakers, who see their bindings as a final visual frame.

The pieced basket with appliqué handle, a representation of a common household container, is identical to one published on September 2, 1899, in the agricultural magazine *Orange Judd Farmer* as the Basket Quilt. The maker may have found her pattern sketched there; however, observation indicates that pieced baskets had begun to appear in sampler quilts in about 1850, and the design likely had been handed from seamstress to seamstress for decades. Once treadle sewing machines became widely available in the 1870s, patterns with lots of seams, such as baskets, became especially popular. Treadle machines, unlike later electric machines, were acceptable in most Ana-

baptist communities. The quiltmaker here followed mainstream fashion by hand-piecing the triangles in the basket and appliquéing the handles by machine. This celebration of the machine stitch confuses some of today's quiltmakers who consider themselves traditionalists. Many would approach this pattern in the opposite manner, hiding the machine work in the seams of the triangles and using a hand stitch to attach the handles. But nineteenth-century quiltmakers were proud of their machines and the stitches they produced.

The combination of curved elements with the rigid straight-edge geometry of normal block design is usual for basket designs, but quite rare otherwise. The increased difficulty of sewing such curved elements means there were often some variations in the handles. These slight breaks in the rigid regularity of the design often add, as here, subtle but pleasing visual touches. The grid formed by the sashes with squares at the intersections is extremely powerful, and it may be some time before the viewer notes the idiosyncratic basket sections that form the outermost images at the edge of the quilt.

■ **Barbara Brackman**

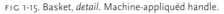

FIG 1-15. Basket, *detail*. Machine-appliquéd handle.

ue to clever diagonal placement of dark and light materials and the number of square pieces and varieties of fabrics, this Split Nine Patch quilt (plate 1-12) looks at first glance to be unique and complicated patchwork. Analysis of the design repeat by isolating the simplest construction unit, a nine-patch block, reveals, however, that it is not a one-of-a-kind idea but a sophisticated variation on a regional standard. It is one of the type that uses contrasting shape and color to create overall grid patterns that can constantly shift visually, moving forward and back and, often, also diagonally. The effect of movement may, in fact, be quite disconcerting as the eye tries in vain to find a single, overall stable design.

As published quilt patterns became the standard source for quiltmakers around the nation at the beginning of the twentieth century, women in Germanic communities in southeastern Pennsylvania and nearby areas developed pattern and coloring ideas neither influenced by the popular press nor recorded by publishers looking for pattern ideas. More than just the brainchild of one inspired quiltmaker, a few patterns became regional styles.

One of the most distinctive of the regionalisms is this Split Nine Patch variation. Rather than the usual nine equal squares, the pattern requires that two squares be constructed from two half-square triangles, one dark and one light. Due to the placement of those split squares at opposite corners of the Nine Patch, the block can then be shaded into a dark half and a light half, similar to the Log Cabin designs so popular between 1870 and 1910. A central square, as in the Log Cabin block, is often colored red, as here. And, as in Log Cabin quilts, blocks can be set side by side to create a multitude of overall patterns, echoing the Log Cabin's concentric diamond settings called Barn Raising or the linear arrangements called Straight Furrow and Streak of Lightning.

In the early 1980s Nancy Roan and Ellen Gehret, studying quilts in their own Pennsylvania neighborhood, a region called Goschenhoppen by the locals, heard about variations of the Split Nine Patch. In two books on quilt folklore, the Goschenhoppen historians explained the subtleties. Local quiltmakers see the overall pattern as a metaphor for the hills and valleys of the Pennsylvania landscape, with different arrangements called Perkiomen Valley, Center Valley, Road to Collegeville, or Road to California (California

in this case being a town in Bucks County). The patterns were not drawn on paper; instead, makers took the patterns directly from other quilts. As one told Roan, "You need one to make one."[28]

Perkiomen Creek runs southeast from Allentown, Pennsylvania, to Maryland, but the Split Nine Patch quilts cover a broader area. Gehret and Roan found the design in Montgomery, Berks, Lehigh, and Bucks Counties, Pennsylvania, places long home to Pennsylvania German folk traditions. The New Jersey Quilt Project also found variations in northwestern New Jersey, calling it "a modest New Jersey trend." Names they found included the block name Hayes Corner. As in Pennsylvania, most of the quilts were made between 1900 and 1925.[29]

Among the regional conventions of the design is the requirement that the quiltmaker piece one hundred blocks and arrange the design in a ten-by-ten grid, a goal more than doubled in this quilt to include 224 five-inch blocks. The particular setting that creates this overall design isn't found in other sources. The layout might best be called Light and Dark because of its similarity to a classic Log Cabin setting by that name.

The fabric, as in most of the Split Nine Patch quilts, contrasts light shirting prints and chambrays with darker indigos and blacks, common everyday clothing materials of the period. Some of the solid-block centers appear to be a Turkey red; although not a common clothing fabric, it was a standard for quiltmaking. The 1925 mail-order catalog from Sears, Roebuck

FIG 1-16. Split Nine Patch, block.

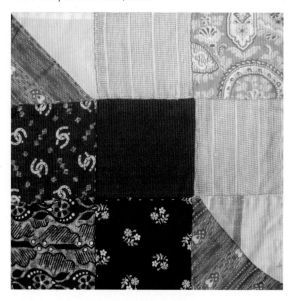

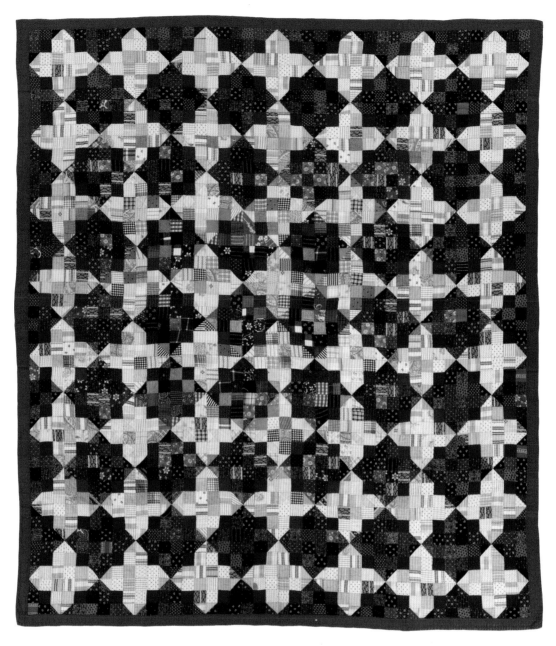

PLATE 1-12. Split Nine Patch.
Maker unknown.
Probably made in Pennsylvania or New Jersey, 1890–1940.
Cottons, 84" x 74". QSPI: 5-6.
2003.003.0129. *Jonathan Holstein Collection.*

and Co. advertised "Turkey red calico. All women who make patchwork quilts know this good cloth. The bright cheery color forms needed contrast to make patchwork designs stand out sharply." Solid Turkey red fabric, which has a subtle bluish cast, wears in a distinctive manner: the outer coloring of each yarn gradually abrades, revealing the white inner shaft.

Aside from this long-term abrasive wear, Turkey red did not fade from light or bleed in water, characteristics that encouraged quiltmakers to pay a premium price for authentic Turkey red material.

Dating the quilt top is relatively easy. Style, patchwork pattern, and fabrics agree on the period 1890 to 1925, but the border may have been added later.

Although a solid red, it does not match any of the Turkey red block centers, nor does it have the distinctive bluish cast of that dye. It likely is one of the many synthetic reds that were available around the turn of the century. The backing fabric, a black-and-white sprigged print, looks to be from the 1930s, indicating that it may be an older top that was quilted later.

Assigning a place of origin is also relatively uncomplicated. In the New Jersey Quilt Project's 1992 book, the authors speculated that once quilt historians were alerted to the Split Nine Patch style, "it will be reported in areas other than the adjoining states of New Jersey and Pennsylvania."[30] Yet, more than a decade later, no other places where it was popular have been reported.

■ **Barbara Brackman**

PLATE 1-13. Square in a Square.
Maker unknown.
Possibly made in Illinois, 1900–1920.
Cottons, 74" x 70". QSPI: 7.
1997.007.0181. *Ardis and Robert James Collection.*

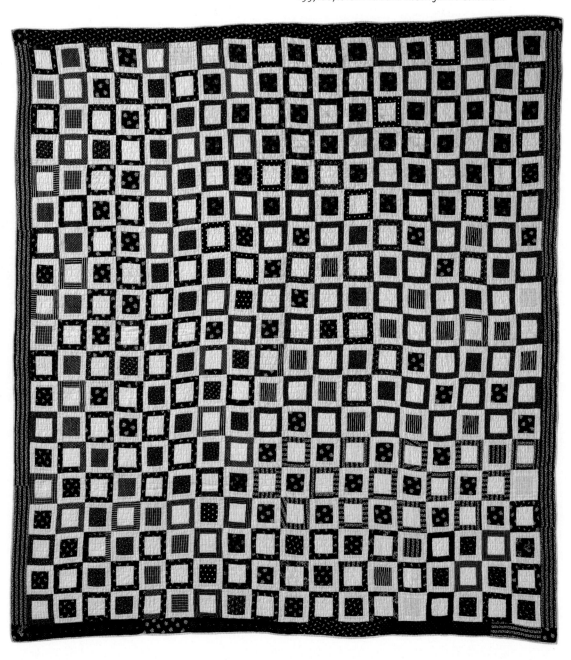

American quiltmakers often employed the simplest of means to produce sophisticated visual results. This superb example is a square within a square in blue and white only (plate 1-13). The basic design can be seen as a form of the classic Log Cabin, but the block challenges the definition. Doesn't a Log Cabin require at least two rows of "logs" around the center square? With only a single row, is this merely a generic Square in a Square?

The block is so basic it doesn't seem to have been published in the era's literature, yet the design itself was relatively popular, especially for utilitarian quilts made up of clothing scraps. To use the terminology of the twentieth-century quiltmakers of Gee's Bend, Alabama, this minimalist Log Cabin block is not "a book pattern" but is related to the concentric squares of a block called Housetops. African American quiltmakers in Gee's Bend, among other places, have stitched many variations.[31] My observations indicate that different renditions of the Housetops design have been made by women in other isolated communities; one prominent example is Ohio's Amish country.

Although kin to many less sophisticated cousins, this particular example, with its 342 hand-stitched blocks, each finished to three and a half inches, is a triumph of simple pattern and color that create a remarkable illusion of movement. It is hard to believe that the blocks are the same size. The alternating value of the center square makes the blocks appear to shrink and expand as the eye moves around the composition. This phenomenon is a result of counterchange, the design principle in which dark figures on a light ground are juxtaposed with light figures on a dark ground. What's dark in one block is light in the next.

The variety in the indigo blue calicoes is typical of the 1890–1920 period, when quiltmakers took advantage of the increasingly common and increasingly inexpensive indigo dyed and printed fabrics.[32] This vat dye, which colors fabric various shades of blue, is so lightfast and vibrant that trade in the natural form of the dyestuff was once a vital product in the world economy. This changed toward the end of the nineteenth century as German chemists synthesized the colorant in 1879 and a successful commercial production process for it was achieved in 1897.[33] Shortly after this, commercial growing of indigo ceased; India, which had dominated the world market in natural indigo, quickly lost a cornerstone of its economy.

FIG 1-17. Square in a Square, *detail*.

Another, more important development in the production of indigo fabrics occurred in the 1880s. In 1883, the invention of the glucose process for the *direct* printing of indigo likely contributed more to the greater variety of inexpensive blue calicoes than did the synthesis of indigo. With the glucose process for direct printing, textile printers finally had a dependable method available to produce dark blue indigo prints in a more economical and efficient manner than either discharge or resist indigo printing methods previously allowed.[34]

These advancements caused American quilts to become bluer by the early 1900s. Cheaper prints meant more blues in the scrap bag, more blues bought specifically for quilts, and more variety in the prints. American mills printed much of our indigo cotton, but the dyes were primarily German. When the outbreak of the First World War in 1914 put an end to the supply of German dyes, small American mills that specialized in the cloth were forced to diversify or close. Note that several swatches in this quilt contain faded browns and pinks that were probably once blue, possibly indicating the presence of other synthetic blue dyes, some of which were not as colorfast as either natural or synthetic indigo.

■ **Barbara Brackman**

FIG 1-18. Sampler Album, *detail*. Unidentified basket and hourglass designs.

The state of quiltmaking at the beginning of the twentieth century is nicely represented in this Sampler Album (plate 1-14). The forty-two different blocks are a design workbook of piecing and appliqué, although any sewing lessons learned here might only be cautionary. The maker's needlework skills are merely adequate, as demonstrated by her very simple utility quilting, and her cottons were not first quality. Yet the awkwardness of the appliqué and the skewed seams result in a primitive quality that is appreciated today by aficionados of American folk art. The unknown maker's grandmother, raised before the sewing machine age, might have frowned on the needlework, but any of the maker's granddaughters, decorating in contemporary "country style," might consider the quilt a folk art treasure.

Most of the pieced-block designs can be found in the publications of the day, which diagrammed the Bow Tie, Jacob's Ladder, and Drunkard's Path. Two exceptions are the red-and-white basket in the lower right and the hourglass design to its immediate right. The pattern choices are simple designs, what today might be classified as beginner blocks. There is some thought that these blocks are the work of children, which could be true. In earlier generations, children's sewing was closely supervised; careless stitches were ripped out and techniques practiced until girls were proficient. But by the 1890s, generations raised with a sewing machine in the house acquired fewer hand-sewing skills. Therefore, it's just as likely that an adult with little talent or experience with sewing made the quilt during a time when needlework skills were at a low ebb and the impressive patchwork and quilting styles of earlier decades were the exception.

Because appliquéd quilts had fallen from favor in the late nineteenth and early twentieth centuries, this sampler is unusual for its time in the inclusion of appliqué designs among its blocks. One can criticize the appliqué—the curves lack grace, the flowers lack naturalism, and the symmetries are awkward—but each block, particularly the appliquéd cabin in the center area, has an undeniable charm.

The sampler also reflects the lower standards for fabric at the time. Cottons were inexpensive, with manufacturing costs kept low by sacrificing the quality of yarn and intricacy of printed designs. The cotton prints we most often see in quilts made during these years were minimally designed, with little detail or skill in the renderings, and employing only one or two colors per print. Simple geometric and floral figures were the dominant subject matter. New synthetic dyes, like that used in the blue-green sashing here, were often unreliable, prone to fade with light or laundry. Harriet Robinson, a cotton mill worker, spoke for her generation in 1898: "As for cheap American prints, who prefers to buy them nowadays? Certainly no woman who remembers with affection the good, pretty, durable and *washable . . .* old time calico."[35]

■ **Barbara Brackman**

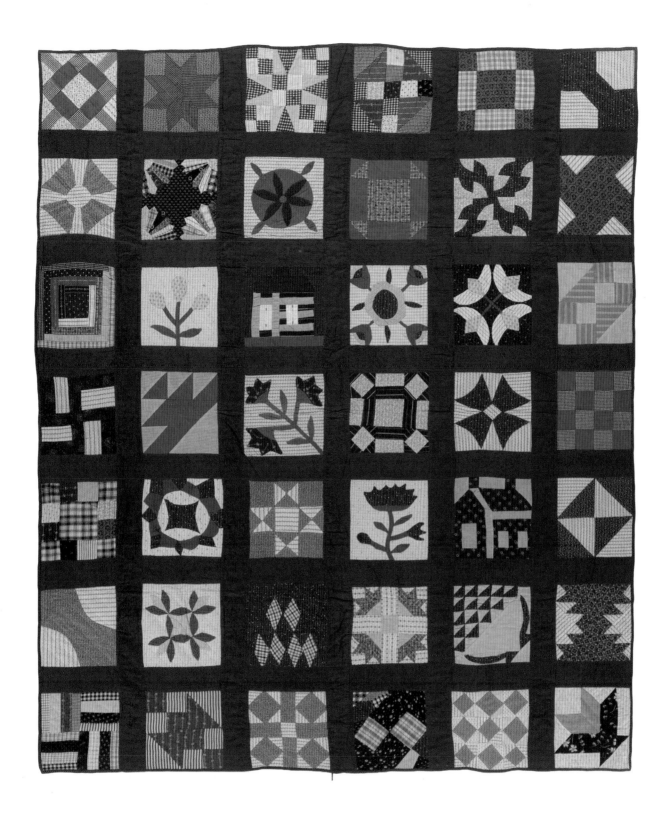

PLATE 1-14. Sampler Album.

Maker unknown.

Possibly made in Pennsylvania, 1900–1920.

Cottons, 80" x 68". QSPI: 6.

1997.007.0338. *Ardis and Robert James Collection.*

PLATE 1-15. Hearts and Gizzards.
Maker/location unknown, 1900–1920.
Wools and cottons, 72" x 68.5". Tied.
2003.003.0212. *Jonathan Holstein Collection.*

he collector Jonathan Holstein named this quilt
Gothic Windows, seeing in it a "pattern de-
rived from the Gothic motifs which were re-
popularized in the nineteenth century"[36] (plate 1-15).
The maker may have intended that effect. The richly
colored quilt has the look of the stained glass windows
in country churches built in the vernacular style called
Carpenter Gothic. The quilt pattern is commonly done

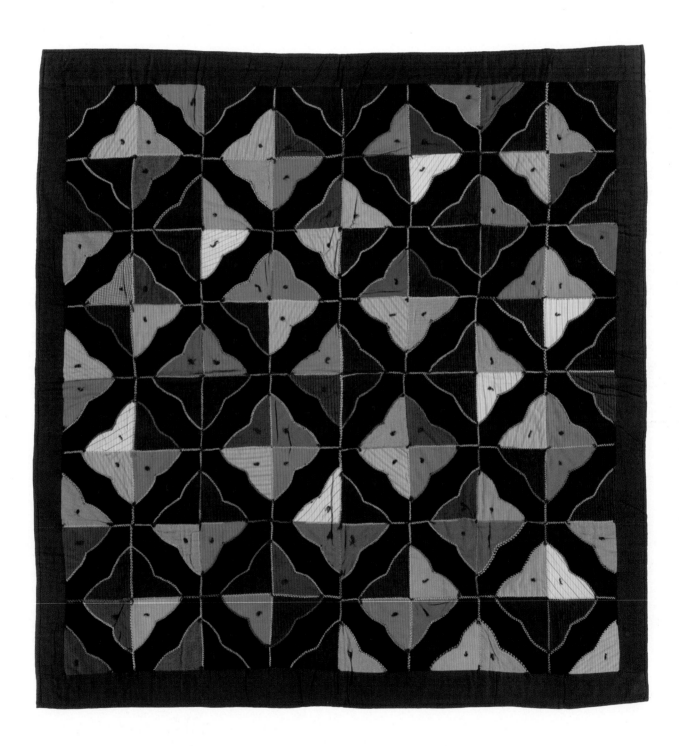

up in cotton, where it is called Hearts and Gizzards, a rather down-to-earth name given it by the Ladies Art Company in an early catalog of about 1890.

Although unusually graphic in design, this quilt is typical in construction and materials of the time when wool quilts with embroidered embellishment were popular utility bedding. The quiltmaker used a variety of everyday woolens with a cotton scrap or two in the mix.

The fashion for wool quilts was a response to the industrialization of American woolen production. During the eighteenth and into the nineteenth centuries, England dominated world woolen production with time-tested systems relying on hand weaving. The processes of woolen production—the picking, carding, and combing of the raw product, the spinning of the yarn and the weaving, and the dyeing and fulling (finishing) of the fabric—were more difficult to mechanize than processes used for cotton.[37] In the early nineteenth century, the United States focused on cotton production as its primary textile industry.

During the 1850s, however, change was on the horizon as power looms replaced hand weavers for woolen production in the United States.[38] Civil War cotton shortages and a need for inexpensively manufactured uniforms soon increased factory-woven woolen fabric and factory-made clothing. By the beginning of the twentieth century, off-the-rack clothing was commonplace, much of it made from American cottons or woolens. Many of these end-of-the-century commonplace woolens tended to be rather coarse.

To stitch this quilt from her supply of inexpensive woolens, the seamstress used the piecing technique we call foundation piecing or pressed patchwork. She began with a backing square of cotton cloth cut to the size of the block. She then basted or pinned two different-colored woolen pieces in opposite corners. She laid the black "gizzard" atop and secured it with a machine stitch, finally covering the machine stitch with hand embroidery.

The foundation patchwork technique, particularly popular in Log Cabin and Crazy quilts, developed about the time of the Civil War, when seamstresses had scrap bags full of fine imported wool and silk fabrics from their wardrobes. Although cotton fabrics are easily assembled into blocks using conventional piecing techniques, silk satins and wool challis, delaines, and similar fabrics have more of a tendency to stretch,

FIG 1-19. Hearts and Gizzards, block.

slip, and fray than cottons when pieced with a running stitch by hand or machine. Building the block over a fabric foundation eliminates most of the construction problems. As coarse domestic woolens became available at inexpensive prices, quiltmakers adapted by using the heavier woolens in their foundation patchwork (see, for example, plates 3-31, 3-32, and 3-34).

The decorative embroidery covering the seams features a linear design in a variety of colors. The fad for foundation-pieced Crazy quilts that developed in the 1880s created a corresponding fashion for embroidery-covered seams, a taste that reflected the late Victorian penchant for adorning any straight line, from cottage gable to parlor mantel. The stitch here is generally called the feather stitch or briar stitch, the most common of the many decorative stitches used in Crazy quilts. In March 1886 Mary Dodge Woodward, caught up in the latest fad, wrote to a friend, "I have made two crazy blocks which just suit my addled brain. My writing resembles feather-stitching and French knots."[39]

For all its decorative energy, this quilt was intended to be a utilitarian comforter. It is tied with wine-red yarn, a typical finish for heavy woolen bedding. There may be another quilt inside this one, serving as the batting. It weighs quite a bit, and one can feel the outline of another binding inside the top.

■ **Barbara Brackman**

This dazzling Wild Goose Chase quilt (plate 1-16) is signed and dated in the quilting in the outer border "Viola / Nov 29 / 1902." It is likely that Viola was the maker, but it is possible she was the lucky beneficiary of a gift. An inscription is always a pleasant surprise. We are particularly fortunate here because quilts such as this, made of plain-colored cottons, are difficult to date. Fabrics such as the red, probably dyed using the Turkey red process, appear in patchwork from about 1840 to 1940, offering few clues to a specific time period. White cotton is even less useful because it is commonly found in the first American patchwork of the 1770s through quilts finished just yesterday. The chrome orange fabric narrows the options; this mineral dye was used widely from about 1840 to 1910. The green, likely dyed with a synthetic dye that became widely available in about 1880, is our most helpful clue, indicating a date from about 1880 to 1940. The overlaps in the time spans of the four fabrics might give us a vague date of 1880 to 1920, but Viola was kind enough to narrow the date to the fall of 1902.

Although her choice of fabric might have offered little help to experts interested in dating quilts, her decision to use plain colors is a stroke of good luck

FIG 1-20. Wild Goose Chase, block.

for fans of graphic quilts. Her composition is a striking example of a design guideline that seems to have been communicated among quiltmakers working at her time: simple fabrics plus complex patchwork equals effective composition.

Viola was working in the era of the magazine pattern, yet a search through pattern indexes reveals nothing quite the same as her design. Similar arrangements of triangles and squares were given names such as Wild Goose Chase and Railroad Crossing, but even in a time of complex patterns, this is an exceptionally complex design and illustrates the ease with which square block designs could be manipulated for visual effect. The best way to analyze it is to grid it into sixteen large four-patch blocks, each with a central pinwheel. The large blocks are made up of four smaller units, an X with two red sides and two yellow. Her careful arrangement of the units results in a design that jumps back and forth between negative and positive space. Our eyes can focus on the grid of white geese or the red and yellow shapes with a sawtooth edge. A triple border, two plain and one pieced, frames her composition.

The quilting is utilitarian, a grid of lines and small links of leaf-shaped lozenges in the plain-colored borders. The quilt marking, a heavy pencil line, remains in areas, indicating that the quilt has not been washed or used to any significant degree. The fact that the green is still vibrant is another indication that the quilt hasn't been washed or exposed to a good deal of light. The dark bottle green, probably colored with a synthetic dye, is common in end-of-the-century quilts, but one doesn't often find it in its original shade. Like many early synthetic dyes, it is prone to fade to a dun color, a tan. Many of the red, yellow, and (now) brown quilts that survive once had the vitality of this red, yellow, and green design.

By 1902 synthetic dyes had been available for nearly half a century. The Englishman William Perkin discovered the first synthetic coloring agent in 1856 as a chemistry student hoping to duplicate the medicine quinine by manipulating coal gasses in the laboratory. He accidentally produced a dark powder that could color a piece of silk a brilliant purple and turned his research focus to dyes. He marketed this first aniline dye as *mauve*, from a French word for purple, and opened the door to laboratory manufacture of medicines, flavors, and fibers as well as color. Initially, syn-

thetic dyes were used only for coloring expensive silks and woolens, but by the 1880s they began also to replace the natural dyes in cottons. The red fabric used here may have been dyed in the Turkey red process using synthetic alizarin instead of madder, or it may have been colored using one of many new synthetic red dyes available. It is impossible to determine without expensive chemical analyses.

■ **Barbara Brackman**

PLATE 1-16. Wild Goose Chase.
Made by or for "Viola."
Possibly made in Pennsylvania, dated November 29, 1902.
Cottons, 89.5" x 88.5". QSPI: 7.
1997.007.0521. *Ardis and Robert James Collection.*

PLATE 1-17. Kansas Sunflower.
Mary Adams Abercrombie (1832–1909),
Ella Abercrombie Harnan (1867–1963),
Ruth Harnan Gutherless (1904–2004), and
Gayle Gutherless LeGrand (1932–).
Made near Gothenburg, Nebraska, 1905–1965.
Cottons, 89" x 77". QSPI: 5-8.
2004.012.0001. *Gift of Gail LeGrande.*

Four Generation Quilt
1905 — 1965

This quilt was pieced by Mary Adams Abercrombie sometime before her husband died in 1907.
The pattern is the Kansas Sunflower or Noonday.
Made no doubt from the scrapbag pieces.

Mary Abercrombie
1832 - 1909

Ella Abercrombie Harnan set the circles in red, then sashed the top.
Date unknown. She chose the red, green & orange fabrics.

Ruth Harnan Gutherless held a quilting bee in her home to quilt this piece. Notice the different size stitches. About 1940

Ella Harnan
1867 - 1963

Ruth Gutherless
1904 - 2004

This quilt was made in Lincoln County, Nebraska out on a cattle ranch miles from town.

The quilt was given to me by my mother to bind. I did this about 1965. At the time we lived in Minn.

Gayle Gutherless Le Grand.

Gayle Le Grand
1932 -

A quilt with such detailed provenance as this Kansas Sunflower (plate 1-17) is rare. The donor, Gayle Gutherless LeGrand, inherited the quilt from her mother, Ruth Harnan Gutherless, who received it from her mother, Ella Abercrombie Harnan, whose own mother, Mary Adams Abercrombie, started it around the beginning of the twentieth century. All four generations of women worked on the quilt, adding their own skills and sensibilities to the final piece. Begun by Mary Abercrombie on a cattle ranch in Lincoln County, Nebraska, the quilt was finished by Gayle LeGrand in Minnesota around 1965.

In addition to knowing this family history, the quilt itself tells us quite a bit about the time line of its creation. Many of the fabrics in the sunflower blocks are typical of the late nineteenth and early twentieth centuries; they feature vibrant, neon prints on black grounds, white prints on indigo and claret grounds, and woven plaids and ginghams, all of which were common from the 1880s through the 1920s. These blocks point to Mary Abercrombie as the maker. A few other blocks, however, display fabrics clearly from the 1920s and 1930s, one of which fiber microscopy revealed to contain rayon (rayon was not widely commercially available until the late 1920s). Some of these later Sunflowers are set into a slightly different shade of red for the background. These later sunflowers were probably made in the 1930s by Ella Harnan, who, perhaps wanting to make a larger quilt, decided to supplement with her own.

Construction techniques also vary among the blocks. Many of the early sunflowers were pieced by machine, reminding us that sewing machines were common in every type of household by the beginning of the twentieth century, even on cattle ranches in remote Nebraska. Most of the later ones, however, were made by hand, perhaps because Ella Harnan, influenced by the Colonial Revival, wanted to make a quilt the way early nineteenth-century women would have done it, or perhaps she simply preferred the hand-sewing method, especially with a pattern that is as difficult as this one to piece.

The round sunflowers were inserted into the red backgrounds by two different hand-sewn methods; one was to set the sunflower directly into the background by cutting a circle in the middle of the red fabric and sewing the sunflower into the hole, the other was to attach the background to the sunflower in quarter-circle segments, meaning that there is a small seam running out to the edge on each side of the block. There is no pattern to whether the early blocks or later blocks were put into the background using one method or the other. Family history tells us that it was Ella Harnan who set the sunflowers into the red backgrounds; if so, she must have started with one method, perhaps the more difficult one of using a whole piece of red for the background, then later on switched to the easier method of using four separate pieces of red to create the background.

Ella Harnan was also the one who machine-set the blocks into the bold orange-and-green-striped sashing, which meets at the corners in a Nine Patch. Her daugh-

ter Ruth Gutherless held a quilting bee around 1940 to do the quilting, evidence of which can be seen in the differing quality of stitches. Some of the quilting—most of which is "in the ditch" (right along the seam) or in a diamond pattern—is tight and even, while in other areas it is sparser and less consistent. Gayle LeGrand finished the quilt around 1965 by binding it with a bright orange that also matches the backing fabric.

We are lucky to have such a well-documented quilt in the Center's collections. In fact, we are lucky that the quilt still exists at all: in 1936, Ella Harnan's home near Brady, Nebraska, burned to the ground, but with the help of neighbors, she was able to save several household items, including the cedar chest in which this quilt was stored![40]

■ **Marin F. Hanson**

FIG 1-22. Kansas Sunflower, *detail*.
Block made with 1890s–1910s fabrics.

FIG 1-23. Kansas Sunflower, *detail*.
Block made with 1920s–1930s fabrics;
the green circle is a cotton-rayon mixture.

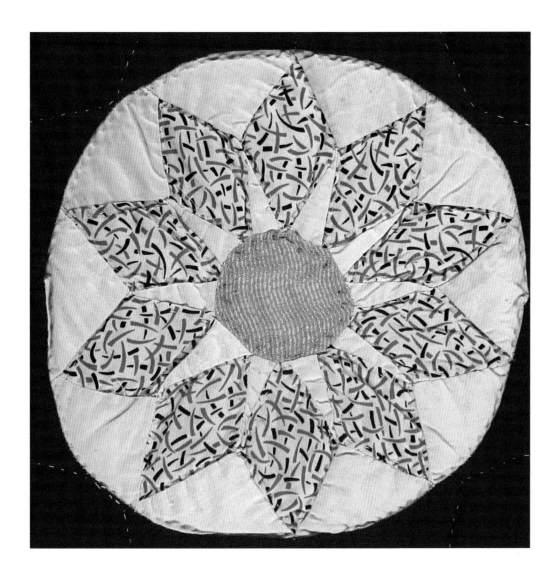

A serene blend of pastels and deeper shades, this quilt's style (plate 1-18) is typical of the first half of the twentieth century, when solid-colored cottons were the height of fashion and plain white backgrounds dominated the era's quilts. The colors are typical of those used during the period in much Art Deco design. The pattern, however, is unusual, one not found in the pattern archives, perhaps a creation of the talented seamstress, who was also innovative in her binding design, piecing together bias strips from the scraps left over from the blocks.

Although there is no provenance for this quilt, other than that it was found in West Virginia and the pattern is unique, it is easy to date. The rules that defined the look from the 1920s through the 1940s were unwritten, but they were so widely followed that quilts from that era are easily identified. Quiltmakers could use a controlled color scheme or a multicolored scrappy palette, but white was the prevalent background that united the composition. Enough white could tame the wildest color combinations, and the rule seemed to be that any color could go with any other color, as long as there was enough white.

We have no trouble seeing how important plain white cotton was to the look in this era, but it's difficult to explain the style's origins. It may have been functional. The large white areas echo those in fancy quilts from the mid-nineteenth century, when elaborate quilting designs were favored. During the 1930s, a revival of interest in fine quilting required space to show off the stitches.

The style may have resulted from technological changes in housework, especially the advent of washing machines and factory-produced soaps and deter-

gents. White showed the dirt, and a woman who could easily wash her bedding was more likely to choose lighter colors. Interior style, in general, changed as home economists and public health officials advocated white bedrooms and bathrooms so that dirt and soiling could easily be identified and eliminated. As people began to understand hygiene, the housewife was obligated to keep surfaces clean and germ-free. A crisp white quilt reflected her diligence.

Quilts and fabric also reflected trends dictated by twentieth-century decorators, particularly Elsie de Wolfe and Syrie Maugham. De Wolfe, a stylish actress, decided in 1905 to become an interior decorator, defining both a career and twentieth-century taste. She hated old-fashioned rooms of walnut, wainscoting, and velvet plush, saying, "I believe in plenty of optimism and white paint."[41] De Wolfe inspired Americans to throw out the Victorian antiques and paint the woodwork white.

Londoner Syrie Maugham, like de Wolfe, was a designer whose most interesting creation was herself. Taking de Wolfe's ideas to extremes, she created a dramatic "all-white room" in 1927. White walls, white carpet, and furniture in shades of pearl, putty, and oyster created a sensation on both sides of the Atlantic when the room was featured in *Harper's Bazar* in October 1929, inspiring white rooms for everyone from the Mellons to movie stars and many new brides. We can view her influence in the high-style movies of Mae West, Fred Astaire, and Myrna Loy. Although fashion arbiters might have determined that the fad was over by the mid-1930s, the trickle-down effect had hardly begun. White bedding and light quilts dominated bedroom style until the 1970s.

■ **Barbara Brackman**

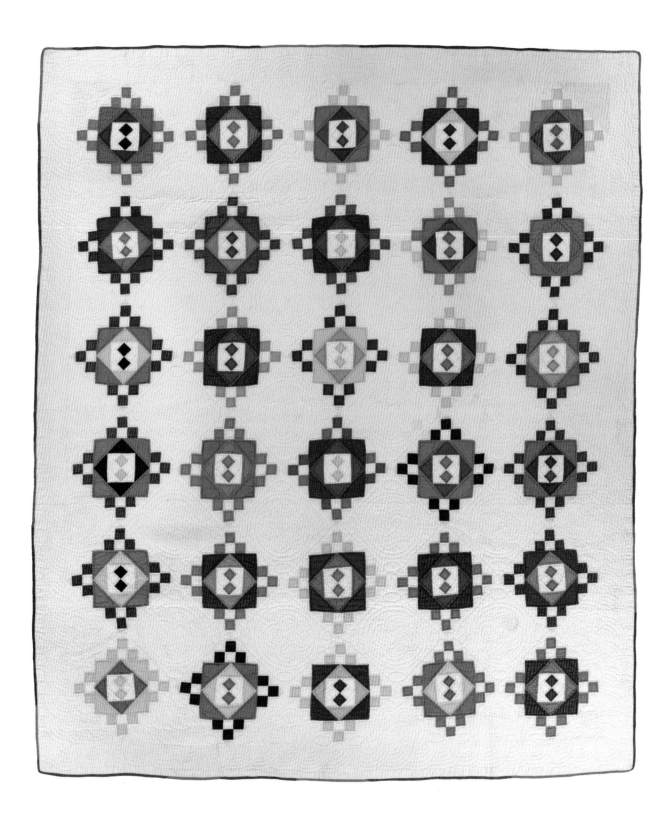

PLATE 1-18. Four Patch variation.
Maker unknown.
Possibly made in West Virginia, 1920–1940.
Cottons, 83" x 70.5". QSPI: 7-8.
1997.007.0176. *Ardis and Robert James Collection.*

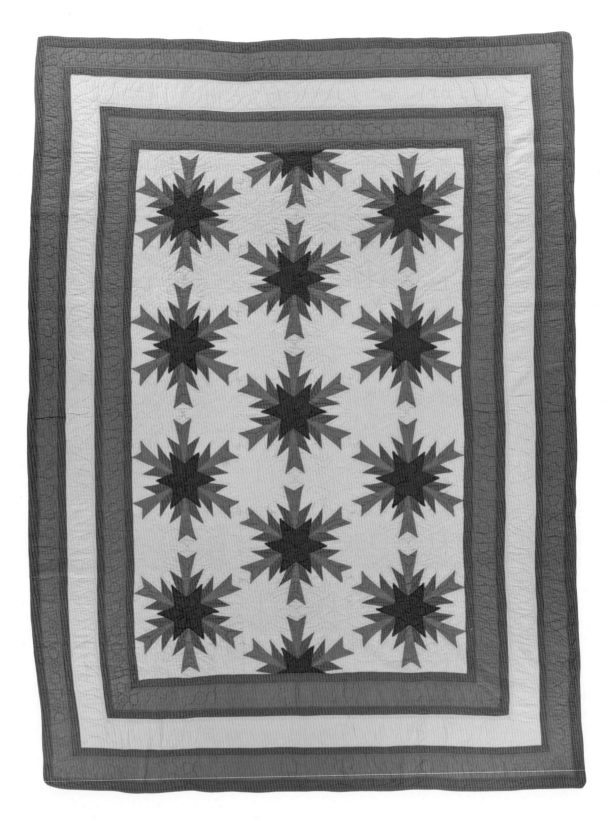

PLATE 1-19. Modernistic Star.
Maker unknown.
Possibly made in Moline, Illinois, 1930–1950.
Cottons, 106.5" x 79.5". QSPI: 7-10.
1997.007.0250. *Ardis and Robert James Collection.*

This Modernistic Star quilt (plate 1-19), found in Illinois, offers a stellar example of modernistic design, a cosmos of exploding stars. The innovative composition, rather than being a one-of-a-kind work of art, is typical of its time in that it is a copy of a commercial pattern. The Modernistic Star was pictured on the cover of a 1931 pattern catalog from the Aunt Martha Studios, also known as the Colonial Pattern Company, in Kansas City, Missouri. Owners Clara and Jack Tillotson, having run out of ideas for traditional designs, asked customers to mail favorite blocks for a quilt contest. Winners were featured in the booklet *Prize Winning Designs.* Rose Marie Lowery of Davenport, Nebraska, submitted this hexagonal pattern, described as an original design that "typifies all that is lovely in today's trend in line and color, yet carries us back to the tranquil atmosphere of yesteryear."[42]

This statement captures the ambiguity in the needlework industry at the time, when commercial pattern companies and women's magazines struggled to achieve a balance between tradition and Modernism. Aunt Martha—a name with the necessary colonial ring—is personified on the catalog cover, seated in her colonial-style parlor with Priscilla curtains, portraits of her ancestors, and a wicker sewing basket at her side. A fashionable young woman, perhaps representing Rose Marie Lowery, stands nearby and displays her striking quilt. Aunt Martha and her terrier, a fashionable breed, seem pleased. Inside there is praise, though faint praise, for the modern entries: "Several of the newer original quilts were made in most interesting manners. Some were inspired by pictures of linoleum and are certainly lovely." There is an implicit recognition here of the manner in which quiltmakers might co-opt common design sources to create their uncommon results.

Despite the cover quilt, the booklet's emphasis is quiltmaking's nostalgic past, a theme summarized in an introductory paragraph that combined colonial history, frontier hardships, and the mystique of the handcrafted object: "Many of these patterns were taken from quilts that were made by great great grandmother, who grew the cotton, spun it by the light from pine knots in the fireplace, wove it, and used her own formulas for dying it. . . . Many of these quilt[s] have been in families through four generations, and so many have homespun linings." The references to home grown, homespun, and home-dyed cotton, fabric rarely found in any surviving quilts today, captures an essential American myth still popular in the twenty-first century.

FIG 1-24. Aunt Martha Studios catalog cover, *detail*, 1931. Courtesy of Merikay Waldvogel Collection and Colonial Patterns, Inc., Kansas City MO.

If the copywriters at Aunt Martha Studios appear confused, their descriptions reflected the tenor of the times: a drop of up-to-date design in a sea of nostalgia. The company has been remarkably successful at catering to the needs of the pattern-buying public and is still in business after almost three-quarters of a century.

The unknown maker of this quilt must have been taken with Lowery's dramatic pattern. She reproduced the quilt exactly as the booklet directed, with an orange and green color scheme and a complex border of seven strips of various widths. A minor change was her decision to appliqué the center star instead of piecing it into the block as the pattern indicated.

The quilting lines are fairly close together, an indication of quality quilting, as is the use of a variety of motifs, such as tulips and stars. But the quilting stitches, like the running stitches that attach the stars to the center of each block, are somewhat sparse—only six to eight per inch—and uneven.

We can guess that the quilt top was made after the 1933 pattern appeared. There is evidence that the top was quilted later. A black-light examination indicates that the thread was purchased after the mid-1940s, when manufacturers began adding optical brighteners to white thread and fabrics to give them a blue-white appearance.

■ **Barbara Brackman**

An unsigned note accompanied this Stars quilt (plate 1-20) when it was purchased by Robert and Ardis James in 1990: "Grandmother Vermillion's quilt. Blocks pieced by Easter An [*sic*] Vermillion, died Jan 1925. Quilted by Hattie E. Vermillion." We do not know who wrote the note, nor do we know whether "Grandmother" refers to Easter or Hattie. We do, however, know quite a bit about Easter Ann (Keicher) Vermillion and Hattie Ellen (Broadbent) Vermillion.

Easter Keicher was born in 1842 in Madison County, Indiana, and married Chancey Vermillion in 1863. They had seven children, and their eldest son, Willis, eventually married Hattie Broadbent, daughter of a locally prominent doctor, in 1890. Easter was known in Madison County as a fine quiltmaker and passed along her crochet and quiltmaking skills to her daughter-in-law, Hattie. The two women were very close; Hattie named her daughter Easther after her mother-in-law (using a slight spelling variation). Quilts made by both mother-in-law and daughter-in-law were passed down through several generations of

the family. Indeed, Hattie made at least five quilts for family members between 1920 and 1933, one for each of her grandchildren. In her later years she even had a quilting frame set up in her bedroom.[43] How and when this particular quilt became separated from the family is unknown.

Although the note states that the blocks were made by Easter, evidence in the fabric itself points to Hattie as the probable sewer. Many of the prints and colors are more consistent with the late 1920s and 1930s, after Easter had already died. In particular, one block has a solid fabric in a grayish green color that was called Nile green. The color, described in a 1927 Sears® catalog simply as "a light green," was popular between 1925 and 1950.[44] In addition, many of the floral and plaid prints are in a larger scale than was popular in the 1920s, when smaller, less bold prints were the style.

Other evidence also argues for Hattie's hand in the making of the quilt. According to her great-grandson, who has read many of her Bible entries and personal letters, all but one of the several penciled markings found on the quilt appear to be in her handwriting.

FIG 1-25. Easter Vermillion (seated, second from left) and family, c. 1890. Courtesy of Vermillion Family of Madison County, Indiana, Collection and Douglas M. Vermillion.

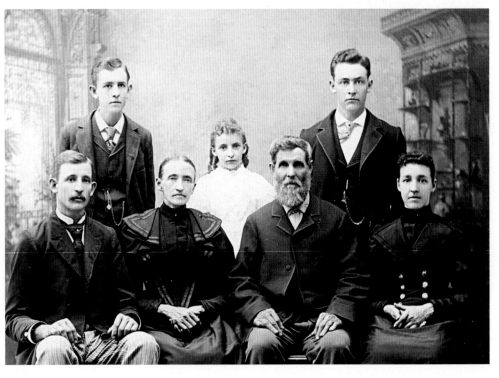

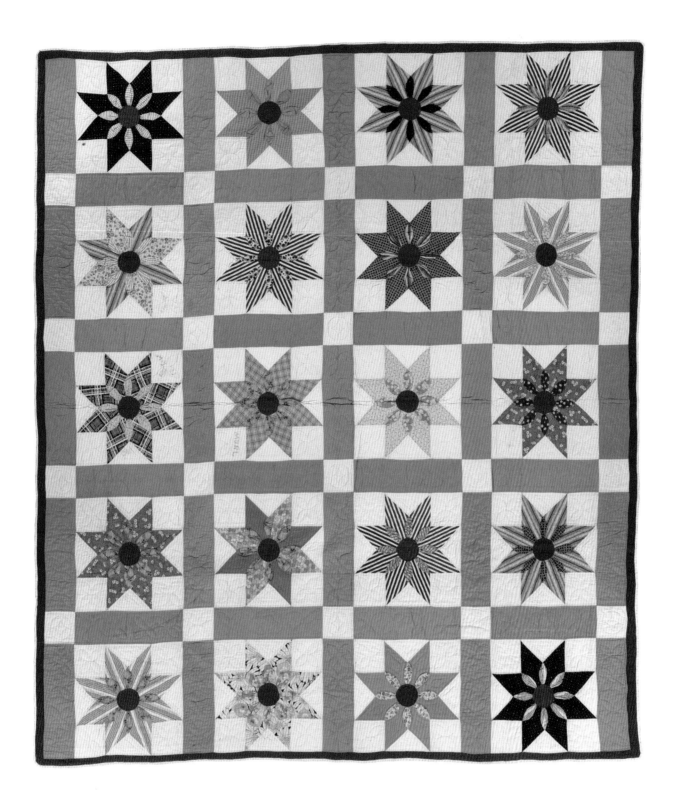

PLATE 1-20. Stars.
Hattie Ellen (Broadbent) Vermillion (1872–1960),
possibly with contributions by
Easter Ann (Keicher) Vermillion (1842–1925).
Madison County, Indiana, c. 1938.
Cottons, 86" x 76.5". QSPI: 9.
1997.007.0527. *Ardis and Robert James Collection.*

FIG 1-27. Stars, *detail*.

FIG 1-26. Hattie and Willis Vermillion, c. 1920. Courtesy of Vermillion Family of Madison County, Indiana, Collection and Douglas M. Vermillion.

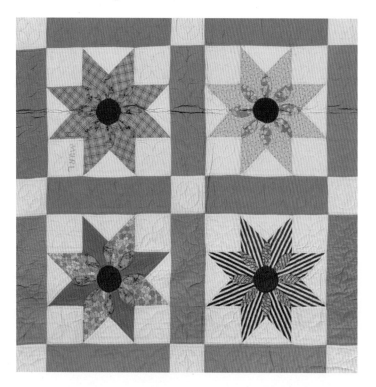

One of these inscriptions says, "May 28, 1938"; another reads, "May 31, 1938." These dates could indicate a finishing date for the quilt. But the family in fact does not know what they signify. Another penciled inscription that is not in Hattie's hand reads "MURL," but, once again, the family does not know to what or whom this might refer and who may have written it.[45]

The pattern Hattie chose is an interesting and complicated one. In each block, eight diamonds radiate from a red center circle. Overlapping the seam between each diamond is an almond-shaped fabric in a contrasting color and pattern. This ellipse, though looking as if it has been appliquéd over the diamonds, is actually a pieced inset. In other words, rather than laying the fabric on top of the already seamed diamonds and stitching it down with an appliqué stitch, she cut curves out of the diamonds to fit the shape of the ellipse and pieced it in along the curves. In addition, along the seam with the center circle, the ellipse has been gathered, much in the same way a pleated skirt would be attached to a flat bodice. The gathering causes the fabric to puff up, looking somewhat as if these areas have been stuffed with extra batting. So although the quilt from afar seems to be flat, on closer inspection it has a visually pleasing dimensionality. The gathering and the piecing along a curved line would have made these blocks difficult to assemble, much less made to lie flat, indicating Hattie's virtuosity as a seamstress. The unusual and highly successful use of common print patterns, along with the confident grid system that ties the disparate jumble of stars together yet gives each a chance to shine, demonstrate her prowess as a designer and a quiltmaker.

■ **Marin F. Hanson**

GALLERIES

Four Patch and Nine Patch

The simplicity of piecing squares of fabric into Four and Nine Patch blocks was used to advantage in the nineteenth century to teach young girls basic stitches and needlework skills. Quilts made from these simple blocks were completed by children as young as six years old. The skills they learned transferred to garment construction, a necessity in the days before women's ready-made clothing had replaced home garment construction.[46]

As a youngster improved her sewing skills she might have taken on more challenging dressmaking projects or applied her skills to quiltmaking projects of increasing complexity. The sequence of the pieced, block-style quilt groupings on the remaining pages of this chapter suggest the increasing complexity of designs and quiltmaking projects a young person might have undertaken as her skills improved.

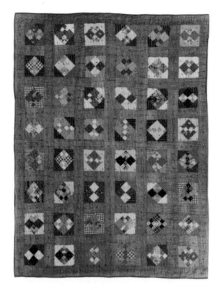

PLATE 1-21. Four Patch.
Possibly made in Pennsylvania, 1890–1910.
Cottons, 87" x 66". 2003.003.0025.

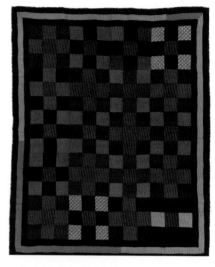

PLATE 1-23. Nine Patch.
Possibly made in Pennsylvania, 1880–1900.
Wools, 85" x 68". 2003.003.0020.

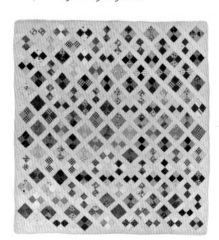

PLATE 1-22. Four Patch.
Possibly made in Pennsylvania, 1930–1950.
Silks, 81" x 83". 2003.003.0011.

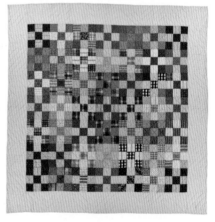

PLATE 1-24. Nine Patch.
Possibly made in Pennsylvania, 1910–1930.
Cottons, 69.5" x 69". 2003.003.0055.

Split Nine Patch

The Split Nine Patch was a popular pattern in regions of Pennsylvania and New Jersey during the early twentieth century. The pattern, which is fascinating in both its visual complexity and its simple construction, was passed around in true folk tradition from quilter to quilter. Two distinct variations of the block developed. One had a square in the center, often colored red. The other had a split square in the center, which allowed the quiltmaker to halve the block diagonally into two contrasting colors or values. Either block could be set in all the complex grids developed for the more difficult-to-piece Log Cabin block. Quiltmakers familiar with Log Cabin sets will recognize the Straight Furrow, the Barn Raising, and the Sunshine and Shadow variations. Other sets and colorings seem unique—if not to an individual quilter, then to a single community.

PLATE 1-25. Split Nine Patch.
Probably made in Pennsylvania, 1890–1910.
Cottons, 73" x 75". 2003.003.0138.

PLATE 1-27. Split Nine Patch.
Probably made in Pennsylvania, 1900–1920.
Cottons, 70" x 69.5". 2003.003.0165.

PLATE 1-26. Split Nine Patch.
Probably made in Pennsylvania, 1890–1910.
Cottons, 74.5" x 73". 2003.003.0135.

PLATE 1-28. Split Nine Patch.
Probably made in Pennsylvania, 1910–1930.
Cottons, 81.5" x 81.5". 2003.003.0346.

Squares with Pieced Corners

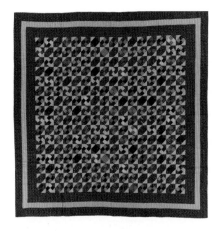

PLATE 1-29. Four Patch variation.
Possibly made in Lancaster County,
Pennsylvania, 1870–1890.
Cottons, 83" x 80.5". 1997.007.0622.

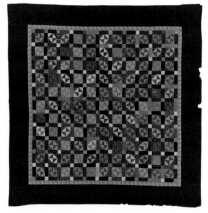

PLATE 1-31. Broken Dishes.
Possibly made in Pennsylvania, 1880–1900.
Cottons, 75" x 77". 2003.003.0293.

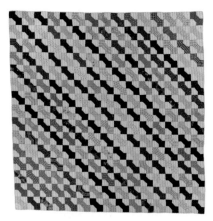

PLATE 1-33. Bow Tie.
Made by Rebecca Alford Dinsmore,
Lawrence County, Pennsylvania, dated 1891.
Cottons, 84.5" x 84.5". 1997.007.0945.

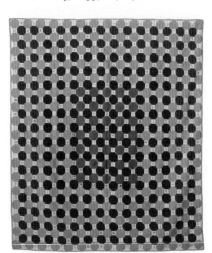

PLATE 1-30. Snowball variation.
Possibly made in Indiana, 1880–1900.
Wools, 66" x 57". 1997.007.0418.

PLATE 1-32. Bow Tie.
Possibly made in southern Indiana, 1890–1910.
Cottons, 76" x 88". 1997.007.0029.

PLATE 1-34. Album, Signature.
Made in St. Louis, Missouri, c. 1932.
Cottons, 85" x 83". 1997.007.0738.

String Designs

Early examples of foundation patchwork —Log Cabin and Crazy quilts—were usually pieced onto cotton foundations. In about 1890, some thrifty seamstresses began substituting paper for the foundation as a new pattern, the String quilt, composed of long, irregular strips of fabric, became popular. String quilts resemble an informal combination of Crazy and Log Cabin quilts. Cotton prints were the usual fabric, and String quilts were rarely embellished with embroidery or other decorative techniques.

The fad for String quilts was a vernacular stylistic innovation, possibly considered too lowly for publication by magazine tastemakers. Few of the String quilt variations and their names (if they had names) were recorded in print at the time. One exception is Rocky Road to Kansas, the four-pointed star that was sold as a pattern by that name by the Ladies Art Company in the 1890s. Despite a humble reputation, the String quilt style is among the most innovative designs in its use of a multitude of thin strips of fabric.

PLATE 1-35. Rocky Road to Kansas.
Possibly made in Pennsylvania, 1890–1910. Cottons, 86" x 68". 2003.003.0176.

PLATE 1-37. Rocky Road to Kansas.
Possibly made in Pennsylvania, 1900–1920. Cottons, 80" x 80.5". 2003.003.0146.

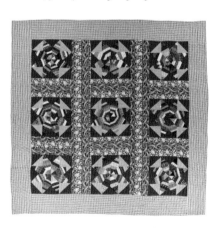

PLATE 1-36. String Star.
Possibly made in Pennsylvania, 1900–1920. Cottons, 72" x 71". 2003.003.0250.

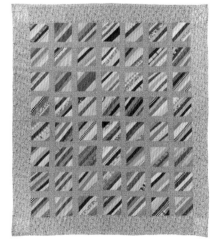

PLATE 1-38. String Squares.
Possibly made in Pennsylvania, 1920–1940. Cottons, 82.5" x 72.5". 2003.003.0001.

Two-Color

Although many believe quilts to be salvage art made of fabrics recycled from other sewing projects, the quilts themselves indicate that women have always budgeted for yardage bought specifically for their needlework. Two-color quilts are good evidence that some seamstresses could afford to choose a palette.

Red on white or blue on white have long been the most common two-color combinations. Both palettes became popular after 1840, when cotton fabric became inexpensive enough that American quiltmakers could be selective. In the last quarter of the nineteenth century, quilts made in these two-color styles increased in number, probably due to another drop in fabric prices as dye chemistry improvements enabled fabric mills to offer less expensive Turkey red and indigo blue fabrics. These colorfast cottons had always been far more expensive than the undyed plain white muslin with which they were paired, but as chemists developed test-tube copies of these natural coloring agents, prices fell and quiltmakers enjoyed new access to old favorites.

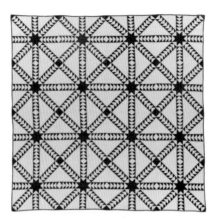

PLATE 1-39. Flying Geese.
Possibly made in Ohio, 1880–1900.
Cottons, 74" x 75". 1997.007.0227.

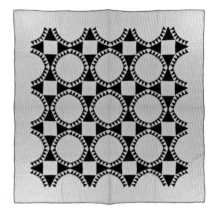

PLATE 1-41. Sunburst.
Possibly made in Union County, Pennsylvania, 1875–1895.
Cottons, 84.5" x 83.5". 1997.007.0372.

PLATE 1-40. Turkey Tracks.
Maker/location unknown, 1875–1895.
Cottons, 86.5" x 70.5". 1997.007.0229.

PLATE 1-42. Flying Geese.
Possibly made in Ohio, 1900–1920.
Cottons, 79.5" x 70". 1997.007.0487.

Two-Color

PLATE 1-43. Delectable Squares.
Possibly made in Ohio, 1860–1880.
Cottons, 88" x 77". 1997.007.0397.

PLATE 1-45. Crossed Ts.
Possibly made in western Pennsylvania, 1880–1900.
Cottons, 84" x 82.5". 1997.007.0379.

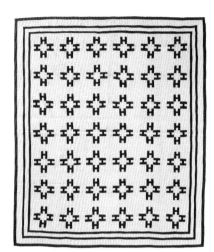

PLATE 1-47. Four H.
Probably made in Ohio, 1900–1920.
Cottons, 74" x 63.5". 1997.007.0494.

PLATE 1-44. Triangles.
Possibly made in the midwestern United States, 1870–1890.
Cottons, 86" x 66". 1997.007.0202.

PLATE 1-46. Rob Peter to Pay Paul.
Possibly made in Wabash County, Indiana, 1880–1900.
Cottons, 75" x 64.5". 1997.007.0106.

PLATE 1-48. Hole in the Barn Door.
Possibly made in Ohio, 1900–1920.
Cottons, 89.5" x 74.5". 1997.007.0656.

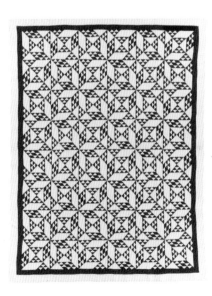

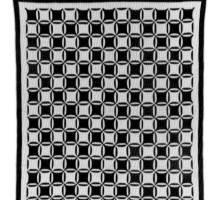

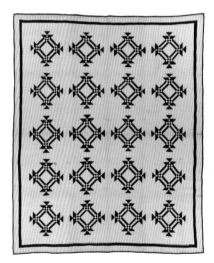

Two-Color Secondary Designs

An individual quilt block is a complete design idea. When identical or nearly identical blocks are set side by side, however, a secondary design may appear, which can be more interesting than the block design. Bars merge into squares; Xs blend to become crosses; pinwheels whirl in the interstices; and Rocky Roads turn into brilliant eight-pointed Stars. One often has to look closely to find the individual blocks.

Although early nineteenth-century quiltmakers might have experimented visually with the secondary patterning possible with a Sawtooth Star or a Pinwheel pattern, it is only in quilts made after the Civil War that a new emphasis on carefully controlled side-by-side sets can be seen. The wildly popular Log Cabin style of the 1870s seems to have begun the trend, which increased during the 1880s and 1890s as new designs such as the Drunkard's Path made the most of the interaction between blocks.

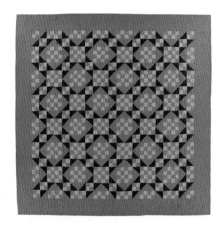

PLATE 1-49. Rocky Road to California.
Possibly made in Pennsylvania, 1930–1940.
Cottons, 77" x 77.5". 2003.003.0033.

PLATE 1-51. Spider Web.
Maker/location unknown, 1920–1940.
Cottons, 91.5" x 88". 2003.003.0290.

PLATE 1-50. Eccentric Star.
Possibly made in Pennsylvania, 1930–1940.
Cottons, 83.5" x 77". 2003.003.0039.

PLATE 1-52. Star.
Maker/location unknown, 1930–1940.
Cottons, 72" x 71.5". 2003.003.0355.

Secondary Designs

PLATE 1-53. Garden Maze.
Possibly made in Pennsylvania, 1880–1900.
Cottons, 87" x 79". 1997.007.0233.

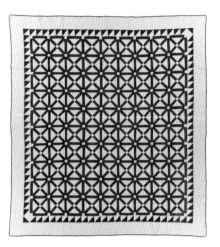

PLATE 1-55. Crosses.
Probably made by Nancy Miller, Vistula,
Michigan, dated 1888.
Cottons, 79.5" x 73". 1997.007.0327.

PLATE 1-57. Hearts and Gizzards.
Possibly made in Pennsylvania, 1880–1900.
Cottons, 76" x 76". 2003.003.0312E.

PLATE 1-54. Pinwheel.
Possibly made in Pennsylvania, 1880–1900.
Cottons, 78.5" x 74.5". 1997.007.0142.

PLATE 1-56. Kaleidoscope.
Possibly made in Pennsylvania, 1900–1920.
Cottons, 72.5" x 67". 2003.003.0038.

PLATE 1-58. Hearts and Gizzards.
Possibly made in central Pennsylvania,
dated 1898.
Cottons, 81" x 71". 1997.007.0828.

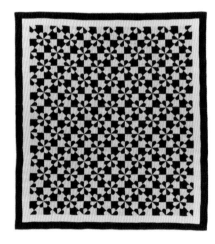

One Block, Two-Color Reversal

Counterchange is a design technique in which figure and ground reverse. Like the Square in a Square quilt in plate 1-13, counterchange quilts are optical delights. One way quiltmakers have affected this reversal in two-color quilts has been to exchange the position of the colors in every other block. This created value contrasts, secondary patterns, and reversals of negative and positive space. Perhaps influenced by published designs, quiltmakers began to experiment with more complex counterchange patterning in the 1880s. Although two-color quilts had been favorites for decades, the addition of color reversal to the style created a bold and formal geometry and a visual ambiguity that was prescient of 1960s Op Art.

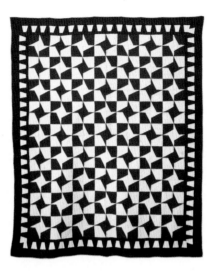

PLATE 1-59. **Shooting Star.**
Possibly made in Indiana or Ohio, 1870–1890. Cottons, 89" x 72". 1997.007.0200.

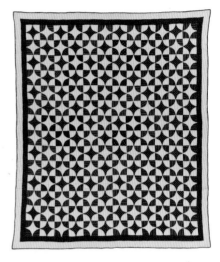

PLATE 1-61. **Mill Wheel.**
Possibly made in southern Indiana, 1875–1895. Cottons, 81" x 67.5". 1997.007.0141.

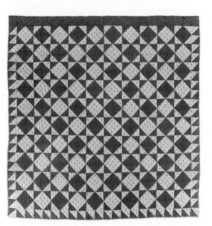

PLATE 1-60. **Shoo Fly.**
Possibly made in Vermont, 1880–1900. Cottons, 75" x 76". 2003.003.0052.

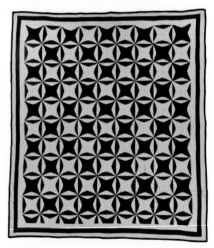

PLATE 1-62. **Rob Peter to Pay Paul.**
Probably made in Kansas, dated 1892. Cottons, 83" x 72". 1997.007.0925.

Stars

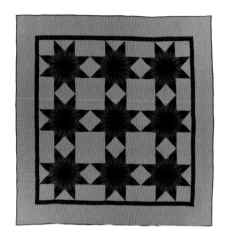

PLATE 1-63. Touching Stars.
Probably made in Pennsylvania, 1880–1900.
Cottons, 87.75" x 85". 1997.007.0861.

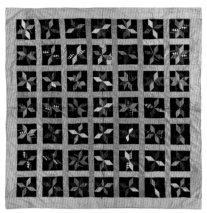

PLATE 1-65. Eight-Pointed Star.
Maker/location unknown, 1870–1890.
Silks, 82.5" x 82". 2003.003.0333.

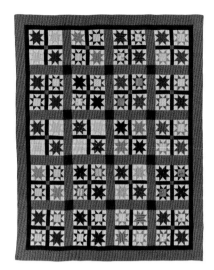

PLATE 1-67. Sawtooth Star.
Possibly made in Ohio, 1890–1910.
Cottons, 81" x 63.5". 1997.007.0674.

PLATE 1-64. Feathered Star.
Maker/location unknown, 1880–1900.
Cottons, 77" x 65.5". 1997.007.0001.

PLATE 1-66. LeMoyne Star.
Possibly made in New York, 1870–1890.
Cottons, 78" x 62". 1997.007.0936.

PLATE 1-68. Morning Star.
Possibly made in Ohio, 1920–1940.
Cottons, 91.5" x 78". 1997.007.0293.

Traditional Settings: Sashing

Although the variety in pieced blocks seems infinite, the way blocks have been set together in the quilt top has been more limited. Commonly, blocks were assembled into a grid that was oriented either diagonally or perpendicularly to the sides of the quilt. In addition, quiltmakers had the option of placing blocks side by side or separating them with sashing strips or a grid of setting blocks—squares of fabric that alternate with the pieced blocks. Sashing strips were sometimes pieced, but most often were plain strips of cloth. Setting blocks were generally unpieced squares of a solid or subdued calico print that complemented rather than competed with the pieced design.

In contrast, quiltmakers working before the Civil War often used a different group of setting options than their later counterparts did: blocks set into strips, blocks framing a central medallion, and setting blocks of busy, large-scale, floral chintz. As the choices in block patterns increased at the end of the nineteenth century, the number of setting styles in use seemed to decrease. However, the small sample of effective setting options on these pages illustrates, once again, the ingenious variety obtainable within a limited structure.

PLATE 1-69. Rising Sun.
Possibly made in Van Buren County, Michigan, 1860–1880.
Cottons, 86" x 72". 1997.007.0038.

PLATE 1-70. North Carolina Lily.
Possibly made in Indiana County, Pennsylvania, 1880–1900.
Cottons, 82" x 80". 1997.007.0042.

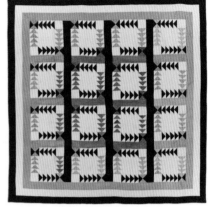

PLATE 1-71. Wild Goose Chase.
Possibly made in Pennsylvania, 1880–1900.
Cottons, 81.5" x 81.5". 2003.003.0008.

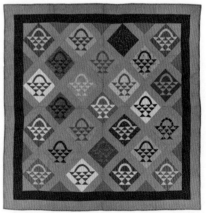

PLATE 1-72. Baskets.
Probably made in Pennsylvania, 1890–1910.
Cottons, 79.5" x 78". 2003.003.0320.

Traditional Settings: Alternate Setting Block

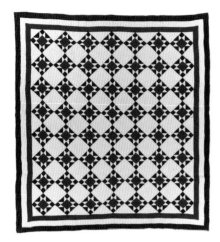

PLATE 1-73. Sawtooth Star.
Maker/location unknown, 1900–1920.
Cottons, 77.5" x 70". 1997.007.0491.

PLATE 1-75. Baskets.
Possibly made in southern Indiana,
1890–1910.
Cottons, 78" x 64". 1997.007.0532.

PLATE 1-77. Pine Tree.
Possibly made in Lititz, Pennsylvania,
1875–1895.
Cottons, 89" x 75". 1997.007.0651.

PLATE 1-74. Sawtooth Star.
Possibly made in Pennsylvania, dated 1886.
Cottons, 75.5" x 69". 2003.003.0317.

PLATE 1-76. Baskets.
Probably made in Pennsylvania, 1900–1920.
Cottons, 74" x 63.5". 2003.003.0360.

PLATE 1-78. Shoo Fly variation.
Possibly made in Portland, Michigan,
1900–1920.
Cottons, 80" x 72.5". 1997.007.0041.

Traditional Settings: On Point

PLATE 1-79. Broken Dishes.
Possibly made by Humphry family member,
Pennsylvania, dated 1883.
Cottons, 89" x 86". 2003.003.0306.

PLATE 1-81. Checkerboard.
Possibly made in New Jersey, 1880–1900.
Cottons, 87" x 88". 2003.003.0022.

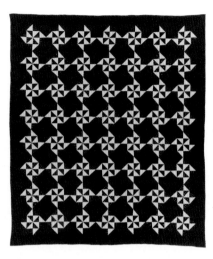

PLATE 1-83. Pinwheel.
Maker/location unknown, 1890–1910.
Cottons, 89.5" x 79". 1997.007.0452.

PLATE 1-80. King's Crown.
Possibly made in Pennsylvania, 1880–1900.
Cottons, 82" x 79". 2003.003.0018.

PLATE 1-82. Crown of Thorns.
Possibly made in eastern Pennsylvania,
1890–1910.
Cottons, 85" x 86". 1997.007.0614.

PLATE 1-84. Fence Post.
Possibly made in Pennsylvania, 1920–1940.
Cottons, 75.5" x 69.5". 2003.003.0223.

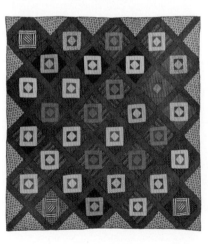

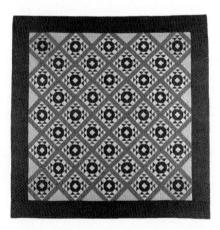

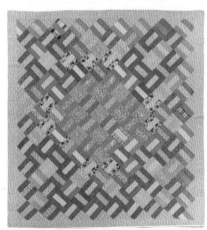

PLATE 1-85. Wild Goose Chase.
Possibly made in western Pennsylvania,
1880–1900.
Cottons, 78.5" x 77.5". 1997.007.0425.

PLATE 1-87. Ohio Star.
Possibly made in Ohio, 1875–1895.
Cottons, 72" x 70.5". 1997.007.0493.

PLATE 1-89. Double Irish Chain.
Possibly made in Maine, 1900–1920.
Cottons, 85.5" x 74.5". 2003.003.0029.

PLATE 1-86. Ocean Waves variation.
Possibly made in Pennsylvania, 1880–1900.
Cottons, 87" x 85.5". 2003.003.0183.

PLATE 1-88. Irish Chain variation.
Probably made in New England, 1870–1890.
Cottons, 80" x 66". 1997.007.0776.

PLATE 1-90. Double Irish Chain variation.
Possibly made in Pennsylvania, 1880–1900.
Cottons, 91.5" x 72.5". 1997.007.0677.

Drunkard's Path Variations

The basic design unit of three of these quilts is a quarter-circle inside a square, a pattern Ruth Finley called Robbing Peter to Pay Paul in her 1929 book, *Old Patchwork Quilts and the Women Who Made Them*. "A 'robbed' white square is compensated with a patch taken from the colored block and vice versa," she explained.[47] Quilts in complex variations of the quarter-circle design began to appear about 1875. The undulating chain, commonly call Drunkard's Path, was among the earliest arrangements. This name may have been inspired by the Temperance movement, whose adherents preached about the alcoholic's road to perdition. The Crossed Ts pattern, though not a Drunkard's Path variation, was also inspired by the Temperance movement.

Other published names for variations of the Drunkard's Path block include Fools' Puzzle and Wonder of the World from early Ladies Art Company catalogs about 1890. *Farm and Home* magazine in 1888 called one variation Wanderer's Path in the Wilderness, and in 1896 the *Ohio Farmer* saw it as an Old Maid's Puzzle.[48] The International Quilt Study Center collections have three quilts in an unusual arrangement not found in the published sources until Jonathan Holstein gave it the name Around the World in *American Pieced Quilts*.[49]

PLATE 1-91. Drunkard's Path.
Possibly made by E. Mitchell and B. Mitchell, Bowling Green, Kentucky, 1890–1930. Wools, 83" x 68". 1997.007.0566.

PLATE 1-93. Around the World.
Possibly made in New Hampshire, 1930–1950. Cottons, 80" x 101". 2003.003.0050.

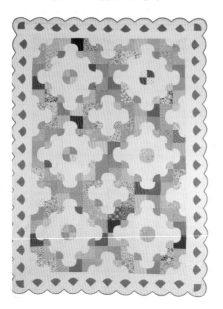

PLATE 1-92. Around the World.
Possibly made in Ohio, 1930–1940. Cottons, 94" x 68". 1997.007.0384.

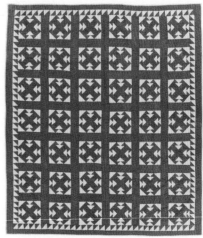

PLATE 1-94. Crossed Ts.
Possibly made in Pennsylvania, 1880–1900. Cottons, 88" x 77". 1997.007.0477.

Rotational Symmetry

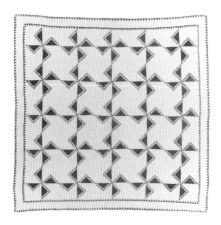

PLATE 1-95. Pinwheel.
Maker/location unknown, 1900–1920.
Cottons, 71" x 69". 1997.007.0291.

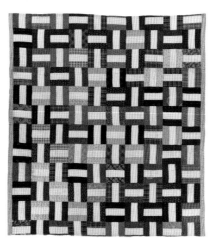

PLATE 1-97. Roman Square.
Possibly made in New Jersey, 1890–1910.
Cottons, 80" x 71". 2003.003.0044.

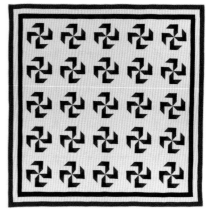

PLATE 1-99. Crazy Ann variation.
Maker/location unknown, dated 1920.
Cottons, 77.5" x 77.5". 1997.007.0088.

PLATE 1-96. Sailboat.
Possibly made in Indiana, 1890–1910.
Cottons, 88.5" x 72.5". 1997.007.0045.

PLATE 1-98. Orange Peel.
Possibly made in Indiana or Pennsylvania,
1910–1930.
Cottons, 84" x 76". 1997.007.0174.

PLATE 1-100. Flyfoot.
Maker/location unknown, 1920–1940.
Cottons, 84.5" x 82.5". 2001.002.0001.
Gift of Litzenberg Memorial Hospital Auxiliary.

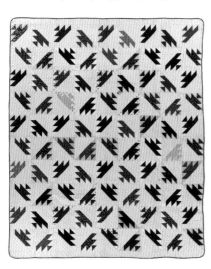

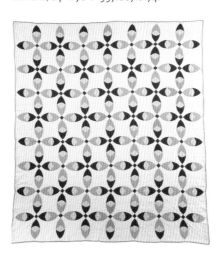

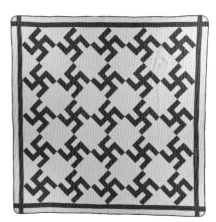

Samplers

Most block-style quilts repeat a single pattern, but in a Sampler or Album each block is different. Some of these Samplers may be the work of one needlewoman; others appear to be friendship quilts with block contributions from a group of seamstresses. (Plate 1-104 is inscribed with various signatures.)

Aside from functioning as expressions of friendship, Samplers sometimes served to document how various blocks were made. Before inexpensive paper patterns were published, women sometimes preserved their patterns in fabric form. During the 1920s, the writer Lyle Saxon interviewed a woman who was a former slave: "Upon the white washed wall of her cabin hung a 'pattern quilt.' . . . In a pattern quilt are included all the varying patterns of patchwork that a woman knows."[50] The quilt historian Wilene Smith found a 1914 reference in the magazine *Hearth & Home* to "variety" or "oddity" quilts as "a nice way to keep sample blocks."[51]

PLATE 1-101. **Album.**
Possibly made in Maine, 1880–1900.
Cottons, 82" x 72". 2003.003.0186.

PLATE 1-103. **Album.**
Possibly made in Logansport, Indiana, 1890–1910.
Cottons, 82.5" x 69". 1997.007.0352.

PLATE 1-102. **Album.**
Possibly made in Battle Creek, Michigan, 1900–1920.
Cottons, 89" x 77". 1997.007.0308.

PLATE 1-104. **Album, Signature.**
Probably made in Maine, dated 1895.
Cottons, 107" x 89". 2002.010.0001.
Gift of Ky and Jane Rohman.

A Sampler of Pieced Quilts

PLATE 1-105. Rob Peter to Pay Paul.
Possibly made in Pennsylvania, 1880–1900.
Cottons, 83" x 77.5". 2003.003.0017.

PLATE 1-107. Split Patch.
Probably made in Pennsylvania, 1890–1910.
Cottons, 81" x 80.5". 2003.003.0386.

PLATE 1-109. Album.
Maker/location unknown, 1920–1940.
Cottons, 77.5" x 70.5". 1997.007.0196.

PLATE 1-106. Postage Stamps.
Possibly made in Pennsylvania, 1870–1890.
Cottons, 75" x 80". 2003.003.0216.

PLATE 1-108. Irish Chain variation.
Possibly made in Pennsylvania, 1890–1930.
Cottons, 85.5" x 85.5". 2003.003.0204.

PLATE 1-110. Square in a Square.
Possibly made in Pennsylvania, 1910–1950.
Cottons, 78" x 72". 2003.003.0054.

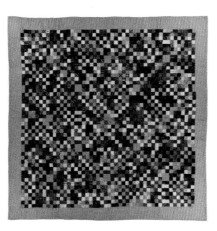

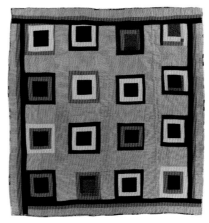

Designs of Many Pieces

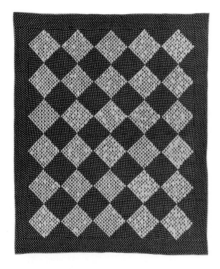

PLATE 1-111. Birds in Air.
Possibly made in Blair County, Pennsylvania,
1870–1890.
Cottons, 78.5" x 66". 1997.007.0158.

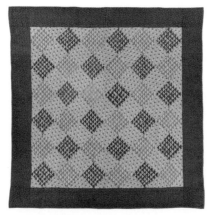

PLATE 1-113. Birds in Air.
Possibly made in Lancaster County, Pennsyl-
vania, 1880–1900.
Cottons, 73.5" x 73". 1997.007.0034.

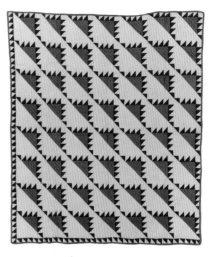

PLATE 1-115. Sawtooth.
Possibly made in Pennsylvania, 1860–1880.
Cottons, 76.5" x 66". 1997.007.0779.

PLATE 1-112. Birds in Air.
Possibly made in Pennsylvania, 1870–1890.
Cottons, 83" x 80.5". 2003.003.0040.

PLATE 1-114. Jacob's Ladder.
Maker/location unknown, 1870–1890.
Cottons, 74.5" x 67.5". 1997.007.0037.

PLATE 1-116. Squares, Sawtooth.
Maker/location unknown, 1880–1900.
Silks, 73" x 73". 1997.007.0430.

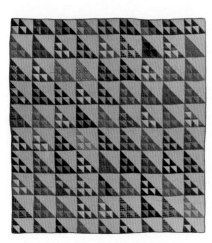

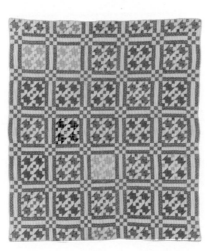

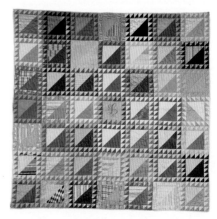

Designs of Many Pieces

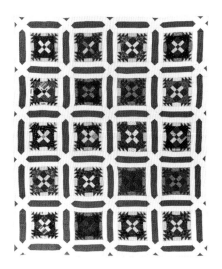

PLATE 1-117. Four Patch.
Possibly made in southern Indiana, 1900–1920.
Cottons, 85.5" x 70.5". 1997.007.0793.

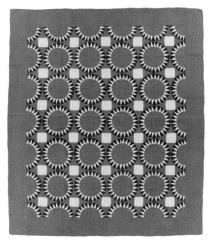

PLATE 1-119. Sunburst.
Probably made in Hamilton County, Ohio, 1900–1920.
Cottons, 78" x 68". 1997.007.0215.

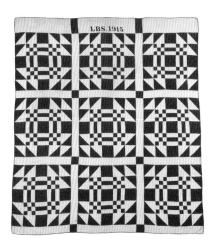

PLATE 1-121. Goose in the Pond.
Possibly made in Amsterdam, New York, dated 1915.
Cottons, 78.5" x 71". 1997.007.0602.

PLATE 1-118. Jack in the Pulpit variation.
Probably made in Indiana, 1890–1910.
Cottons, 91" x 74". 1997.007.0295.

PLATE 1-120. Young Man's Fancy.
Possibly made in Pennsylvania, 1910–1930.
Cottons, 82" x 76". 2003.003.0205.

PLATE 1-122. County Fair.
Possibly made in York County, Pennsylvania, 1930–1950.
Cottons, 71.5" x 71.5". 1997.007.0435.

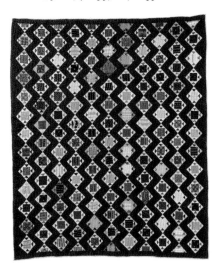

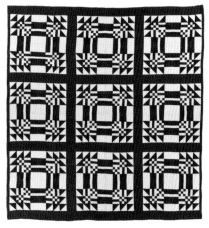

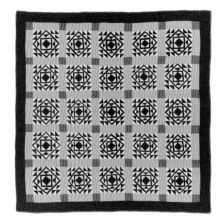

Schoolhouse

Pieced "neighborhoods" are among the most literal of quilt patterns. Introduced in catalogs and magazines at the end of the nineteenth century, buildings constructed of rectangles and rhomboids remain popular with quilt-makers and quilt collectors today.

The pattern historian Ruth Finley, writing in 1929 about a quilt she called the Little Red School House, found it "appealing but absurd."[52] Today's quilt-makers continue to call a variety of styl-ized buildings schoolhouses, reflect-ing a nostalgia for the country school buildings that still dot rural America. Yet early published names illustrated a different longing for rural life. Before Finley's book popularized the school-house image, magazines and catalogs called the design the Old Homestead, Log Cabin, and Old Kentucky Home. Names such as Lincoln's Cabin Home and Tippecanoe also reflected presiden-tial politics dating to the early 1840s, when images of a small house with a door in the gable end were meant to represent William Henry Harrison's supposedly humble origins, despite the fact that he came from an aristocratic Virginia family.[53] The symbol may be older, but the pieced quilt pattern dates to 1890.

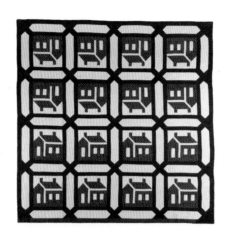

PLATE 1-123. Schoolhouse.
Possibly made in Wayne County, Indiana, 1875–1895.
Cottons, 82.5" x 82.5". 1997.007.0109.

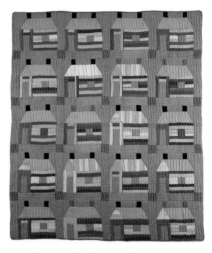

PLATE 1-125. Schoolhouse.
Possibly made in Tennessee, 1925–1945.
Wools, 84.5" x 73". 1997.007.0156.

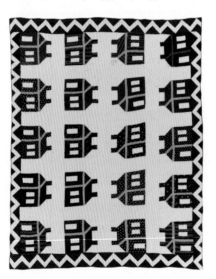

PLATE 1-124. Schoolhouse.
Possibly made in Pennsylvania, 1890–1910.
Cottons, 70" x 86.5". 1997.007.0193.

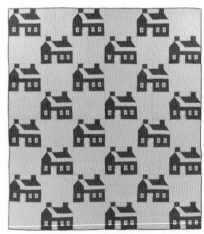

PLATE 1-126. Schoolhouse.
Maker/location unknown, dated 1931.
Cottons, 86" x 77". 1997.007.0192.

Figural Designs

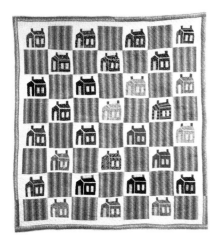

PLATE 1-127. Schoolhouse.
Probably made in Oklahoma, 1890–1910.
Cottons, 78" x 72". 1997.007.0314.

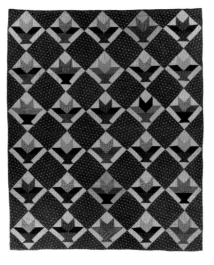

PLATE 1-129. Baskets.
Possibly made in Pennsylvania, 1870–1890.
Cottons, 91.5" x 75". 2003.003.0051.

PLATE 1-131. Baskets.
Possibly made in New Jersey, 1900–1920.
Cottons, 68" x 67". 2003.003.0037.

PLATE 1-128. Schoolhouse.
Possibly made in New Hampshire, 1880–1900.
Cottons, 75" x 76". 2003.003.0014.

PLATE 1-130. Pine Tree.
Maker/location unknown, 1880–1900.
Cottons, 75.5" x 75.5". 1997.007.0458.

PLATE 1-132. Coffee Cups.
Possibly made in Colorado, 1910–1930.
Cottons, 81" x 72". 2003.003.0225.

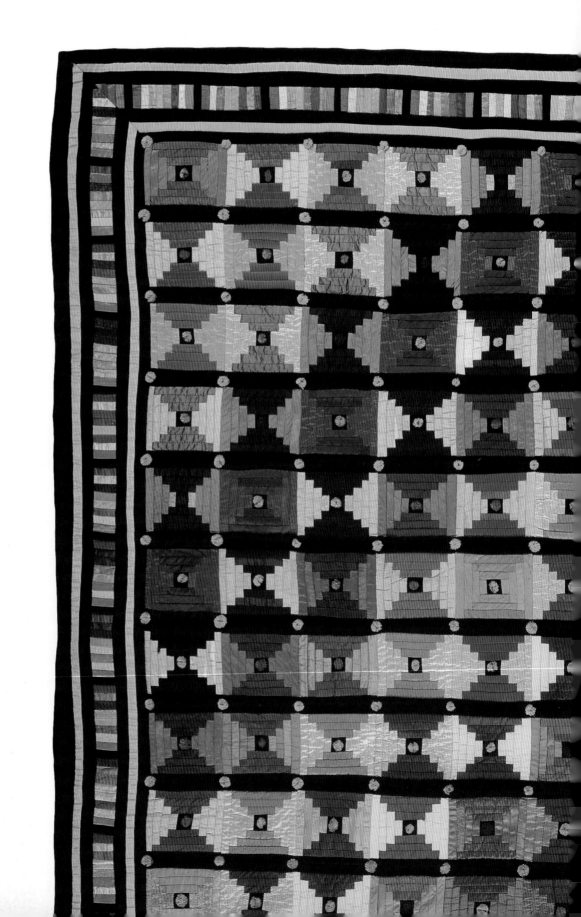

Building on a Foundation *Log Cabin Quilts*

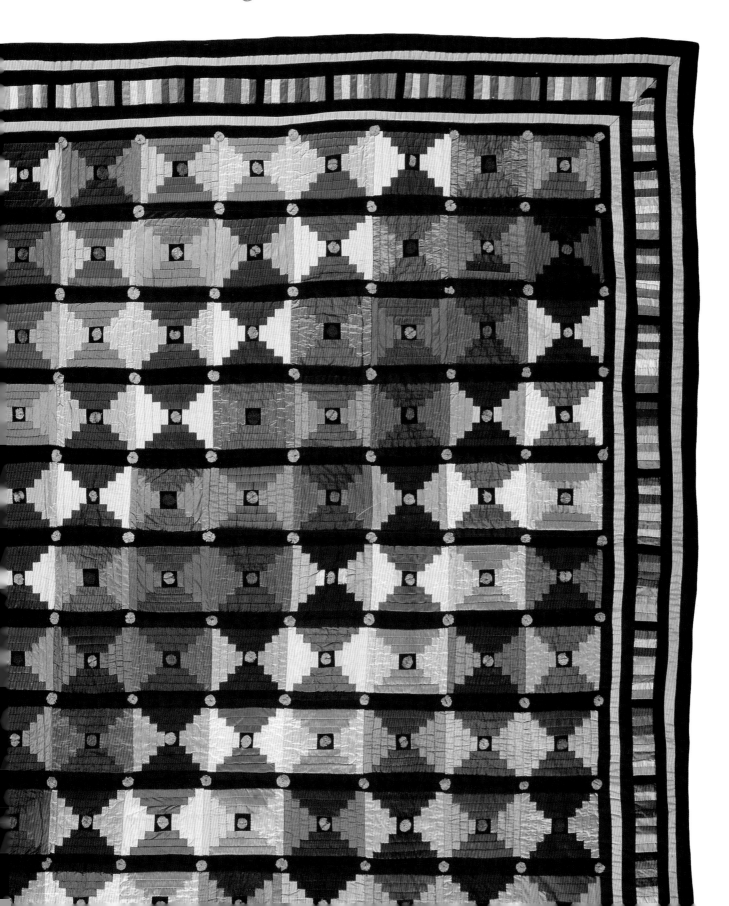

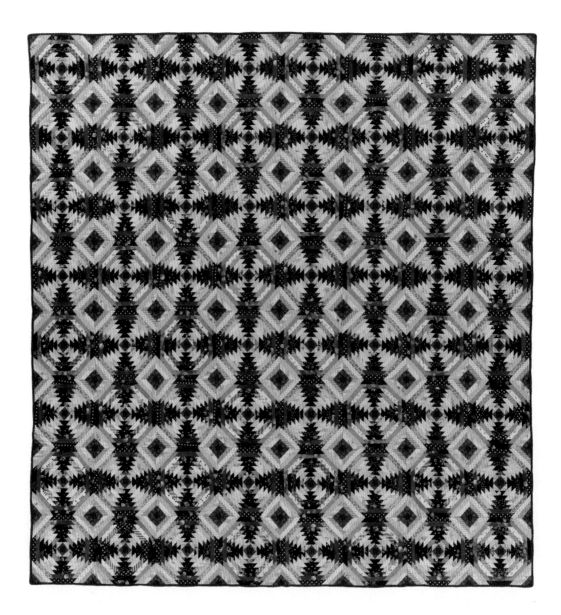

The Log Cabin block, whose construction consists of narrow, straight strips of fabric pieced in succession around a central square, is one of the simplest yet most graphic of quilt patterns, and often, with names like Streak of Lightning, Barn Raising, Straight Furrow, and Sunshine and Shadow, reflects literal aspects of rural American life of the maker's time. Constructed on a foundation fabric, Log Cabins likely helped to pave the way for later foundation-pieced styles such as Crazy quilts and string-pieced quilts.

The standard Log Cabin block, divided into light and dark halves along the block's diagonal, may be manipulated in many ways to create distinctive overall quilt layouts, or settings. In fact, eighteen different block settings are shown in Bonnie Lehman and Judy Martin's *Log Cabin Quilts*, and their compilation is by no means exhaustive.[1] The myriad design possibilities of the Log Cabin block likely contributed to its rise in popularity during the last decades of the nineteenth century and to its continued popularity among quiltmakers today. Variations on the standard Log Cabin block, in particular Pineapple and Courthouse Steps, provided quiltmakers with further tools for creating interesting designs.[2]

Log Cabin quilts are particularly engaging because the viewer is drawn into an analysis of the positioning of the light and dark fabrics. What the human eye

PLATE 2-1. Log Cabin, Pineapple variation.
Maker unknown.
Possibly made in Ohio, 1870–1890.
Cottons, 70.5" x 70.5". Tied.
1997.007.0222. *Ardis and Robert James Collection.*

PLATE 2-2. Log Cabin, Streak of Lightning setting.
Maker unknown.
Possibly made in Jackson County, Missouri, 1880–1900.
Cottons, 76" x 66". QSPI: 6.
1997.007.0572. *Ardis and Robert James Collection.*

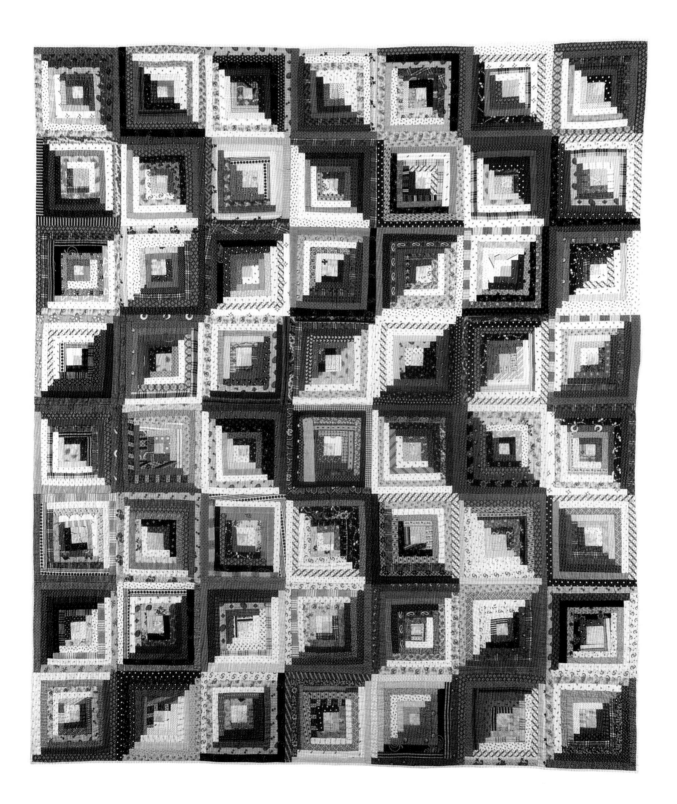

seeks first when viewing an object or image is value contrast, the point at which the darkest dark of a design meets the lightest light. The eye combines the myriad dark fabrics (and alternatively, light fabrics) into a single unit as it searches for patterns formed by dark and light areas. This visual involvement engages us psychologically and emotionally and contributes significantly to the dynamic qualities of Log Cabin quilts, whether constructed in the standard Log Cabin block or the Courthouse Steps or Pineapple variations.

Another factor that scholars believe contributed to the popularity of the Log Cabin pattern in the last quarter of the nineteenth century was the increased availability of inexpensive, colorful, and varied printed cotton fabrics. Fabric production grew dramatically in the nineteenth century as American manufacturers entered the market in competition with their European counterparts. In the 1830s, New England mills were producing 120 million yards of cloth annually. By the late 1880s annual production exceeded 800 million yards.[3] As the supply increased, prices dropped, ensuring that individuals from all walks of life could afford fabrics for quiltmaking. Some historians speculate that the invention of the sewing machine (and the Singer Sewing Machine Company's development of the installment payment plan) also contributed to the popularity of patterns such as Log Cabin that use simple straight-line stitching.[4] In 1860, 500,000 sewing machines were in use in America; by 1890, the Singer Sewing Machine Company had sold 9 million machines.[5]

Many Log Cabin quilts in the International Quilt Study Center's collections showcase the abundance of fabric choices available to American women during the later nineteenth century; the Barn Raising setting pictured in plate 2-3 is composed of nearly one hundred different dark and light fabrics, ranging from double pink calicoes for the center squares, to robe prints and printed plaids for the dark halves of the blocks, and red, black and white, and red, blue, and white shirting prints for the lights. This variety of fabrics is not unusual for the period. In fact, some Log Cabin quilts in the Center's collections feature more than one hundred different cotton prints.[6] Many American textile printing factories produced more than one thousand new designs each year as early as the 1850s.[7] Consequently, quiltmakers and dressmakers had myriad choices, as clearly displayed in this quilt.

Several other factors may have contributed to the popularity of the Log Cabin pattern. Popular presidential campaigns—William Henry Harrison's in the 1840s and Abraham Lincoln's in the 1860s—used the log cabin as a symbol of American pioneer spirit and ingenuity. Both campaigns recognized the iconic power of the log cabin, often the first structure built by pioneer settlers. Its evocation demonstrated to the American people that their candidate was a hardworking individual who understood the problems of the average person. The appeal of the log cabin as an American icon was also a reflection of the interest in the American centennial of 1876. Citizens hearkened to romanticized versions of their past and developed an appreciation for objects such as quilts that supposedly demonstrated the self-sufficiency, frugality, and resourcefulness of the founders of the nation. The connection between actual log cabins and the Log Cabin pattern can also be noted in construction parallels; both are built in a layered fashion with successive "logs" placed on top of each other.

Evidence of the great popularity of Log Cabin quilts can be found in the records of county and state fairs of the last decades of the nineteenth century. Fair premi-

PLATE 2-3. Log Cabin, Barn Raising setting.
Maker unknown.
Possibly made in Pennsylvania, 1910–1920.
Cottons, 90.5" x 89.5". QSPI: 6-7.
2003.003.0175. *Jonathan Holstein Collection.*

FIG 2-1. Standard Log Cabin block (see plate 2-44).

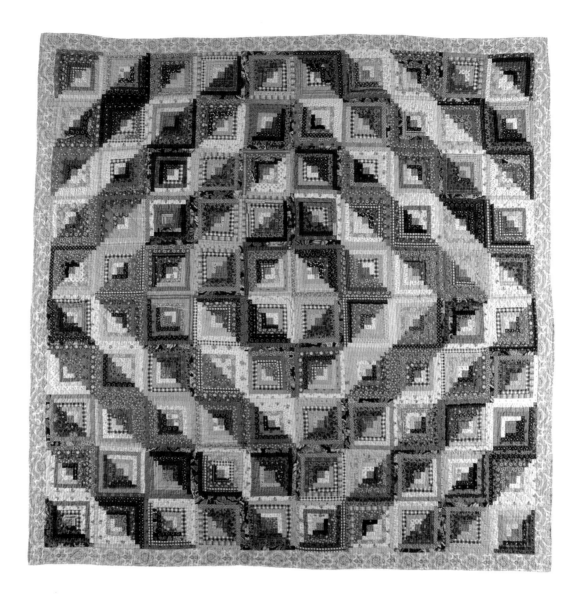

FIG 2-2. Log Cabin, Pineapple block (see plate 2-1). FIG 2-3. Log Cabin, Courthouse Steps block (see plate 2-28).

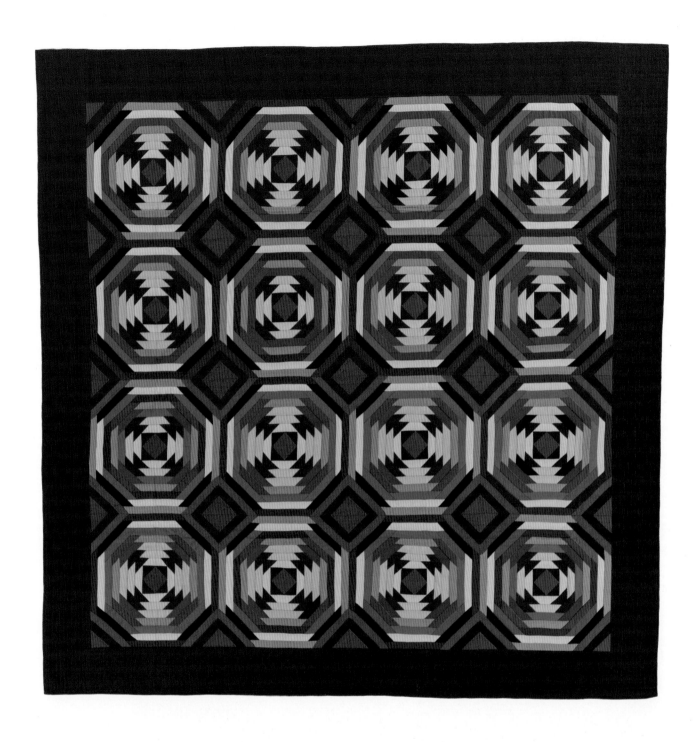

PLATE 2-4. Log Cabin, Pineapple variation.
Maker unknown.
Possibly made in Lancaster County, Pennsylvania, 1890–1900.
Wools, 82" x 82". QSPI: 8-9.
1997.007.0691. *Ardis and Robert James Collection.*

ums specifically for Log Cabin quilts were common. In 1880 the Wayne County (Ohio) Independent Agricultural Society fair awarded $1.00 premiums for Log Cabin quilts in addition to patchwork quilts.[8] In 1886 the Nebraska State Fair Needlework Department added two categories solely for Log Cabin quilts, one for silk and one for worsted (wool).[9] In 1894, Log Cabin quilts were accorded their own category at the Ohio State Fair.[10]

Log Cabin quilts continued to be popular into the twentieth century. The quilt with the Barn Raising setting in plate 2-3 features a cotton flannel backing with an interesting print on it that helps date the quilt. The printed design depicts Billy Possum playing golf with another opossum. During the presidential race of 1908, when William Howard Taft was the Republican and William Jennings Bryan the Democratic nominee, the Taft campaign created Billy Possum as a character to represent Taft, who handily defeated Bryan. Political cartoonists depicted Billy Possum in all manner of situations, each meant to show how little concern such a rich person could be expected to have for the concerns of ordinary citizens.[11] The drawing used on this cotton flannel may be suggesting "Don't let poli-

tics get in the way of a good game of golf." Was the maker a Taft supporter, or did she find the fabric for a bargain price after the election? We'll never know, but it provides an interesting cloth record of presidential campaign memorabilia. The fabrics in the top appear to be from the last quarter of the nineteenth century, yet it is backed with a fabric produced around 1908; thus, it appears that the maker turned to her plentiful scrap bag for the fabrics to piece the top and purchased the cotton flannel to back the quilt top when she completed it.

Quiltmakers continued to make Log Cabins into the 1920s and 1930s. These later versions have a distinct aesthetic, constructed as they are from the lighter and brighter fabrics typical of the era.

The last quarter of the nineteenth century, however, was the true peak of the Log Cabin quilt's popularity, the years when it, along with the Crazy quilt, virtually dominated American quiltmaking. More was written about Crazy quilts in the popular press, as will be seen in the following chapter, but the sheer numbers of Log Cabin quilts that were made during these years indicates the grassroots popularity of the pattern.

■ **Patricia Cox Crews and Carolyn Ducey**

FIG 2-4. Log Cabin, Barn Raising setting. Backing fabric featuring Billy Possum, *detail* (see plate 2-3).

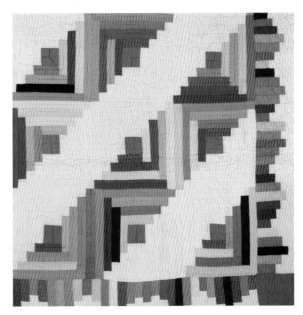

FIG 2-5. Log Cabin, Barn Raising setting, c. 1930–1950, *detail* (see plate 2-13).

Luxurious silk dress fabrics make up this Log Cabin quilt (plate 2-5), whose blocks are set into the overall pattern called Barn Raising. The tan fabric is a figured silk with coral-shaped and arborescent motifs. The black silk has a dobby weave pattern of checks and stripes. The green center squares are made from a plain weave silk.

From afar, the quilt may seem plain, with only three colors, each color composed of the same fabric. But closer in, the eye registers the subtle textures created by the figured weaves in both the black and the tan silks. The green silk, though simple in construction, offers a counterpoint to the neutrals surrounding it. Even the backing fabric, a tan glazed cotton, adds to the sumptuousness of the quilt. The chemical and heat treatments used in the glazing process give the cotton a polished, lustrous sheen. The overall effect is one of rich, understated beauty.

Show quilts, such as this Log Cabin, were at their height of popularity between 1870 and 1890. Made of silks and fine wools, they were never intended to be functional bed coverings. Instead, a show quilt was created "to demonstrate its maker's good taste and knowledge of the popular decorative trends" of the day.[12] The most commonly recognized show quilts were the high-style Crazy quilts, which peaked in popularity in the 1880s, but other types, including Hexagon Mosaics and Log Cabins, also were completed in fancy dress goods.

Although Log Cabins were more often made in cottons and wools, silk versions were highly fashionable. Indeed, in the 1880s they were considered by some as an alternative to the faddish Crazy quilt, as noted in an 1884 *Arthur's Home Magazine*: "Old patterns, and modifications of old ones, are continually coming to the front in silk quilts, so that when the Crazy quilt has had its day there will be plenty of styles to supplant it. A variation of the log cabin is very pretty."[13] The writer goes on to describe a quilt similar to this one, with only two colors of silk on either side of the center square.

This quilt's black and tan silks display extensive evidence that they were recycled, likely from a woman's garment. In many places, the fabrics contain a row of evenly spaced holes along each side of a crease, indicating that they had once been folded and sewn, perhaps to create a series of gores or pleats in a skirt. In addition, many of the individual logs have angled seams. Because each one was cut on the bias (against the natural perpendicular grain of the fabric), this might indicate that the maker cut across any seams she encountered in the recycled fabrics.

Unlike the majority of the Log Cabin quilts in the Center's collections, this one exhibits a great deal of machine stitching on its top side. All of the logs were hand-stitched to a foundation square, but most of the blocks were then joined to each other by machine. The four lengths of glazed cotton fabric that make up the backing were also assembled using both methods. It may be that the maker started off piecing by hand—she completed one whole seam plus a partial seam that way—then tired of it, finishing the rest by machine.

A small tag is fastened to a corner of the quilt's back and says "Mrs. B. H. Wilson, Hastings, NY." We have not been able to find out more about Mrs. Wilson and do not know if she was the maker or one of the quilt's later owners.

■ **Marin F. Hanson**

FIG 2-6. Log Cabin, Barn Raising setting, *detail*. Fabric with indications that it may be recycled from an old garment.

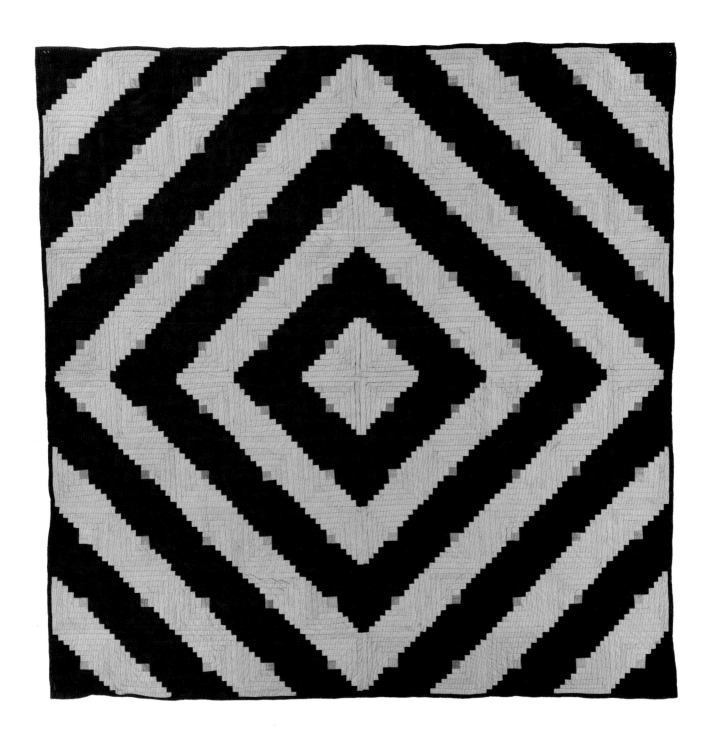

PLATE 2-5. Log Cabin, Barn Raising setting.
Maker unknown.
Possibly made in Hastings, New York, 1870–1890.
Silks, 81" x 80.5". Unquilted.
1997.007.0031. *Ardis and Robert James Collection.*

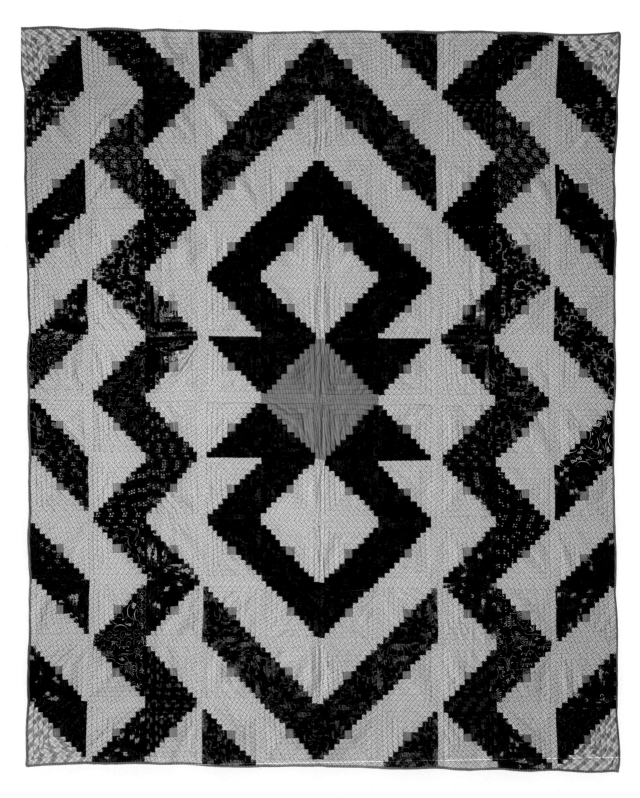

PLATE 2-6. Log Cabin, an original setting.
Maker unknown.
Possibly made in York County, Pennsylvania, 1870–1890.
Wools, wool-cotton mixtures, 90" x 75.5". Unquilted.
1997.007.0127. *Ardis and Robert James Collection.*

FIG 2-7. Log Cabin, an original setting, *detail*.

A simple change in a quilt's setting—the placement and configuration of its blocks—completely alters its character by creating a wholly different overall pattern. Standard Log Cabin blocks (as opposed to Pineapple and Courthouse Steps variations) are particularly versatile and effective in creating setting changes. Because they are divided diagonally into halves, one dark and one light, a seemingly endless array of overall patterns may be created. While typical settings, such as Barn Raising (where the assembled blocks form a series of light and dark concentric diamonds), are among the most common, the Log Cabin block may also be used to make one-of-a-kind arrangements, as this quilt (plate 2-6) demonstrates. The unknown maker combined several of the most common settings into an interesting amalgamation; elements of Barn Raising, Streak of Lightning, and Light and Dark are all seen (see plates 2-3, 2-2, and 2-65).

The component fabrics create a secondary group of patterns. All of the dark fabrics are of the same type: a pigment-printed cotton–wool mix in a two-by-one basket weave. Although the contemporary name for this fabric is unknown, it is commonly seen in quilts of the last quarter of the nineteenth century, most often Log Cabins and non-silk Crazy quilts. The fabrics in this quilt have a shared aesthetic, suggesting that they might have come from the same company and designer. There are a small number of individual designs among these fabrics, but each is printed in a range of colorways, or different color combinations. There are at least four distinct designs, each printed in two to four colorways, making for twelve different fabrics.

When a quilt contains many colorways of a single design, one wonders how the maker obtained them. Normally, a quiltmaker did not have access to more than one or two color variations on a print, although it is possible that her local dry goods or department store carried multiple colorways of popular designs. Another possibility, however, is that she obtained them through a family member or acquaintance employed at a textile mill. An 1830s quilt described in *Down by the Old Mill Stream: Quilts in Rhode Island* provides evidence of this practice. Featuring six different colorways of a single fabric design, it was made by a member of the Allen family of Scituate, Rhode Island, a family in which two generations of men worked in a local textile mill, with access to printers' mistakes and experiments.[14]

Although we cannot know how this quilt's maker obtained her fabrics, we can see in her construction her concern for using them to create a precise pattern. Each distinct colorway is placed so that the quilt, with only a few exceptions, displays perfect quadrilateral symmetry. In other words, fabric placement is mirrored along both the horizontal and vertical axes, a design decision that gives this unique setting even greater cohesion. ■ **Marin F. Hanson**

FIG 2-8. Log Cabin, Courthouse Steps variation, *detail*, "Mary Groff 1871."

ecause it is one of the earliest known date-inscribed Log Cabin quilts, this Courthouse Steps variation (plate 2-7) is particularly important. The name "Mary Groff" and the date "1871" are embroidered in red thread onto one of the black-and-white shirting print logs. Log Cabin quilts, a popular American quilt style during the last quarter of the nineteenth century, were being made as early as the 1860s.[15]

Many of the fabrics in this quilt are typical of the styles of fabric available from the 1840s onward. The red calicoes appear to be colored with dyes from the root of the madder plant or from the synthetic version of the madder colorant, alizarin. (Used in conjunction with aluminum, tin, and iron mordants, madder could produce a variety of reds, oranges, brownish blacks, and purples.) In addition, most blocks include calico strips in the popular chrome yellow, as well as the dis-

tinctive overdyed greens, types available for most of the nineteenth century. The blocks forming the two columns of Courthouse Steps on the right side of the quilt include strips of the distinctive double blue calico, often referred to as Lancaster blue because it was so popular among quiltmakers of Lancaster County, Pennsylvania, adding support for the quilt's Pennsylvania attribution. Many of the light-colored fabrics used throughout the quilt are shirting prints. Because black-and-white shirting fabrics are more typical of the 1880s and 1890s, the embroidered numbers were carefully scrutinized in this quilt. Although the "7" in the date could be read as a 9 made in an unusual angular fashion, it seems doubtful that the maker intended to do this because she embroidered the "8" in a conventional curvilinear fashion.

Like most Log Cabin quilts, this one was foundation-

PLATE 2-7. Log Cabin, Courthouse Steps variation.
Probably made by Mary Groff.
Probably made in Pennsylvania, dated 1871.
Cottons, 85" x 82.5". Unquilted.
2003.003.0211. *Jonathan Holstein Collection.*

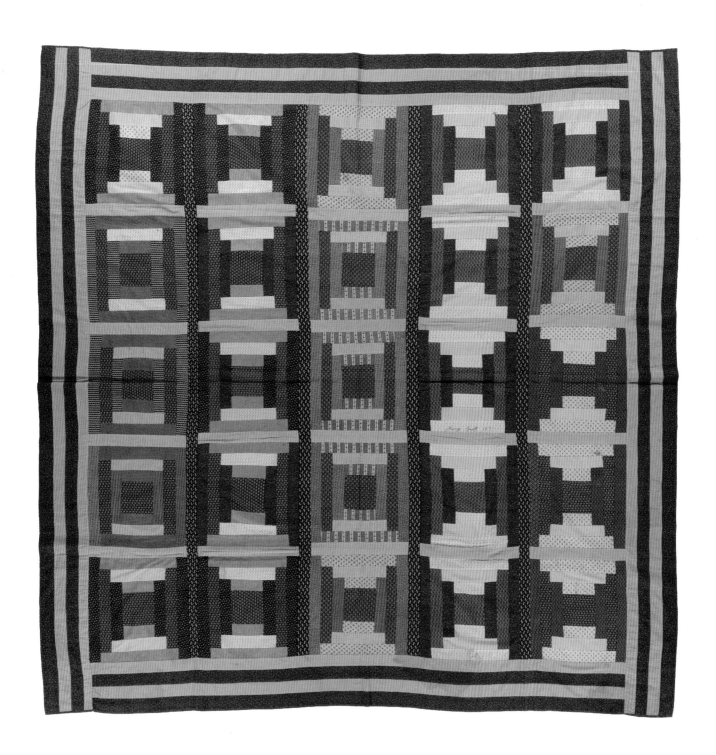

pieced by hand. Furthermore, Mary Groff did not use a sewing machine at all, even for the long seams of running stitches required to construct the borders of alternating strips of chrome yellow and green calicos.

The Courthouse Steps block is regarded as the easiest to sew of the three Log Cabin block formats (Log Cabin, Courthouse Steps, and Pineapple). This would have been a good block for an inexperienced quiltmaker. It appears that Mary may have been a novice because many of the logs pucker along the edges; con-

FIG 2-9. Log Cabin, Courthouse Steps variation, *detail*. On the reverse, seams joining the foundation-pieced blocks are covered with strips of fabric.

sequently, the quilt ripples and does not lie flat. In addition, the center squares are unusually large, yet another indication that this quilt may have been the first or one of the first quilts made by her. Though sewing for the family remained an expected task for most American women until the end of the nineteenth century (and for rural women, this remained true well into the twentieth century), it was not a task that all women enjoyed, nor one in which all excelled. Nevertheless, Mary cared enough about this quilt to embroider her name and the date, suggesting that the construction flaws were due to her inexperience rather than carelessness or a dislike for sewing.

Most Log Cabin quilts are not quilted; instead, the layers usually are tied together with yarn or thread at regular intervals. However, this quilt is neither tied nor quilted, nor is it backed in a conventional manner; instead, the maker whipstitched long strips of cloth over the seams where the foundation-pieced blocks were joined. The foundation fabric became the backing in this way.

All of the large center squares are red; ten of them are from the same calico, a brick red ground with brown and white geometric patterning. Red was a popular center square color choice. In fact, it is the most frequently found center square color among the nineteenth-century Log Cabin quilts in the Center's collections.

■ **Patricia Cox Crews**

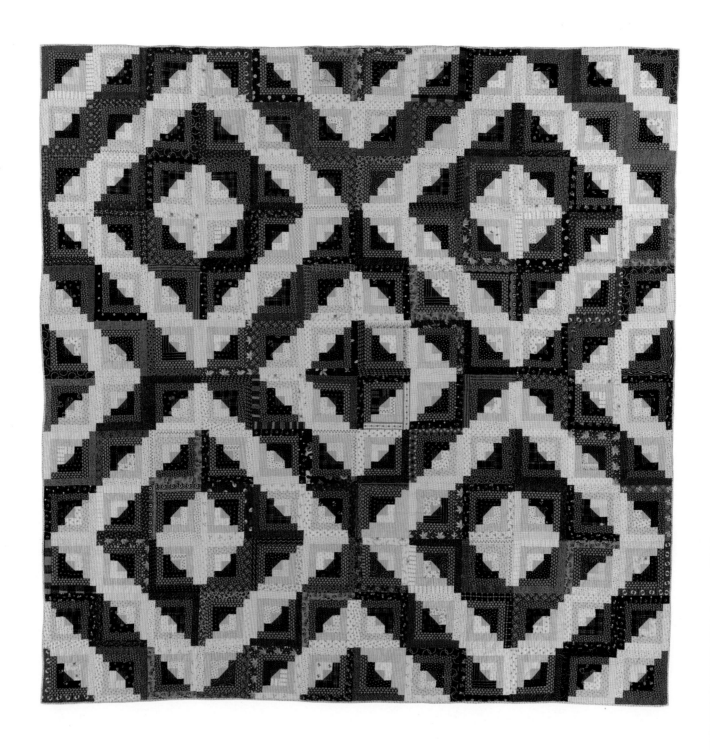

PLATE 2-8. Log Cabin, Chimney and Cornerstone setting.
Maker unknown.
Possibly made in Pennsylvania, 1890–1910.
Cottons, 80" x 80". QSPI: 10.
1997.007.0544. *Ardis and Robert James Collection.*

An extremely crisp quilt, both in "hand" (the tactile quality of a textile) and in aesthetics, this Chimney and Cornerstone Log Cabin (plate 2-8) has never been washed. Several qualities indicate this. One is that the fabrics are not puckered along the seams and quilting lines as they likely would have been if they had slightly shrunk during washing. Also, there are several glazed fabrics that retain their high sheen, which normally would have been dulled by the washing process. Finally, the penciled quilting lines remain clear; washing would have removed or lightened them. Many antique quilts that survive today are unwashed. Although probably not true in every case, an unwashed state often indicates that a quilt was highly valued, brought out on special occasions, and rarely soiled enough to require laundering.

Shirting prints were often used for the lighter half of Log Cabin blocks. The prints sometimes featured such novelty motifs as birds, dogs, and even tennis rackets. More often, however, as in this quilt, shirtings were printed with small geometric patterns, floral groupings, and simple stripes.

While the lighter sections of Log Cabin quilts naturally contrast with the darker ones, this quiltmaker gave an extra glow with the addition of a medium-value chrome yellow print, strategically placed as the middle log of each light half. The corresponding middle logs in the dark areas are rusty red calicoes that are considerably lighter than the brown, blue, and gray-blue prints and the saturated indigo-colored logs that punctuate the dark half of each block. The result is that the yellow and red logs join to create square outlined forms that appear to be superimposed on the setting. Also present in the dark areas, and important for dating the quilt, are several claret-colored fabrics typical of the early twentieth century.

Half-square triangles in the center of each block form the square that is the foundation of every Log Cabin block. It is unusual to see the center square divided into two diagonal halves; normally it is a single piece of fabric. In fact, of the seventy-two Log Cabins in the Center's collections, this is the only one with a pieced, rather than solid, center square. One half of its color, red, is the most commonly used color for center squares (43 percent of the Center's Log Cabins have a red center); the other half, blue, is much more rarely used (5 percent of the Center's Log Cabins).

Most Log Cabin quilts are tied, not quilted. If they do have quilting, it is normally accomplished in an outline fashion that echoes the lines of the logs, or is "in the ditch" (in the depression created by the seams). This quilt, however, is quilted with an allover clamshell pattern that completely ignores the lines of the pieced blocks. Clamshell quilting, though used over a broad range of time, was at its peak of popularity in the early to mid-nineteenth century. On a late nineteenth-century quilt it looks somewhat out of place.

■ **Marin F. Hanson**

FIG 2-10. Log Cabin, Chimney and Cornerstone setting, *detail.*

FIG 2-11. Log Cabin, Courthouse Steps variation, *detail.*

This Courthouse Steps quilt (plate 2-9) is a tour de force of careful planning and design. Composed in the same way as a traditional British frame or early American center-medallion quilt, the nine successive borders surround a center square formed from nine Courthouse Steps blocks. The concentric borders alternate between rows of narrow diagonal fabric strips and chains of Courthouse Steps blocks. The diagonal arrangement in the string-style borders—first slanting to the right and then to the left—further contributes to the quilt's dynamic quality. Another, subtle design layer was added to the quilt by the use of a single red-dominated Courthouse Steps block in each corner of the borders. These blocks create a secondary pattern, a large X, across the surface of the quilt from corner to corner.

Though it initially has the look of a scrap quilt, with its multitude of narrow fabric strips, careful examination of the quilt's various borders gives a glimpse into the elaborate planning and execution that underlie it. Each of the Courthouse Steps blocks is composed of like fabrics: a solid red center square and a combination of printed plaid and solid black logs. Only in the outermost Log Cabin border does this consistency break down, where a variety of fabrics is used in the block. The strip-pieced borders show a mastery of color and design. The innermost border contains only shades of light brown and tan accented with a rich maroon fabric at regular intervals. The second border contains the same fabrics, with additional new fabrics in shades of green and blue, once again placed rhythmically throughout the border. This careful placement and expansion of the pattern continues to the outermost border. There, the quilt is framed on two sides with a straight horizontal strip border. On the alternating sides a series of five fabrics are repeated in an angled pattern accented by strips of bright green fabric placed next to strips of green-and-red plaid. This uniformity establishes the quilt's structure and helps contain its visual exuberance.

Underlying these structural design elements, the maker's use of contrasting light and dark strips of plaid fabrics adds texture to the overall effect. The use of the high-contrast black fabric in the Courthouse Steps borders creates dark frames that draw the eye inward while also delineating the two distinct border types and providing a relief from the busy visual activity of the quilt.

One reason Log Cabin quilts are popular is the way they engage the viewer in an analysis of color and shape. The eye searches out the dominant colors and forms, such as those of the successive borders. It then further processes the secondary details of the overall design, including recognition of the Courthouse Steps block and the various hues and prints of the fabrics that make up the light and dark portions of the quilt.

The small Courthouse Steps blocks and the border sections of narrow fabric strips were foundation-pieced and backed to create individual segments. The completed segments were then stitched together with a running stitch on the top, then turned over and whipstitched together to complete the quilt. This technique of working small sections of the quilt one at a time simplified its construction.

■ **Carolyn Ducey**

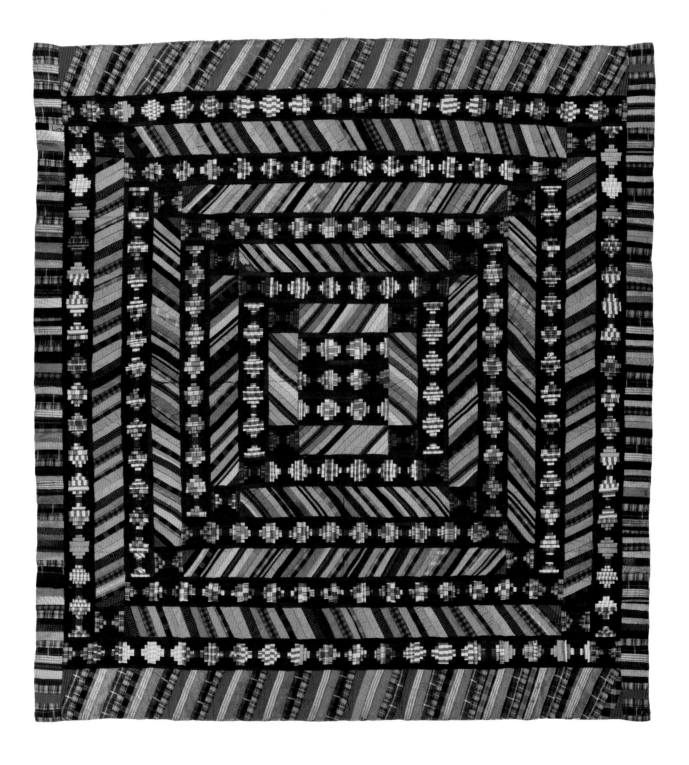

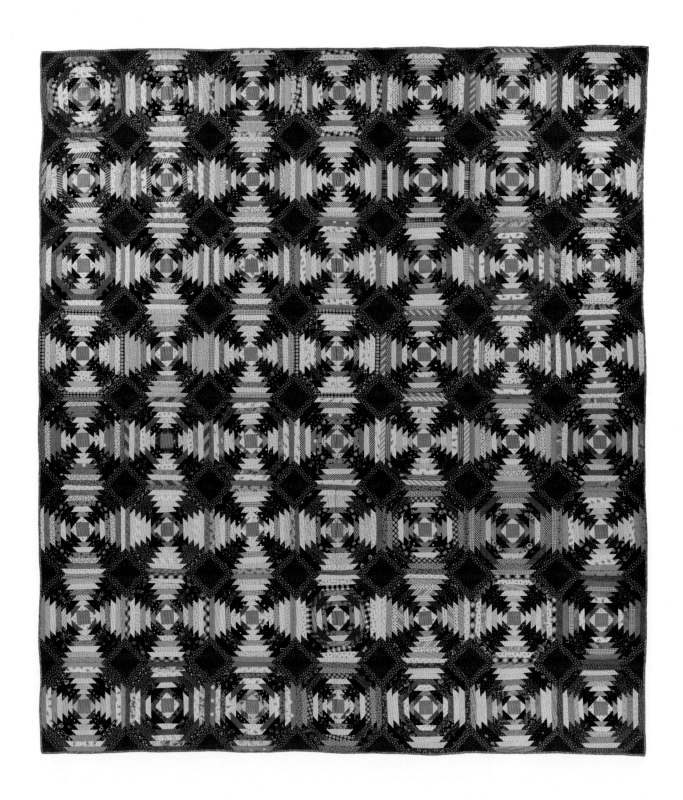

PLATE 2-10. Log Cabin, Pineapple variation.
Anna Hazel Burmeister (1875–1959).
Waukesha, Wisconsin, c. 1894.
Cottons, 85" x 75". Unquilted.
1997.007.0933. *Ardis and Robert James Collection.*

The visual shifts and interplays in this Pineapple quilt (plate 2-10) demonstrate the way quiltmakers manipulated the complex relationship between color and form. The large red diamonds framed by complementary green logs pulse visually. Contrasting colors cause the figure and ground to reverse repeatedly: at one moment the X shapes formed by the dark "pineapples" appear as figures on a light ground; in the next the light crosses appear to float on a dark ground. The maker's use of occasional rounds of medium-value logs in the light areas of some blocks creates ripples emanating from the pink centers. Each block has seven rounds of logs cut from a variety of calicoes, shirtings, and woven stripes and plaids, which adds to the liveliness of the quilt surface. The eye seeks some individual fabrics, particularly bias-cut plaids and stripes, the occasional red or blue print, and a dark purple print.

There is clear evidence that the surface was carefully planned. The outer round of logs of the four corner blocks, made of double pink calico prints, establishes the quilt's boundaries. The darkest fabrics in the quilt, several indigo cottons with white polka-dots or scattered stars, are consistently placed near the center of each block. The number of pieces (3,641), the necessary planning involved, and the hand-piecing on a foundation indicate the maker's intent to produce a showpiece.

Anna Hazel Burmeister, who made the quilt, was no stranger to determination or accomplishment. She was born on the family farm in rural Wauwatosa, Milwaukee County, Wisconsin, to William and Sophie Mueller Burmeister, German immigrants from Mecklenburg, Germany.[16] Anna's parents were among the (at least) 150,000 people who migrated to the United States from Mecklenburg "to break with the past and to achieve freedom in social relations."[17] Anna became a dressmaker in Waukesha, Wisconsin, after finishing two years of high school, and shared a business with her sister, Elsie, a milliner. During this time she made the Pineapple quilt and entered it in the 1894 Wisconsin State Fair. Anna won first place in the Log Cabin Quilt Division, receiving a premium of $4.00. By December 1905 she had moved to Chicago and gained work as the head of a department in the dressmaking section of Marshall Field's. While there she determined to pursue a career in dentistry. She enrolled in night school at the Lewis Institute to finish her last two years

FIG 2-12. "Girl Works Way through Milwaukee Dental School," *Milwaukee Journal*, May 26, 1912 (article about Anna Burmeister).

of high school, a necessary entrance requirement for dental school. She then moved to Milwaukee to attend dental school at Marquette University and graduated in 1912 as one of the first female dentists. A May 26, 1912, *Milwaukee Journal* article quotes her: "It has been hard work. The money didn't come easy and my course took a lot. But I did no more than other girls have done and can do. All that is required is the determination. I made up my mind to get my dental degree and I went after it with all the power in me."[18]

Anna practiced dentistry in Milwaukee until her retirement in 1954. She was a founding charter member of the Federation of American Women Dentists in 1921 (now the American Association of Women Dentists). She never married, and she died on October 15, 1959.

How and why some nineteenth-century immigrant communities adopted quiltmaking is an area of ongoing research. A number of state quilt documentation projects have recorded the ancestries of the makers in hopes of providing information for further research into immigrant quiltmaking. The Nebraska Quilt Project, for example, found that the majority of makers (47 percent) documented by the project were women who claimed German ancestry. The researchers suggested that German women possessed the requisite needlework skills upon arrival in the United States and were thus able to successfully adopt and begin quiltmaking in their new country.[19]

■ Jonathan Gregory

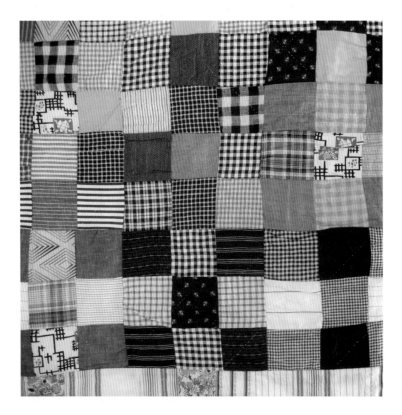

FIG 2-13. Log Cabin, Sunshine and Shadow setting. Pieced Nine Patch backing, *detail*.

The Sunshine and Shadow variation is a basic, uncomplicated Log Cabin setting: standard Log Cabin blocks are simply lined up in exactly the same orientation and pieced together. The effect can be static because the light and dark halves of the blocks always maintain the same positions relative to one another. In addition, this Sunshine and Shadow variation (plate 2-11) does not have any of the wild color contrasts or highly organized color schemes as some of the other Log Cabins featured in this chapter.

What is interesting about this quilt, however, is that its various parts were constructed over a period of nearly half a century, from the 1890s to the 1940s. One way of establishing this time line is through consideration of the fabrics. The oldest fabrics in the quilt are found not on the front side, but on the back. The back, rather than being a single piece or type of fabric, is composed of a series of Nine Patch blocks made from dark prints, plaids, and stripes typical of the early twentieth century. Mourning prints (fine-lined black prints on a white ground), indigo discharge prints, claret prints, and gray and blue chambrays give strong dating clues. These

colors and prints were popular around the turn of the century for work clothing and often found their way into quilts of the era.[20] White figures on a dark indigo-blue background were particularly common around the turn of the century, when they became very inexpensive due to the development of a new method for directly printing indigo. Additionally, they were attractive, conservative textiles designed for a middle-class market. (For additional information on direct indigo printing, see discussion of plate 1-13, Square in a Square.)

There are also some anomalous fabrics on the back. A boldly stylized, almost Modernist, geometric print in turquoise, black, and white as well as some scattered solid pink fabrics give clues to a later date. These inconsistencies suggest that some of the Nine Patch blocks might have been completed around the turn of the century, whereas others were made a few decades later using a combination of early and later fabrics. (Many women kept fabrics long after they had faded from fashion.) In addition, the Nine Patch blocks were insufficient to form a backing large enough to accommodate the quilt top, so rows of 1910s–1940s pastel

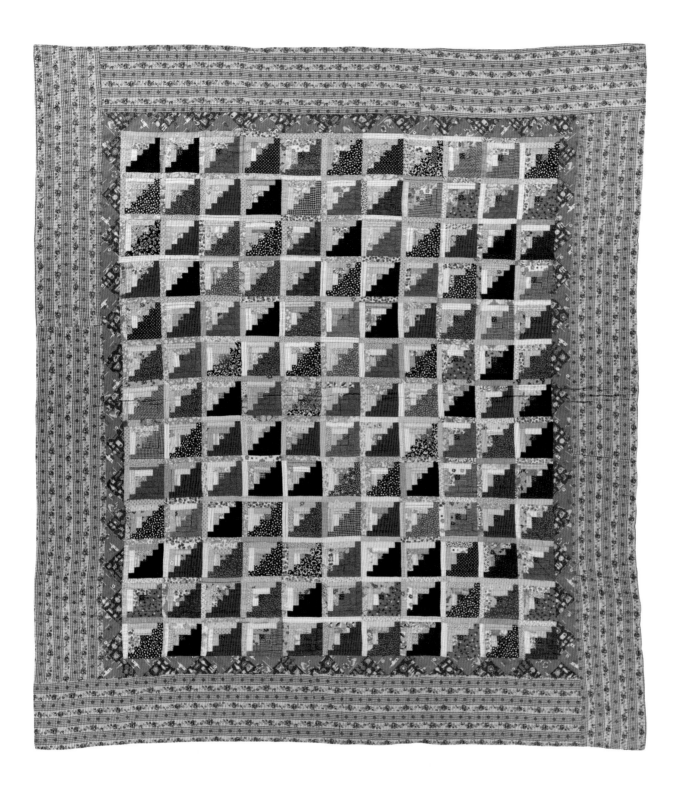

PLATE 2-11. Log Cabin, Sunshine and Shadow setting.
Maker/location unknown, 1940–1950.
Cottons, linens, 87" x 77". QSPI: 5.
2003.003.0354. *Jonathan Holstein Collection.*

chambrays and stripes were added to two sides of the back to enlarge it to the appropriate size.

The fabrics on the front of the quilt also represent a range of dates. Most of the Log Cabin blocks are composed of fabrics typical of the 1920s and 1930s. Pastel prints, frequently featuring small-scale florals, make up the light half of the blocks, while the dark halves alternate between solids, plaids, polka dots, and florals. Once again, however, some irregular fabrics appear, in particular some indigo discharge prints much more consistent with the late nineteenth-century fabrics on the back of the quilt than with the 1920s and 1930s fabrics on the top. Because there is such a mix of fabrics in the Log Cabin blocks, it is likely that they were created at the same time using both old and new materials.

Conversely, the fabrics in the quilt's borders appear to have originated in the late 1930s and 1940s only. The solid bright turquoise background of one of the prints in the pieced triangle inner border was more commonly seen in the late 1940s than in the 1920s or 1930s. In addition, the design technique of leaving a "halo" around a figure to separate it from the solid background and therefore allowing for registration mistakes during printing was a common technique in these later years and can be seen in the bright red fabric that alternates with the turquoise.[21]

Another, less immediately visible clue to the quilt's date range can be found in two of the border fabrics and in the quilting thread. Viewed under a black light, both the white areas in the pieced triangle border and the quilting thread fluoresce. Fluorescence indicates that these fabrics and the quilting thread were treated with optical brighteners when they were being finished at the mill. This treatment, which makes white appear whiter, did not become common in the United States until after World War II.

■ **Marin F. Hanson**

FIG 2-14. Log Cabin, Sunshine and Shadow setting, *detail*. Border fabrics.

GALLERIES

Barn Raising Setting

The Barn Raising setting was a popular layout for the standard Log Cabin block during the years covered in this volume. The related quilt in the Chevron setting can be imagined as a Barn Raising setting split in the middle, with the two halves swapped. There are clear contrasts between the nineteenth- and twentieth-century examples in the Center's collections. In addition to differences in color palettes, the later quilts tend to be made from fewer and larger blocks, which required less time to construct. This may reflect a simplified modern aesthetic or a preference by makers who divided their time between domestic and outside amusements.

The two pastel-colored quilts from the 1930s and 1940s reveal an Art Deco influence; one even has an Art Deco border. Reinterpretation of a pattern from the mid to late nineteenth century in updated colors and contemporary style illustrates the embrace of modern decorative aesthetics while ostensibly holding to tradition, a paradox of the Colonial Revival.

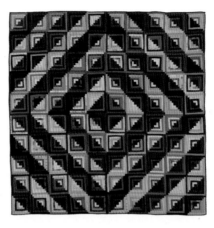

PLATE 2-12. Log Cabin, Barn Raising setting.
Possibly made in Berks County, Pennsylvania, 1880–1900.
Wools, 75" x 75". 1997.007.0005.

PLATE 2-14. Log Cabin, Barn Raising setting.
Possibly made in New Jersey, 1930–1950.
Cottons, 88" x 70.5". 2003.003.0042.

PLATE 2-13. Log Cabin, Barn Raising setting.
Possibly made in Pennsylvania, 1930–1950.
Cottons, 80.5" x 71.5". 1997.007.0782.

PLATE 2-15. Log Cabin, Chevron setting.
Probably made in Pennsylvania, 1880–1900.
Cottons, 83" x 83". 2003.003.0184.

Barn Raising Setting

PLATE 2-16. Log Cabin, Barn Raising setting.
Possibly made in the midwestern United
States, 1880–1900.
Cottons, 81" x 78.5". 1997.007.0305.

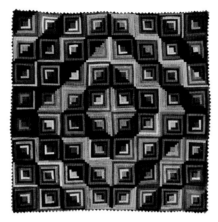

PLATE 2-18. Log Cabin, Barn Raising setting.
Maker/location unknown, 1880–1900.
Silks, 82.5" x 80.5". 1997.007.0891.

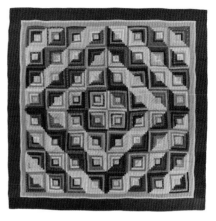

PLATE 2-20. Log Cabin, Barn Raising setting.
Probably made in Pennsylvania, 1890–1910.
Cottons, 84" x 82.5". 2003.003.0237.

PLATE 2-21. Log Cabin, Barn Raising setting.
Made by Abba Jane Blackstone Johnson,
Curtis, Frontier County, Nebraska, c. 1910.
Cottons, 81" x 75". 2004.015.0001.
Gift of Mary Oba.

PLATE 2-17. Log Cabin, Barn Raising setting.
Possibly made in Pennsylvania, 1880–1900.
Cottons, 78" x 78". 1997.007.0543.

PLATE 2-19. Log Cabin, Barn Raising setting.
Possibly made in Maine, 1900–1920.
Cottons, 77" x 78". 2003.003.0174.

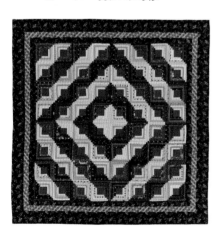

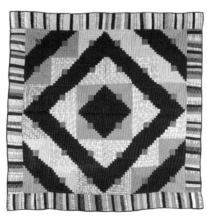

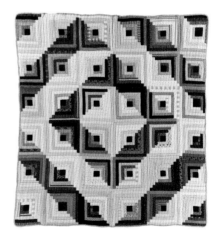

Courthouse Steps Variation

The Courthouse Steps variation of the Log Cabin block is divided into four light and dark triangular sections by two corner-to-corner diagonals. Typically, the sections alternate so that the light and dark areas are opposite each other. Courthouse Steps blocks have limited arrangement options and are usually set for an allover pattern, rather than the large-scale geometric figures possible with standard Log Cabin block settings.

The creative challenge to makers of a Courthouse Steps quilt was to use fabric choice, color placement, and value contrasts to enhance the otherwise more limited visual effects than were possible with the standard Log Cabin block. The quilts pictured on these pages demonstrate that surfaces can vary from complex to simple, dynamic to static, dimensional to flat, and from having vertical to diagonal to horizontal movement. Each combination provides a different aesthetic that masks their shared block style.

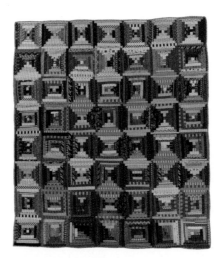

PLATE 2-22. Log Cabin, Courthouse Steps variation.
Possibly made in eastern Massachusetts, 1870–1890.
Cottons, 85" x 74". 1997.007.0926.

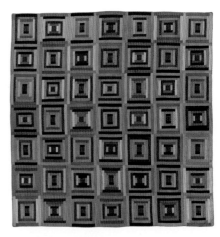

PLATE 2-24. Log Cabin, Courthouse Steps variation.
Possibly made in Pennsylvania, 1870–1890.
Wools, 86.5" x 86". 2003.003.0057.

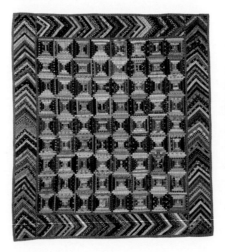

PLATE 2-23. Log Cabin, Courthouse Steps variation.
Probably made in New York, 1870–1890.
Wools, 97" x 86". 1997.007.0928.

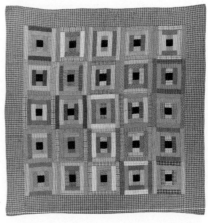

PLATE 2-25. Log Cabin, Courthouse Steps variation.
Maker/location unknown, 1910–1930.
Cottons, 72.5" x 71". 2003.003.0382.

Courthouse Steps Variation

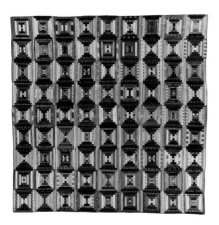

PLATE 2-26. Log Cabin,
Courthouse Steps variation.
Possibly made in eastern Pennsylvania,
1870–1890.
Silks, 92" x 89.5". 1997.007.0815.

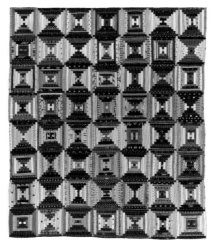

PLATE 2-28. Log Cabin,
Courthouse Steps variation.
Probably made in Pennsylvania, 1870–1890.
Cottons, 85.5" x 76". 2003.003.0149.

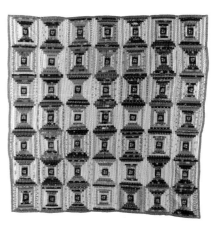

PLATE 2-30. Log Cabin,
Courthouse Steps variation.
Probably made in Pennsylvania, 1870–1890.
Wools, 81.5" x 82". 2003.003.0319.

PLATE 2-27. Log Cabin,
Courthouse Steps variation.
Possibly made in Pennsylvania, 1880–1900.
Wools, 84" x 73.5". 2003.003.0028.

PLATE 2-29. Log Cabin,
Courthouse Steps variation.
Probably made in Pennsylvania, 1880–1900.
Wools, 47" x 41.5". 2003.003.0227.

PLATE 2-31. Log Cabin,
Courthouse Steps variation.
Possibly made in New England, 1870–1890.
Cottons, 84" x 75.5". 2003.003.0357.

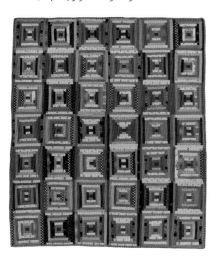

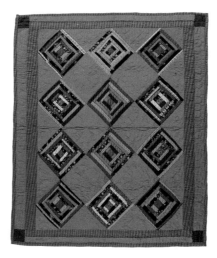

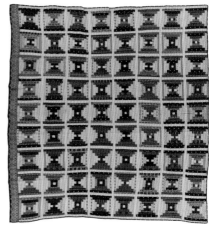

Pineapple Variation

The Pineapple variation block is constructed by adding angled logs at the corners in each round of pieces in the standard Log Cabin block. This technique results in saw-toothed lines that radiate from the center and divide the block into eight wedges, which usually alternate between light and dark colors.

The makers of these Pineapple variation quilts manipulated the graphic effect of the pattern by limiting the range of colors used, choosing fabrics that provided stark value contrasts, interspersing medium-value logs within the light-value areas, or varying the width and number of logs in each block. The effects range from calm to busy, quiet to loud, and static to dynamic.

Most standard Log Cabin and Courthouse Steps variation quilts possess strong diagonal lines or figures. However, Pineapple variation quilts are enlivened by angled intersections of fabric strips and the lines of the pattern that create the illusion of circles and arcs across the surface.

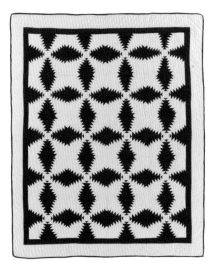

PLATE 2-32. Log Cabin, Pineapple variation. Maker/location unknown, 1900–1920. Cottons, 67" x 53.5". 1997.007.0004.

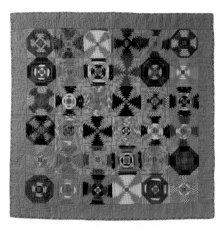

PLATE 2-34. Log Cabin, Pineapple variation. Probably made in Pennsylvania, 1880–1900. Wools, 69.5" x 68.5". 1997.007.0923.

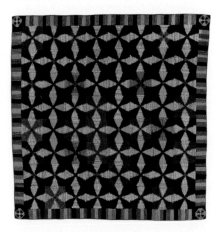

PLATE 2-33. Log Cabin, Pineapple variation. Possibly made in Pennsylvania, 1880–1900. Wools, 82.5" x 83.5". 1997.007.0899.

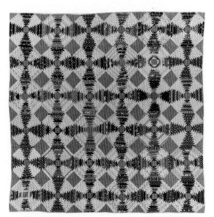

PLATE 2-35. Log Cabin, Pineapple variation. Maker/location unknown, 1880–1900. Cottons, 85.5" x 86". 2003.003.0242.

Pineapple Variation

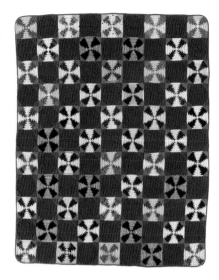

PLATE 2-36. Log Cabin, Pineapple variation.
Possibly made in Ohio, 1900–1920.
Cottons, 80" x 63.5". 1997.007.0010.

PLATE 2-38. Log Cabin, Pineapple variation.
Possibly made in southern Illinois, 1900–1920.
Wools, 81" x 67.5". 1997.007.0190.

PLATE 2-40. Log Cabin, Pineapple variation.
Possibly made by Jennie M. Bryant,
Greenwood, Massachusetts, 1870–1890.
Cottons, 74.5" x 74". 1997.007.0483.

PLATE 2-37. Log Cabin, Pineapple variation.
Possibly made in Ohio, 1865–1885.
Wools, 79" x 70". 1997.007.0179.

PLATE 2-39. Log Cabin, Pineapple variation.
Possibly made in Michigan or Ohio, 1890–1910.
Cottons, 71" x 70.5". 1997.007.0475.

PLATE 2-41. Log Cabin, Pineapple variation.
Possibly made in Ohio, 1865–1885.
Wools, 77" x 68". 1997.007.0551.

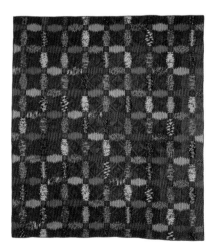

Translucence, Layers, and Shadows

One appeal of making a Log Cabin quilt is the graphic quality that can be created by adjusting fabric hues and values. Quiltmakers have achieved shadowy and translucent effects that appear to be cast across the surface of an underlying square grid. For example, the Light and Dark setting gives the illusion of dark translucent diamonds floating above a light-colored field, and the Sunshine and Shadow setting fools one's eye into thinking that each block is a shaded portal, receding into the space behind the surface. Similar illusory dappled, shadowy, and translucent effects are possible regardless of the setting.

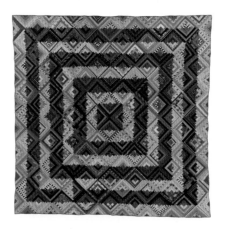

PLATE 2-42. Log Cabin, Concentric Squares setting.
Possibly made in Lancaster County, Pennsylvania, 1870–1890.
Wools, 87.5" x 84.5". 1997.007.0808.

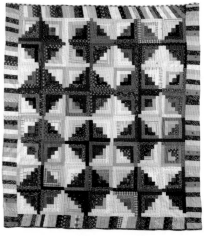

PLATE 2-44. Log Cabin, Light and Dark setting.
Probably made in Pennsylvania, 1890–1910.
Cottons, 71.5" x 64". 2003.003.0217.

PLATE 2-43. Log Cabin, Streak of Lightning setting.
Possibly made in Hagerstown, Maryland, 1870–1890.
Wools, 87" x 79.5". 1997.007.0825.

PLATE 2-45. Log Cabin, Sunshine and Shadow setting.
Possibly made in New Jersey, 1880–1900.
Cottons, 86" x 75". 2003.003.0254.

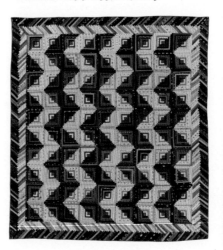

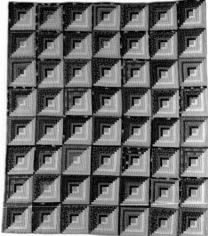

Translucence, Layers, and Shadows

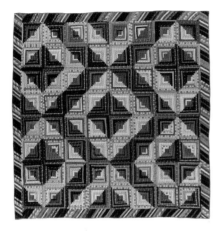

**PLATE 2-46. Log Cabin,
Chimney and Cornerstone setting.**
Possibly made in Pennsylvania, 1870–1890.
Wools, 82" x 85". 1997.007.0294.

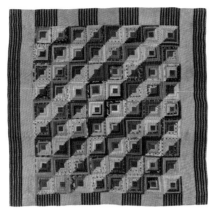

PLATE 2-48. Log Cabin, Straight Furrow setting.
Possibly made in New Jersey, 1870–1890.
Wools, 86.5" x 88.5". 2003.003.0004.

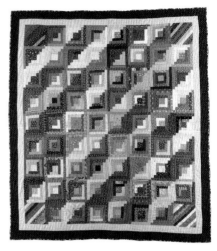

PLATE 2-50. Log Cabin, Straight Furrow setting.
Probably made in Pennsylvania, 1880–1900.
Cottons, 78.5" x 69". 2003.003.0224.

PLATE 2-47. Log Cabin, Straight Furrow setting.
Possibly made in Pennsylvania, 1880–1900.
Cottons, 83" x 71". 1997.007.0855.

**PLATE 2-49. Log Cabin,
Chimney and Cornerstone setting.**
Possibly made in Pennsylvania, 1880–1900.
Wools, 74" x 75". 2003.003.0222.

PLATE 2-51. Log Cabin, Straight Furrow setting.
Probably made in Pennsylvania, 1880–1900.
Cottons, 78" x 78". 2003.003.0344.

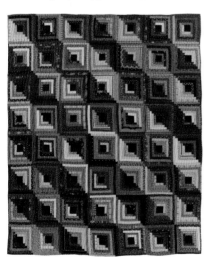

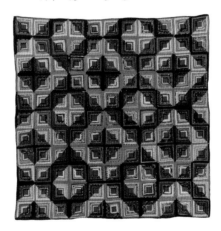

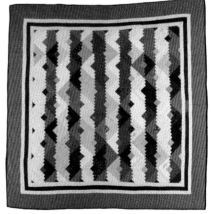

Bold Geometry

The strong colors, high contrast, and bold geometry of these nineteenth-century quilts (plates 2-52–2-55) have been compared to the simple and modern aesthetic used by a number of artists working in the mid-twentieth century. Jonathan Holstein and Gail van der Hoof focused the world's attention on this phenomenon in the 1971 Whitney Museum of American Art exhibition Abstract Design in American Quilts, which included several quilts with similarly bold color and graphic statements. Although there is visual similarity, makers of these quilts were not working from the same aesthetic impulses as those later artists. It is far more likely that these quilts reflect the result of each maker's color preferences and the availability of fabrics when applied to a popular late nineteenth-century quilt style. These quilts, interestingly, date from the period of the high-style Crazy quilt (ca. 1880–1895), revealing a diversity of quiltmaking aesthetics in the late nineteenth-century United States.

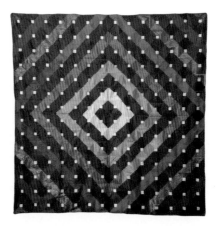

PLATE 2-52. Log Cabin, Barn Raising setting.
Possibly made in eastern Pennsylvania, 1865–1885.
Silks, 83.5" x 83.5". 1997.007.0871.

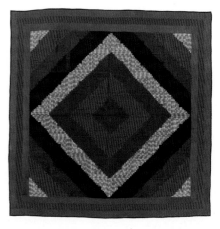

PLATE 2-54. Log Cabin, Barn Raising setting.
Possibly made in Pennsylvania, 1890–1910.
Wools, 79" x 79". 2003.003.0249.

PLATE 2-53. Log Cabin, Straight Furrow setting.
Possibly made in Ohio, 1890–1910.
Wools, 79.5" x 67". 2003.003.0197.

PLATE 2-55. Log Cabin, Straight Furrow setting.
Possibly made in Pennsylvania, 1890–1910.
Wools, 75" x 73". 2003.003.0252.

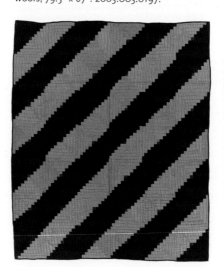

"Much in Little Space"

"Much in little space" describes the late Victorian aesthetic in home decorating and furnishings.[22] It was considered fashionable to ornament every surface with decorative objects and fine textiles and in a plethora of patterns to create an artistic atmosphere. Crazy quilts, with their multitude of luxurious fabrics and stitches, fit this aesthetic, and so did the Log Cabin quilts pictured here (plates 2-56–2-59). The number of pieces in these quilts range from approximately 2,400 to 13,000! The quilts are not large, but they provide much for the eyes to behold in pattern, color, luminosity, depth, and texture.

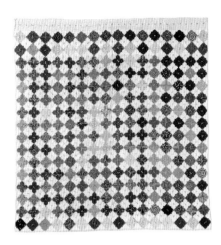

PLATE 2-56. **Log Cabin, Light and Dark setting.**
Probably made in New England, 1890–1910.
Cottons, 74.5" x 70.5". 1997.007.0114.

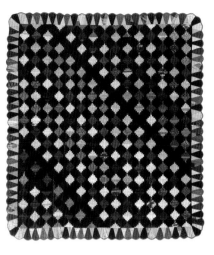

PLATE 2-58. **Log Cabin, Courthouse Steps variation.**
Probably made in southeastern Ohio, 1870–1890.
Silks, 65" x 59". 1997.007.0439.

PLATE 2-57. **Log Cabin, Pineapple variation.**
Possibly made in Ohio or Pennsylvania, 1870–1890.
Cottons, 76.5" x 66". 1997.007.0184.

PLATE 2-59. **Log Cabin, Courthouse Steps variation.**
Possibly made in Ohio, 1870–1890.
Silks, 74" x 56". 1997.007.0934.

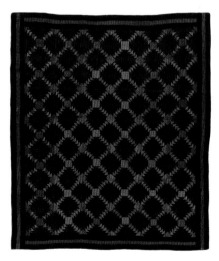

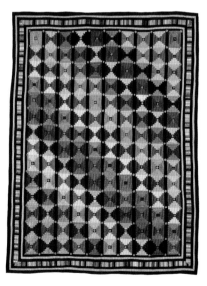

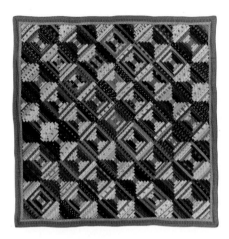

PLATE 2-60. Log Cabin,
Courthouse Steps variation.
Possibly made in Pennsylvania, 1870–1890.
Wools, 87.5" x 87.5". 1997.007.0204.

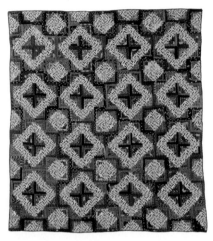

PLATE 2-62. Log Cabin,
Chimney and Cornerstone setting.
Probably made in Ohio, 1880–1900.
Wools, 74" x 68". 1997.007.0561.

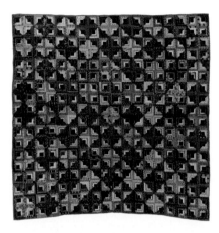

PLATE 2-64. Log Cabin, Light and Dark setting.
Possibly made in Pennsylvania, 1870–1890.
Cottons, 72" x 74". 2003.003.0031.

PLATE 2-61. Log Cabin,
Courthouse Steps variation.
Possibly made in Ohio, 1870–1890.
Wools, 77" x 62.5". 1997.007.0280.

PLATE 2-63. Log Cabin, Light and Dark setting.
Possibly made in Ephrata, Pennsylvania,
1870–1890.
Cottons, 94" x 96". 1997.007.0863.

PLATE 2-65. Log Cabin, Light and Dark setting.
Possibly made in Pennsylvania, 1900–1920.
Wools, 69" x 67.5". 2003.003.0036.

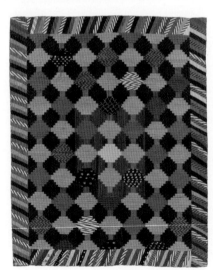

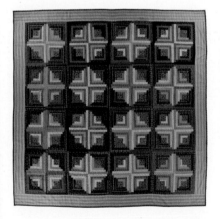

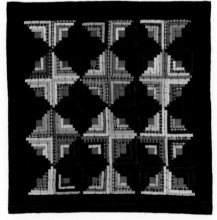

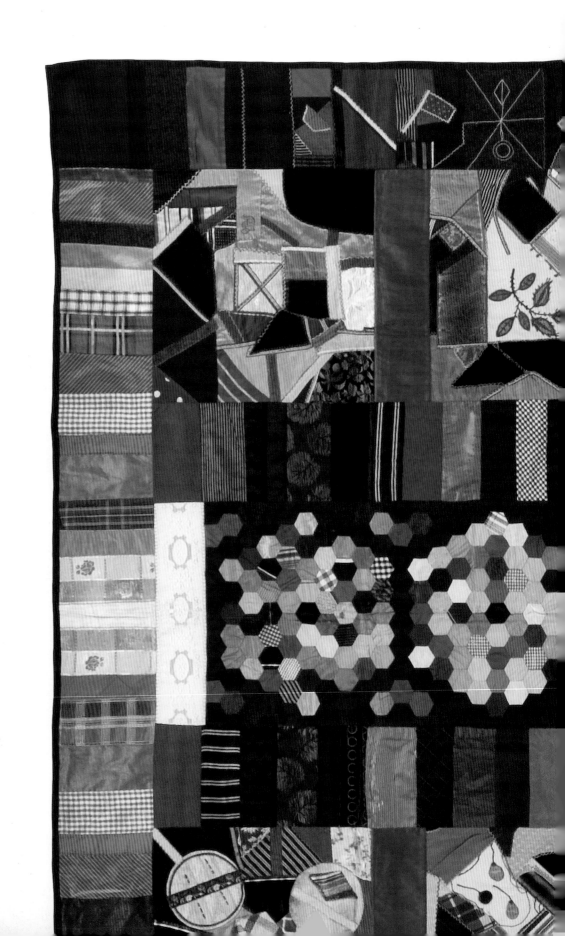

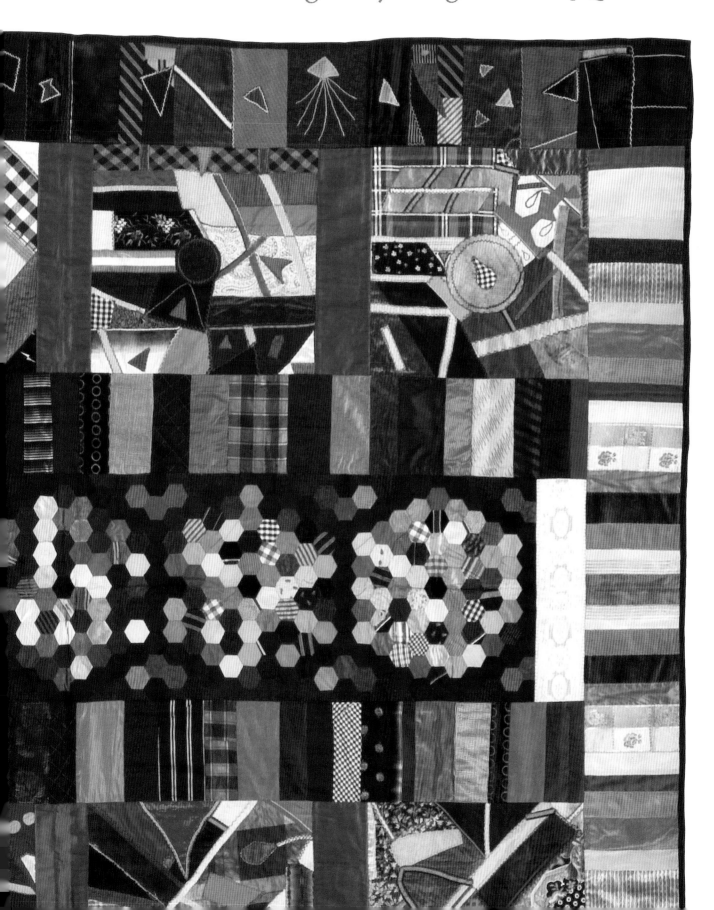

America was swept by a seeming "mania" for Crazy quilts in the last two decades of the nineteenth century; as *Dorcas* magazine put it in 1884, "Nothing has taken a stronger hold on the women—crazy quilts have engulfed us." *Good Housekeeping* echoed this idea in 1890:

Oh, the crazy-quilt mania triumphantly raves,
And maid, wife, and widow are bound as its
slaves. . . .
And thus it has been since the panic began,
In many loved homes it has wrought desolation,
And cursed is the power by many a man,
That has brought him so close to the verge of
starvation,
But make it she must,
She will do it or bust,
Beg, swap, and buy pieces or get them on trust.[1]

Crazy quilts were complex fabric tours de force; they were referred to even in their own time as "bewildering" and "kaleidoscopic."[2] They were made with scraps of irregular sizes and shapes, cut and pieced in seemingly random shapes, and then further embellished with decorative embroidery and other surface treatments. Such quilts functioned as textile scrapbooks, collections of appealing materials and of color, pattern, texture, imagery, stitches, and ornament. The genre arose at a time when the preponderance of manufactured goods had led to a new preoccupation with collecting and memorabilia and when the textile industry was turning out an astonishing variety of relatively inexpensive velvets and brocades.[3] These were available in a wide range of colors and novel effects. Three-dimensional and textured plush fabrics were common, many of which had areas cut away or woven in different pile heights. Textured chenilles, corduroys, and bouclés were also popular. There were silk fabrics of all kinds: plain and pattern weaves in a variety of densities, striped and textured novelties, silks with painted and marbled surfaces, and "wa-

tered" (moiré) varieties, to name a few. Silk ribbons were abundant as well. Every hue was available, and many fabrics featured variegated color or iridescent or shaded effects—even a single ribbon might be made to look like a woven rainbow.

Quiltmakers delighted in showcasing this abundance. Crazy quilt mania stemmed from the seemingly irresistible urge to find yet more novel and beautiful fabrics. In addition to saving their own dress silks, women literally did beg men for satin hat linings and pieces of their cravats. They also hounded dressmakers and merchants for fabric samples, to the point that Montgomery Ward and Company wrote in its 1894 catalog, "Samples of silks and satins will be sent upon request, but in such small pieces as to be useless for . . . crazy patchwork."[4] By the 1880s, manufacturers realized they could profitably sell packages of mill ends and offered mail-order kits of Crazy quilt scraps for as little as 25 cents.

The eclectic nature of the Crazy quilt also made it a perfect repository for fabrics that served as souvenirs. Some quilts included scraps with signatures of friends or family members or scraps that had been made from their clothing. Others featured fabrics that served as "relics" from famous people, including political, literary, and entertainment figures. Still others were filled with prize ribbons from state fairs or badges from activities such as temperance or garden club meetings, veterans' reunions, and political conventions. Additionally, there were ribbons printed with messages such as "Merry Christmas" and preprinted pieces that came as premiums with tobacco products.

Crazy quilt mania also applied to the urge to cover the surface with novel effects. The convention was to highlight the piecing seams with free-form embroidery (for instance, herringbone or feather stitches) and to add a miscellany of motifs to individual patches. Images might be embroidered in a variety of ways, everything from a simple outline stitch to a highly dimensional treatment with a textured thread such as chenille. Motifs made with ribbon or felt appliqué

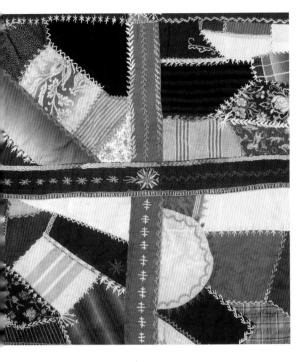

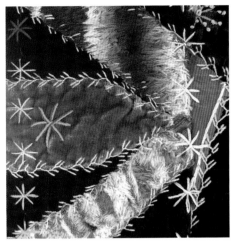

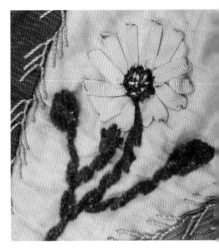

CLOCKWISE FROM TOP LEFT:

FIG 3-1. Crazy quilt, *detail* (see plate 3-24).

FIG 3-2. Crazy quilt, *detail* (see plate 3-21).

FIG 3-3. Crazy quilt, *detail* (see plate 3-16).

FIG 3-4. Crazy quilt, *detail* (see plate 3-24). Silk patch featuring James G. Blaine and John Logan, 1884 Republican presidential candidates.

FIG 3-5. Crazy quilt, *detail* (see plate 3-23).

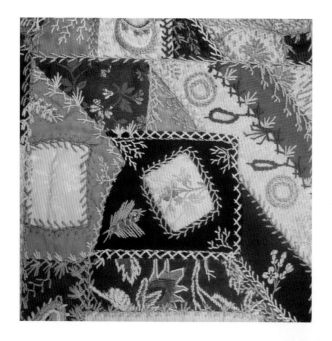

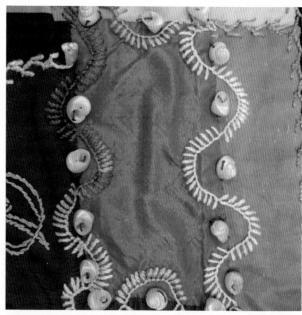

FIG 3-6. Crazy quilt, *detail* (see plate 3-27).

FIG 3-7. Crazy quilt, *detail* (see plate 3-19).

FIG 3-8. Crazy quilt, *detail* (see plate 3-21). Manufactured peacock decal.

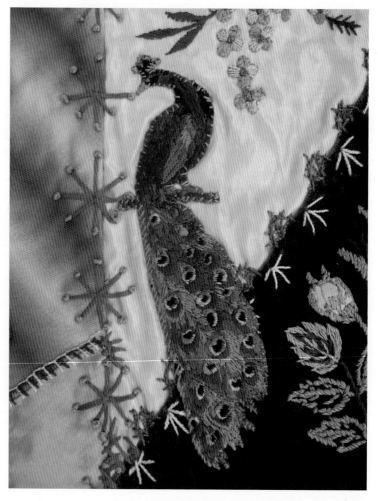

PLATE 3-1. Crazy quilt pillow sham.
Probably made by Dorothy Tompkins, Yonkers,
New York, 1880–1890.
Silks, 28" x 22". Unquilted.
1997.007.0230.2. *Ardis and Robert James Collection.*

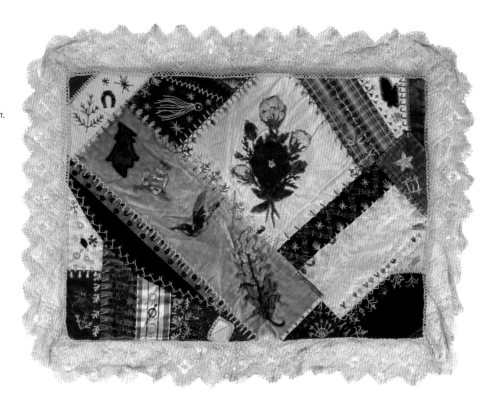

FIG 3-9. Crazy quilt, *detail* (see plate 3-14).
Embroidered portrait of Oscar Wilde.

were also common. Many quiltmakers incorporated novelties such as metallic threads and spangles, shells, beads, decals, and tassels. Sometimes they painted parts of the surface or had photographs transferred onto pieces of silk. Manufacturers were happy to cater to this audience. They supplied heat-transfer patterns for embroidery, premade cloth decals, and all of the embellishments mentioned above. Crazy quilts provided their makers the opportunity to try out a range of needlework techniques; coupled with the seemingly infinite choice of fabric, texture, color, and motif, the range of creative possibility seemed almost endless. It is worth noting, however, that most Crazy quilts were not mere hodgepodges; quiltmakers usually favored specific elements and expressed themselves accordingly. The busy and seemingly random quality of the quilts often masks skillful planning and compositional treatment. Many Crazy quilts were veritable showpieces and true labors of love. *Harper's Bazar* estimated in 1884 that a full-size Crazy quilt might take fifteen hundred hours of labor to complete.[5]

When Crazy quilt mania first took hold, the "crazy" look was seen as the epitome of urbane, sophisticated taste. Asymmetrical, irregular geometric patterns and crazed lines (the term came from ceramics) were associated with the Japanese style, which had taken the

public by storm at the 1876 Centennial Exposition in Philadelphia. Such compositions seemed fresh, free of old constraints and rules, and "modern." In contrast, older quilts with repeating patterns seemed rigid and were associated with a more rural sensibility. The Crazy quilt was thus embraced as part of the new Aesthetic look and was touted in women's magazines and the popular press. The companies that supplied the decals, embroidery patterns, ribbons, and other materials used in these quilts referred to themselves as purveyors of "art needlework." The "artistic" Crazy quilt was not meant to be a functional bedcover. It was not warm (it was never stuffed with batting), and the materials and surface treatments were too fragile for everyday use. Rather, it was "fancywork" and functioned as a display piece. Made of shimmering, rich-looking textured and light-reflective materials, a Crazy quilt evoked luxury and refinement. Exhibiting one in the parlor was a way of showing off one's gentility, taste, and artistic skill. Consequently, many Crazy quilts were made in smaller sizes or were fashioned expressly as sofa or piano throws, lap robes, or table or pillow covers.

In addition to its overall composition and appearance, the Crazy quilt was linked to the Orient through its sensuous fabrics (in the popular imagination, the

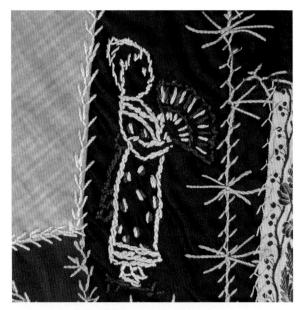

FIG 3-10. Crazy quilt, *detail* (see plate 3-16; see also figure 3-26 for a nearly identical embroidered figure).

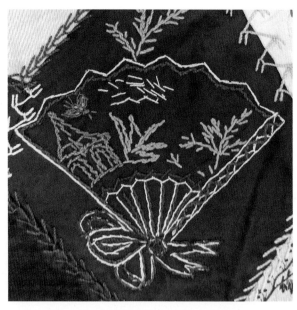

FIG 3-11. Crazy quilt, *detail* (see plate 3-16).

Orient was associated with an aestheticized sensuality) and its iconography. Japanese-identified motifs, including fans, pottery, kimono-clad figures, cranes, and lily pads, were common, and there were exotic animals such as peacocks and elephants. What really mattered on a Crazy quilt, however, was not a particular geographic reality but a particular feeling—an evocation of a happy, dreamy place, an enchanted "fairyland" or Neverland that existed far away, apart from any painful realities or practicalities. This was the same brightly colored, sensually rich, children's world epitomized in contemporary literature such as Frank Baum's *Wizard of Oz* books and James Barrie's *Peter Pan*. The fairyland quality was also associated with artistic taste (it was embraced by individuals associated with the Aesthetic Movement). Crazy quilts rarely included images of actual fairies, but ethereal winged creatures such as butterflies and dragonflies were common, as were woodland motifs such as oak leaves, acorns, ferns, deer, and violets. There were also many images alluding to a magical nighttime, including stars, crescent moons, owls, bats, and dew-covered spider webs. Other motifs evoked an Edenic garden; there were beautiful flowers, sumptuous-looking fruits (strawberries, grapes, and cherries were especially typical), and graceful birds. The garden was often filled with picturesque children, usually garbed

in old-fashioned dress copied from Kate Greenaway's children's book illustrations. Some images were taken from nursery rhymes; Puss in Boots was a particular favorite. There was Crazy quilt iconography relating to love and happiness (hearts and good-luck horseshoes), to leisure and artistic activities (badminton rackets and shuttlecocks, sailboats, artist's palettes, musical instruments), and to a sunny domestic world. In the last category, there were familiar animals such as chickens, ducks, dogs, and horses and homey icons such as rocking chairs, cutlery, and teapots and cups. Although some quilts illustrated religious, patriotic, and fraternal symbols, these were typically subsumed by the predominantly feminine references and the strong tactile properties of the genre.

The gestalt of the Crazy quilt is indeed a bewildering sense of oversaturation. Such a quilt cannot be taken in or processed at a glance; it is first *experienced*, and only gradually are its many components sorted out. The exuberant, feel-good quality of these quilts, their opulent color, texture, and pattern, and their ever-surprising juxtapositions make them a unique and endlessly fascinating genre. It is easy to understand the mania they engendered in the late nineteenth century and to appreciate the far-reaching associations they embodied.

■ **Beverly Gordon**

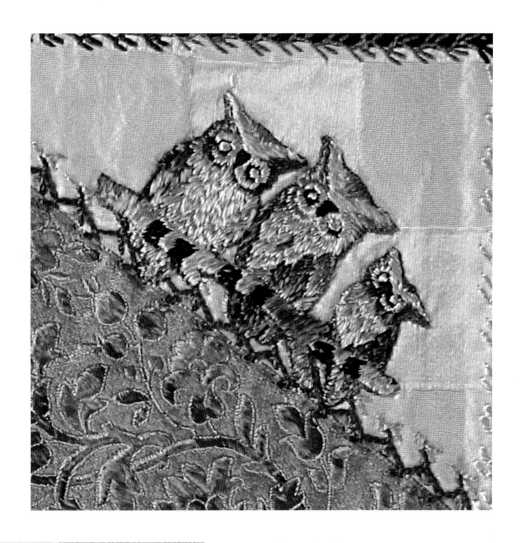

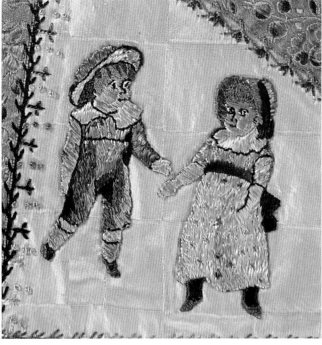

FIG 3-12. Crazy quilt table cover, *detail* (see plate 3-7).

FIG 3-13. Crazy quilt table cover, *detail* (see plate 3-7).

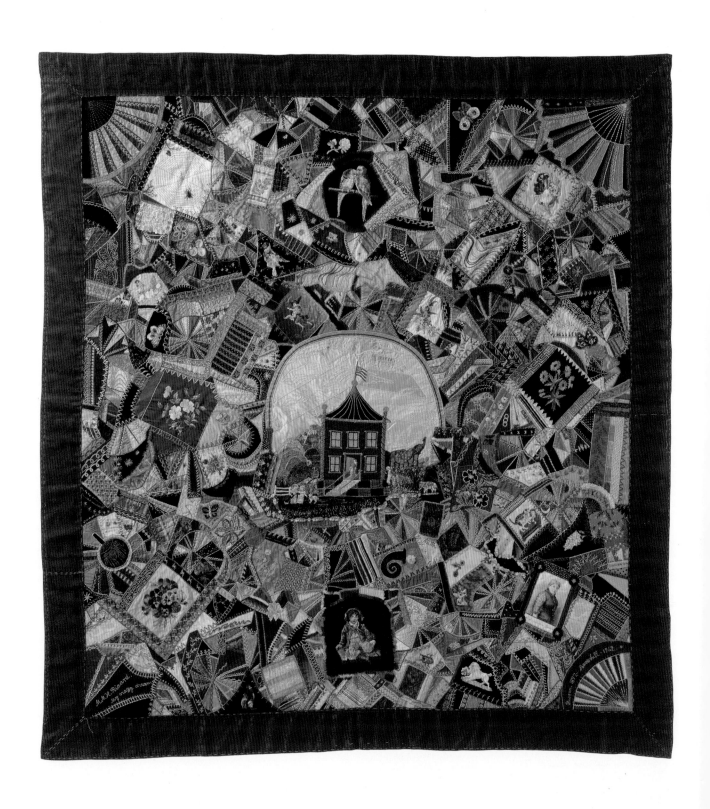

PLATE 3-2. *My Crazy Dream*
Mary M. Hernandred Ricard (1838–1915).
Boston and Haverhill, Massachusetts, dated 1877–1912.
Silks, 74" x 68.5". Unquilted.
1997.007.0541. *Ardis and Robert James Collection.*

The crazy quilt, *My Crazy Dream* (plate 3-2), was featured in Penny McMorris's seminal book, *Crazy Quilts*, with the statement that it was the "epitome of all that a crazy quilt should be."[6] Indeed, it includes a wonderful selection of fabrics, abundant and intriguing imagery, and a wide array of surface treatments. It is true to the Crazy quilt genre in that it is fully "kaleidoscopic" and yet has an overall compositional plan and unified treatment.

Like the Campaign Ribbons Crazy quilt (plate 3-12), this piece was made over a long period of time. It was clearly understood as a major achievement—a kind of masterpiece. Marked on the quilt is the maker's signature, the title "My Crazy Dream," and the words "Boston 1877–Haverhill 1912." In addition, the maker, Mary M. Hernandred Ricard (1838–1915), even included her own self-portrait in the lower left corner. She used a photograph of the type popularly seen in carte de visite images and had it transferred onto a piece of silk, which she then used as a quilt patch. Judging from the garments and hairstyle in this image, the photograph was probably taken when Mary was in her forties. She continued to work on the quilt for decades, until she was in her seventies. It was never fully completed; the maroon brocade border is merely basted on, and there is no backing fabric. We may surmise that Mary must have been unable to sew in the last few years of her life since, based on the perfectionist treatment of the rest of the quilt, she would have finished it if she could.[7]

The fabrics of *My Crazy Dream* are extremely rich, with a great many sumptuous velvets and textured plushes, but the Ricard family does not appear to have been wealthy. According to census records, Mary's husband was, at various times, a blacksmith, machinist, and salesman of house furnishing goods. Mary herself was a landlady and a milliner. It is likely that some of the materials may have been procured through the family's professional endeavors. The quilt is testimony to the fact that middle-class families could aspire to luxurious-looking goods and that artistic sophistication was not dependent on formal education or family income.

The title of the quilt reinforces the sense that Crazy quilts represented a kind of enchantment or dream-like state; they epitomized the brightest, richest, and most pleasurable qualities of life. The composition here is well balanced, with fans in each of the corners

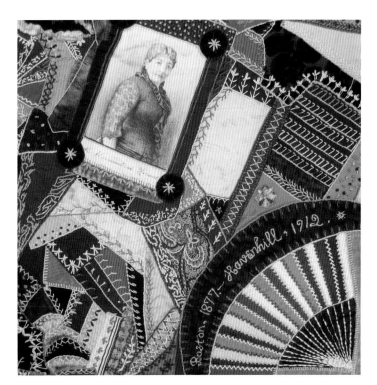

FIG 3-14. *My Crazy Dream, detail.* Image and signature of the maker, Mary Hernandred Ricard, with dates and locations of the quilt's creation: "Boston, 1877.—Haverhill, 1912."

helping to direct attention to the central medallion. There, a cheerful building is framed by a rainbow-like archway. It looks in some ways like a schoolhouse, but it has more fantastic qualities as well. The barber pole–style supports lead up to a roof reminiscent of a circus tent, and the checkerboard treatment at the bottom of the building is also more fanciful than realistic. This structure is set in an Edenic garden, complete with peacock, elephant, blooming flowers, and innocent, picturesque children dressed in the Kate Greenaway style. The scene is topped by a dreamy sky, and given the way the stitches punctuate the silks, the viewer can almost feel the wind drifting through the clouds. Larger eye-catching patches circle around the central scene, punctuating the space and helping the eye to keep moving around the whole.

There is abundant detail in every area of *My Crazy Dream*. The images are worked with great precision and technical mastery; the spider web is constructed with a continuously spiraling thread, for example, much the way a spider would have made it. Butterflies appear with three-dimensional bodies and bead-

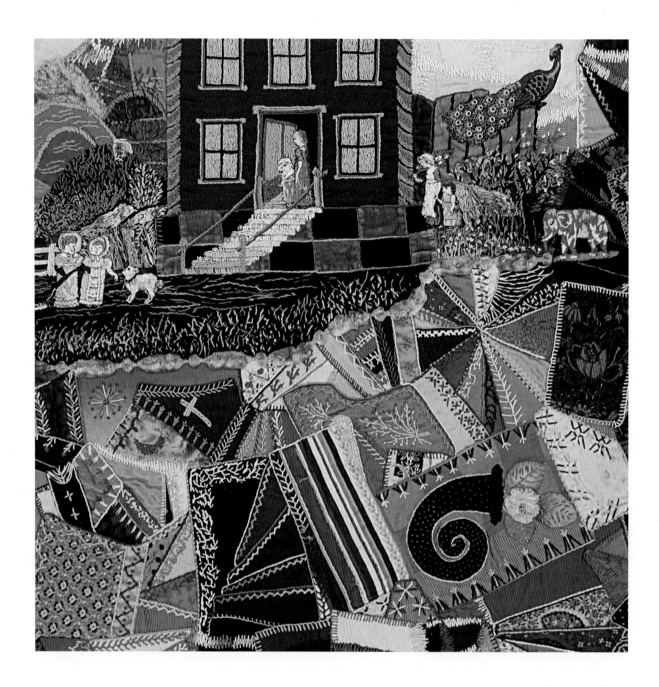

ed eyes. Leaves are shaded with great sensitivity, with one side a darker green than the other. Embroidery is added to some of the brocade patches to make even more complex and colorful patterns. Embroidery flosses vary from thick to very fine, depending on the subject and context of the individual patches, and even plain (unpatterned) patches are made extraordinary with their masterful edge-stitch treatments. Mary's millinery skills are apparent; in fact, many of the flowers are reminiscent of the types added to turn-of-the-century hats.

Although the central "dream" image is certainly original, much of the iconography is standard Crazy quilt fare; in some senses, in fact, the piece serves as a compendium of motifs common to the genre. Some of the images were clearly worked from transfer patterns (the pattern lines are still visible on close inspection), and others consist of purchased decals (decorative embroidered patches) that are appliquéd on (this is even true for components of the central medallion, including the children, the peacock, and the elephant). We see the expected fans; butterflies; flowers; domestic

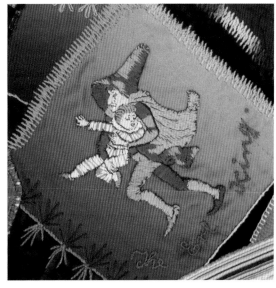

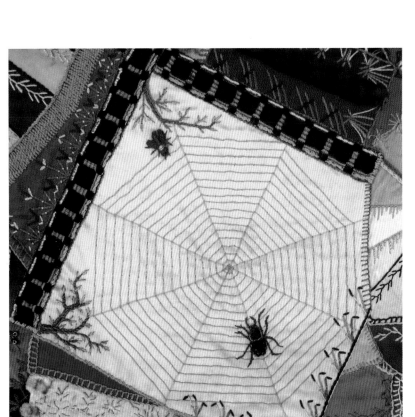

animals such as dogs, cats, roosters, and parakeets; moons and stars; deer; and badminton rackets. There are also some interesting surprises, including the "Erl King" (a mischievous and sometimes malevolent northern European folk figure, whose name translated into English is "Elf King"), who is stealing a child, and on the center bottom is a boy sitting on a slab that looks almost like a magic carpet. In any case, even the most familiar motifs seem to come alive by virtue of their contextual placement.

■ **Beverly Gordon**

FIG 3-18. Coffin cover, *detail*. Velvet appliquéd cartouche.

FIG 3-19. Coffin cover, *detail*. Appliquéd grapes.

offin quilts, though noted in the literature, are extremely rare, and none precisely like this one (plate 3-3) have been previously documented. Built in the Crazy quilt format (with rich silk fabrics, including velvets and satins, pieced together onto a cotton foundation fabric and covered with surface embellishment), it has the saturated, jewel-like hues, stitching treatments, and motifs of an Orientalist sensibility. Its size and proportions indicate that it was draped over a standard-size coffin (the widened top matches the head area, and the extra fabric would gracefully drape over the sides).

There is a long tradition of draping coffins in fabric. In ancient Rome, a man's cloak (pallium) was spread over his coffin when it was carried from his home to the cemetery. By the Middle Ages the pallium had become a rectangular pall used to cover a coffin as it lay in a Christian church. It symbolized the idea that the deceased was "clothed" in Christ and in grace.[8] Such worked textiles might be used repeatedly at subsequent funerals. There is an embroidered velvet pall owned by a weaver's guild in Worcester, England, for example, that was draped over the caskets of guild members from the sixteenth to the nineteenth centuries.[9] Similar handmade casket covers were not common in America, but there was a regional Appalachian tradition, well enough known to have led Ann Rinaldi to title her 1999 historical novel about the feud between the Hatfield and McCoy families *The Coffin Quilt*. Appalachian palls were stylistically different from this example (they were usually more squared and worked around a large central motif), but there are occasional references to coffin covers that link them to Crazy quilts.[10] Betty Pillsbury mentions one, made by a Missouri woman at the turn of the century who added new embellishments to honor the deceased each time it was used.[11]

This pall was found in Florida, and stylistically it bears some resemblance to the Worcester pall in its rich embroidery and its series of cartouches. Its design, however, relates it most closely to Oriental carpets and Kashmir shawls. Like a carpet, it features a medallion-filled central field surrounded by mul-

tiple complex borders. Like a shawl, it includes many botehs (paisley-shape motifs) and features a regular patchwork-like treatment with areas of juxtaposed bright color in its large border, echoing design motifs in the Oriental rugs and shawls that were popular in the West in the late nineteenth century. Despite this Oriental feel, the specific motifs on the cover are generally more Western than Eastern, and in many cases are similar to those found in Crazy quilts. There are fans and grapes, for example, and realistically rendered leaves and such flowers as carnations, pansies, roses, fuchsia, a lily, and a lily pad. The scrolls recall turn-of-the-century Neoclassical Beaux Arts architectural detailing. In appearance, if not function, the textile would have fit perfectly into a turn-of-the-century "cozy" or "Turkish corner," the section in some parlors devoted to Oriental fantasies. Filled with luxurious textiles, such corners were a popular fad during the 1890s and represented the height of "artistic" taste. The cover might have been used in an actual home parlor or in that of a funeral home.[12]

The workmanship is of the highest level. The piecing of some background fabrics within a single section is sometimes so subtly accomplished that its seams can be discerned only by careful study. Stitching is near perfect, whether in the couching of the embroidery thread surrounding individual motifs, the filled-in areas of satin stitch, or the more free-form outline-stitch borders. The quilt's visual effects are equally impressive. In some areas the maker added texture by varying the direction of the grain of the pieced fabric and ribbons; in others she placed several different values of the same hue side by side to achieve subtle shifts and harmonies. The color of the thin strip of an outlining velvet changes at regular intervals depending on the hues it is surrounding. No prepared decals are used, and the motifs do not seem to have been applied with pattern transfers; each is original and made to fit its particular space.

■ **Beverly Gordon**

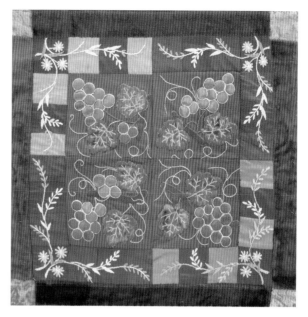

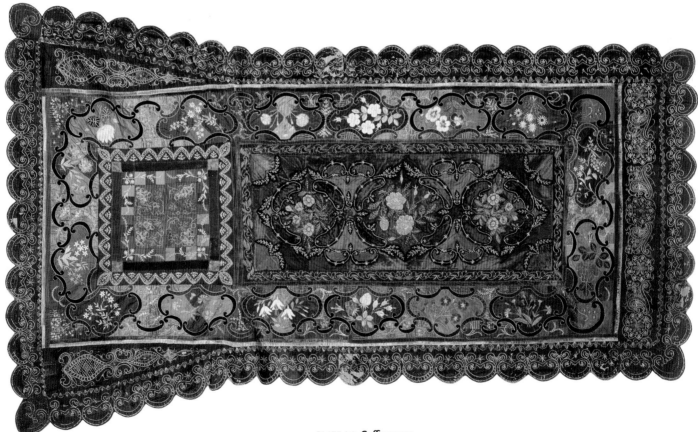

PLATE 3-3. Coffin cover.
Maker unknown.
Possibly made in Florida, 1880–1900.
Silks, silk-cotton mixtures, 101" x 61". Unquilted.
1997.007.0360. *Ardis and Robert James Collection.*

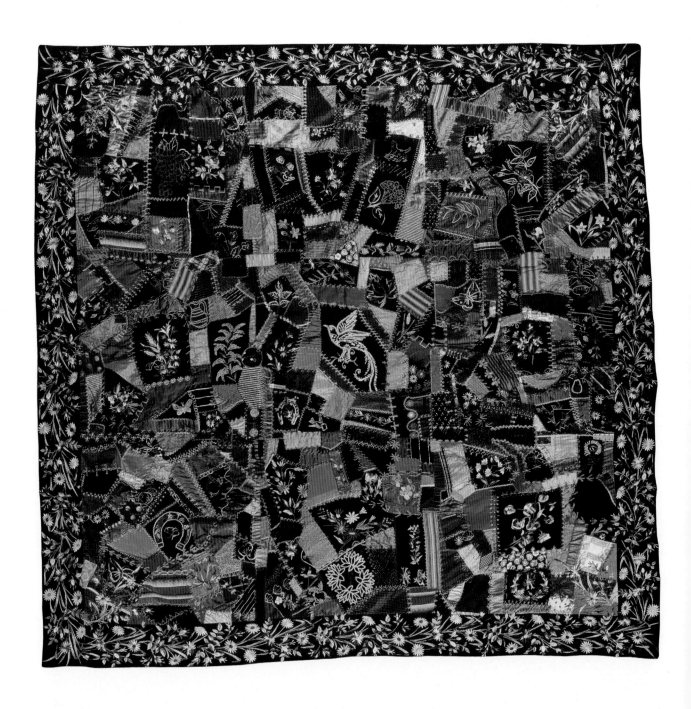

PLATE 3-4. Crazy quilt.
Maker unknown.
Possibly made in Bucks County, Pennsylvania, 1880–1900.
Silks, 80" x 79". QSPI: 2-3.
1997.007.0764. *Ardis and Robert James Collection.*

Perhaps the most immediate impression one has of this Crazy quilt (plate 3-4) is of its bright, almost fluorescent coloring. In addition to silk fabrics with the usual saturated primary and rich tonal colors, the quilt is worked with embroidery floss in unusually strong acid greens, pinks, and yellow-browns. Much of the thread is variegated, leading to a constantly changing surface. The wide border is completely filled with a repeating pattern of exuberant-looking

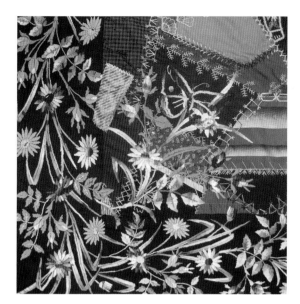

FIG 3-20. Crazy quilt, *detail*. Flowers embroidered in variegated and solid yarns.

FIG 3-21. Crazy quilt, *detail*. Embroidered horseshoe.

leaves and flowers worked in these strong colors and effects. The flowers consist of daisies and rosebuds. Although they are given realistic shapes, their colors are not true to life, and they perch atop grasslike stems that do not appear in nature. The most important effect is not veracity but an overall graceful pattern. The border motifs are not actually confined to the border; in the corner areas, in particular, they are carried from the black faille frame into the body of the quilt. Similar floral motifs using the same color palette are worked on some of the patches. The result is a unified piece that seems less haphazard than many Crazy quilts.

The fabrics used for the patches vary considerably. Unlike most quilts of this type, there are no velvets or other heavily textured pile fabrics; rather, there is a concentration on lighter-weight dress silks. There are many striped examples and others with watered or shaded effects.

The embroidered embellishments are one of the strengths of this quilt. The border motifs are completed in a neat satin stitch, but a great variety of stitches are worked into the piece overall. The effects used to outline the patches are playful and seldom repeat. The "mount stitch," which creates the feeling of a crimped yarn, is used to particularly good effect. It appears on the central phoenix, which stands out by virtue of its placement and strong color contrast. It is also used on the large lucky horseshoe, making the shape seem particularly three-dimensional. (For unknown

reasons, the "Good Luck" inscription on the horseshoe is in mirror image.) Sometimes motifs worked in mount stitch are used as a kind of top layer, as in the case of the yellow and brown butterfly applied over the border flowers in a corner area. There are other examples of overlayering, with stitches overlapping each other and creating a sense of confusion between figure and ground. In addition to motifs wandering from the border into the center of the quilt, a few of the central patches are carried over into the border, again creating a feeling of overlay. The already complex surface becomes even more of a visual puzzle. In the late nineteenth century, this complexity was considered sophisticated and was a source of delight.

In many ways the quilt creates the impression of a fanciful garden. Flowers dominate, both in the border and the center of the quilt. Sometimes they appear in vases. In addition to the floral imagery and the birds and butterflies already mentioned, there are images of tempting fruits: grapes, an apple, a strawberry, and a pear. There is also the spider web that appears on so many Crazy quilts and seems to be associated with a fairylike woodland setting, as well as the familiar bird carrying a letter in its beak, bringing good news. The quiltmaker (we do not know her name, but the initials "K" and "K. G." are worked into the piece) created a kind of happy, "saturated" world, an enchanted place, which is still able to create a sense of pleasure and delight.

■ **Beverly Gordon**

t is unusual to find quilts that combine Log Cabin and Crazy quilt construction, although both techniques could be made from similar silk fabrics, and both highlighted the sensuous materials available on the market in the late nineteenth century. The quilt-maker experimented with both formats in this piece (plate 3-5). She successfully negotiated the transition from one area to another by adding embroidery to the Log Cabin blocks surrounding the center Crazy panel and building them with fewer "logs" (strips). As a design, her quilt works well from two different distances. Many of the intricate figures in the central block are best experienced at close range, whereas the dark–light contrast of the overall Log Cabin is best experienced from several feet away.[13] The quilt was clearly a show-piece, which, not surprisingly, bears little sign of use.

Sandra Mitchell (now deceased) of Midwest Quilt Exchange, from whom Ardis and Robert James purchased this quilt, provided a typewritten statement of the quilt's history, possibly based on recollections of the quiltmaker's grandson. According to this statement, the quilt was made by Elizabeth Shelton, a native of Kentucky, while living in Coeur d'Alene, Idaho. The International Quilt Study Center conducted genealogical research in an attempt to learn more about the maker and this intriguing quilt. Unfortunately, the statement provided by the dealer did not include the grandson's name or that of his mother, the maker's daughter. No birth, marriage, death, or land records were found that might verify that any Sheltons from Kentucky were living in or near Coeur d'Alene or anywhere in the western states at the end of the nineteenth century.[14]

Although impossible to verify, the written statement includes an explanation of the highly personal imagery in the central Crazy portion of the quilt, which is still worthy of discussion. The statement explains that the image of the Greek muse Flora is a tribute to Shelton's husband, who was a classics scholar. The image of the Confederate soldier was in memory of the maker's brother, who died while fighting in the Civil War. The cat was a family pet. No explanation was given for the preponderance of Chinese figures, however. They are distinctive enough to imply more than a generalized Orientalism or chinoiserie. Some seem almost comical, but all are portrayed sympathetically and are well observed. Clothing details are visible, as are iconic Chinese architectural elements and ceramics. We cannot be sure whether this de-

tailed rendering is due to the maker's personal associations or inspired by photographs or illustrations depicting Chinese life, which were widely available in late nineteenth-century books and magazines. It is a reminder, however, that Shelton was highly cultured and attuned to worldly issues, an especially salient point if she lived in a frontier area.

In addition to expected Crazy quilt icons such as the spider web, owl, butterfly, and crescent moon, the quilt is filled with lighthearted motifs that emphasize leisure, pleasure, and the "good life." Some of the embroidered images allude to sports; there are baseball and football players, an alpine hiker, and a runner. There are also amusing vignettes, including a juggling jester, Puss in Boots holding an umbrella, and a cat in a hat. Some of the images are familiar, but others, including the drummer with an oversize drum, the boys playing with a chair, and the woman dragging or holding a child upside down, seem quite original. In any case, the images engage our imagination and are rendered with a great sense of animation. The large-scale motif of a bright parrot on a flowering tree bursts out of the central panel and is dramatically framed by the diamonds of the Log Cabin and the rich velvet border.

The maker used twelve colors of embroidery floss and a combination of free-form and controlled stitches; her treatment of the Crazy patch seams is spontaneous and varied, but she filled in the large motifs with dense satin stitch. Overall, the quilt has great energy and speaks of a woman with a rich life who was willing to experiment and combine different ideas. It reminds us that even the "craziest" of quilts was really the result of conscious planning and thoughtful decision making.

■ **Beverly Gordon**

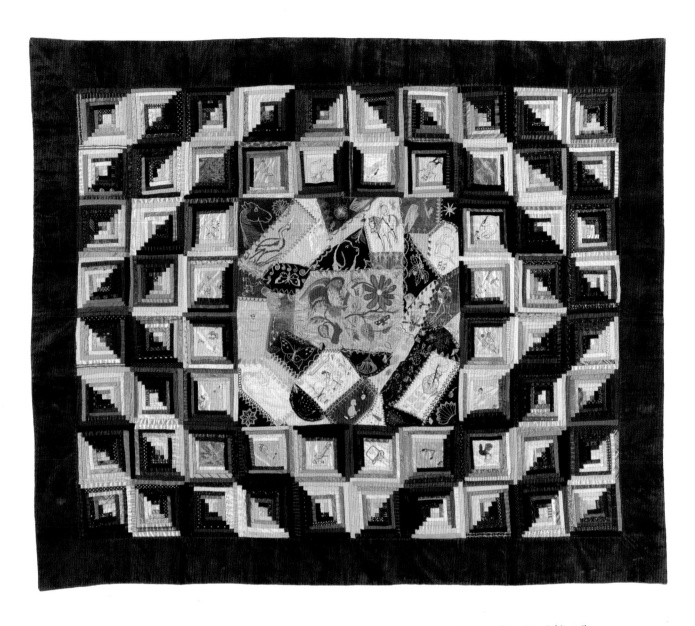

PLATE 3-5. **Crazy/Log Cabin quilt.**
Possibly made by Elizabeth Shelton.
Possibly made in Coeur d'Alene, Idaho, 1880–1900.
Silks, cotton-silk mixtures, 77" x 63". Unquilted.
1997.007.0802. *Ardis and Robert James Collection.*

OPPOSITE: FIG 3-22. Crazy/Log Cabin quilt,
detail. Embroidered Confederate soldier.

LEFT: FIG 3-23. Crazy/Log Cabin quilt, *detail.*
Embroidered Chinese figures.

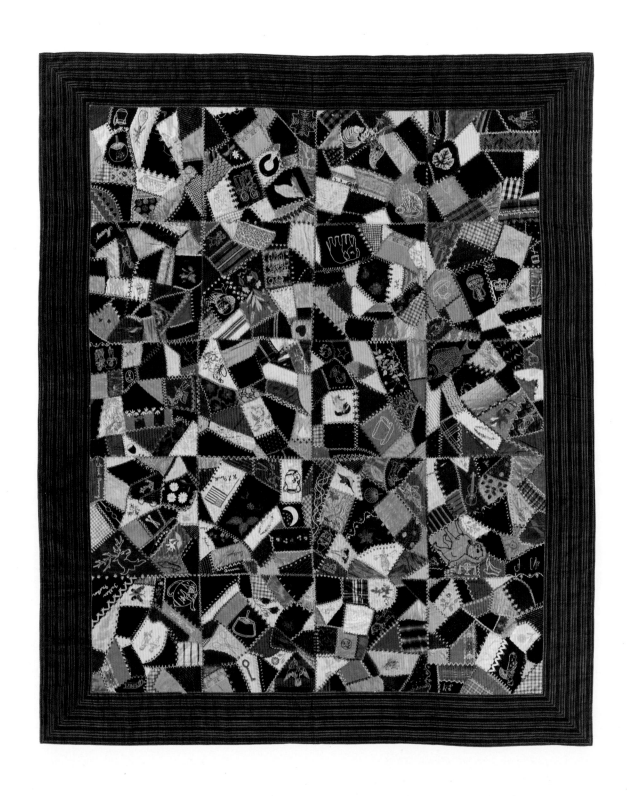

PLATE 3-6. Crazy quilt.
Maker unknown.
Possibly made in Mt. Clemens, Michigan, dated 1884.
Silks, 76" x 63". Tied.
1997.007.0552. *Ardis and Robert James Collection.*

The amount and variety of silks in this Crazy quilt (plate 3-6) is almost staggering. They range from taffetas to brocades to satins to pile fabrics resembling fake fur. The maker never relaxed her standards by filling a large portion of any of her blocks with a single piece of silk; instead, she

FIG 3-24. Crazy quilt, *detail*. Embroidered multiblade knife.

FIG 3-25. Crazy quilt, *detail*. Embroidered gypsy.

FIG 3-26. Crazy quilt, *detail*. Embroidered woman wearing a kimono.

consistently filled each block with an abundance of diverse fabrics. During the 1880s, sources for silks were plentiful through mail order, dry goods stores, and through the recycling of old garments. Recycling was fictionalized in an 1884 *Godey's Lady's Book* story entitled "The Career of a Crazy Quilt." In it, a young woman has become obsessed with obtaining as wide a variety of silks as possible, but in a letter to a friend she confesses, "Papa was in a fearful rage this morning because I cut the lining out of his spring overcoat. . . . I wish I'd never begun this crazy quilt."[15]

In the same story, the young woman attempts to hoodwink a fancy goods (silk) wholesaler by pretending to represent a dry goods firm. She writes to them requesting a sample book for her fictional store. Her plan backfires, however, when the company sends a representative to check on the "commercial standing" of her business to determine that it is not simply a front for an obsessed Crazy patchworker. The moral is "When a woman undertakes a bit of crazy patchwork, all natural compunctions seem to sink out of sight and mind completely." In typical fashion for Victorian women's magazines, the story takes a romantic turn: the wholesaler's representative, after gently scolding the young woman for her deceptive behavior, falls in love with her and the two are married.[16]

While the number and range of silks used is impressive, the embroidery is the most charming and absorbing aspect of this quilt. A great number of the typical Crazy quilt motifs—paddle fans, owls, swal-

lows, dogs, moons, and a host of naturalistic flowers—whose patterns were widely available from magazines and stamping companies, are represented. What is more interesting, however, is the amusing assortment of everyday objects embroidered on it: a sled; a pair of scissors; a shoe; a boot; a baby's pram; a pair of glasses; a knife, fork, and spoon set; a violin; and a multiblade pocket knife partially opened. In addition, several of the motifs go beyond fans and cranes to lend it the exotic appeal that was an essential characteristic of Crazy quilts. A detailed depiction of a dancing gypsy, replete with head scarves and a tambourine, adds a lively, reckless character. Standing prim and proper in contrast is a Japanese geisha, proof that depictions of Japanese characters were popular even prior to the 1885 debut of Gilbert and Sullivan's hugely successful operetta *The Mikado*. (See figure 3-10 for a nearly identical embroidered geisha, likely made from the same pattern.)

The name "H. J. North," as well as a series of given names without surnames ("Arthur," "Annie," "Fred," and "Floss") appear on the quilt but give very few clues to their holders' identities.

The border, made from a multicolored cut velvet fabric resembling corduroy, contains this plethora of imagery while supplementing the quilt's luxuriousness. Holding together all the layers, including a Japanese-inspired cotton print backing, are a series of red and green wool ties.

■ Marin F. Hanson

FIG 3-27. Crazy quilt table cover, *detail*. Manufactured painted pansy decal.

PLATE 3-7. Crazy quilt table cover. Maker/location unknown, 1885–1900. Silks, 90.5" x 60". Unquilted. 1997.007.0698. *Ardis and Robert James Collection.*

The dimensions and tasseled edgings on the short sides of this splendid Crazy quilt (plate 3-7) suggest that it was used as a table or bureau cover (the tassels would hang down on either side). Moreover, unlike many Crazy quilts, the piece has a distinct orientation, with the representational images all facing the same way. It is possible that it was intended for a table that was positioned against a wall. The piece is in excellent condition, never subjected to much wear, so it was most likely placed out of harm's way in a parlor or possibly a guest bedroom or other private space.

The workmanship on this textile is extraordinary. The stitching is so skillful that at first it appears as if the finishing treatment on the sides and the lining were machine-made; it is only after very careful study that one realizes there are different stitch sizes that had to have been worked by hand. The decorative embroidery at the seams of the patches is done with great finesse. Almost all the joins involve a combination of stitches and color sequences; as many as four colors of embroidery thread are used in each (and some threads are variegated in themselves). The treatment around each patch is unique, moreover, implying that the quiltmaker delighted in her virtuosity. She also seems to have enjoyed collecting a great many sensual fabrics and as great a variety of premade images as she could find. Although she certainly was capable of embroidering the decorative motifs herself, she chose instead to adorn the quilt with manufactured appliqués (decals), ribbons with brocaded patterns, painted silks, and silks printed with figurative lithographs or photographs. All this is again done with complete mastery. Prepared appliqués are sewn down with almost invisible stitches in matching threads. Each is treated as a distinct framed picture, with contrasting colors, patterns, and finishing stitches surrounding it and setting it off.

The applied images evoke a pleasant, feminized world; there are beautiful fans, birds and flowers, at-

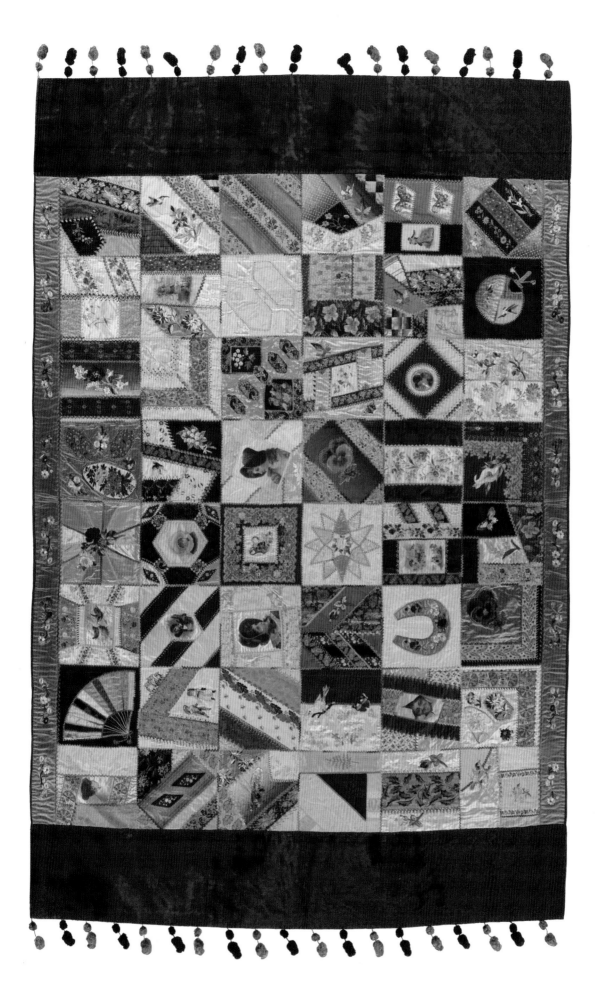

147

OPPOSITE: FIG 3-28. Crazy quilt table cover, *detail*. Lithographed image of Cupid strewing flowers.

FIG 3-29. Crazy quilt table cover, *detail*. Lithographed image of a smiling woman.

tractive young ladies in fashionable bonnets, a gay dancing couple, Cupid strewing flowers, and children and adults in picturesque Aesthetic dress. There are also Orientalist references; in addition to a prototypical Japanese-style fan, there is a ribbon with an interesting Egyptian Revival pattern framing one of the lithographed heads. The general color palette is bright and cheerful; there is a minimum of black fabric and a relatively large amount of light background.

Three of the printed ribbons bear a barely legible copyright from a Boston firm, Robertson Engraving Company, and one is dated 1883. Because lithographed ribbons were commercially available, it is not surprising that identical examples appear on unrelated quilts. This piece includes the interesting visage of a smiling woman who appears to be breaking through a paper frame (she is well framed by contrasting red fabrics). She is featured on several other known quilts, and the quilt historian Penny McMorris hypothesized

that it is an image of the popular actress Anna Held, although this now seems unlikely.[17] Although it is difficult to tell if any personalized photograph transfers were included on this particular quilt, it was definitely possible to have them made at this time. *The Stevens Point (Wisconsin) Journal* included two advertisements in May 1884 from the photographer W. C. Huff, who offered to transfer photographs to handkerchiefs or Crazy quilts. Huff said he would take photographs (for example, of one's house) and then print the images on squares of cloth, thus helping to preserve "happy memories" for a lifetime.[18]

Crazy quilts were sometimes criticized for being hodgepodges that required little skill; the idea was that nothing had to match or fit together precisely. This quilt is testimony to the fact that in reality the Crazy quilt format could require even more skill than quilts of other types.

■ **Beverly Gordon**

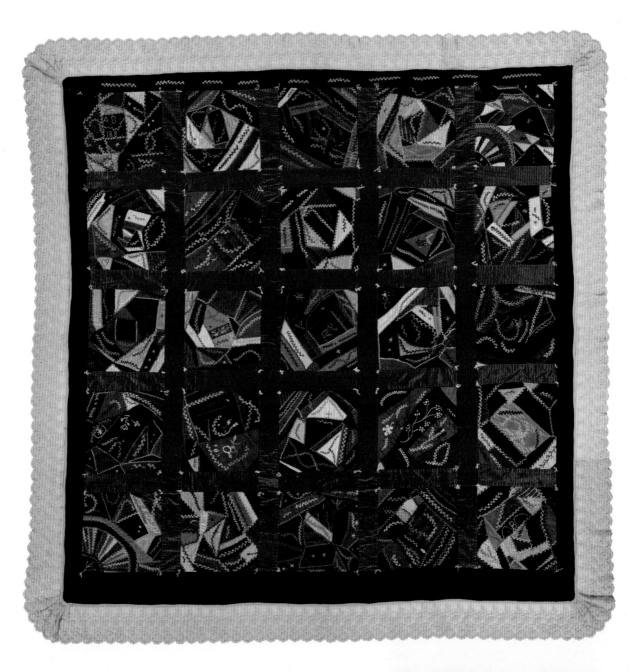

PLATE 3-8. Crazy quilt.
Maker/location unknown, dated 1888.
Silks, Cottons, 74" x 74". Tied.
1997.007.0431. *Ardis and Robert James Collection.*

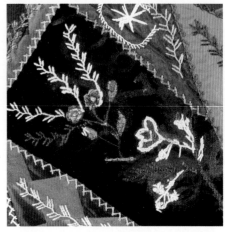

Each of the blocks of this vibrant Crazy quilt (plate 3-8) has a strong sense of fluidity, with undulating feather stitching leading the eye around the square. Nevertheless, the quilt has an overall feeling of compositional control and order. The twenty-five blocks are perfect ten-inch squares arranged in a five-by-five grid. They are framed by a thick, bright red sashing, an inner black border, and a wide outer border of embroidered machine-made net lace with a scalloped edge. Regular bands of additional feather stitching further punctuate one side of the black border, and the quilt ties are worked neatly in each corner of the sashing, adding to the orderly effect of the grid. Strong value and color contrasts make the piece seem particularly powerful and well planned. In addition, many of the same fabrics are used repeatedly in different blocks, further reinforcing the sense of unity even within the Crazy quilt format.

Although the maker of the quilt is unknown, she signed it twice with the initials "A. B. R.," which probably stand for her name. The letters are embroidered in two corners, appearing on one side with the date "1888." Interestingly, close examination reveals that the quilt was originally dated 1887. That date was painted on a velvet scrap and subsequently obscured with embroidery in high-contrast thread. Indeed, this situation is not isolated; there are quite a few painted velvet pieces that were similarly covered with embroidery. (The embroidery did not merely outline what was painted; rather, entirely different images were su-

perimposed.) Perhaps the paint did not show up well (in areas where it still remains, it is quite muted) or did not give the effect the maker wanted. In any case, A. B. R. kept reworking the quilt until it satisfied her. The process appears to have taken about a year.

Several of the images in the quilt combine painting and embroidery in a way that makes them seem especially spontaneous and charming. There is a rooster on a black velvet patch, for example, with a painted body (the brush strokes effectively mimic the soft effect of feathers) and embroidered feet, tail, and comb. A painted spotted dog (his fur seems highly textural because the paint is worked on a velvet nap) has embroidered facial features, making him particularly endearing. A painted shoe is crossed by a curving line of stitches, creating the feeling of a floating shoelace or ribbon. Embroidery stitches are worked across the surface of all the blocks, often in surprising ways. The chain-stitch line that makes up the curve of the letter "B" in one initial, for example, escapes from the letter completely and meanders over into the neighboring patch. Embroidered lines also dress up scraps of unpatterned fabric, as when a winding stem makes an otherwise unremarkable tiny piece of cloth appear festive and important. A. B. R. turned her sharp compositional eye to many other small details. Sometimes she used particular fabrics as framing devices. The aforementioned spotted dog is a good example. Yellow and gray, he is set off nicely by his dark background, but beyond that, he is banked on either side by a red and purple ombre check fabric. This functions almost like a drapery framing a proscenium stage.

A. B. R. also seems to have appreciated and made use of the fabrics she had available. As indicated, she used the same fabrics in multiple combinations, always making them seem fresh by her innovative contextualizations. She seems to have been both thrifty and patient, for she included even very small patches that would have been difficult to work. In addition, there are several instances of reused fabric; she included pieces with visible stitch holes or opened seams and fabrics that are differently faded. The large lace border must have seemed like a luxury and a sign of elegance to this quiltmaker. When we remember the high standards that led her to keep reworking the quilt for an additional year, we once again see how much a Crazy quilt served as an expression of artistry, luxury, and pride. ■ **Beverly Gordon**

LEFT: FIG 3-30. *Detail.* Flowers embroidered over a painted date, "1887."

BELOW: FIG 3-31. Crazy quilt, *detail.* Painted dog on velvet.

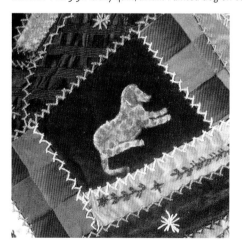

FIG 3-32. Crazy Stars, *detail*. Diagram of Crazy Stars construction units.

Although Crazy Stars (plate 3-9) looks like a "true" Crazy quilt, it is only masquerading as one. Behind its haphazard appearance is a surprising amount of structure. It uses a complicated piecing pattern and preprinted "Crazy" cloth to create its complex look. The repeating pieced pattern is based on eight string-pieced, irregular diamonds (they are kite-shaped) that join to form eight-pointed stars. Octagons and small diamonds, whose points fit within the angles of the star units, are used to set the quilt together. The setting pieces are made of what we today call "cheater" cloth, a cloth printed to look as if it is pieced, appliquéd, embroidered, or all three. In this case, it is printed with Crazy quilt patches and stitches, as well as a wide variety of fanciful images. The effect is convincing, and from afar the quilt appears to be a real Crazy quilt, with eight-pointed stars scattered about.

Methods for making it easier to construct a Crazy quilt abounded in the 1880s and 1890s. The Yale Silk Works of New Haven, Connecticut, which claimed to be "the originators of the Silk Patchwork craze," offered a bundle of silk for $1.00 and six bundles for $5.00.[19] Stamping patterns took away the need to design one's own embroidery motifs, and premarked

foundation muslin allowed one to cut out and place the silks without having to plan each block oneself.[20]

The ultimate facilitator to the painless production of a Crazy quilt, however, was preprinted Crazy fabric, like that found in this quilt. The number of faux embroidery stitches (including a line of musical notation, complete with treble clef and staff lines) and the complexity of the "patchwork" rival the very best of the high-style Crazy quilts of the era. Crazy quilt prints were not the only type of faux patchwork produced, however. According to Barbara Brackman's *Clues in the Calico*, the earliest documented printed patchwork example is from about 1850, well before Crazy quilts had appeared. Other printed patchwork styles included Log Cabins, charm quilts, and various block patterns (patchwork with no repeating fabrics).[21]

Besides a staggering number of embroidery stitches, the printed Crazy fabric also reveals a fascinating mix of images. A fat spider stalks a small insect on her web, a little boy roller-skates with arms akimbo, a hive of bees buzzes with activity, and a frog climbs a ladder onto a large rock. This last image is a puzzling one, made even more so by a caption below it saying

PLATE 3-9. Crazy Stars.
Maker/location unknown, 1890–1900.
Cottons, 86" x 82.5". QSPI: 6-7.
1997.007.0742. *Ardis and Robert James Collection.*

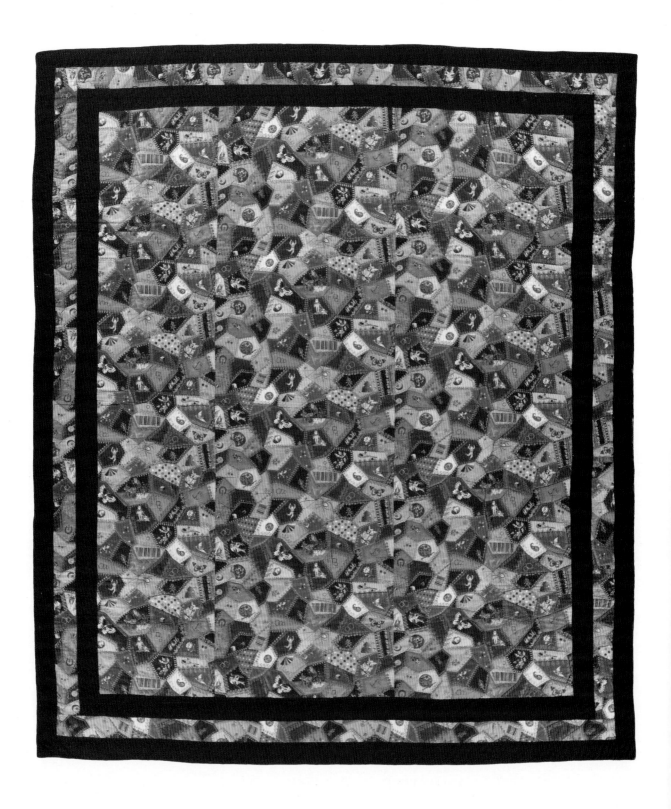

PLATE 3-10. Crazy cheater cloth quilt.
Maker unknown.
Possibly made in Pennsylvania, 1890–1900.
Cottons, 91" x 78.5". QSPI: 7.
2005.057.0001. *Purchase made possible through James Foundation Acquisition Fund.*

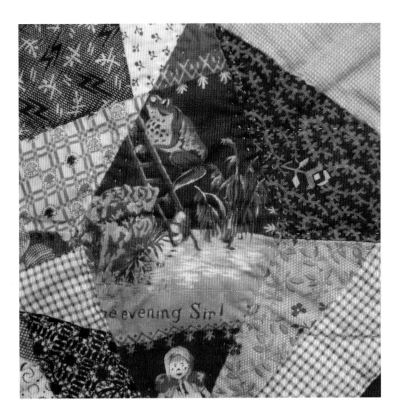

FIG 3-33. Crazy Stars, *detail*. A frog climbing a ladder with the caption, "Fine evening Sir!"

"Fine evening Sir!" Apparently, this was a particularly popular printed Crazy fabric, as it appears in numerous extant quilts and yardage.[22] The specific literary or pictorial reference, however, has yet to be located.

The preprinted Crazy patchwork is merely one among many interesting fabrics in the quilt. Trompe l'oeil designs appear as well. One, printed to look like delicate black lace on a white background, is betrayed as a fake by the word "POCKET" that is printed directly above it, giving the impression that it was taken from a preprinted garment pattern, perhaps for an apron or smock. Other fabrics have faux dobby or brocade weaves or are printed in imitation of woven stripes and plaids. The overall effect is one of almost overwhelming patterning.

Making quilts from non-silk fabrics began rather early in the Crazy quilt fad. In 1884, at the height of popularity of the silk Crazy quilt, a writer in *Arthur's Home Magazine* stated, "A new form of crazy-work is seen in piecing together odds and ends of linen, oatmeal-cloth, crash, and other wash-materials, instead of silk."[23] Most, however, were made well after the Crazy quilt had faded from mainstream popularity. The IQSC has ten cotton Crazy quilts from the 1890–1940 period (see, for example, plates 3-38, 3-39, and 3-47).

■ **Marin F. Hanson**

REGULARLY IRREGULAR 155

Although many Crazy quilts feature embroidered dates, initials, or given names, very few have full names on them, let alone locations. This quilt (plate 3-11) gives us all the information we need to learn more about its maker. One Crazy patch is embroidered with the words "Eva-Wight / Salina / Saline Co. / Kansas." On another is the date "May, 1891." Eva Wight did, indeed, live in Saline County in north-central Kansas between 1874 and her death in 1940. In 1891, she was nineteen years old, unmarried, and living on the family farm just a few miles east of the county seat of Salina.[24] Like many other young women her age, she spent time doing needlework, perhaps preparing her dowry or simply making a quilt in the current fashion. In many ways, Eva's quilt exemplifies the way the Crazy quilt evolved during its transformation from high-style urban fad to perennial rural favorite.[25]

As chronicled by articles in women's magazines, the Crazy quilt craze started to dissipate as soon as the late 1880s. Criticisms over the amount of time it took to complete a Crazy quilt and over the gaudiness of

the saturated colors and asymmetrical patterns began to shift the fashionable woman's gaze to other trends. One author wrote, "The time, patience, stitches and mistakes the crazy quilt represents, are too awful for words."[26] But in parts of the country that were less concerned with national fashions, such as in rural areas and small towns, the Crazy quilt continued to be a favored style. In these areas, however, whether by necessity, preference, or sensibility, Crazy quilts were most often made from workaday fibers such as wool, cotton, and wool–cotton mixes rather than the luxurious silks of the high-style versions.

In the last quarter of the nineteenth century, women's everyday dresses were often made of wool and wool–cotton fabrics such as challis and delaine. These fabrics were easily found in dry goods stores, even in the most isolated parts of the country. Eva's quilt exhibits a variety of both printed and solid woolen dress goods. She would have been able to purchase these fabrics in Salina, at such dry goods stores as E. W. Ober, McHenry and Co., and Litowich and Wolsieffer, all of whom advertised profusely in the local newspaper. She also could have purchased them via mail order from national companies such as Sears, Roebuck and Co. and Montgomery Ward.

LEFT: FIG 3-34. Crazy quilt, *detail*. Maker's embroidered name and location.

ABOVE: FIG 3-35. Crazy quilt, *detail*. Embroidered date.

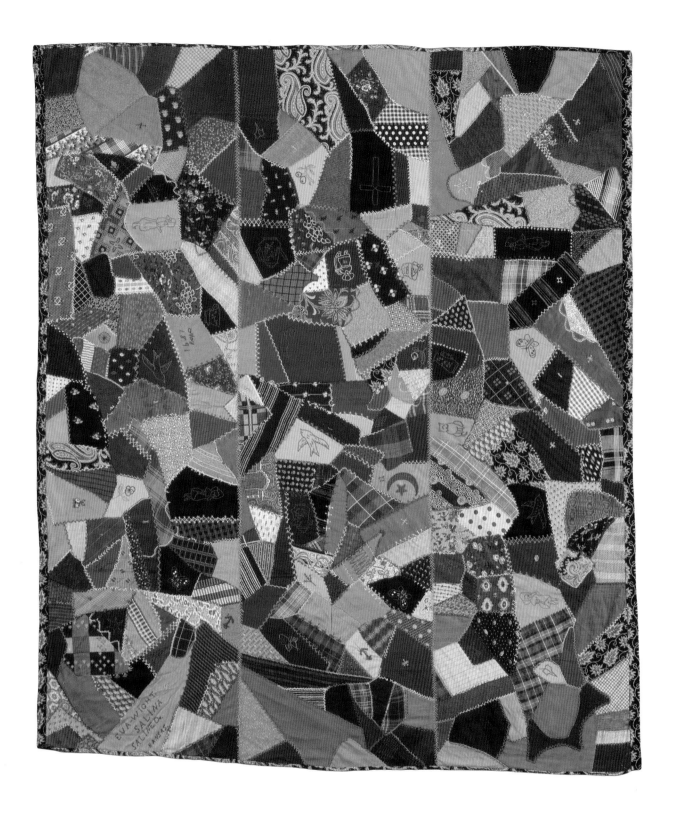

PLATE 3-11. Crazy quilt.
Eva Wight (1872–1940).
Saline County, Kansas, dated 1891.
Wools and wool-cotton mixtures, 81.5" x 71". Unquilted.
1997.007.0929. *Ardis and Robert James Collection.*

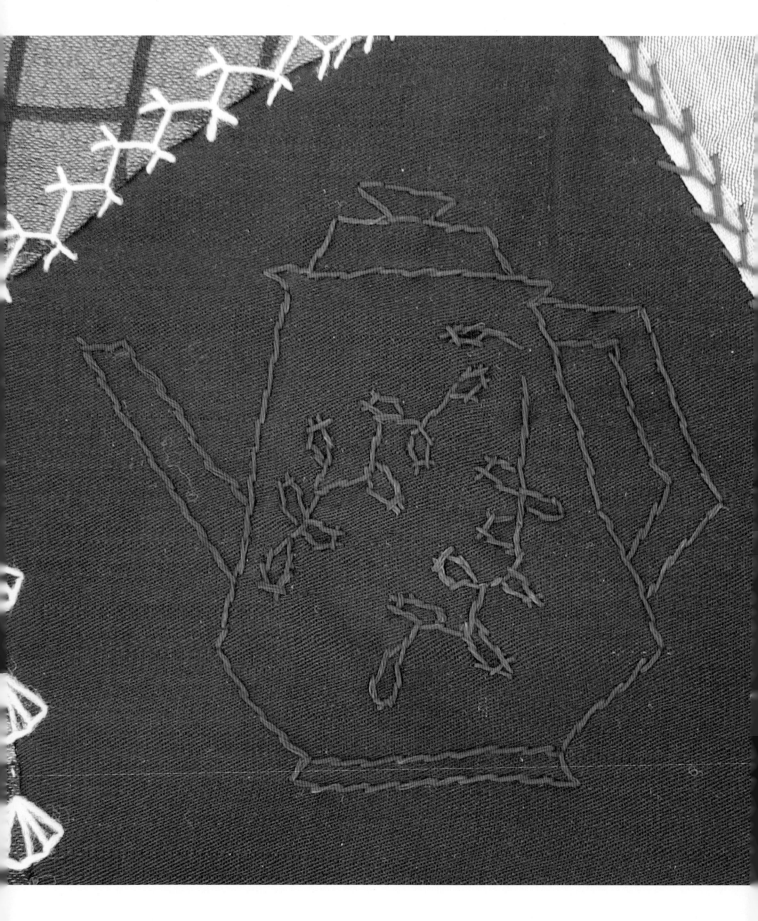

Eva's quilt, like many other "country" Crazy quilts, is embroidered with a combination of coarse cotton and wool yarns rather than all silk or smooth cotton flosses, and is much sparser and cruder than the earlier silk extravaganzas. Her seam-covering stitches are all worked in a relatively small number of stitches, mainly feather, buttonhole, and herringbone, and are all done with wool crewel yarns. Often, the embroidery stitches, rather than basting stitches, are all that is holding the fabrics down to the three foundation strips, which also serve as the quilt's backing. This technique, along with the limited number of decorative stitches, illustrate how quiltmakers like Eva took shortcuts and made material choices that transformed the Crazy quilt into a new but related art form.

Eva's figurative embroidery is mostly completed in an outline stitch and reveals an inexperienced hand: the stitches are large and often uneven. The motifs are typical of Crazy quilts: Kate Greenaway figures, swallows, butterflies, and teapots, among others. Most of these motifs are repeated at least twice across the quilt, suggesting that Eva had access to a limited number of patterns or perhaps was only skilled enough to attempt these designs. All in all, her quilt is typical of the kinds of Crazy quilts that were made in nonurban areas of the country after the style faded from national popularity: it is composed of non-silk fabrics, its embroidery is limited and fairly plain, and it is less complex, both in technique and aesthetics.

All of this is not to say that it is not without charm. The vibrant red suiting fabrics and the intricately printed dress fabrics combine with the plainer plaids and browns to make a quilt full of visual interest. In any case, we can be sure that Eva was very proud of her accomplishment since she so clearly marked it as her own.

■ **Marin F. Hanson**

FIG 3-36. Crazy quilt, *detail*. Embroidered teapot.

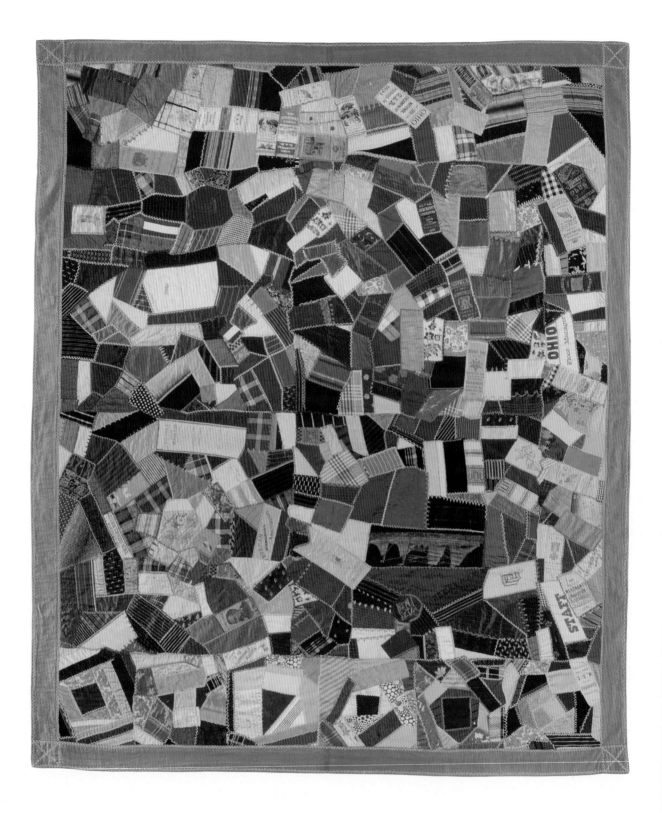

PLATE 3-12. Campaign Ribbons Crazy quilt.
Possibly from Folger or Stuart family.
Possibly made in Springfield, Ohio, 1915–1925.
Silks, Cottons, 77.5" x 64". Unquilted.
1997.007.0516. *Ardis and Robert James Collection.*

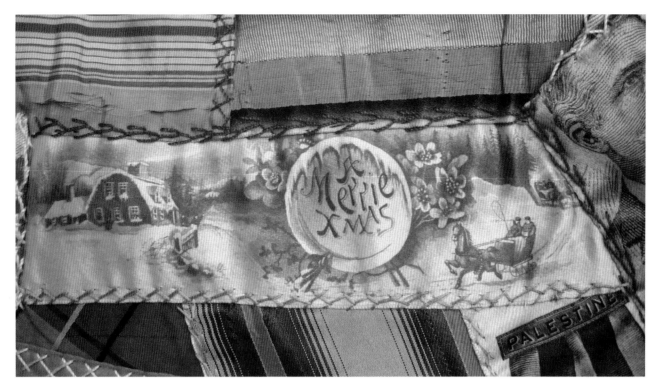

FIG 3-37. Campaign Ribbons Crazy quilt, *detail*. Lithographed silk ribbon.

As silk fabrics proliferated at the end of the nineteenth century, it was common for organizations sponsoring meetings or other events to print ribbons that could be worn as badges and kept as souvenirs. The practice was so popular that silks were printed for all kinds of occasions. Crazy quilts were perfect repositories for these badges, since their eclectic and irregular surfaces could easily accommodate fabrics of disparate color, size, and imagery. This Campaign Ribbons Crazy quilt (plate 3-12) holds dozens of souvenir silks, some of which are unusual and highly evocative. It includes a ribbon with a Currier and Ives–like winter scene with the words "A Merrie Xmas," for example, as well as a printed menu from a festive meal at the Arcade Hotel in Springfield, Ohio. (The many-course dinner included "blue points on the half shell," trout, chicken and shrimp salad, and

a fine claret.) Another ribbon commemorated an 1885 wedding joining the Folger and Stuart families of the same town. It is possible that the menu was from the wedding dinner.

Most of the ribbons on the quilt, however, are badges from meetings of veterans and fraternal organizations, professional conventions, or political campaigns. Most took place in Ohio over a thirty-one-year period, from 1884 to 1912. If we assume they came from the same family, the quilt can be "read" as a kind of scrapbook. The man of the family was a veteran of the Union Army who was active in the Republican Party and worked as a merchant, probably dealing in groceries. He belonged to two fraternal organizations, the Knights of Pythias and the Benevolent Protective Order of Elks, both of which were service societies, and he was a regular attendee of political conventions

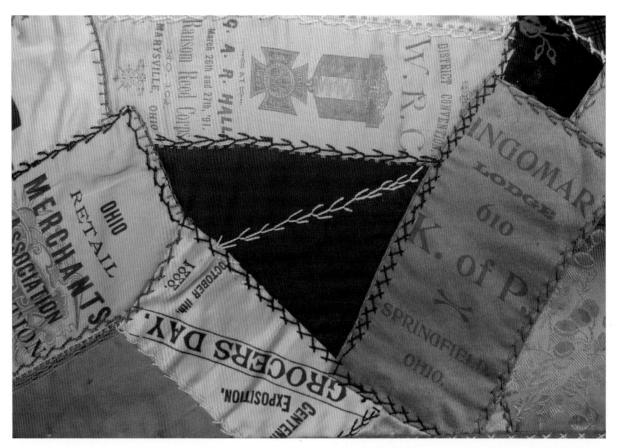

FIG 3-38. Campaign Ribbons Crazy quilt, *detail*. A range of silk souvenir ribbons.

and Grand Army of the Republic (GAR) encampments, traveling to communities such as Pittsburgh and Louisville to meet with other Civil War veterans. He was also a bicyclist, who one year traveled to northern Ohio for a "wheelmen's" convention. His wife was active in the Women's Relief Corps, the auxiliary organization of the GAR; she was a delegate to many of its conventions in the 1890s, and after an apparent hiatus, attended another in 1912. (Because all of the badges relating to the man's activities predate the turn of the century, we might surmise that she was a widow by this latter date.) Someone in the family had a connection with Wittenberg College, which is located in Springfield.

The quilt may have been started in the last two decades of the nineteenth century, the height of the Crazy quilt era, since so many of the badges date from the 1880s and 1890s. It was not completed, however, until about World War I, based on the date of its most recent badge. Tellingly, the sateen lining and edging have a Colonial Revival feel, based on their particular color of blue and the fact that they are made in cotton rather than silk. The quiltmaker must have been strongly devoted to the piece to have worked on it for so long, completing it when Crazy quilts were no longer even in vogue.

In addition to the souvenir ribbons, this quilt embodies the Crazy quilt genre in other ways. The quiltmaker collected a great variety of different silk fabrics; there are myriad examples of stripes, plaids, polka dots, brocades, textured plush, moiré, and shaded ombre effects, and there are even some pieces that were salvaged from the linings of men's hats (these bear the words "self-conforming"). A variety of threads was used as well, including some with variegated effects. Embroidered ornamentation includes familiar domestic imagery such as cats, dogs, and a log cabin. The quiltmaker tied the many disparate elements together by using relatively controlled, tight stitches around most scraps, but she still experimented with a range of embroidery effects, and the treatment was never rigid.

■ **Beverly Gordon**

LEFT: FIG 3-39. Campaign Ribbons Crazy quilt, *detail*. 1891 souvenir ribbon for a Springfield, Ohio, "Wheelmen" event (possibly with a *Mikado* theme).

FIG 3-40. Campaign Ribbons Crazy quilt, *detail*. Ribbon with the latest date, 1912.

PLATE 3-13. Crazy quilt variation.
Maker unknown.
Possibly made in Pennsylvania, 1930–1945.
Wools, Cottons, cotton-rayon mixtures, 82.5" x 62.5". Tied.
2003.003.0140. *Jonathan Holstein Collection.*

What makes a Crazy quilt? According to Barbara Brackman's *Clues in the Calico*, "A strict definition of a Crazy Quilt requires pieces of irregular shapes and sizes."[27] This quilt (plate 3-13) certainly fulfills that requirement. Composed of recycled knitted clothing, it takes common, everyday garments and transforms them into new shapes and gives them a new function. Some of the reused items are socks, sweaters, hats, and gloves. Flattened out into two-dimensional forms, the clothing becomes a layered field of random shapes. Many of the pieces are striped, patterned, or brightly colored, further adding to the haphazard Crazy quilt aesthetic.

Brackman also describes Crazy quilts by saying that "most are covered with linear embroidery patterns covering the seams" and that "nearly all Crazy Quilts are constructed on a foundation which is visible only on unbacked or damaged examples."[28] All of the joins between these knitted garments are covered with a white wool yarn embroidery in a simple herringbone stitch. In fact, like the Eva Wight Crazy quilt (plate 3-11), the embroidery stitches serve dual duty as decoration and as the stitches securing the knitted fabrics to the foundation fabric. Because this is a mostly wool quilt, some areas show damage, probably from insects. The resulting holes as well as areas of loosely knitted stitches allow us to see that the knits indeed are attached to a foundation fabric, which, at least in some areas, is a bright blue cotton.

All of the garments have been cut apart to lie flat or deconstructed into their component pieces. The front of a handsome tan, blue, and white argyle vest has been cut in half and filled in at the neck with a variegated tan-and-orange knit, possibly taken from the back of the sweater. A vertically striped v-neck sweater has been cut into many pieces, its front side dominating the center of the quilt and smaller bits of it spread about. A white cap betrays its former use by the shape of its gently curved ribbed bottom. A pair of black gloves has been cut apart and placed side by side with one thumb sticking out, almost creating the silhouette of an elephant (albeit an eight-legged one). A pink rib-knit cardigan has likewise been deconstructed and is placed inside out so that its cotton–rayon facing is visible. The presence of rayon trim in an otherwise wool quilt top points to a post-1911 date. (See discussion of plate 7-16, Landon/Knox quilt, for a summary of the development and commercial availability of rayon and acetate in the early twentieth century.)

FIG 3-41. Crazy quilt variation, *detail*. Deconstructed glove.

LEFT: FIG 3-42. Crazy quilt variation, *detail*. Sears, Roebuck and Co.–brand man's swimming suit.

FIG 3-43. Sears, Roebuck and Co. Spring and Summer catalog, 1931, "Bathing Apparel of Real Worth," *detail*. Courtesy of Sears® Holdings.

Perhaps the most interesting recycled piece, and one of the best clues to the quilt's date, is a one-piece men's bathing suit in navy blue with three wide red stripes across the chest and back. The suit's tag reads, "100% All Wool Worsted / Sears, Roebuck and Co." The cut of the tank-top suit is distinctive because of large openings in the sides, which look like second, lower armholes. The evolution of men's swimwear styles is pictured in Sears catalogs. In the 1897 edition, bathing suits were listed only for men and nearly covered the body, much as long one-piece underwear or union suits did. In 1914, swimming suits were two-piece and again pictured only for men. The styles were less conservative, with sleeveless tops and short bot-toms. Women were told to "write for prices" if they wanted a bathing suit. In both the 1923 and 1927 Sears catalogs a full page was dedicated to bathing suits for the whole family. Men's and women's suits were in a tank-top design, and a bold chest stripe was featured on some men's models. Most of the suits were wool, and the description of one in the 1927 catalog reads, "Men's Medium Weight All Wool Worsted Bathing Suit. Dark brown color with orange and royal blue chest stripes. A very attractive color combination." In both the 1931 and 1934 Sears catalogs, men's bathing suit styles had become more revealing. Trunk-style suits for men and boys were pictured, as were the open-sided tank-top one-piecers, called "Speed Suits," seen in this Crazy quilt. The 1934 designs, however, did not have stripes. The swimming suit that was re-cycled for this quilt, therefore, was likely purchased from Sears, Roebuck and Co. sometime in the early 1930s and then subsequently recycled for use in this Crazy-style quilt.[29]

■ Marin F. Hanson

GALLERIES

"Wilde" and Crazy

Oscar Wilde, the Anglo-Irish playwright and proponent of the idea of "art for art's sake," was the most visible figure of the late nineteenth-century Aesthetic Movement, which was concerned with the intentional artistic beautification of every surface and space of one's home. One of these quilts actually features an embroidered portrait of Wilde (plate 3-14; see figure 3-9), who, in 1882, took America by storm by engaging in a countrywide lecture tour, which was warmly received by some and ridiculed and scorned by others. All of the high-style quilts on the next few pages (plates 3-14–3-29) feature the mélange of luxurious silk fabrics, ribbons, colors, textures, embellishments, and artistic and Oriental imagery championed by Wilde and the Aesthetic Movement. High-style Crazy quilts were consciously made as artistic objects to be appreciated in the home, and many makers signed their quilts just as painters signed their canvases.

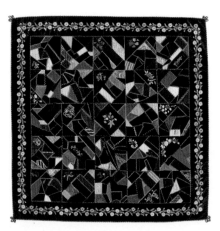

PLATE 3-14. Crazy quilt.
Possibly made in Indiana, 1880–1890.
Silks, 71" x 70". 1997.007.0234.

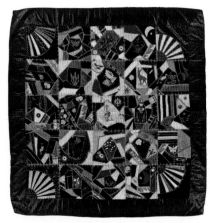

PLATE 3-16. Crazy quilt.
Possibly made in Pennsylvania, dated 1883.
Silks, 68" x 65.5". 2003.003.0192.

PLATE 3-17. Crazy quilt.
Maker/location unknown, 1880–1900.
Silks, 77.5" x 80". 2006.012.0003.
Purchase made possible through James Foundation Acquisition Fund.

PLATE 3-15. Crazy quilt.
Possibly made in Ohio, 1880–1890.
Silks, 66" x 62.5". 1997.007.0670.

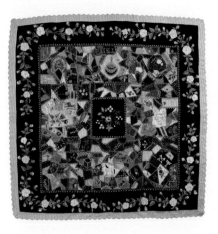

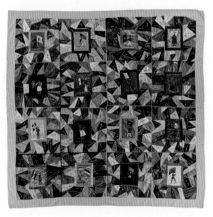

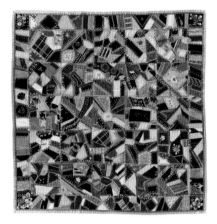

PLATE 3-18. Crazy quilt.
Probably made by Dorothy Tompkins,
Yonkers, New York, 1880–1890.
Silks, 65.25" x 65". 1997.007.0230.1.

PLATE 3-20. Crazy quilt.
Made by Sarah C. Schooley, Noble County,
Ohio, dated 1890.
Silks, 74.5" x 67". 1997.007.0695.

PLATE 3-22. Crazy quilt.
Probably made in Turtle Creek, Pennsylvania,
dated 1896.
Silks, 74" x 76". 1997.007.0952.

PLATE 3-19. Crazy quilt.
Probably made by Mattie Linville. Possibly
made in Ohio, 1880–1890.
Silks, 54" x 55". 1997.007.0456.

PLATE 3-21. Crazy quilt.
Probably made by Lizzie M. Bradley.
Location unknown, dated 1883–1884.
Silks, 67.5" x 67". 1997.007.0803.

PLATE 3-23. Crazy quilt.
Maker/location unknown, 1880–1900.
Silks, 62.5" x 61.5". 2003.003.0337.

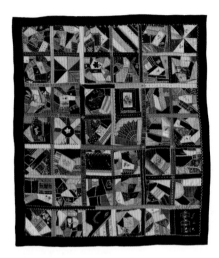

PLATE 3-24. Crazy quilt.
Possibly made in St. Louis, Missouri,
dated 1886.
Silks, 66.5" x 59". 1997.007.0247.

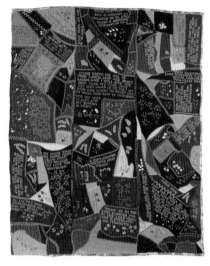

PLATE 3-26. Crazy quilt.
Made by Mary T. H. Willard, Evanston,
Illinois, dated 1889.
Wools, 83" x 67". 1997.007.0318.

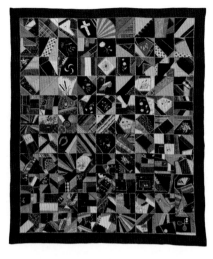

PLATE 3-28. Crazy quilt.
Maker/location unknown, dated 1884.
Silks, 75" x 63". 1997.007.0783.

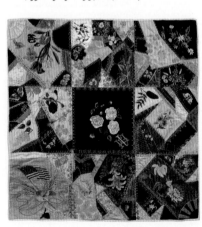

PLATE 3-25. Crazy quilt.
Possibly made in Indiana, 1880–1900.
Silks, 53" x 52.5". 1997.007.0284.

PLATE 3-27. Crazy quilt.
Maker/location unknown, 1880–1900.
Silks, 55" x 41.5". 1997.007.0608.

PLATE 3-29. Crazy quilt.
Made in Nebraska, c. 1896.
Silks, 69" x 67.5". 2001.005.0002.
Nebraska State Quilt Guild Collection.

In the Vernacular

High-style Crazy quilts reached their peak in the mid- to late 1880s. As the style trickled down to the working classes and rural society it was pared down, but it retained the essential aesthetic qualities. Simplified and practical approaches have long been the American vernacular interpretation of high-style artistic movements. In this group of quilts (plates 3-30–3-39), fine silks, velvets, brocades, lavish embellishment, and smallish size have given way to cotton and wool of the type used for work and durable clothing, spare or no embellishment, and strength and size improved enough to be used regularly as warm bedcoverings. Far from sedate, the saturated hues of the wool fabrics and the soft luster of the cotton fabrics lend a pleasing richness and an air of simplicity.

PLATE 3-30. Crazy quilt.
Possibly made in Minnesota, 1900–1920.
Wools, 84" x 76". 1997.007.0279.

PLATE 3-32. Crazy quilt.
Maker/location unknown, 1890–1910.
Wools, 80.25" x 65.5". 1997.007.0893.

PLATE 3-31. Crazy quilt.
Possibly made in Michigan, dated 1897.
Wools, 86" x 64". 1997.007.0683.

PLATE 3-33. Crazy quilt.
Possibly made in Pennsylvania, 1920–1940.
Wools, 79.5" x 54". 2003.003.0027.

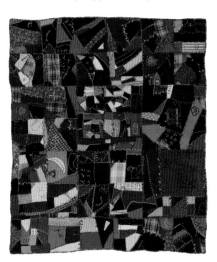

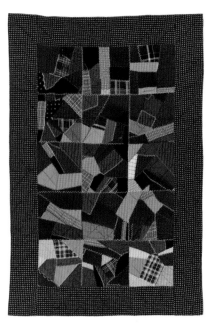

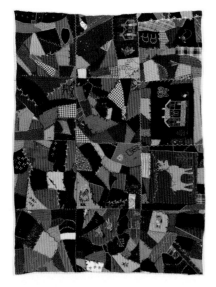

PLATE 3-34. Crazy quilt.
Possibly made in Michigan, dated 1897.
Wools, 80" x 69.75". 1997.007.0684.

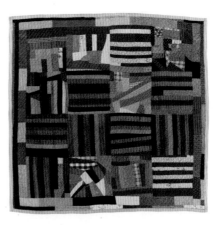

PLATE 3-36. Crazy quilt.
Possibly made in Pennsylvania, 1900–1920.
Cottons, 73" x 73.5". 2003.003.0043.

PLATE 3-38. Crazy quilt.
Possibly made in Vermont, 1910–1930.
Cottons, 72.5" x 63.5". 2003.003.0053.

PLATE 3-35. Crazy quilt.
Possibly made in Pennsylvania, 1900–1920.
Wools, 88" x 70.5". 2003.003.0002.

PLATE 3-37. Crazy quilt.
Possibly made in Maine, 1900–1920.
Cottons, 66.5" x 35". 2003.003.0046.

PLATE 3-39. Crazy quilt.
Possibly made in New Jersey, 1900–1920.
Cottons, 73.5" x 65". 2003.003.0144.

A Date with Modernism

The Crazy style, which emerged on the cusp of the Modernist artistic era, anticipated the formal complexity of Cubism and the abstraction of Pablo Picasso and Georges Braque, among others. It is unlikely that their beginnings were directly connected, but it is worth noting that both trace their genesis to the 1870s. For quilts it began with the experimental design of Crazy quilts. For painting it began with the radical approach of the Impressionists, who parted with the formalism of the art academy.

What is a Crazy quilt, really? High-style Crazy quilts were typically foundation-pieced from silk fabrics, but categorization based on material or technique would exclude many quilts that have a Crazy *essence*. Crazy quilts encompass the lavish and luxurious and also the humble and utilitarian. What unifies all of them, however, is the Crazy *aesthetic* of abstraction, asymmetry, irregularity, and busyness.

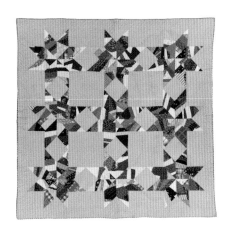

PLATE 3-40. String Star.
Possibly made in Ohio, 1890–1910.
Cottons, 77.5" x 76". 1997.007.0093.

PLATE 3-42. Crazy quilt.
Maker/location unknown, 1880–1900.
Cottons, 83.5" x 74". 1997.007.0453.

PLATE 3-41. Tile quilt.
Made by Burdick family members, New London, Connecticut, c. 1876.
Cottons, 81" x 80". 1997.007.0163.

PLATE 3-43. Crazy quilt.
Possibly made in New England, 1910–1930.
Cottons, 88" x 79.5". 2003.003.0247.

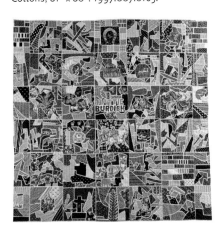

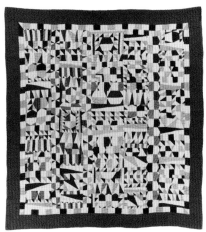

PLATE 3-44. Crazy quilt.
Possibly made in Indianapolis, Indiana,
1880–1900.
Silks, 37.5" x 36.5". 1997.007.0393.

PLATE 3-46. Crazy quilt.
Possibly made in Illinois, 1930–1940.
Cottons, 82.5" x 67.5". 1997.007.0866.

PLATE 3-48. Crazy quilt.
Possibly made in Pennsylvania, 1900–1920.
Cottons, 37.5" x 28". 2003.003.0049.

PLATE 3-45. Crazy quilt.
Probably made in Pennsylvania, 1870–1890.
Wools, 82" x 73". 1997.007.0610.

PLATE 3-47. Crazy quilt.
Possibly made in Vermont, 1890–1900.
Cottons, 86.5" x 76.5". 2003.003.0032.

PLATE 3-49. Crazy quilt.
Possibly made in Massachusetts, 1880–1900.
Cottons, 81.5" x 81". 2003.003.0243.

A Hold on Tradition

Crazy quilts depart markedly from the American quiltmaking tradition of geometrical piecing and symmetrical appliqué. That is not to say, however, that Crazy quilts never echo tradition. Quiltmakers may have made quilts that included some Crazy style elements as a tentative expression of freedom from tradition, an effort to creatively combine divergent aesthetics, or simply an excuse to clean out the scrap bag.

Such quilts are successful because they provide both point and counterpoint. The incorporation of traditional settings and block designs are like pauses in an animated conversation, and the Crazy elements like outbursts of laughter. Apart from all speculation, these mixtures are reminders that quilt style has not been static but has been richly dynamic as various influences were encountered, interpreted, and incorporated as part of the developing traditions of American quiltmaking.

PLATE 3-50. Chinese Lantern.
Possibly made in Pennsylvania, 1880–1900. Cottons, 67" x 67". 1997.007.0538.

PLATE 3-52. Crazy quilt.
Possibly made by Betsey Richards. Possibly made in Massachusetts, 1880–1900. Silks, 55" x 65". 2003.003.0193.

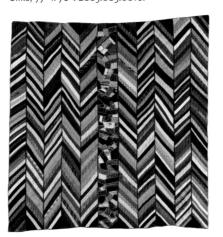

PLATE 3-51. Zigzag.
Possibly made in Pennsylvania, 1880–1900. Silks, 77" x 76". 2003.003.0016.

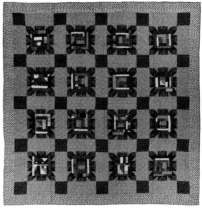

PLATE 3-53. Crazy Star.
Possibly made in Pennsylvania, 1880–1900. Cottons, 82" x 81.5". 2003.003.0251.

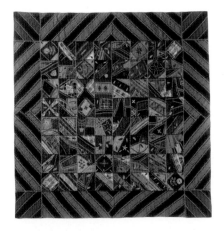

PLATE 3-54. Crazy quilt.
Probably made in Lancaster County,
Pennsylvania, dated 1891.
Wools, 82.5" x 64". 1997.007.0107.

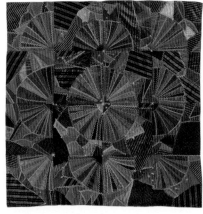

PLATE 3-56. Crazy quilt.
Possibly made in Massachusetts, 1890–1910.
Silks, 58.25" x 57". 1997.007.0375.

PLATE 3-58. Crazy quilt.
Possibly made in Pennsylvania, 1880–1900.
Cottons, 81.5" x 79.5". 2003.003.0157.

PLATE 3-55. Crazy quilt.
Possibly made in Pennsylvania, 1870–1890.
Cottons, 81.5" x 80". 1997.007.0120.

PLATE 3-57. Lattice with Crazy border.
Possibly made in southern Indiana, 1910–1930.
Cottons, 75" x 68". 1997.007.0525.

PLATE 3-59. Crazy quilt.
Maker/location unknown, 1880–1900.
Wools, 62" x 60.5". 2003.003.0339.

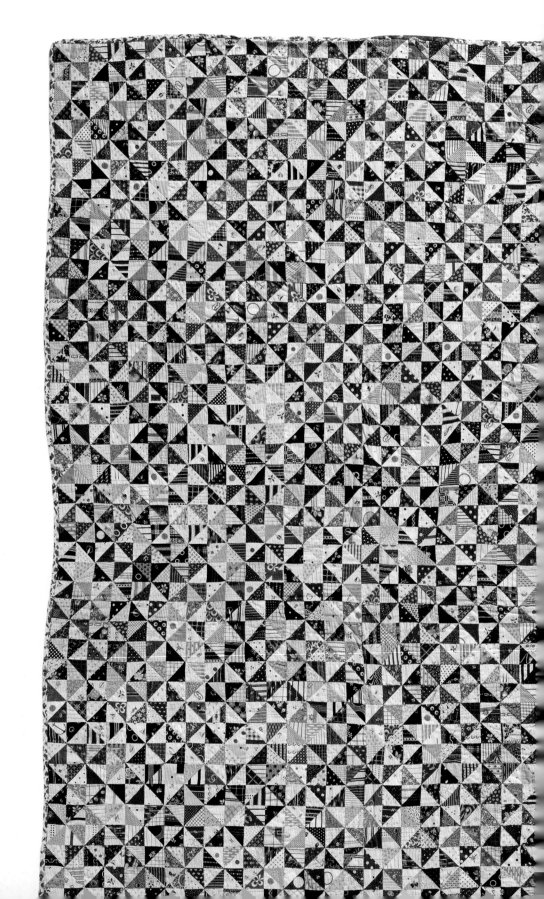

Simple and Complex *Allover-Style Quilts*

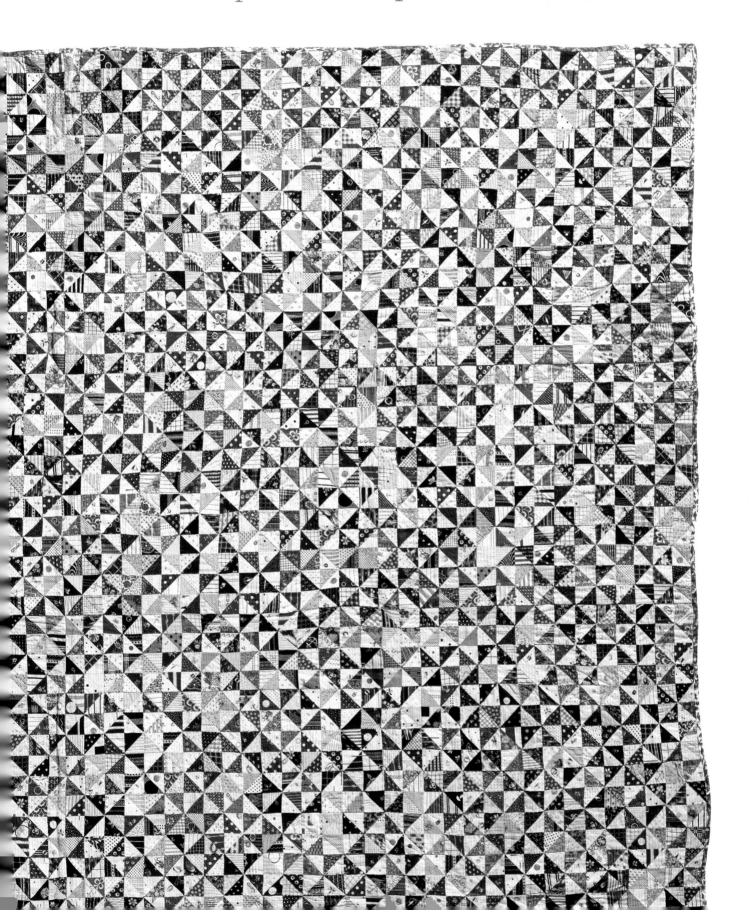

While block-style patterns dominated American quiltmaking between the mid-nineteenth and the mid-twentieth centuries, other patchwork formats persisted during this period. Indeed, the urge to sew a multitude of small pieces of fabric together to create geometric designs is evident in the ancient decorative traditions of many world cultures, including both European and American quiltmaking traditions. Although whole-cloth quilts appear to have predominated during the eighteenth century, surviving examples of patchwork, quilted and unquilted, indicate that pieced bedcovers were also produced in some areas.

The earliest known surviving example of a patchwork bedcover is a 1718 coverlet in the collection of the Quilter's Guild of the British Isles. Purchased by the Guild in 2000 at auction from a private seller, the unquilted coverlet contains a block with the pieced inscription "E H 1718" and other blocks with a variety of human, animal, and geometric figures. Like most other surviving pieces from this period, including the McCord Museum quilt in Canada and several pieces in the Victoria and Albert Museum in London, the 1718 coverlet was pieced over paper templates, around which the silk fabrics were wrapped, basted in place, and then oversewn (whipstitched) together to form a decorative surface.[1]

Immigrants from the British Isles and Europe brought the mosaic patchwork technique to the American colonies, but a shortage of paper seems to have limited its popularity during the eighteenth century. In 1835, *Godey's Lady's Book* published an engraved illustration of hexagon patchwork, "also called honeycomb patchwork." This is the only patchwork design offered in an American magazine during the first half of the nineteenth century.[2] During the 1850s, *Godey's* published additional mosaic patchwork designs, some three dozen patterns in combinations of geometric shapes—some of them quite intricate.[3]

During the nineteenth century, mosaic patchwork (also called English paper-template piecing) became

FIG 4-1. Thousands Pyramids, *detail* (see plate 4-20).

FIG 4-2. Hexagons, *detail* (see plate 4-41). Template-pieced fabrics.

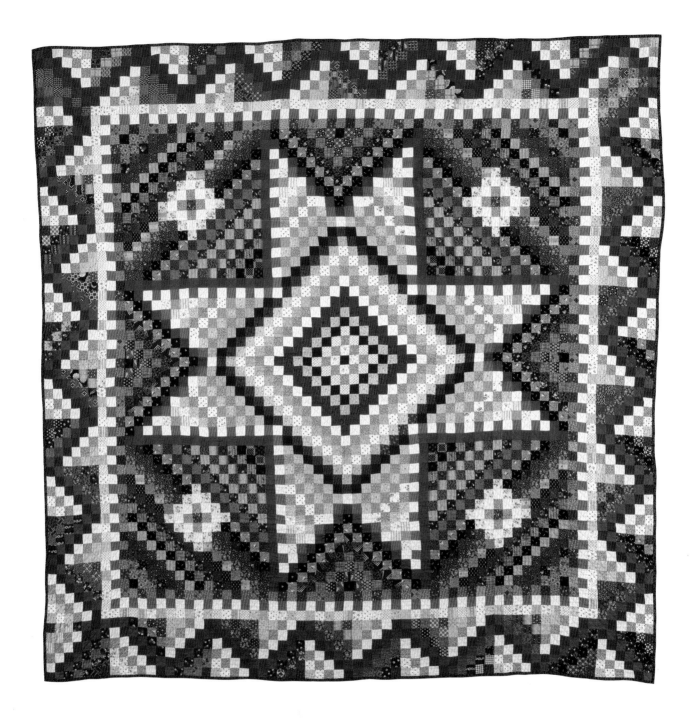

PLATE 4-1. Postage Stamp Star.
Maker unknown.
Probably made in Bowmansville, Lancaster County,
Pennsylvania, 1880–1900.
Cottons, 79" x 78". QSPI: 9-11.
1997.007.0133. *Ardis and Robert James Collection.*

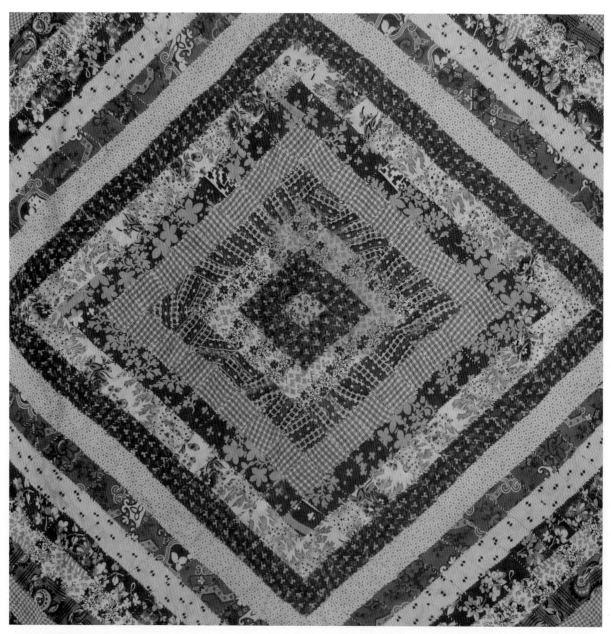

FIG 4-3. Medallion, *detail* (see plate 4-45).

FIG 4-4. Split Bars, *detail* (see plate 4-61).

popular in many parts of the United States.[4] Hexagons and diamonds were the most frequently used geometric shapes, and the majority of examples using these shapes were pieced over paper templates. Examples of the technique are recognizable by the crisp, exact angles of the individual patches and the close parallel stitches of the oversewn seams. The technique produces a very flat surface, and it is apparent that some surviving examples were not intended to be quilted.

Mosaic patchwork was widely, though not evenly distributed in the United States. For example, a comparatively large number of mosaic patchwork pieces were made in South Carolina, yet the technique was described as "almost totally absent" among ten thousand quilts documented in neighboring North Carolina.[5] Most of the publications resulting from state quilt projects include one or more examples of mosaic patchwork, but as yet there has been no study of the distribution or relative frequency of surviving examples.

Mosaic patchwork was not the only popular technique for producing patchwork from small repeated geometric shapes. A number of designs produced from the repetition of a single shape, such as those now known as Thousand Pyramids, Postage Stamp, and Trip Around the World, emerged during the late nineteenth century, constructed by the "conventional" piecing method, by stitching together adjacent pieces with straight seams, without templates. Patterns constructed of long strips, such as those now called Bars, Wild Goose Chase, and Tree Everlasting, were another patchwork form that persisted from the late eighteenth century. Center-medallion quilts, largely supplanted by block designs in the second half of the nineteenth century, never completely disappeared and enjoyed a revival in the early twentieth century. Although block patterns are emblematic of American quilts, quiltmakers have a long tradition of experimentation, creating and re-creating patchwork in a variety of formats.

■ **Laurel Horton**

More complex than many hexagon-based mosaic quilts, this Hexagon Star quilt (plate 4-2) combines hexagons in two sizes with a less commonly used geometric shape, a pentagon, to form six-pointed stars. The irregular pentagons (the five sides are not all equal in length) are made from a single piece of fabric, although a similar but more exacting result could have been obtained by adding a small triangle to one side of a hexagon. The stars are set together with large hexagons of solid black between them, producing a dynamic figure-ground contrast. The arrangement of the star motifs into concentric hexagonal rings echoes the transition from the predominant framed-center layout of the early nineteenth century into the allover designs of the second half of the century.

The precise distribution and arrangement of colors and fabric patterning indicate that the maker planned the design from the outset, not as an afterthought. For instance, she selectively placed fabric pieces to create secondary patterns among adjoining pentagons. This attention to detail is evident in the second and third rows from the center, where a geometric print, in both red and light blue colorways, was carefully cut so that the rings of pentagons convey a secondary pattern of rings. The maker also carefully incorporated small pieces of a detailed paisley print into some of the stars. In one, the paisleys are delicately arranged as "petals" around the bright red center. The limited and precise use of this fabric suggests that the maker had a small piece available and wished to make the best visual use of it. Her placement of partial stars at the corners of the quilt was another effective visual device, giving the impression of a much larger field of stars extending beyond the borders.

The earliest examples of mosaic patchwork, from eighteenth-century England, were typically made from silk. During the first half of the nineteenth century in the southern United States, however, quiltmakers favored cotton fabrics.[6] Later, during the third quarter of the century, dark-colored silks predominated across the country as their availability, and the paper-piecing technique, spread widely. At the same time, some quiltmakers also used woolen goods to create mosaic quilts, particularly in states further inland, such as Kentucky, where this quilt is thought to have originated. The fabrics in this paper template-pieced quilt include delaines and challis—dress-weight woolens

FIG 4-5. Hexagon Star, *detail*. "Fussy cut," template-pieced stars.

—some in solid colors and others printed in a variety of geometric figures, dots, florals, and paisleys. Heavy woolens would have been unwieldy for wrapping over paper templates and forming crisp edges, but these lighter-weight dress fabrics were easily manipulated.

Dark quilts, whether made of wool or silk, suited the Victorian aesthetic of dark interiors, rich patterning, and multiple design elements. The geometric complexity of mosaic patchwork gave way by the 1880s to the irregular patterning of Crazy patchwork, perhaps the ultimate textile expression of late Victorian sensibility.

The rich, saturated colors of the woolens—particularly the shades of red, fuchsia, and pink—produce an intense visual surface. A single ring of pink stars, echoed by the pink centers in other rings, provides an effective contrast to the darker hues and buoys the design. The border of a lighter shade of peach forms a frame that both contains and highlights the vitality of the concentric rings of stars. A darker border would have brought out the dark elements, producing a more somber result.

Each fabric piece is quilted with a single row of stitches about a quarter-inch inside the seam. The larger black hexagons are further quilted in a web design of lines joining opposite points crossing in the center. The quilting was done primarily in black cotton thread, although some of the lighter fabrics were quilted with yellow silk thread. The border is quilted in an overall clamshell design, also with yellow silk thread.

■ **Laurel Horton**

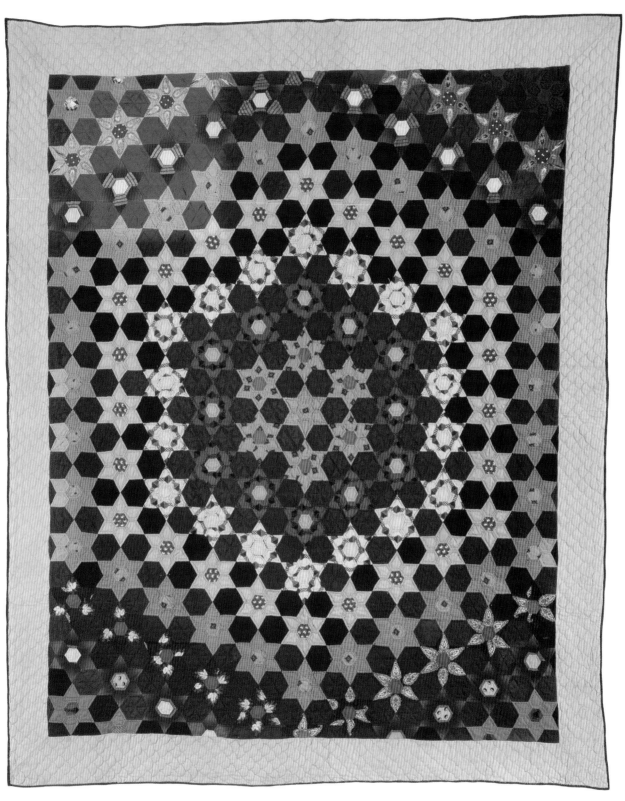

PLATE 4-2. Hexagon Star.
Maker unknown.
Possibly made in Kentucky, 1860–1880.
Wools, 81" x 66". QSPI: 5-6.
1997.007.0178. *Ardis and Robert James Collection.*

PLATE 4-3. Hexagons.
Maker unknown.
Possibly made in Ohio, 1860–1880.
Silks, 81" x 71". QSPI: 7-9.
1997.007.0437. *Ardis and Robert James Collection.*

FIG 4-6. Hexagons, *detail*. Template-pieced hexagon rosettes.

The maker of this Hexagon quilt (plate 4-3) combined a variety of silk fabrics to create a classic example of mid-nineteenth-century mosaic patchwork. These materials include plain-woven taffetas in both solid colors and stripes; deep-piled velvets; and brocades in which detailed floral figures are woven into the structure of the fabric itself. The maker placed her hexagon templates to isolate specific motifs and, after cutting out multiples of the same figures, carefully aligned them to create pleasing patterns. Attention to this process of selective cutting produced exquisite visual details that are not immediately obvious when the quilt is viewed from a distance. Many fine mosaic patchwork quilts exhibit overall balance and harmony and also carefully aligned details. The inability to see both characteristics simultaneously is a visual paradox shared by other forms of fine needlework.[7]

As with many other examples of hexagon mosaic patchwork, the individual blocks were constructed in rosettes of six hexagons of the same fabric set around a contrasting center. The maker then placed six of these units around a contrasting seventh to make a larger, compound rosette, joining the rosettes with a single row of green damask-striped hexagons. Extending the theme a third time, she then positioned six of these compound rosettes around a contrasting center, connecting the whole with a single row of pink taffeta hexagons. The compound unit in the middle of the quilt features bold outlines of black velvet, creating a central focus that echoes the earlier style of center-medallion quilts.

To make her quilt top square, the maker filled in the edges and corners with partial rosettes. Instead of strictly following the design set in the center of the quilt she allowed some irregularities in the rosette placement, while maintaining visual cohesiveness with a single row of pink hexagons joining the units together.

The borders are formed from a voided velvet with green silk taffeta ground overlaid with alternating broken and unbroken black pile stripes. The maker carefully cut the border strips across the grain so that the short stripes of the broken lines are centered within the border's width. Her attempts to miter the corners of the border were less successful. Perhaps because she made the diagonal cut too steep, she had to add a black gusset in three of the corners so the corners would meet and the quilt lie flat.

The quilting was done in silk thread chosen to match the predominant color in each fabric. Each hexagon contains a single row of stitching about one quarter-inch inside the seam. The binding is of red wool tape.

■ **Laurel Horton**

The popularity of mosaic patchwork in the mid-nineteenth century coincided with an increased interest in the decorative arts of Asia and the Middle East during one of a number of periodic rediscoveries and adaptations of Eastern culture.[8] Perhaps the most lasting legacy of the Crusades during the eleventh to the thirteenth centuries was the transmission of cultural knowledge from Eastern cultures to the West,[9] including fabrics and textile processes and techniques. The Crusades also encouraged the spread of architectural elements such as the use of interlocking geometric tile designs for floors and walls. As foreign travel became more common for Europeans and Americans in the eighteenth and nineteenth centuries, such mosaic tile designs increased in popularity and were another possible inspiration for the mosaic patchwork quilts that proliferated throughout the era.

This Hexagon quilt (plate 4-4) presents a complex visual appearance reminiscent of Old World mosaic tile floors. The relationship between geometric tile designs and quilt patterns is certainly suggested, yet

FIG 4-7. Hexagons, *detail*. Butterfly-printed cretonne fabric.

specific documentation is lacking. In any culture visual elements of both natural and constructed environments supply humans with images that are reflected in the decorative arts. The symmetry of flowers, the delicate patterning of a snowflake, the structural geometry of architecture all have influenced the design of quilt patterns, both directly and indirectly.

Casual observation indicates that the majority of nineteenth-century quilts pieced from repeated hexagons were constructed using paper templates, but the technique is quite rare among American quilts of the twentieth century. This quilt, however, while made entirely from hexagons, was pieced with a simple running stitch rather than oversewn seams, indicating that the maker did not use paper templates in the construction process. A number of nineteenth-century Hexagon quilts thought to have been made in Pennsylvania were not pieced over paper templates. It is possible that Pennsylvania quiltmakers of German descent became familiar with the visual appearance of mosaic patchwork constructed by their English neighbors but were unfamiliar with the template-based technique and interpreted the designs using conventional piecing.

The maker of this quilt made effective use of a wide variety of late nineteenth-century printed fabrics. Some of the prints appear to be reproductions of the styles of prints available in the early nineteenth century—in double pink, chocolate brown, and butterscotch tones—suggesting that the maker may have wanted her quilt to look "antique." She also used many of the double pinks and madder-style prints that were prevalent since the 1850s, and she included pieces of contemporary cretonnes printed with peacocks and butterflies. Although she incorporated many different fabrics, she organized them in a regular fashion, a characteristic the quilt historian Suellen Meyer noted among German quiltmakers in Missouri.[10]

The symmetrical design resulted in a somewhat elongated quilt top, and the addition of narrow borders of a predominantly blue, floral cretonne restored more normal dimensions. The maker quilted each hexagon with one row of stitches a scant one quarter-inch from the seam, and the borders with parallel diagonal lines. The backing is of plain muslin, and the machine-sewn binding is of the same fabric as the borders.

■ **Laurel Horton**

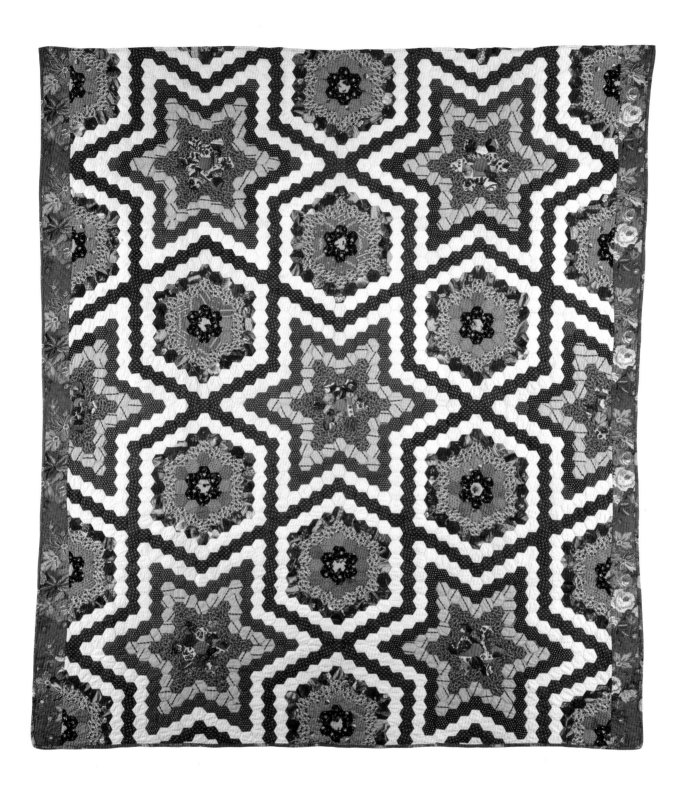

PLATE 4-4. Hexagons.
Maker unknown.
Possibly made in Pennsylvania, 1870–1890.
Cottons, 94" x 83". QSPI: 6.
1997.007.0145. *Ardis and Robert James Collection.*

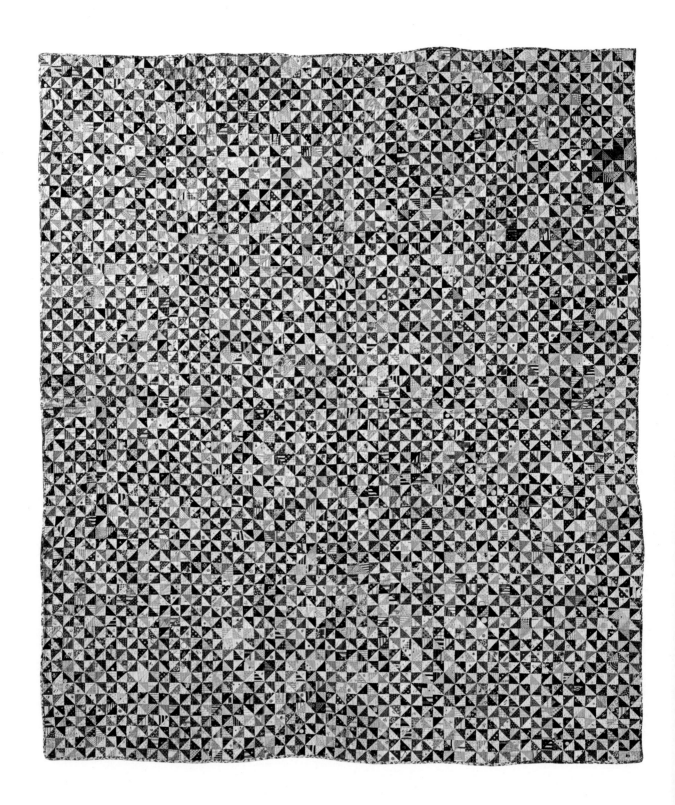

PLATE 4-5. *Bird in Air.*
Salome Thorpe (1836–1936).
Westport, Fairfield County, Connecticut, 1880–1900.
Cottons, 77.5" x 65.5". Tied.
1997.007.0781. *Ardis and Robert James Collection.*

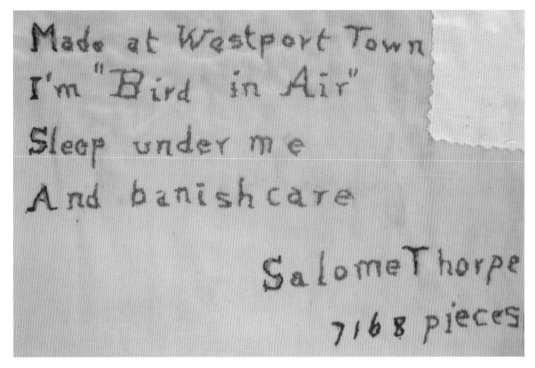

FIG 4-8. *Bird in Air, detail.* Embroidered inscription on reverse.

Stitched in colored thread in a corner of the back of this quilt (plate 4-5) is the following inscription: "Made at Westport Town / I'm 'Bird in Air' / Sleep under me / and banish care / Salome Thorpe / 7168 pieces." The name and location of the maker provide a welcome starting point for further identification of the maker and her quilt.

Salome was born to Peter and Abigail Guyer (or Guire) on April 6, 1836, in Westport, Fairfield County, Connecticut. Sometime around 1859, at the age of twenty-three, she married her twenty-six-year-old second cousin, Joseph W. Thorpe. Salome and Joseph loved horses, and they reportedly made frequent trips to Goshen and other regional race tracks. Their daughter, Hattie, was born in July 1860. Joseph died in 1865, and Salome operated their two-hundred-acre farm, which included raising turkeys. Hattie never married, and after her death in 1907, Salome lived alone in the

family home until her own death on March 22, 1936, just a few weeks short of her hundredth birthday. A newspaper article described her as "a favorite with the young people of the town," who enjoyed visiting her. The reporter noted that Salome was "cheerful and active" before suffering a fall about three months before her death. Her funeral was attended by "many relatives, friends, and neighbors."[11]

Salome's Bird in Air, also known as the Broken Dishes pattern, consists of squares formed by two triangles, one dark and one light. The small size of the pieces produces an active overall appearance, and the maker made no attempt to create a central focus or other secondary design. Looking at this quilt from a distance the viewer may be overwhelmed by the number of small pieces and a realization of the time required to sew them together by hand. One might, indeed, wonder how Salome endured the tedium of the work. A close

look at the quilt offers one possible answer. Salome incorporated small pieces of dozens of different "object prints," that is, representations of human and animal figures, everyday items, symbolic objects, and other recognizable pictorial elements. According to the quilt historian and author Barbara Brackman, object prints "were especially popular with quiltmakers collecting swatches for their charm quilts and scrap quilts during the last quarter of the nineteenth century."[12]

The number and variety of different figured fabrics suggest that Salome Thorpe took particular delight in collecting, selecting, and incorporating these fabrics into her quilt. The prints display a wider range of subjects than is typical for similar quilts of this period. For example, depictions of dogs include a poodle smoking a pipe, a hound's head surrounded by a horseshoe, a greyhound with a red blanket, an empty dog collar, a dog standing on the back of a running horse, and a bulldog with jingle bells attached to its collar. Other prints feature horses, which are variously

shown jumping through hoops, standing in a group, and carrying wild riders. Children are shown crying and smiling, standing with umbrellas and what look like flyswatters. There are tribesmen riding camels and a dancing woman in Eastern European dress. A parrot sits on a disembodied hand, and other parrots and songbirds perch or fly on their own. Inanimate objects include sailboats, anchors, open books, chains, a fan decorated with a crane design, a folded paper airplane, a horseshoe stickpin, and various chains, spikes, pins, and thumbtacks.

Salome seems to have had more interest in creating her unusually detailed patchwork top than in quilting the result. The top is attached to the backing with widely scattered knots, which are not visible from the front. In her later years, when she entertained the groups of local children who liked to visit her home, perhaps she brought out her Bird in Air quilt and watched with delight as her visitors discovered the various figures and objects within the 7,168 pieces.

■ **Laurel Horton**

OPPOSITE: FIG 4-9. *Bird in Air, detail.*
Object print shirting fabrics.

ABOVE: FIG 4-10. *Bird in Air, detail.*
Object print shirting fabrics.

FIG 4-11. Mary Ann Grosh Stoner (front left) and family, c. 1885. Courtesy of Annis Strine.

Mary Ann Grosh was born on August 28, 1834, the third of nine children of Joseph Conrad and Magdalena Greiner Grosh. In 1838 the Grosh family left Warwick, Lancaster County, Pennsylvania, for a new life in Ohio.[13] Mary Ann was four years old at the time, and she later recalled that her parents loaded up their belongings in a large covered wagon pulled by four horses. A smaller one-horse wagon carried the family, consisting of Joseph, Magdalena, and six children under the age of seven. The youngest child, Henrietta, died shortly after their arrival in Ohio. In 1843 the family settled in Ashland County, Ohio, where Joseph bought eighty acres. The following year he built a large log house for the family.[14]

On December 6, 1860, Mary Ann married Jacob Stoner, a carpenter, in the home of her parents. Jacob's parents had also come from Pennsylvania; he was born in Ashland County on June 16, 1834. Mary Ann and Jacob Stoner had three daughters, Elnora June (born 1862), Anise Barbara (born 1863), and Mary Myrtle (born 1875).

According to family oral tradition, Mary Ann made this Hexagon quilt (plate 4-6) for her second daughter, Anise Barbara Stoner, in honor of her marriage to Justus Fox on September 6, 1884. The date "1887" is quilted into the center hexagon of the quilt, which might suggest that its construction took place over

a period of at least two or three years. The quilt was handed down through two more generations of the family before it was sold to a dealer, who fortunately preserved the history along with the quilt.[15]

The quilt is made from relatively large hexagons (about three inches across), pieced with a running stitch rather than whipstitched over paper templates. The central, date-inscribed piece is surrounded and highlighted by six hexagons, each of a different solid color; otherwise, nearly all of the fabrics are printed. The large number of different printed fabrics in a quilt is often an indication of a charm quilt, in which each fabric is used only once. An examination of the quilt reveals only a few duplicated fabrics; the extreme rarity of repeats suggests that the maker may indeed have intended this to be such a charm quilt.

The fabrics include a variety of print styles and colors. The lighter ones include shirtings printed in small figures, florals, and stripes. Many of the darker fabrics are brown and olive shades typical of the manganese-style prints (fabrics colored with the mineral colorant manganese dioxide, produced by printing manganous chloride on the fabric, then passing the fabric through an alkali bath) of the 1870s and 1880s. Along with contemporary pieces, Mary Ann included

FIG 4-12. Hexagons, *detail*. Centennial commemorative print.

a few earlier prints from the 1840s, which she may have inherited from her mother. Strategically placed in one corner is a piece of fabric printed with the date "1776," a souvenir of the nation's centennial celebration of 1876.

For the backing of her quilt, Mary Ann selected a dark brown fabric printed with a design of trefoils and dots. Instead of quilting the individual hexagons "by the piece"—the method of choice for many quilters of this era—she used a pencil to mark out an overall quilting design of diamonds, with one set of lines parallel to the edge of the quilt and a second set at a forty-five-degree angle to the first.

Hexagon patchwork results in two of the quilt top's edges having protruding points and the other two having protruding flat sides. The maker faces a number of options in finishing the edges of such a quilt. She could simply fold under the protruding edges, creating a straight, smooth edge. Or she could do as Mary Ann did and retain the overhanging hexagons, binding all around them and creating a crenellated edge. With smaller hexagons, this task becomes more complex. Some makers appear to have given up, leaving their patchwork not only unquilted but unfinished.[16] Because of the simplicity and large pieces of her one-patch design, Mary Ann could finish her edges without difficulty, creating a well-balanced, symmetrical design with even rows and identical corners.

◾ **Laurel Horton**

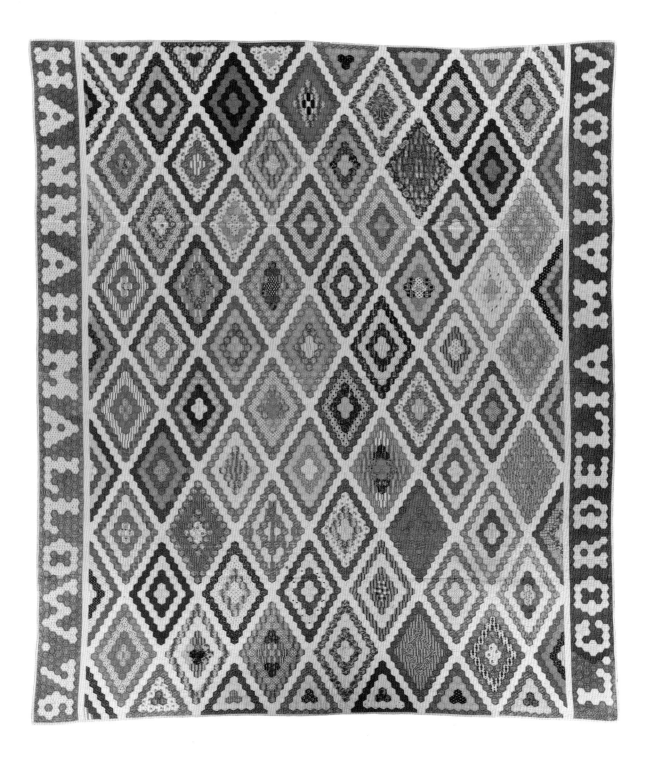

PLATE 4-7. Diamond Field.
Probably made by L. Cordelia Mallow (1839–1914) and
Hannah Mallow (1816–1892).
Union, Johnson County, Indiana, 1890–1900.
Cottons, 90" x 77". QSPI: 9-11.
2003.003.0292. *Jonathan Holstein Collection.*

The hexagon mosaic borders of this Diamond Field quilt (plate 4-7) have been designed to include the names "L. Cordelia Mallow" and "Hannah Mallow. 76" in large letters. This made it possible to locate biographical information about the two women, who we assume were involved in making the quilt. These factual data add to the clues em-

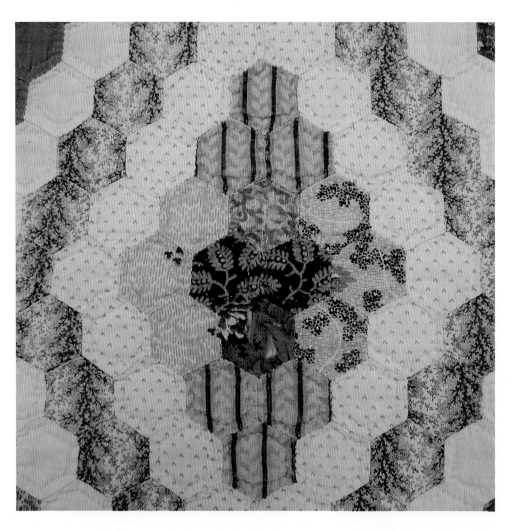

FIG 4-13. Diamond Field, *detail*.

bedded in the quilt, suggesting some of the circumstances in which it was created.

Hannah Surface Mallow (1816–1892) was the great-granddaughter of John Ulrick Zerfass, born in 1735 in Koblenz, Germany. He immigrated to Augusta County, Virginia, where the family lived for several generations. Hannah was born in Virginia on April 25, 1816, and sometime later she moved with her parents to Johnson County, Indiana. On June 11, 1836, she married William Harrison Mallow, whose ancestors also had emigrated from Germany to Virginia and then to Indiana. Hannah and William had four children: Ulysses (1837–1919), Lucinda Cordelia (1839–1914), and two younger children who died in their twenties. William Mallow died in 1891 and Hannah in 1892. Neither Cordelia nor Ulysses married, and they remained in the family home until their deaths, in 1914 and 1919, respectively.[17]

The body of this quilt is hand-pieced with running stitches from hexagons arranged to form diamonds. Diamond configurations are much less common in hexagon patchwork than the more frequent rosettes. The pattern name Diamond Field is probably a twentieth-century attribution, as the earliest documented usage of this name is 1932.[18] There are at least two ways to form hexagons into diamonds. In the method used here, the maker begins by joining two hexagons along one edge and then adds two more in the angles produced by this seam, creating an elongated, diamond-shaped unit. She adds successively larger rows of hexagons until the desired size of diamond was achieved.[19] In the second construction method, the maker first creates a seven-hexagon rosette, then tucks two additional hexagons into opposite angles before surrounding this unit with additional rows of hexagons. In this method a single hexagon gives each diamond a more definite center. This technique predominates among twentieth-century examples (see, for example, plate 4-31).[20]

The quilt is pieced with a running stitch rather than over paper templates. This is consistent with other late nineteenth-century Hexagon quilts made by quiltmakers of German heritage in Pennsylvania and several north-central states (see, for example, plate 4-4). The names may not have been included in the original plan of this quilt. The two borders were constructed separately, and the border hexagons are aligned in an orientation different from those of the body of the quilt. Instead of forming a continuous surface, the borders are attached with strips of white fabric to resolve the irregular edges where the sections come together at an odd angle.[21]

The quilt is worn and faded from use and exposure. The original colors were much brighter, and, in addition to the surviving reds, greens, and blues, there were apparently a number of purple prints that have since turned to shades of brown. (A bit of purple can still be seen in the low-relief areas of quilting.)

The fabrics include prints and styles from throughout the second half of the nineteenth century, suggesting that the maker was using an existing fabric collection rather than acquiring new materials. The prints include delicate sprigged florals, checked and striped shirtings, and a variety of printed mottled designs. Although most of the diamonds are consistent in the use of a single fabric within each concentric row, a few appear to have been pieced more randomly, perhaps to use up hexagons already cut. The quilt is backed with a small-figured geometric print. Each hexagon is quilted with a single row of stitches inside the seam, in dark or light thread to match the top; the applied binding was machine-sewn to the top, then turned and sewn by hand to the back.

The prominent display of the names "L. Cordelia Mallow" and "Hannah Mallow" suggests that both women were involved in the making of the quilt. It is tempting to assume that the number "76" refers to the date 1876. However, the fabrics in the quilt include some that date from the 1880s. The number is believed instead to refer to Hannah's age at the time of her death.[22] It is possible that mother and daughter both worked on the quilt and that Cordelia completed it after her mother's death in 1892.

Although it is impossible to draw the full meaning of the quilt from available information, what seems clear is that Cordelia manifested a desire to honor both herself and her mother with this quilt. Perhaps she created a fabric memorial that represented both a long shared experience of making clothing (suggested by the abundance of fabrics) and the actual communal practice of sewing together. Cordelia would have valued this quilt during her lifetime, and it is unlikely that it was used as a bedcover. However, after the deaths of Cordelia and her brother Ulysses, there were no close family members with an interest in preserving the quilt as a memorial. The quilt evidently was used, washed, and exposed to sunlight, but it survives as a testament to the bond between mother and daughter.

■ **Laurel Horton**

This Trip Around the World quilt (plate 4-8) appears at first glance to be rather ordinary. The unknown maker cut a variety of everyday fabrics into small squares, then arranged them in rows to form concentric diamonds. She inserted wide strips of blue chambray to make an internal diamond frame, dressing up the corners of this frame with red and white Nine Patch blocks. The fabrics are typical of inexpensive shirting and dress fabrics of the late nineteenth century. The wide variety of fabrics suggests that the maker used remnants from making clothing, and the workaday border and inner frame fabric likewise point to the quilt's humble origins. The quilt was pieced by hand and backed with a blue-and-white gingham woven in an eighth-inch check. The binding, cut from the same gingham check, was topstitched by machine. The top was hand-quilted in diagonal lines, and the blue strips and border were quilted in a standard cable design.

The design characteristic that sets this quilt apart from other examples of this pattern is the use of two different sizes of squares. The smaller squares in the interior measure one inch, while the larger ones in the four corners are a quarter-inch larger. The maker's reason for using two different sizes of squares is unknown. It is unlikely that she was adding to an older,

unfinished project (the center section), as some of the same fabrics were used in both the middle and the four corners. Regardless of her motivation, the result is visually dynamic. The transition from small rings of diamonds to suddenly larger ones and the shifting light and dark values combine to produce the impression of a pulsating surface.

The provenance of this quilt is unknown, but the quilt itself holds clues to dramatic events in its life story. At some point after the quilt was completed, it suffered damage from unknown causes; afterward, it was painstakingly restored to its original appearance. The repairs are not immediately obvious. Instead of merely appliquéing replacement fabric to cover the damaged patchwork, the mender carefully opened the seams and pieced in the new squares. The damaged small squares along one central axis have been replaced with small-figured prints that are very similar but not identical to the originals. However, the mender apparently had access to remnants of the original chambray and gingham fabrics. The repairs are most visible in the plain blue chambray strips and border. The binding and backing are patched in a number of places, but these repairs are less obvious. Not only did the mender match the original fabric, but she care-

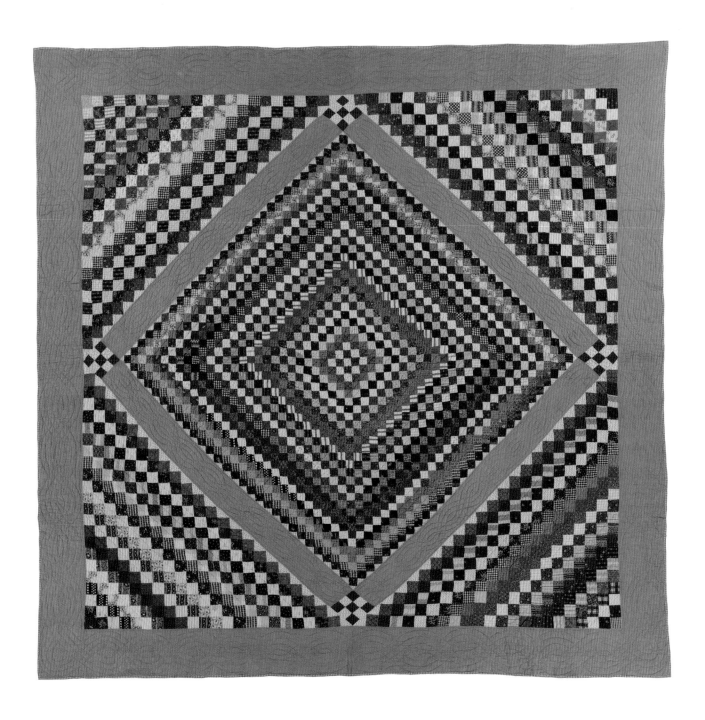

PLATE 4-8. Trip Around the World.
Maker unknown.
Possibly made in Pennsylvania, 1890–1910.
Cottons, 81.5" x 64.5". QSPI: 7-10.
1997.007.0242. *Ardis and Robert James Collection.*

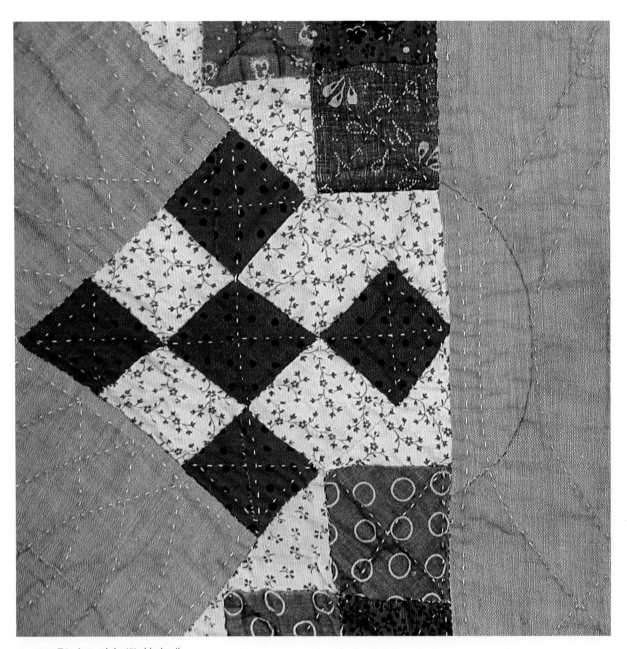

FIG 4-14. Trip Around the World, *detail*.
Repair work done to damaged border.

fully aligned the tiny squares of the gingham to perfectly maintain the alternating pattern of tiny blue-and-white checks.

The areas surrounding the mended areas are discolored by a brownish residue, which suggest fire, chemical, or other localized damage. By lining up the patched areas we can see that the quilt was folded when the damage occurred. Further, the quilt seems to have been folded with the backing out, as the patches in the backing are larger than those on the front.

The quilt was initially pieced around 1900, and the repairs were done sometime after the 1940s, when fabric and detergent manufacturers began to add optical brighteners. The presence of these more recent products can be detected by their fluorescence when viewed under black light. In this quilt, some of the light prints and portions of the wide blue strips fluoresce, indicating that they were washed, if not manufactured, after the 1940s. The gingham patches on the backing and border also fluoresce, suggesting that remnants of the original fabrics were washed in post-1940s detergents before they were used in the restoration effort.

Whoever mended this quilt went to extraordinary efforts. The extent of the repairs is apparent only under close examination. Clearly, the mender wished not simply to repair the damage but to replicate the quilt's original appearance.

The question remains as to why the mender made such efforts. Such careful attention to detail suggests that this humble quilt may have held some powerful personal significance. It is possible that the quilt was mended by the original maker, but it seems unlikely, given the forty-year period between making and mending. One possible scenario is that the quilt was one of the few surviving works of a beloved person, a mother or a grandmother perhaps, or another influential figure. The physical act of carefully removing the damaged areas, searching out matching fabrics, cutting and piecing the replacement patches, and requilting the sections would certainly have been a labor of love. No hired seamstress would have been expected to match the tiny squares of the gingham check while patching the border.

Although the identities of the original maker and the later mender are unknown, this quilt is a tangible record of one person's meticulous efforts to honor and preserve the work of another.

■ **Laurel Horton**

FIG 4-15. Trip Around the World, *detail*. New squares pieced into damaged area of quilt (center four squares).

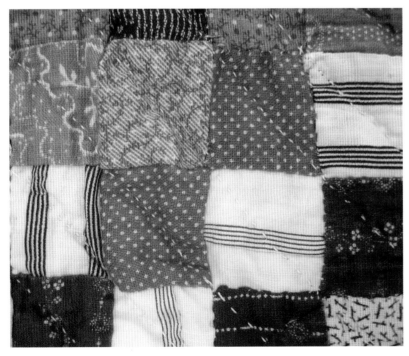

The majority of traditional American pieced quilts in the late nineteenth century were constructed from square blocks. Quilts designed in vertical or diagonal strips are less common, yet they span the entire nineteenth century. The pattern generally known as Wild Goose Chase has been an enduring and popular one for some two centuries, appearing in a variety of formats that include square blocks in both vertical and diagonal settings as well as in strips, as in this example (plate 4-9). The identifying characteristic of the Wild Goose Chase is a series of triangles that are stacked one above another, all pointing in one direction. Technically, this effect is created by joining two small right triangles to the short sides of a larger right triangle to form a rectangular unit. By selecting contrasting fabrics for the two different-sized triangular patches, it is possible to regulate the degree to which the figures—the "geese"—stand out from the ground. Arranged in a strip, the repeated figures suggest the Vs and files of migrating birds that pass through the sky with the seasons.

The unknown maker of this quilt seems not to have been interested in producing a classic example of the pattern, which would have been more regular and orderly in its use of colors and values. The degree of figure-ground contrast here is markedly inconsistent. In some strips, brown triangular geese figures appear on a light gray ground; in others they are distinctly lighter than the ground. An entire strip near the center of the quilt is pieced of identical red and white units, while a neighboring strip contains a mixture of fabrics with varying degrees of contrast. Although the maker has maintained a degree of regularity in alternating the direction in which the geese are "flying" (half are heading north and half south), the colors and fabrics are distributed unevenly across the quilt's surface. This irregular distribution suggests that the maker worked with a small selection of fabrics at any given time—cutting the triangles, constructing the rectangular units, and then sewing them into strips—without a preconceived vision of how the top would look when completed. She did, however, use the strong center red and white strip to give the quilt an organizing visual center: an effective, easy, and quick device.

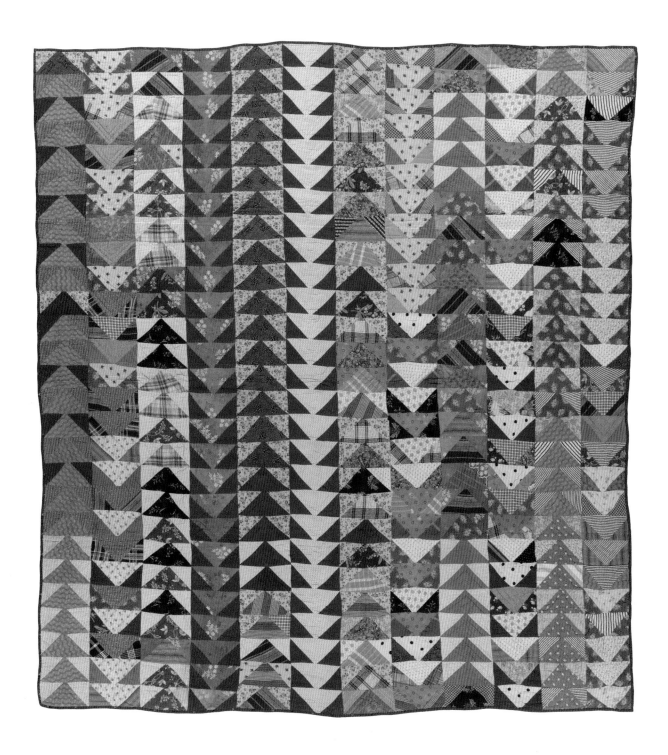

PLATE 4-9. Wild Goose Chase.
Maker unknown.
Possibly made in Pennsylvania, 1890–1910.
Cottons, 74" x 68.5". QSPI: 5-7.
2003.003.0136. *Jonathan Holstein Collection.*

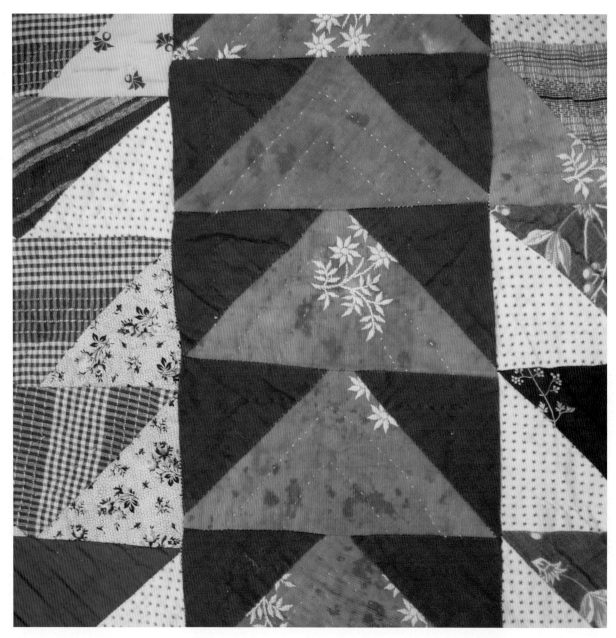

FIG 4-16. Wild Goose Chase, *detail*.

The maker completed most of the piecing on a sewing machine, but some of the work was pieced by hand. She may not have had much experience with patchwork, however, before beginning this top. When an experienced quiltmaker draws templates for patterns such as the Wild Goose Chase, she recognizes that the two small triangles must overlap slightly, the width of the seam allowance, so that the point of the large triangle is not truncated. The maker of this quilt seems to have cut and sewn the units without this slight overlap, as all of the large triangles have abbreviated points. Recognizing this, another seamstress might have modified her technique, but this maker continued in her original direction, apparently content with the results.

The fabrics in this quilt include a wide variety of calicoes, sateens, woven stripes and plaids, and broadcloths. One somewhat unusual fabric, a piqué with widely scattered machine-embroidered floral sprays, is puzzling. The embroidered figures are bright white, but the piqué background is discolored, now a mottled brown. It is possible that this fabric was in its present state when the maker incorporated it into her quilt, suggesting that the fabric was recycled. It is also pos-

sible that the mottling may have resulted from sensitivity of the fabric or dye to some unknown chemical after the quilt was constructed.

The quilt is backed with a lively print of brown stylized floral figures. The binding, cut from red fabric sparsely printed with black figures, was sewn to the front by machine and finished by hand. The quilting consists of one or two lines echoing the right angle of each triangle, a discontinuous process that would have required much starting and stopping.

This Wild Goose Chase, like many of the quilts made at the beginning of the twentieth century, seems to have been motivated by the desire of an inexperienced quiltmaker to make use of available fabrics left from family sewing. The quilt is not the result of efforts to produce an heirloom that shows off delicate needlework; instead, it is a collage of color fashioned with the aid of, but with minimal regard for, the design possibilities of a pattern selected by convenience or passing interest. The quilt survives to demonstrate that quiltmaking was practiced by women with varying degrees of skill and a range of motivations.

■ **Laurel Horton**

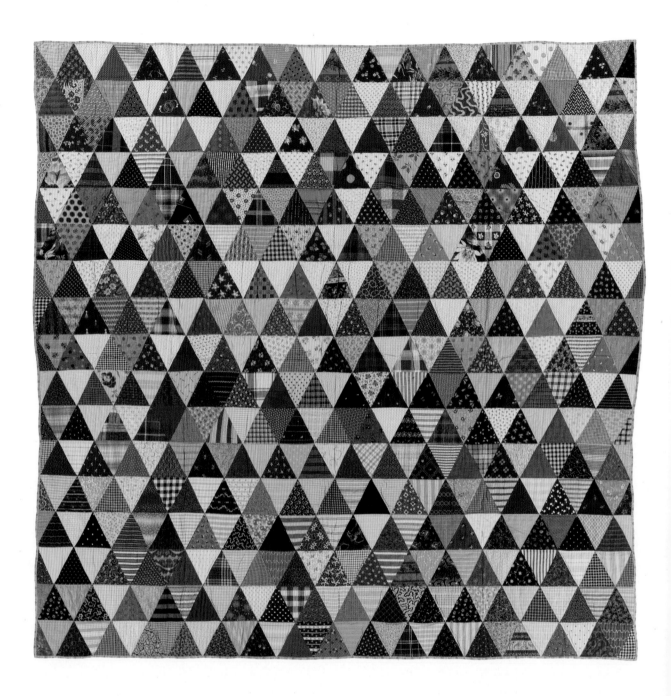

Quilts made of small pieces in a bewildering assortment of textiles are called charm quilts, an expression of a popular practice among some quiltmakers during the late nineteenth century to create a quilt in which each fabric was used only once. A charm quilt is typically constructed as a one-patch pieced design, consisting of patches of a single size and geometric shape in an allover distribution.[23] Charm quilts are an expression of more general quiltmaking

trends during the late Victorian era: complex, busy surfaces and an interest in collecting and display.

During the final decades of the nineteenth century, fabrics were available in a dazzling variety of prints, both in local stores and by mail order from Sears, Roebuck and Co. and Montgomery Ward. Not only were printed fabrics readily available, but the "wash goods" favored by quiltmakers were among the least expensive.[24] The use of small pieces of many different fabrics in a quilt is often misinterpreted as evidence of poverty—the inability to purchase sufficient fabric—or the desire for thrift. Multifabric quilts, however, were more likely expressions of a desire to collect, own, and display fabrics, not unlike the motivations of many current quiltmakers.

The fabrics in this Thousand Pyramids quilt (plate 4-10) are typical of those available between about 1890 and 1910. They include multicolored floral prints with light and dark grounds; object prints with recognizable depictions of sporting and fishing equipment; nonrepresentational prints of assorted geometric shapes; various forms of patterning on black and dark blue grounds; printed textures, including imitations of basket weaves and moiré; and fanciful designs such as shooting stars with multicolored tails. Also present are more humble stripes, plaids, and checks that were popular for shirts and dresses at the turn of the century.[25] This quilt is one of a pair, and several fabrics appear in both. (See plate 4-21 for the other quilt.)

Charm quilts are frequently made with squares, diamonds, rectangles, and hexagons. Equilateral triangles also were favored, due to the visual possibilities inherent in juxtaposing dark and light fabrics. The pattern name Thousand Pyramids, frequently applied to quilts of this construction, apparently dates from the twentieth century. It has been suggested that the pattern name may have developed in response to the interest sparked by the discovery of the tomb of the Egyptian King Tutankhamen in 1922. The pattern name, if any, used by the maker of this quilt is unknown.

The visual impact of this quilt belies the simplicity of its construction. The optical effect of overlapping pyramids, whose boundaries constantly shift like a mirage in the Sahara, produces a quilt that visually delights when viewed from some distance. The occasional use of dark—or at least medium—triangles in the place of light ones heightens the dimensional illusion.

The primary intention of the unknown maker was

FIG 4-17. Thousand Pyramids, *detail.*

to successfully construct a quilt top in which each piece is from a different fabric. As this was almost certainly modeled on an earlier example, she would also have been aware of the optical properties particular to the equilateral triangle, her unit of choice. Having demonstrated her success in obtaining samples of some 517 different fabrics, the major effort was behind her. The further completion of the top would have been almost an afterthought. There is no border, as this would compromise the one-patch, one-fabric rule. Both the backing fabric and the binding are a green printed stripe with a simple floral figure. Quilting stitches outline the inside of each triangle.

In the 1960s, Jonathan Holstein and Gail van der Hoof collected quilts (including this pair), primarily pieced quilts with stunning optical effects. The exhibition and publication of quilts from their collection in the 1971 Whitney Museum of American Art exhibition Abstract Design in American Quilts introduced these patterns and styles to the emerging generation of quiltmakers of that era and elevated the status of surviving traditional quilts. This quilt's companion was included in the Whitney exhibition. The unknown maker could not have foreseen that one of her quilts would be displayed in museums and seen by tens of thousands of viewers as an example of the similarities between traditional American patchwork and elite art styles of the mid-twentieth century.

■ **Laurel Horton**

PLATE 4-11. Philadelphia Pavement.
Maker unknown.
Probably made in Pennsylvania, 1900–1920.
Cottons, 78" x 78.5". QSPI: 7-9.
2003.003.0196. *Jonathan Holstein Collection.*

Philadelphia Pavement is one of a number of names that emerged during the twentieth century for patterns pieced from small squares arranged to form diagonal bands of color. The rainbow bands may extend across the entire quilt surface, working outward from the center, as in Trip Around the World (see, for example, plate 4-8), or, as in this quilt (plate 4-11), forming multiple diamonds. Quiltmakers in southeastern Pennsylvania in the late nineteenth and early twentieth century explored many variations on these designs, creating a number of distinctive combinations of pattern and color that are characteristic of that region. In this example, the serrated edges and value modulations in the series of color bands produce an explosive visual effect, similar to expanding novas.

Technically, this quilt could be described as a One Patch pattern, as all the squares are identical in size. In joining small squares to make a quilt top, the maker has a number of options. A quiltmaker generally pieces a top in sections, when possible, as this makes the process less unwieldy. The ability to work in sections is a major factor in the popularity of block-style pieced quilt patterns.

For overall patterns and those, like this one, in which the repeating design is not clearly defined by the outlines of a block pattern, it is not immediately clear how the top is constructed. The maker could first sew the small individual squares together to make long strips, then join the strips in long seams. As an alternative, she might first piece the squares into larger rectangular units, which could then be joined to make larger units or strips.

In this quilt, the maker left clues to indicate how she approached the construction of the top. An examination of the seams revealed that some were sewn by hand and others were sewn by machine. The distribution of machine work appeared to be irregular and random at first, but the pattern eventually became clear, revealing the maker's modus operandi. She conceived of the quilt as a set of sixteen identical blocks, each consisting of ten rows of ten squares. Each block features diagonal bands of color, symmetrical along one diagonal axis. The maker then set these blocks together with narrow strips pieced from additional squares, as if adding sashing strips. The isolated red squares at the centers of the five diamonds are actually the cornerstones where the sashing strips meet between the diagonal blocks. The squares were pieced by hand to form the blocks, but the squares for the

sashing were individually joined by machine, then seamed by machine to the hand-sewn blocks.

The fabrics in this quilt include lightweight small-figured cotton calico prints typical of late nineteenth-century quilts. The fabrics are consistent throughout, suggesting that the quiltmaker purchased materials specifically for this work. The colors, produced by the chemical dyes of the period, have remained bright, with the exception of the green print, which has faded to nearly tan. This fading has the effect of increasing the contrast between the red and dark blue diagonals and the lighter colors, and this effect is further heightened by the frame formed by the red-print border.

With such a colorful and active quilt top, the decorative role of the quilting stitches is minimized. The squares are quilted in zigzag lines across each row—up one square and down the next—and the border is quilted in a cable design. The fabric on the back is cotton that was printed in shades of gray to create a mottled texture. The binding fabric is printed with small geometric figures on a navy ground. The maker sewed the binding to the top by machine and turned it to the back by hand, a common practice.

■ **Laurel Horton**

FIG 4-18. Philadelphia Pavement, *detail*. Diagram showing piecing method: block and sashing.

GALLERIES

Triangles

Triangles of many proportions have been used in quilt designs, but there are two triangles that are most commonly used. The first is an isosceles right triangle, often called a "half-square" triangle by contemporary quiltmakers because two triangles fit together perfectly to form a diagonally seamed square. Although the Ocean Waves pattern, two examples of which are pictured here (plates 4-13 and 4-14), is constructed in blocks, it gives the impression of an allover pattern through its plentiful usage of half-square triangles. The other common shape is the equilateral triangle used in Thousand Pyramids quilts and variations. Both triangle shapes can be repeated side by side across an entire surface in a mosaic or tessellated design.

Quiltmakers achieved the illusion of a textured, three-dimensional surface in allover triangle quilts by alternating light- and dark-value fabrics in side-by-side triangles. The result is a surface that appears faceted like cut jewels or sculpted like architectural ornamentation.

PLATE 4-12. Thousand Pyramids.
Possibly made in Pennsylvania, 1870–1890.
Cottons, 75" x 80.5". 1997.007.0055.

PLATE 4-14. Ocean Waves.
Possibly made in Sandgate, Vermont, 1890–1910.
Cottons, 94" x 78". 2003.003.0045.

PLATE 4-13. Ocean Waves.
Possibly made in Henry County, Indiana, 1870–1890.
Cottons, 79.5" x 64". 1997.007.0070.

PLATE 4-15. Thousand Pyramids.
Maker/location unknown, 1925–1945.
Cottons, 78" x 78". 2003.003.0296.

Triangles

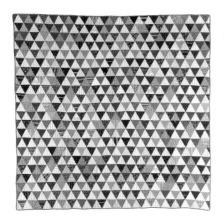

PLATE 4-16. Thousand Pyramids.
Possibly made in Posey County, Indiana,
1890–1910.
Cottons, 79.5" x 83". 1997.007.0058.

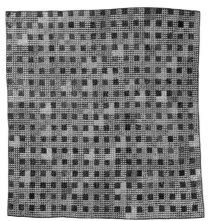

PLATE 4-18. Birds in Air.
Possibly made by Mary Linderburger, New
Jersey, 1880–1900.
Cottons, 86" x 84". 1997.007.0731.

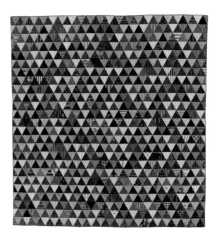

PLATE 4-20. Thousand Pyramids.
Possibly made in eastern Pennsylvania,
1880–1900.
Cottons, 79.5" x 76.5". 1997.007.0944.

PLATE 4-17. Thousand Pyramids variation.
Possibly made in Michigan, 1880–1900.
Cottons, 84" x 64". 1997.007.0079.

PLATE 4-19. Roman Stripe.
Possibly made in Knox County, Ohio,
1880–1900.
Silks, 68" x 62.5". 1997.007.0847.

PLATE 4-21. Thousand Pyramids.
Possibly made in Pennsylvania, 1880–1900.
Cottons, 77.5" x 78". 2003.003.0009.

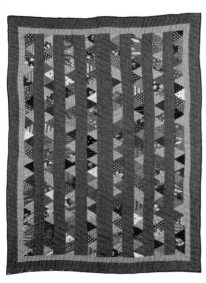

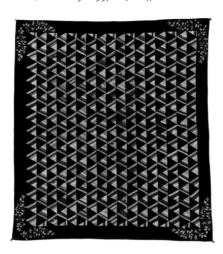

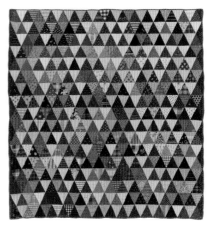

Squares

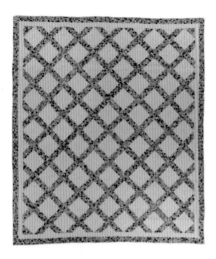

PLATE 4-22. Squares.
Maker/location unknown, 1925–1945.
Cottons, 84" x 73.5". 1997.007.0451.

PLATE 4-24. Nine Patch.
Possibly made in New Jersey, 1900–1920.
Wools, 72" x 64". 2003.003.0030.

PLATE 4-26. One Patch.
Possibly made in Pennsylvania, c. 1876.
Cottons, 85" x 82.5". 2003.003.0381.

PLATE 4-23. Bow Tie.
Possibly made by Rachel Scofield, Corbin,
Indiana, 1930–1950.
Cottons, 81" x 67". 1997.007.0845.

PLATE 4-25. One Patch.
Possibly made in Pennsylvania, dated 1914.
Cottons, 80" x 72.5". 2003.003.0318.

Secondary Patterns

Allover quilts constructed from fabric pieces of identical size and shape were often designed to have a secondary pattern built up from the basic piece. Squares were joined to become larger squares, diamonds, or diagonal lines. Diamonds were tessellated into larger diamonds, tumbling blocks, or radiating stars. Hexagons were set together into mosaics of larger hexagons, diamonds, stars, and stylized flowers. All of these secondary patterns were determined by the maker's selection and placement of contrasting colors and values of fabric. Quilts of this type were constructed throughout the years addressed in this catalog, which suggests that this type of quilt was not a fad, but continued to offer creative appeal to quiltmakers.

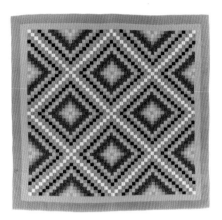

PLATE 4-27. **Philadelphia Pavement.**
Possibly made in eastern Pennsylvania, 1910–1930.
Cottons, 83" x 80". 1997.007.0091.

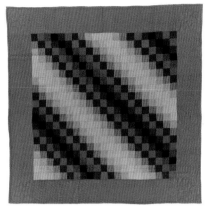

PLATE 4-29. **One Patch.**
Possibly made in Pennsylvania, 1920–1940.
Cottons, 82" x 80". 2003.003.0143.

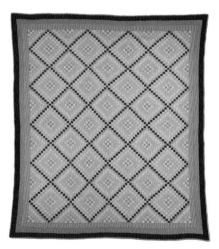

PLATE 4-28. **Trip Around the World.**
Maker/location unknown, 1925–1945.
Cottons, 81" x 73.5". 1997.007.0122.

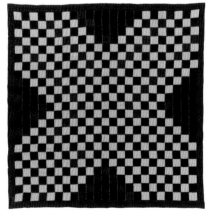

PLATE 4-30. **One Patch.**
Possibly made in New Jersey, 1900–1920.
Wools, 77.5" x 77.5". 2003.003.0215.

Secondary Patterns

PLATE 4-31. Diamond Field.
Possibly made in Iowa City, Iowa, 1930–1940.
Cottons, 107" x 104". 1997.007.0139.1.

PLATE 4-33. Diamond Flower Garden.
Maker/location unknown, 1930–1940.
Cottons, 87" x 77". 1997.007.0679.

PLATE 4-35. Tumbling Blocks.
Possibly made in Pennsylvania, 1880–1900.
Cottons, 82" x 75.5". 2003.003.0202.

PLATE 4-32. Hexagons.
Possibly made in Kentucky, 1860–1880.
Wools, 80.5" x 66". 1997.007.0598.

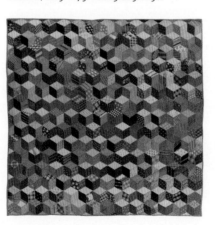

PLATE 4-34. Tumbling Blocks.
Possibly made in Massachusetts, 1880–1900.
Cottons, 80.5" x 79". 2003.003.0056.

PLATE 4-36. Tumbling Blocks.
Possibly made in Pennsylvania, 1920–1930.
Cottons, 69" x 67.5". 2003.003.0327.

Medallion Echoes

Colonial and Federal Period quilts often followed a medallion design format, influenced directly by eighteenth- and nineteenth-century medallion-style British and Dutch quilts. Whether built around an appliquéd Indian chintz print, a printed cotton panel by the eighteenth-century Philadelphia printer John Hewson, or other similar textile, a central focus permeated these early American quilt designs. As a style, these quilts possessed a commanding presence, a visual hierarchy descending from center to edges, a quality of bold announcement and emanating echoes, and a sophisticated vocabulary of construction techniques, pieced components, and fabric selections.

The late nineteenth- and early twentieth-century medallionesque quilts pictured on these pages (plates 4-37–4-46) are simplified echoes of the preferred format and graphic hierarchy of earlier generations of quilts. They range from those bearing a strong resemblance to older medallion-style quilts to those displaying simpler and more modern restatements of the style.

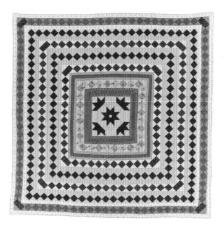

PLATE 4-37. Medallion.
Possibly made in Pennsylvania, 1870–1890.
Cottons, 75" x 72". 1997.007.0542.

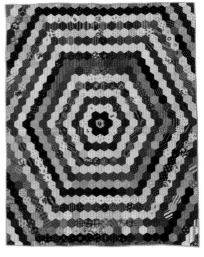

PLATE 4-39. Hexagons.
Possibly made in Pennsylvania, c. 1876.
Cottons, 77" x 64". 1997.007.0911.

PLATE 4-38. Concentric Squares.
Maker/location unknown, 1890–1910.
Cottons, 42" x 41.5". 1997.007.0705.

PLATE 4-40. Sawtooth.
Possibly made in Massachusetts, 1890–1910.
Cottons, 89.5" x 76". 2003.003.0024.

Medallion Echoes

PLATE 4-41. Hexagons.
Possibly made in New England, 1870–1890.
Cottons, 84.5" x 79.5". 1997.007.0238.

PLATE 4-43. Hexagons.
Possibly made in Virginia, 1870–1890.
Wools, 87" x 75.5". 1997.007.0315.

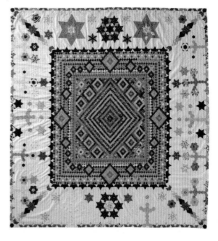

PLATE 4-45. Medallion.
Probably made in New Hampshire,
1860–1880.
Cottons, 88.5" x 81.5". 1997.007.0818.

PLATE 4-42. One Patch.
Possibly made in Indiana or Ontario, Canada,
dated 1914.
Wools, 73" x 65". 1997.007.0311.

PLATE 4-44. Blazing Star.
Possibly made in Missouri, 1880–1900.
Cottons, 91" x 82". 1997.007.0405.

PLATE 4-46. Trip Around the World.
Possibly made in Pennsylvania, 1880–1900.
Cottons, 84" x 82". 2003.003.0160.

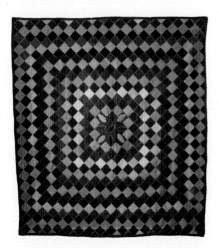

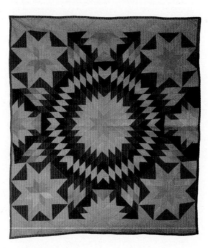

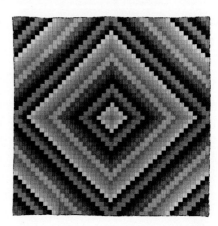

Lines

Straight lines, in graphical terms, are unambiguous, simple, and direct. One's eye readily recognizes lines and follows them across a quilt. Lines make a quilt alive and dynamic.

Makers of allover-style quilts have used simple basic shapes—strips, rectangles, diamonds, triangles, and flying geese units—to construct lines that move, pulse, vibrate, or shimmer. In the Ocean Waves variation and Brick Wall quilts pictured (plates 4-51 and 4-47), the lines make hard turns and begin to suggest three dimensions. One reason for the enduring popularity of quilt-making in the modern age may have been that creating graphically pleasing designs was possible through even the simplest of linear compositions.

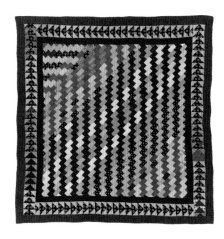

PLATE 4-47. **Brick Wall.**
Possibly made in Wabash County, Indiana, 1880–1900.
Cottons, 75" x 74.5". 1997.007.0323.

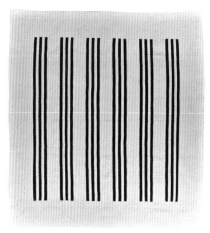

PLATE 4-49. **Split Bars.**
Possibly made in Pennsylvania, 1880–1900.
Cottons, 76.5" x 82.5". 2003.003.0330.

PLATE 4-48. **Streak of Lightning.**
Possibly made in Pennsylvania, 1890–1910.
Cottons, 79.5" x 77". 2003.003.0021.

PLATE 4-50. **Streak of Lightning.**
Possibly made in Pennsylvania, 1870–1890.
Cottons, 95" x 92". 2003.003.0343.

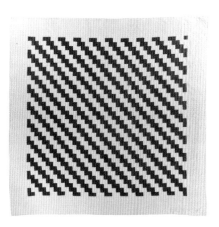

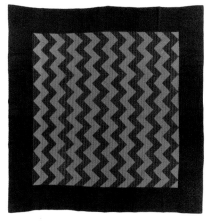

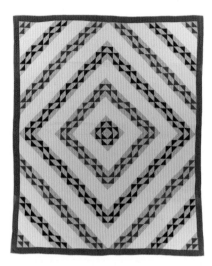

PLATE 4-51. Ocean Waves variation.
Possibly made in Pennsylvania, dated 1872–1897.
Cottons, 85.5" x 70". 1997.007.0396.

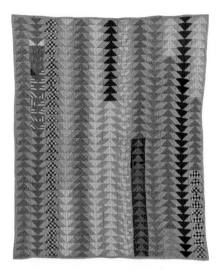

PLATE 4-53. Wild Goose Chase.
Possibly made in Pennsylvania, 1900–1920.
Cottons, 66" x 55.5". 2003.003.0034.

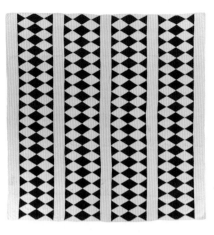

PLATE 4-55. Diamonds.
Possibly made in Pennsylvania, 1890–1910.
Cottons, 76.5" x 76". 2003.003.0221.

PLATE 4-52. Wild Goose Chase.
Possibly made in Pennsylvania, 1870–1890.
Cottons, 85" x 76.5". 2003.003.0010.

PLATE 4-54. Wild Goose Chase.
Possibly made in Pennsylvania, 1900–1920.
Cottons, 89" x 83". 2003.003.0172.

PLATE 4-56. Wild Goose Chase.
Possibly made in Pennsylvania, 1880–1900.
Cottons, 89" x 82.5". 2003.003.0326.

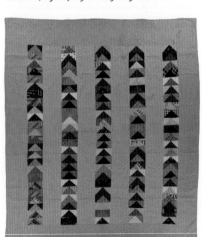

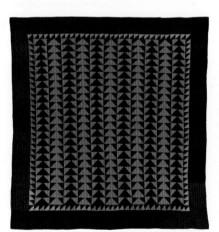

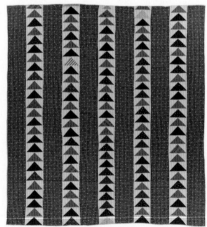

Bars

One of the fastest ways quiltmakers have achieved an overall, non-block-style look is through assembling long strips of fabric. Appropriately called strippies, this style was popular at the same time as early nineteenth-century medallion quilts. Like the medallion style, the strippie style also is of British origin.

In regions near Atlantic seaports in the first half of the nineteenth century, American strip quilts were often made of wide strips of imported English chintzes. However, in the second half of the century, when cotton goods became abundant and less expensive due to a vibrant American textile manufacturing industry, strip quilts were more commonly made of cotton calicoes and solids.

In *Old Patchwork Quilts and the Women Who Made Them*, Ruth Finley explains that the Tree Everlasting pattern, a strip design that dates at least to the 1830s, was also known as Herringbone, the Prickly Path, the Path of Thorns, and Arrowheads. These names and the survival of quilts of this pattern spanning almost a century reveal quiltmakers' comfort with highly abstracted interpretations and representations. Such angular abstraction didn't enter mainstream art and decoration until the Art Deco style came into vogue in the late 1920s. Writing in 1929, Finley declares that Tree Everlasting and other old patterns "are so prophetic of the latest trend in decorative design as to be quite startling."[26]

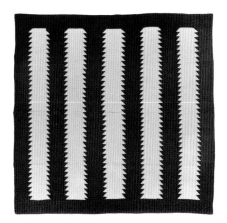

PLATE 4-57. Tree Everlasting.
Possibly made in Pennsylvania, 1880–1900. Cottons, 72" x 75". 2003.003.0003.

PLATE 4-59. Tree Everlasting.
Possibly made in Pennsylvania, 1900–1920. Cottons, 83" x 75.5". 2003.003.0248.

PLATE 4-58. Tree Everlasting.
Possibly made in Pennsylvania, 1880–1900. Cottons, 88.5" x 90". 2003.003.0166.

PLATE 4-60. Tree Everlasting.
Possibly made in Pennsylvania, 1890–1910. Cottons, 77.5" x 73". 2003.003.0300.

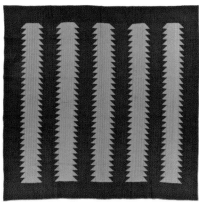

Bars

PLATE 4-61. Split Bars.
Possibly made in Pennsylvania, 1880–1900.
Cottons, 85" x 84". 2003.003.0035.

PLATE 4-63. Bars.
Possibly made in Pennsylvania, 1890–1910.
Cottons, 79" x 75". 2003.003.0058.

PLATE 4-65. Split Bars.
Possibly made in Pennsylvania, 1880–1900.
Cottons, 86" x 89". 2003.003.0303.

PLATE 4-62. Rainbow Stripes.
Probably made by E. S. Reitz. Possibly made
in Pennsylvania, 1890–1910.
Cottons, 73" x 80". 2003.003.0041.

PLATE 4-64. Split Bars.
Possibly made in Pennsylvania, 1890–1910.
Cottons, 86.5" x 86.5". 2003.003.0291.

PLATE 4-66. Bars.
Possibly made in Pennsylvania, 1880–1900.
Cottons, 87.5" x 82". 2003.003.0310.

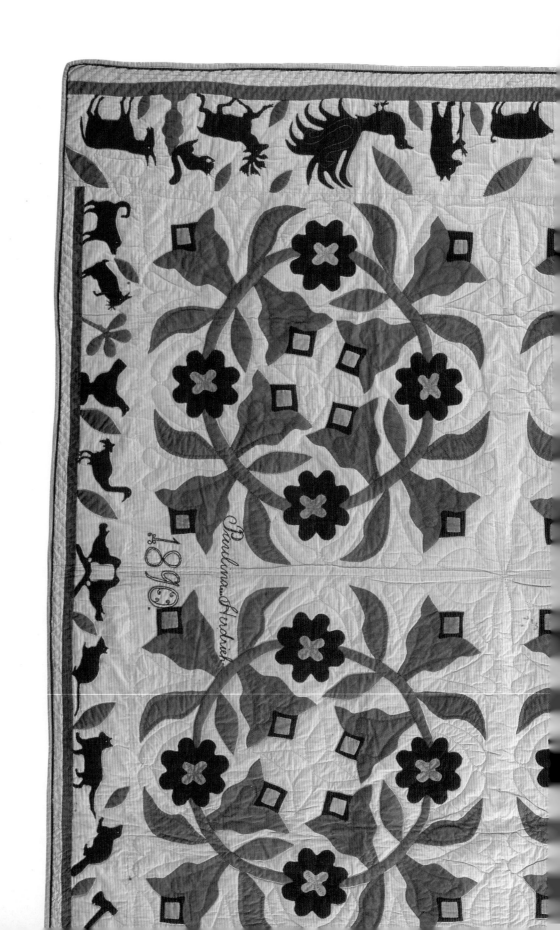

Paulina Frobrick
1890

Perfecting the Past *Colonial Revival Quilts*

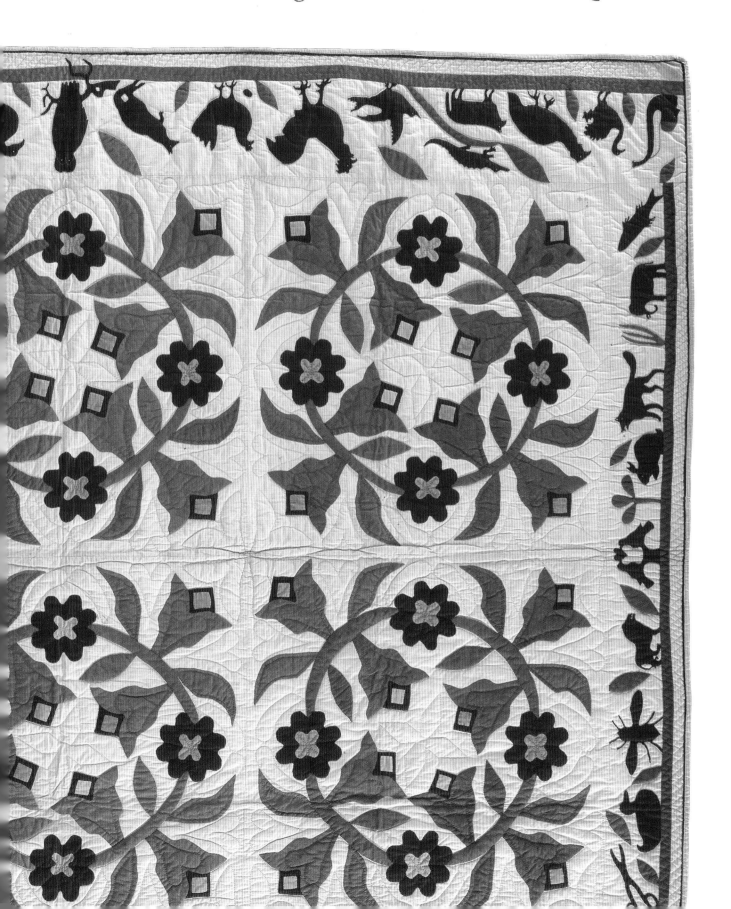

FIG 5-1. Colonial History, Ruby Short McKim pattern, *detail* (see plate 6-23).

To understand women's choices in quiltmaking, one must investigate cultural trends, especially those affecting the decorative arts. In the late nineteenth and early twentieth centuries, people who had enthusiastically embraced the exotic and eclectic styles of the Victorian Aesthetic Movement were ready for change. Instead of looking for something totally new, many Europeans and Americans turned to furnishings and architecture based on interpretations of the past. Old-fashioned styles became the new fashion. As the tastemaker A. T. Covell explained in an article on the preference for period styles, "We do not feel that we must invent a new language in order to express thoughts of the times in which we live."[1] The Colonial Revival style promoted in the United States was a romanticized, not a pure, interpretation of the past. Its advocates were willing to blend colonial themes with ideas taken from the Arts and Crafts, Art Nouveau, Art Deco, and Modernist movements. As Roy Underhill, the Colonial Williamsburg master housewright, stated, "The Colonial Revivalist seeks a synthesis, using the evidence of our ancestors . . . as a 'catalyst to the imagination.'"[2]

When and why did interest in Colonial Revival themes begin? The dates for the Colonial Revival period in the United States are fluid, for the movement developed gradually, took off in the 1890s, and dominated decorative arts and architecture through the 1920s. Traditional design continued to be appreciated and has never really disappeared. Authors often note that the Colonial Revival started in an era of nationalism and patriotism as a reaction on the part of mainstream white Protestant Americans to changes wrought by industrialization, urbanization, and immigration. The world as they had known it was changing rapidly.[3] They sought refuge in the past and used both fact and myth to help socialize newcomers to principles they held dear. Mainstream Americans believed that early historical figures and pioneer values needed to be esteemed by all who lived in the United States. They told stories of Betsy Ross sewing the flag for her country, of George Washington admitting the truth to his father about chopping down the cherry tree, and of Paul Revere riding through the night to warn his countrymen.

At the great Sanitary Fairs held in major northern cities during the Civil War, women staged reenactments of the past to raise funds for their work on behalf of sick and wounded soldiers. A common attraction was the colonial kitchen, where women in old-fashioned costumes served meals and put on tableaux about revolutionary days and customs. Recalling the past was a way to remind patrons that their ancestors who fought for freedom had set an example for them to emulate. Displays of old artifacts and curiosities helped raise interest in antiques, especially items associated with known people and events in the country's history.[4]

Community leaders continued to introduce colonial settings at fairs and celebrations across the nation, thus sustaining nostalgic interest in old-time colonial days. Almost ten million people attended the 1876 Centennial Exposition held in Philadelphia. As its designers had hoped, the event "left an impress upon the minds of the American people likely to endure for a generation."[5] Attendees were awed by the giant Corliss engine in Machinery Hall, but the New England log cabin furnished with quaint relics of the past was also a favorite stop. Women dressed in the costumes of their great-grandmothers escorted people through the house explaining the "story and uses of its contents." Visitors could see an ancient spinning wheel beside the huge cooking fireplace and the cradle (its rockers worn away) of Peregrine White, born on the Mayflower in 1620.[6] The bedroom contained "an old-fashioned bedstead, with a quilt of 200 years old."[7] The purpose of the display was to furnish a distinct contrast to the New England Modern Kitchen built right next door and to dramatically show visitors how far their country had progressed.[8] These exhibits, however, also made people realize that a simpler way of life was passing and created interest in displaying old family artifacts

and collecting them before they disappeared. A few antiquarians, mostly men, had already begun to amass collections of colonial artifacts.[9] Frances Clary Morse, the author of *Furniture of the Olden Time*, an early Colonial Revival book, believed that "while there have always been a few who collected antique furniture, the general taste for collecting began with the interest kindled by the Centennial Exposition in 1876."[10] *Demorest's Monthly Magazine* published sketches of a young lady raiding her grandmother's attic to redecorate her boudoir after "she had been seized with the fashionable mania for old china, bric-a-brac, antique furniture, etc., etc."[11] Designers of the huge Queen Anne–style Victorian homes began to offer versions with details in the "old-colony style."[12]

Interest in colonial and classical ideas did not really influence the general populace until the Columbian Exposition was held in Chicago in 1893. People who attended this great midwestern fair might later forget the details of the immense collections on display, but the vision they remembered clearly was one of great marble buildings, "by day richly robed, at night in gorgeous electric colors, with fountains playing, gondolas moving, with beauty in form and construction all around."[13] The architects had designed a grand lakeside environment known as the White City because of its snowy white pseudo-Classical architecture. The dignified buildings, actually formed of "staff," a composition of plaster and jute fiber that gave the effect of marble, provided a strong contrast to the sprawling and ugly urban environments people often experienced in the late nineteenth century. The seeds of what came to be called the City Beautiful movement had been planted.[14] Mayors began efforts to clean up and beautify the urban landscape. Middle-class people painted their huge Victorian houses white, and those building new homes began to select Colonial Revival styles.

Looking to the past was not just an American phenomenon. The International Paris Exposition of 1889 played an influential, if largely unacknowledged, role in shaping American taste. French cabinetmakers put on a marvelous display of finely crafted eighteenth-century furniture that "revived a taste for the costumes and furniture of that period which spread rapidly to other countries, and was quickly followed by the people of the United States."[15] Those with wealth at first looked to Europe for fine furniture and antiques, but

as the movement for Colonial Revival took hold they began to consider American antiques important. The "modern Georgian" houses needed to be furnished with symbolic American objects. Men and women became "engaged in hunting ghosts of American artisans, painters, cabinetmakers, silversmiths, clockmakers, pottery and glass manufacturers, and the concrete expression of their genius." By the twentieth century, the American antique chase was in full force.[16]

In 1897 Edith Wharton and Ogden Codman Jr. published the influential book *The Decoration of Houses*. It made a strong case for reform in decoration. The authors urged Americans to abandon the "superficial application of ornament" and return to the Classical tradition in decoration and architecture. Tired of coping with Victorian clutter and heavy textiles, women agreed that because it was unhealthy to sleep in a room "with stuff hangings, heavy window-draperies and tufted furniture[,] the old fashion of painted walls and bare floors naturally commends itself."[17]

Though not all had the means to totally redecorate their homes as Wharton did, middle-class Americans were nevertheless ready to make changes. In a democracy, most people want to participate to some degree in fashionable trends. Because numerous Americans lived in states far from the thirteen colonies, tastemakers defined the term colonial very loosely, applying it to anything made in the preindustrial period from 1620 to 1830. Colonial could include "all of the furniture of the early times and the early shapes," and it could include reproductions, for as Robert and Elizabeth Shackleton pointed out in their 1907 book, *The Quest of the Colonial*, not even the wealthy could furnish a whole house with true Colonial.[18]

As early as 1895, furniture manufacturers were aware that Colonial designs, with "their beautiful simplicity, always appeal to the heart of an American."[19] They also believed that "the supply of pedigreed antiques" would be inadequate to meet the demand. They began to provide what customers wanted, producing adaptations and reproductions of Colonial-style furniture at all price levels.[20] They knew that most American households would include at least one old-fashioned room.

Tastemakers and authors of Colonial Revival books and magazine articles tried to portray accurate interpretations of Colonial rooms. Their photographs of bedrooms, often taken in New England historic

8.—HER BOUDOIR AFTER SHE HAS BEEN SEIZED WITH THE FASHIONABLE MANIA FOR OLD CHINA, BRIC-A-BRAC, ANTIQUE FURNITURE, ETC., ETC.

THE GOVERNMENT BUILDING

CLOCKWISE FROM UPPER LEFT

FIG 5-2. *Demorest's Monthly Magazine*, June 1879, illustration of a young lady who has redecorated her boudoir in the "old-fashioned" style.

FIG 5-3. The Government Building, Chicago's Columbian Exposition, 1893.

FIG 5-4. *Ladies' Home Journal*, October 1925, illustration of a Colonial Revival interior.

homes, usually featured four-poster beds with whole-cloth spreads or quilts. Early collectors and authors rarely paid attention to appliquéd or pieced quilts, which were still ubiquitous, utilitarian objects in middle-class homes. Most of them had been made after 1840, when textiles became less expensive and more widely available. As Americans looked to the past for inspiration, women wanted to honor their foremothers. They insisted that traditional quilts be prominent objects in the Colonial Revival memory. This desire was prompted by more than aesthetic preference; placing quilts in Colonial-style rooms also put the women who made them into the story of history. American women began to shape the interpretation of Colonial Revival, using quilts as a powerful strategy.[21]

Illustrations began to feature appliquéd and pieced quilts with elaborately quilted white backgrounds, made circa 1840–1860. Early pattern collectors such

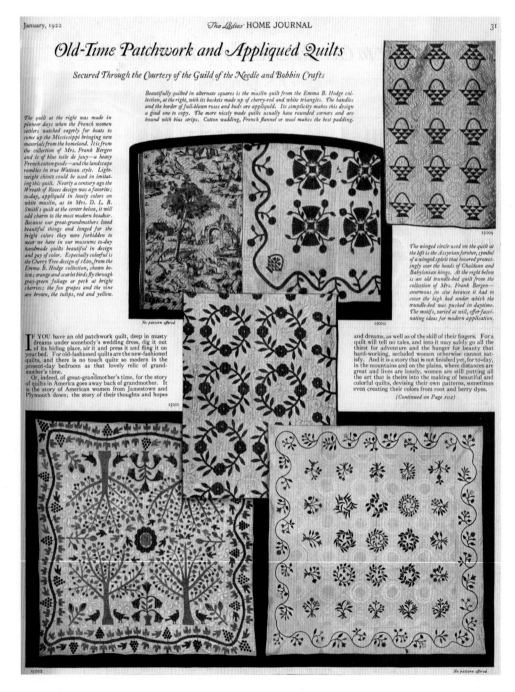

FIG 5-5. "Old-Time Patchwork and Appliquéd Quilts," *Ladies' Home Journal*, January 1922.

as Fanny D. Bergen, Ida L. Jackson, Elizabeth Dangerfield, and Eliza Calvert Hall shared their designs and knowledge with the public.[22] Pieced and appliquéd quilts became the bedcoverings of choice. Ruth Finley, the author of the twentieth century's second book devoted completely to quilts, declared in 1929 that it was "the ambition of every possessor of a bedroom done in the popular Colonial manner to own at least one piece of old-time calico patchwork for use as a counterpane."[23]

The decorating expert Sarah M. Lockwood later voiced the sentiments of American women who wanted to "keep the furniture as early and as consistent as we can, but since this is not a museum but a house to be lived in, we need not be tied down too hard." She described suitable decoration for a Colonial bedroom in a modest middle-class Colonial Revival home:

The bed is curly maple—a beauty with slender reeded and carved footpost of Sheraton design. We may throw one of those fringed fish nets over the "sprung" or "tent top" or trim it in white muslin with tied fringe and put a deep valance of muslin around the bottom of the bed; but the making of the room will be the spread. There are wonderful white knitted ones, or the stuffed ones with marvelous quilted designs, or the most usual candlewick tufted ones, but we would like a patchwork quilt that has been washed many times until the green of the baskets and the pink of the flowers are faded and soft.[24]

Needlework and women's magazines included numerous patterns and directions for reproducing appropriate quilts, accompanied by romantic stories of quiltmaking in the past. Women without treasured family quilts were encouraged to make their own, which they could then "hand down as heirlooms to generations that are to come."[25] Although women willingly adopted the spinning wheel as a Colonial Revival icon representing domestic virtue and industry, most did not wish to take up weaving again. Piecing and quilting, on the other hand, provided a logical way for American women to experience and understand colonial processes as well as products. If the emphasis were placed on "homemade" instead of strictly "handmade," then one could justify the use of sewing machines and other modern improvements to make the project more manageable. It was even acceptable to turn the quilting over to a hired expert. Women with entrepreneurial and artistic talent found new career opportunities. They provided the patterns, kits, articles, and materials that helped to fuel what the quilt historian Cuesta Benberry identified as the "20th century's first quilt revival."[26] Over time, women gradually found ways to incorporate all the new European trends, designs, and colors into their Colonial Revival quilts. The large number of extant quilts testifies to the widespread popularity of Colonial Revival quiltmaking. *The Modern Priscilla* called the revival of patchwork "the most interesting feature in the realm of fancy-work."[27]

Perhaps unexpectedly, collecting, using, and reproducing quilts gave women a deeper and more personal interest in history. They agreed with Finley that quilts were "aids to understanding of the long since past."[28] They started to see quilts as "family histories written in bits of silk and wool and calico."[29] They found themselves wanting to know more about the earlier women who had made the quilts and textiles they now treasured and copied. They began to understand that "the charm of old things lies not alone in the fact that they are quaint or curious or well made, but also that they connote so much."[30] They agreed with Marie Webster, a quilt artist and the author of the first twentieth-century book devoted to quilts, that "such treasures are worthy of study and imitation, and are deserving of careful preservation for the inspiration of future generations of quilters."[31] Quilts had become symbols of the important roles and contributions of women in the nation's history.

Unlike Crazy quilts, the distinctive icons of the Aesthetic era, quilts influenced by the Colonial Revival do not all look alike. They take a wide variety of forms. Michael Kammen, a professor of American history and culture and the author of a major work exploring the roles of tradition, collective memory, and patriotism in American society, acknowledged that "inconsistencies . . . inevitably creep in when a culture wishes to cherish both tradition and progress."[32] By reflecting on why these quilts take the forms they do, we can begin to appreciate the complexities and nuances of the Colonial Revival phenomenon.

■ Virginia Gunn

The Pine Tree pattern was a favorite all through the Colonial Revival era. There are numerous variations on this design. Quiltmakers were happy to reproduce this traditional pattern, which had pre–Revolutionary War roots, graphic qualities easy to express in the favored two-color combinations, and visual ties to border designs on woven coverlets, the other bedcovering type deemed appropriate for old-fashioned rooms. Ruth E. Finley included a beautiful dark green and white Pine Tree quilt and spelled out the pattern's history in *Old Patchwork Quilts and the Women Who Made Them*, published in 1929: "It originated in Massachusetts along with the Pine Tree Shilling and the Pine Tree Flag. . . . Nothing could have been more symbolic of North America. It was—all of it that the colonists knew—a land of pines. It is still a land of pines. From coast range to coast range, from southern swamp to north woods, there is a pine."[33] The silver Pine Tree Shilling was coined in the Massachusetts Bay Colony in 1652 in defiance of instructions from the mother country. Over a century later, in 1776, during the Revolutionary War, Massachusetts

adopted a white flag with a green pine tree and the motto "Appeal to Heaven" for its naval ensign.

Although Finley's information on the pattern's roots was accurate, her declaration that this was one pattern whose name had always "remained the same" cannot be substantiated. Marie Webster had noted in 1915 that slight variations on this design were responsible for at least three names: Pine Tree, Temperance Tree, and Tree of Paradise. In her book *Quilts: Their Story and How to Make Them*, Webster illustrated an early red and green Tree of Paradise quilt made in Indiana.[34] A similar, but not identical, Tree of Paradise pattern was sent by Ida L. Southard to the publishers of *Comfort* magazine in Maine (the Pine Tree State), and appeared in their 1922 booklet on appliqué and patchwork.[35]

There is no consistent connection between the numerous variations of the Tree pattern and the names associated with each of the variations, but the pattern appeared all through the Colonial Revival era. Fanny Bergen, a quilt pattern collector, provided one of the earliest published versions, which she called a Tree

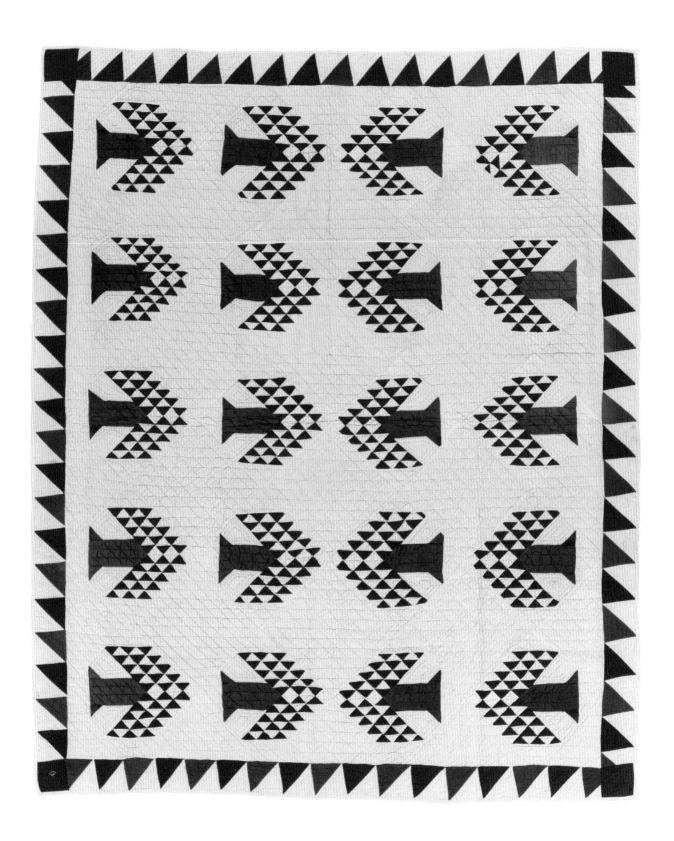

PLATE 5-1. Pine Tree.
Maker/location unknown, 1890–1910.
Cottons, 77" x 62.6". QSPI: 9.
2003.003.0331. *Jonathan Holstein Collection.*

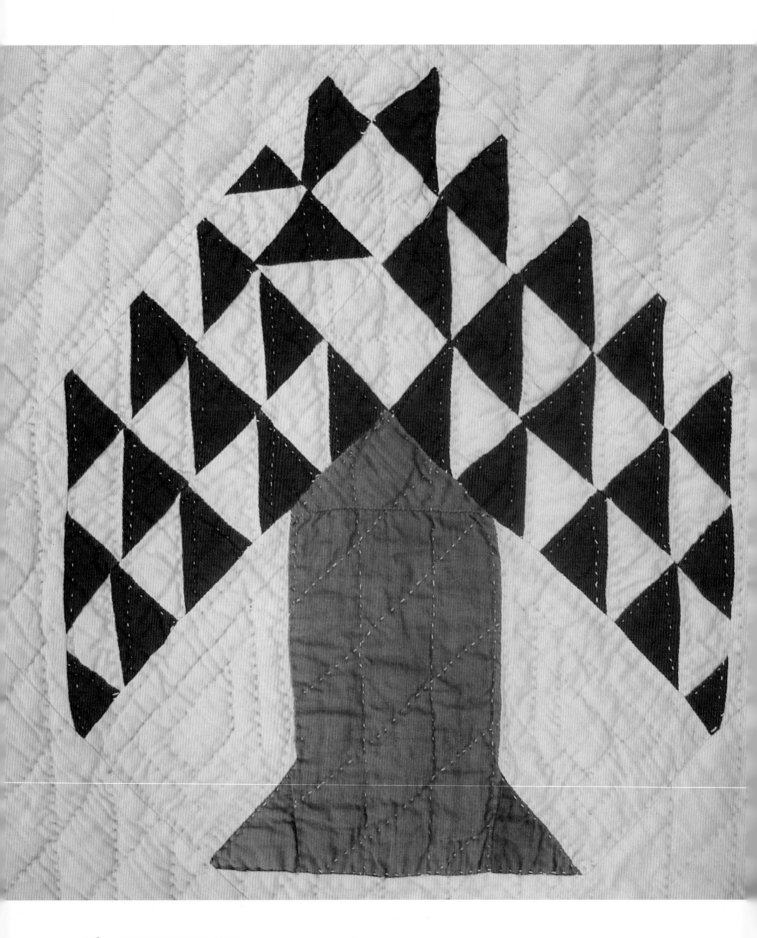

of Paradise, in 1894.[36] Other early versions include the unusual Pine Tree variation offered by Mary Harriett Large in her 1905 article for *House Beautiful* and a Pine Tree pattern illustrated in Charlotte F. Boldtmann's 1911 article for the *Woman's Home Companion*.[37] Carrie Hall and Rose Kretsinger included a reproduction of a "very old colonial pattern" they called a Tree of Life quilt in their 1935 book.[38] By the 1930s almost every pattern source had some kind of tree variation. Barbara Brackman includes four pages of these tree designs in her *Encyclopedia of Pieced Quilt Patterns*.[39]

Pine Tree quilts were often made in two colors, with green and white, blue and white, and red and white combinations the favorite choices of the Colonial Revival period. Those labeled Tree of Paradise quilts, and later Washington Tree quilts, sometimes had red, green, and white combinations, perhaps alluding to the apple trees associated with Adam and Eve or the cherry trees associated with George Washington.

This Pine Tree quilt (plate 5-1), made by an unknown maker, is an excellent early Colonial Revival example of the pattern, featuring a forest of twenty pine trees with green trunks and red branches. The trees are aligned so that the two rows of five trees on each of the longer sides point toward the center. The quiltmaker pieced the small triangles of the branches by machine, losing a few of the points in the process. One corner tree has several of the triangles out of position, an intentional or unintentional error that adds to the personal appeal of the quilt. The maker finished her quilt with a bold border of alternating green and red triangles set off by a red square in each corner. Once again, the pieces are not perfectly spaced, but the little imperfections add to the charm of the quilt.

The quilt is nicely quilted with tiny, nine-to-the-inch stitches and finished with a white binding that matches the background. Surely its maker took pleasure in her accomplishment. Her early Revival version of the Pine Tree is what Charlotte Boldtmann called "a strikingly handsome quilt," one that continues to bring pleasure today.[40] Ruth Finley said it best: "The Pine Tree Shilling is gone. The Pine Tree Flag is gone. But 'The Pine Tree' quilt remains."[41]

■ **Virginia Gunn**

FIG 5-6. Pine Tree, *detail*.

This striking four-block, red-and-white Sawtooth Diamond quilt (plate 5-2) is almost identical to a pattern published in the October 1894 issue of *Ladies' Home Journal.* Sybil Lanigan, one of the magazine's editors, reported that a "revival of patchwork quilts is at hand." Mrs. Lanigan provided several designs that were chosen to "avoid the rock of ugliness and the whirlpool of intricacy," a veiled reference to the then-popular Crazy quilt as well as to the mythical Scylla and Charybdis. Lanigan stated that her Illustration No. 3, titled "Red and White Quilt," had been obtained from a minister's wife who had made four quilts of this design, "finding the work convenient while chatting with the frequent visitors incident to her position." Lanigan noted that this "easily made and effective" pattern began with a ten-and-one-half-inch centered square surrounded by two-inch strips. She cautioned readers to take "great care . . . that all the patches are cut evenly and well." Acknowledging that most women in the 1890s had the skill to change and revise patterns, she stated that the quilt, intended to be an all-over central-medallion design, could be made "larger or smaller by altering the size of the centre square."[42]

The bold pattern with its sawtooth edging was a modern Colonial Revival version of center-medallion quilts made in the late eighteenth and early nineteenth centuries. The simple contrasting color palette provided a refreshing change from the busy surface of multicol-

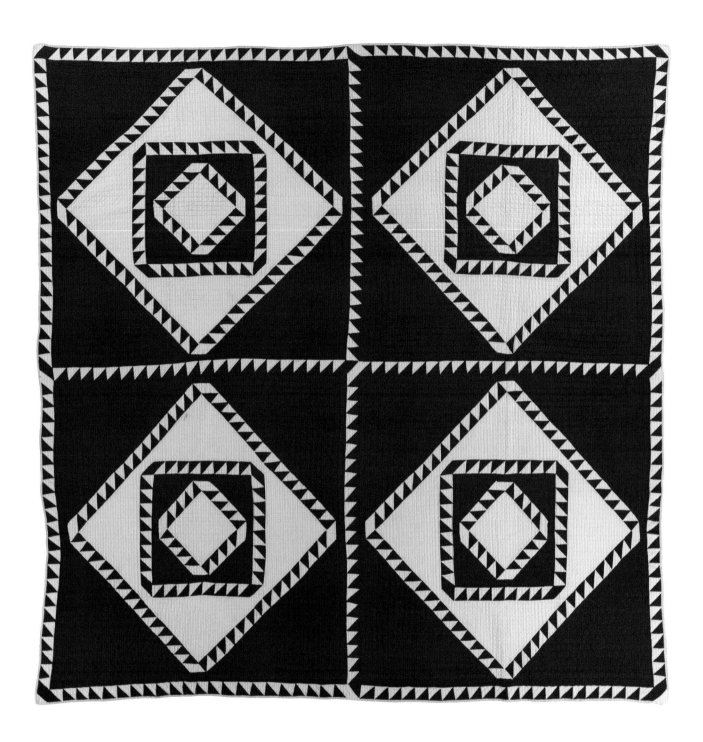

PLATE 5-2. **Sawtooth Diamond.**
Maker unknown.
Possibly made in New Jersey, 1890–1910.
Cottons, 89.5" x 89.5". QSPI: 6-9.
2004.016.0032. *Linda Giesler Carlson and
Dr. John V. Carlson Collection.*

ored Crazy quilts. The choice of washable "Turkey red and white cotton" meant that the finished quilt could be a useful as well as a decorative bedcovering, just as quilts had been in the good old "colonial days."

It seems likely that the anonymous maker of this red-and-white cotton four-block quilt may have been inspired by Lanigan's article. By 1893 *Ladies' Home Journal* was printing 712,000 copies per month and enjoyed "the largest present circulation of the single edition of any periodical, whether of daily, weekly or month[ly] publication, not only of America but of the world."[43] Numerous women chose to get "busy placing the blocks together in new and artistic patterns, as well as in the real old-time order." As people recognized that "old-fashioned" was now the new fashion, the Colonial Revival movement gained momentum.[44]

The maker of this quilt started each block with a seven-and-one-half-inch center square and placed four identical units together to form her quilt top, carrying out Lanigan's advice to vary or modify the patterns "according to taste." The quilt's creator also followed Lanigan's advice to use solid colors or bright tiny prints, with "white the basis of all," choosing to reproduce the original colors illustrated.

The quilt is machine-pieced, with the exception of the small center triangles on one of the four blocks, which are hand-pieced. The machine piecing is skillfully and carefully sewn, with sharp, distinct points on all of the small triangles. Lanigan knew that women preferred to sew by machine, and she cautioned readers that this was the "worst way of all" to finish a quilt. If they were not up to hand quilting she advised them to "find some skillful, old-fashioned sewing woman" willing to quilt for a moderate sum. On this four-block version, hand quilting, six to nine stitches per inch, enhances the bold design. The outer red corner triangles are filled with small repeated shell curves, while the inner red corner triangles feature evenly spaced double-line quilting emphasizing the corner turn. The white spaces are quilted in a simple grid pattern. The maker used white cotton twill tape, applied by hand, to bind the quilt edges.

Lanigan told her audience that "a well-made quilt will last in constant use for many years." This quilt has been washed and used by its owners, but it remains an eye-catching and dramatic example of quilts made in the era when women began to embrace Colonial Revival themes. Ornate silk Crazy quilts lost their favored status as quiltmakers returned to the more functional Colonial-style quilts, intended to be used on beds to provide warmth and comfort as well as beauty.[45]

■ **Virginia Gunn**

FIG 5-7. Sybil Lanigan, "Revival of the Patchwork Quilt," *Ladies' Home Journal*, October 1894.

REVIVAL OF THE PATCHWORK QUILT
By Sybil Lanigan

THE vagaries of fashion are unaccountable and no one can tell in what direction they will lead next. Of late months everything which could be recognized as old-fashioned is the new fashion, and this is as truly the case in needlework as in sleeves or furniture. The decree has gone forth that a revival of patchwork quilts is at hand, and dainty fingers whose owners have known only patches and patchwork from family description are busy placing the blocks together in new and artistic patterns, as well as in the real old-time order.

In past days the artistic instinct that knew of no other outlet pleased itself often over intricate mosaics of calico, and we cannot despise the love of beauty that tried to express itself by form and color in simple materials, though sometimes the time and labor bestowed seem to us to be altogether disproportionate to their object.

SOME OLD DESIGNS

THE subjoined patterns are chosen with an effort to avoid the rock of ugliness and the whirlpool of intricacy. The de-

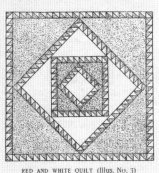

RED AND WHITE QUILT (Illus. No. 3)

sign in Illustration No. 1 is taken from a quilt made nearly fifty years ago; it was called the Odd Fellows' March for some unknown reason, such as has prompted the naming of classic patterns, like the Irish Chain or Fox and Geese. The completed square measures sixteen inches; it was made of a finely flowered red print and white cotton. The squares were put together with strips of white about three inches wide.

COMPLETED SQUARE
(Illus. No. 2)

For this pattern and others take a square of stiff paper the size of the square desired; rule it according to the diagram given; cut the several squares or angles required out of this diagram; add small seams when cutting the cotton, and the result will be an accurate and altogether satisfactory copy.

QUILT OF RED AND WHITE

NO. 2 is a modification of the first. The square should be smaller and three shades of print could be used. The patch in Illustration No. 3 comes from a manse whose mistress says she has made four like this, finding the work convenient while chatting with the frequent visitors incident to her position. The materials are Turkey red and white cotton. The centre square is ten and one-half inches, the surrounding strip is two inches wide. It is, perhaps, the most easily made and effective pattern that can be given. The quilt is made oblong by adding a strip at top and bottom, and can be made larger or smaller by altering the size of the centre square.

A CRADLE QUILT

THE design in Illustration No. 4 is a cradle quilt, made by a grandmother a good many years ago; the baby is now a stalwart man, but the little quilt is gay and pretty enough still to begin a second career of usefulness. The inner square measures seven and one-half inches, the stripe is four inches wide. It is made of two shades in plain colored print, or of two contrasting colors. The triangles on the side are from squares of about an inch. The corner stars, like the centre of No. 5, are formed of eight diamonds. The pattern is obtained by folding a four-inch square of paper diagonally twice; from the long points cut a square, and a triangle from between the other two points of the star. One diamond, the square and triangle will give the needed patterns. Even the deft Canadian who gave this pattern owned that it was a great deal of work, but the fact that it was for the baby's bed was an ample justification in her eyes. On a larger scale the border might be used very effectively.

From the same source Illustration No. 5 was obtained. Nine of these stars, inclosed in a narrow border of diamonds, brightened the bed. Three shades of red print were used. I think this is one of the most æsthetic patterns of the olden time; still it may be new to many of the rising generation. I would not recommend any one to put nine stars on one quilt, but one star enlarged according to taste and either bordered or not as preferred, would make a pretty centrepiece. By employing more shades the star can be enlarged, as well as by increasing the size of the diamond used in the centre. A smaller star in silk could be used for a cushion, and making it would form a pleasant task for fingers unskilled in embroidery.

TWO SIMPLE PATTERNS

ILLUSTRATIONS No. 6 and No. 7 will atone by their simplicity for the difficulty of the last pattern. The completed square of No. 6 measures nine inches. The squares are joined together, light to dark, so that four squares apparently form a larger square. The diagram is so simple that no directions are necessary, and the same may be said of No. 7. This has been known as the album quilt unfortunately, which may prejudice some against the neat little squares that look so pretty either in blue and white or pink and white. Both of these last are given for the sake of beginners, so they will not need much instruction or help. The circle of No. 5 before the rays of the star begin is sometimes set in a square of white, which is bordered with colored diamonds. This arrangement makes a very pretty quilt.

In following any of these designs it must not be forgotten that small pieces of any kind of colored print may be utilized. The general effect is not so good without uniformity, of course; but with care one may avoid unpleasing in-

ALBUM QUILT (Illus. No. 7)

FINISHING THE QUILT

AFTER having made the patchwork of the desired dimensions tack two layers of wadding on the inner side. Then make a lining of soft, white cotton exactly the same size, and baste it very carefully upon the wadded patchwork. Be lavish with your basting thread, running it around the edges diagonally from corner to corner, and across again, after the fashion of the Union Jack; give it some additional lines until the patchwork and lining are smoothly and firmly fastened together and ready for the final process of quilting.

The old-fashioned quilting bars, into which the work is now ready to be fastened, insure the most perfect results.

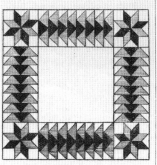

CRADLE QUILT (Illus. No. 4)

The lines that are to be followed with a light-running stitch are marked with colored chalk in diamonds or squares of any angle or size preferred. A quilting bee is the merriest and quickest way of finishing the quilt after all these preliminary preparations have been made. If the quilting bars and the bee are not attainable the work may be spread upon a bed, and with a little extra care and trouble may be quilted in that way. The worst way of all is to use the sewing machine for the purpose, and the best is to find some skillful, old-fashioned sewing woman who will take your dainty, bright patchwork, line it, quilt it in delicate, fine tracery, and bind it for as moderate a sum as the making of a print dress.

A well-made quilt will last in constant use for many years, and can be renovated by re-covering when worn or faded.

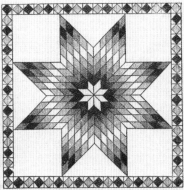

AN ÆSTHETIC QUILT (Illus. No. 5)

The old-fashioned art of patchwork can never become entirely obsolete while there are in the majority of households little fingers just learning to hold the needle, or failing eyes that require some simple occupation or pastime.

The result of the hours pleasantly spent over the bright-colored fragments is always acceptable to the good house mother, for these pieced quilts are light, warm, durable and easily cleansed.

All of these patterns may be varied or modified according to taste, but a fixed principle should be to make white the basis of all, and to use only solid colors or a tiny-patterned bright print as the contrast. If this is done the inner patchwork quilt will always be a pretty as well as a useful part of the bed covering. In many respects it

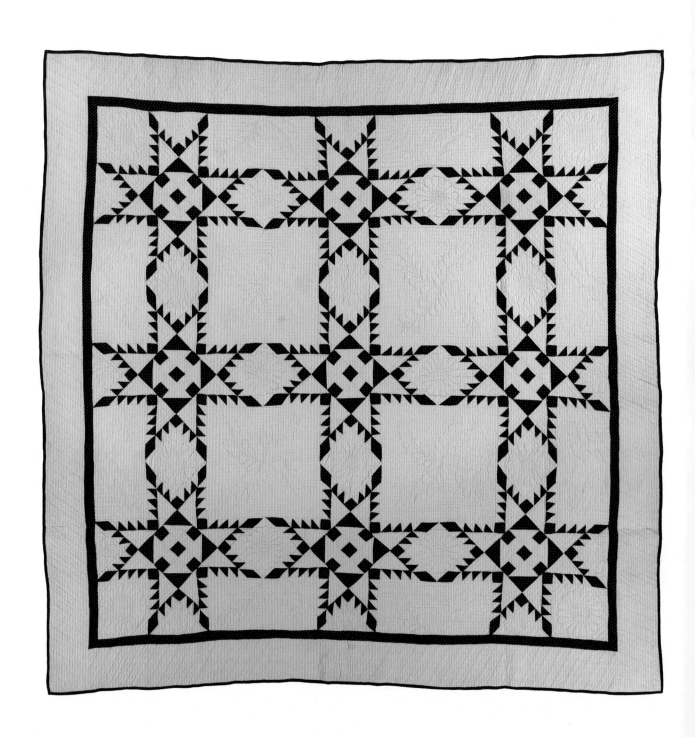

PLATE 5-3. Feathered Star.
Mary Caroline Robinson Olds (1826–1909).
Probably made in DeKalb County, Indiana, c. 1895.
Cottons, 78" x 78". QSPI: 9-10.
1997.007.0172. *Ardis and Robert James Collection.*

This Feathered Star quilt (plate 5-3) was attributed to the "Olds Family" of LaGrange County, Indiana, when Ardis and Robert James added it to their collection. Subsequent research revealed that this quilt, with its fine stitching and workmanship, was made by Mary Caroline Robinson Olds, possibly as a wedding gift for her youngest son, Arthur, and his bride, Rose Wildred Kline, who were married on April 30, 1895, in Auburn, Indiana. The 1910 census records Arthur B. Olds, his wife, Wildred, and five of their seven children living next to his older brother, William J. Olds, in LaGrange County. The quilt descended in the family of Arthur, who lived in LaGrange from about 1905 until his death in 1955.[46]

Mary Caroline Robinson (b. 1826) and Samuel Olds (b. 1818), her husband, were both born in Vermont, where they married on October 30, 1844. They moved to Indiana in the mid-1850s. Samuel worked in the hatter's trade in Fort Wayne and farmed for a few years in Allen County. In 1866 they and their children moved to the small village of Spencerville in DeKalb County, located in the northwest corner of Indiana. Arthur, born in 1871, was the youngest of their ten children. Samuel was a prosperous dry goods merchant in DeKalb County until he retired in 1883.

The stars on the quilt Mary Olds made for her son and new daughter-in-law are fashioned from indigo blue fabric with tiny white polka dots. Jane Benson informed *Ladies' Home Journal* readers in 1896, "Nowadays the patchwork quilt is most often made from material specially bought for the purpose, and usually one color and white are used."[47] She suggested choosing Turkey red or blue, including a shade called Delft, because the colors were "effective" and safe to wash. Jane W. Guthrie, writing for *Harper's Bazar* in 1905, recommended blue and white patchwork quilts or homespun coverlets for Colonial Revival bedrooms. If the rooms also contained "old Delft or Staffordshire ware, or rare Japanese or Chinese porcelains in blue and white decorative effects," the color scheme would achieve "soft and exquisite harmony."[48] People living in Indiana liked the blue and white color scheme; it had been the favorite choice for handwoven coverlets made in that state in the mid-nineteenth century.

The Feathered Star design was also a favorite. Jean Thompson, writing for *The Delineator*, agreed that

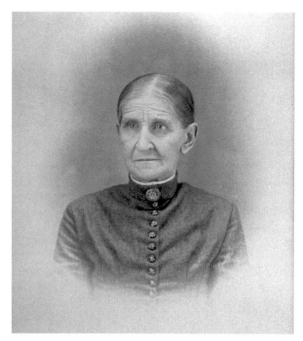

FIG 5-8. Mary Caroline Olds, c. 1890. Courtesy of Richard Olds.

"vivid colorings, combined with plain white, afforded the greatest possible contrast," and stated that if they were "fashioned into a geometrical star . . . upon a white background, the effect was brilliant and dazzling beyond belief."[49] The Feathered Star pattern used by Mary Olds has an unusual center motif that Fanny D. Bergen identified as Screw Plate in 1894.[50] Other names for this pattern are Monkey Wrench, Hole in the Barn Door, and, perhaps most appropriate for this quilt, Love Knot.[51]

This striking quilt is completed with fine quilting, another feature that awed Colonial Revival tastemakers. When describing "quilts of long ago," Lewis Edwin Theiss marveled, "How they ever wrought those marvelously intricate designs found in some quilts is almost past comprehension."[52] Mary would have been familiar with early Feathered Star quilts, with their fine quilting done in wreaths and vines, which were especially popular at the time she was married. She would have developed the skills that allowed her to successfully piece this intricate design and to set it off with superb quilting.

The quilting designs are more controlled and evenly spaced than those found on earlier versions of the pattern, but the choice of motifs that fill in the background is based on tradition. The quilting motifs were

planned carefully, and light pencil marks can still be seen in places on the surface. The stitches are small and even, about nine to ten per inch. Crossed feather plumes with straight lines in the background fill the four large central squares, and half-crosses are used in the eight rectangular sections between the stars. The four corners and the nine squares formed by the joining star points each feature a small feather wreath with a grid center. This "sunflower" effect became a favorite in the Colonial Revival repertoire. The border has carefully spaced triple diagonal lines. The narrow binding, cut on the straight of grain, is formed of a smaller scale blue polka-dot print and is applied by machine and hemmed to the back by hand. Although the piecing is done by hand, the maker used her sewing machine to join some of the set-in white squares and to add the borders to the centerfield.

Mary and her husband lived with their daughter's family in St. Joe, DeKalb County, in their later years. Samuel died in 1899 and Mary in 1909. This Feathered Star quilt became an Olds family heirloom that was handed down and treasured for several generations. It continues to impress and sparkle a century later, reminding us of a time when "old-fashioned designs" were again appreciated and replicated, often as gifts of love for family or friends.

■ **Virginia Gunn**

FIG 5-9. Feathered Star, *detail*.

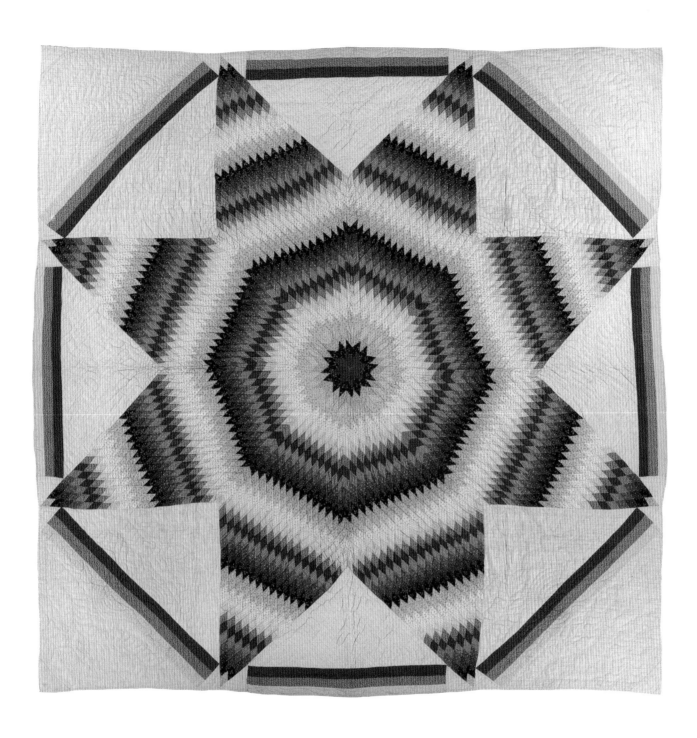

PLATE 5-4. Star of Bethlehem.
Maker unknown.
Possibly made in Pennsylvania, 1900–1920.
Cottons, 85" x 85.5". QSPI: 7-8.
1997.007.0374. *Ardis and Robert James Collection.*

The great central star, an early favored design called Star of Bethlehem, is seen here in a twentieth-century Colonial Revival version (plate 5-4). In the first half of the nineteenth century, as Ruth Finley pointed out, diamond patchwork was "often reserved for 'best quilts.'"[53] These large star patterns had a variety of names: Blazing Star, Lone Star,

Rising Sun, Star of Bethlehem, Star of the East, Starburst, Sunburst, and Texas Star. When Sybil Lanigan included this pattern in her 1894 article on the quilt revival for *Ladies' Home Journal*, she labeled this challenging design (her Illustration No. 5) "an æsthetic Quilt," explaining, "I think this is one of the most æsthetic patterns of the olden time; still it may be new to many of the rising generation." (See figure 5-7 for an image of this article.) Lanigan had obtained her version from a Canadian source. The original quilt had nine of these stars, each separated by a narrow border of diamonds and carried out in shades of red prints. Diamond Star patterns had been traditionally done in repeated blocks as well as in the one-star format, but Lanigan told her readers, "I would not recommend any one to put nine stars on one quilt, but one star enlarged according to taste and either bordered or not as preferred, would make a pretty centerpiece." She suggested increasing the size of the diamond template and adding additional shades to the color palette. This version of the Star of Bethlehem became a favorite in the United States throughout the Colonial Revival era.[54]

Fanny D. Bergen's article on quilt patterns, "The Tapestry of the New World," had been published one month earlier than Lanigan's in the September 1894 issue of *Scribner's Magazine*, a well-established periodical serving the educated public and designed to

FIG 5-10. Star of Bethlehem, *detail*. Background print.

help keep them informed of contemporary trends, including those in the decorative arts. Bergen, who had collected "between two and three hundred quilt patterns," rightfully concluded, "The same pattern occurs in various parts of the country under the most diverse names." She obviously knew of the large star patterns and their various names. She reported, "I hear of a pattern that, in Washington DC, is said to be of good omen. I have not its name, but from its description think it probably the peculiar form of the 'rising sun,' that consists of one gigantic star, whose centre is the centre of the quilt, the open spaces between the star points being filled in with patchwork."[55]

Filling in the open background spaces with cut-out chintz designs, smaller pieced stars, or intricate patchwork (now called appliqué) was the preferred treatment on the earliest large-star quilts. When quiltmakers of the twentieth century embraced this design they often left the background spaces surrounding the star empty, to be filled in with quilting. The maker of this modern Star of Bethlehem quilt created rectangular bars made from three shades of red fabric and placed a bar in each of the background spaces, dramatically framing her giant star composed of 2,888 diamonds.

The anonymous quiltmaker carefully selected, arranged, and hand-pieced the cotton prints used in her star. She combined three shades of green, three shades of red, three shades of yellow to orange, and two shades of blue. The bright double blue is known today as Lancaster blue because this hue was a particular favorite of people in Lancaster County, Pennsylvania. The background fabric, which appears white from a distance, is a shirting print featuring tiny black stars on a white ground. The backing fabric is also a print that has small black floral sprigs evenly spaced on a lighter grid background. These small-scale, brightly colored, high-quality prints, sometimes called "oil boiled calicoes," were especially useful for Colonial Revival quilts replicating early examples.[56]

The hand quilting, with seven to eight stitches per inch, effectively completes this Star of Bethlehem quilt. Each strip of the three-color bar motif is filled with a small cable pattern. Feathered vines are placed in the large background spaces, and the star is anchored with quilting along the seam lines of the diamonds. The maker pieced the binding to match exactly either the background fabric or the bar fabric to which it was joined so it would blend with the quilt design.

Women continued to make large-star quilts well into the World War II era. The graphic qualities and the patriotic and religious symbolism of such quilts had wide appeal. This stunning Star of Bethlehem interpretation is an excellent example of revival quilts at their best.

■ **Virginia Gunn**

FIG 5-11. Double Nine Patch, *detail*. "Aug 14 1907" in quilting. FIG 5-12. Double Nine Patch, *detail*. "Feb 26 1824" in quilting.

Two different dates are quilted in two of the edge triangles filling in the center field of this Double Nine Patch quilt (plate 5-5). One date is "Aug 14 1907" and the other "Feb 26 1824." It is likely that 1907 is the date the maker completed the quilt. The size of the quilt and the materials used are appropriate for an early twentieth-century date. The two-color scheme combines plain white cotton fabric with a polka-dot print in claret or wine, a color popular in the early twentieth century. All the piecing is capably done by machine.

The significance of the earlier date is harder to explain, but it may be the birth date of the quiltmaker. If so, she was eighty-three years old when she finished her Double Nine Patch quilt. The tiny quilting stitches, ten to eleven per inch, had to be done by someone experienced at the art. The wide white borders are filled with rows of alternating clamshell motifs. The white fill-in blocks set between the on-point Double Nine Patch blocks are each quilted with a different motif, including feather patterns, stars, and swirls. This quilting sampler technique was widely used in Ohio in the mid-nineteenth century and supports the attribution to that state. Someone born in 1824 would

have been in her early twenties when simple pieced quilts with elaborate sampler quilting were being completed, shared, and exhibited at fairs and social events in Ohio. A person familiar with these quilting samplers made during the years she learned and perfected her quiltmaking techniques would have been likely to incorporate the same type of quilting designs in her later revival or memory quilt.

Marie Webster included a stunning Ohio blue-and-white Double Nine Patch with sampler quilting in her 1915 book, *Quilts: Their Story and How to Make Them*. Her date of 1808 may be a little early for the "beautifully quilted" masterpiece that features a variety of intricate motifs in the center field and a graceful feather vine in the wide borders.[57] Another early Ohio Double Nine Patch with stuffed sampler quilting designs is illustrated in *The Quilt Engagement Calendar 1998*.[58] There are other outstanding quilts with sampler quilting in both private and public collections, a large number with Ohio provenance.[59]

The arrangement of the blocks and borders also supports an Ohio attribution. The center field of the quilt is formed of pieced blocks set on point, alternating with plain blocks to create a dynamic arrangement

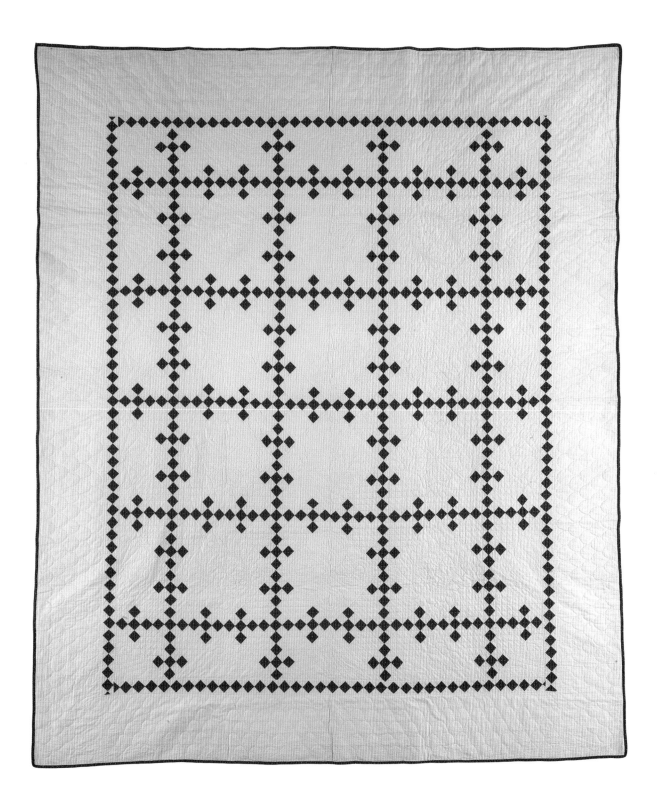

PLATE 5-5. Double Nine Patch.
Maker unknown.
Probably made in Ohio, dated August 14, 1907,
and February 26, 1824.
Cottons, 88.75" x 74.5". QSPI: 10-11.
1997.007.0273. *Ardis and Robert James Collection.*

of a simple pattern. The center field is surrounded with a narrow inner border and a wide outer border, and the edge is finished with a contrasting binding. This style, which was particularly popular in counties having large numbers of people with Germanic heritage, found wide favor across the state in the mid-nineteenth century. On this quilt the narrow inner border has a chain of wine-colored squares made and then cut to fit the four borders, creating some mismatching at the corners.

Another name for the Double Nine Patch pattern is Single Irish Chain. If the Nine Patch blocks alternate with plain squares in a checkerboard arrangement, they form a diagonal pattern on the surface of the quilt just like another favorite revival pattern, the Double Irish Chain. These simple but graphic all-over patterns, usually carried out in two-color combinations, probably reminded women of the geometric patterns found on woven coverlets. When *House Beautiful* magazine gave its readers "A Note on Coverlets" in 1904, it emphasized, "A 'colonial home' or an 'old-fashioned room' is not complete without one or more of them." In the same issue Helen Blair's article on "Dower Chest Treasures" featured a blue and white Irish Chain quilt whose quilting she described as "fine and beautiful, but not too elaborate." Blair called it "the best illustration of what a modern quilt should be" and just the right choice to reproduce if one did not possess an antique quilt or coverlet.[60] This Double Nine Patch is a perfect example of Colonial Revival styles favored by the tastemakers.

■ **Virginia Gunn**

PLATE 5-6. Whig Rose variation.

Maker unknown.

Possibly made in Cleveland, Ohio, 1920–1940.

Cottons, 86" x 85". QSPI: 10-11.

1997.007.0831. *Ardis and Robert James Collection.*

The maker of this striking Colonial Revival Whig Rose quilt (plate 5-6) remains unknown, but her quilt is an excellent example of the high-quality appliqué work done in the early twentieth century. Her use of a bright and limited palette of solid-color cottons carries on a trend established by Marie Webster and brought to national attention when *Ladies' Home Journal* first published her quilts in 1911

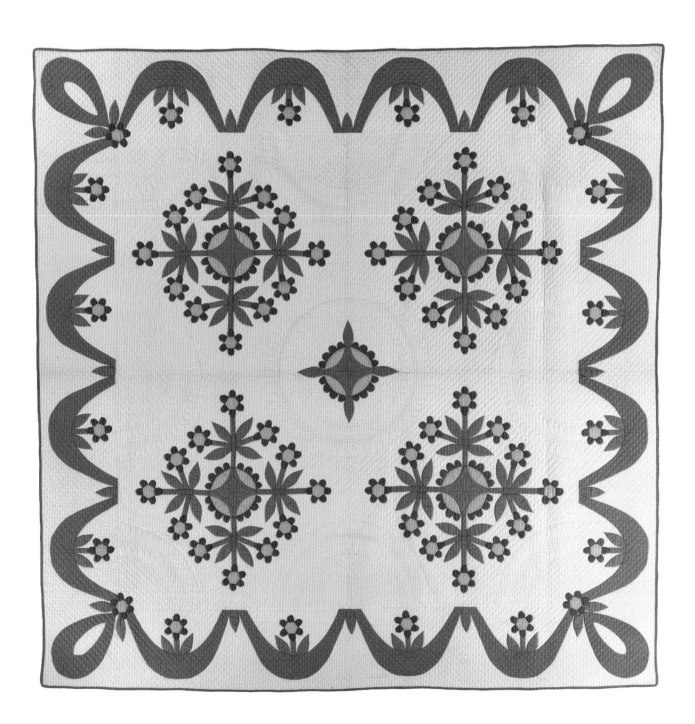

FIG 5-13. Whig Rose, *detail*. "Festoon" border and feathered plume quilting.

and 1912.[61] Webster's Pink Rose quilt had repeated blocks and a graceful scalloped-edge swag border. This new interpretation of a traditional design and her more modern "conventionalized" design of an iris, stitched in shades of lavender with green leaves, had immediate appeal and wide influence.[62]

This Whig Rose is a modern revival of an appliqué pattern that was especially popular in the mid-nineteenth century. Its numerous variations had diverse names, including Whig Rose, Democrat Rose, Rose of Sharon, California Rose, and Tea Rose. The traditional block featured a large central rose surrounded by leaf forms. Four extending stems, ending in two smaller flowers or buds, bent gracefully to fill in the corners of the block. The favorite color scheme had red roses and green foliage, with touches of gold or orange in the flower centers. In this Colonial Revival version, the stems are very straight rather than curved, and three small flowers are symmetrically arranged on each stem. The creator chose bright cottons in green, gold, and lavender and placed them on a white background. The flowers have hexagon centers with attached petals. A dramatic green "festoon" border with distinctive corner loops and floral trim completes the design. An early version of this border appeared on an "old-fashioned" Wild Rose quilt illustrated in the January 1, 1914, issue of *Vogue*, an influential fashion magazine.[63]

It is very likely, however, that the maker of this Whig Rose variation was inspired by prize-winning quilts of the early 1930s. A Colonial Rose appliquéd quilt with festoon border, made by Mabel Langley of Dallas, took second prize in the Sears National Quilt Contest held at Chicago's Century of Progress Exposition in 1933.[64] A year earlier, a Rose quilt with festoon border made by Mrs. D. T. Larimore of New York City received first prize in the Modern category at the "Quilt Contest sponsored by the Eastern States Exposition at Springfield, Massachusetts, as a feature of the Annual Fair of 1932." It was pictured in the January 1933 issue of *Needlecraft*, a magazine with a large national audience.[65]

At the Eastern States Exposition the quilts were displayed to the public in the "Town Hall of Storrowton, a New England Colonial Village on the Exposition grounds." The revival building had been established with the "vision and generosity of Mrs. James J. Storrow" and the work of Mrs. Schuyler F. Herron as headquarters for the exposition's Home Department. Thirteen hundred women had indicated their interest in competing for the four cash prizes; about half that number sent in quilts. They were of such high quality that the organizers decided to award four prizes in the Antique category and four prizes in the Modern category, with two additional "special mentions" and fifty blue ribbons to the next in rank. Anne Orr of Nashville, Mary Reynolds of Philadelphia, and Christine Ferry of Boston spent three arduous days in August judging the entries.

Mrs. Larimore's prize-winning modern quilt was praised for its "uniform excellence in design, workmanship and color harmony" and was described by *Needlecraft* as "lovely in color combination and exquisitely quilted." The editor commented at length on the quilting and noted, "Every detail of the work was done with meticulous precision and, judged as a whole, it was a perfect example of a well designed quilt, beautifully made and suitable for use in a modern room."[66]

The words used to describe the quilt contest's "modern" winner could also be applied to this Whig Rose variation. It, too, achieves the highest standards in workmanship, color harmony, and uniform excellence in design. The appliqué stitches are meticulously done in thread matching each fabric. The quilting, carried out in tiny hand-stitches, features intricate feather wreaths and fine grid quilting in the background of the four-block design. Light pencil marks indicate that the quilt has never been washed. The edge is finished with a narrow green binding cut on the straight of grain. Though the creator of this lovely work remains unknown, those who inherited her quilt obviously treasured and cared for it. It met the highest standards of its era and, like other beautiful quilts exhibited at contests in the 1930s, "will linger long in the memory of all who were so fortunate as to see them."[67]

■ **Virginia Gunn**

This Floral Bouquets quilt (plate 5-7), with its stylized bouquets of irises, pansies, and roses, exhibits the modern feminine qualities associated with early Art Deco design. The editors of monthly women's magazines and specialized needlework periodicals worked to provide readers with designs that reflected the latest trends from Europe. By 1910, new motifs and color combinations originating in Germany, Austria, and France began to influence needlework in the United States. *Home Needlework Magazine* reported that "designers of patterns for embroidery can scarcely keep up with the demand for new ideas and artistic variations upon the old ones."[68] Creators of the decorative arts on the Continent often looked to the fine designs of the eighteenth century for inspiration. Their modern interpretations appealed to American women who wanted to embrace both the latest European fashions and the fashion for the colonial past.[69] They used the new ideas first in embroidery and then in quilts.

Marie Webster was a leader in interpreting these new trends in her appliquéd quilts. By the late 1910s, however, professional needlework designers such as Helen Grant, Cora and Hugo Kirchmaier, Sophie T. LaCroix, and Anne Orr offered appealing cross-stitch patterns with European influence.[70] These new designs blended Modern with Colonial and included old-fashioned silhouettes; birds and butterflies; wreaths, garlands, and baskets of flowers festooned with ribbons and bows; and small bouquets of stylized posies in the favored boudoir shades of blue, lavender, rose, yellow, and green. LaCroix and Orr later designed quilts with the same color combinations and design motifs.[71]

Quilt designers and entrepreneurs watched each other as well as the trends and often advertised similar designs. In the October 1929 issue of *Harper's Bazar* the Wilkinson sisters of Ligonier, Indiana, producers of Wilkinson Art Quilts, introduced their Forget-Me-Knot design, which could be made in "delicate flower colors."[72] Their appliquéd central-medallion quilt featured large scallops joined with small bouquets of forget-me-nots. In April 1931 Eleanor Beard, whose Hedgelands Studio was located in Hardinsburg, Kentucky, ran a large ad in *House Beautiful* for her new and "delightful" Garden of Flowers quilt, which took "its name from a profusion of gay posies—peach, blue, violet with green leaves."[73] Not to be outdone, Anne Orr Studios in Nashville, Tennessee, offered its own version of a Forget-Me-Knot quilt in the June

FIG 5-14. Anne Orr Old-Fashioned Spray quilt pattern, source unknown, 1932. Courtesy of Merikay Waldvogel Collection.

PLATE 5-7. Floral Bouquets.
Maker unknown.
Possibly made in Pittsburgh, Pennsylvania, 1925–1935.
Cottons, 94" x 84". QSPI: 7-8.
1997.007.0796. *Ardis and Robert James Collection.*

1932 issue of *House Beautiful.*[74] Orr must have experienced success with this pattern, No. 107, because she soon added other quilts to her catalog offerings.

At first glance, this appliquéd Floral Bouquets quilt appears to be a kit designed by a professional artist, but to date it has not been identified as such. Anne Orr's designs may have provided the inspiration for this quilt. Orr's Tulip quilt, No. 111, featured small appliquéd bouquets of "rose, yellow, and orchid tulips" tied with blue bow-knots, spaced on the quilt's surface in checkerboard fashion. Her Old-Fashioned Spray Patched Quilt, No. 112, had a large central spray of "rose, orchid, and yellow flowers, tied with blue."[75] Four individual blue bows and one smaller spray surrounded the center bouquet. The arrangement and spacing of the design motifs in the Orr quilt are very similar to that on this Floral Bouquets quilt.

Anonymous designers who created quilt kits sold by the Needlecraft Company of Augusta, Maine, also capitalized on women's desire to make modern bouquet quilts for their Colonial-style bedrooms or boudoirs. Ribbon-tied bouquets are the main design feature on the following Needlecraft kits offered in the late 1930s and early 1940s: Bouquet Quilt, Bridal Bouquet Quilt, "Old Georgetown" Bowknot Quilt, "Betsy Ross Tulip Bed" Quilt, and Tulip and Bow-Knot Quilt.[76] The color palette for these quilts includes rose, pink, green, orange, lavender, yellow, and blue.

Whatever source of inspiration or pattern, this quilt features the creator's stylish bouquets of garden flowers tied with blue bow knots. They are arranged in Orr's central-medallion fashion on a white background formed of three lengths of white muslin. A large oval formed of three sets of mirror-image sprays and small roses in each corner section surrounds the central bouquet of flowers. The flower colors on the mirror-image sprays are not identical. The maker obviously mixed and matched colors, but the final result balances beautifully.

The quilting has seven stitches per inch. The appliqué motifs are outlined and the background is filled with a variety of motifs. There is a frame of scallops around the center spray. Echo quilting and parallel diagonal lines, interrupted with pointed-petal flowers, surround the smaller sprays. The corner spaces have sunflower motifs with concentric circles. Surely the maker was pleased with the harmonious and nicely balanced effect of her floral quilt. It would have been the perfect choice for a modern Colonial boudoir.

■ **Virginia Gunn**

PLATE 5-8. Basket of Lilies.

Maker/location unknown, 1925–1935.

Cottons, 89" x 80". QSPI: 12.

1997.007.0886. *Ardis and Robert James Collection.*

This quilt (plate 5-8) is a magnificent interpretation of the mid-nineteenth-century pattern Basket of Lilies, which has a number of variations and names. It was a favorite of both early and Revival-era quiltmakers. The Ladies Art Company 1928 catalog featured three versions, none exactly like this one: No. 55 Basket of Lilies, No. 273 Tulip in Vase,

FIG 5-15. Basket of Lilies, *detail*.

and No. 291 Royal Japanese Vase.[77] Herbert Ver Mehren called this design Tulips and Vase, No. 1109 in his 1933 catalog.[78] All of these pattern offerings were for fifteen- or eighteen-inch blocks. This quilt is composed of smaller twelve-and-a-half-inch blocks.[79]

Ruth Finley featured a nineteenth-century Basket of Tulips quilt belonging to Madge Farquhar Holstein in her 1929 book, *Old Patchwork Quilts and the Women Who Made Them*. This all-pieced quilt was made in Philadelphia in 1839. Finley wrote, "It, too, was originally of the favorite red and green of the period, but it is now a soft bluish green and faded pink. It shows the marks of much usage."[80] In the 1920s women were attracted to the mellow tones of heirloom textiles. The softened colors suited the color palettes favored for Colonial bedrooms or boudoirs and the fashionable clothing of the period.

As Ruby Short McKim advised *Better Homes and Gardens* readers in 1933, "The Turkey Red, with pink, marigold yellow, and shutter green" used in Grandmother's quilt "may not be in keeping with our pastel-tinted boudoirs of today."[81] In 1928 the columnist Gertrude Shockey wrote that a "young modern" woman ought to "set to work with her own little electric machine and her needle" and copy "the fine old patterns in colors satisfying to her decorative scheme."[82]

The maker of this quilt decided to work her pattern in cotton sateen fabric. Its soft texture and smooth, lustrous finish fit in well with the fashionable fabrics used in clothing and interiors. In April 1928 Withers, a quilt cottage industry in Kirk, Kentucky, advertised an "exact reproduction of the old time 'Basket of Lilies' quilt" made in "sunfast sateens" with a scalloped edge.[83] By the early 1930s, French sateen in "exquisite shades for making the highest grade quilts" could be had for 60 cents a yard, and domestic sateen was available for 50 cents a yard. Ver Mehren offered "four contrasting shades of yellow, blue, orchid, pink or green" as well as shades of peach, red, ecru, and tan.[84] In 1922 the Montgomery Ward & Company catalog offered plain-colored sateen in medium, good,

and best quality grades at 23, 28, and 35 cents per yard, respectively.[85] It would not have been difficult for this quilt's maker to procure the sateen fabrics for her quilt: two shades of pink for the flowers, two shades of blue for the basket, and green for the stems. The blue and pink shades used for the border were often referred to as Copenhagen Blue and Old Rose.

The maker set her sixteen floral blocks on point in a four-by-four traditional arrangement, alternating with plain white square blocks and completed with triangles to form the square center field. She then added extensions of background fabric to the upper and lower edges of the top to change it from a square to a rectangle. She completed the design with three narrow pink, blue, and white borders.

This Basket of Lilies quilt is meticulously quilted in tiny even stitches, twelve to the inch. The nine white background squares feature beautiful feather wreaths with grid centers and corners. Subtle pencil marks indicate that the maker carefully traced the same pattern in each square. Feather half-wreaths are repeated in the triangles completing the center field. The borders and the top and bottom extensions are quilted in a repeated clamshell pattern, again carefully marked on the fabric. In the pieced blocks, the flowers and small spaces are outlined by eye, but the basket and larger triangular spaces are filled with a square grid. The tension of the stitching sets off the quilting design in perfect fashion. The edge is finished with narrow bias fabric applied by hand.

This quiltmaker honored tradition as she arranged her tulip blocks on point and selected her quilting designs, but her choice of colors and fabric and the simple striped border let us know that she was a modern woman well aware of fashion. This Basket of Lilies quilt clearly demonstrates the concept that Ethelyn J. Guppy delivered to readers of *The Modern Priscilla* in 1923: "When a fashion cycle has been made complete and 'something old' has become 'something new' again, this 'something new' is never an exact reproduction of the old."[86]

■ **Virginia Gunn**

This brilliant red-and-green appliqué Coxcomb and Berries quilt (plate 5-9) was the perfect choice for a Colonial Revival quilt made in southwestern Pennsylvania, the heart of a region where red-and-green appliqué quilts had flourished in the nineteenth century. This Coxcomb and Berries quilt is one of several passed down in the Dinsmore family of New Castle, Lawrence County, Pennsylvania, on the western edge of that state, right next to Ohio.[87] Undoubtedly people in this area had seen numerous antique red-and-green appliqué quilts made by their pioneer grandmothers, and it would have been easy to find a design to copy or adapt as they came back in style. The large four-block arrangement of coxcomb and berries, bordered by vases holding stems of flowers and berries, is typical of Pennsylvania German work. The background of the quilt has even been tinted a pale blue to give it the color intensity favored in that state. But the stiff and stylized arrangement of the berries in the border, the choice of grayed shades of red and green, and the simple quilting pattern clearly reveal that this is a modern revival interpretation.

In Pennsylvania, appliquéd quilts with their bold colors and designs were accorded a place of honor in a family's quilt collection. Early Colonial Revival tastemakers, targeting a national audience, lavished high praise on appliqué work. Jean Thompson, writing in *The Delineator* in 1906, noted that appliqué quilts were "the 'show' or company spreads, reserved more especially for the 'spare room.'" Compared to a pieced quilt, the "applied" design was a "more ambitious style of patchwork, one which called for rather more refinement of detail and was perhaps more artistic in effect."[88] Five years later, in 1911, Charlotte Boldtmann wrote in the *Woman's Home Companion*, "The most magnificent specimens of patchwork which have been handed down for generations are not pieced at all, but have the patterns appliquéd on white muslin or, as they used to speak of it, hemmed on." Ironically, Boldtmann also predicted that the days of the "great popularity of the American patchwork quilt" had already passed, because modern women had so many other interests "claiming our time and energy."[89] This Coxcomb and Berries quilt and numerous others made in the first decades of the twentieth century clearly demonstrate that she was, unknowingly, reporting on the strong beginnings of a revival and not the demise of a colonial art.

By the twentieth century most people used the term patchwork to refer to all categories of quilts, with special divisions for those pieced and appliquéd. Thus journalists and authors writing about quilts often explained to their readers that in the "good old colony days" terms such as "sewed on," "patched," "laid on," and "hemmed on" were commonly used for appliqué work.[90]

According to family descendents, the Coxcomb and Berries appliqué quilt was made by Cora Arabelle Eckles Dinsmore. Cora Eckles was born in September 1904. She graduated from New Castle High School in 1923 and taught in a county school for three years before her marriage to Marvin Bell Dinsmore on June 7, 1926. The young couple lived next door to her parents-in-law, Abbie and John Dinsmore. Marvin's mother was a quiltmaker and so was Cora's mother, Mary Anna McConahy Eckles.[91] Cora probably learned to quilt from her mother. The edge of the Coxcomb quilt is finished with a bias binding, the same technique her mother used on a Colonial Revival quilt she made in the 1930s (plate 6-25). Cora's appliqué is neat, although the tiny berries are slightly irregular in shape. The background quilting is well done in an all-over diagonal one-inch grid pattern. The appliqué motifs are outline-quilted. Cora and her mother worked together on a Daughters of the American Revolution pattern quilt in the 1940s (plate 6-98). They were both active members of the DAR. Thus it is not surprising that Cora prized her quilt as well as the ones she inherited from her mother and from her husband's family.[92] The Coxcomb and Berries quilt remains in excellent condition. ■ **Virginia Gunn**

PLATE 5-9. Coxcomb and Berries.
Cora Arabelle Eckles Dinsmore (1904–1983).
New Castle, Lawrence County, Pennsylvania, 1925–1935.
Cottons, 79" x 79.5". QSPI: 10.
1997.007.0942. *Ardis and Robert James Collection.*

PLATE 5-10. Colonial Lady.
Maker unknown.
Possibly made in Ohio, 1925–1945.
Cottons, 103" x 87.5". Unquilted top.
1997.007.0290. *Ardis and Robert James Collection.*

Quiltmakers of the 1930s liked "old-fashioned" Sunbonnet Baby, Overall Boy, and Colonial Lady designs, using scraps left from sewing to outfit the appliquéd figures. Sunbonnet Sue and Overall Bill were adaptations of the illustrations created by Bertha L. Corbett for Eulalie Osgood Grover's children's books, first published in 1902 and 1905.[93] Colonial Lady patterns, however, evolved gradually from a combination of Colonial Revival and Art Deco themes apparent in the world of French fashion during the 1910s and 1920s.

In 1910, the French couturier Paul Poiret decided to give beautifully dressed dolls to clients who made expensive clothing purchases, a trend followed by such other noted designers as Lanvin and Paquin. Recipients displayed the chic dolls in their boudoirs but also carried them to restaurants and theaters as status symbols. Soon the fad spread to other countries. In the United States, manufacturers began to create boudoir dolls, some dressed as modern "vamps" or "flappers," others in historic costumes.[94] *Vogue*, a leading fashion periodical, adopted a colonial lady as its official trademark.[95] Ladies in colonial garb began to grace the covers of needlework magazines.[96] Jeanne Lanvin developed her famous robe de style creations with side panniers as the fashion silhouette became more feminine and romantic during World War I.[97]

Needlework designers and editors took notice of these fashionable trends. The H. E. Verren Company, under its Royal Society trademark, offered a stamped embroidery kit for a Crinoline Girl Doll in 1924. Her wide skirt could be used as a night lamp shade or a telephone cover. As colonial ladies became decorative accessories in bedrooms and living rooms, Royal Society offered kits for boudoir sets in sheer lawn or organdy. One set featured a bonneted flower girl standing in a garden. Another set had a lady, whose face was hidden by her bonnet, with a long ruffled skirt and matching parasol.[98] *Needlecraft Magazine* offered numerous versions of embroidery sets for Colonial bedrooms throughout the 1920s. Editors noted that "the little colonial lady who plays the leading part as a repeating motif will take any place assigned to her." She appeared on a variety of textiles intended to create "a most delightful atmosphere, redolent of 'the good old colony days.'"[99] Other needlework designers and publications offered their own "Modern Versions of Colonial Designs."[100]

McCall Needlework magazine also presented appealing Colonial patterns in the 1920s: Bonnet Girl bedspreads, Colonial Lady dresser sets, boudoir dolls and clothes, and a "smart dresser doll of French chic."[101] In summer 1925 *McCall Needlework* illustrated an appliquéd and embroidered bedspread featuring a

For the Needed Touch of Color Here and There

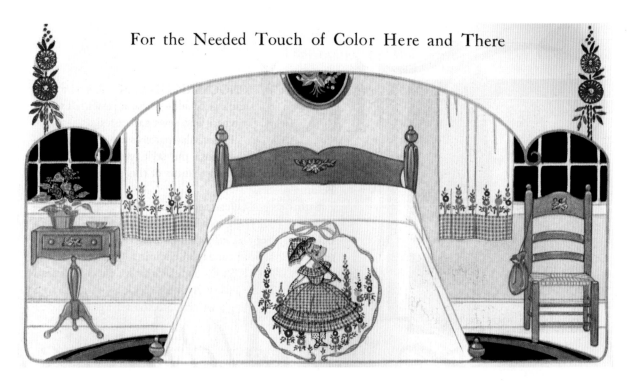

FIG 5-17. Designs for Gingham Girl bedspread and curtain borders, *McCall Needlework*, Summer 1925. Courtesy of Virginia Gunn Collection.

OPPOSITE: FIG 5-18. Colonial Lady, *detail*.

"quaint lady in her garden" of hollyhock flowers. Her full skirt, edged with ruffles, is slightly short, revealing her shoes and pantalettes. A ruffle encircles her low neckline. A wide-brimmed bonnet hides her face, and she carries a fringed parasol. This central medallion is framed by a circle of ribbon ending in a blue bow. *McCall Needlework* offered another version of this Appliqué Girl, wearing a gingham dress, in 1928.[102]

By the early 1930s, companies creating quilt patterns and kits began to offer Colonial Lady designs. The Rainbow Quilt Company created one they described as "quaint and demure in her colonial hoop-skirt."[103] An unofficial pamphlet offered a pattern for the Old Fashioned Lady from a quilt shown at the 1933 Century of Progress exhibition.[104] Virginia Snow Studios sold a "Grandma Dexter" stamped block for a Colonial Girl, with a pose very similar to the *McCall Needlework* version. It also designed a popular series of six Colonial Ladies—holding a parasol, cane, flowers, fan, basket, or book—which were copied into the 1950s and 1960s.[105]

With dozens of ideas to choose from, the unknown maker of this Colonial Lady quilt top (plate 5-10) made her own original interpretation of this stylish motif. She seems very aware of fashionable trends, even though her needlework indicates that she was not ex-

perienced at appliqué. Instead of using scraps, she chose a dramatic black-and-white color scheme for each of her sixteen repeated blocks and the triple lattice strips that separate them. This striking combination was seen in fashion, in the decorative arts, and in the Colonial silhouette cross-stitch patterns popular in this era.[106] Her lady's pose is similar to the patterns offered by Virginia Snow Studios and *McCall Needlework*, but the size and rectangular shape of her blocks, the penciled outline of the design, and the awkward curves of the arms indicate that she made her own design. The skirt on her lady has been shortened to reveal stylish pumps, not pantalettes, and its streamlined flare with vertical lines speaks of the 1930s rather than colonial or Victorian ruffles. Her lady's bonnet looks like the wide-brimmed cloche hat worn in the late 1920s and early 1930s. The hollyhocks are an Art Deco modern interpretation. Tiny pearl buttons on the front of the bodice add another fashionable touch. This is definitely a modern Colonial Lady.

■ **Virginia Gunn**

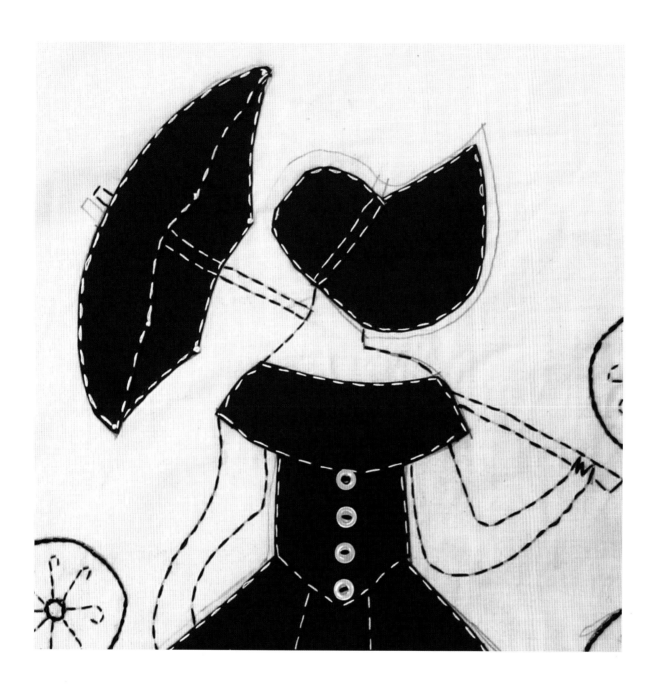

PLATE 5-11. Wagon Wheel.
Maker/location unknown, dated 1926.
Cottons, 77.5" x 88". QSPI: 6-7.
2003.003.0315. *Jonathan Holstein Collection.*

The Wagon Wheel pattern emerged as a modern favorite in the early Colonial Revival period, from 1890 to 1920. It conjured up images of the migration of settlers from the colonial states of the East to the newly formed western states. Pioneers gradually spread across the continent in covered wagons, their iron-rimmed wooden wheels following the overland trails. They headed to Ohio, Indiana, and Illinois and then on to Iowa and Minnesota. They crossed the Missouri River into Kansas and Nebraska Territories and braved the trails across the Rocky Mountains into the Far West. The Wagon Wheel pattern signified that post–Revolutionary War pioneer mothers as well as pre–Revolutionary War colonial women were to be honored in the new Colonial movement.

The Wagon Wheel pattern was a particularly favored pattern for fundraising quilts. Women solicited donations and embroidered the names or signatures of the donors on the spokes and rims of the wagon wheels that covered the quilt top.[107] They also made entirely embroidered versions of this design for fundraising quilts, the embroidered names actually forming the spokes and rim of each wheel (see, for example, plate 7-60).[108] Makers of these quilts often belonged to Protestant (very often Methodist) ladies' aid societies. They used the funds generated to carry out worthy projects for their churches. In her research on fundraising quilts, Dorothy Cozart found that the primary focus of fundraising quilts in the early twentieth century was on the signatures. She noted, "In the majority of quilts the embroidered signature's placement created the design. The embroidered circular shape, usually

in a wheel design, was used most often . . . as was red embroidery thread."[109] The second favorite color was blue. The Turkey red or indigo blue shades of embroidery thread were colorfast, and thus the lucky winner of a fundraising quilt could be assured that her prize would wash successfully if she wished to use it.

In what historians call the Progressive Era, roughly 1890 to 1920, active women used a variety of strategies to further the causes they believed in.[110] Not allowed to vote except in a few local and state elections, they used their creativity to effect change and raise funds needed to support their work and causes. They put on fairs, bazaars, and parties and collected donations for signature quilts to be drawn as prizes or raffled for additional money. They often used colonial themes. A tableau featuring "pretty, fair-haired Priscilla, dressed in Quakerish gray, with a little cap and kerchief, sitting whirling a spinning-wheel," reminded women that their colonial and pioneer foremothers had also worked and sacrificed for their families and the causes they believed in.[111]

The dramatic red and white Wagon Wheel quilt in the International Quilt Study Center collections (plate 5-11) has no signatures. The maker interpreted the pattern in a bold and direct spirit, giving it a modern appearance while honoring the past. Quiltmakers in the United States were increasingly influenced by the stylized design trends that were brought to prominence by the Exposition des Arts Décoratifs et Industriels Modernes hosted by France in 1925, from which the term Art Deco is derived. This Wagon Wheel quilt is more stylized in presentation than some of the earlier versions. The eight red spokes separated by eight white spaces create a powerful contrast. The maker boldly embroidered the date "1926" in black chain stitch on one of the bright red squares of the side borders.

The design is completely hand-appliquéd on a one-piece muslin background. Even the flying geese border is appliquéd rather than pieced. The quilting is very simple but effective. The border triangles and the wagon wheels are outlined, and the background is filled with a diamond grid. The maker finished her quilt with a serrated treatment. The edges of the quilt are turned in and stitched, enclosing the trim that is formed of alternating red or white folded points. In the 1970s revival of colonial themes, women admired this edging and called the folded triangles "prairie points."

■ Virginia Gunn

FIG 5-19. Wagon Wheel, *detail*. Embroidered date.

Eulalie E. Woodhouse's name and the dates "1891–1928" are boldly emblazoned on this vibrant red and white Burgoyne Surrounded quilt (plate 5-12). Eulalie Elaine was born on June 5, 1889, in Phelps, Ontario County, New York. She moved with her parents, Edward A. and Addie I. Fish Woodhouse, and her older brother, Ira, to Newark, Arcadia Township, Wayne County, New York, in 1891. On August 29, 1908, at age nineteen, she married Charles A. Ebertz. Their son, Charles Dexter, was born in about 1910. Eulalie's husband died in 1926. About three years later she married Reitz Beeman and was living with him and her son in the village of Newark when the 1930 census was taken in April.[112]

The quilt features Eulalie's maiden name, the only part of the design done in a printed red fabric, even though she was married and widowed before it was completed. According to her granddaughter, Andrea Coleman, Eulalie was not a quiltmaker. She probably worked at and then ran her first husband's grocery store; as the automobile became more common she operated a gas station at her corner location. Her granddaughter believes the quilt was made for Eulalie by her mother, Addie. Addie may have started it in 1891, when their family moved to Newark. Perhaps she completed it in 1928, when she was sixty-seven years old, as a gift of love and support for her recently widowed daughter. Some questions remain unanswered, but there is probably a reason the quilting stitches on this intricately pieced quilt are small though the quilting design is rather simple and imprecise. Much of the quilting simply outlines shapes. Irregular diagonal quilting, marked with pencil lines, fills in the lattice areas between blocks and lettering. The edge is finished with applied bias binding.

The quilt is an outstanding Colonial Revival quilt, very appropriate for a family living in the state of New York, where there was a tradition of incorporating names and dates in large pieced letters on quilts. They are found, for example, on the Joseph and Deborah Wildman quilt, Castile, New York, 1833; on the Jane D. Waldron quilt, Castile, New York, 1848; on the Eliza S. and Andrew F. Finch quilt, Nassau, New York, 1853; and on the Cornelia Catharine Vosburgh quilt, Red Hook, New York, 1874.[113]

FIG 5-20. Addie (far right) and Eulalie (far left) Woodhouse and family, c. 1913. Courtesy of Andrea Coleman.

PLATE 5-12. **Burgoyne Surrounded.**
Probably made by Addie I. Fish Woodhouse (1861–1943).
Probably made in Newark, Arcadia Township,
Wayne County, New York, c. 1928.
Cottons, 88.5" x 72". QSPI: 9.
1997.007.0485. *Ardis and Robert James Collection.*

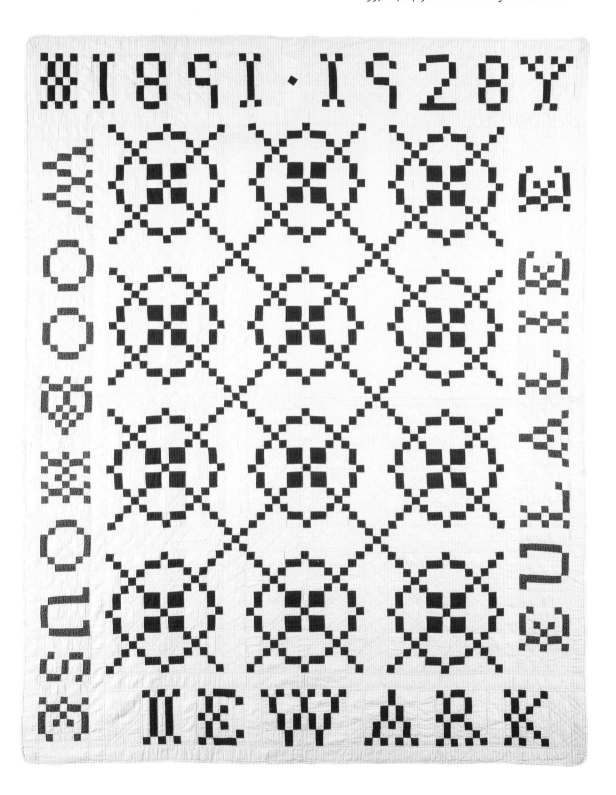

The choice of the Burgoyne Surrounded pattern was also meaningful to a New York family. The title commemorated the surrender of Gen. John Burgoyne of the British Army to Gen. Horatio Gates of the American forces on October 17, 1777, following the battle of Saratoga. The large American force surrounded Burgoyne's troops, which had taken refuge on the heights of Saratoga, north of Albany, New York. This decisive victory was a turning point of the American Revolution.

The Burgoyne Surrounded design, a striking geometric motif, interprets historic weaving patterns found on early nineteenth-century double-weave or summer-and-winter coverlets. Numerous coverlets had been produced in northern New York. Like quilts, these coverlets were highly desirable textiles for interpreting Colonial Revival themes. As Jane W. Guthrie pointed out to readers of *Harper's Bazar* in her 1905 article "Old Fashioned Counterpanes," "The household industries that have excited the most ardent admiration of the woman of to-day, and upon which she has eagerly seized for their decorative effects are the patchwork quilts and the old blue and white homespun coverlets. . . . In themselves possessing a quaint and peculiar charm, their artistic value is much enhanced when placed, as they should be, among harmonious surroundings—the furniture of the Colonial and Revolutionary period."[114]

Martha A. Page made a beautiful signed quilt of this pattern in 1852, surrounding her geometric design with an appliquéd grapevine border. Marie Kin-more of Tomah, Wisconsin, made a red-and-white version of this design in 1857.[115] Ruth Finley owned an early quilt of this pattern, its allover design pieced in dark blue and white cotton. She reported that the pattern was known as the Wheel of Fortune before 1850, but by 1860 people in northern Ohio, where her quilt probably originated, referred to it as the Road to California.[116] As this design returned to favor in the Colonial Revival period, quiltmakers seemed to prefer the name with revolutionary connotations. A small booklet of quilt designs published in 1914 by the *Household Journal* in Springfield, Ohio, labeled the pattern Burgoyne Surrounded.[117] The quilt book author Alice Beyer used the term Burgoyne's Surrender in 1934.[118]

The Stearns and Foster Company copyrighted their version of the pattern in 1932. They called it Homespun and featured it on their quilt-batting wrappers in red and white. Advertisements stated that the design came from "covered wagon days" and explained, "In their log cabins, by firelight or candlelight, women pieced quilts like this from worn calicoes and cloth of their own dyeing. Reminiscent of those pioneers who brought civilization into Ohio, across the Mississippi, and to the Pacific Coast, this new Mountain Mist Quilt is called 'Homespun.'"[119] Savvy entrepreneurs interpreted Colonial Revival to include both eastern colonial women and western pioneer women as the foremothers of the modern generation.

■ **Virginia Gunn**

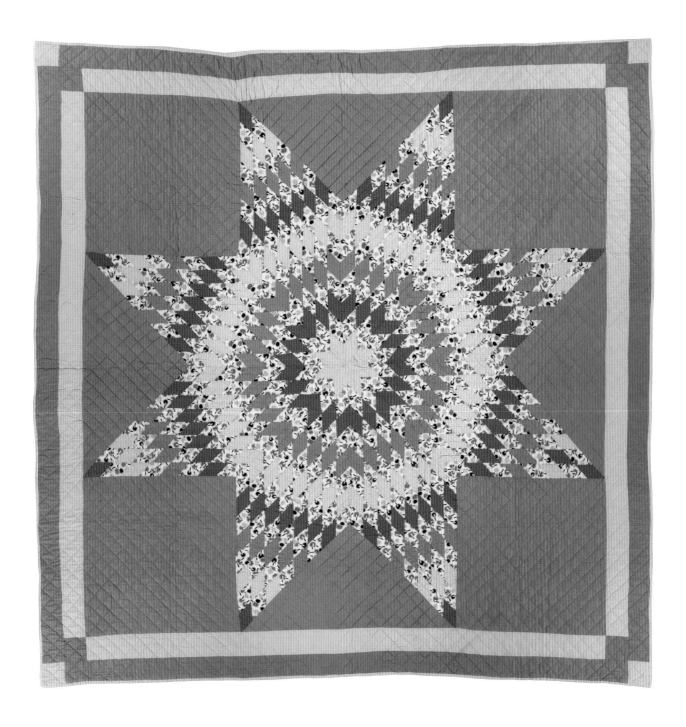

PLATE 5-13. Lone Star.
Christine Heide Sorensen (1890–1997).
Rockville, Nebraska, 1928–1930.
Cottons, 83" x 84". QSPI: 8.
1998.005.0001. *Gift of Gladys E. Sorensen.*

By the 1920s, Lone Star had become the favorite name for a large single-star quilt. The Ladies Art Company chose that name for its version of the design introduced in its 1928 catalog.[120] Midwesterners Carrie A. Hall and Rose G. Kretsinger included two Lone Star quilts, one made in 1910 and one dated 1929, in their book *The Romance of the Patchwork*

FIG 5-21. Christine Sorensen, c. 1955.
Courtesy of Gladys E. Sorensen.

FIG 5-22. Lone Star, *detail*.

Quilt in America, published in 1935.[121] The Needle-craft Supply Company, which sold ready-cut pieces for Lone Star quilts in an assortment of rainbow colors, declared in 1938 that there was "no other patchwork quilt, either of old Colonial design or of more modern times that has won more prizes at quilt exhibitions than this beautiful quilt."[122]

Christine Sorensen made her own version of a Lone Star quilt (plate 5-13) sometime between 1928 and 1930, when her three young children ranged in age from two to eight years. Christine lived in the small town of Rockville, Nebraska (population 240), and traveled to Grand Island to purchase her fabric at the J. C. Penney store. Her favorite clerk, Bertha Pat, helped her pick out the plain fabric to match the print scraps she had left after making matching dresses, edged with bias tape, for herself, her two daughters, and a niece. Christine liked bright colors, and the Nile green, canary yellow, and dark orange solids they selected coordinated perfectly with the leftover print material in a modern combination of green, yellow, orange, black, and white. She announced to her family that she intended to make a star quilt. Her children later thought she may have gotten the directions from *Work Basket* magazine.[123]

Christine pieced the diamond shapes of the star together on her White treadle sewing machine. When she had completed her top, members of the Ladies' Aid of the Community Church did the quilting in the family's living room. Christine's husband had a local carpenter build the eight-foot quilting frame, and the ladies sat on both sides of it to quilt, rolling as they completed each section. Her children remember that "lots of talking and visiting went on while the quilting was being done. Lunch was always served after an afternoon of quilting."

Christine referred to her quilt as the Lone Star and used it as a bedspread in the guest room. Her children note that it was "never used as a regular quilt. It was more to look at and enjoy." This explains the light pencil marks remaining on the quilt's surface and the excellent condition of the quilt three-quarters of a century later.

Although quiltmaking was a "big pastime for women in the small community of Rockville," Christine's daughter Gladys believes this was the only quilt her mother made. She rolled and saved the numerous scraps left from sewing most of the family's clothing and then used them for smaller items such as doll clothes and patchwork pillow covers. She also knitted hundreds of afghans and lap robes for family and friends. In her later years she crocheted thousands of butterfly refrigerator magnets for gifts, staying active in the needle arts until two years before she died, at the age of 107.

Christine's Lone Star quilt is composed of 512 diamonds. Slight variations in the size of the diamond shapes indicate that she cut the pieces herself. She used the Nile green fabric for her background and framed the quilt top with an inner yellow border with green corners and an outer green border with yellow corners. She chose the brilliant canary yellow fabric for the backing. The quilting was done in simple grid patterns, a one-and-a-half-inch square grid in the background, and a diagonal grid running through the centers of each diamond shape. Her experienced friends made neat quilting stitches, about eight to the inch. The edge was finished by bringing the yellow backing fabric to the front and hand-hemming it in place. This touch of yellow provided the perfect accent to complete the quilt border.

Christine's bright and cheerful, well-cared-for quilt serves as a reminder that the urge to participate in the Colonial Revival permeated most households in the United States by the time the Great Depression was beginning to be felt. Thrifty, hard-working women took the time to make the stylish quilts that tastemakers declared most suitable for special bedrooms. They enjoyed friendship and family support and the hours of pleasure associated with making, using, and giving quilts and other textile arts.

■ **Virginia Gunn**

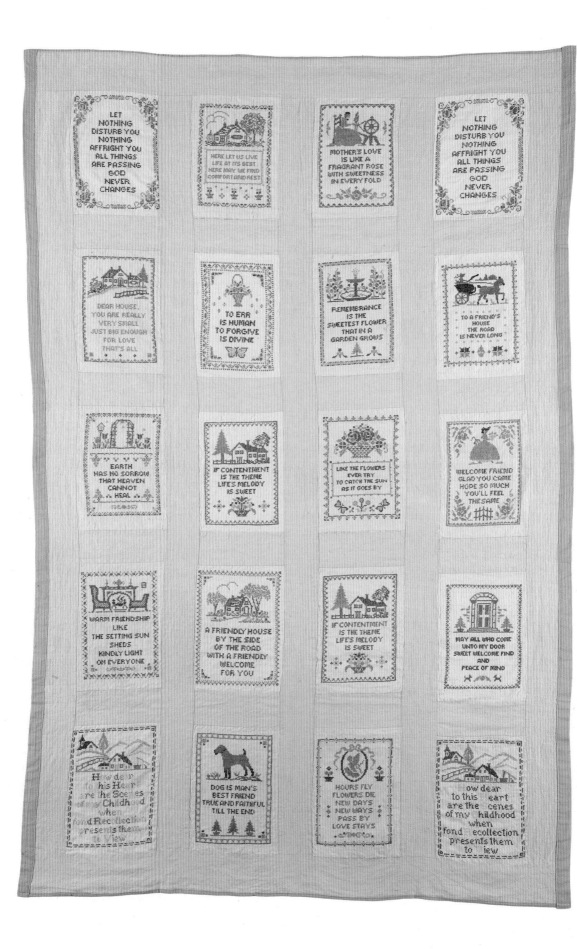

This unusual quilt (plate 5-14) is a scrapbook of Colonial Revival samplers that women in the United States made in large numbers during the 1930s and 1940s. These old-fashioned samplers were offered as replicas of genuine antiques and were guaranteed to "add period feeling to an early American interior."[124] Like the schoolgirl samplers of the eighteenth and early nineteenth centuries, they were done in cross-stitch on linen backgrounds. There were significant differences, however. The designs were already stamped on the background, rather than counted out, and they were embroidered in cotton rather than silk or linen threads. Instead of alphabets and passages dwelling on mortality and religion, modern samplers featured "messages of friendship and welcome."[125] Early samplers were displayed in homes, much like a diploma, to attest to the maker's training and skill in domestic arts. Modern samplers were designed "for definite rooms in the homes," and appropriate mottoes were "thought out" for use in entrance halls, living rooms, dining rooms, bedrooms, and kitchens. While the majority of samplers were framed in narrow black molding or in frames painted to "fit into the room color-scheme," tastemakers also suggested inserting them in glass-top serving trays and mirror panels.[126]

Knowing that needleworkers might shy away from completing the "massed stitchery" found on traditional samplers, sampler designers "deliberately planned to keep the work open. They are the sure-to-be finished kind, with no tedious spots to slow up the progress of the picture." For best results, designers suggested keeping the top threads of each cross-stitch running in the same direction and making "each stitch meet its neighbor," not always easy when following stamped lines rather than counting threads. A completed sampler was said to be "a definite accomplishment, a permanently lovely thing to own, or to give to one who will cherish it."[127]

The maker of this Sampler Album quilt decided to

place twenty of her embroidered samplers together in a quilt. She chose linen fabric, of higher thread count than the blocks, for the sashing and borders. Though she obviously liked to make samplers, she was not a perfectionist. Her bright cotton embroidery stitches do not meet each other. She did not pay attention to grain line before attaching the sashing strips and the borders. The gray binding, formed by folding the cotton backing fabric to the front and stitching it down by machine, is narrower on the ends than on the sides. The quilting, in large stitches, is done in widely spaced horizontal lines over the samplers, with a basic cable motif in the sashing and borders.

Her imperfection in joining the samplers allows us to see the stamps left on the edges of two of the samplers. The edge of one sampler is stamped "No 1049—PURE LINEN COLONIAL SAMPLER F34 VOGUE N. CO." The other sampler's stamped edge, partially revealed, reads "COLONIAL SAMPLER VOGART NY." Vogart needlework products were often sold at five-and-dime stores such as the S. S. Kresge Company, the J. J. Newberry Company, and the F. W. Woolworth Company. These stores also distributed seasonal catalogs of the latest offerings. Needlework magazines, such as *McCall Needlework* and *Home Arts-Needlecraft*, also offered samplers. A variation of the Colonial Lady driving a buggy with the motto "To a Friend's House the Road is Never Long" was offered in 1940 by the Needlecraft Company at 15 cents for the sampler and 15 cents for the colorful embroidery floss.[128]

The maker of this Sampler Album quilt has preserved seventeen sampler patterns (three are repeated) that are an excellent record of the types of motifs and mottoes favored by women in the mid-twentieth century. The emphasis is on the welcoming home; seven blocks feature cozy small houses, one a colonial doorway, and another has a warm fireside scene. Flowers are also important; there is a garden arch, a garden fountain, and two popular basket motifs, the Biedermeier basket of roses and flowers and the Art Deco tall basket with handle and flowers. Colonial ladies are also prominent, driving a buggy, sitting at a spinning wheel, holding a bouquet, and in bonneted silhouette on the wall, framed and trimmed with a fashionable blue bow. In homage to men and modernity, one sampler has a terrier, a favorite dog of the 1930s, with the motto "Dog is Man's Best Friend, True and Faithful to the End." It was probably designed to be used in a den. Modern samplers were intended to "conjure up mind pictures of the past."[129] This interesting quilt provides windows onto both the colonial and the Colonial Revival eras.

■ **Virginia Gunn**

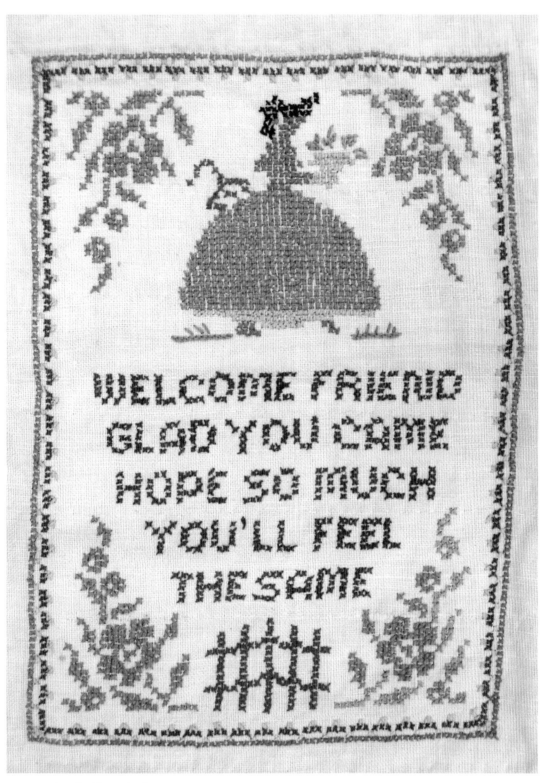

FIG 5-23. Sampler Album, *detail*.

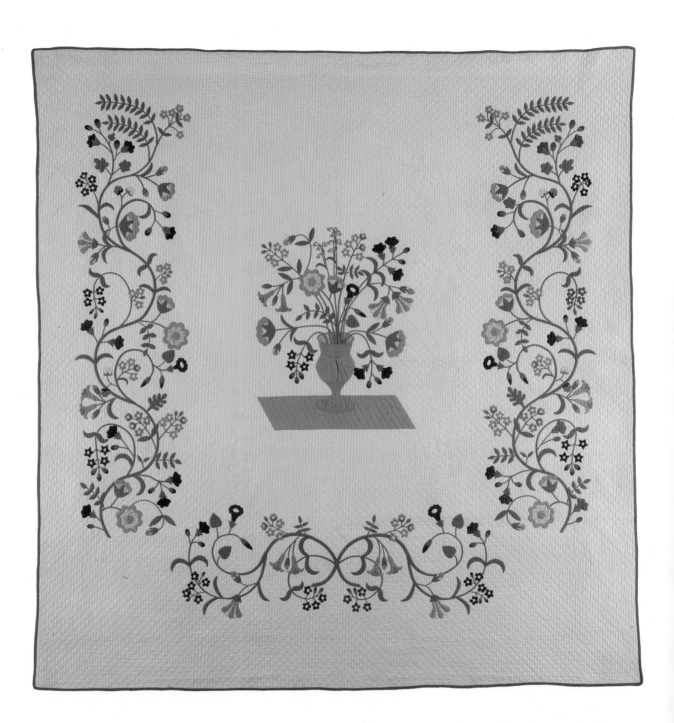

PLATE 5-15. Vase of Flowers.
Maker/location unknown, 1935–1950.
Cottons, 90.5" x 86.5". QSPI: 13-14.
1997.007.0722. *Ardis and Robert James Collection.*

OPPOSITE: FIG 5-24. Antique Urn made
by Laura May Clarke, c. 1935–1939.
Courtesy of Michigan State University Museum.

The appliqué on this meticulously made Vase of Flowers quilt (plate 5-15) is done in tiny, almost invisible stitches along the smooth curves, sharp points, and narrow stems of the floral elements. The quilting stitches are small and even, thirteen or fourteen to the inch. They outline the appliqué, surround the vase with a feathered vine, and fill in the background with a diamond grid.

The flower-filled vase reminds us of the famous block-printed designs created by John Hewson in Phil-

adelphia between 1774 and 1810. The bedspreads and quilts incorporating portions of his central-medallion design, with its prominent urn of flowers surrounded by floral motifs, are highly prized.[130]

The central-medallion arrangement, inspired by "tree of life" palampores imported from India, also appears on crewel-embroidered bed hangings made by colonial women, especially those living in New England. They modified traditional English Jacobean embroideries, creating simpler interpretations of the floral motifs for bedspreads and valances. They embroidered with hand-spun and home-dyed crewel wool yarn on handwoven linen fabric. The earliest designs were often carried out in shades of indigo blue and white, with shades of pink, green, yellow, and brown added to later work.[131]

In the mid-1890s, as the Colonial Revival movement was gathering momentum, two young women who had studied art together at the New York Academy of Design returned to their homes in Deerfield, Massachusetts. Both Margaret Whiting and Ellen Miller had already written and illustrated books. Impressed with remnants of eighteenth-century crewel work done in that small village, they set out to revive the colonial art of blue and white embroidery. They founded the Deerfield Society of Blue and White Needlework in 1896, using flax for both the stitchery and the fabric. The cottage industry they founded participated in numerous exhibitions and helped to foster a revival of other crafts in Deerfield. Whiting and Miller studied old embroideries in private collections and reproduced and adapted designs for modern use. Several of the bed-hanging designs they revived feature a central vase of flowers surrounded by long floral borders formed of reversed curves. World War I put a damper on the society's work, but the women carried on until 1926.[132]

Georgiana Brown Harbeson, an embroidery artist and expert on American needlework history, called attention to "the simple charm of the finely stitched, quaintly patterned, and beautifully colored crewel embroideries of early colonial days" in her 1938 book, *American Needlework*. She included a picture of an eighteenth-century valance with a running floral vine and also called attention to the early revival work of the Blue and White Society, illustrating a bed curtain pattern with a central vase and curved vines, courtesy of Margaret Whiting.[133]

By the 1930s American women had renewed their interest in English crewelwork, or Jacobean embroidery. Tastemakers found it a perfect choice for both Colonial Revival and Tudor Revival houses. Christine Ferry reported in a 1935 issue of *American Home*, "During recent years crewel embroidery has once again become popular with needleworkers and decorators have employed it in various ways—for cushions, screen panels, and hangings, as well as for upholstery." She further noted, "The varied coloring of the embroidery looks particularly well when contrasted against the neutral coloring of a linen twill background."[134]

It was in this period that an unknown, talented quilt designer worked out the pattern for this Vase of Flowers quilt that interprets the spirit of crewel embroidery in appliqué.

The Michigan State University Museum has a remarkably similar Antique Urn quilt made by Laura May Clarke and quilted by Bozena Vilhemina Clarke, circa 1935–1939. The two women "shared the cost" of the $3.50 pattern, and their beautiful quilt won a prize in the 1940 *Detroit News* Quilt Show. The museum has the "prize ribbon, entry form, templates used in the design, and the congratulatory letter" they received.[135]

One quickly notices, however, that the Clarke quilt and the International Quilt Study Center quilt are not identical. The color palette on the Center's Vase of Flowers quilt has the darker and grayer tones gaining favor in the late 1930s and early 1940s. The maker of the Center's quilt used a rectangular form rather than an oval under the vase, used a straight rather than a scalloped edge, and did not place a floral vine at the top of the quilt. Closer inspection reveals that her floral vine is formed of a mirror-image symmetrical arrangement, whereas the vine on the Clarke quilt is asymmetrical. The side vines on both quilts share some identical floral motifs, but there are also variations in design elements and placement. It is obvious that talented quiltmakers of the 1930s and 1940s could successfully modify and interpret professional patterns, just as their colonial ancestors had done. Although we do not know the maker of this magnificent revival quilt, it meets the highest standards of beauty and workmanship.

■ Virginia Gunn

The maker combined old and new materials to make this unusual Star and Chintz Album appliqué quilt (plate 5-16). She gave a nod to tradition by recycling antique pieced stars and by replicating the method of chintz appliqué found on quilts dating from the late eighteenth and early nineteenth centuries. The hand-pieced six-pointed stars with hexagon centers are joined template fashion with overhand stitches and are carefully attached to white background squares. They embody a variety of high-quality fabrics from the 1840–1860 period.

The quiltmaker may have been practicing what the quilt historian Florence Peto called a "preservation" motive, designing a quilt to "accommodate the surviving fragments" of treasured old prints. Peto followed this philosophy herself, incorporating "surviving fragments of rare, historic American prints" in quilts that she made. She urged women to look for such fabrics in "antique shops, antique shows and perhaps one's own attic" and to rescue them "from oblivion or destruction."[136]

"Making something out of nothing" was a phrase Peto and others of her generation had heard often from their mothers and grandmothers. It was particu-larly appropriate in the Depression era and war years, when women had to make the most of what they had for economic and patriotic reasons as well as for sentimental or historical reasons.[137] "Make it over, Wear it out, Make do, or Do without" was an oft-repeated refrain. It told of hard times but also encouraged women to find creative ways to recycle materials and to solve the inescapable problems of the times.

Peto authored two influential books on antique quilts: *Historic Quilts*, published in 1939, and *American Quilts and Coverlets*, published in 1949.[138] She wrote for women's magazines and lectured widely on the history of quilts, illustrating her talks with examples from her own collection.[139] She wanted to connect the story of each quiltmaker, her family and her community, with her needlework. Peto's presentations and publications increased the nation's appreciation for historic quilts, and she helped museums develop important collections. At the same time, she encouraged modern women to use antique quilt designs and historic techniques in new ways.[140]

To alternate with her star blocks, the maker of this quilt created blocks with hand-appliquéd motifs cut from Colonial Revival chintz fabric. Her floral chintz

FIG 5-25. Star and Chintz Album, *detail.* Mid-nineteenth-century template-pieced star.

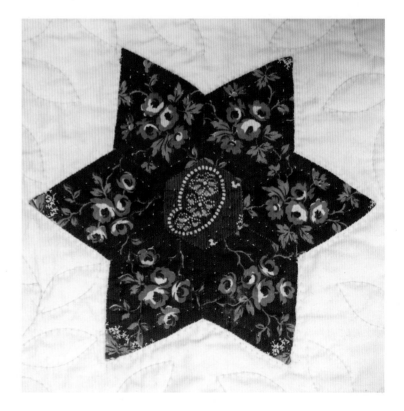

PLATE 5-16. Star and Chintz Album.
Maker unknown.
Possibly made in Pennsylvania, 1935–1955.
Cottons, 84.5" x 82". QSPI: 7-8.
1997.007.0387. *Ardis and Robert James Collection.*

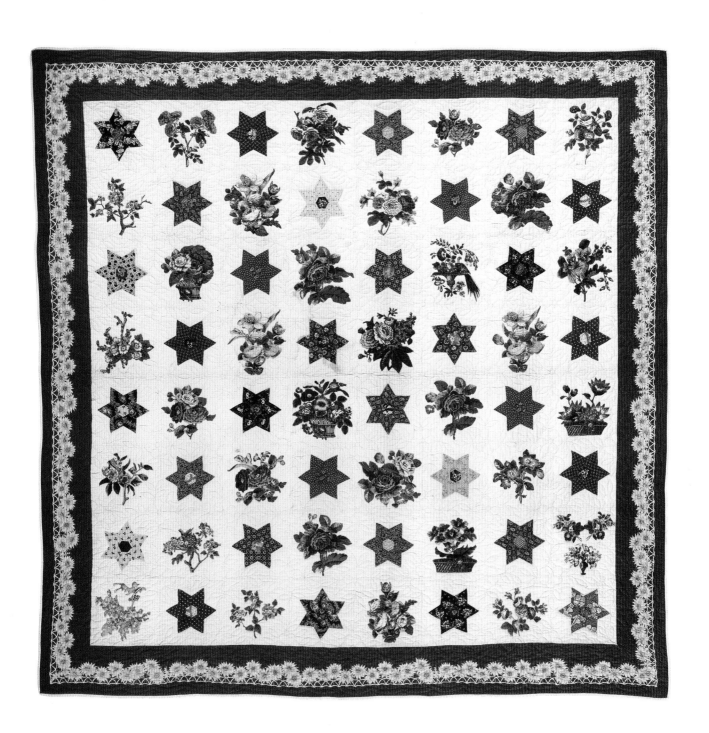

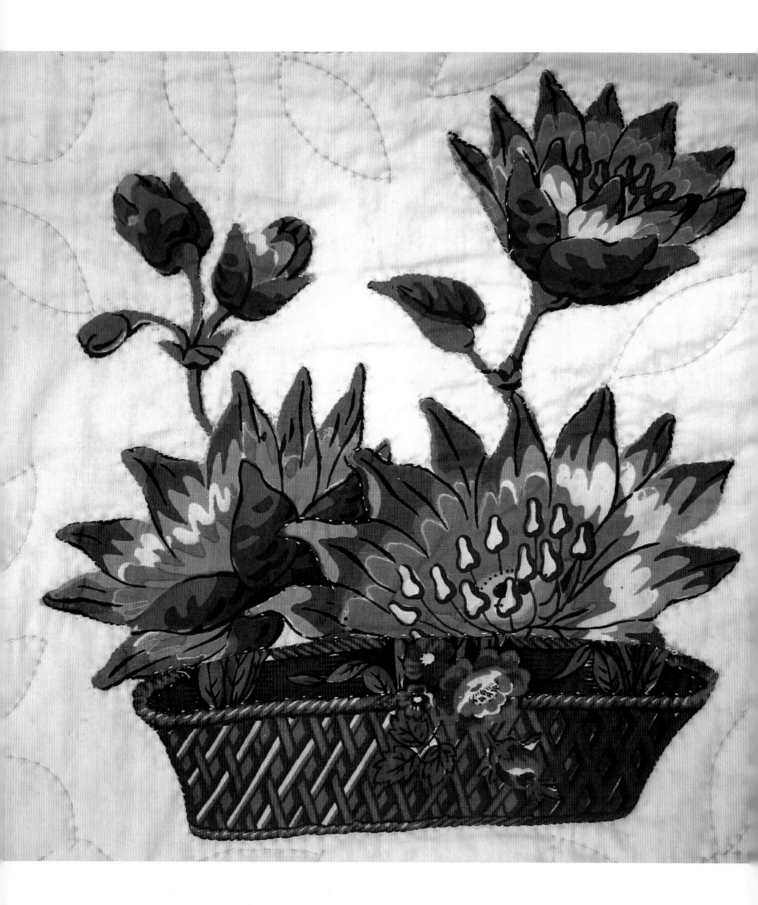

fabric features bleeding hearts, morning glories, nasturtiums, roses, and other old-fashioned garden flowers popular for home decorating during the period.[141] By the 1940s chintz was a favorite fabric for "curtains, draperies, furniture covers, dressing table skirts," dresses, housecoats, and smocks. The bright chintz prints were often semi- or fully glazed. Many of the glazes could wash out, but manufacturers had also perfected permanent chemical glazes.[142] Clark's "Everglaze" chintz, for example, was made of "fine close-woven American cotton, processed to be water-repellent, mildew-resistant, color-fast and wonderful for wear."[143] The new chintz fabrics must have inspired quiltmakers to try their hand at the type of appliqué their grandmothers sometimes called "broderie perse" work.[144]

This maker cut out, combined, and arranged her floral components to create a unique design for each chintz block. She then combined her star blocks and chintz blocks in a pleasing checkerboard fashion and framed the center field with a border-print fabric featuring yellow daisies and white garden edging on a red ground. Bright border prints were popular in this era and designed to be used on the edges of skirts, curtains, and pillowcases.

The quilting pattern was carefully thought out, and light pencil marks are still evident on the quilt's surface. The stars and the chintz appliqués are outlined, and the white background is quilted in a floral design. A simple six-petal flower is centered at each point where four of the blocks join, and sprigs with three-pointed leaves fan out from the flower in four directions to fill the white spaces and cover the seams. An interesting and effective repeat pattern composed of cables, scallops, and trefoil points runs through the border fabric. This charming Colonial Revival quilt exemplifies what Peto called a successful "melding of the old and new." Peto opined, "It seems a pity a woman's work should survive her identity—surely the quiltmaker is as important as her quilt."[145] Alas, this quiltmaker remains anonymous, but her quilt reminds us of a time when women in the United States took time to create works of beauty and found comfort in remembering and honoring the women of the past who had done the same.

■ **Virginia Gunn**

FIG 5-26. Star and Chintz Album, *detail*.
Colonial Revival–era cut-out chintz appliqué.

Olive Emily McClure Cook, the maker of this English Rose variation quilt (plate 5-17), was born in Union County, Illinois, on April 14, 1862, during the Civil War. She was the daughter of John and Lydia Hargrave McClure and traced her ancestry for membership in the Daughters of the American Revolution back to John Hargrave, her great-great-grandfather on her mother's side. He served in the Revolutionary War as a private from South Carolina. Olive married Louis Heinrich Cook on April 30, 1882, in Jonesboro, Illinois. They soon moved to Cairo, Illinois, where their children were born: B. Irene Cook Nelson (1883–1953), Louie McClure Cook (1889–1890), and Alice Margaret Cook Wilhelm (1893–1983). By 1900 the family lived in Anna, Illinois. Olive was a talented seamstress who enjoyed making fashionable dresses for her two daughters and later special outfits for her grandchildren. She was active in the Evangelical Lutheran church and in the DAR, the American Woman's League, and the Illinois Federation of Woman's Clubs. She wrote articles, gave talks and lessons, and did genealogical research. Louis worked as a tailor in his uncle's clothing store, which he later managed until his death in 1929. After her husband's death, Olive remained in Anna and lived with daughter Alice and her family.[146] During this period she made her striking quilt.

By the 1930s, fashion favored appliqué quilts with color combinations toned down and mellow in color. Pink replaced red as the favorite color in floral appliqué. These quilts blended with the softer color schemes, white and pastel combinations, favored for Colonial Revival interiors. Romantic interpretations of faded quilts believed to be from the colonial era seemed especially appropriate in old-fashioned bedrooms.

Olive used unique combinations of bright red, pink, yellow, and orange in her floral motifs, but she softened the overall appearance. The bright flowers are toned down by the dominant apple green color that forms the stems and outlines each bud or flower and by the open spacing of the central floral vine dividing the four large floral blocks. She also chose to use cotton sateen, a soft fabric with a slight sheen, for her appliqué work. She would have agreed with the editor of *Needlecraft* magazine that "while we appreciate the oldtime designs, there is any amount of enjoyment in the creation of 'something new.'" Olive's interpre-

FIG 5-27. Olive Emily McClure Cook, c. 1901. Courtesy of Cynthia Morris and Tanya Maggs.

tation is certainly contemporary, showing that in her seventies she still embraced new ideas. She followed the advice to take "the opportunity of making it 'different' by exercising one's own tastes or talent in the choice of colors for applying."[147] The total effect is attractive and appealing.

In their 1935 quilting book, Carrie Hall and Rose Kretsinger featured a similar, but more controlled, version of the pattern Olive chose. They called the "modern quilt of Colonial inspiration made in 1931" a Rose Cross Pattern.[148] Olive's four-block arrangement of the rose pattern is based on tradition, but her interpretation of the design is original. Her quilt is playful and has distinctive folk art qualities. Each of the floral motifs is somewhat primitive and stylized. The layered flowers are individual interpretations, not carbon copies, of a pattern. The centers vary in color and shape. The small circular flowers in the borders and central vine look like layered lollipops.

The quilting is likewise free-spirited. The white background is filled with a variety of traditional patterns tucked in the spaces where they fit. Motifs include short lengths of cable, various leaf arrangements, clamshells, and small areas of cross-hatch grid work laid in tick-tack-toe fashion. There is echo quilting around the appliqué. Three sides of the quilt have a scalloped edge, a very stylish choice in the 1930s. Olive, a seamstress who liked to make fancy clothes, would have been aware of the scalloped edges fea-

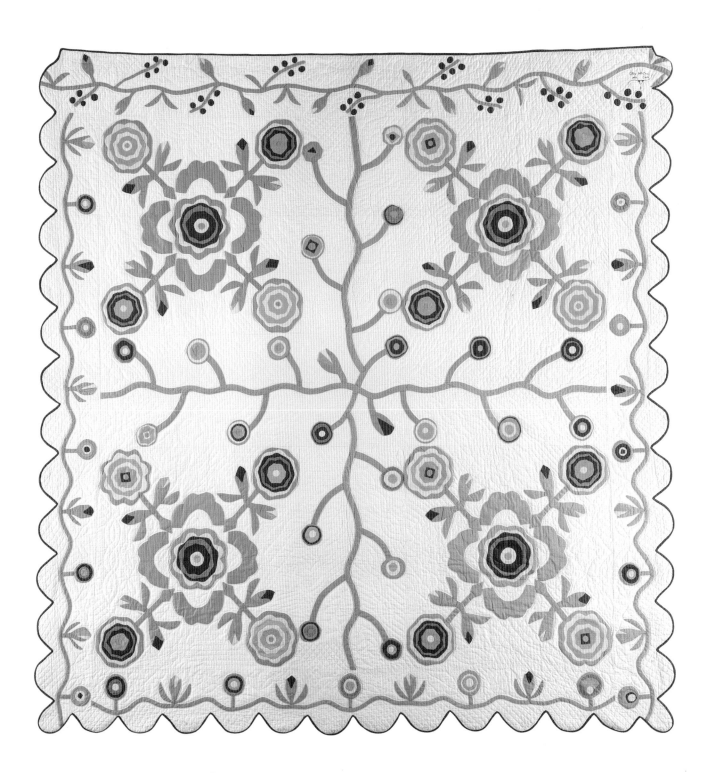

PLATE 5-17. English Rose variation.
Olive Emily McClure Cook (1862–1945).
Anna, Union County, Illinois, dated 1939.
Cottons. QSPI: 8.
1997.007.0669. *Ardis and Robert James Collection.*

tured on quilts by such artists as Eleanor Beard, who advertised regularly in leading fashion and decorating periodicals.[149] Olive finished the scallops with red sateen bias binding. Near the top of the quilt, the artist embroidered her name and the date, "Olive McClure-Cook 1939," in bright red letters, adding an embellished curve as a final artistic flourish.

Olive moved to Kansas City, Missouri, the later home of her daughters, in 1943 and died there on October 25, 1945. She is buried in Illinois beside her husband. This great-great-granddaughter of a Revolutionary War veteran completed a distinctive Colonial Revival quilt that interpreted traditional art in a modern spirit. Her work remains as a testimony to women of all eras who found time to create beauty in spite of all the changes and challenges of life.

■ **Virginia Gunn**

FIG 5-28. English Rose, *detail*. Embroidered name and date.

GALLERIES

The Woven Coverlet Influence

Quilt patterns influenced by late eighteenth- and early nineteenth-century geometric woven coverlet designs were popular in the Colonial Revival era.[150] Although a Colonial lady seated at a spinning wheel became one of the best-known icons of the period, most modern women preferred to piece quilts rather than spin yarn and weave coverlets. Quilts that reflected the coverlet aesthetic were viewed as prime choices for a Colonial-style bedroom. The Burgoyne Surrounded pattern was a favorite, but Irish Chain variations and Nine Patch variations, which formed diagonal grids over the surface of a quilt, were also fashionable. Patchwork quilts that resembled handwoven textiles conjured up the mystique inherent in "old blue and white homespun coverlets." As Jane W. Guthrie noted in the August 1905 issue of *Harper's Bazar*, these "old fashioned counterpanes" possessed a "quaint and peculiar charm" as well as "artistic value."[151]

PLATE 5-18. Burgoyne Surrounded.
Possibly made in West Virginia, 1935–1945.
Cottons, 84" x 58". 1997.007.0177.

PLATE 5-20. Double Irish Chain variation.
Made by Abbie Bell Dinsmore, Lawrence County, Pennsylvania, 1920–1940.
Cottons, 85" x 83.5". 1997.007.0951.

PLATE 5-19. Burgoyne Surrounded.
Maker/location unknown, 1900–1920.
Cottons, 86" x 69". 1997.007.0395.

PLATE 5-21. Double Irish Chain.
Maker/location unknown, 1900–1920.
Cottons, 68" x 66.5". 2003.003.0364.

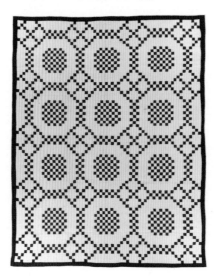

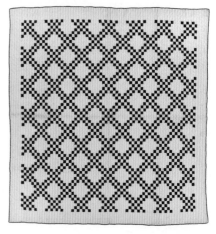

The Woven Coverlet Influence

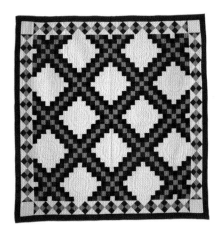

PLATE 5-22. Triple Irish Chain.
Possibly made in northeastern Ohio,
1880–1900.
Cottons, 75" x 72.5". 1997.007.0012.

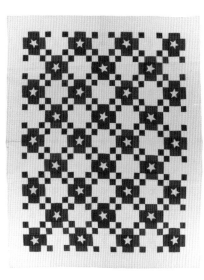

PLATE 5-24. Nine Patch variation.
Possibly made in Holmes County, Ohio,
1935–1945.
Cottons, 94" x 73". 1997.007.0370.

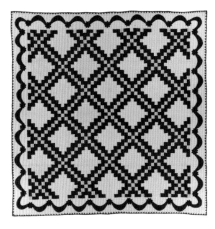

PLATE 5-26. Triple Irish Chain.
Possibly made in Pennsylvania, 1880–1900.
Cottons, 84" x 83". 1997.007.0787.

PLATE 5-23. Double Nine Patch.
Probably made in Pittsburgh, Pennsylvania,
1880–1900.
Cottons, 83.5" x 73.5". 1997.007.0363.

PLATE 5-25. LeMoyne Star.
Possibly made in Ohio, 1900–1920.
Cottons, 78" x 71". 1997.007.0663.

PLATE 5-27. Triple Irish Chain.
Probably made in Pennsylvania, 1880–1900.
Wools, 84" x 83". 2003.003.0023.

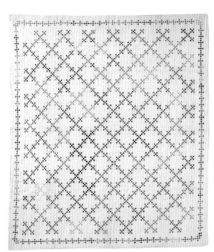

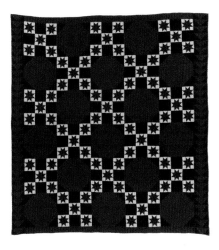

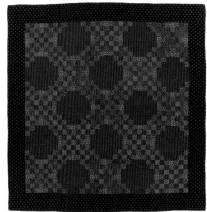

Pine Tree Designs

The Pine Tree design found wide appeal in the Colonial Revival era. This well-known pattern, with its colonial roots on the East Coast, continued to resonate with quiltmakers all across the country. Some species of pine tree flourished in almost every state, whether the terrain featured woods, hills, mountains, or prairie. The tree symbol reminded families of their ancestors' efforts to clear land, to build and establish homes, and to stand tall and fast when strong winds blew. It was a common motif on nineteenth-century coverlets, which were pulled out of old trunks during this era of looking to the past. Quiltmakers enjoyed the challenge of piecing this distinctive design, usually arranging the finished tree blocks in orderly rows surrounded by simple borders. They favored two-color combinations: blue and white, red and white, or green and white. A creative Pennsylvanian, however, tipped and combined her tree blocks to form four large eight-point stars (plate 5-31). She also used the saturated color scheme favored in the Pennsylvania Dutch tradition.

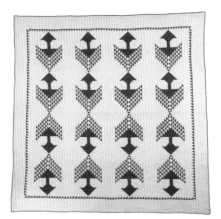

PLATE 5-28. Pine Tree.
Possibly made in Ohio, 1880–1900.
Cottons, 80" x 81". 1997.007.0130.

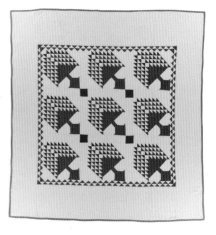

PLATE 5-30. Pine Tree.
Possibly made in western Pennsylvania, 1940–1950.
Cottons, 81" x 77". 1997.007.0426.

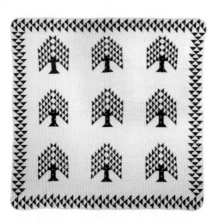

PLATE 5-29. Pine Tree.
Probably made in Indiana, Pennsylvania, 1890–1910.
Cottons, 67.5" x 70". 1997.007.0408.

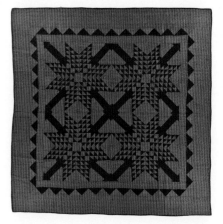

PLATE 5-31. Pine Tree variation.
Probably made in Pennsylvania, 1890–1910.
Cottons, 77.5" x 78.5". 2003.003.0198.

Eagles and Animals

After Congress adopted the American bald eagle as a symbol for the Great Seal in 1782, women began to feature the eagle, with wings outspread and uplifted, as the centerpiece on quilts made to celebrate the country's independence. When quiltmakers prepared for centennial celebrations in 1876, they returned to this patriotic motif for Colonial Revival quilts. An unknown quiltmaker surrounded her bright red eagle with pieced and appliquéd flowers and the words "VIRTUE LIBERTY AND INDEPENDENCE / JULY FOURTH / 1776" (plate 5-33). Other quiltmakers made their own versions of the distinctive four-eagle woven coverlets that professional weavers in Pennsylvania had designed for the Centennial market. Mid-nineteenth-century coverlet weavers often included birds and eagles in the border designs used on Jacquard-loomed coverlets. In a like manner, two quiltmakers added familiar farm animals and birds in silhouette form to the borders of their Colonial Revival floral appliqué quilts (plates 5-32 and 5-34).

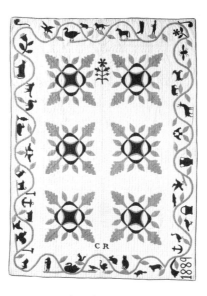

PLATE 5-32. Oak Reel.
Made by Caroline Ruth, Marion County, Ohio, dated 1889.
Cottons, 91" x 68". 1997.007.0429.

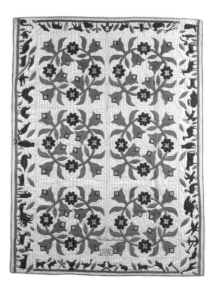

PLATE 5-34. Wreath.
Made by Paulina Herdrich, Sheboygan County, Wisconsin, dated 1890.
Cottons, 88.5" x 68.5". 1997.007.0878.

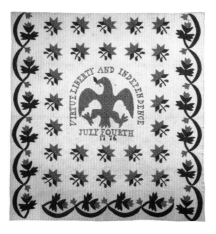

PLATE 5-33. Eagle.
Maker/location unknown, c. 1876.
Cottons, 90.5" x 83". 1997.007.0696.

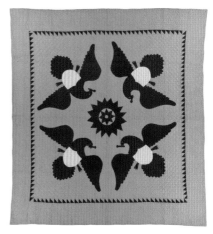

PLATE 5-35. Eagle.
Probably made in Pennsylvania, 1880–1900.
Cottons, 80.5" x 76". 2004.016.0013.
Linda Giesler Carlson & Dr. John V. Carlson Collection.

Rose Appliqué

Charlotte F. Boldtmann, writing for the *Woman's Home Companion* in January 1911, called floral appliqué quilts "the most magnificent specimens of patchwork which have been handed down for generations."[152] Needlework editors often noted that these appliqué patterns were challenging and time-consuming, but this did not deter the Colonial Revival quiltmakers who favored appliqué and the romantic appeal of floral designs. They liked rose patterns in numerous forms. Single Rose patterns, sometimes given the biblical name Rose of Sharon, and old-fashioned Wreath of Roses patterns were particular favorites. The Whig Rose or Democrat Rose pattern, which first emerged in the Whig Party's Harrison–Tyler political campaign of the 1840s, had wide appeal again at the end of the century. During the early Colonial Revival period American women were still fighting for voting privileges and expressing their opinions in textile form. The language of flowers continued to thrive.

PLATE 5-36. Wreath of Roses.
Possibly made in Coshocton County, Ohio, 1935–1945.
Cottons, 77" x 75". 1997.007.0112.

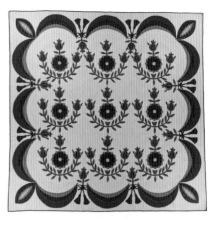

PLATE 5-38. Prairie Rose.
Possibly made in Indiana, c. 1935.
Cottons, 92" x 90". 1997.007.0820.

PLATE 5-37. Rose.
Possibly made in Maryland, 1900–1920.
Cottons, 76.5" x 73.5". 1997.007.0207.

PLATE 5-39. Whig Rose.
Possibly made in Carlisle, Pennsylvania, 1900–1920.
Cottons, 83" x 82". 2004.016.0018.
Linda Giesler Carlson & Dr. John V. Carlson Collection.

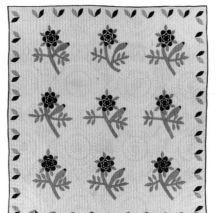

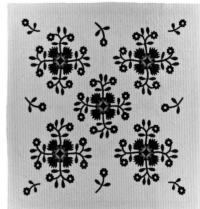

Rose Appliqué

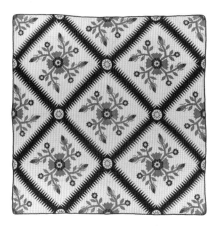

PLATE 5-40. Whig Rose.
Probably made by Dell Patterson, Fayetteville, Tennessee, 1895–1905.
Cottons, 83.5" x 85". 1997.007.0261.

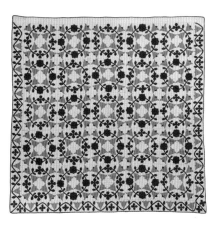

PLATE 5-42. President's Wreath.
Maker/location unknown, 1870–1880.
Cottons, 72.5" x 71.5". 1997.007.0888.

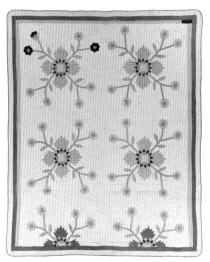

PLATE 5-44. Whig Rose.
Possibly made in Iowa, 1880–1900.
Cottons, 78.5" x 64.5". 2004.016.0009.
Linda Giesler Carlson & Dr. John V. Carlson Collection.

PLATE 5-43. Twenty-five Patch.
Possibly made in the southeastern United States, 1880–1900.
Cottons, 80" x 89". 1999.004.0001.
Gift of Betty D'Arcy.

PLATE 5-41. Rose.
Possibly made in Pennsylvania, 1890–1910.
Cottons, 96" x 86.5". 1997.007.0667.

PLATE 5-45. Whig Rose.
Probably made in Manheim, Pennsylvania, 1870–1890.
Cottons, 91" x 91". 2004.016.0021.
Linda Giesler Carlson & Dr. John V. Carlson Collection.

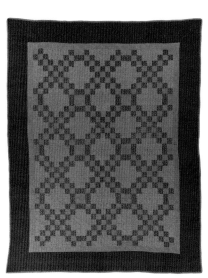

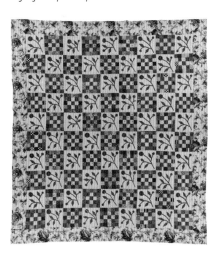

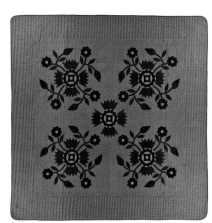

Flowers in Baskets, Pots, and Borders

When Colonial Revival devotees made quilts, they creatively combined aspects of traditional quilt design with modern interpretations. Ethelyn J. Guppy expressed this tendency in the January 1923 issue of *The Modern Priscilla*, stressing that "when a fashion cycle has been made complete and 'something old' has become 'something new' again, this 'something new' is never an exact reproduction of the old."[153] For example, an Ohio quiltmaker copied her heirloom Snowflake pattern in a new color combination (plates 5-46 and 5-47). A Pennsylvania quilter re-created a Pots of Flowers pattern in traditional colors but made two matching quilts to fit the twin-size beds new to her generation (plates 5-48 and 5-49). Women who liked traditional Basket patterns used stylized versions that showed the influence of Art Deco trends. Quiltmakers also changed the spacing and style of floral vine and flower pot borders to reflect modern taste.

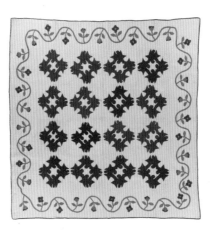

PLATE 5-46. Snowflake.
Possibly made in Ohio, 1880–1900.
Cottons, 82.5" x 81". 1997.007.0263.1.

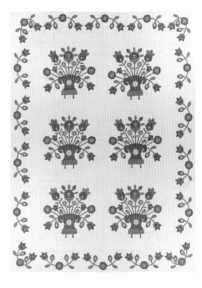

PLATE 5-48. Pots of Flowers.
Possibly made in Pennsylvania, 1930–1950.
Cottons, 105" x 74.5". 1997.007.0702.

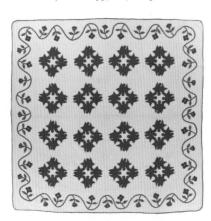

PLATE 5-47. Snowflake.
Possibly made in Ohio, 1930–1950.
Cottons, 84" x 82". 1997.007.0263.2.

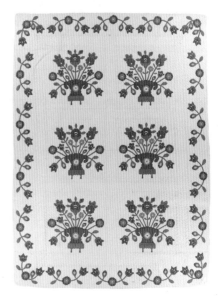

PLATE 5-49. Pots of Flowers.
Possibly made in Pennsylvania, 1930–1950.
Cottons, 105.5" x 76.5". 1997.007.0703.

Flowers in Baskets, Pots, and Borders

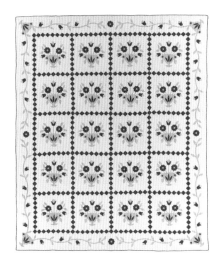

PLATE 5-50. Pots of Flowers.
Possibly made in Ohio or Pennsylvania, 1935–1945.
Cottons, 94.5" x 79". 1997.007.0167.

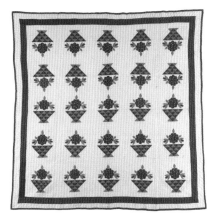

PLATE 5-52. Baskets.
Possibly made by Lucille Meyer, Highland, Illinois, 1880–1900.
Cottons, 85" x 85". 1997.007.0708.

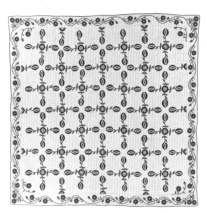

PLATE 5-54. Love Apple.
Possibly made in Pennsylvania, 1920–1940.
Cottons, 73" x 71". 1997.007.0881.

PLATE 5-55. Pots of Flowers.
Probably made by Mary Eliza Sykes.
Possibly made in Iowa, dated 1904.
Cottons, 81.5" x 83.5". 2004.016.0002.
Linda Giesler Carlson & Dr. John V. Carlson Collection.

PLATE 5-51. Original.
Possibly made by E. Heldman Walther, southern Indiana, 1880–1900.
Cottons, 81.5" x 79". 1997.007.0448.

PLATE 5-53. Baskets.
Possibly made in Ohio, 1880–1900.
Cottons, 89" x 85". 1997.007.0813.

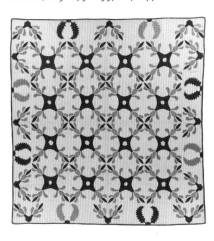

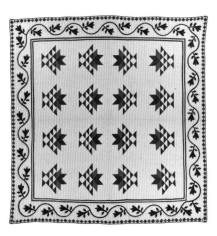

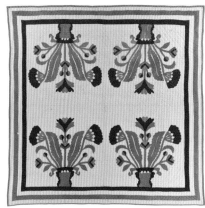

Four-Block

Most heirloom four-block appliqué pattern quilts were made in the mid-nineteenth century, when Germanic tradition had wide influence in Pennsylvania and Ohio. Later, Colonial Revival quiltmakers from these areas also had an affinity for this style, making quilts in a similar format but often with simpler, more streamlined designs and comparatively less quilting. Those attracted to these striking quilts agreed with the editors of the June 1931 *Needlecraft Magazine* that they should be included with the "'laid-work' of the good old colony days" ("laid-work" being a synonym for appliqué). Busy modern women also acknowledged that the use of large blocks meant that "not many of them will be required for a quilt or counterpane."[154] The appliqué process was further streamlined by simplifying or eliminating fancy borders. Variations of the Coxcomb pattern and the Princess Feather pattern were favorite choices, but quiltmakers also replicated other designs, such as Christmas Cactus, Jester's Plume, and Pineapple.

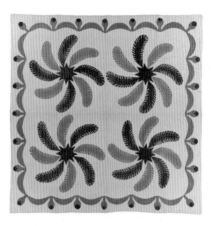

PLATE 5-56. Princess Feather.
Possibly made in Iowa, 1870–1890.
Cottons, 84" x 84". 2004.016.0004.
Linda Giesler Carlson & Dr. John V. Carlson Collection.

PLATE 5-57. Pineapple.
Possibly made in Anson County, South Carolina, 1880–1900.
Cottons, 76" x 75.5". 2004.016.0007.
Linda Giesler Carlson & Dr. John V. Carlson Collection.

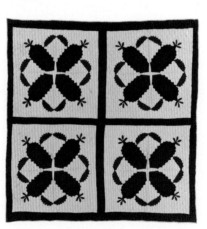

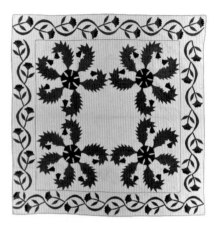

PLATE 5-58. Christmas Cactus.
Possibly made in Pennsylvania, 1880–1910.
Cottons, 85" x 85". 2004.016.0017.
Linda Giesler Carlson & Dr. John V. Carlson Collection.

PLATE 5-59. Coxcomb.
Possibly made in Lancaster County, Pennsylvania, 1870–1890.
Cottons, 94" x 88". 2004.016.0033.
Linda Giesler Carlson & Dr. John V. Carlson Collection.

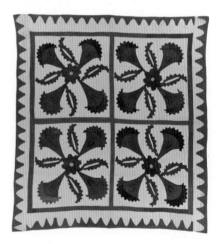

Four-Block

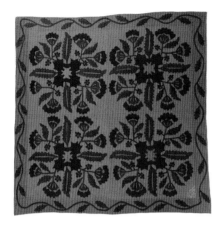

PLATE 5-60. Coxcomb.
Probably made in Pennsylvania, 1880–1900.
Cottons, 76.5" x 76". 1997.007.0123.

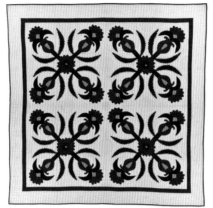

PLATE 5-62. Coxcomb.
Possibly made in southern Indiana,
1880–1900.
Cottons, 83" x 83". 1997.007.0833.

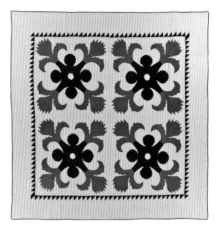

PLATE 5-64. Coxcomb.
Probably made in Pennsylvania, 1890–1910.
Cottons, 78.5" x 76.5". 2004.016.0029.
Linda Giesler Carlson & Dr. John V. Carlson Collection.

PLATE 5-61. Jester's Plume.
Possibly made in Lancaster County,
Pennsylvania, 1890–1910.
Cottons, 89" x 88.5". 1997.007.0625.

PLATE 5-63. Princess Feather.
Possibly made in Ohio, 1890–1910.
Cottons, 83" x 81". 2004.016.0027.
*Linda Giesler Carlson & Dr. John V. Carlson
Collection.*

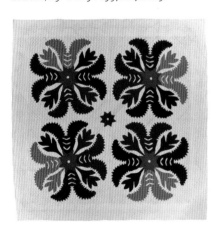

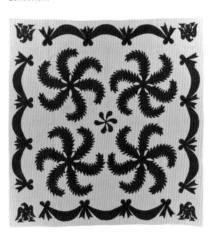

Stars

During the Colonial Revival era, star patterns of all sizes and arrangements found great favor. These old-fashioned favorites had new appeal in a time of renewed nationalism and patriotic pride, spurred on by the Colonial Revival urge to idealize the past. The single large Star of Bethlehem or Rising Sun design was both reproduced and simplified. Geometric motifs, rather than the appliqué motifs of earlier quilts, often filled the spaces between the large-star points. Eventually the giant star blazed against a plain background. In the West, the name for this long-favored pattern became Lone Star or Texas Star. Four-block, nine-block, and smaller scale Star variations such as Feathered Star and Touching Stars were also favorites of Colonial Revival quiltmakers. As Sybil Lanigan informed readers of the October 1894 *Ladies' Home Journal,* the star was "one of the most aesthetic patterns of the olden time."[155]

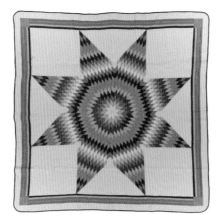

PLATE 5-65. Star of Bethlehem.
Possibly made in Akron, Ohio, 1930–1950.
Cottons, 83" x 83". 1997.007.0445.

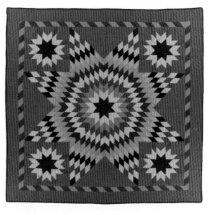

PLATE 5-67. Star of Bethlehem.
Probably made in Pennsylvania, 1880–1900.
Cottons, 85" x 81.5". 2003.003.0139.

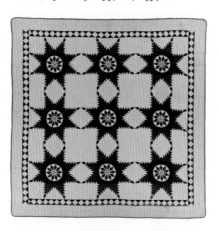

PLATE 5-66. Feathered Star.
Possibly made in Indiana, 1890–1910.
Cottons, 83" x 82.5". 1997.007.0554.

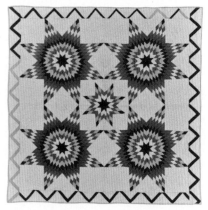

PLATE 5-68. Blazing Star.
Possibly made in Cumberland County, Pennsylvania, 1890–1910.
Cottons, 79" x 77.5". 2004.016.0031.
Linda Giesler Carlson & Dr. John V. Carlson Collection.

Stars

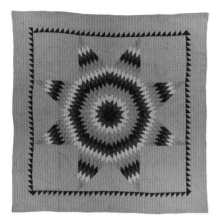

PLATE 5-69. Star of Bethlehem.
Maker/location unknown, 1890–1910.
Cottons, 80" x 78.5". 1997.007.0657.

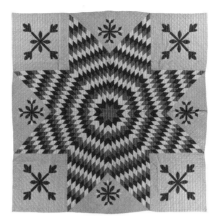

PLATE 5-71. Star of Bethlehem.
Maker/location unknown, 1880–1900.
Cottons, 80.5" x 81.5". 2003.003.0233.

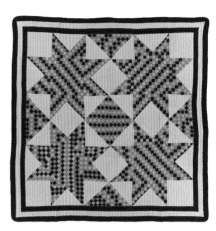

PLATE 5-73. Postage Stamp Star.
Possibly made in York County, Pennsylvania,
1880–1900.
Cottons, 83" x 82.5". 2004.016.0022.
Linda Giesler Carlson & Dr. John V. Carlson Collection.

PLATE 5-70. Carpenter's Wheel.
Possibly made in Pennsylvania, dated 1887.
Cottons, 78.5" x 79". 2003.003.0159.

PLATE 5-72. Touching Stars.
Possibly made in Indiana, 1870–1890.
Cottons, 73.5" x 73". 2004.016.0020.
*Linda Giesler Carlson & Dr. John V. Carlson
Collection.*

PLATE 5-74. California Star.
Possibly made in Pennsylvania, 1890–1910.
Cottons, 79" x 72.5". 2004.016.0024.
Linda Giesler Carlson & Dr. John V. Carlson Collection.

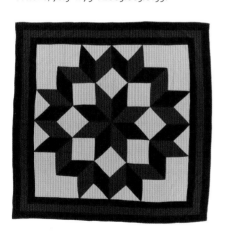

Colonial Revival Color Schemes

Colonial Revival quiltmakers moved away from the dark colors and patterned fabrics characteristic of the late Victorian era. They instead chose color schemes and combinations that were simpler and brighter. Patriotic colors were among the favorites. Combinations of red and white, of blue and white, or of all three together were visually striking and underscored old-fashioned patriotic values, then in vogue. Another trend called for interpreting earlier patterns in brighter and lighter versions of the traditional palette. When Gertrude Shockey discussed quiltmaking with readers of *The Modern Priscilla* in February 1928, she noted that patterns in vivid contrast such as red and white would still be delightful in modern bedrooms, but some would find "soft pink or blues, cool greens or lavenders, or gay yellows combined with the mellow tint of unbleached cotton, much better."[156]

PLATE 5-75. Star of Bethlehem.
Possibly made in Arkansas, 1930–1950.
Cottons, 69.5" x 54.5". 1997.007.0672.

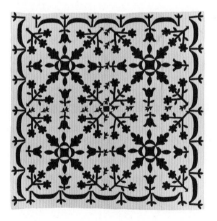

PLATE 5-76. Oak Reel.
Possibly made in Pennsylvania, 1890–1910.
Cottons, 83" x 83.5". 2004.016.0010.
Linda Giesler Carlson & Dr. John V. Carlson Collection.

PLATE 5-77. Carpenter's Square.
Possibly made in Cumberland County, Pennsylvania, 1910–1930.
Cottons, 74" x 73". 2004.016.0014.
Linda Giesler Carlson & Dr. John V. Carlson Collection.

PLATE 5-78. Whole Cloth.
Made by Eleanor Beard Studios, Hardinsburg, Kentucky, c. 1930.
Rayons, 80" x 68". 2006.008.0001.
Gift of Robert and Ardis James.

Colonial Revival Color Schemes

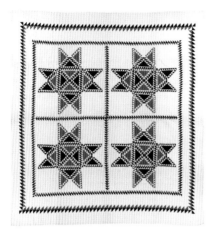

PLATE 5-79. Feathered Star.
Maker/location unknown, 1890–1910.
Cottons, 72.5" x 67". 1997.007.0288.

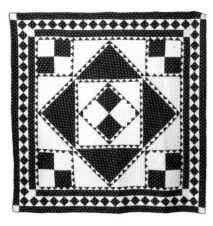

PLATE 5-81. Center Diamond.
Possibly made in Pennsylvania, 1890–1910.
Cottons, 83" x 82". 1997.007.0423.

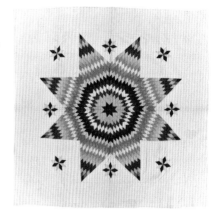

PLATE 5-83. Star of Bethlehem.
Possibly made in Pennsylvania, 1880–1900.
Cottons, 81.5" x 79". 2003.003.0365.

PLATE 5-80. Feathered Star.
Possibly made in Ohio, 1930–1940.
Cottons, 94.5" x 93.5". 1997.007.0367.

PLATE 5-82. Baskets.
Probably made in Ohio, 1900–1920.
Cottons, 79.5" x 79". 1997.007.0489.

PLATE 5-84. Royal Stars.
Possibly made in eastern Pennsylvania, 1920–1940.
Cottons, 78" x 78". 2004.016.0019.
Linda Giesler Carlson & Dr. John V. Carlson Collection.

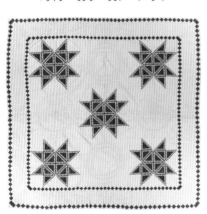

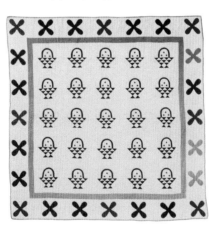

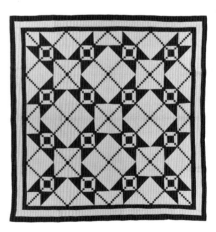

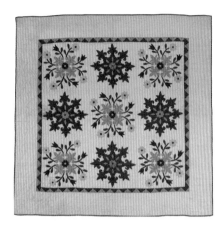

PLATE 5-85. Fleur-de-lis.
Possibly made in Lancaster County,
Pennsylvania, 1870–1890.
Cottons, 91" x 89.5". 1997.007.0349.

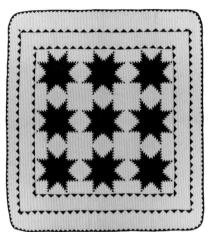

PLATE 5-87. Feathered Star.
Possibly made by Mrs. Matilda B. Houk,
New England, 1900–1920.
Cottons, 80.5" x 74". 1997.007.0661.

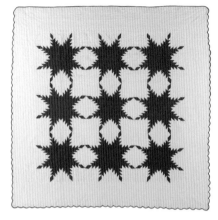

PLATE 5-89. Feathered Star.
Probably made by Ida E. Jacks. Possibly made
in Pennsylvania, dated 1888.
Cottons, 83" x 84". 2003.003.0299.

PLATE 5-86. Touching Stars.
Possibly made in Ohio, 1935–1945.
Cottons, 90.25" x 69.75". 1997.007.0567.

PLATE 5-88. Oak Reel.
Possibly made in Pennsylvania, 1880–1900.
Cottons, 96.5" x 97". 2003.003.0148.

PLATE 5-90. Double Nine Patch.
Maker/location unknown, 1890–1910.
Cottons, 90" x 76.5". 2003.003.0384.

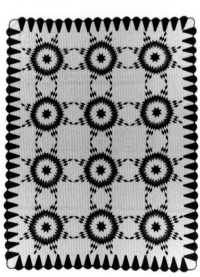

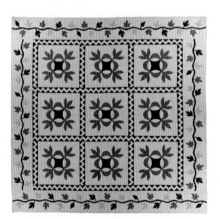

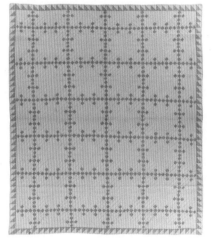

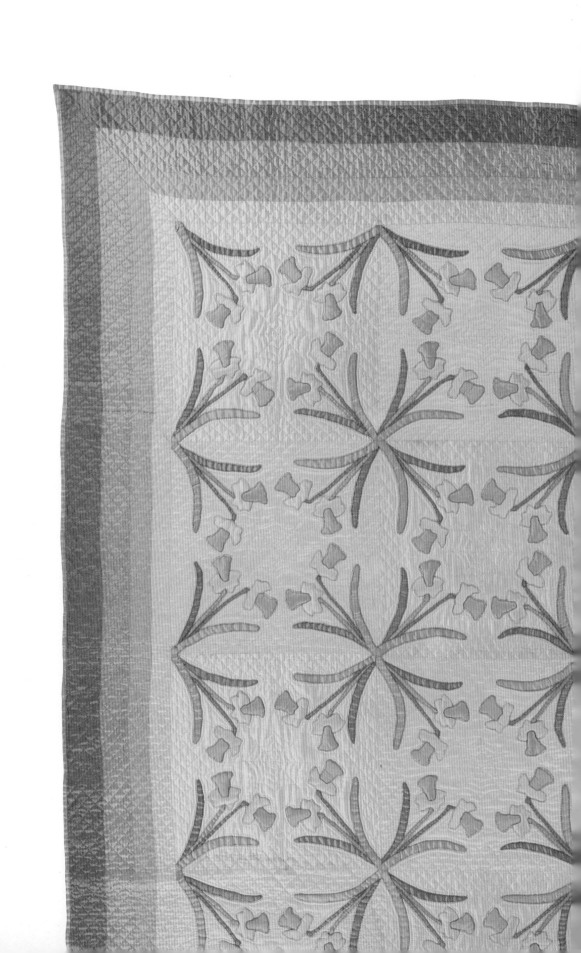

Repackaging Tradition *Pattern and Kit Quilts*

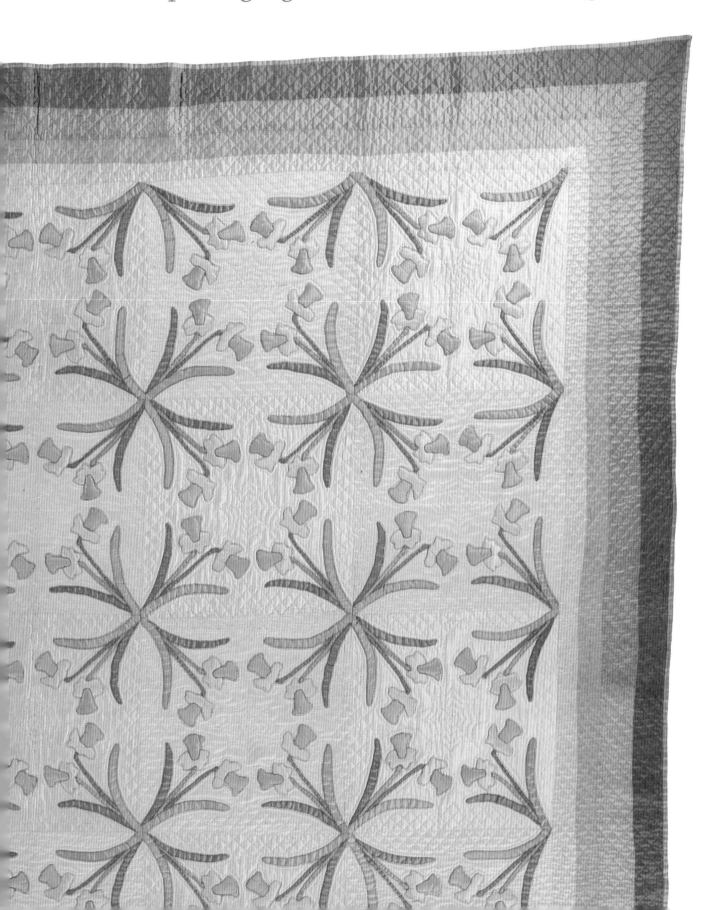

Feature headlines in the needlework pages of 1920s women's magazines made it clear that "what is old is new once again." No matter how quickly life had modernized for American women, a revival of the "old-fashioned" pastime of quiltmaking was in full swing. By revamping and renaming old-time favorites, enlivening them with the new, lighter and brighter colors of the period, and repackaging them for the modern woman, quilt industry leaders had captured the fancy of an eager new audience.

"Old-fashioned quilts are the new-fashioned quilts," declared an editor in the January 1922 issue of *Ladies' Home Journal*. "There is no touch quite so modern in the present-day bedroom as that lovely old relic of grandmother's time."[1] *The Modern Priscilla* needlework editor, Gertrude Shockey, reminded her readers in the February 1928 issue:

> Today's bride rarely has bulging scrap bags to draw from for material, but she often does have a better schooling in color selection, a wonderful supply of fascinating designs, and any number of delightful sun and tubfast fabrics to choose from. Modern manufacturers are co-operating with modern quiltmakers even to reproducing the old time calico prints as staunch and strong in color as the originals. There are books and magazines galore offering instruction and inspiration for quilts and quilting—for this placid art has somehow captured the fancy of this hurrying age.[2]

How did quilts gain favor among flapper girls with boyish bobbed haircuts? With the bridge players? With the new college graduates eager to start their glamorous careers? One way was by marketing "modern" quilt patterns and kits to this new audience as well as to the already existing one. By examining the pattern sheets, the advertising, and the quiltmakers' renderings of the patterns and kits into cloth, one can get a better understanding of the industry's attempts to appeal to various audiences. Indeed, instruction sheets and advertisements provide a virtual window onto the designers' understanding of their intended audience—who they were and what skills they assumed they had.

As the twentieth century dawned, women were wearing tucked long-sleeved blouses with long skirts and high-topped boots. Electric and gas utilities were not widely available. Cloth and notions were purchased at dry goods stores or through mail-order catalogs. Thread companies offered needlework patterns for crochet, tatting, cross-stitch, and embroidery. Crazy quilts had provided a ready canvas for such handwork, but their popularity was in decline; they were often derided as "garish," "odd," and "queer."

Pieced and appliqué blocks published in farm and women's publications in the waning years of the nineteenth century helped maintain people's interest in traditional quilt patterns. The twentieth century opened with the same magazines—*Hearth & Home, Farm & Fireside,* and *American Woman*—offering quilt patterns sent in by their readers. When a reader ordered the pattern, she usually received hand-cut templates in a small envelope. Ladies Art Company of St. Louis went a step further, and compiled several hundred block patterns in a mail-order catalog. They, too, provided only flimsy hand-cut templates, but they also included a color palette card and basic instructions that were of some help to quiltmakers.

Women also clipped quilt block illustrations out of magazines and pasted them into scrapbooks. In fact, the Ladies Art Company catalog looked very much like these scrapbooks because the compilers also took many of their quilt block illustrations from nineteenth-century magazines. The catalog remained a popular source of historically accurate patterns for repeat-block pieced and appliqué quilts well into the twentieth century.

The publication of Marie Webster's appliqué quilts in the *Ladies' Home Journal* in January 1911 and January 1912, however, marked the beginning of a new

FIG 6-1. Poppy, Marie Webster pattern, *detail* (see plate 6-27).

phase, a period of true innovation in quilt design. Breaking with traditional colors and fabrics, Webster's quilts reflected a refinement of the decorative aesthetic. Her well-balanced floral designs with sinuous appliqué in bright pastels (rather than the darker saturated colors popular in the nineteenth century) closely resembled the flowers they depicted. Hers were not conventional tulips in the Pennsylvania German style, revampings of the red-and-green appliqué designs popular in the 1850s. Nor were they intensely colored or densely embroidered, as Crazy quilts had been. Webster's designs were a breath of fresh air.

Although she had not planned to offer patterns for her new designs, Webster was swamped with requests after the *Ladies' Home Journal* articles appeared. Her family helped make and distribute the patterns for her appliqué quilts, establishing a cottage industry that would last into the 1940s. The immediate acceptance of her quilts led other designers and needlework companies to emulate what she had begun. Following the lead of the *Ladies' Home Journal*, other upscale magazines, including *Good Housekeeping*, *The Modern Priscilla*, and *Needlecraft Magazine*, featured quilt patterns in the new style.

CLOCKWISE FROM TOP LEFT:

FIG 6-2. Grandmother's Fan, *detail* (see plate 6-68).

FIG 6-3. "Favorite Old Quilt Blocks," *The Modern Priscilla*, 1929.

FIG 6-4. Fruit Basket, Ruby Short McKim quilt series pattern, *detail* (see plate 6-17).

FIG 6-5. French Wreath, Anne Orr pattern, *detail* (see plate 6-21).

In 1915, Webster published America's first quilt book, *Quilts: Their Story and How to Make Them*. In it she addressed quilt history from ancient Egypt to the present day and gave instructions on making one's own quilt. She also featured color pictures of several of her modern quilt designs. While Webster's own appliqué quilts broke new ground, her writings fed the Colonial Revival myths of "traditional" quilting customs and styles. (For more about the Colonial Revival, see chapter 5.)

Just as Webster lauded earlier quiltmakers while encouraging her contemporaries to make their own quilts, women's magazines and pattern and kit purveyors had a similar two-pronged marketing approach: Treasure your heirloom quilts if you are lucky enough to have them; if you have none, make your own—it will be tomorrow's heirloom.

The economic situation of the era provided further incentive for home quiltmaking. The Great Depression, followed by rationing of gasoline, clothing, shoes, and tires in World War II, required Americans to think differently about resource use. They were reminded of the sacrifices American pioneers had been forced to make in the previous century, and quiltmakers were inspired to make quilts in the old-fashioned way: using scraps, quilting with friends, and making warm, colorful bedcovers by hand instead of purchasing them.

Farm magazines, daily newspapers, and some women's magazines carried regular quilt features with low-cost patterns. Harkening back to the late 1800s, when women's magazines included quilt blocks sent in by their readers, the early to mid-twentieth-century newspaper columnists (publishing under real names as well as pen names) Ruby Short McKim, Nancy Page, Eveline Foland, Nancy Cabot, Laura Wheeler–Alice Brooks, and Kate Marchbanks also featured patterns from readers and friends.[3] They updated old patterns, created modern designs, and gave advice, hoping to build a loyal cadre of readers—a modern quilting bee, so to speak. Thousands of new patterns flooded the market, feeding a nearly insatiable desire for quilt patterns—something old, something new, and something different.

Ruby Short McKim and Florence LaGanke (writing as Nancy Page) were among the most prolific of the newspaper quilt pattern designers, and their columns were often published in competing newspapers in the same city. Both were known for offering serial quilts, that is, quilts made of multiple blocks depicting a particular theme, which appeared once a week in the newspaper's quilt column. When the series ended, the newspaper editors often hosted an exhibit or contest that showcased the finished quilts and gave awards for fine workmanship.

Also successful were the one-woman businesses owned by Marie Webster, Anne Orr, and Mary McElwain, all of whom offered a full range of quilt products. A single quilt design might have been offered in a range of formats: as a sheet of instructions, a partially completed basted appliqué top, a completed quilt, or a boxed kit with appliqué shapes stamped on colored fabric and foundation cloth stamped with appliqué placements and quilting lines. The price of Anne Orr kits, for example, in the late 1930s ranged from $6.00 to $8.00, and her instruction sheet prices cost from 50 to 75 cents.[4] For most women, however, an $8.00 kit was beyond their means. Even a 10-cent pattern sheet was beyond the means of some during those dire economic times. For these women, sharing patterns with friends or copying a pattern from an existing quilt were ways to obtain new designs.

For those totally new to quiltmaking but familiar with sewing and traditional needlework, pattern designers tried to make the work as appealing as possible. Embroidered quilts were often an entrée to quiltmaking. Rainbow Quilt Blocks, for example, came in sets of a dozen stamped cloth blocks for $1.20. Also enclosed was a pamphlet illustrating various ways of setting the quilt blocks together.[5]

Kits also eased the transition for those new to quiltmaking and saved time and effort for those who wanted to complete their quilt more quickly. By the early years of the twentieth century, women had already become accustomed to doing needlework from kits, considering it a modern way to accomplish a project. In 1912, *Priscilla Needlework* showed many household items in stamped muslin ready for embroidery. These included pincushions, bags, cases, collar and cuff sets, bibs, baby clothes, pillows, waists, and women's underwear.[6] A 1916 wholesale catalog of James H. Durham and Company of New York offered items stamped for embroidery, including infants' and children's wear, tea aprons, and guest towels. These items were sold with the embroidery floss to complete them.[7] The 1927 Sears, Roebuck and Co. catalog included kits for "art needlework," offering

such items as baby dresses, luncheon sets, tea aprons, nightgowns, dresser scarves, and bedspreads stamped on cotton ready to embroider.[8]

What may be the earliest example of a kit for a quilt was published in *Home Needlework Magazine* in May 1916. The kit was for a "Patchwork Bedspread," design No. 165-1, and included a stamped background on unbleached cotton sheeting. Patterns and fabrics were provided for the appliqué motifs that formed a floral border. In August 1922 *Needlecraft Magazine* offered kits for a bedroom ensemble that included a bedspread (quilt), dresser scarf, pillow cover, pincushion, and table cover, all in white with appliquéd pink roses. The background fabrics were stamped for appliqué placement.

Vendors of kits encouraged their readers to think of constructing a quilt from a kit as an easy and rewarding pastime. *Quilts, Patchwork, Appliqué: Needlework That Is Worthy of Your Time* was published by the Robert Frank Needlework Supply Company of Kalamazoo, Michigan, in the 1930s. The caption of their offering of "the Rainbow Quilt," a postage stamp variation, reads, "It is no longer necessary to spend hours of time to sort the right color combinations, and then hour after hour, day after day, cut these pieces with the scissors. All this work has been done for you. The color combinations blend perfectly. Our labor saving machines cut the pieces for you to perfect size, and all you have to do [is] sew these . . . pieces together."[9]

Kits of die-cut pieces for appliqué and pieced quilts sold for as little as $2.85, thus saving the time needed for tracing around templates and cutting out each design. The show-stopping Lone Star and Broken Star quilts, so common in the 1930s, even came packaged with all the diamond pieces sorted by color.

Quilting designs were as plentiful as quilt blocks. One method of transferal was to trace them from a printed pattern or another quilt and make templates from shirt box cardboard or cereal boxes. However, some companies (W. L. M. Clark Company of St. Louis and Lockport Cotton Batting Company of Lockport, New York, for instance) sold ready-made slotted templates, simplifying yet another tedious task: drawing the quilting lines.

While pattern and kit purveyors made quiltmaking a widely accessible pastime, the 1933 Sears Century of Progress Quilt Contest, held in conjunction with the Century of Progress Exposition in Chicago, is recognized as the engine that drove the quilt revival right through the 1930s. When it was announced in January 1933 in the Sears, Roebuck and Co. catalog, the contest immediately prompted thousands of people to make quilts, all of them hoping to win one of the prizes, which totaled $7,500.00, at local, regional, or national levels. Many of the quilts submitted were made from commercially available patterns and kits. When the May 15 deadline arrived just four months later, more than twenty-four thousand quilts had been submitted for judging. This onslaught was all the more amazing as it occurred in the midst of the Great Depression, when resources for most families were stretched thin. (For more on the 1933 Sears Quilt Contest, see chapter 7.)

With all the new patterns, gadgets, colorful cloth, contests, and articles geared toward quiltmaking, no wonder this traditional form of needlework attracted new converts outside its established base. But why did quiltmaking resonate so strongly with a rapidly changing society? The question remains today: What is it about quilts that continues to attract so many people? Marie Webster might have said it best in her 1915 book:

> In reality, there are more idle, listless hands in the hearts of crowded bustling cities than in the quiet country. City women, surrounded by many enticing distractions, are turning more and more to patchwork as a fascinating yet nerve-soothing occupation. Not only is there a sort of companionship between the maker and the quilt, but there is also the great benefit derived from having found a new interest in life, something worth while that can be built up by one's own efforts.[10]

The quilts featured in this chapter with full catalog entries are from the years 1900 to 1950. They include traditional pieced and appliqué patterns and kits as well as modern designs reflecting both the streamlined Art Deco style and traditional designs updated in colorations to complement the decorating styles of the day. The patterns are from the following sources: mail-order companies (Ladies Art Company of St. Louis), quilt designers and their cottage industries (Marie Webster and Anne Orr), women's magazines (*The Modern Priscilla* and *Farm & Fireside*), newspaper

FIG 6-6. Double Wedding Ring, kit source unknown, *detail* (see plate 6-73).

quilt columnists (Nancy Cabot, Ruby Short McKim, Nancy Page, and Kate Marchbanks), and the Mountain Mist pattern line manufactured by the Stearns and Foster Company of Cincinnati, Ohio.[11]

Only three of the six kit quilts have confirmed sources (Needlecraft Guild of Grand Rapids, Michigan, and designers Mary McElwain and Marie Webster). All three are appliqué quilts, which are easier to identify as kits because they often still display the markings the manufacturer used to indicate where appliqué motifs or quilted designs should be placed. The other three quilts were likely made from pieced kits. Pieced kits are much harder to positively iden-

tify because there are no markings to reveal their origins; however, by searching primary sources (catalogs, magazines, and advertisements) for a visual match and by examining a quilt's fabrics for uniformity and quantity of distinct fabric prints, its probable source can often be found.

The quilts featured in the groupings at the end of the chapter are either confirmed patterns or kits—from a wide variety of sources—or they have the hallmarks of being a kit or pattern, featuring, for example, sophisticated design, coordinated fabrics, or commonly used imagery.

■ **Merikay Waldvogel**

Quilts incorporating letters or numbers as significant parts of the pattern are unusual, especially if, as in this Alphabet and Eight-Pointed Star quilt (plate 6-1), they are the main focus of the design. Some earlier nineteenth-century quilts had the maker's name, where she lived, or significant dates depicted in large pieced or appliquéd letters and numbers as part of their overall format. The twentieth-century advent of published patterns for Alphabet quilts made such quilts more common.

This red and green Alphabet quilt top (the fugitive green has begun to change to khaki) was based on patterns in the Ladies Art Company catalog. A full page of letter block designs plus four new appliqué and pieced blocks, including the Eight-Pointed Star used in the four corners of this quilt top, appeared together in the company's mail-order catalog. The cost was 25 cents per block, with lower prices charged for multiple block orders. Stamped on the outside of the pattern envelope were simple instructions that related more to the difference between piecing and appliqué techniques than how to construct the intricate blocks. Also tucked inside each envelope was a "color card" printed on heavier stock paper. It served as a general guide for arranging the print or solid-colored fabrics. A new quiltmaker might have been frustrated with the limited instructions, but this was, in fact, an improvement over quilt patterns sold through the women's magazines. Ladies' Art Company further improved the ease of use of their products by adding kits to their repertoire in the 1920s. In the 1930s, the company sold mimeographed instruction sheets for each block.[12]

The Ladies Art Company Alphabet Series consisted of block letters configured from triangles and trapezoids to convert even the curved letters to straight lines. The Q and the G are the most intricately designed and are distinctive of the Ladies Art Company blocks. The maker of this red and green quilt top followed the instructions precisely, except for those two letters and the Eight-Pointed Stars in the corners. She constructed her Q differently than the pattern indicates, but the overall appearance is the same. Her G, on the other hand, is not only pieced in a new way but has a different look as well: the leg at the bottom right of the letter is much bulkier than in the pattern. She added some variety to the stars by using two different colors to construct the rays that extend to each corner, rather than giving them the same color as designated in the pattern. Interestingly, there is another Alphabet quilt in the International Quilt Study Center collections made from Ladies Art Company patterns, in which the G design has been modified in a similar way (see plate 6-44).

Established by H. M. Brockstedt in 1889 in St. Louis, the Ladies Art Company advertised in women's magazines throughout the nation in the late nineteenth and early twentieth centuries. Their original inventory included needlework patterns for cross-stitch, beading, embroidery, lace, and stenciling. In 1895 they added quilts to their catalog. Pattern Nos. 1 through 272 were in the first edition; 273 through 400 were added in 1897, 401 through 420 in 1901, and 421 through 450 in 1906.[13] The following November 1907 advertisement in *The Modern Priscilla* magazine announced a doubling of the original number of quilt blocks in the catalog and the complete set of Alphabet blocks: "450 Quilt Block Designs—Only collection of the kind ever published. The prettiest, quaintest, most curious, with hundreds of original designs you never saw before . . . [including] the complete Alphabet in uniform size."[14]

The Ladies Art Company's catalog of hundreds of quilt patterns was one of the largest in print at the time. The company culled some of its blocks from various magazines without crediting the original designer or contributor. Nevertheless, the company's impact on twentieth-century quiltmaking, through its efforts to provide a large and diverse pool of pieced and appliqué designs, cannot be underestimated.

■ **Merikay Waldvogel**

FIG 6-7. Alphabet, letter G.

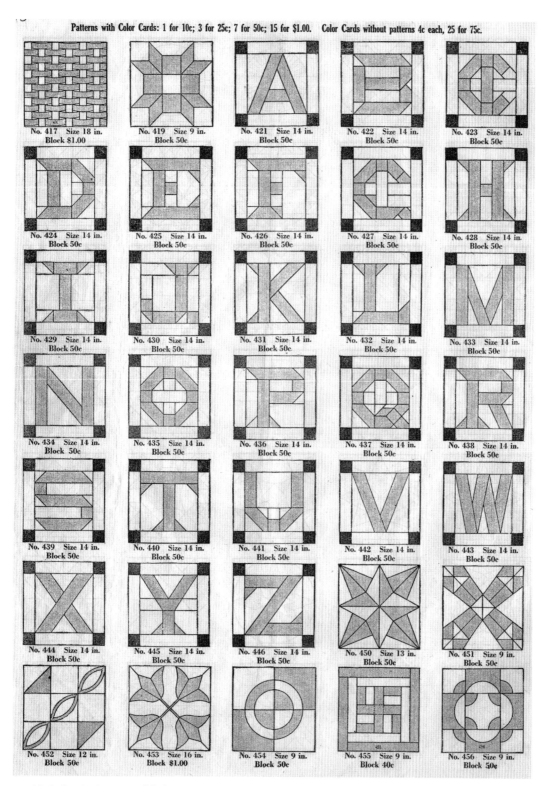

Patterns with Color Cards: 1 for 10c; 3 for 25c; 7 for 50c; 15 for $1.00. Color Cards without patterns 4c each, 25 for 75c.

FIG 6-8. Ladies Art Company Alphabet pattern. Courtesy of Connie Chunn Collection.

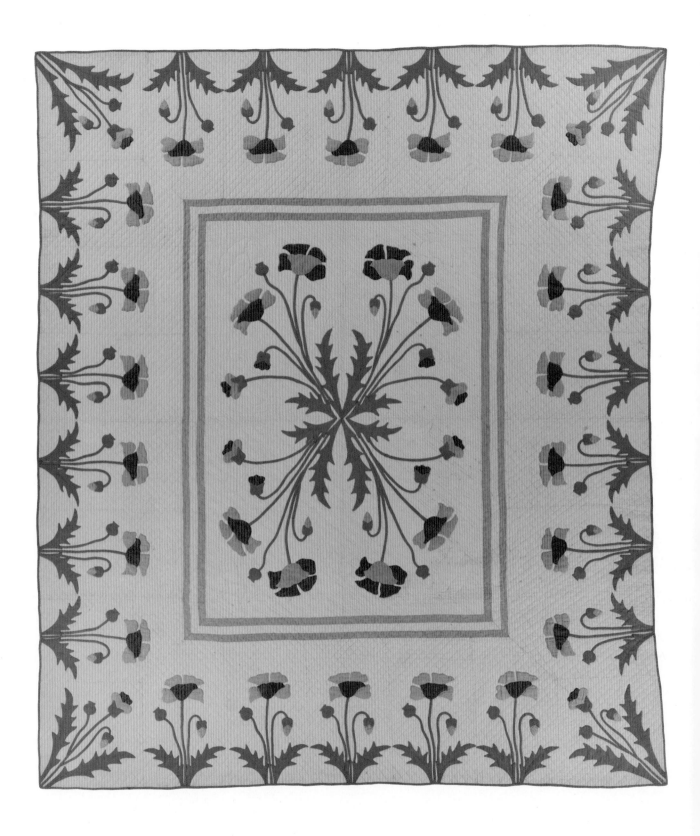

arie Webster of Marion, Indiana, is credited with permanently altering the look and style of American quilts. The highly original designs, all constructed in pale, soft colors that would soon dominate the 1920s and 1930s palette, set a new aesthetic and quality standard for American quiltmakers to follow. The central-medallion layout seen in some of her best-known quilts, such as this famous Poppy design (plate 6-2), was derived from her study of early American quilts. This design layout was a marked innovation compared to the geometric repeating blocks quiltmakers had been accustomed to making for the previous half-century. Other elements of her designs, such as gracefully curving motifs, delicate pastel color schemes, plain rather than print fabrics, and curved borders, were widely adapted by other designers. (See plates 6-5 and 6-27 through 6-36 for Webster design quilts in the Center's collections.)

Her friends, upon seeing four floral appliqué quilts Webster had made, urged her to try to get them published. They suggested that she contact the nation's leading women's magazine, the Philadelphia-based *Ladies' Home Journal.* The editor, Edward Bok, was impressed enough to invite Webster to send her quilts to the magazine office so they could be examined for possible publication. In the end, her four quilts filled a page of the January 1911 issue of the magazine, the first time quilts were published in color. The caption under the quilts reads, "Transfer patterns cannot be supplied for any of these four quilts, but Mrs. Webster will be glad to answer inquiries regarding them if a stamped, addressed envelope is supplied."

The following year, four more quilts from Marie Webster were published in the *Ladies' Home Journal*'s January 1912 issue. The Poppy quilt, of which this is

a fine example, was included in the 1912 group, along with Dogwood, Morning Glory, and Sunflower.

Three years later, in 1915, Webster published the first full-length American text on quilts. *Quilts: Their Story and How to Make Them* was a historical study of quiltmaking. A color photograph of the Poppy design appeared, its caption reading, "This is applied patchwork and therefore much more easily made than pieced work; very simple quilting gives prominence to the design."[15]

Seeing color photos of her quilts, Webster's admirers clamored for patterns. Being a resourceful, creative

FIG 6-9. "The New Flower Patchwork Quilts, Designs by Marie D. Webster," *Ladies' Home Journal*, January 1912. Courtesy of Merikay Waldvogel Collection.

woman, she devised an unusual pattern package. Transfer patterns on tissue were the norm for embroidered patterns. Most were hot-iron transfers, meaning the quiltmaker laid the tissue paper with the ink side down and passed an iron over it to transfer the inked outline to the cloth. Webster instead used architectural blueprint paper for the template shapes. She wrote, "Cut a card board copy of each section of the blue print, lay on the material and mark around with pencil."[16]

Webster also provided colored tissue paper appliqué placement guides, suggested fabric swatches, directions, and an illustration of a finished quilt. Each pattern sold for 50 cents. The Webster family helped with the pattern making: her son processed the blueprints and her sister constructed the tissue paper appliqué guides. It was a tedious, time-consuming process.

In 1921 Webster brought two friends into the business, Ida Hess and Evangeline Beshore, and named it Practical Patchwork Company. The new partners decided to focus on basted quilts and quilt kits, adding eleven new patterns to their offerings. In 1928 Webster's book was reprinted for a third time, making her an even more widely known quilt designer. She was also in demand as a judge and lecturer.

As interest in quiltmaking increased, Webster's quilts were sold widely through department stores and fine linen shops. In a 1931 booklet, Webster's Poppy quilt was offered in three formats: as a kit, as a partially finished quilt, and as a finished quilt. The design came in two shades of pink or yellow, with green leaves and stems. The prices were $10.00 for stamped, $40.00 for basted, and $90.00 for a finished quilt.[17]

After close examination of this Poppy quilt in the Center's collections, it was determined that it was not made from a kit. No stamped markings were visible along the appliqué pieces or under the quilting stitches. However, it was made as Webster suggested: with the appliqué leaves, blooms, and stems cut from linen and then appliquéd to a cotton foundation. Webster's own Poppy quilt was made in 1909 of linen appliquéd on cotton. In her earliest pattern feature, in the January 1911 *Ladies' Home Journal*, she wrote, "The aim has been to make [the quilts] practical as well as beautiful by the use of fast-color linens of good quality in the patterns and a foundation of equally good white muslin."[18]

■ **Merikay Waldvogel**

FIG 6-10. Poppy, *detail.*

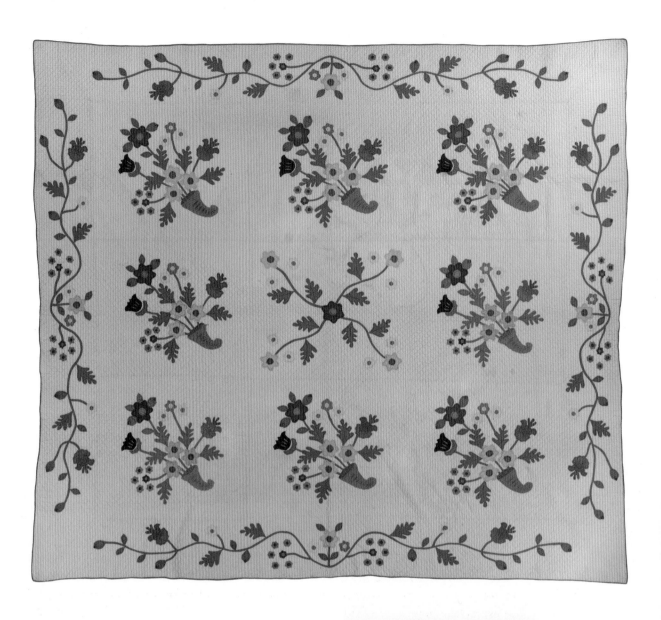

PLATE 6-3. Horn of Plenty.
Priscilla Publishing Company pattern No. 19-27-62.
Josephine Justus (1885–1959),
Trenton, Missouri, c. 1920–1930.
Cottons, 91" x 81.5". QSPI: 8.
1997.007.0642. *Ardis and Robert James Collection.*

FIG 6-11. Josephine Justus, c. 1918.
Courtesy of Richard M. Justus.

osephine Ripper Justus, the maker of this Horn of Plenty quilt (plate 6-3), was born December 12, 1885, in Seymour, Iowa. She married Charles Justus on July 4, 1900, in Newtown, Missouri. She and her husband, a railroad engineer, had only one child, Ernest Milton Justus. She lived her married life in Trenton, Missouri, and died there on October 2, 1959. According to her grandson, she was a prolific quiltmaker, and her family still owns many of her quilts.[19]

It is unclear exactly when Josephine made this quilt. The pattern appeared as early as 1919 in *The Modern Priscilla* and in the early 1920s in pattern book compilations put out by the Priscilla Publishing Company of Boston. For example, in 1920 it was included, under the name Horn of Plenty, in *Priscilla Patchwork Book: Appliqué and Pieced Designs Old and New with Patterns for Making*. A revised edition of the compendium of patterns appeared in 1925.[20]

In 1928 the pattern was slightly simplified, with the number of flowers in the bouquet and the number of blue "slashes" on the cornucopia reduced. The redesigned Horn of Plenty was included with several other "Favorite Old Quilt Blocks" in the August 1928 and the January 1930 issues of *The Modern Priscilla*. Also in 1928 the editors offered the block (not including the border or center appliqué block) as a stamped cloth kit for 35 cents per block: "All blocks are stamped on unbleached muslin and all are 12 inches square. All stamped, fast color materials necessary to complete one block are included in every case."[21]

According to the 1920 *Priscilla Patchwork Book* editors, the nineteenth-century quilt on which the pattern was based was "a fine example of the elaborate appliqué effects popular in the early part of the nineteenth century. It is very beautifully quilted . . . with the favorite plume design." The editors suggested a color scheme of red with orange centers for the medium and large flowers, except one that was to be navy blue. The small flowers were to be red with white centers.[22]

With this information in mind, we note that Josephine's quilt matches the earlier, 1919, pattern design, and therefore she likely began making it sometime between then and when the pattern was redesigned in 1928. In addition, she chose violet and pink fabrics for the medium and large floral appliqués instead of the red and blue suggested in 1920. This points to a date later in the 1920s, when the quiltmaking palette was becoming lighter and more pastel. Also, Josephine's quilt was

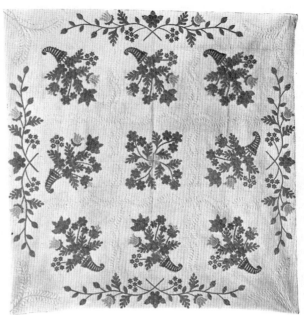

Horn of Plenty Design

No. 19 · 27 · 62

FIG 6-12. "Horn of Plenty Design," *Priscilla Patchwork Book*, 1920.

not made from a kit of stamped muslin squares and accompanying fabrics for the appliqué flowers, leaves, and borders. Instead, the pattern shapes and quilting designs were printed on a supplement inserted in the back of the *Priscilla Patchwork Book*, the materials to be selected and provided by the maker.[23]

Josephine further departed from the editors' suggestions by making her blocks larger and rectangular, effectively eliminating the five-inch-wide sashing in which the plume quilting was to be worked. Instead, she chose to completely fill the space between the appliqué designs with diamond grid quilting. Possibly she didn't find the provided instructions as easy to follow as promised: "The branched plumes are easily arranged from the pattern used on the five-inch strips, reversing when necessary by the simple process of holding the pattern to a window and tracing the reversed side."[24]

Two other quilts in the Center's collections have components of the same Horn of Plenty pattern, and neither was made from the stamped cloth kits. One, made by an unknown quiltmaker, is nearly identical in layout and appliqués to Josephine's (plate 6-39). Another, by Marie Mueller, titled Cornucopia, was entered in the 1933 Sears Quilt Contest (plate 7-42). The green merit ribbon she received is still attached to the quilt.

■ **Merikay Waldvogel**

Clementine Paddleford drew heavily from Marie Webster's book, *Quilts: Their Story and How to Make Them,* a title she recommended to her readers. Paddleford's booklet included black-and-white photos of heirloom quilts made in Indiana and Ohio in the late nineteenth century as well as individual quilt blocks. In addition to the folklore of political and religious quilt pattern names, she offered how-to instructions, giving tips on piecing and appliqué. The catalog provided a glimpse into the beliefs, customs, and practices of quiltmakers in the 1920s. She wrote, "Quilting is a tedious job that requires years of practice to be really well done. It isn't easy to make running stitches through two thicknesses of material with a lining between. . . . If you try quilting continuously for several hours your fingers will become very sore. A remedy for this is to put them in hot alum water which toughens the membrane."[27]

She also discussed the price to charge for quilting. "When many of the old quilts treasured today were made," she wrote, "one dollar per spool was the usual price paid for quilting. As the number of quiltmakers has decreased the price of quilting has increased until as much as $5 per spool is now asked in some sections. But in spite of advanced prices it is difficult to find enough quilters to complete the many pieced and appliquéd quilts being made."[28]

This Four Swallows quilt pattern offered by Paddleford in the mid-1920s appeared in subsequent years in a host of other sources, under many different names: Dove in the Window (*Kansas City Star Weekly,* September 25, 1929, and *101 Patchwork Patterns* by Ruby Short McKim, 1931); The Blue Birds (*Rural New Yorker,* 1933); and Four Birds (*Woman's World,* 1929).[29] Another quilt in the Center's collections was made from the same pattern as this one, but the quiltmaker set the blocks side by side in a square grid, a format suggested by McKim in *101 Patchwork Patterns.*[30]

In the 1937 *Farm Journal Quilt Patterns Old and New,* published in Philadelphia, this pattern was renamed Airplanes. The editors wrote, "Quilts make beautiful heirlooms, for they are not a passing fad, and that is more than can be said of most other types of needlework."[31]

■ **Merikay Waldvogel**

B ased on a nineteenth-century pattern, this Four Swallows quilt (plate 6-4) is made from a pieced block pattern that was published under various names in magazines and newspapers of the 1920s and 1930s. The most probable source for this particular version, judging by its construction and layout, is Four Swallows, published in the mid-1920s in *Patchwork Quilts: A Collection of Thirty-seven Old Time Blocks.* This undated booklet was compiled by the needlework editor of *Farm & Fireside* magazine, Clementine Paddleford.[25] Paddleford named the pattern Four Swallows because, she wrote, "it takes only a little stretch of the imagination to see the Four Swallows on the wing with their bills together in the center of the block. The design is most effective with the swallows pieced in blue material with the other parts in white. . . . Notice the two quilted squares used in setting the blocks together. Our pattern includes both the patchwork and quilting designs. Price 15 cents."[26] Although the quilting in this piece is not as elaborate as that recommended by Paddleford (a simple diamond grid is quilted in the setting squares), the block pattern is otherwise identical to the advertisement.

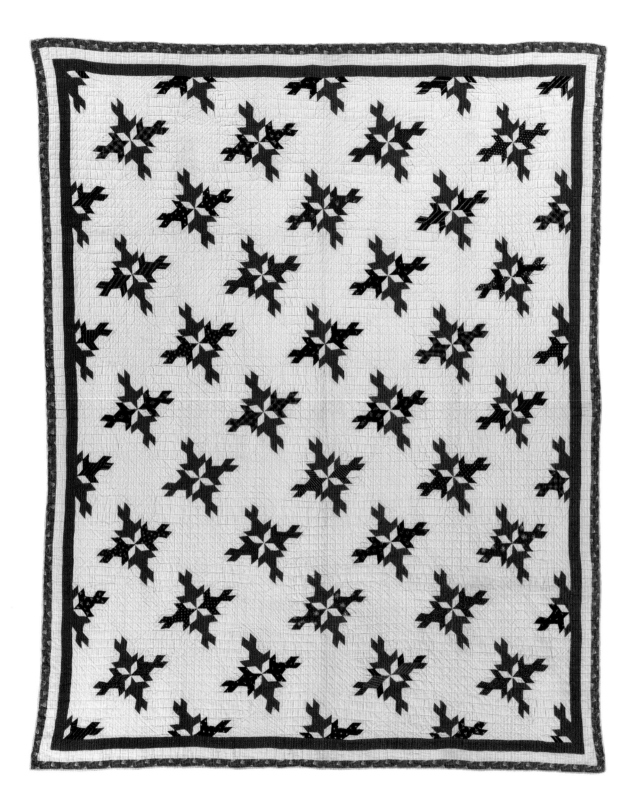

PLATE 6-4. Four Swallows.

Farm & Fireside magazine pattern, 1925.

Maker unknown.

Possibly made in Illinois, c. 1925.

Cottons, 76.5" x 62.5". QSPI: 9-10.

1997.007.0015. *Ardis and Robert James Collection.*

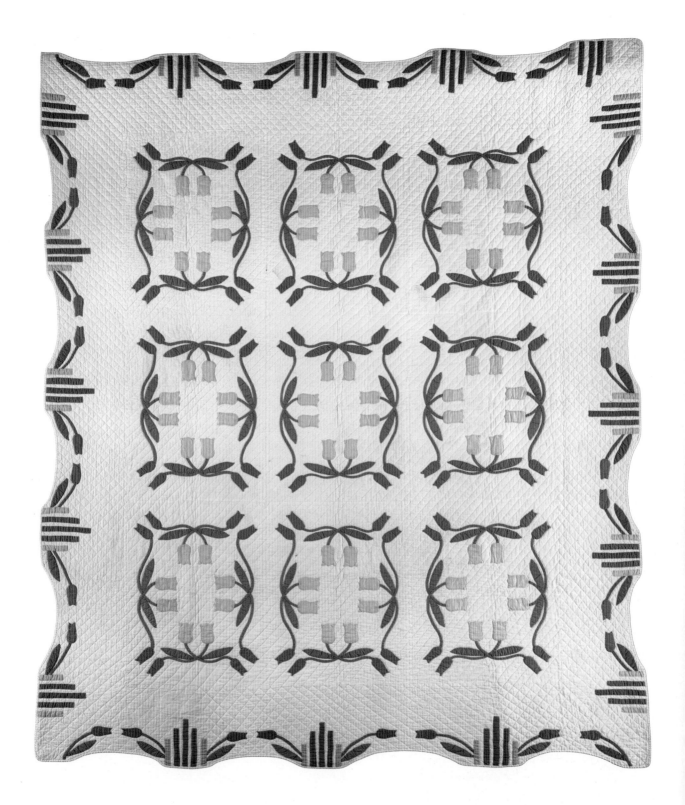

PLATE 6-5. May Tulips.
Marie Webster kit.
Maker unknown.
Possibly made in Ohio, c. 1925.
Cottons, 91" x 76". QSPI: 8-10.
1997.007.0643. *Ardis and Robert James Collection.*

Marie Webster, one of the most influential quilt designers of the early twentieth century, was an educated woman who had traveled in Europe. When she decided to make her first quilt, she based it on a traditional Rose of Sharon pattern, but she adapted the design to the Colonial Revival style and her own color preferences. She called the design Pink Rose. Her subsequent quilts were also original, often based on sketches she made of flowers in her garden. Her designs were influenced by Arts and Crafts principles of fine workmanship, use of natural materials, and themes drawn from nature. Edward Bok, the editor of *Ladies' Home Journal*, in which Webster's quilts were published, had a mission not only to entertain his readers, but to educate them. He sought out examples of fine handcrafts, such as Webster's quilts, that illustrated the ideals of the Arts and Crafts movement.[32]

May Tulips first appeared in the 1920s and shows the influence of the emergent Art Deco style. As was true of many of Webster's later designs, it was somewhat easier to appliqué than her earlier ones, due to the streamlined Art Deco aesthetic. The curved border of this quilt was one of Webster's design innovations and was widely copied, with many variations. Another Webster innovation is that the quilt blocks are rectangular rather than square, a departure from tradition and an elegant solution to the problem of constructing a quilt to fit neatly on a rectangular bed without adding an extra row of blocks.

May Tulips was offered as a stamped kit in Webster's catalog, *Quilts and Spreads*, in several color combinations: pink and lavender, yellow and lavender, and in two shades of pink, yellow, or lavender, all with green leaves and stems and a white background. Because this quilt follows the pink and lavender color scheme precisely, it is likely that it was made from one of these kits.

Later, in May 1931, *Needlecraft Magazine* carried an article written by Webster describing her May Tulips quilt and offering patterns for 50 cents. A meticulous quiltmaker herself, Webster encouraged her readers to turn under each patch and baste the edge before applying it to the background. Except for this, she did not offer details about the process of how to appliqué, stating simply, "Appliqué methods are so well-known that further instruction seems needless." In subsequent issues, the magazine offered kits. Stamped blocks of unbleached muslin, each twenty-two and a half by twenty-seven inches, with percale stamped for the appliqué patches, were 30 cents apiece. Complete kits for single-size quilts could be ordered for $3.65; full-size quilt kits were $3.90. The text accompanying the illustration reassured makers that assembly of the kit was easy and "fascinating."[33]

Webster's patterns thrilled American quiltmakers. Other companies and designers came perilously close to copying her floral appliqué designs, including the Ladies Fancy Work Company of St. Louis, Anne Orr Studio in Nashville, Nancy Cabot in Chicago, Mrs. Danner's Quilts in El Dorado, Kansas, and Stearns and Foster's Mountain Mist patterns. Mountain Mist's Sunflowers (plate 6-16), Dancing Daffodils (plate 6-59), and Windblown Tulips are strikingly similar to Webster's Sunflower, Iris, and Wind-Blown Tulip designs, respectively. Imitation is the highest form of flattery, and the frequency with which Webster's patterns were borrowed validates Edward Bok's publication of her finely crafted and innovatively designed quilts.

■ **Deborah Rake**

FIG 6-15. May Tulips quilt, Marie Webster catalog, *Quilts and Spreads*, 1931. Courtesy of Merikay Waldvogel Collection.

May Tulips Quilt

This Quilt comes in combinations of pink and lavender, also yellow and lavender, or two shades of either pink, yellow or lavender, with green leaves and stems.

Stamped	$ 10.00
Basted	35.00
Finished	80.00

**No. 493 Size 18 in.
Block $1.00**

FIG 6-16. Ladies Art Company catalog, 1922, Baby Bunting
pattern. Courtesy of Connie Chunn Collection.

The exact design source for this Fan quilt (plate
6-6) is not known. It resembles a number of
different patterns but does not follow any one
of them precisely. A close match is the 1922 Ladies
Art Company pattern, Baby Bunting, which was pre-
sented again a decade later in Carrie A. Hall and Rose
Kretsinger's 1935 *The Romance of the Patchwork Quilt
in America*. The setting of the individual fans in rela-
tionship to one another is the same, but the number
of "rays" is greater in this quilt's fans than in the pat-
tern's (seven instead of five). The fan units and the
setting also resemble Nancy Cabot's 1943 Chinese
Fan (again, except for two additional rays), and the
setting is the same as in her 1933 Mohawk Trail. The
virtuosity of the maker, evident in her expert piec-
ing and intricate quilting, suggests that she had the
skills to adapt an existing pattern to her own design.
Therefore, any one of these could have been the in-
spiration. It is equally likely, however, that she used
a pattern that our research has not yet been able to
identify. Pattern designers of the 1920s, 1930s, and
1940s often recycled their own designs or "borrowed"
them from others, meaning that pattern sources were
nearly endless.

The maker utilized a wide assortment of both prints
and solids for the hundreds of triangles that form the
background to the block's radiating points, suggest-
ing that she pulled from a scrap bag. She also chose
a single purple, yellow, and orange print for all of the

PLATE 6-6. Fans.
Pattern source unknown.
Maker unknown.
Possibly made in Cass County, Illinois, c. 1930–1945.
Cottons, 81" x 81". QSPI: 9-11.
1997.007.0366. *Ardis and Robert James Collection.*

FIG 6-17. Fans, *detail*.

fans' quarter circles and a solid purple for her sashing and border, both of which tie the piece together and create a harmonious color scheme. Once again, the quiltmaker was either an experienced designer, or she followed a professionally designed pattern.

The quilt's fabrics and its "ice-cream cone" border point to the 1930s and early 1940s, an era when fan designs were enjoying a return in popularity. During the late nineteenth century, fans were frequently depicted on Crazy quilts to evoke the exoticism of the Far East, particularly Japan. After the turn of the century, Crazy quilts fell out of favor, and for several decades fans were rarely seen on quilts. In the 1920s, 1930s, and 1940s, however, popular interest in the East was renewed. This was Hollywood's era of Charlie Chan, Fu Manchu, Anna May Wong, and Grauman's Chinese Theater. In the arts, Art Deco design drew on Eastern sources, and Pearl S. Buck's novel The Good Earth won the 1932 Pulitzer Prize, while geopolitical unrest in the region meant that news from Asia frequently made the headlines. In this era of rekindled awareness of the East, fans were restored to fashion.

Fan patterns were given a variety of names. Sometimes they were old-fashioned names, such as Grandmother's Fan, which reflected the popularity of the Colonial Revival. Just as often, however, fans were given Oriental names, for example, Japanese Fan or Imperial Fan. The use of pattern names to evoke an era or popular decorating style was one of the key marketing strategies of quilt column writers. Asian-inspired and exotically named patterns followed a general trend, and names such as Chinese Gongs, Japanese Poppy, and Oriental Star abounded. Unlike fans, however, the visual appearance of many of these patterns had little or no connection to their exotic-sounding names. Appropriating exotic names and assigning them to largely traditional quilt patterns was simply a method of increasing their appeal to an audience who saw anything Asian as mysteriously appealing.[34]

One designer who frequently relied on exotic names for her patterns was Nancy Cabot. A sampling of her patterns includes Arab Tent, Chinese Waterwheel, Formosa Fan, Japanese Lantern, Oriental Magnolias, Persian Poinsettia, and Yokohama Banner. About Cabot's frequent publication of "colonial" patterns the quilt historian Barbara Brackman has written, "Interest in colonial antiques during the 1930s dictated that quilt patterns have a historical connection, accurate or not . . . therefore the Cabot column is a poor source for quilt history; the newspaper writer tossed in dates and facts with abandon."[35] The same could be said for her presentation of "Oriental" patterns, most of which are only fancifully related to Asian culture or design. In her quilt column for Chinese Coin (which is simply a new name for the traditional Monkey Wrench or Hole in the Barn Door pattern) she wrote, "An adventurous wanderer returned from the Far East, landed in New York about 1869 and brought with him many souvenirs of his wanderings. He presented to his lady fair, among other gifts, a rare curio, a Chinese coin. Intrigued with the then unusual token, the enterprising young lady worked the coin into a quilt design. Today we still have the lovely pieced block, Chinese Coin."[36] This fable allowed Cabot to grant a familiar pattern an exotic allure, a tactic used by many designers in an era when fancy superseded fact and romance trumped reality in the effort to sell quilt-related products.

■ Marin F. Hanson

By the 1930s a variety of quilt kits was available in a range of formats. One of the most popular types, called "ready-cut" kits, contained perfectly uniform die-cut fabric pieces in diamonds, squares, hexagons, or other shapes ready to sew together or appliqué. This Trip Around the World quilt (plate 6-7) appears to be one made from a ready-cut kit. Quilts made of identical small squares, measuring less than two inches along a side, also were often called postage stamp quilts.

It can be difficult to determine whether or not a pieced quilt was made from a kit. Once the quilt has been constructed, die-cut fabric pieces look exactly like pieces cut with scissors from a pattern. To determine whether a particular quilt might be of kit origin, the researcher must first confirm that a kit for such a quilt was available, and then examine the quilt itself for clues.

Trip Around the World was a popular postage stamp pattern for quilt kits, available in nearly every catalog and in many variations. This is easy to understand; rotary cutters had not yet been invented, so a quilt-maker's only alternative was to draw around a template with a pencil, and then cut out the individual patches with scissors. A Trip Around the World quilt might have more than two thousand pieces. This quilt contains 2,397 pieces.

The fabric squares in a typical kit were packaged in a box or envelope just large enough to hold them; brief instructions and a chart showing color placement were also included. For example, the Robert Frank Needlework Supply Company catalog, *Quilts, Patchwork, Appliqué: Needlework That Is Worthy of Your Time*, offered a die-cut kit for a "Rainbow Quilt" of 2,475 pieces. No. 40-AP was available in shades of red, orange, and yellow; No. 40-CP had shades of blue, orchid, and pink. Mary McElwain's catalog, *The Romance of the Village Quilts*, included a kit for "American Tapestry" in assorted prints for $11.50. A more economical choice was available in *Quilts, "Mickey" Cut-to-Size Quilt Patches*, catalog No. 5 of the John C. Michael Company of Chicago. Item No. 48 was a Trip Around the World kit of 5,285 squares (6,000 were actually supplied in the kit). The Michael Company's colors were arranged in three rows of print fabrics, then one of a plain fabric, progressing from light to dark values. The purchaser was offered the option of buying a partial set of squares. The first 115 pieces to make the center, and instructions, were offered for 35 cents. Five subsequent sets were available for $1.25 each. This allowed the customer to spread out the cost of her purchase over time or to make a smaller quilt without wasting material.[37]

The second step in confirming that a quilt was probably made from a kit is to examine its construction and fabrics. This quilt is constructed of forty-eight concentric rows of one-inch squares. Two rows of a solid color, a light and then a medium, are paired with two rows of prints in coordinated shades. There are forty-seven different fabrics used; only one plain medium green is repeated. One piece of evidence that

PLATE 6-7. **Trip Around the World.**
Kit source unknown.
Maker unknown.
Possibly made in Ohio, 1930–1940.
Cottons, 78" x 70". QSPI: 5-7.
1997.007.0819. *Ardis and Robert James Collection.*

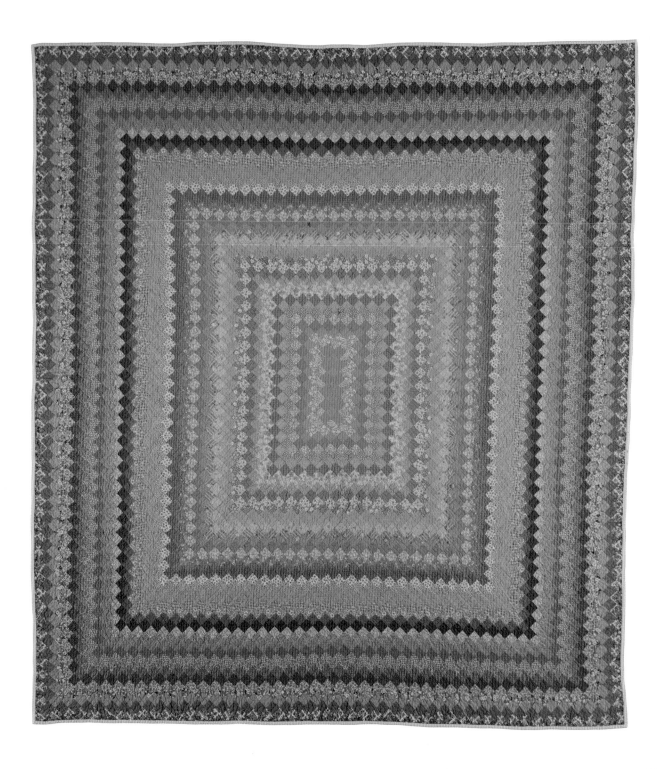

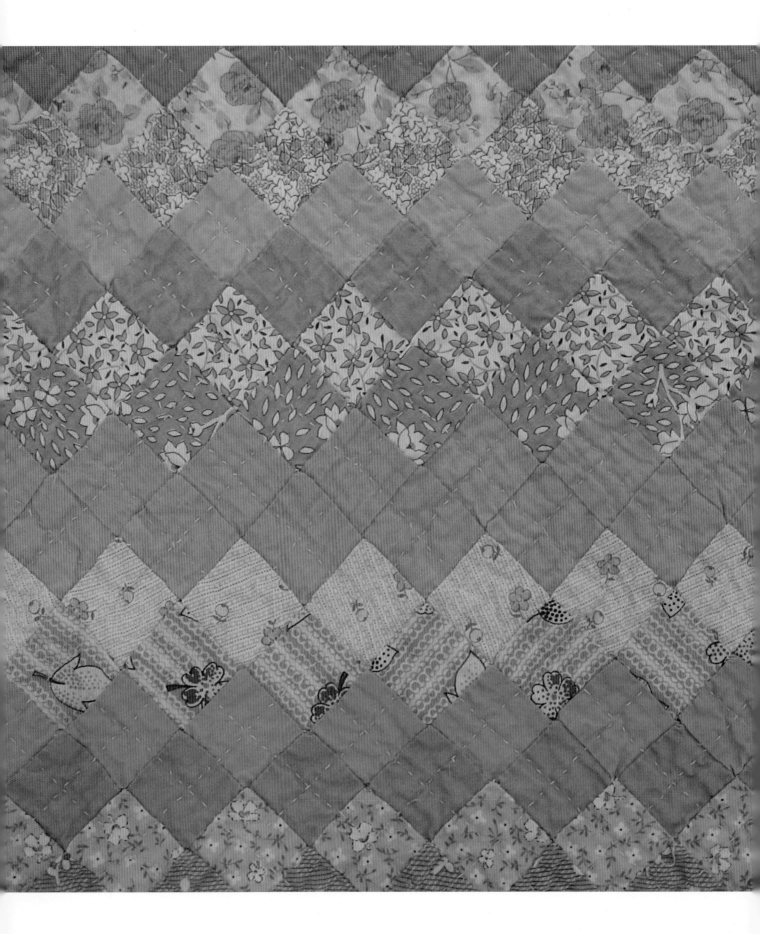

this quilt was made from a kit is that every row of fabric is uniform; the quiltmaker had enough of every fabric to complete an entire row. It was possible to buy packages of perhaps twenty different cut fabrics, but these did not normally include more than a fourth of a yard of any one fabric. The outermost row of this quilt would have required at least a half of a yard.

Another clue to its kit origin is that the fabrics are all typical of the Depression era. A variety of new, fast colors became available due to developments in synthetic dye technology during the 1920s and remained popular into the 1930s. Floral and novelty prints in bright pinks, blues, and yellows were widely offered. A green with a slightly grayed tone called Nile green was so popular that it is now often referred to as "Depression green." Orange was newly available in the 1930s and popular as a novelty. Purple and true lavender were also widely used. Prints of the period often showed a narrow band of white around the elements of the print. This made registration easier when the fabric was printed, and therefore less expensive to produce.[38] By contrast, a quilt made from a scrap bag rather than a kit would likely contain some fabrics from an earlier time. The third clue provided by the fabrics in the quilt is the way the rows of colors are orchestrated for a nicely coordinated whole. The consistency of the fabrics, their use in complete rows, and the attractive blending of colors and patterns all point to this quilt's origin as a kit.

■ **Deborah Rake**

FIG 6-18. Trip Around the World, *detail*.

FIG 6-19. Carrie Stelzer, c. 1935.
Courtesy of Lynn and Linda Jones.

Carrie Stelzer, the maker of this Grandmother's Flower Garden quilt (plate 6-8), was born Carrie Schafer in Montgomery, Alabama, on January 20, 1876. Her family moved to Sullivan, Missouri, where she was raised. On November 4, 1896, she married Joseph Stelzer in Missouri. In 1918 Joseph and Carrie moved their family to a farm southeast of Geneva, Nebraska, and in 1920 Joseph was killed when he was kicked by a horse. Carrie continued to operate the farm until it became too difficult to keep up. She then purchased a large home with the help of her son, James, in the town of Geneva, where she lived until her death on August 1, 1963. To make ends meet Carrie took in boarders, cultivated a vegetable garden, and assiduously avoided waste of any kind. She also sewed bonnets, aprons, and other clothing and used the scraps in patchwork quilts. Her grandson, Lynn Jones, the donor of the quilt, along with his older brother and his mother, Teresa, lived with his grandmother until he graduated from high school. Lynn remembers quilts being used on beds in the house and others kept in storage. Carrie was a close friend to other elderly single ladies in the neighborhood, and Lynn believes she shared her interest in sewing and quiltmaking with them.[39]

Carrie embroidered dates and initials on the reverse of the quilts she made. The initials correspond to the name of the family member to whom she wished the quilt to be given. The Grandmother's Flower Garden quilt has a "T" embroidered in one corner on the reverse side, indicating that Lynn's mother, Teresa, was to receive it. Carrie made quilts as gifts for weddings and other events in family members' lives. Lynn remembers that on one occasion relatives arrived for Sunday

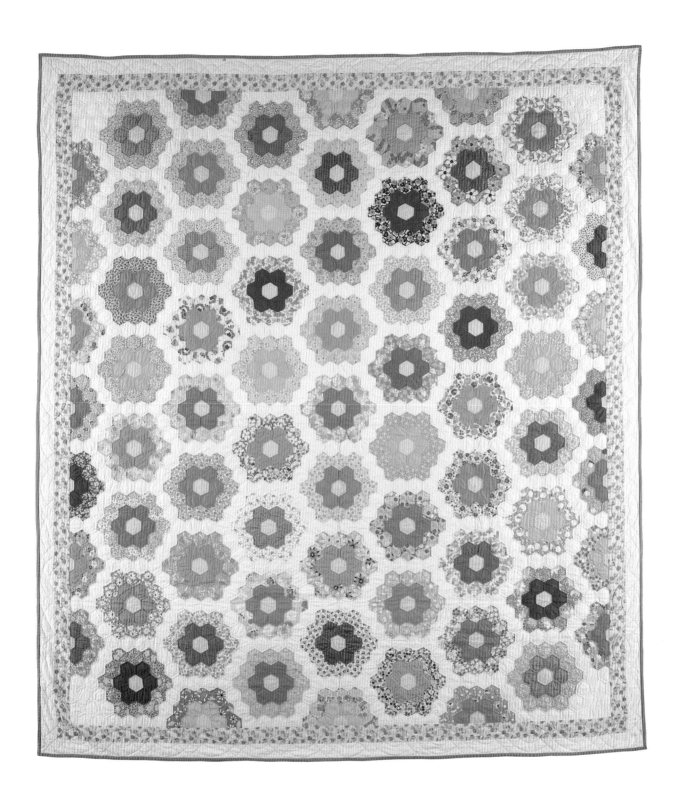

PLATE 6-8. Grandmother's Flower Garden.

Kit source unknown.

Carrie Stelzer (1876–1963).

Geneva, Nebraska, dated 1931–1934.

Cottons, 88" x 76". QSPI: 7-10.

1999.006.0001. *Gift of Lynn and Linda Jones.*

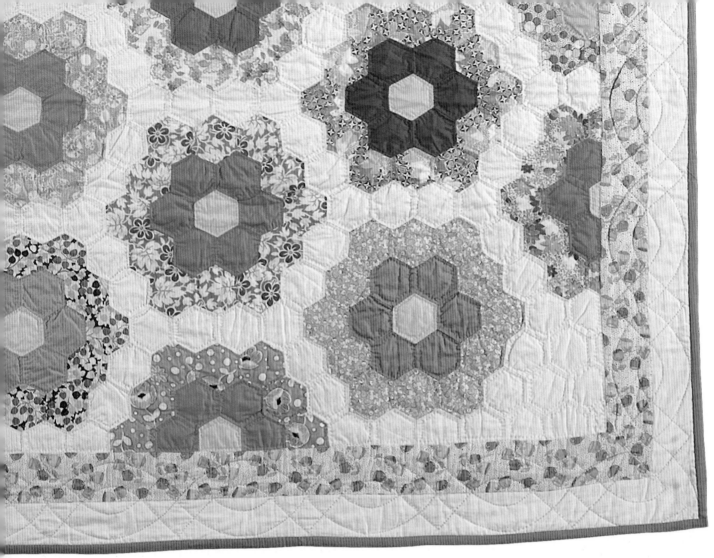

FIG 6-20. Grandmother's Flower Garden, *detail*.

dinner, with a quilt Carrie made being used as a front seat cover in their car. That sight made her angry; she did not see that as an appropriate use of the quilt.

This quilt is made of identical hexagons seamed together to form fifty-three whole-flower motifs, with twenty more half-flowers around the edge. Each flower has a yellow center ringed with six hexagons in a plain color and twelve more in a coordinating print. The motifs are then linked with plain white hexagons that form a background. Many Grandmother's Flower Garden quilts were made with a scalloped edge that followed the outline of the flower motifs. Carrie, however, chose to straighten the edges and then add two narrow borders, one a pink print and the other white. She then added a bright pink binding. Although curved or scalloped edges for quilts were popular, there can be no doubt that straight ones were

much easier to bind. With her tendency toward practicality and thriftiness, Carrie possibly felt a scalloped edge would have been excessive.

An example of a kit for a quilt like this one may be found in The 1939 *Catalog of Patchwork Quilts, Appliqué, Art Needlework*, printed by the Needlecraft Supply Company of Chicago. A Grandmother's Flower Garden kit, No. 93, was offered for $5.95. It made an "artistic" quilt in "beautiful pastel shades of Orange, Green, Dark Blue, Light Blue, Red, Orchid, Rose Pink and Tangerine." The kit included 3,300 die-cut hexagons of Royal Crown 80 square percale, instructions, and a color chart.

Vendors of kits during the Depression were very much aware that buyers might have limited income. The Virginia Snow Studios of Elgin, Illinois, printed *Art Needlework Creations 1932*, Grandma Dexter Quilt Patches and Blocks. They offered twelve-inch blocks stamped with the outlines of a patchwork motif. The buyer used her own fabric patches and simply appliquéd them in place. No. 2479, Grandmother's Flower Garden, was offered for as little as 3 cents apiece or 30 cents per dozen.

It is not possible to say definitely that Carrie fashioned this quilt from a kit, especially when one considers that she would have had scraps from her sewing projects and sources of fabric exchange with friends who also sewed. In addition, the financial needs of her household may have discouraged her from buying a quilt kit. Nevertheless, there are several factors that suggest this quilt was made from a kit: the uniform style and variety of print fabrics used are characteristic of those to be found in many quilt kits; the description of the quilt matches those in quilt kit catalogs; and kits for this type of quilt were widely available. Whether the quilt derives from a kit or not, it remains an excellent example of popular quiltmaking of the Depression era and a material reminder of the efforts of many women like Carrie, whose beautiful quilts serve as a contrast to the hardships of the times.

■ **Deborah Rake**

Floral Basket is the type of quilt often thought of as a quintessential Depression-era kit quilt. The large central floral medallion, the pastel colors and white background, the scalloped edge, and the generally pretty appearance of the quilt all conform to the Colonial Revival style, at its height during the 1930s. Such colonial-inspired images were ubiquitous in American popular design during the 1920s and 1930s, reflected in mass-circulation magazine illustrations, home furnishings, and movie sets.

Kits for appliqué quilts consisted of a background fabric, usually white or a light color, stamped with blue dotted lines outlining where the pieces of the appliqué design should be placed. For quilts such as this one (plate 6-9), with a large, centrally focused design, the background could be all of one piece or of three lengths that were seamed together. The appliqué elements were stamped on pieces of colored cloth, ready for the quiltmaker to cut out and appliqué. Many quilts made from such kits may be found today in attics and closets, though their owners may not recognize their origins. They survive because they were made in large numbers and because they were often saved for best and handed down as important family artifacts.

The kit for the Floral Basket quilt was offered in an undated catalog titled *Colonial Needlecraft Heir-loom Quilts, for Appliqué, for Patchwork*. It was published by Needleart Guild of Grand Rapids, Michigan. Needleart Guild was the retail sales division of the F. A. Wurzburg Company, a manufacturer and wholesaler of quilt kits. From the 1920s to the 1940s, Wurzburg was the largest producer of art needlework kits in the United States.[40] Initially the company sold to needlework shops and department stores, but the growing demand for quilt-related products led to the establishment of a direct mail-order line, Needleart Guild, in 1932.[41] Needleart Guild published a number of catalogs; they often carried the company slogan, "Needlework that is worthy of your time." Their kits were also sold by Frederick Herrschner, Inc., of Chicago. Herrschner's catalog carried art needlework, household textiles, and ready-to-wear clothing. The Needleart Guild catalogs offered quilts, quilting patterns, quilting frames, and art needlework. Two kinds of quilt kits were available: die-cut patchwork and stamped appliqué. The Floral Basket kit was available with a background fabric of "soft white Nainsook," a soft, fine white cotton fabric, and appliqués of "hand tinted" colorfast "80 square percale" for $5.25.[42]

On this quilt the appliqué is sewn in a fine buttonhole stitch rather than a whipstitch. The binding is unusual because quilts were almost always bound with a solid color; this quilt employs a fine green-and-

PLATE 6-9. Floral Basket.
Needleart Guild kit.
Maker unknown.
Possibly made in Cleveland, Ohio, c. 1932.
Cottons, 87.5" x 76". QSPI: 10.
1997.007.0791. *Ardis and Robert James Collection.*

white check. The same checked binding material is used to make the basket and the basket-weave designs in the corners of the quilt.

It was not uncommon for quiltmakers to add to or change kits to suit their own needs and tastes. In this case, the trio of pink flowers near each corner was part of the original kit; the flowers at the center of the top and the two sides were added by the maker. In addition, she added her own quilting motifs. The catalog illustration shows simple crosshatched background quilting, but the maker has added a feather wreath encircling the center medallion, butterflies, and large stylized flowers. The maker also added colorful details to the appliquéd flowers with cotton embroidery floss. The catalog descriptions do not mention embroidery, and the black-and-white sketches that illustrate these catalogs do not show enough detail to discern whether the embroidery was intended to be part of the kit.

Although quiltmaking had gone out of fashion in urban areas by the end of the nineteenth century, early twentieth-century trends associated with the Colonial Revival made it desirable and fashionable again. The Colonial Revival, inspired by nostalgia for a romanticized version of the past, had its greatest impact on the decorative arts, including architecture, interior design, and needlework. Even as Americans enthusiastically purchased modern consumer goods, they also searched for artifacts of the past. Women decorated their homes with antiques and reproductions of antiques, and they were told that if they did not already have old quilts to throw over their beds, they should make new ones.[43]

This trend is evident in the Needleart Guild catalog. The title describes the quilts offered as "Colonial" and "Heirloom," although most were new designs. Appliqué kits were pictured under the heading "Colonial Appliqué Quilt," and pieced quilts were categorized as "Authentic Patchwork." A Bear's Paw kit was described as an "early American design of Frontier origin . . . adapted to our modern times." A pieced star was described as a "glorious old Colonial design." Many more descriptions used the words "quaint," "old fashioned," or "Colonial." The catalogs assured women that by quilting they were harkening back to the earliest years of their foremothers in the American Colonies, and that by using kits they were assured of the most modern methods and beautiful results.

■ **Deborah Rake**

FIG 6-21. Floral Basket, *detail*. Buttonhole stitch appliqué.

In 1932, Eda Sharpe of Noblesville, Indiana, finished this exceptional quilt (plate 6-10) using the State Flowers set of quilt patterns designed by the syndicated quilt columnist Ruby Short McKim. Eda's local newspaper, the *Indianapolis Star*, published the quilt blocks that year at a rate of one per week beginning in September 1931. At the end of the series, the newspaper hosted a contest and exhibition of its readers' completed quilts.[44]

The State Flowers series was a popular newspaper feature and figured in several different contests. A Jacksonville, Illinois, schoolteacher, Emma Mae Leonhard—who is represented in plate 7-43 with a quilt she made for the 1933 Sears Quilt Contest—completed the same State Flowers quilt with designs that were published in her local newspaper; she went on to receive the top prize of $50.00 at the state level, and then the first prize of $250.00 at the national level in Washington DC.[45] In Muncie, Indiana, the State Flowers Quilt Contest was announced with a full-page advertisement. The local prizes ranged from $2.50 to $50.00. All quilts entered in the contest had to be made from the designs printed in the newspaper during the contest period. All forty-eight blocks had to be in the quilts. Any technique was allowed—embroidery, crayon, paint, or appliqué. Children were encouraged to use the same quilt drawings and paste them in a scrapbook and then color them. When all forty-eight state flower blocks were pasted and colored into the scrapbooks, they were sent to the newspaper office for judging, where prizes ranging from $1.00 to $10.00 were awarded.[46]

There is no record that Eda entered a contest with her State Flowers quilt, but her work is meticulous and might well have won if she had entered. The quilt exhibits her high level of sewing and quilting skills: intricate, even quilting stitches, mitered corners, and a scalloped edge with a double binding in green and lavender. This series of forty-eight blocks did not include a plan for a border or alternate blocks. The overall design printed at the beginning of the series was a simple six-by-eight-block grid. The individual state designs were drawn four-by-six inches to be traced onto seven-by-nine-inch pieces of background fabric. Eda finished her quilt with three-inch sashing strips and a six-inch border. The introductory article specified the yardage and made fabric suggestions of muslin, percale, sateen, or satin in white, cream, or ecru, and it suggested colors for the embroidery floss.

Eda's skills had won her some acclaim two years

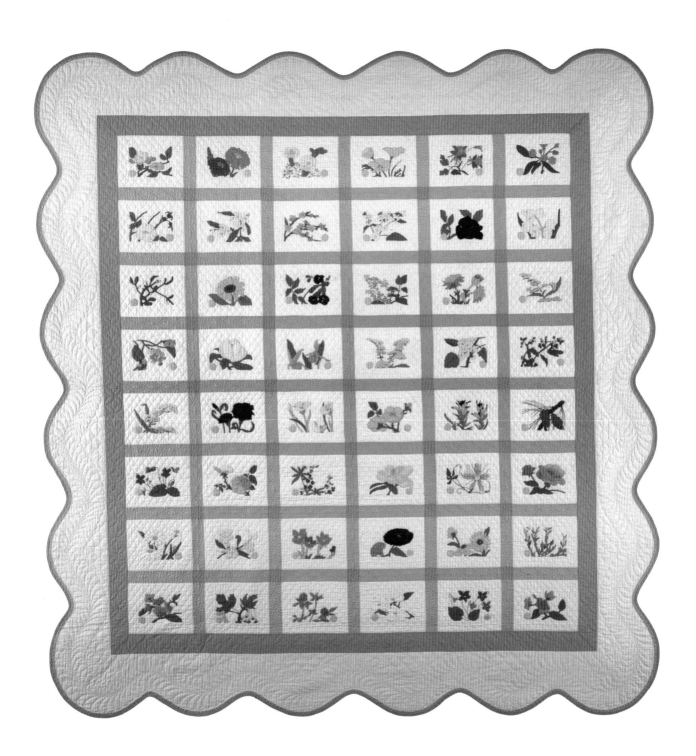

PLATE 6-10. State Flowers.
Ruby Short McKim pattern series.
Eda R. Sharpe (1885–1981).
Noblesville, Indiana, dated 1932.
Cottons, 83" x 78.5". QSPI: 8-11.
2004.021.0001. Purchase made possible through
Robert and Ardis James Foundation Acquisition Fund.

FIG 6-22. State Flowers, *detail*. Nebraska block.

FIG 6-23. Ruby Short McKim State Flowers pattern, Nebraska block. Courtesy of McKim Studios and Merrily McKim Touhy.

The State Flowers Quilt Pattern

© McKim Studios

NEBRASKA, GOLDENROD | seashore species, bog and swamp 9 for your quilt block. Some daint

FIG 6-24. Reprint of 1930 photograph of Eda Sharpe with her quilt, the Flower Garden (Ruby Short McKim pattern series), *Indianapolis Star*, November 14, 1976. Courtesy of *Indianapolis Star*.

earlier, when she won third place in a newspaper-sponsored contest with a different McKim series quilt, the Flower Garden. A photo of Eda standing beside her prize-winning quilt appeared in a 1930 issue of the *Indianapolis Star*.[47] The Flower Garden series, which ran from November 1929 through February 1930, consisted of twenty-five blocks stamped for embroidery, a quilting motif for the alternate plain blocks, and a picket fence pattern designed to be used on all four sides to make a double-bed-size quilt. The newspaper printed copies of all twenty-seven patterns and sold

them for 10 cents apiece for those quiltmakers who had forgotten to clip them from the newspaper.[48]

In 1976, as a mini quilting boom developed in response to the U.S. Bicentennial, the *Indianapolis Star* decided to repeat the 1930 Flower Garden series, with a contest to follow. There was a special division for quilts started by entrants during the original 1929 Flower Garden Quilt Contest.[49] Eda made a second quilt in the Flower Garden pattern and entered it. In a 1976 interview for the newspaper, she compared her two quilts. "The chrysanthemum is different," she pointed out. "In the 46-year-old quilt I appliquéd each of the petals separately. This time I appliquéd one piece for the flower and outlined the petals in embroidery."[50]

■ **Merikay Waldvogel**

PLATE 6-11. Springtime in the Rockies.
Louise Fowler Root, *Capper's Weekly* pattern.
Maker unknown.
Possibly made in Maryland, c. 1931.
Cottons, 91" x 73". QSPI: 5-9.
1997.007.0165. *Ardis and Robert James Collection.*

Originating in the South in the late 1800s, this pattern (plate 6-11) was known by various names: Crown of Thorns, Sunrise, and Rocky Mountain Road. Composed of hundreds of tiny pieces, quilts made in this striking pattern and its variations were often considered masterpieces, ensuring that many were handed down as family heirlooms. The pattern in its different manifestations is always visually interesting and often evocative of modernist images. Sometimes, as here, an overlying grid seems fixed with gears, as if we were seeing the workings of an intricate machine. Such quilts eventually reappeared in early twentieth-century magazine articles about antique quilts and inspired a new generation of quilt designers and quiltmakers.

This quilt is particularly interesting because it is an exact replica of another 1930s pattern with yet another name. Published on March 21, 1931, in the farm magazine *Capper's Weekly* of Topeka, Kansas, Louise Fowler Root, writing under the pseudonym Kate Marchbanks, titled the pattern Springtime in the Rockies. Mimeographed pattern sheets of the actual-size pieces sold for only 25 cents. She wrote in the short description beneath the illustration that she had seen the quilt on a quilting pilgrimage to Denver: "A first glimpse at the original quilt reminded me of the rising sun with its radiations—the glorious sunrises one sees only in the mountains—while the green and white stripes were mountain pathways with the spring's first green grass peeping thru the snow." Beneath the headline she included a stanza of the popular tune "When It's Springtime in the Rockies."

As the quilt revival of the 1970s was unfolding, Root reminisced in the foreword to *Kate's Blue Ribbon Quilts* about her days of writing the *Capper's Weekly* column, which debuted on February 12, 1927: "I drafted my first pattern from a quilt Mother was making. . . . Hundreds of women put 15 cents in a letter and sent for that pattern. From then on I had a new chore added to my other Weekly duties—hunting for quilts, drafting their patterns. . . . I haunted State Fairs and Quilting Bees and Teas."[51] Some of these hundreds of women who requested patterns didn't end up making the quilt. But at least in one case, the next generation did. A reader writing to *Capper's Weekly* on August 23, 1977, enclosed a photo of her first finished quilt made from the Springtime in the Rockies pattern. She wrote, "In my collection of over 1,000 designs, I have

FIG 6-25. "When 'Springtime in the Rockies' Is Quilted," *Capper's Weekly*, March 21, 1931. Courtesy of Merikay Waldvogel Collection and Ogden Publications, Inc.

not found it anywhere else. Mother liked the pattern but never got around to making it. I can understand why—with over 3,000 pieces in it! I collect patterns but don't make quilts; this is my first and I'm pleased with the outcome."[52]

Root's column was not quite as widespread as the Stearns and Foster Company's patterns published on Mountain Mist batting wrappers. Today, therefore, this pattern is often called New York Beauty, the name given to it, without explanation, in 1930 by Stearns and Foster. According to the daughter of Stearns and Foster's sales manager F. J. "Fritz" Hooker, he collected antique quilts in Kentucky and Tennessee for the company's quilt collection.[53] It is likely that Mountain Mist's New York Beauty pattern was taken from one of these quilts, but no clue to the source of the pattern name has yet been discovered.

■ **Merikay Waldvogel**

PLATE 6-12. Dresden Plate.
Kit source unknown.
Louise Thonstad (1885–1974).
Deadwood, South Dakota, 1930–1940.
Cottons, 97" x 76.5". QSPI: 6-7.
1997.007.0681. *Ardis and Robert James Collection.*

FIG 6-26. Louise Thonstad, c. 1915. Courtesy of Mariam Wheeler.

Louise Thonstad, who was born in Norway in 1885 and immigrated with her family to the Dakota Territory, made this Dresden Plate quilt (plate 6-12) around 1935. Louise, who never married, lived most of her life in Deadwood, South Dakota.[54] The quilt is composed of twenty blocks joined without sashing. Each "plate" is made from fourteen "petals" of assorted print fabrics, which are first seamed together along their straight sides and then appliquéd to the muslin background. The border is made up of 110 more print petals alternating with plain white. This type of border is often called an ice-cream cone border for the obvious resemblance of its pieces to that dairy treat.

Louise added an individual touch to her Dresden Plate quilt. She carefully cut circles out of one of her fabrics, each with the same printed flower in the center. She then appliquéd these circles to the center of each plate, leaving visible a narrow ring of background fabric. She then outlined the circles with a running stitch of black cotton embroidery floss. It was not unusual for quiltmakers to modify or embellish kits to suit their own needs or tastes.

The pattern name, Dresden Plate, comes from the fine china produced in Dresden, Germany, beginning in the early eighteenth century. Dresden and Meissen were the first cities in Europe to produce porcelain, and Dresden's colorful products were widely distributed and admired. The pattern was popular during the Depression era; along with Lone Star, Grandmother's Flower Garden, and Double Wedding Ring, it was in-

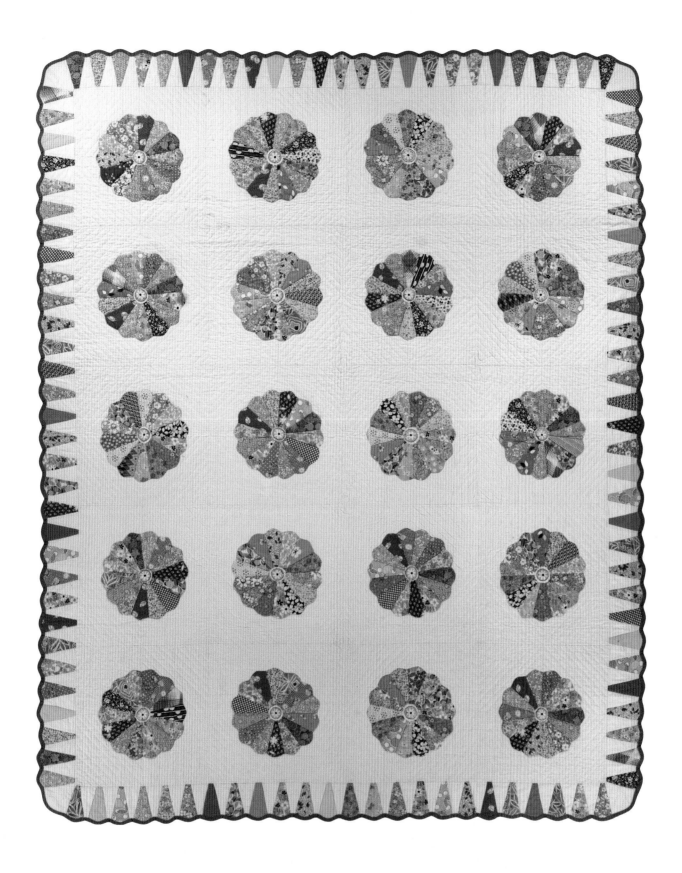

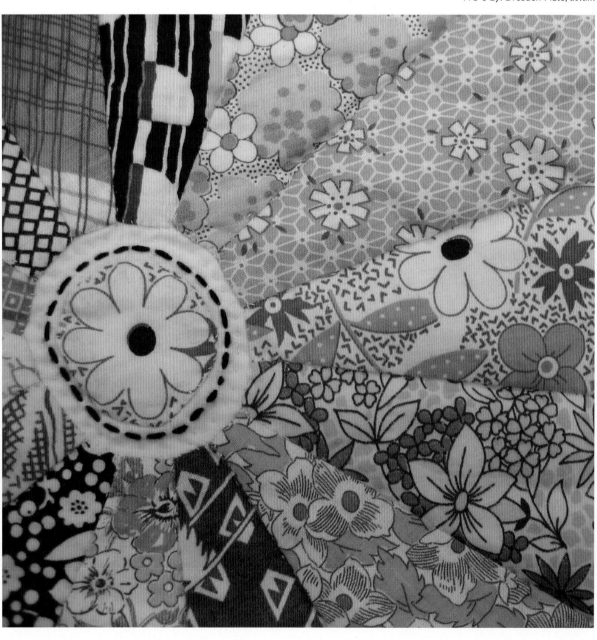

FIG 6-27. Dresden Plate, *detail*.

cluded in nearly every catalog of kits. Often it was available in more than one variation and even with different names. Kits for this type of quilt usually included the die-cut petal shapes and the muslin background.

Often, as is the case with this quilt, the fabrics provide the first indication that a quilt might have been made from a kit. The fabrics in this quilt are a veritable sampler of Depression-era prints. There are no fabrics that appear to be of an older vintage, such as one would expect to see if the fabrics were from a scrap bag and cut using a cardboard template. Also, although a wide variety of fabrics is included, there is repetition from plate to plate. Further, some of the fabrics are different colorways of the same print. Die-cut quilt pieces were often cut from stacks of scraps left over from ready-to-wear garment construction, so finding the same print in different colors is a clue that points to a kit origin.[55]

Determining the exact kit from which this and other die-cut pieced quilts were made is difficult, since no evidence appears on the surface of the finished quilts. Catalogs and advertisements for quilt kits of the 1930s included a sketch of the finished quilt top and information about it, such as finished dimensions, number of blocks or pieces, and usually what materials were included in the kit. An example can be found in the *Catalog of Quilts and Quilting, Cut, Ready-to-Sew Quilt Tops*, which was the 1933 catalog of the Ladies Art Company in St. Louis. They offered No. 536, Dresden Plate. It had a pink scalloped border and pink centers for each plate. The catalog offered two choices: "All pieces cut of white muslin, assorted prints, and plain pink gingham, $4.90; cut of all gingham and prints, $5.60." Pink bias binding was 35 cents extra.

Another example is found in *Quilts by Boag, the Most Authentic Quilt Line in America*, the catalog of the Boag Company of Elgin, Illinois. Their Dresden Plate kit, No. 423, was designed with sashing between the blocks. The catalog listed its finished dimensions and the colors offered: "Pink, Blue, Yellow, Orchid, Peach, Green." The kit contents were also given: "Box contains all materials for making complete quilt top, including background blocks and borders cut to size, all die cut pieces for plates, and matched binding for edge." The backing and batting were not included.[56]

Instead of the detailed technical information that would be helpful to a researcher seeking to identify kit sources, the catalogs of this era often contained fanciful stories about the quilts offered. The Colonial Revival was at its height in the 1930s, and merchants sought to convince their customers that quilting had its origins in the admired thrift and industry of their early American ancestors. In the Boag catalog a Dresden Plate variation with a diagonal setting, No. 440, was named Friendship Ring. An invented historical background was offered in the description: "The origin of the 'Friendship' series can be traced to some years before the Revolution. At that time, it was the custom for the maker to beg from each of her friends enough material for one block. Then followed parties at which the contributing friends helped with the piecing and quilting." In truth, this pattern first became popular in the twentieth century.[57]

■ **Deborah Rake**

With obvious references to celestial signs, months of the year, and personality characteristics, this quilt (plate 6-13) came to the Center's collections bearing the name "Zodiac quilt." In fact, its correct name is Old Almanac quilt, and it was published as a syndicated series in newspapers throughout the nation in 1932. *The St. Louis Star and Times* announced the debut of the quilt series in the Nancy Page Quilt Club column this way: "It will be fun to make this Old Almanac Quilt. No matter how many quilts you may have, this one will be the most unique of all. You'll enjoy following the signs of the Zodiac as you work on it, and when finished you can entertain your friends by reading their horoscopes. Join the Nancy Page Quilt Club Beginning Next Monday on the Woman's Pages of *The St. Louis Star and Times*."[58]

The Old Almanac quilt ran from October 1932 through January 1933. It was the eighth syndicated quilt series offered by the Nancy Page Quilt Club.[59] Known for her conversational writing style, Florence LaGanke, using the pseudonym Nancy Page, opened this series by telling her readers where she found the idea for this unusual quilt. Speaking of herself in the third person, she wrote:

> The great idea came to Nancy when she was house-cleaning and going over a pile of old books that had belonged to her grandmother. She found an old almanac. Its blue cover attracted her first of all. Then she turned the pages, found a rebus or two, some riddles, some medicinal hints, facts of geographical and of historical importance. The queer signs of the zodiac interested her as much as the predic-

Beginning of Old Almanac Quilt

FIG 6-28. Old Almanac quilt advertisement, *St. Louis Star and Times*, 1932. Courtesy of Merikay Waldvogel Collection.

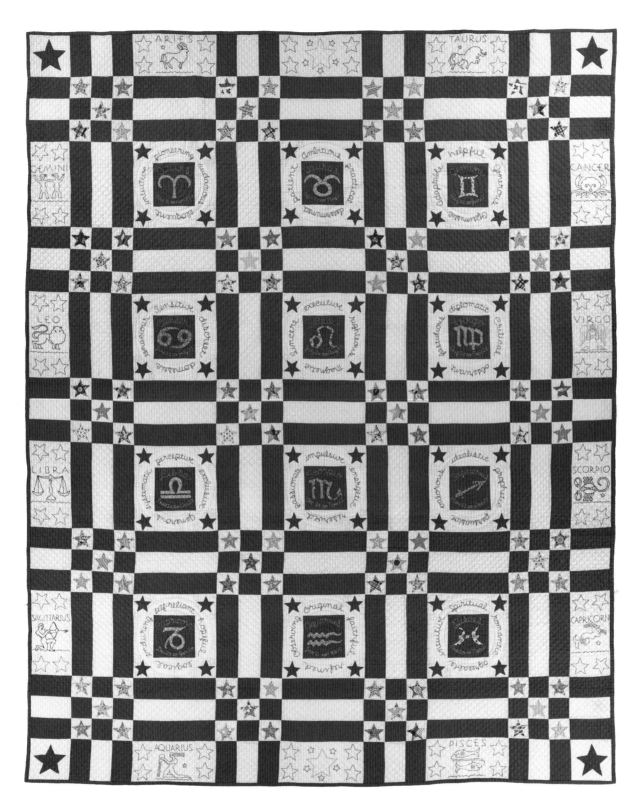

PLATE 6-13. Old Almanac.
Nancy Page pattern.
Maker unknown.
Possibly made in Pittsburgh, Pennsylvania, c. 1933.
Cottons, 103.5" x 82". QSPI: 9.
1997.007.0637. *Ardis and Robert James Collection.*

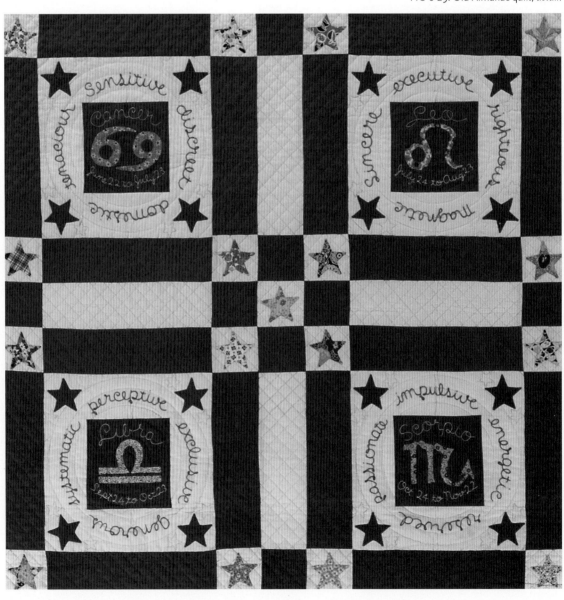

FIG 6-29. Old Almanac quilt, *detail*.

tions of coming events, which were now, of course past history. All of a sudden she jumped—"Why here was the very idea for her new quilt. Here was the quilt for her—an Old Almanac Quilt. It would be in blue and white like the old volume. It would have the signs of the zodiac as well as the month when each sign rules."[60]

The Old Almanac series consisted of all the patterns for the appliquéd zodiac signs, embroidery patterns to trace for the dates and personality characteristics, a template for the appliqué stars, and a quilting pattern.

This quiltmaker followed Page's suggestion to make a smaller quilt by leaving off a three-inch white sashing between the outside border and the first set of sash strips, which was to be quilted with symbols of the planets. Otherwise, this quiltmaker followed the pattern exactly. At the end of the series, Page reminded her readers:

No quilt like this has ever been designed before. It may well be handed down in your family as an heirloom. Take great care, therefore, with all the cutting, seaming, appliquéing, embroidering and pressing. Your descendants will say "How did they ever do such fine work? Isn't it marvelous? I wish I could have known my grandmother better and had her show me how she did such exquisite work."

And your contemporaries will say, "Goodness, did you really make that beautiful quilt? Do you suppose I could ever do anything as nice as that?"

Florence LaGanke Harris was trained as an educator and home economist and taught in universities after graduating from Columbia University in 1908. Later, she began a writing career at her hometown's major newspapers, the *Cleveland Plain Dealer* and the *Cleveland Press*. Writing her own biographical notes for a 1952 story, LaGanke, mentioned the origin of her Nancy Page Quilting Column:

For 17 years she wrote a daily Nancy Page column that appeared in newspapers all across the continent. She covered not only problems of food and cooking, but also questions of dress, interior decorating, etiquette and anything else that interested women. Out of the "Nancy Page" columns came one of Miss LaGanke's most popular features—the quilting column. A chance reference to quilting patterns in a regular column brought a host of queries. At the time she knew little about quilting, but she soon learned. As her readers' interest grew she started up a separate column. Soon she was one of the nation's leading experts on quilt designs. She still has at her home one of the finest collections of quilts, both in new and traditional patterns, in the country.[61]

■ Merikay Waldvogel

FIG 6-30. Rose Bower, *detail.*

instructions precisely and then adding her own improvements. One design change—the use of a black sateen foundation instead of the suggested "pastel green" background—produced a dramatic and sensuous impact. She also added French knots to accent the flower centers, used bias tape for the stems, and designed a quilted wreath for the center area. The rosebuds around the central open area were also added.

Cabot favored appliqué patterns over pieced patterns, and her instructions were not very helpful. Here is the description for the Rose Bower quilt:

> Clever manipulation of attractive appliqué patches creates this beautiful "Rose Bower" quilt. It is one of the most gorgeous bed coverlets available to present day quilt makers. The amazing feature of the quilt is the simplicity with which it is made. It is composed entirely of 12-inch square appliquéd blocks, set together to form the bower of flowers illustrated. A pastel green background, white lattices, soft rose for petals, and leaf green makes a most ideal color combination. For those who still fancy a white background the choice of coloring for lattices might be a shade similar to natural wood, a pale yellow or deep rose.[64]

Cabot's sparse instructions for this pattern did not mention embroidered touches or suggest the use of bias tape for the stems. Makers also had to create mirror images of the appliqué design and add four roses at the vertical axis to replicate Cabot's Rose Bower layout. This was a quilt design for an expert quiltmaker, and Rose Modjeska clearly was such.

Cabot's column had an unlikely beginning, initiated by the young secretary to the Sunday editor of the Chicago Tribune. In her article "Who Was Nancy Cabot?" Barbara Brackman wrote, "Twenty-six-year-old Loretta Isabel Leitner adopted the pen name Nancy Cabot and talked her boss into letting her organize a column that grew to be one of the most extensive and popular sources of quilt designs in the 1930s, with more than 2,000 patterns." The patterns were also syndicated and appeared in, among others, the New York Daily News, the St. Louis Globe-Democrat, Grit, and Progressive Farmer. The name Nancy Cabot appeared only in the Chicago Tribune.[65]

■ **Merikay Waldvogel**

Rose Pagers Modjeska was born on April 17, 1877, in Chicago. Her parents, Charles and Adelhide Pagers, immigrated from Bremen, Germany, arriving in New York City in 1865. They settled in Chicago, where Rose, her four sisters, and one brother were born. In 1900 she married Alexander Modjeska, a Russian immigrant who had arrived in the United States in 1882. Alexander and Rose had two children, Lorraine and Roland. Lorraine's son, L. Lowell Stough, remembers living with his mother's parents in Downers Grove, DuPage County, near Chicago, after his father died in 1929 and until his mother remarried and moved to New Mexico in 1938. He remembers that occasionally the furniture was pushed aside to make room for a large quilting frame in the Modjeska dining room. Stough particularly recognized the Rose Bower quilt (plate 6-14) as one that his grandmother had made with the help of her sisters.[62] Rose likely saw the quilt design in the newspaper. It is a Nancy Cabot pattern called Rose Bower, published in the Chicago Tribune on October 20, 1935.[63]

One might surmise that Rose was drawn to this particular quilt because of its name. She certainly took care with its construction, following the basic

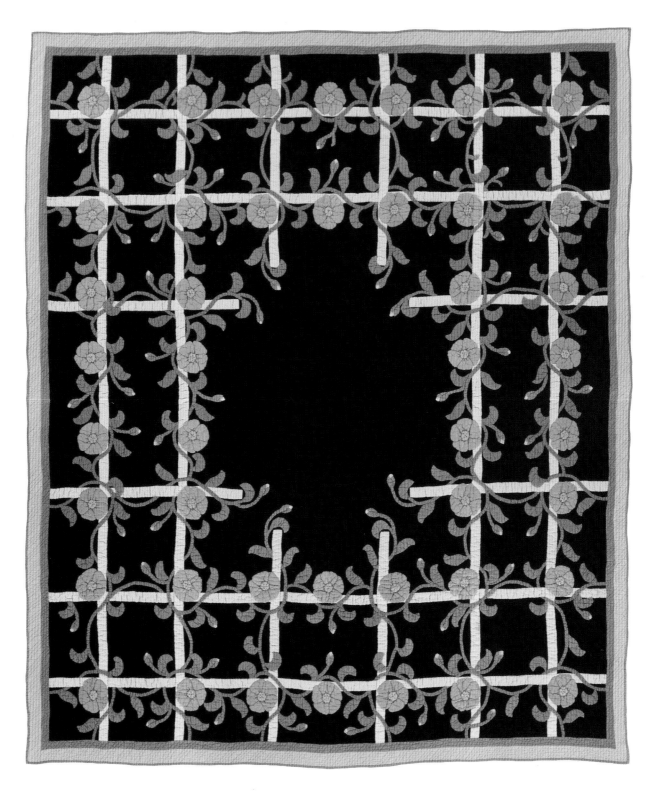

PLATE 6-14. Rose Bower.
Nancy Cabot, *Chicago Tribune* pattern.
Rose Modjeska (1877–1962).
Downers Grove, Illinois, c. 1935.
Cottons, 85" x 72". QSPI: 12-14.
1997.007.0638. *Ardis and Robert James Collection.*

358

Mary A. McElwain, the designer of this Painted Daisy kit quilt (plate 6-15), was a successful businesswoman. She sold quilt goods not only through her well-known shop in Walworth, Wisconsin, but also through mail order. She hired a number of women to stamp, cut, and sometimes baste the kits she offered, and also to quilt finished tops.[66] In 1936 she published *The Romance of the Village Quilts*, a catalog of quilts and quilt-related merchandise whose themes and images were largely drawn from the Colonial Revival. She prefaced it with a romanticized two-page essay about the importance of quiltmaking to American women, its place in history, and why modern women found it so appealing. It read, in part:

The early Americans were really exiles, seeking new homes and freedom. These women stitched hour by hour in the creative art of harmony to ease their memories. They viewed each day with the glorious sunrise and adjusted their working hours to the sun. We have recaptured the spirit of early America and caught the glamour and romance of the old days, for the quilts do cast an irresistible spell upon the rooms they adorn. . . . The pioneers with happy hearts and willing hands enjoyed spinning, weaving, dyeing, and quilt making, as everyday routine work in the first homes of their beloved land. . . . What a wholesome thought it is that our American women have so saved, planned, and pieced the quilts. To have wrought beauty from beautiful surroundings has not always been achieved, but these early pioneer women salvaged beauty and usefulness from waste materials. This was one of their everyday accomplishments.[67]

In the 1936 catalog McElwain offered a variety of quilt kits, including Marie Webster designs, copies of historical quilts, and some of her own design. Her products also included paper patterns, kits with precut pieces, basted kits, and finished quilts, all at prices varying from 35 cents for most of the paper patterns to as much as $85.00 for a full-sized finished quilt.[68] McElwain often recommended to her customers that they complete their tops and then return them to her shop for professional quilting. She used local women, as well as some in Kentucky, as quilters.[69] She also sold sheets, silk comforters, batting, thread, metal templates for pieced quilts, and yard goods.

Painted Daisy, a crib quilt, was offered as a stamped kit in blue or pink with white daisies and yellow centers and green leaves and stems. The stamped kit sold for $1.75; a finished quilt could be purchased

for $7.50. McElwain's catalog illustrated five types of background quilting suggested for application to her designs, including a diagonal grid, which she called "checking," and triple diagonals, which she called "broken diagonals." The dainty Painted Daisy quilt was pictured with checking within the wreath and broken diagonals outside of it. It had no border.[70]

The maker of this version included several additions to the original design, such as a two-inch white border and pink binding. The quilting is worked in one-quarter-inch checking within the wreath and a half-inch grid outside of it, with feather wreath hearts in each corner, all of which are derivations of McElwain's design. Only in the border is the broken diagonal pattern of the catalog illustration carried out. The quilting is an amazing seventeen stitches per inch within the center medallion and fifteen stitches per inch in the rest of the quilt. Such quilting, which required a high level of skill, may indicate that it was professionally done.

The quilt revival of the early twentieth century offered many economic opportunities to women like McElwain, with needlework or designs skills and an entrepreneurial spirit. Women with needlework skills were able to supplement their family income by quilt-making. They might work individually in their home or church or as employees of quilt-related businesses, and some went on to establish their own business ventures. A particularly successful example is Anne Orr, who in 1919 began writing for *Good Housekeeping* magazine, where she served as the needlework editor for many years. Through the magazine, she offered patterns and, later, kits.[71] Although she designed a variety of needlework items, her best known quilt designs are made from small squares and resemble cross-stitch patterns.[72] Another example of a quilt entrepreneur is Edna Foster of Perry, Oklahoma. Foster cut and basted appliqué blocks and sold them ready to finish. She also offered to assemble finished blocks into a top and quilt it. She employed a group of women from a Catholic church in St. Genevieve, Missouri, to do the quilting for her.[73]

■ **Deborah Rake**

FIG 6-31. Painted Daisy, *detail.*

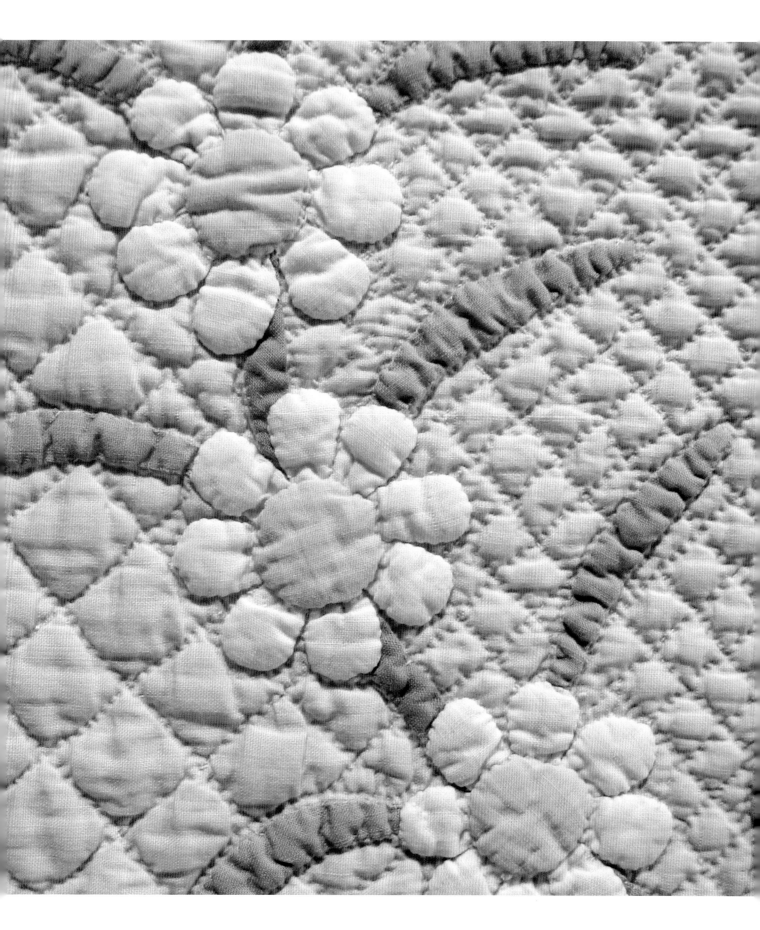

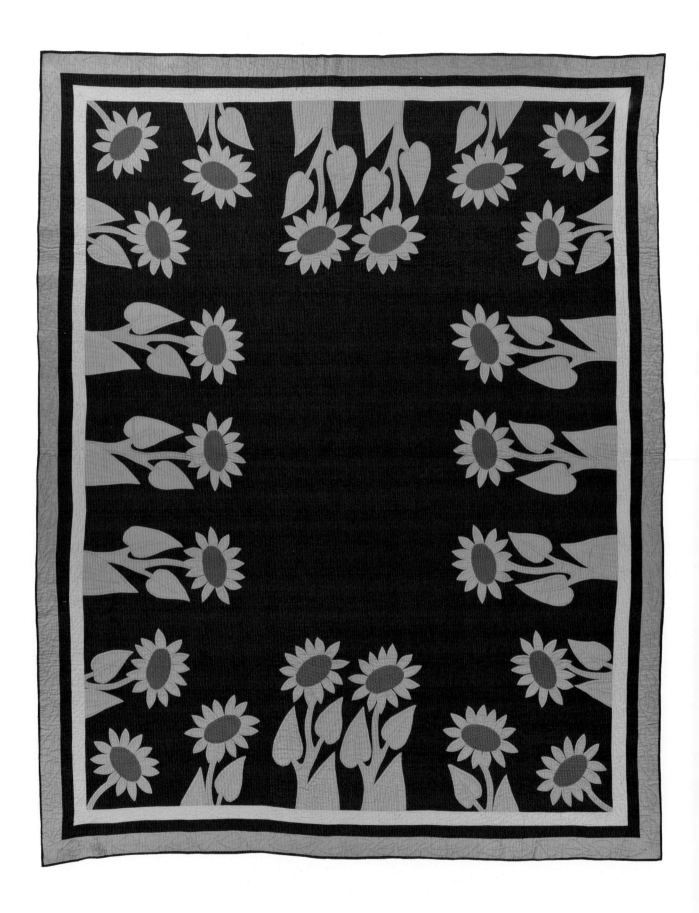

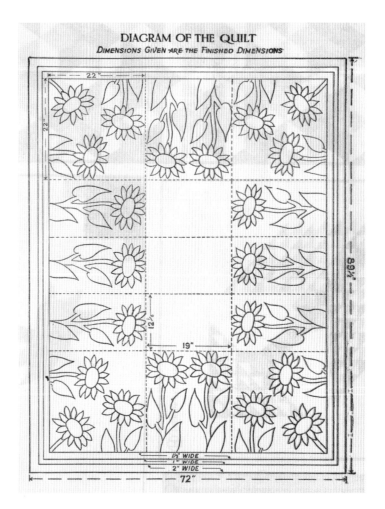

The Sunflower is a Mountain Mist pattern, one of the most influential and longest lasting quilt pattern lines. Stearns and Foster Company, the producers of Mountain Mist batting, also had one of the earliest and most effective strategies for marketing quilt patterns.

As a means of increasing sales of his company's quilt batting, the sales manager F. J. "Fritz" Hooker decided to reach out to quiltmakers. He offered quilt patterns to increase quiltmaking and, thereby, sales of batting. First, he settled on just one name for the company's cotton batting: Mountain Mist. Then he redesigned the plain brown wrapper to make it more attractive. He chose colorful quilt blocks (pieced and appliquéd) for the outside wrapper and had it printed at the company's own printing plant.

At the time, Hooker did not expect to provide patterns for each illustration, but when quiltmakers asked for them, he had to quickly find someone who would rework the illustrations into usable patterns and instructions. Hooker eventually located a freelance artist and designer, Margaret Hays, living in Chattanooga, Tennessee. Neither the sales manager nor the artist had experience in quiltmaking.

This Sunflower pattern (plate 6-16), developed by Hooker and Hays, is often misidentified as Marie Webster's Sunflower quilt design published in 1912. It is, in fact, a streamlined Art Deco version of Webster's Art Nouveau Sunflower. The maker of this quilt took an even more dramatic departure by using a dark background rather than white or off-white, as suggested in the Mountain Mist wrapper instructions. Further instructions suggested signing and dating the Sunflower quilt: "If one wishes to sign the quilt with name and date of making, this record may well be substituted for the [quilted] diamonds in the center part of one of the corner flowers."[74] Instead, this quiltmaker turned the quilt over and embroidered only the date "Jan. 1–43."

FIG 6-32. Diagram of Sunflower pattern quilt, Mountain Mist batting wrapper, 1932, *detail*. Courtesy of Stearns and Foster Collection, Leggett and Platt.

FIG 6-33. Sunflower. Embroidered date on reverse, *detail*.

Correspondence from Fritz Hooker to Margaret Hays belongs to a niece who inherited it upon Hays's death. The correspondence provides a rare opportunity to follow the evolution of a classic design.[75] On September 22, 1929, Hooker responded to the color sketch Sunflower, which Hays had submitted:

We are returning this color sketch to you today. . . . Of course, I think your sketch is a decided improvement over the design we show on our wrapper and while we have given you license to depart somewhat from the wrapper-designs, at the same time, we must not get too far away. . . . However, you may have some ideas about working in more of a "sunflower" motif for the center blocks.[76]

Hays evidently submitted another design, but the staff at Stearns and Foster was still not satisfied. In his October 18, 1929, response, Hooker reveals the balance he was attempting to achieve between a realistic design and a modern interpretation of a sunflower:

We are returning this color sketch for the reason that we feel that the figure for the blocks strays a little too far from the actual flower and has too much appearance of a star. The pencil tracing enclosed was taken from an excellent illustration from the National Geographic magazine of June 1917 and the names of the colors I indicate were matched up with the Peter Pan colors. Also is enclosed a seed envelope sunflower. I think we can get the proper effect if we draw a little curve into the outside petals. So will you see if you cannot make up another color sketch.[77]

Evidently Hays was able to achieve the balance because, on November 4, Hooker wrote that he liked the latest sketch "very much" and asked Hays to proceed with drafting the pattern.[78] Hooker was preparing for the demand for patterns he anticipated when batting wrappers with printed patterns on the reverse arrived on the market in January.[79]

Hooker's sales strategy included national advertising plans to create a demand for modern designs, even though market research on quiltmakers indicated a preference for the traditional. Phoebe Edwards,

the pseudonym of Phoebe Lloyd, Hooker's assistant and the director of Stearns and Foster's Quilters Guild, addressed these plans in her July 8, 1930, letter to Hays that mentions Iris and Chanticleer, both Hays's original, modern designs:[80]

We are enclosing the photographs which we sent out to the list of women to determine whether old fashioned or modern patterns were preferred. . . . However, the results of the questionnaire showed that the old patterns are preferred; that bright colors are preferred to pastels; and that the favored size for quilts is 72 x 90. . . . We expect the pattern business to pick up when the regular batt business picks up, and we also look for a lot of impetus from our national advertising, which begins in the *Woman's World* magazine in September.

We do not believe that the old fashioned quilts are going to be so far ahead of the modern ones once the new ones become known to quilt makers. Like other people, the latter have to be educated to the idea, and this mostly by this visual method. Witness the case of the Iris.

We had a quilt top made from this [Iris] pattern and we showed it, though still unquilted, at several quilt exhibits. It was quite the center of attraction. All who see it, even those who consider quilt making "too much work," [were] seized with a desire to make one like it. No wonder, because it certainly is lovely, both as to color and design. We wish you might see it.

We have also exhibited "Chanticleer"; it makes quite a "hit" with everyone, particularly mothers of small children, not to mention grandmothers and aunts. As both the Iris and the Chanticleer are scheduled for illustration in our advertising program, we feel that this is all they will need to take their places among the most popular patterns.[81]

Approximately 150 quilt patterns, including Sunflower, Iris, Chanticleer, and other patterns drafted or designed by Hays, are still available from Stearns and Foster. That fact is testimony to the ongoing effectiveness of Hooker's marketing and advertising methods and Hays's now classic modern designs.

■ **Merikay Waldvogel**

GALLERIES

Designers

In the twentieth century many quilt patterns were designed and compiled by professionals and widely distributed by newspapers, magazines, and mail order. Ruby Short McKim's 1916 Quaddie Quiltie was one of the first set of block patterns published in a weekly series. At the end of the sequence, the quiltmaker had patterns for a complete quilt, such as the Fruit Basket quilt represented here (plate 6-17). Florence LaGanke, writing under the pseudonym Nancy Page, penned a syndicated column that also included series designs and chatty descriptions. Mary McElwain owned a quilt shop and mail-order business in Walworth, Wisconsin. Her catalog, *The Romance of the Village Quilts*, included some of her own designs, as well as photo illustrations and poetry. Another designer, Anne Orr, was the needlework editor for Good Housekeeping from 1919 to 1940. Her sophisticated designs appealed to the style-conscious woman. She was best known for her innovative postage stamp quilts.

PLATE 6-17. Fruit Basket.
Ruby Short McKim pattern. Possibly made in Pennsylvania, dated 1937.
Cottons, 86.25" x 68.5". 1997.007.0640.

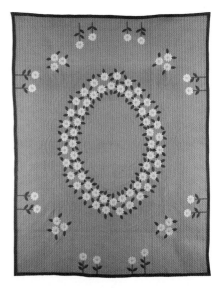

PLATE 6-19. Daisy Chain.
Mary McElwain kit. Possibly made in Shaker Heights, Ohio, c. 1936.
Cottons, 100" x 76.5". 1997.007.0834.

PLATE 6-18. Dresden I.
Anne Orr kit. Maker/location unknown, c. 1932.
Cottons, 87" x 74". 1997.007.0771.

PLATE 6-20. Laurel Wreath.
Nancy Page pattern. Probably made in Ohio, c. 1935.
Cottons, 93.5" x 76.5". 1997.007.0864.

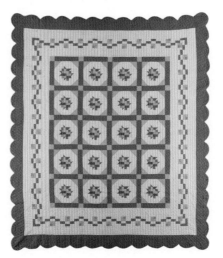

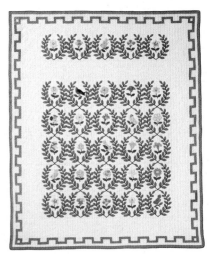

Designers

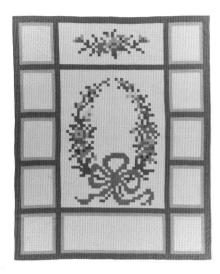

PLATE 6-21. French Wreath.
Anne Orr pattern. Possibly made in
Michigan, c. 1932.
Cottons, 92.5" x 77.5". 1997.007.0097.

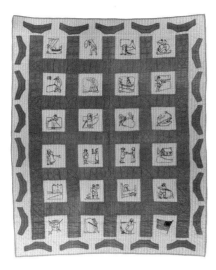

PLATE 6-23. Colonial History.
Ruby Short McKim pattern. Made by Paulina
Mangold, Bennington, Nebraska, c. 1938.
Cottons, 86" x 68.5". 1997.007.0786.

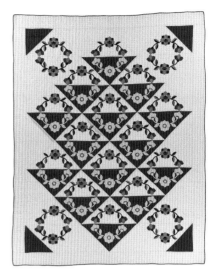

PLATE 6-25. Shadow Wreath.
Homeneedlecraft Creations kit. Made by
Mary McConahy Eckles, Lawrence County,
Pennsylvania, 1940–1950.
Cottons, 90" x 72.5". 1997.007.0941.

PLATE 6-26. Dolly Varden.
Esther O'Neill kit. Maker/location unknown,
1920–1930.
Cottons, 86" x 78". 2006.008.0004.
Gift of Robert and Ardis James.

PLATE 6-22. Daisy Chain.
Mary McElwain kit. Made by Ruth Augustyn.
Possibly made in Wisconsin, dated 1938.
Cottons, 91" x 73.5". 1997.007.0389.

PLATE 6-24. Morning Glories.
Mountain Mist pattern. Possibly made in
Deerfield, Massachusetts, dated 1935.
Cottons, 89" x 70.75". 1997.007.0826.

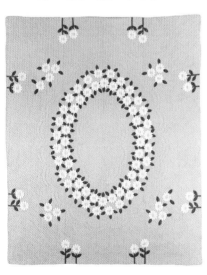

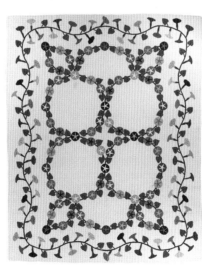

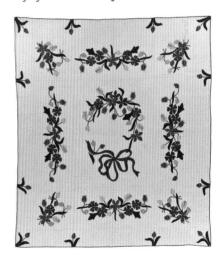

Marie Webster

Marie Webster's quilts, first published in January 1911 in *Ladies' Home Journal*, were widely influential on subsequent quilt design. The Poppy quilt (plate 6-27), published in January 1912 in the same magazine, is one of her best known. Its large arrangement of gently curving flowers, sketched from the garden, helped set the style for center-medallion designs of the early twentieth century. Some of her innovations arose from her study of nineteenth-century quilts. For example, Grapes and Vines (plate 6-28), published in 1914, has a four-block set, a pattern often found in nineteenth-century red-and-green appliqué quilts. Webster had studied old quilts, and in fact wrote the first history of American quiltmaking, *Quilts: Their Story and How to Make Them*. Wreath of Roses (plate 6-30), published in the October 1915 issue of *Ladies' Home Journal*, and Pink Dogwood (plate 6-29), first published in the 1920s, repeat many of her innovative elements: pastel colors, graceful flowers, appliquéd borders, and curved edges.

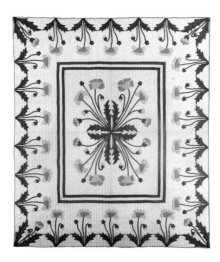

PLATE 6-27. Poppy.
Marie Webster pattern. Maker/location unknown, 1925–1940.
Cottons, 89" x 77". 1997.007.0411.2.

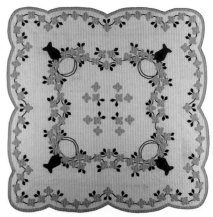

PLATE 6-29. Pink Dogwood.
Marie Webster kit. Possibly made in Indiana, c. 1927.
Cottons, 84" x 83". 1997.007.0824.

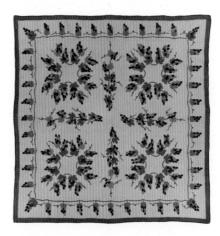

PLATE 6-28. Grapes and Vines.
Marie Webster pattern. Probably made by Josephine Justus, Trenton, Missouri, c. 1914.
Cottons, 85" x 85". 1997.007.0635.

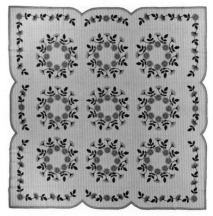

PLATE 6-30. Wreath of Roses.
Marie Webster pattern. Made by Mary Spriggs Murray, Agawam, Massachusetts, dated 1931.
Cottons, 88" x 89". 2006.008.0003.
Gift of Robert and Ardis James.

Marie Webster

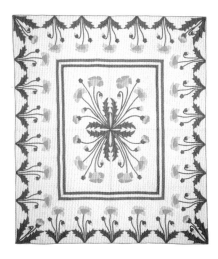

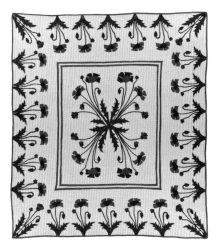

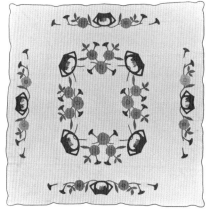

PLATE 6-31. Poppy.
Marie Webster pattern. Maker/location unknown, 1925–1940.
Cottons, 88" x 76". 1997.007.0411.1.

PLATE 6-33. Poppy.
Marie Webster pattern. Possibly made in Indiana, 1930–1940.
Cottons, 89.5" x 80.5". 1997.007.0675.

PLATE 6-35. Dutch Baskets.
Marie Webster pattern. Maker/location unknown, 1930–1940.
Cottons, 80.5" x 82". 1997.007.0954.

PLATE 6-36. French Baskets.
Marie Webster pattern. Possibly made in Claremore, Oklahoma, 1930–1940.
Cottons, 83" x 83". 2005.048.0002.
Given in memory of Sharon Lea Hicks Newman.

PLATE 6-32. Grapes and Vines.
Marie Webster pattern. Possibly made in Indiana, c. 1914.
Linens, 82.5" x 82". 1997.007.0563.

PLATE 6-34. Pink Dogwood.
Marie Webster pattern. Probably made by Sarah Laughlin, Guernsey County, Ohio, c. 1927.
Cottons, 76" x 76". 1997.007.0737.

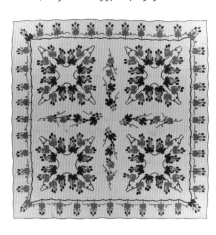

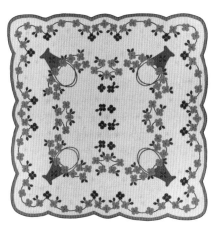

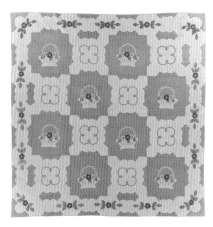

Flora and Fauna

PLATE 6-37. Bird of Paradise.
Possibly made in Maryland, 1940–1950.
Cottons, 78.5" x 66.25". 1997.007.0162.

PLATE 6-39. Horn of Plenty.
Modern Priscilla pattern. Possibly made in
Missouri, 1920–1935.
Cottons, 95" x 86". 1997.007.0801.

PLATE 6-41. Poppy.
Maker/location unknown, 1920–1940.
Cottons, 93" x 76". 2005.048.0003.
Given in memory of Sharon Lea Hicks Newman.

PLATE 6-38. Tulip.
Bucilla kit. Maker/location unknown,
dated 1938.
Cottons, 87.5" x 72.5". 1997.007.0798.

PLATE 6-40. Roosevelt Rose.
Ruth Finley pattern. Probably made in
Missouri, c. 1934.
Cottons, 82" x 67". 2005.048.0001.
Given in memory of Sharon Lea Hicks Newman.

PLATE 6-42. Floral Basket.
Made by Murl (Mabel) Brickner Gunnerson,
Aurora, Nebraska, 1930–1940.
Cottons, 80.5" x 69.5". 2006.023.0001.
Gift of James and Dee Gunnerson.

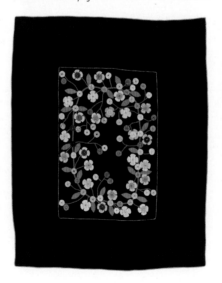

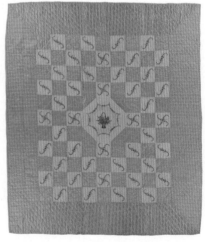

Just for Kids

Childhood in American history is not a static concept. The childhood historian Steven Mintz has written that in premodern times the young were viewed as "adults in training," but by the mid-nineteenth century childhood was increasingly viewed as "a separate stage of life that required special care and institutions to protect it." It was not until the mid-twentieth century that the ideal of a protected childhood became universal in American culture, quickly followed by cultural changes that have broken down the ideal.[82]

Some kit and pattern designers marketed designs resonant with childhood as a distinct and protected time of life that possessed its own special imagery, stories, and entertainment. Sunbonnet Sue was a figure likely inspired by Kate Greenaway's late nineteenth-century children's book characters. Mickey and Minnie Mouse depict favorite early animated cartoon characters. Airplanes were a favorite toy of many youngsters fascinated with flight (though the pattern may also reference the Lindbergh commemorative pattern, Lone Eagle, published by *Successful Farming* in 1929). Alphabet blocks reflect the importance of a child's education. Delicate-winged butterflies were appropriately chosen for a quilt recording the care of Dr. B. I. Mills of Maywood, Nebraska, for the youngest members of his community: it is embroidered with 364 names of infants he delivered between 1909 and 1940 (plate 6-46).

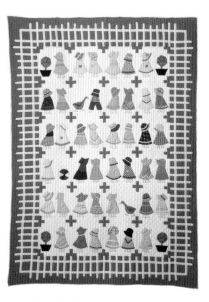

PLATE 6-43. Sunbonnet Sue.
Maker/location unknown, 1920–1940.
Cottons, 84" x 60". 1997.007.0256.

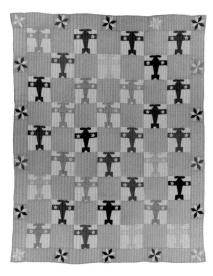

PLATE 6-45. Airplanes.
Possibly made in Ohio, 1930–1940.
Cottons, 90" x 72.5". 1997.007.0713.

PLATE 6-46. Butterfly.
Possibly made by Mrs. Joseph Perkin, Maywood, Nebraska, dated 1940.
Cottons, 93.5" x 92". 2002.003.0001.
Gift of Bernard C. Mills.

PLATE 6-44. Alphabet.
Ladies Art Company pattern.
Possibly made in Ohio, 1930–1940.
Cottons, 89" x 78.5". 1997.007.0392.

PLATE 6-47. Sunbonnet Sue.
Possibly made in Indiana, 1920–1940.
Cottons, 72.5" x 50". 1997.007.0285.

PLATE 6-49. Sunbonnet Sue variation.
Maker/location unknown, 1930–1940.
Cottons, 82.5" x 71". 1997.007.0723.

PLATE 6-51. Alphabet.
Possibly made in Pennsylvania, 1920–1940.
Cottons, 51.5" x 36.5". 2003.003.0253.

PLATE 6-48. Giddap.
Kansas City Star pattern. Possibly made
in Illinois, 1940–1950.
Cottons, 86.5" x 80.5". 1997.007.0476.

PLATE 6-50. Album.
Possibly made in Pennsylvania, 1920–1940.
Cottons, 76" x 75". 2003.003.0131.

PLATE 6-52. Mickey and Minnie.
Possibly made in Pennsylvania, 1930–1940.
Cottons, 83" x 67.5". 2005.049.0002.
*Purchase made possible through James
Foundation Acquisition Fund.*

Albums

Quiltmakers had to subscribe to all issues of the publication to assemble a set of patterns issued in a series, a tactic publishers used to maintain loyal subscribers, and a strategy especially important for staying competitive during the Great Depression. Most Album quilt series were designed to be executed in appliqué or embroidery, but some quiltmakers applied the designs with paints or crayons instead of fabric or floss. For example, plate 6-53 combines hand and machine appliqué, painted designs, and embroidery, each reflecting the preference of the individual women who made and signed the blocks.

PLATE 6-53. Album, Signature.
Probably made in Graves County, Kentucky, dated 1933.
Cottons, 85" x 68.5". 1997.007.0223.

PLATE 6-55. Album.
Possibly made in Iowa, 1935–1945.
Cottons, 83" x 70.5". 1997.007.0680.

PLATE 6-56. Flower Garden.
Made by Wilhelmine Ziemke Foth, Ord, Nebraska, dated 1930.
Cottons, 83.5" x 74.5". 2004.020.0001.
Gift of Kathleen Clement.

PLATE 6-54. Basket of Flowers.
Probably made in Zanesville, Ohio, 1920–1940.
Cottons, 86" x 78". 1997.007.0597.

Mountain Mist

Mountain Mist designers often took inspiration from other popular patterns of the day. Dancing Daffodils (plate 6-59), for instance, is almost identical in layout to Marie Webster's 1911 Iris design; in both patterns, four stems meet at a single point and the flowers join to form a circular garland. The swirling, rotating feel of the daffodils is also similar to Webster's Windblown Tulips. Webster's 1914 Grapes and Vines (plate 6-32) seems to have inspired several grape-themed patterns in the 1920s and 1930s, including Mountain Mist's Martha's Vineyard (plate 6-57), which has a meandering vine border similar to Webster's. But Mountain Mist also produced some strikingly original patterns. The stars in Mountain Star (plate 6-58) have a polished, Art Deco appearance, belied somewhat by the awkward zigzag sashing, which resembles giant rickrack stuck on as an afterthought. Wild Ducks (plate 6-60) features an out-of-scale duck flying through the sky—not a common theme for patterns of this, or any time.[83]

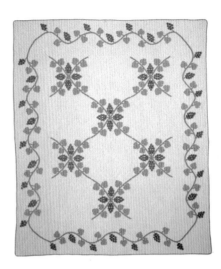

PLATE 6-57. Martha's Vineyard.
Mountain Mist pattern. Possibly made in Ohio, c. 1931.
Cottons, 92" x 78". 1997.007.0219.

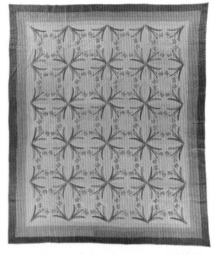

PLATE 6-59. Dancing Daffodils.
Mountain Mist pattern. Possibly made in Pittsburgh, Pennsylvania, c. 1931.
Cottons, 98.5" x 84.5". 1997.007.0912.

PLATE 6-58. Mountain Star.
Mountain Mist pattern. Possibly made in Ohio, c. 1932.
Cottons, 92" x 72.75". 1997.007.0286.

PLATE 6-60. Wild Ducks.
Mountain Mist pattern. Possibly made in Ohio, c. 1934.
Cottons, 88" x 70". 1997.007.0922.

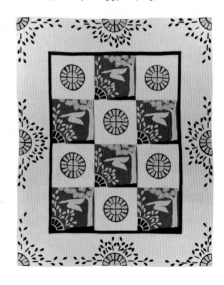

Exotics

Western fascination with exotic cultures has often influenced quilt design. One of the most obvious examples is the impact of Japanese-inspired design on the genesis of the Crazy quilt in the late nineteenth century. But well into the twentieth century quiltmakers and designers continued to be drawn to non-Western design sources. Nancy Cabot, the quilt columnist for the *Chicago Tribune,* announced her Oriental Tulips pattern with the headline "Out of Ancient Egypt Comes Gay Design for Modern Quilt."[84] The unknown designer of Plum Blossoms combined Japanese-inspired, naturalistic plum flowers with Chinese-influenced fretwork borders. The embroidered peacock, also from an unknown source, recalls Indian-inspired peacock chintz prints of the early nineteenth century. Native American–inspired designs also appeared and reflected the romanticization of the American West.

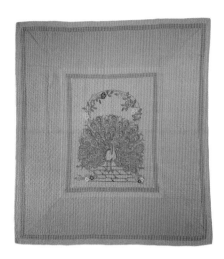

PLATE 6-61. **Peacock.**
Possibly made in Tennessee, 1930–1950.
Cottons, 86.5" x 77". 1997.007.0804.

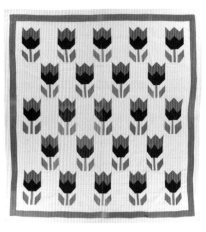

PLATE 6-63. **Oriental Tulip.**
Possibly made in Pennsylvania, 1930–1935.
Cottons, 81" x 75". 2003.003.0141.

PLATE 6-64. **Young Indian.**
American Home magazine pattern. Made by Bessie Jackson Mayborn, Diller, Nebraska, c.1949. Cottons, 86.5" x 68". 2003.011.0001.
Gift of Robert and Ardis James.

PLATE 6-62. **Plum Blossoms.**
Possibly made in Indiana, 1935–1945.
Cottons, 93.5" x 76". 1997.007.0857.

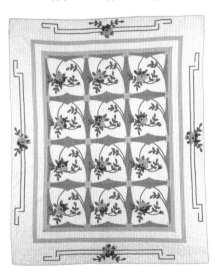

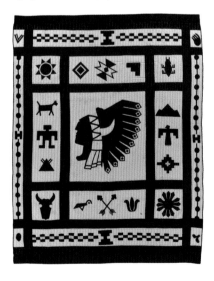

Exotics

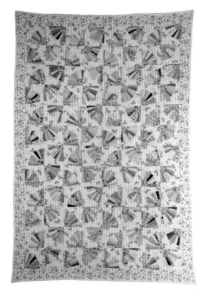

PLATE 6-65. Grandmother's Fan.
Possibly made in the midwestern United
States, 1920–1940.
Cottons, 93" x 63.5". 1997.007.0036.

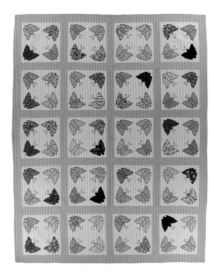

PLATE 6-67. Butterfly.
Possibly made in Pennsylvania, 1920–1940.
Cottons, 105" x 83". 1997.007.0383.

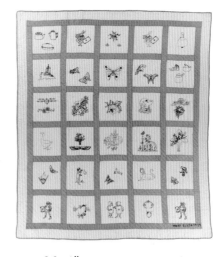

PLATE 6-69. Album.
Possibly made in Peru, Indiana, dated 1929.
Cottons, 86.5" x 72.5". 1997.007.0526.

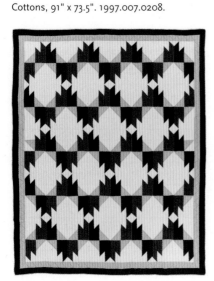

PLATE 6-66. The Chief.
Lockport Cotton Batting Company pattern.
Maker/location unknown, c. 1944.
Cottons, 91" x 73.5". 1997.007.0208.

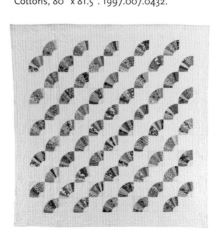

PLATE 6-68. Grandmother's Fan.
Probably made in the midwestern United
States, 1930–1940.
Cottons, 80" x 81.5". 1997.007.0432.

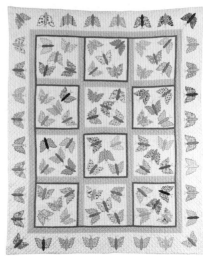

PLATE 6-70. Butterfly.
Possibly made in Ohio, 1920–1940.
Cottons, 92" x 74". 1997.007.0596.

Rings and Pickles

PLATE 6-71. Double Wedding Ring.
Possibly made in Pennsylvania, 1940–1960.
Cottons, 89.5" x 60.5". 1997.007.0420.

PLATE 6-73. Double Wedding Ring.
Possibly made in Kentucky, 1930–1940.
Cottons, 97" x 79.5". 1997.007.0498.

PLATE 6-75. Pickle Dish.
Possibly made in Cleveland, Ohio, 1930–1940.
Cottons, 85" x 67.5". 1997.007.0594.

PLATE 6-72. Double Wedding Ring.
Possibly made in Kentucky, 1930–1940.
Cottons, 98" x 84.5". 1997.007.0497.

PLATE 6-74. Pickle Dish.
Possibly made in Ohio, 1930–1950.
Cottons, 79.5" x 81". 1997.007.0524.

PLATE 6-76. Double Wedding Ring.
Possibly made in Missouri, 1930–1940.
Cottons, 83" x 65.5". 1997.007.0639.

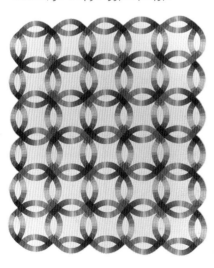

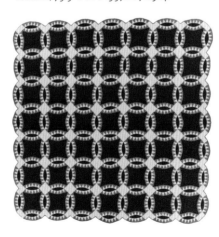

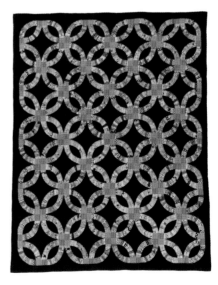

Stars

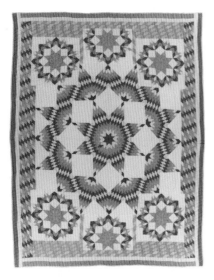

PLATE 6-77. Broken Star.
Possibly made in Montgomery County, Ohio, 1930–1940.
Cottons, 79.5" x 62". 1997.007.0348.

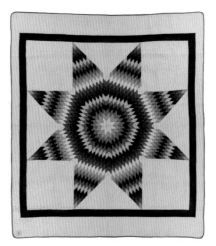

PLATE 6-79. Star of Bethlehem.
Possibly made in Ohio, 1920–1940.
Cottons, 68" x 67". 1997.007.0592.

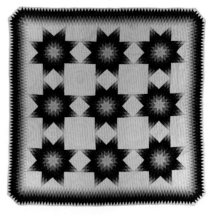

PLATE 6-81. Blazing Star.
Possibly made in Bremen, Indiana, 1930–1940.
Cottons, 90" x 83.5". 1997.007.0789.

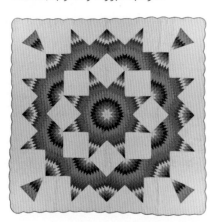

PLATE 6-78. Broken Star.
Possibly made in central Ohio, 1920–1940.
Cottons, 87.5" x 85". 1997.007.0380.

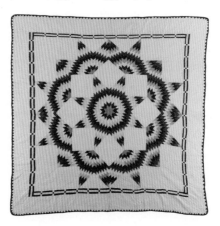

PLATE 6-80. Broken Star.
Possibly made in Canton, Ohio, 1920–1940.
Cottons, 83.5" x 81". 1997.007.0710.

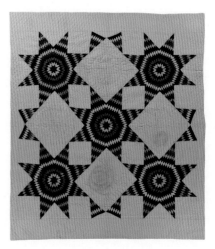

PLATE 6-82. Broken Star.
Made by Jenney Young Ward Mayer and Marion Mayer-Foeht, Denton, Nebraska, c. 1925.
Cottons, 79.5" x 69.5". 2001.007.0001.
Gift of Lyle Mayer.

Art Deco Influence

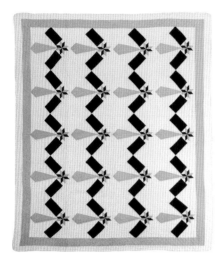

PLATE 6-83. Shooting Star.
Possibly made in Indiana, 1920–1940.
Cottons, 72" x 85.5". 1997.007.0218.

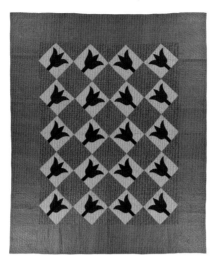

PLATE 6-85. Tulips.
Probably made in Pennsylvania, 1890–1910.
Cottons, 93" x 77". 2003.003.0206.

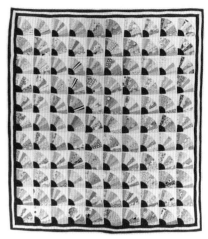

PLATE 6-87. Grandmother's Fan.
Possibly made in New Jersey, 1930–1940.
Cottons, 76.5" x 70.5". 2003.003.0218.

PLATE 6-84. Dogwood Blossom.
Capper's Weekly pattern.
Probably made in the midwestern
United States, c. 1928.
Cottons, 88" x 67.5". 1997.007.0851.

PLATE 6-86. Fan.
Possibly made in New York, 1930–1940.
Cottons, 82" x 82.5". 2003.003.0213.

PLATE 6-88. Lily.
Possibly made in Iowa, 1920–1930.
Cottons, 88" x 81.5". 2004.016.0001.
*Linda Giesler Carlson and Dr. John V. Carlson
Collection.*

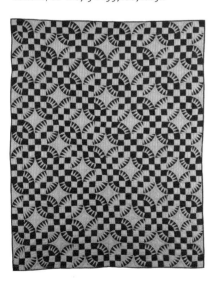

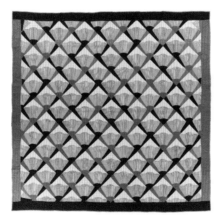

Pieced

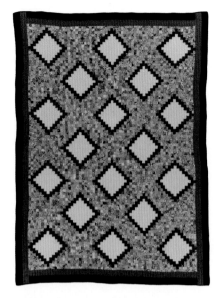

PLATE 6-89. Rainbow Around the World.
Household Art magazine pattern.
Maker/location unknown, c. 1934.
Cottons, 89.5" x 66.5". 1997.007.0103.

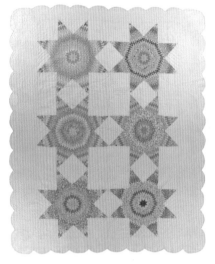

PLATE 6-91. Touching Stars.
Possibly made by Mr. and Mrs. Stutzman,
Elkhart, Indiana, 1930–1940.
Cottons, 92" x 64.5". 1997.007.0559.

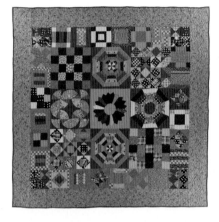

PLATE 6-93. Album.
Possibly made in New Jersey, 1940–1950.
Cottons, 86" x 85". 2003.003.0199.

PLATE 6-90. Double Irish Chain.
Possibly made in western Pennsylvania,
dated 1939.
Cottons, 104.5" x 83". 1997.007.0447.

PLATE 6-92. Spider Web.
Grandma Dexter pattern.
Possibly made in Ohio, 1930–1940.
Cottons, 104.5" x 81.5". 1997.007.0853.

PLATE 6-94. LeMoyne Star.
Made by Murl (Mabel) Brickner Gunnerson,
Aurora, Nebraska, 1930–1940.
Cottons, 90" x 77". 2006.023.0002.
Gift of James and Dee Gunnerson.

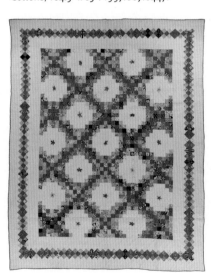

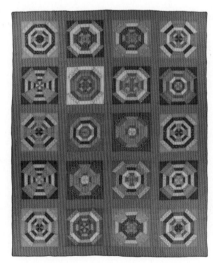

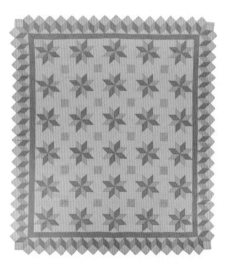

Medallionesque

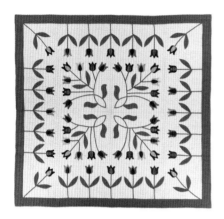

PLATE 6-95. Tulips.
Possibly made in western Pennsylvania,
1920–1940.
Cottons, 78" x 82.5". 1997.007.0472.

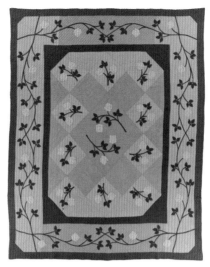

PLATE 6-97. Rose.
Possibly made in Ohio, 1920–1940.
Cottons, 90" x 72". 1997.007.0565.

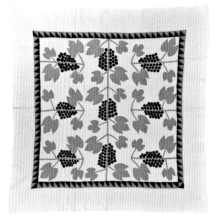

PLATE 6-99. Grape Clusters.
Possibly made in Pennsylvania, 1930–1940.
Cottons, 69" x 68". 2003.003.0363.

PLATE 6-96. Poppy.
Martha Washington Patchwork Quilt
Company pattern.
Possibly made in Ohio, 1925–1935.
Cottons, 84.5" x 82". 1997.007.0522.

PLATE 6-98. Pots of Flowers.
Woman's Day magazine pattern.
Made by Cora Eckles Dinsmore and Mary
McConahy Eckles, Lawrence County,
Pennsylvania, c. 1941.
Cottons, 72" x 71". 1997.007.0948.

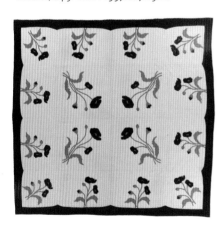

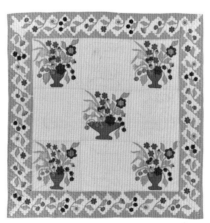

Innovation and Imagination *One-of-a-Kind and Niche Quilts*

LEFT: FIG 7-1. *Uncle Clint's Quilt, detail* (see plate 7-65).
RIGHT: FIG 7-2. Peacock, *detail* (see plate 7-41).

Although many American quilts made between 1870 and 1940 can be easily categorized, some defy narrow definitions. These one-of-a-kind and "niche" quilts—small groups of quilts united by a particular aesthetic, technique, or cultural origin—are important representatives of the heterogeneity of American quiltmaking. This does not imply a lack of diversity within the quilt categories represented in the previous chapters; individual quiltmakers have always been inspired to alter existing patterns and formats in many ways. But the quilts in this chapter are either creations with few or no discernible links to existing designs or represent a satellite quiltmaking tradition—related, yet distinct from other traditions.

Some of the quilts are true originals: pictorial depictions or abstract patterns that have no direct source other than the maker's imagination and fancy. Others represent a novel technique, yo-yos or puffs, for instance, and another group is united by the use of interesting materials such as tobacco premiums or county fair ribbons. Redwork quilts and Hawaiian appliqué quilts are included as American quilt subgenres, and there are even some quilts that were likely made from published patterns yet contain striking visual elements that distinguish them from the larger field of pattern quilts.

CLOCKWISE FROM LEFT:

FIG 7-3. Target, *detail* (see plate 7-27).

FIG 7-4. Original, Chicken Ribbons, *detail* (see plate 7-28).

FIG 7-5. Album, Signature, *detail* (see plate 7-61).

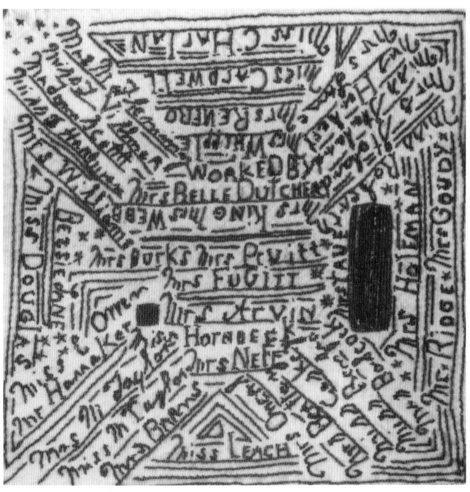

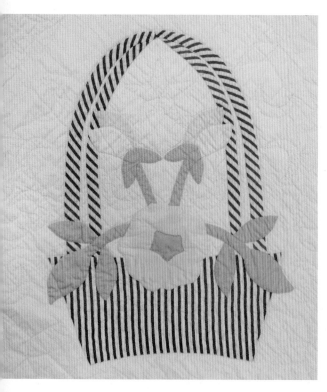

ABOVE: FIG 7-6. Magpie Rose, Marie Webster pattern, *detail* (see plate 7-44).

RIGHT: FIG 7-7. *From 1833 to 1933, detail* (see plate 7-43). Representation of women's fashions in 1833.

OPPOSITE: FIG 7-8. *From 1833 to 1933, detail* (see plate 7-43). Representation of women's fashions in 1933.

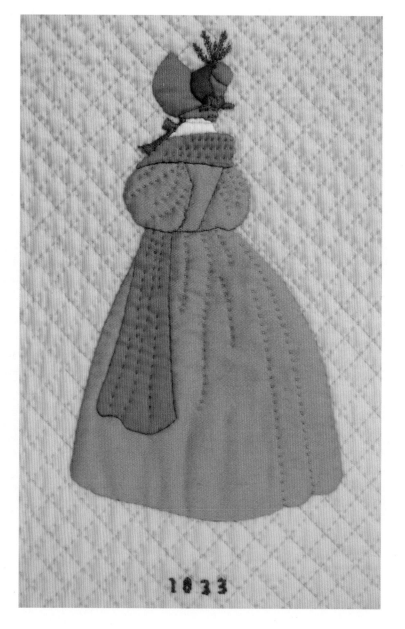

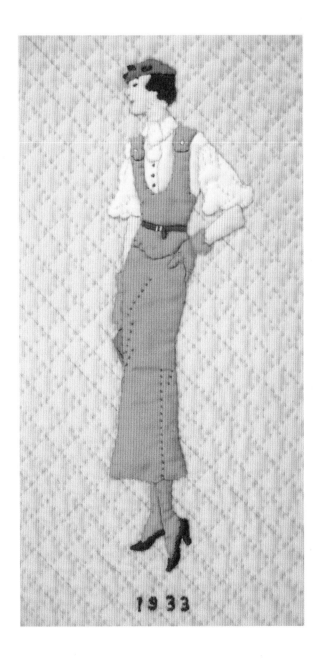

A final grouping in the chapter is those quilts that were made or likely made as entries in the Sears Century of Progress Quilt Contest that was held in conjunction with the Chicago World's Fair of 1933. The IQSC has seven quilts in its collections that were made for the contest or that bear strong evidence that they were entered in it. Some were made from patterns, such as Marie Webster's Magpie Rose (plate 7-44); others were original designs, such as Emma Mae Leonhard's quilt (plate 7-43) depicting the changes in women's fashion during the century between 1833 and 1933. (The Fair's official theme, commemorating Chicago's centennial, was "A Century of Progress.")

The Sears Quilt Contest was not the first quilt contest, but it was the largest in terms of number of entries (more than twenty-four thousand) and size of the grand prize. The $1,000.00 grand prize went to Margaret Rogers Caden, who, as it turned out, did not put a stitch in her quilt entry. She worked in the A. M. Caden Shop, owned by her sister, Annie M. Caden. The shop, which sold gifts and fine furnishings (linens), including handmade quilts, was in downtown Lexington, Kentucky, where the recognition from winning a national contest would undoubtedly help future business. The professional quiltmakers she hired to make the quilt—Mattie Clark Black, Ida Atchison Rhorer, and Allie Price Taylor and daughters—did not receive any credit and kept quiet because they needed the quilting work to support their families. The pattern for the prize-winning quilt design, Star of the Bluegrass, was printed in *Capper's Weekly* and other newspapers immediately after the contest. In 1948 the pattern was copyrighted by the Stearns and Foster Company, makers of Mountain Mist batting. (See plate 7-45 for a quilt that follows the Mountain Mist pattern.)[1]

■ **Marin F. Hanson and Merikay Waldvogel**

The Victorian sense of pictorial symbolism is powerfully illustrated in this quilt (plate 7-1), which might be titled something like "The Pleasures and Perils of Nature." Middle-class Victorian sensibilities, forged in the disruptive philosophical and social changes that accompanied the triumph of the Industrial Revolution, saw in nature both the promise of innocence and redemption and the menace of the "primitive" and instinctual behavior. In such works as Joseph Conrad's *Heart of Darkness* (1902) the ambiguities inherent in society's views of the so-called civilized and primitive worlds were clearly delineated. We see in some segments of this quilt a seemingly idyllic country scene. A pair of swans float on a pond; swans mate for life and are thus symbols of marital fidelity, and the male is larger than the female, as befits the Victorian sense of an appropriately ordered world in which sexual dimorphism predominates. The pond, itself a symbol of unspoiled nature, innocence, and natural beauty, is fitted with two ubiquitous period symbols of peaceful, hidden waterways: the cattail and lotus. The latter is symbolic of purity, a notion much prized by Victorians, the triumph of spirituality over sensuality and the pleasures of the world. To the right is a panel with calla lilies, also symbols of purity and beauty, and on each side are long panels with grape clusters, symbols of fertility, the goodness of providence, abundance, and fidelity, powerful symbols in a time of accelerating social change and upper-class excess. The complementary central panel at the top carries the images of ferns, ancient symbols of the characteristics of an idealized human relationship, loyalty, the bond of love, confidence, and fecundity. The outer border, filled with leaves, appears at first random, but is in fact symmetrical. The images are flattened, like mounted botanical specimens, emblematic of the order Victorians attempted to impose on the natural world through study and scientific cataloguing.

Then we see the central panel. The figures, worked in wool materials, are raised from the surface for emphasis, dramatic against a black background. A dog, symbol in the Victorian world of protection, family life, and peaceful interaction with nature, the compromise between man and the natural world, confronts a menacing serpent, clearly an allusion to Eden and the human fall from grace, the danger of knowledge and carnal love. The snake actually has a beady eye, symbolic of malicious intent, and if more support for

FIG 7-9. Pictorial quilt, *detail*.

the notion were needed, a cuckoo, emblematic both of redemption, the coming of summer, and perfidy, perches ominously on a branch above. (The cuckoo lays its eggs in smaller birds' nests, and when they hatch, the cuckoo nestlings push the natural chicks out and the unwitting foster parents then raise them. For this reason the bird became a symbol of infidelity, enshrined in the English word "cuckold.")

So in this remarkable creation we have a perhaps unwitting sketch of the Victorian psyche, a textile never intended to be a warm bedcover, but, rather, something for the parlor, perhaps even a table cover, denoting the maker's status both through her knowledge of genteel needlework and accepted Victorian sentimental symbolism. One wonders how intentional was the contrast between the symbolic representations of idealized marriage and the dangers lurking at the center of human sensuality. We can see in it how quilts became a means of expressing both societal values and aspirations and individual creative energy and concerns.

The maker used a variety of materials—woolens, cottons, felt—as was common in such nonfunctional Victorian showpieces. Many have faded, but their desired sumptuous quality remains. The surrounding leaf forms were cut using templates, perhaps derived from actual leaves. The *horror vacui* characterizing much of this textile and typical of such Victorian objects as Crazy quilts and, indeed, much else in its decorative canon, serves to emphasize the intense drama of the central panel, where the figures are given visual space against a sharply contrasting background. This quilt illustrates clearly why such pieces are often time capsules of their periods, carrying information

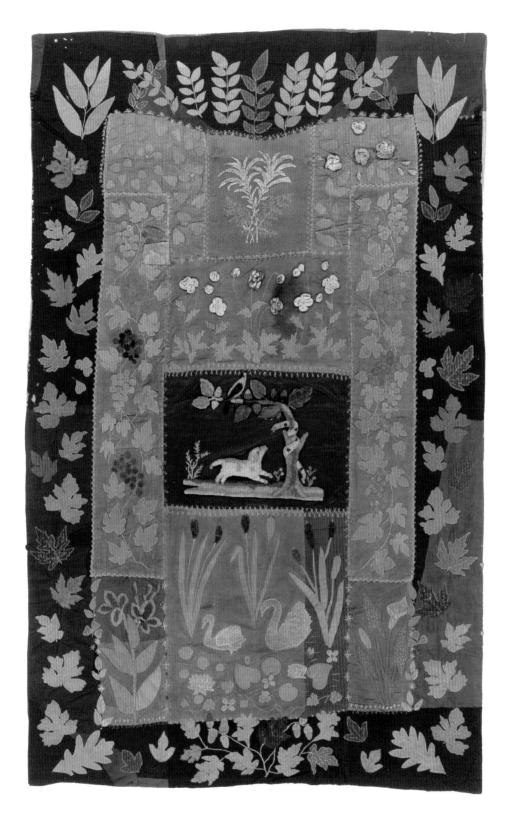

about design, manufacturing trends and technology, the economy, social customs, individual political and social attitudes, and concerns about such things as religion, morality, and family life.

■ Jonathan Holstein

PLATE 7-1. Pictorial quilt.
Maker/location unknown, 1870–1890.
Wools, Silks, 85.5" x 52.5". Unquilted.
1997.007.0875. *Ardis and Robert James Collection.*

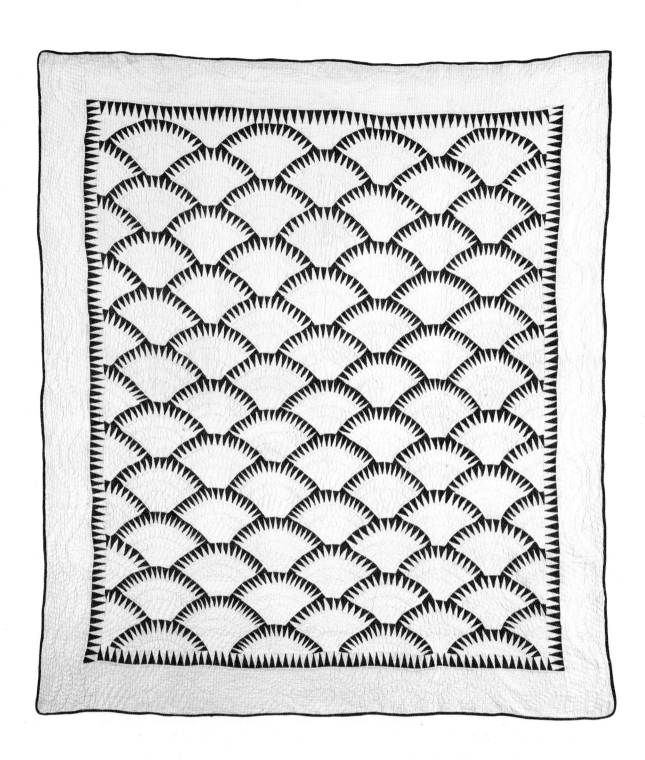

PLATE 7-2. Rising Sun.
Maker unknown.
Possibly made in Ohio, 1880–1900.
Cottons, 83.5" x 74.5". QSPI: 10-12.
1997.007.0399. *Ardis and Robert James Collection.*

apanese arts and handicrafts, displayed in international expositions beginning in the 1860s, were responsible for a number of decorative and fine arts innovations in the West, not the least of which was the influence of Japanese prints on Western painting. Gilbert and Sullivan's wildly popular operetta, *The Mikado*, first produced in 1885 in London and soon seen widely in America, gave further impetus to the

interest in things Japanese, and characters from the production were depicted on some Crazy quilts. Also, the Japanese aesthetic fit neatly with the notions of the Western middle-class cult of domesticity, in which wives were expected to be guardians and teachers of "civilized" standards in their homes.

There are several Japonaiserie motifs represented in this Rising Sun quilt (plate 7-2); in fact, the design may be a composite, a conscious evocation or unconscious adoption of several or many of them, long since absorbed into the American design vocabulary. First, fans were an intrinsic part of Victorian culture and, as trade goods from Japan and China, appeared in the hands of Victorian women in both paintings and photographs. By the time this quilt was made, Japanese fans had become accepted cheap goods on the Western market. They can be seen as specific delineated objects in Victorian Crazy quilts, denoting the exoticism and eclecticism that had become ubiquitous in that culture.

This quilt's pattern can be seen as fans superimposed in rows, an overall design often seen in richly decorated Victorian quilts made of silk satins, taffetas, and velvets, the preferred materials for high-style Crazy quilts (see, for example, plates 3-16 and 3-56). Versions of the fan motif were also carried forward in cotton quilts until World War II ended interest for a time in evoking Japanese design (see plates 6-86 and 6-87).[2] These cotton versions, often in two colors—red and white being the most symbolic—point to a second possibility: that the quilt pattern represents a rising sun with rays, the motif featured on the Japanese naval flag from 1889 to 1945. (Nippon, the Japanese word for the country, means "land of the rising sun," and this was well-known in the West.) The third possibility is that it evokes overlapping ocean waves, a recurrent and popular theme in Japanese art and decoration. And the fourth is that the pattern is based on a stylized outline of the ginkgo leaf, a symbol of longevity and a beloved and common motif in Japanese art for centuries.

There were a number of popular American quilt designs that embodied curvilinear forms with projecting triangular points during this period, some with titles related to the sun, a persistent symbol during the Westward movement (see, for example, Sunburst, plate 1-119). The design of this quilt embodies a simple but subtle visual trick that makes the identification of a specific, single pattern somewhat difficult. The image can be read as having white radiating points,

FIG 7-10. Rising Sun, block.

emblematic of a blazing morning sun, or as having a solid outer edging with white ribs extending into it, as might a fan or ginkgo leaf. However it is interpreted, the design illustrates the facility with which American quiltmakers practiced abstraction in their work.

Crazy quilts and the more ordered silk and velvet fan quilts were at the baroque end of the quilt aesthetic spectrum. Here, however, a typically American transformation has taken place. The image's most salient characteristics, the crescent shape and ribbing, have been abstracted and the sumptuous silks and velvets replaced by a simple combination of cheap blue and white cottons to form a powerful and evocative image that, as abstractions often do, hints at meanings beyond the literal image. There are echoes of Japanese painting and textiles, of the manner in which the Japanese order their planned landscapes, and certainly of the ubiquitous image in their art of Mt. Fuji, often simplified to a few suggestive strokes. There is an ingenious and economical visual sleight of hand working here, the eye coached to see fans even though they are actually represented by no more than their curved tops and the open spaces formed by the tops in the rows beneath. It is really more of a drawing, like a spare Japanese sumi work, than a painting. The Sawtooth border, its unusually sharp and spiky points facing inward, has the effect of enlivening as much as defining the central field. The workmanship seems somewhat carefree, the number of points in each segment irregular. One reason for this is that, unlike most quilts, its blocks have curved edges, which are much more difficult to control during construction. As a consequence the quilt shows signs of technical improvisation, doing whatever was needed at the moment to make the design work, and it does not lie flat. Its air of successful invention is, of course, also a measure of its strength. ■ **Jonathan Holstein**

The restless spirit of American quiltmakers often found expression in ingenious variations of popular designs. In this Carpenter's Square quilt (plate 7-3) the maker reversed the pattern's normal color combination: dark material on a light background. (See plate 5-77 for the normal value arrangement.) Done either way it produces an effective optical trick: there appear to be two grid patterns, one rising from the surface of the other, and a grid advances and recedes as you observe it.

The symbolism in many quilt patterns could be evoked by titles that might bear a direct resemblance to the design (Burgoyne Surrounded, a central red British infantry square surrounded by smaller squares of American troops, for instance) or might have no discernible visual relationship but simply carry the weight of their titles (Underground Railroad, Fifty-four-Forty-or-Fight, Whig's Defeat). The name of this quilt reflects an endless American fascination with the tools that were necessary both to early settlement and the Industrial Revolution as it developed (witness the quilt pattern names Anvil, Monkey Wrench, Chips and Whetstones, Sawtooth). Being a trained craftsman—carpenter, wheelwright, mechanic—was

a source of pride and, very often, economic independence in an earlier America.

There were many coded messages in Victorian culture: floral and animal symbolism, the manner in which calling cards were folded, the way fans were handled by women. Such intricate continuous knot-like patterns, as the one featured on this quilt, were dear to the times and had many different possible interpretations. The patterns recall formal gardens in Renaissance style, Celtic patterning, romantic ideas such as the true lovers' knot, the continuous knots often seen in Victorian jewelry, and the complex decoration in furniture and domestic products of the period. Also noteworthy and clearly symbolic are the four crosses that are created at the midpoint of each side.

The particular genius of this design is in part its great simplicity, the maker's skill in finding just the right proportion of line to line, of pattern to frame, the minimal border. The piecing of the pattern was done by hand and machine, the long runs of the edges by machine. Barthelemy Thimonnier, a French tailor who invented a simple sewing machine in 1830, established a manufactory that made army clothes. In 1841, however, a mob of tailors who felt their livelihood was threatened by his invention destroyed all of his machines.[3] In the United States, on the other hand, treadle-powered sewing machines, introduced just after 1850 and skillfully marketed, vastly altered ancient patterns of clothes making. In the home, an article of clothing might take less than one-quarter the time to sew on a machine as by hand.[4] The machines also greatly increased capacity for commercial production of products incorporating textiles and brought prices for them down, but at the expense of exploitive labor practices. In the later part of the nineteenth century there was even a quilting attachment offered for sewing machines, but it appears not to have been very successful. Even the conservative Pennsylvania Amish used treadle machines to piece the large sections of their classic wool quilts, and many of them use treadle machines to this day.

The maker of this quilt used classic early quilting patterns, parallel lines in the borders, and a grid in the pieced sections. This might indicate that it was constructed by an older quiltmaker, one who had learned the craft in the early nineteenth century, or that it was simply a conservative retention of early practices.

■ **Jonathan Holstein**

FIG 7-11. Carpenter's Square, *detail.*

PLATE 7-3. Carpenter's Square.
Maker/location unknown, 1880–1900.
Cottons, 75" x 75". QSPI: 9.
1997.007.0939. *Ardis and Robert James Collection.*

t is at times difficult to resist the temptation to note the similarities between the techniques and results of painting and quiltmaking. Format, use of colors and shapes, and aesthetic methods that can certainly be described as painterly encourage such comparisons. This is especially true when considering a quilt such as this (plate 7-4), which uses small squares of material in a very Modernist manner to build images embodying traditional concerns of painting, landscape, figure and architecture, and the play of light. One can discern in the composition a house and a carriage house or barn with a large door behind it (to the left), a typical American architectural footprint of the period in both town and country. One can also see a shade tree with light sifting through the leaves and branches, shadows, interior space, and, in the foreground, a man sitting on what is probably a buckboard wagon seat. Portions of other trees, most likely the great shade trees that once lined many American streets and roads, project partly into the view left and right, and another tree rises behind the house and outbuilding. A solid surround, suggestive of a bold folk art frame of the period, completes the work.

There were earlier appliqué quilts, such as the so-called Baltimore Album quilts, that embodied figurative images. In addition to floral arrangements there were depictions of architecture, humans, public monuments, ships, carriages, and animals, rendered in academic or folk styles, and often very colorful. These were produced almost entirely in middle-class or upper-middle-class homes, at least in part because cotton fabrics remained relatively expensive. But prices of fabrics fell dramatically as American cotton manufacturing increased dramatically in the nineteenth century through the greatly expanded agricultural production of raw cotton, significant advances in the technology of manufacturing and printing cotton tex-

tiles, and, after midcentury, the introduction of the first synthetic dyes. By the 1870s some printed cottons were a few pennies per yard; improved manufacturing processes and distribution had made them more widely available, and American women were thus offered a vastly increased palette of affordable materials for making quilts.[5] That, and the widespread adoption of the sewing machine through clever marketing strategies, produced an extraordinary outpouring of creativity. Many thousands of quilts, often employing original and innovative designs, were made. One style that first appeared in the nineteenth century, called generically "postage stamp" quilts, used very small squares of material stitched edge to edge, mosaic fashion.[6] Thousands of pieces were used in the making of each one, and often the makers attached labels proudly noting the huge number of pieces involved in their creations; it seems now, with our different sense of time, a sort of endurance feat, like marathon dancing. Sometimes the small pieces were organized to produce large overall images.[7] But the complicated task of creating realistic images from small pieces in a painterly format using a piecing rather than appliqué technique was not undertaken by many.

This quilt is small in scale, of a size normally made for children's beds, and it likely represents an actual house and yard (and perhaps a father), the sort of iconic images important to children that appear in samplers and other forms of American needlework. This notion may be supported by the heavy use to which it was subjected; this would not have been true of a quilt made only for display, but is especially true of children's quilts, which were much soiled and laundered and so often descend to us, if they survive at all, in compromised conditions. The materials used here were ordinary inexpensive cottons, and the maker was skillful in her manipulation of printed patterns to cre-

ate elements of the composition. Note, for instance, the simple but effective suggestion of flowers on each side of the front door, created by using a few lines from several printed fabrics; the use of darker materials in different tonalities to suggest interior space; the skillful suggestion of clouds with two stripes of contrasting materials; and the use of fine prints to indicate the mixed surface of the typical dirt street or road of the period. Often in folk painting one is able to find a print source for the composition. Here, the composition and, indeed, the idea for it, may have come from the photographs taken by itinerant photographers in the second half of the nineteenth century. Traveling the rural byways of America, they offered to take a portrait of one's home for a reasonable fee and send, some months later, a finished, framed photo. Homeowners would often assemble their families and hired help outside for the picture, and the scene sometimes included a prized wagon or a favorite horse held by a family member or a groom. Such photographs adorned the walls of many American parlors in the late nineteenth century.

The quilt's workmanship is adequate but not particularly fine. Both piecing and quilting were done by hand, though a replaced binding had its top edge attached by machine. Quilting in the border is a simple cross through each block; in the center it is a diagonal grid with elements spaced about two inches apart. The maker was clearly more focused on her visual creation than fine needlework. The extraordinary range and freedom of visual invention employed by American quiltmakers are exemplified in this quilt.

■ Jonathan Holstein

FIG 7-12. *An American Home, detail.* Man sitting on wagon seat.

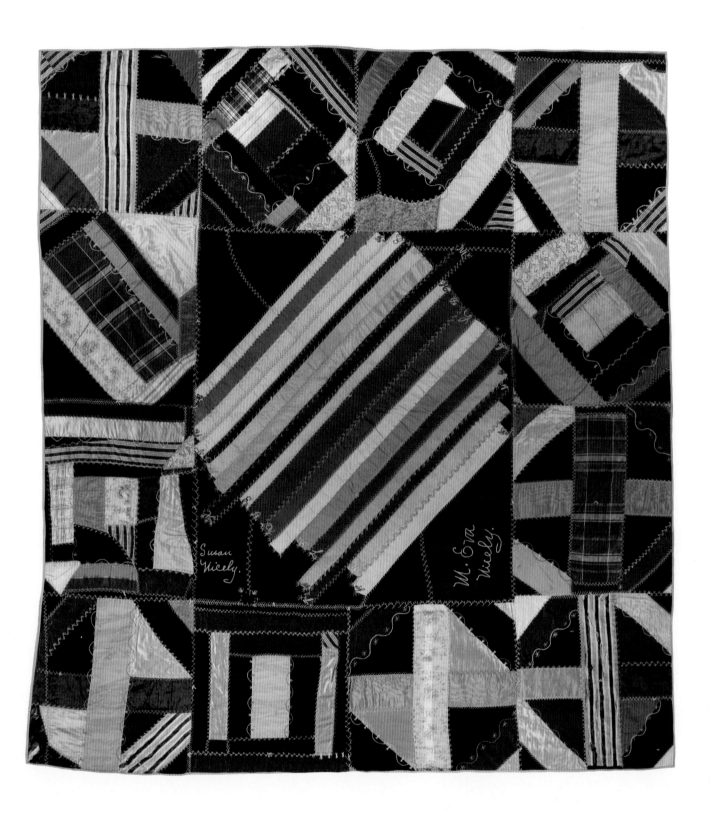

PLATE 7-5. Crazy quilt.
Probably made by Susan and/or M. Eva Nicely.
Possibly made in Indiana or Pennsylvania, 1890–1910.
Silks, 78" x 70". Unquilted.
2003.003.0194. *Jonathan Holstein Collection.*

I once thought of this Crazy quilt (plate 7-5) as the Nicely Sisters quilt, but genealogical research reveals that they might actually have been mother and daughter. Two different Nicely families from the proper time period have been found with a "Susan" mother and an "M. Eva" daughter. In Pennsylvania, Susannah Bieber, born on September 28, 1831, married Mahlon Augustus Nicely on September 27, 1855, and had nine children, the youngest daughter being Mary Eva Nicely, born on March 7, 1872. In the 1880s, in Boone County, Indiana, Susannah Nicely, wife of William, was living with her daughter Maursarza Eva.[8]

Female relations and friends often worked together on quilts, and ample testimony exists to the pleasures Victorian women found in such communal sewing tasks. Eighteen pairs of initials are embroidered on the ends of the sections of silk ribbons from which the center of the quilt is largely composed. This implies that it was a "friendship" quilt, many of which were made to commemorate rites of passage, weddings, a pastor's departure from a community, the ending of apprenticeship for a young man (a friendship "freedom" quilt), and other important events. Those who contributed to a friendship quilt's making, or who simply were to be commemorated, had initials or names, and sometimes dates, embroidered or inked on the top. The Nicely quilt would be further classified as a friendship Album quilt because the blocks surrounding the center have been made in several styles—Courthouse Steps, Crazy-style blocks, and a simple cross block—and quilts with mixed blocks, a visual album of designs, are so designated.

While the quilt shares a number of technical features with Crazy quilts in addition to the several Crazy-style blocks, most notably the use of satins and velvets, the ornamental fancy stitching, and the elaborate embroidered initials, it is in fact an unusual hybrid. Silk quilts appeared very early in the development of the craft; several English examples have been dated to the early eighteenth century.[9] But those and quilts of other materials of that early period, particularly linen and cotton, were made in families of means; cotton and silk were imported and costly, so wool, the basis of England's textile industry, was the standard. Because it had always been very expensive, silk was not much used in the clothes or quilts of the middle class in either Europe or the United States until the late nineteenth century, when its prices declined significantly and a commensurate taste developed among a growing middle class for high-style, elaborate clothing. It is always a question in quilt design whether supply or intent was more influential. Did a maker use what limited materials might be available to her and tailor her design to those, or did she settle on a design and then go out to find appropriate materials? In this case, for instance, did the maker or makers have the silk ribbons that were designed into the quilt, or did she or they design the quilt and then go out to buy the ribbons that were needed to make the conception work? Because several of the initials on the ends of the ribbons have been truncated and folded into the sewn seams—possibly indicating that their incorporation into such a pieced unit was not taken into account when they were first made—it is likely that the ribbons came first and the design later.

As in many quilts, there is a combination of tradition and innovation. The overall design is that of a bordered central square, one of the earliest quilt formats. But using the framed center as a background for diagonal slashes of bold contrasting colors formed by the ribbons was an adventuresome visual innovation. That, along with the boldness of the surrounding blocks, reminds us of modern paintings. When we think of the predominant academic painting styles that most Americans were aware of during the late nineteenth century, such Modernist touches in quilts

seem quite remarkable. On the other hand, until the quite recent rehabilitation of the American quilt's reputation as a visually interesting object, such bold Victorian designs were often seen as examples of the last throes of a decadent design tradition.

Whoever made this quilt adopted several different modes and styles common to quiltmaking of the time, reconfigured them, added some unique touches, and so created an unusually powerful and aggressive finished textile. Nice work, Nicelys.

■ **Jonathan Holstein**

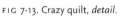

FIG 7-13. Crazy quilt, *detail*.

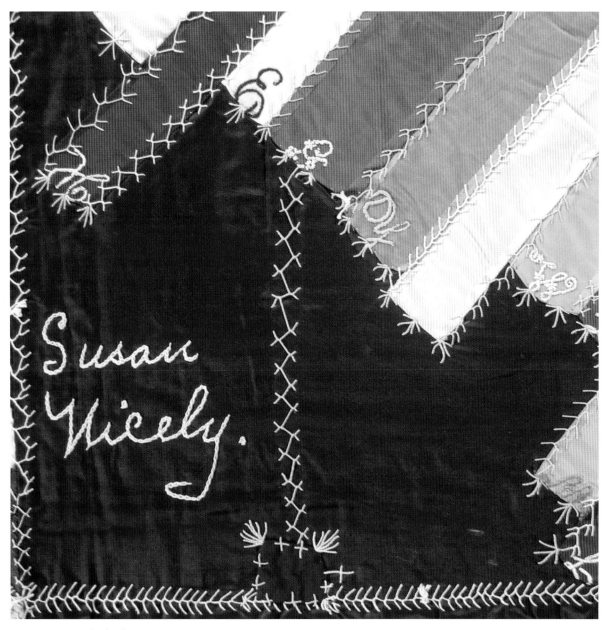

FIG 7-14. Crazy quilt, *detail*.

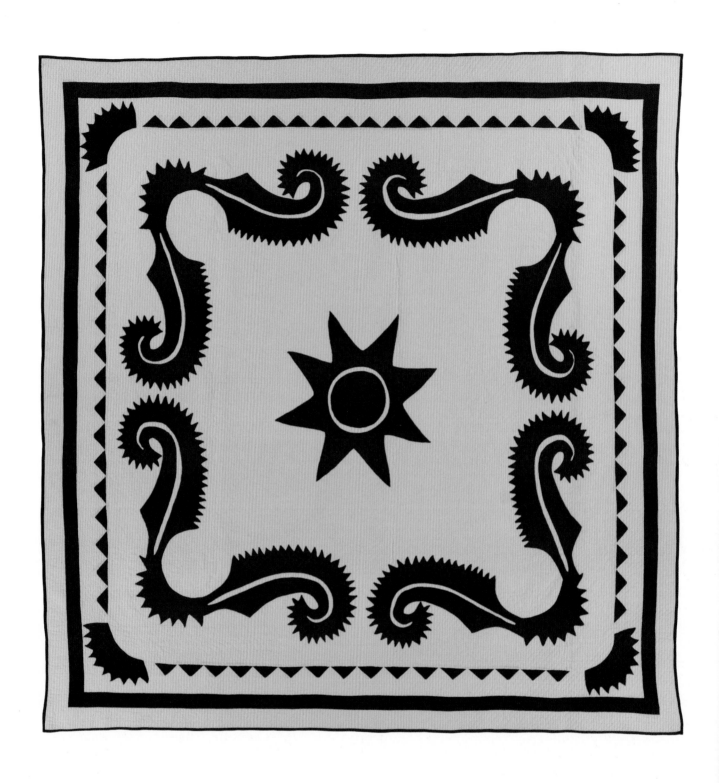

PLATE 7-6. **Princess Feather variation.**
Maker unknown.
Possibly made in Delaware, 1900–1920.
Cottons, 79" x 76.5". QSPI: 8-9.
1997.007.0788. *Ardis and Robert James Collection.*

Strikingly original quilt designs may depend not as much on new aesthetic inventions as on unusual uses or remaking of traditional ones. All of the elements seen in this Princess Feather variation (plate 7-6) had been part of the quiltmaker's aesthetic vocabulary for generations by the time this quilt was made.

The so-called Princess Feather pattern has long been thought of as a derivation of the Prince of Wales crest, a device of three ostrich plumes that has been the prerogative of the heir apparent to the English throne since it was first adopted in the fourteenth century. It was a common motif in English decoration over the centuries, appearing at the tops of mirrors, in chair crest rails, in furniture inlays, and many other decorative arts applications. A similar plumed motif first appeared in American quilts around the middle of the nineteenth century, during a time of middle-class American adulation of English taste and manners, and remained popular as an appliqué quilt motif well into the twentieth. It may well have been occasioned by the 1860 visit of the Prince of Wales to Canada and the United States, which created a considerable stir. Even the great democrat Walt Whitman waxed enthusiastic about it in his "Year of Meteors (1859–60)":

And you would I sing, fair stripling! welcome to
 you from me, young prince of England!
(Remember you surging Manhattan's crowds as
 you pass'd with your cortege of nobles? . . .)

Another possibility for the origin of the name and pattern has recently been proposed: that it came from the amaranth, a popular family of garden plants in the Victorian age, whose common name was "Prince's Feather." Many Victorian women were avid gardeners and would have known the botanical as well as common names for most of the prevalent plants of the day. Some women even called their plumed quilts Amaranth.[10]

The evolution of the name is not difficult to discern. What started as "Prince's Feather" (whether referring to the personage or the plant) was most likely quickly changed, given the lack of attention to the formalities of punctuation in much personal writing of the period, to "Princes Feather." From there it was probably an easy step for someone who did not know its derivation to change the spelling to "Princess," thinking it was an appropriate correction. The names of quilt patterns, as they passed from person to person, were often thus changed, in sometimes delightful ways. Star of Bethlehem in the American East of the early nineteenth century might become Morning Star, Harvest Star, Prairie Star, the Lone Star, and many other names, as the nation's interest moved westward. The eight-pointed star in the center of this quilt, one of the most venerable designs in the American quiltmaker's pattern book, was first called Variable Star,[11] but also had an enormous range of design variations and associated names as it was used and reinvented by American quiltmakers. Lone Star, Texas Star, Sawtooth Star, Crystal Star, Ohio Star, Dewey's Victory, Flying Cloud, Twinkling Star, and Martha Washington's Star were just a few of its many names and variations.

One consistency between this quilt and others of the genre is the eight-pointed star used as a centering device; in this quilt, the eight-pointed star is at the center of the field, whereas in traditional Princess Feather quilts it anchors the rotating plumes, something seen in eleven of the seventeen quilts of this pattern in the International Quilt Study Center's collections; two others are centered on a six-pointed device. The variations seem to be determined by whether the feather designs are composed of eight or six rotating elements. (See plate 5-63 for a six-pointed star; see plate 5-56 for an eight-pointed center star.) Another common form for Princess Feather quilts is its quartered nature, an overall format composed of four major plume sections; this is seen in thirteen of the seventeen quilts of this pattern in the collections.

So the maker fully understood the received tradition and chose to make a number of significant changes. The classic pattern is visually quite dynamic, as the groups of eight or six curved feathers in a circle remind one of a pinwheel, and quilts based on the pattern are

often also quite busy. Here the maker reduced the visual complexity to a unique pair of plumes attached by a curved device with rays, like a rising sun. This motif is repeated in the corners, which are tied together by an inner border of unconnected triangles, a very unusual feature; connected, as such points usually are, it is called Sawtooth for obvious reasons. Additionally, she has used the reverse appliqué technique, where sections of appliqués are cut away to reveal the background fabric, to suggest the quills of the feathers and to create a circle in the center of the central star. Reverse appliqué, a regular feature in Hawaiian quilts, is unusual in American quilts in general and was usually a method practiced by experienced quiltmakers. The quilt in fact shares some of the particular features of Hawaiian quilts, such as the use of natural forms, a single color, and a basic quartered organization. (See plate 7-18 for a representative example of a Hawaiian quilt.) The maker also exploited the possibilities of two-color quilts, an extremely popular visual device during the nineteenth and twentieth centuries, usually confined to red or blue on white, but unusual for this pattern. (Of the seventeen examples in the Center's collections, three are blue or red on white; the rest are two or more colors on a white or colored background.)

The significant level of skill required to make such a quilt is indicated not only in the intricate appliqué and reverse appliqué, but in the quilting, which is done in typical parallel diagonal lines in the border, but more complicated images of sunflowers, single plumes, and feathered plumes within.

■ Jonathan Holstein

FIG 7-15. Princess Feather variation, *detail*.

Enigmatic images, initials, and a specific date: the sort of art history mystery that delights researchers. This quilt (plate 7-7) was purchased in Pennsylvania at an open-air antique market in 1972. It was probably made in Pennsylvania, though that is not possible to ascertain with certainty from any intrinsic evidence, and no external, related history has yet been unearthed. Lacking a familiar place in the large lexicon of American quilt designs, it was given a title by the collector to honor the late eighteenth-century Pennsylvania Whiskey Rebellion, put down by the derisively called Federal Watermelon Army of the great Revolutionary War hero Henry "Light-Horse Harry" Lee. The jug imagery is clear; watermelons may be inferred both from the almost perfect color match and the border, whose elements mirror the common halves and quarters into which watermelons are commonly cut.

The subject matter of most appliqué quilts was figurative, the vast majority floral in nature, yet some can have highly personal references. The quilt bears the date "January 23, 1901," and the initials "D C K" in the quilting. Specific dates on quilts often commemorate such personally important moments as births, marriages, or anniversaries or, in rarer instances, the dates of significant historical events. This quilt's importance as a commemorative vehicle is affirmed by some intrinsic evidence: pencil lines to guide quilting are still visible, and the original sizing is still in the cottons, indicating that it was never washed and, thus, probably never put onto a bed, but carefully preserved. The presence of heart images in the border quilting suggests a matrimonial connection, a marriage date or anniversary.

The work is of medium quality, the figurative images cut with a template and hand-stitched to the backing, the sewing of borders and blocks accomplished by machine. The use of solid green and red as the only colors continued a tradition that began in American appliqué quilts before the middle of the nineteenth century. The powerful combination of red and green, often eye-dazzling in close proximity, was particularly

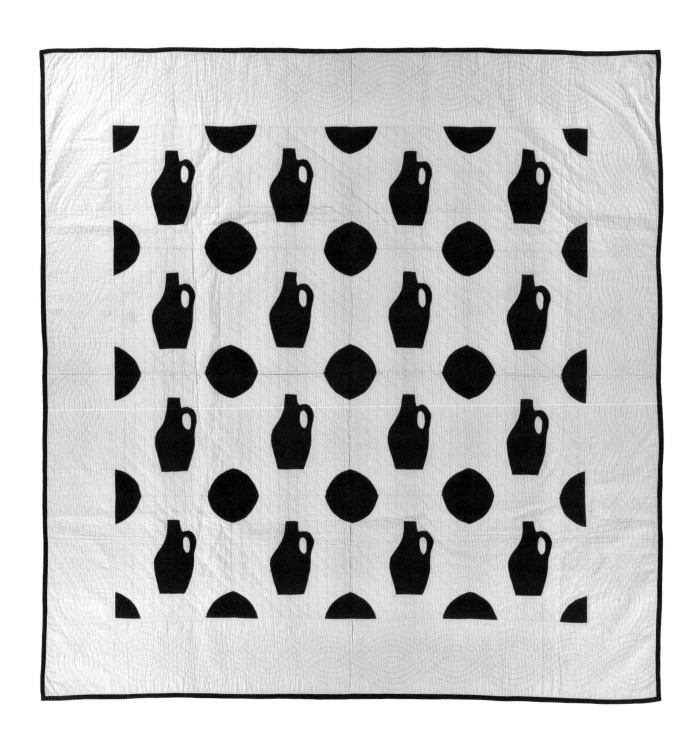

PLATE 7-7. *Whiskey and Watermelon.*
Maker unknown.
Possibly made in Pennsylvania, dated January 23, 1901.
Cottons, 78.5" x 77". QSPI: 6-8.
2003.003.0156. *Jonathan Holstein Collection.*

FIG 7-16. *Whiskey and Watermelon, detail.* Quilted inscription: "1901 / D C K / Jan 23."

popular. Here, in a quilt that was apparently neither washed nor extensively subjected to light, one can see the powerful visual effect the maker wished to achieve with that simple color combination.

The drawing of the jugs and watermelons, spare outlines with no added decorative details, is markedly different from the often extremely elaborate red-and-green appliqué quilts that preceded it. The majority of these earlier pieces have borders of some sort, often elaborate compositions of vines and various other flora; the interior images are usually imaginative stylizations of flowers or such things as pineapples, with fanciful additions. Occasionally, however, a less adorned image, one that sets out the major visual premise without extensive elaboration, will appear, as in the Pennsylvania quilts of the last quarter of the nineteenth century that featured four large appliquéd eagles arranged around a central star motif (see plates 5-35 and 7-39). The intent, as in the *Whiskey and Watermelon* quilt of several decades later, was to emphasize the importance of the image rather than concentrating on an overall decorative effect, though neither suffers from a lack of compositional integrity. The eagle with its shield, created during a period of increasing nationalism, was obviously meant as an expression of patriotism. What the whiskey jugs and watermelons were meant to convey we may never know, but it would be nice to think that a grand country party was somehow associated with it. The spareness of the composition and the images reflects both the limited ambition and sewing skills of its maker and the period's movement away, in the decorative and fine arts, from the overly elaborated Victorian canon. During the time this quilt was made some American quiltmakers were still creating red-and-green appliqué quilts in the traditional, formal, and more academic styles. In comparison to those, this could be considered more of a folk art creation.

■ **Jonathan Holstein**

FIG 7-17. Tobacco Premiums quilt, *detail*. Swedish national dress.
FIG 7-18. Tobacco Premiums quilt, *detail*. "Nantucket Girl."

Shortly after the Civil War, James B. Duke took over his father's tobacco business. It grew so rapidly that by the late 1880s his company virtually controlled the U.S. tobacco industry, and in 1890 he founded the American Tobacco Company. Duke is credited with introducing collectible cards as premiums to promote sales of cigarettes, a gimmick adopted by competing firms as well. Beginning in the 1890s printed silk premiums began to replace the cards, which by this time were waning in popularity. Such ploys, which encouraged people to buy more cigarettes so they might own complete sets of a particular subject matter, initiated an era in which millions of premium inserts on a very wide range of subjects were included with tobacco products. Tobacco product manufacturers began to include premiums with subject matter designed to appeal to women, images nicely printed in different sizes on silk fabrics and cotton flannel. Women soon began to use them in quilts.[12]

The diversity in both size and subject matter is represented in the 385 "silkies" (a common name that has been given to tobacco premiums) appliquéd to this Tobacco Premiums quilt top (plate 7-8). Subjects in this quilt include, among other things, national

flags and anthems, soldiers of different nations, Canadian Mounties, a variety of national dress, bathing beauties, butterflies, Japanese geishas, and animals, birds, and flowers. Also pictured are the royal or elected leaders of several nations. American President Woodrow Wilson (in office 1913–1921), Japanese Emperor Taisho (ruled 1912–1926), Swedish King Gustav V (ruled 1907–1950), and English King George V (ruled 1910–1936) are all present, providing an impressive assemblage of world leaders from the early twentieth century. The practice of putting such premiums in cigarette packages petered out as the twentieth century progressed.

Symmetry was an ordering principal in the vast majority of American quilts, and this was no less true when premade pieces were used. Tobacco premiums used in quilts were often arranged in symmetrical fashion, the lines of rectangular pieces ordered in rows within the (usually) rectangular format of the quilt, and sewn edge to edge, often grouped by subject matter, like little galleries of images (see plate

PLATE 7-8. Tobacco Premiums quilt.

Maker unknown.

Probably made in Michigan, 1915–1925.

Cottons, cotton-silk mixtures, 86.5" x 69.5". QSPI: 6.

1997.007.0198. *Ardis and Robert James Collection.*

FIG 7-19. Tobacco Premiums quilt, *detail*. Passenger pigeon.

FIG 7-20. Tobacco Premiums quilt, *detail*. Woodrow Wilson.

7-30). At other times they were included in such highly decorated textiles as Crazy quilts. Here, however, the maker chose to use an unpatterned whole-cloth foundation as a canvas on which to arrange the silkies in an asymmetrical fashion. The arrangement is not totally without order. It has a rough dividing line down the middle, where two bolt widths of the background cotton were joined to make a larger surface, as if the maker saw that seam, intentionally or unintentionally, as a dividing line. The largest silkies, with images of national flags, were grouped at the top. Beneath, on each side, to about the same length (approximately halfway down the overall length of the quilt), they were arranged in rough rows, and then beneath that for the remainder of the length they were tipped in different directions. The result of this composition is that the more one examines the quilt, the more ordered it seems.[13]

We do not know how this maker constructed the quilt. Did she assemble the silkies to her liking on the backing, then stitch them down, or did she start at the top and work her way down, improvising as she went? Or perhaps she realized halfway down that she would not have enough silkies to finish the quilt if she spaced them in orderly rows close together, so decided to fill the space by leaving more air around each one and tipping them to use their lengths as space fillers. In any case it seems ordered, and, of course, it was, the maker responding to her available materials and the frame of the quilt to create a design dependent not on the imagery within the silkies, little realistic images, but on their mass effect as shape and color on a large canvas. It was a way of overcoming the limitations of received form and subject matter by exploiting it in a collage-like manner. Its unusual asymmetrical composition, which takes advantage of the busy visual vocabulary of the silkies, converts what might have been a banal and commonplace elaborated Victorian surface into a striking composition.

As might be expected, there is minimal quilting, some of which goes across the premiums. These textiles, with their delicate inclusions, were more in the nature of Victorian parlor pieces than practical quilts, and so were usually not subjected to any sort of use that would have required cleaning.

■ **Jonathan Holstein**

PLATE 7-9. Dragon.
Maker/location unknown, 1930–1940.
Cotton sateens, 90.5" x 80". QSPI: 6-9.
1997.007.0225. *Ardis and Robert James Collection.*

Some 150 small pieces of cotton sateen in various shades of gold, yellow, pink, and coral were used to make this splendid Chinese dragon quilt (plate 7-9). The pieces are irregular strips and diamonds that, when put together, create the dragon's scales and give the creature a greater visual depth and complexity than if it had been cut from a single piece of cloth. The floating dragon is hand-appliquéd onto a black sateen background and is surrounded by yellow quilting in a diamond grid and feathered plumes. The yellow sateen border contains the dragon and helps to draw attention to his golden glow.

The dragon is clearly meant to be Chinese, likely taken directly from an image of the Chinese imperial flag of the late Qing Dynasty (1644–1911). Dragons traditionally represented the strength and splendor of the Chinese emperor. Although lesser officials were allowed to wear four- and three-clawed dragons on their robes, only the emperor, his sons, and high officials were permitted to display the five-clawed dragon (although as the last Qing emperors' powers weakened, these sumptuary laws were frequently ignored). Naturally, the Qing imperial flag displayed the five-clawed version, as does our quilt. A bright yellow, similar to the one used in this dragon's, was the color of the imperial flag and of the emperor's court robes.

Despite its impressive intricacy and sumptuous materials, the dragon is more quirky than imposing. Parts of it, especially its claws, are awkwardly shaped, giving it an almost folk art character. Additionally, the placement of its legs and the curve of its back make it difficult to know which way to orient the quilt. While the dragon on the Chinese imperial flag was presented as long and low to the ground, if you turn this dragon to a horizontal position, it appears to be tumbling forward, about to land on its face. Its asymmetrical placement, atypical for American quilt images, adds further to its exotic quality, as does the solid black background. None of these unusual aesthetic elements seems haphazard; the dragon was clearly carefully designed, constructed, and positioned on an unusual surface.

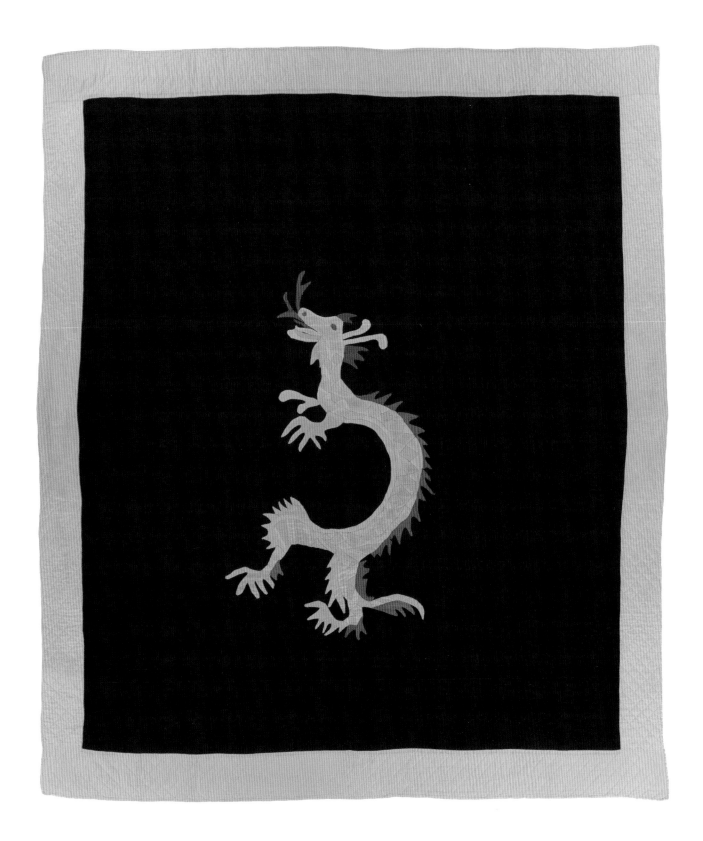

FIG 7-21. Dragon, *detail*. Appliquéd "scales."

But where would the maker have obtained the image? The quilt is too idiosyncratic to be a kit or pattern, though one dragon quilt pattern is known to have been published in the early twentieth century. That pattern, from a 1905 issue of *Ladies' Home Journal*, was so complex and artistically designed that it would have been nearly impossible to make from cloth, and probably existed only as an illustration.[14] A more likely source of inspiration than a kit or pattern would have been a visit to the Chinese village at a World's Fair of the period.

World's Fairs were enormously popular during the second half of the nineteenth and first half of the twentieth centuries in the United States. A part of every Fair was an array of foreign nations representing their daily life and traditions in special buildings or villages. These villages gave Americans a glimpse of the exotic-seeming lives of people of far-off lands, including China. At the 1933–1934 Century of Progress Fair in Chicago, for instance, the Chinese village featured a replica of a Buddhist temple that had been built in China and then shipped to Chicago for the Fair.[15] The pamphlet distributed at the temple displayed a dragon on its cover very similar in shape and detail to the one on this quilt.[16] Visitors also might have seen the imperial dragon flag at the Chinese village or at another Chinese attraction, the "Streets of Shanghai."

Regardless of where the maker received her inspiration, her quilt demonstrates the influence of foreign cultures (especially those perceived to be "exotic") on American popular culture. Although she most likely had very little accurate knowledge about Chinese symbolism, she was intrigued by the image and had enough basic information to create this recognizably Chinese imperial dragon.

■ **Marin F. Hanson**

FIG 7-22. China's Qing Dynasty (1644–1911) imperial flag (1890–1911).

Exploiting and altering construction techniques to create idiosyncratic variations was a typically American approach to quiltmaking. The yo-yo technique, named after the toy of the same name, was developed in the first decades of the twentieth century. Rounds of material were hemmed, then the threads pulled and tied to create a puffed-out circle. These were flattened and centered, then whipstitched together at four points to make a largely decorative textile with open spaces between each round, one that would not tolerate much rough use and was destined to be used as a decorative top spread. Usually made of cheap cottons, the pieces could be easily worked while traveling or talking with friends. In this quilt (plate 7-10), however, a number of changes in the technique were made to create a very different sort of Yo-yo quilt.

First, the pieces are absurdly small. Most yo-yos were made in one-inch diameters or larger. These measure only one half-inch finished, and they number about fourteen thousand pieces. Second, the maker squared the pieces and stitched them together along all four sides, thus assuring both the need for more pieces and the necessity of a good deal more work putting them together. Third, she basted the finished mosaic to a backing. The last two technical changes were perhaps an acknowledgment of the work involved and thus a desire to create a more lasting textile, but the visual result was a field of extraordinary complexity. Although there are a number of pieces made of the same materials, the maker was careful not to juxtapose them. One searches unconsciously for some sort of patterning, and when it becomes apparent that there is none, it can be seen as an extraordinary abstract mosaic, myriads of stars and galaxies, or a vision of minute particles, a surface at once lively and yet curiously stable.

This kind of obsessive work has its counterpart in the earlier Postage Stamp quilts, often made, like this one, of thousands of small squares. Usually, however, they were given some sort of overall visual organization by, for instance, linking diagonal rows of similarly colored materials to create a grid on the surface, or using a bright color in rows, or creating inner designs. (See plate 6-89 for a Postage Stamp quilt with an overall visual organization.) Similar techniques to order the composition were tried with Yo-yo quilts. See Plate 7-22 for a Yo-yo quilt in which darker colored pieces were grouped toward the sides, and a centering hexagonal star formed in the middle.

Such work was one of the later techniques developed by quiltmakers to create more dimensional surfaces. Others, seen earlier, include the techniques of trapunto and stuffed work, usually employed to raise figurative images from the surface, and, during the later Victorian period, the creation of stuffed squares or circles (plate 7-24), and, in rare instances, the actual attachment of three-dimensional objects to the surface of the quilt.

■ Jonathan Holstein

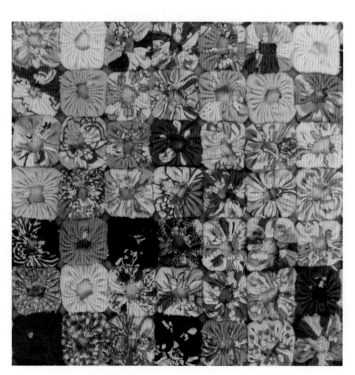

FIG 7-23. Yo-yo, *detail*.

PLATE 7-10. Yo-yo.
Maker unknown.
Possibly made in Illinois, 1930–1940.
Cottons, 79" x 57". Unquilted.
1997.007.0917. *Ardis and Robert James Collection.*

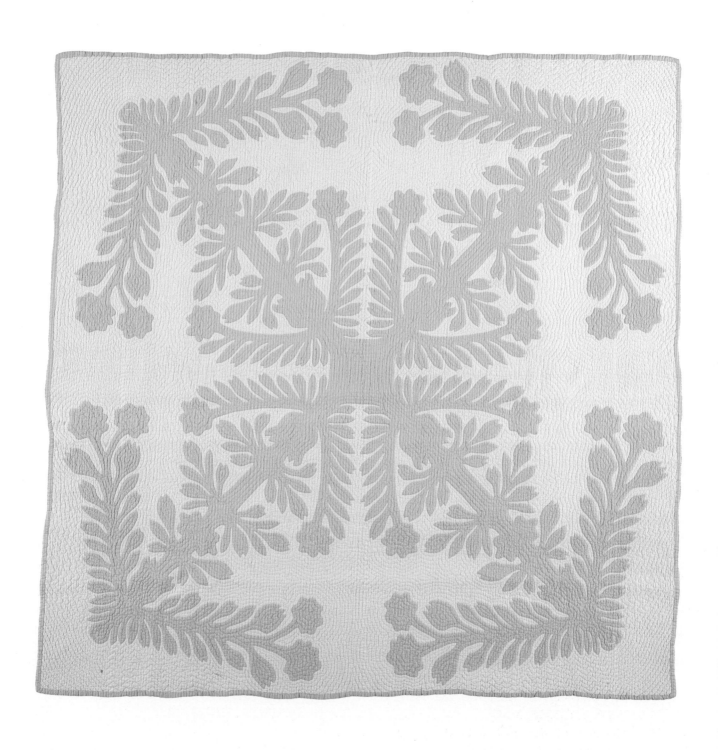

PLATE 7-11. **Beauty of Hilo Bay.**
Maker unknown.
Made in Hawaii, 1930–1950.
Cottons, 74" x 74". QSPI: 8-9.
2005.015.0001. *Purchase made possible through James Foundation Acquisition Fund.*

Hawaiian quilts are quintessential "niche" quilts. Resembling mainstream American quilts in many ways, in other ways they are a wonderfully unique group. They have a relationship to the larger American quilt tradition, but in essential ways retain their own distinct identity.

First of all, the Hawaiian quilt style emerged before Hawaii had a political relationship with the United States. The islands were not annexed until 1898 and did not become a state until 1959; therefore, their grouping with American quilts is a qualified one. Americans did, however, introduce Hawaiians to materials, techniques, and quilts from back home that would spark the development and influence the design of Hawaiian quilt styles.

Native Hawaiians already had a sewn textile tradition long before Westerners began to settle on the islands in the early nineteenth century. Kapa moe were bedcoverings made from layers of bark cloth sewn together and often decorated with designs applied with natural dyes. When New England missionaries arrived in 1820, they introduced Hawaiians to new materials, such as cotton, and to the appliquéd Album quilts so popular back on the mainland. When and how the characteristic Hawaiian appliqué style, of which this Beauty of Hilo Bay quilt (plate 7-11) is an excellent example, appeared is unknown, but it seems sure that appliqué was the first and predominant choice of the native Hawaiian quiltmakers; patchwork did not catch on the same way, despite the fact that missionary women made efforts to teach the skill.[17] (Piecing was used, however, in the most common style of Hawaiian quilt, the Royal Hawaiian flag quilt, but the piecing was mainly done in long rows to imitate the stripes of the royal flag.) By the 1870s Hawaiians had developed the overall design and layout that has come to characterize the Hawaiian appliqué quilt.

Like Beauty of Hilo Bay, most Hawaiian appliqué quilts are dominated by a single appliquéd motif, usually a solid color on a white ground. The motif is typically made from a single piece of fabric, which is folded into eighths (though some designs are folded only into fourths) and then cut out according to a pattern, much in the same way schoolchildren create

FIG 7-24. Beauty of Hilo Bay, *detail*.

paper snowflakes. It is widely theorized that this fold-and-cut technique was inspired by nineteenth-century Pennsylvania German *scherenschnitte* blocks in Album quilts brought to Hawaii by missionaries. A long tradition of paper cutting existed in Germanic areas of Europe and was brought to the United States by immigrants who translated it into an appliqué technique. Paper cutting was also taught in Hawaiian missionary schools, so the influence of *scherenschnitte* on the Hawaiian appliqué technique seems likely.[18]

Many of the appliquéd motifs on Hawaiian quilts are inspired by native vegetation. Patterns such as Ulu (Breadfruit), Ahinahina (Silversword), and Lehua refer to trees and plants found on the Hawaiian Islands. The origin of this quilt's name, Beauty of Hilo Bay, is not clear, though references to it have been found in the Waianae (Oahu) Public Library quilt pattern collection.[19]

Like most Hawaiian appliqué quilts, Beauty of Hilo Bay features echo quilting, multiple "waves" of quilting that repeat the contours of the appliquéd motifs in concentric rings across the entire surface of the quilt, creating textural, rhythmic undulations. The quilt has wool batting, which, unlike mainstream American cotton quilts of this time, is not uncommon for quilts in Hawaii.[20]

■ **Marin F. Hanson**

At first sight, *Deer in Wedgewood*, this white reverse appliqué quilt (plate 7-12), has none of the distinctive features of early or mid-twentieth-century quilts. Fortunately, an embroidered date, "1932," and cloth tags on the back of the quilt connect it to one of the most original but least known quilt designers of the twentieth century, Bertha Meckstroth. The information on this quilt reads, "Bertha A. Meckstroth, Glencoe, Ill., Casa Tranquilla. 1932." Glencoe is a well-to-do suburb north of Chicago. Bertha Amelia Meckstroth lived there with her sister Anna Sears, widow of the founder of Sears, Roebuck and Co., in a Spanish-style villa they called "Casa Tranquilla."

Bertha was born in LeSeur, Minnesota, in 1875 to German immigrant parents, the third of four children. Her mother died when she was very young. The two oldest children, including Anna, were sent to live with relatives. Bertha and her younger sister remained at the family home with their father, a medical doctor, and a beloved housekeeper. As a young girl, Bertha met a quiltmaker, a relative of her housekeeper, and the memory of those quilts led her to take up quilting much later in life.

In 1902, at the age of twenty-seven, she entered Radcliffe College, where she studied art and sculpture. She taught school after graduation, was a nurse, and eventually returned to her sister's home in Glencoe. Bertha set up a studio in the early 1920s and began to make quilts, but she was still a sculptress at heart and found herself drawn to trapunto, reverse appliqué, layered appliqué, and embroidery to create what she termed "sculpted cloth."

By 1933 she had made more than 140 quilts. She must have been overwhelmed with pride when she was invited to display her quilts and lecture at the Illinois Pavilion at the Century of Progress Exposition on July 15, 1933. For the event, she produced a printed four-page program entitled "The Singing Needle." She showed her traditional patterned quilts—Basket, Drunkard's Path, and Robbing Peter to Pay Paul—and explained why she progressed to her own designs: "That the latter were too widely copied and imitated brought a desire to be more original, even to imitate other forms of expression in other media with such examples as: Wedgewood, Copenhagen and Coral Islands, an imitation of China ware and coral Cameo."[21]

This "imitation of other media" would become the signature trait of her quilt designs. At the Century of

FIG 7-25. Bertha Meckstroth, date unknown. Courtesy of the Schlesinger Library, Radcliffe Institute, Harvard University.

Progress lecture she displayed lettered quilts, appliquéd to appear chiseled. The padded and layered appliqué figures in her religious-themed quilts appeared to rise from the quilt's surface. Following the lecture, Allen D. Albert, the assistant to the president of the Century of Progress Exposition, described her quilts' impact on him: "Many things about them gave me pleasure—the use of a new medium, the modeling; above everything, their value as pure decoration. . . . I have hope that this display may widen the range of designs for needlework and help usher in an era of distinctive American design."[22]

Bertha's designs never did gain wide acceptance. No magazine editors paid to use her design patterns, nor did she enter contests to receive compensation and adulation, as another Chicago quiltmaker, Bertha Stenge, did.

Radcliffe College exhibited her quilts during Commencement Week in 1935. Bertha hoped her alma mater would take her quilts and build a museum, but that did not happen. She spent her final years in a mental institution, with a local bank serving as conservator of her assets. When she died on May 25, 1960, the question of the distribution of her quilts was still not decided. After a contentious court battle, two colleges, Barat College in Illinois and Radcliffe College in Massachusetts, split an endowment and the quilts. Later both colleges sold most of her quilts to raise money for their scholarship funds.

Despite her best efforts, she was not able to keep her quilts together as a collection. Occasionally a Meck-

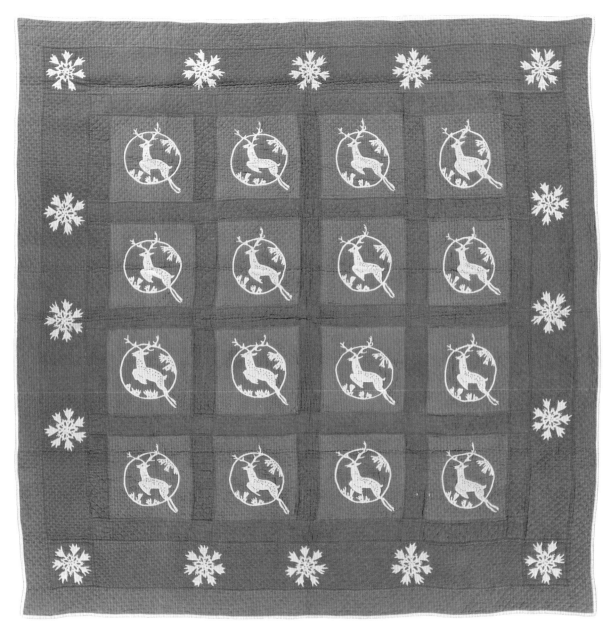

PLATE 7-12. *Deer in Wedgewood.*
Bertha A. Meckstroth (1875–1960).
Glencoe, Illinois, dated 1932.
Blue linen and white cotton, 68" x 68". QSPI: 7-8.
2003.003.0361. *Jonathan Holstein Collection.*

stroth quilt surfaces at an auction or in an antique store. (The best source for information and photos of Meckstroth's quilts is Joyce Gross's 1981 article in *Quilters' Journal*.)[23] The Meckstroth papers at Louisiana State University supply some information and a few more quilt photos. A typed list of quilts entitled "Catalogue of Works, 1916–1938" names the quilts in chronological order. For some designs, multiple quilts were made. Three quilts on the list were identified as "Deer in Wedgewood," made between 1931 and 1933.[24] The IQSC quilt with its 1932 embroidered date is probably one of these. Without the identification label it would have been difficult to link it to Bertha since photos of her quilts published after her death do not include any examples of her Wedgewood series.

■ **Merikay Waldvogel**

PLATE 7-13. Calendar.
Lillian Smith Fordyce (1884–1984).
Probably made in Pennsylvania, c. 1933.
Cottons, 94" x 86.5". QSPI: 7.
1997.007.0915. *Ardis and Robert James Collection.*

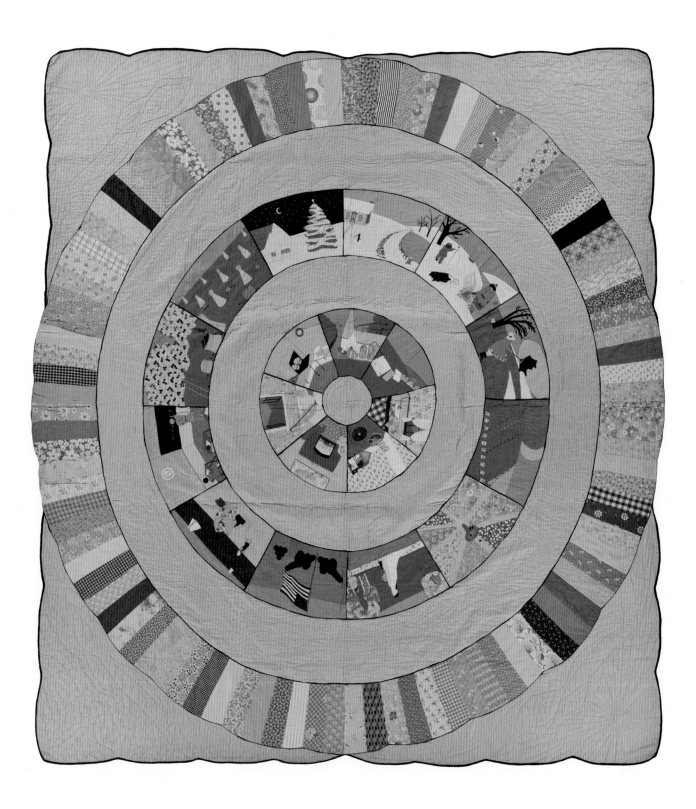

FIG 7-26. Calendar, *detail*. "C P" in quilting.

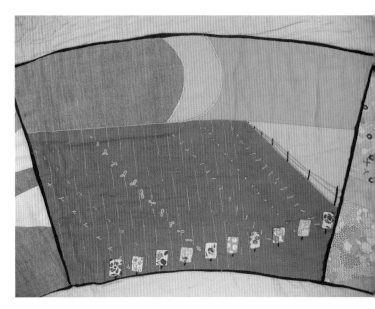

FIG 7-27. Calendar, *detail*.

This Calendar quilt (plate 7-13), an original design made of the typical multicolored print and solid fabrics of the 1930s, contains a mystery. Although the quiltmaker's name is known, the particular circumstances of its making are not. It is likely, however, that it was made as an entrant in the 1933 Sears Century of Progress Quilt Contest sponsored by Sears, Roebuck and Co. and held in conjunction with the Chicago World's Fair.

Sears challenged quiltmakers to make an original design on the theme of "The Century of Progress," offering a bonus prize of $200.00, a significant amount of money during the Great Depression. Most quiltmakers who produced quilts with the theme of progress depicted advances in technology. Others, especially from the Chicago area, incorporated emblems, buildings, and highlights of the Fair itself. This quilt does not exhibit any direct references to the Fair, such as the years 1833 to 1933 or the Fair logo, as Ida Stow's quilt does (plate 7-14). However, on closer examination, several elements point to a Sears Contest origin. The letters "C" and "P" are quilted in the center ring and likely stand for "Century of Progress." In addition, the plain inner and outer rings are quilted with images of inventions and vehicles that represent technological changes in the past one hundred years: a car, a bus, a standing fan, a refrigerator, a radio contrasted with a hand pump, a washing tub, and oxen pulling a plow.

The maker, Lillian Fordyce, was exceptionally adept at using fabrics and embroidery for appliquéd pictorial scenes. The days of the week are represented in the first ring of seven wedges, each showing in remarkable detail the activity appropriate to that day—washing clothes on Monday, for example. The larger ring of twelve wedges shows the months of the year, each appliquéd and embroidered to show in fine detail an activity associated with that month, such as planting a garden in April. The solid rings contain the quilted motifs depicting items from the past and the progress of the future; two notable transportation images show an elevated train, like the ones in Chicago, and a zeppelin.

Another interesting aspect is that the foundation cloth appears to have come from a kit quilt. It has the slightly scalloped edging typical of 1930s kit quilts. Also, the outer ring extends beyond the foundation cloth, possibly indicating that Lillian created the ring after she chose the foundation cloth and decided to leave it as it was.

Lillian moved to Arizona near the end of her life to live with friends who cared for her. The quilt was purchased in Arizona by Laurene Sinema, a quilt collector and historian from Phoenix, and subsequently by Robert and Ardis James, before donation to the International Quilt Study Center. A photograph and historical information pertaining to this quilt were included in the Arizona Quilt Project's book, *Grand Endeavors*.[25]

■ **Merikay Waldvogel**

PLATE 7-14. *A Century of Progress.*
Ida M. Stow (1875–1957).
Park Ridge, Illinois, dated 1933.
Silk crepe, 91.5" x 76". QSPI: 8-9.
1997.007.0947. *Ardis and Robert James Collection.*

Ida Mae Schulte was born on a Missouri farm in 1875 to a family of prolific quiltmakers. Years later, after Ida married Henry Stow, moved to Park Ridge, Illinois, had two children, and was working in her husband's elevator business in Chicago, she decided to enter the 1933 Sears Century of Progress Quilt Contest. Her mother, Carolyn Schulte, was living with her at the time, and the two decided to take up the challenge to make a special quilt on the theme of the Century of Progress. If they won, they would receive the $200.00 bonus promised to a progress-themed winner in addition to the $1,000.00 grand prize.

Ida and Carolyn's *A Century of Progress* quilt (plate 7-14) was merely one of the twenty-four thousand entries. The overwhelming response to the contest revealed the importance of competitions in the marketing of quiltmaking. Leading up to the contest, Sears offered in-store lectures about historic quilt patterns and advice on making quilts for the contest. Some examples of materials for quilts that could be obtained in their yard goods department were batting for 75 cents, colorfast percale and broadcloth for 12–13 cents per yard, and pastel solids in "pastoral cloth" (the trade name for a high-end, finely woven, and Mercerized combed cotton) and sateens for 25 cents per yard.[26]

Ida's son, Lloyd, remembered, "Ida and her mother made the quilt. Then they set up a frame in the house. They devoted a whole room to the quilt. It was a massive job."[27] When she delivered the quilt, Ida attached a typed explanation for the contest judges: "There has been a request for a quilt of unusual, or other than colonial, design which would depict and commemorate the Century. Therefore, this quilt is submitted for your consideration." Her design, including the typefaces she used, was based on the Art Deco aesthetics of the 1930s rather than traditional forms. She then commented on the significance of the colors (blue and gray were the official colors of the Century of Progress) and the official fair logo in the center (the world in its progress around the sun) and quilting

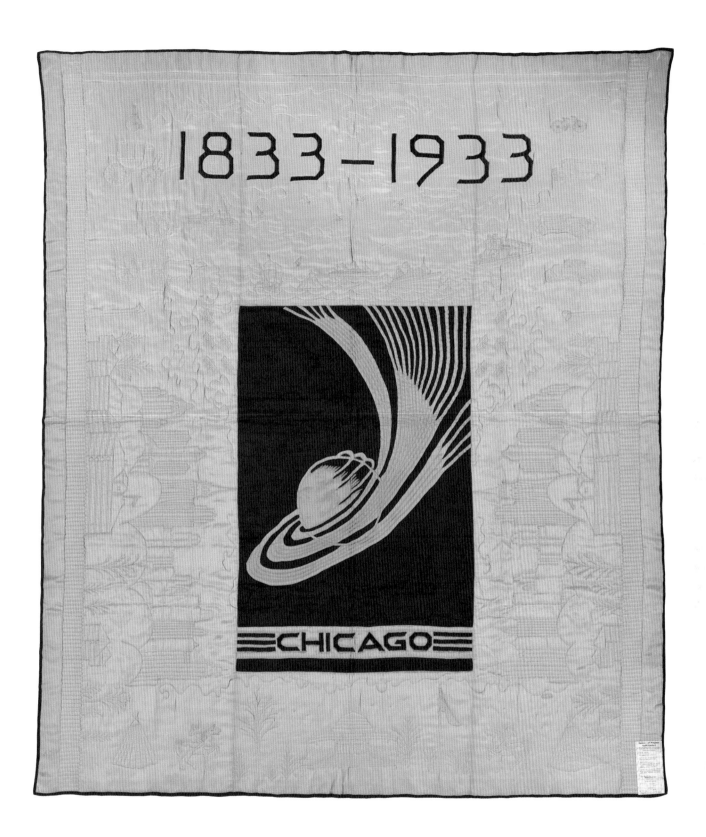

427

designs (one hundred years of achievements and advancements—from sailboat to ocean liner, biplane to zeppelin, and Conestoga wagon to automobile). Unfortunately, the only prize Ida received was an Honorable Mention ribbon.

Displeased with this result, Ida wrote a letter to the contest judges complaining that the Century of Progress theme quilts were being overlooked. She protested:

Your printed instructions were very explicit and I as well as others tried to live up to these instructions in all details. Now I understand that the Century of Progress quilts or those featuring the progress of the last century are not being considered or given recognition over colonial designs. . . . One of the judges [was] heard to state she would not give three minutes of her time to consider a Century of Progress design. . . . [We] spent considerable time,

thought and energy, not to speak of the money, in our efforts to produce something worthwhile along the lines called for by your company, to produce "an unusual design to depict and commemorate the Century of Progress."[28]

Apparently, 1933 was still too early for judges to favor "unusual" patterns over time-honored ones, even though the company had announced the $200.00 bonus prize to encourage the submission of original designs. Instead, the judges chose, for the most part, traditional patterns, pieced and appliqué, that exhibited extremely fine handwork.[29]

The grand-prize-winning quilt, entered by Margaret Caden, is said to have won because of its unusual combination of trapunto work with a pieced Harvest Star block. The second-place winner, Colonial Rose made by Mabel Langley, was a pattern sold by Ladies

Fancy Work Company of St. Louis. Four quilts made with Mountain Mist patterns reached the final round of thirty, as did three quilts made with Anne Orr appliqué designs. The striking medallion quilts, Sunburst and Star of France, in blended colors of orange and yellow introduced in 1932 by Hubert Ver Mehren, won several prizes at local rounds, and two of them reached the final round. Garden Bouquet, based on a series quilt from the Nancy Page Quilt Column, was the only newspaper pattern to be represented by a quilt in the final round.

The search for the top thirty quilts judged at the Sears Contest began in the early 1980s, when Barbara Brackman wrote to the local newspapers of the announced winners, whose names and hometowns were listed in the Sears catalog. Subsequent efforts have been made to search microfilmed newspapers for photographs of the winning quilts. Of the thirty quilts, one Century of Progress–themed quilt made by Mrs. G. R. Leitzel was found to have won third prize in the Philadelphia region, and one Star quilt made by Mrs. M. W. White, which won first prize in the Seattle region, had elaborate Progress-themed quilting motifs similar to those in Ida's quilt—evidence, though scanty, that judges outside the Chicago region probably were following the instructions to find something "unusual to depict and commemorate the Century."

■ **Merikay Waldvogel**

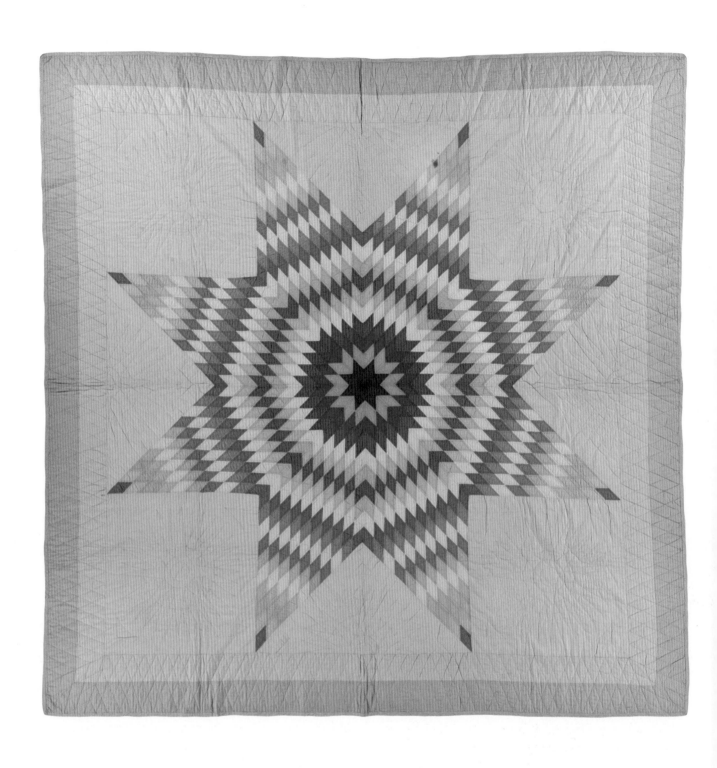

PLATE 7-15. Lone Star.
Ethel Ready Mackey (1887–1980).
Bicknell, Indiana, dated 1933.
Cottons, 79" x 79". QSPI: 7-8. 2004.010.0001.
Gift of Gilbert Gaskill (the Estate of Betty Mackey Gaskill).

thel Ready Mackey grew up on a farm near Emison, Indiana. According to her great niece, Kay Vasey, Ethel was sent to Indiana Industrial School for Girls at the age of fifteen because she had been "acting out." She learned to sew there and went on to lead a happy, productive life. After marrying, she moved to Bicknell, Indiana, and had three children.[30]

Betty Gaskill, Ethel's youngest daughter, inherited this Lone Star quilt (plate 7-15) along with the green merit ribbon it received at the 1933 Sears Quilt Contest and a June 16, 1933, two-page letter to Ethel from Sears, Roebuck and Co. and signed by Sue Roberts, the contest organizer. After learning of the ongoing search for Sears Contest entries, Betty agreed to send the quilt to an exhibition of Chicago World's Fair quilts at the Spring Quilt Festival in Rosemont, Illinois, in April 2004. She was excited about the opportunity to show the quilt and share her mother's story. Sadly, she died unexpectedly before the exhibit, but her husband, Gilbert, sent the quilt anyway because he knew she would have wanted him to. He then donated the quilt and its related correspondence to the International Quilt Study Center.

This quilt is important because it represents the thousands of exceptional quilts made for the contest that received only merit awards, not monetary awards. Of particular importance to scholarship is the fact that the original correspondence has remained with the quilt.

Letters of congratulation signed by Sue Roberts have shown up with many newly discovered Sears Quilt Contest entries. Of course, Roberts could not have signed all the letters—more than twenty-four thousand quilts were judged and returned to their owners—but it is interesting that each contestant may have received such a letter when her quilt was returned.

The June 16, 1933, letter of appreciation from Roberts to Ethel touched on the difficulty of judging both old patterns and new artistic designs in the midst of a burgeoning quilt revival. Roberts wrote, "Some were notable for the beauty of design, some for the thousands of tiny, even stitches in the quilting, some for the artistic blending of colors, and some for the happy choice of materials. Many of the entries were from women with years of experience in quiltmaking. Our difficult task was the selection of those quilts which most perfectly displayed all of these features of excellence."

Ethel's Lone Star quilt exhibits a skillful blending of colors—whether "artistic" or a "happy choice of ma-

FIG 7-30. Ethel Ready Mackey, c. 1939. Courtesy of Betty Mackey Gaskill.

terials" is a subjective matter. Lone Star quilts were often made from packaged kits containing all the necessary die-cut diamonds sorted by colors. Ethel's quilt, because of its wide range of colors, does not appear to be a kit. She quilted around each diamond in the central star and quilted a Mariner's Compass design in the corners and side triangles. The quilt lies perfectly flat and does not have a hole at the very center of the star—all marks of a proficient and careful quiltmaker. The bursting star design, a staple of American quiltmaking since the early nineteenth century, is always, regardless of color, dramatic and effective.

As a side note, the papers that accompanied Ethel's quilt contain an interesting piece of historical information. A typed list of winners in the Chicago region, where Ethel's quilt was judged, was also enclosed with the congratulatory letter. The quilt that went on to win the Sears Quilt Contest grand prize is also listed as having been judged in Chicago at both the local and regional levels, even though it was made in Lexington, Kentucky. It was widely known in Kentucky that Margaret Rogers Caden, the winner of the national contest, did not herself quilt. So she might have decided to send her quilt to Chicago, where it would not have been so well known that she did not make the quilt herself.[31]

■ **Merikay Waldvogel**

Alfred Landon, a successful oilman and lawyer and the governor of Kansas in the 1930s, was a moderate Republican whose beliefs about economics and the responsibilities of government put him at odds with the most conservative wing of his party. Nevertheless, when a strong candidate was needed to oppose Democrat Franklin Roosevelt in the presidential race of 1936, he was chosen, along with Frank Knox as his vice presidential running mate. The Great Depression had made Americans very skeptical about the more conservative American political philosophies, represented by the Republicans, and Roosevelt had built the New Deal, which seemed to offer them hope. The result was the most lopsided political defeat in American history, with Landon and Knox capturing electoral votes from just two states, Maine and Vermont (8 electoral votes to Roosevelt's 523). Landon returned to Kansas to finish his term as governor and remained a beloved leader and Republican spokesman for the rest of his long life.

Fabrics with political motifs have been part of the English and American textile traditions for centuries. Such items as printed handkerchiefs or kerchiefs demonstrating political affiliations date back in the United States to George Washington's era, and often they and other political memorabilia, campaign ribbons, and banners were incorporated into quilts. Materials in this quilt (plate 7-16) in light and dark green, khaki, purple, indigo, and yellow have a stamped design incorporating the Republican elephant, the sunflower, the state flower of Kansas, and the candidates' names, and appear to be colorways of the same acetate material. That, and the peculiar shapes of the pieces, have led to the suggestion that they might have been convention delegates' ties or the materials from which such were made.

The overall layout, however, is somewhat of an enigma. It repeats, consciously or unconsciously, one of the earliest quilt formats, a central diamond with matching corner blocks. But that is where any relation to traditional quilts ends. Looked at one way, the figures in the central diamond might represent highly stylized Ls (for Landon) in a Modernist vein. If one extends that thought, its overall appearance can be seen as an expression of the contemporary design trends of its period, Modernism and Art Deco. Considered in that light, the shapes and format do not seem anomalous; rather, they echo some of the design and color choices that flowed from those aesthetic movements.

The impetus behind the quilt could be read in one of two ways. If the elements of the central diamond do indeed represent Ls, then that, and the choice of the fabrics, clearly indicate that the quilt was made as an expression of support by a Republican enthusiast. On the other hand, the United States was still suffering through a financial depression, so if the maker was simply using materials she was given, or could purchase very cheaply once the campaign was over and the political debacle experienced, the quilt can be seen as a an example of thrift rather than political boosterism. It is in any case a peculiar but strangely compelling image. Its workmanship is crude and imprecise, even to the tipped purple striped diamond. But somehow that does not diminish it, nor does the relatively crude quilting, done in the parallel curved lines called "elbow" quilting, so named because it supposedly is accomplished by the swing and reach of a quilter with her elbow firmly resting in one place.

The fiber content of the fabrics used—acetate in the diamond design on the top and 100 percent rayon backing—is unusual because their poor performance in washing discouraged their use in quiltmaking at

FIG 7-31. *Landon/Knox Quilt, detail.*

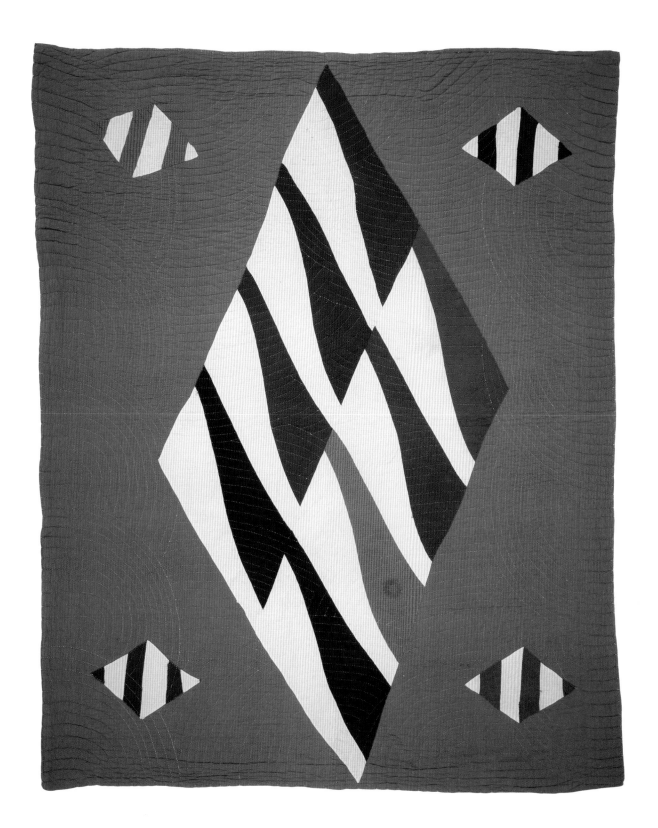

PLATE 7-16. *Landon/Knox Quilt.*
Maker unknown.
Possibly made in Kansas, c. 1936.
Cottons, acetates, and rayons, 83" x 67". QSPI: 6.
1997.007.0488. *Ardis and Robert James Collection.*

the time they were introduced to the market. Both rayon and acetate fibers are regenerated through a manufacturing process from naturally occurring cellulose polymers. Rayon, the first manufactured fiber, was patented in 1884 and was first produced commercially in the United States in 1911, but was used mostly for braids, trims, and knitted hosiery. Mixing rayon with yarns of cotton or other natural fibers was the only way early rayon would perform acceptably in a woven fabric. By 1924 or 1925 manufacturers had successfully developed durable 100 percent rayon dress fabrics. It was not until the 1930s that these fabrics became plentiful.[32] Quiltmakers, including the Pennsylvania Amish, experimented with its use, but it was not generally favored by quiltmakers as it was prone to shrinkage when washed and required special handling to avoid distortion. American commercial production of acetate fabrics began in 1925. Initially, they were approximately twice the price of rayon and therefore were probably not much used until after 1934, when the price moderated.[33]

The *Landon/Knox Quilt*, like most quilts, elicits a number of unanswerable questions. The unknown maker, due to her inclusion of 1936 presidential campaign memorabilia and fabrics from commercially produced rayon and acetate, nevertheless provides a glimpse into the political, economic, and stylistic environment of the times.

■ **Jonathan Holstein**

GALLERIES

Unique Techniques

The fold-and-cut technique of creating appliqué designs is similar to the method used by grade school children to create paper snowflakes. Quadrilateral symmetry is created when fabrics are folded into quarters before being elaborately cut; designs with bilateral symmetry are cut from fabric folded in half. Fold-and-cut allowed quiltmakers to produce complex, symmetrical, organic motifs such as ornate scrolls, plant forms, and abstract designs. Utilized at least since the mid-nineteenth century, the technique became especially popular among members of two cultural groups: German Americans, who transferred their folk art of paper cutting, or *scherenschnitte*, to quiltmaking, and native Hawaiians.

Another unique technique used by quiltmakers was to manipulate their fabric into three-dimensional forms, whether through stuffing shapes with additional batting to form puffs or gathering the edges with a pulled running stitch to form Yo-yos.

PLATE 7-17. Original, Birds.
Maker/location unknown, 1880–1900.
Cottons, 88" x 72.5". 1997.007.0040.

PLATE 7-19. Oak Leaf variation.
Maker/location unknown, 1900–1920.
Cottons, 77.5" x 59". 1997.007.0728.

PLATE 7-18. Hawaiian Appliqué.
Made in Hawaii, 1930–1950.
Cottons, 85" x 81". 1997.007.0111.

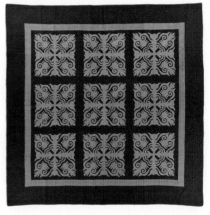

PLATE 7-20. Tulips and Hearts.
Probably made in Pennsylvania, 1890–1910.
Cottons, 85" x 86". 2003.003.0203.

Unique Techniques

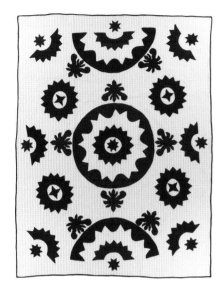

PLATE 7-21. Original.
Possibly made in Grant County, Indiana, 1910–1930.
Cottons, 86" x 68". 1997.007.0328.

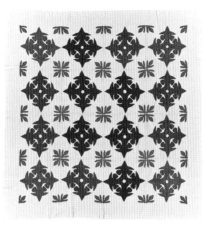

PLATE 7-23. Fleur-de-lis.
Maker/location unknown, 1900–1920.
Cottons, 72" x 72". 2002.009.0003E.
Gift of Erica Kuryla.

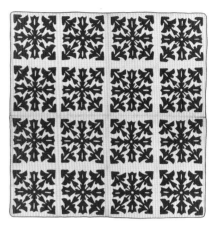

PLATE 7-25. Lobster.
Possibly made in New York, 1890–1910.
Cottons, 75.5" x 75". 2003.003.0207.

PLATE 7-22. Yo-yo.
Possibly made in the midwestern United States, 1930–1940.
Cottons, 89" x 84.5". 1997.007.0896.1.

PLATE 7-24. Puffed Squares.
Possibly made in Maine, 1900–1920.
Wools, 76" x 71". 2003.003.0007.

PLATE 7-26. Oak Leaf variation.
Possibly made in Pennsylvania, 1890–1910.
Cottons, 85" x 65.5". 2003.003.0297E.

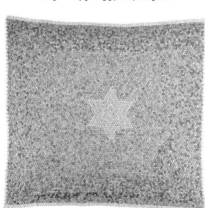

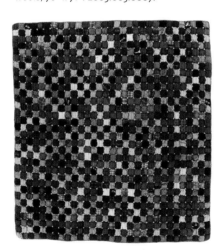

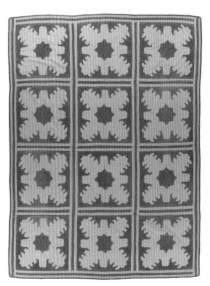

Novel Materials and Techniques

Unusual materials or techniques distinguish this group of quilts (plates 7-27 through 7-36). Collections of poultry fair ribbons, silk cigar bands, and tobacco premiums are the raw materials in a few of them.[34] Other techniques include manipulated fabric, paints, crayons, and stitching as substitutes for appliqué and piecing.

In recent times studio quilt artists, perhaps inspired by their quiltmaking forbears, have incorporated novel materials and techniques in their quilts to great effect, demonstrating the flexibility of quilts to adapt to the use of a variety of artistic media.

PLATE 7-27. Target.
Probably made in the midwestern United States, 1930–1950.
Cottons, 70" x 69". 1997.007.0108.

PLATE 7-29. Pictorial.
Possibly made in Northville, Michigan, 1900–1920.
Cottons, 52" x 34". 1997.007.0689.

PLATE 7-28. Original, Chicken Ribbons.
Possibly made in Sikeston, Missouri, c. 1914.
Silks, 79" x 65". 1997.007.0246.

PLATE 7-30. Tobacco Premiums quilt.
Possibly made in North Carolina, 1915–1925.
Cottons, 96" x 70.5". 1997.007.0902.

Novel Materials and Techniques

PLATE 7-31. Butterfly.
Possibly made in Tennessee, 1920–1940.
Cottons, 82" x 67". 1997.007.0213.

PLATE 7-33. Original, embroidered.
Maker/location unknown, 1910–1930.
Silks, 94" x 78". 1997.007.0734.

PLATE 7-35. Triangles.
Maker/location unknown, 1880–1900.
Silks, 64.5" x 58". 2003.005.0002.
Gift of Joyce Rivers.

PLATE 7-36. Tobacco Premiums quilt.
Made by Rachel Achenback Smith. Probably
made in Sheridan, Wyoming, 1930–1940.
Silks, 91.5" x 70". 2005.002.0001.
*Gift of Smith family in care of
Theodora R. Wintersteen.*

PLATE 7-32. Tobacco Premiums quilt.
Maker/location unknown, 1900–1920.
Silks, 56.25" x 52.75". 1997.007.0271.

PLATE 7-34. Cigar Ribbons quilt.
Possibly made in Vermont, 1890–1910.
Silks, 63" x 41". 2003.003.0005.

National Symbols and Fairs

American quilts connected to themed national fairs, national events, or national symbols and ideals provide primary source evidence of what the art historian Jules David Prown has called the "mind" of the maker. As such, quilts and other objects of material culture are grassroots documentations of the persons and cultures that produced them.[35]

More than twenty-four thousand quilts were made as entries in the 1933 Sears Quilt Contest, sponsored in conjunction with the 1933 Century of Progress Exposition in Chicago. Star of the Bluegrass (plate 7-45) is a replica of the winning entry. The quilts made for this contest provide a glimpse into what was considered progress at that time in American history, as well as the popularity and quality of quiltmaking during the Great Depression.[36]

PLATE 7-37. Eagle.
Possibly made in Cherrytree County, Pennsylvania, 1870–1890.
Cottons, 77" x 73.5". 1997.007.0126.

PLATE 7-39. Eagle.
Possibly made in Pennsylvania, 1910–1930.
Cottons, 76.5" x 76.5". 1997.007.0278.

PLATE 7-38. Original, Centennial Commemorative.
Possibly made in Ohio, c. 1876.
Cottons, 60" x 55.5". 1997.007.0194.

PLATE 7-40. Crazy quilt, Columbian Exposition Commemorative.
Maker/location unknown, c. 1893.
Cottons, 78" x 81". 1997.007.0838.

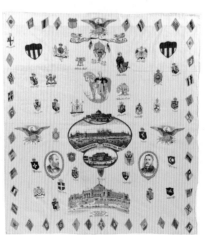

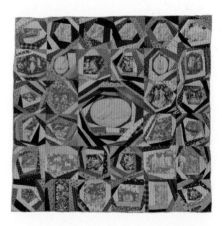

Century of Progress—Sears Quilt Contest

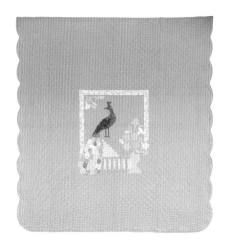

PLATE 7-41. Peacock.
Possibly made in St. Louis, Missouri, c. 1935.
Cottons, 85.5" x 81". 1997.007.0159.

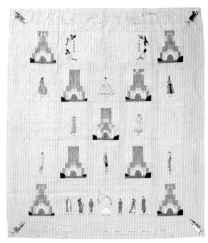

PLATE 7-43. *From 1833 to 1933.*
Made by Emma Mae Leonhard, Virginia,
Illinois, c. 1933.
Cottons, 86.5" x 78". 1997.007.0368.

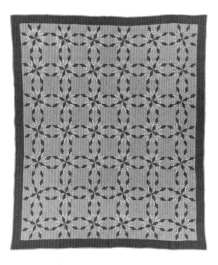

PLATE 7-45. Star of the Bluegrass.
Possibly made in Florida, c. 1950.
Cottons, 91.5" x 76". 1997.007.0550.

PLATE 7-42. Cornucopia.
Made by Marie Mueller, Garnavillo, Iowa,
dated 1933.
Cottons, 95" x 85". 1997.007.0266.

PLATE 7-44. Magpie Rose.
Made by Euphemia Medora Anderson Mounts,
Carlinville, Illinois, c. 1933.
Cottons, 85" x 75". 1997.007.0407.

PLATE 7-46. Original, Flags.
Made by Hattie Heller, Chicago, Illinois, c. 1933.
Silks, 94" x 87". 2006.012.0002.
*Purchase made possible through James
Foundation Acquisition Fund.*

Albums

Album quilts are collections in cloth. Much like seventeenth- and eighteenth-century needlework samplers, some Album quilts display the maker's repertoire of stitches and block designs. Others are a catalog of designs on a common theme. Still others are collections of signatures.

Signature Album quilts serve to materialize the relationships, communities, institutions, and causes that were important to quiltmakers. The evolution of Signature quilts, inscribed with sentimental verses and signatures, owes much to the romanticization of relationships in the early nineteenth century.[37] In the late nineteenth and early twentieth centuries quiltmakers joined their efforts in community, social, and religious causes by making Signature quilts to sell as fundraisers.

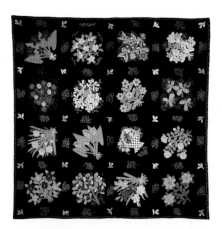

PLATE 7-47. Album.
Possibly made in Philadelphia, Pennsylvania, 1920–1930.
Silks, 87" x 87". 1997.007.0125.

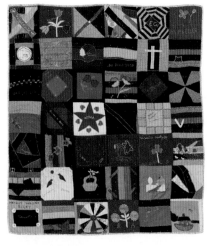

PLATE 7-49. Album.
Possibly made in Kentucky, dated 1932.
Wools, 75" x 66". 1997.007.0840.

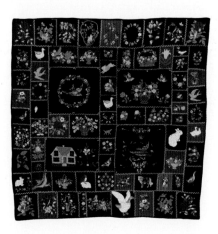

PLATE 7-48. Album.
Maker/location unknown, 1910–1930.
Wools, 64.5" x 64.5". 1997.007.0450.

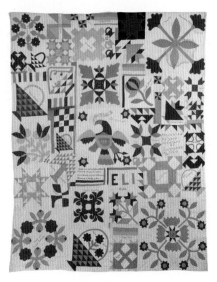

PLATE 7-50. Album, Signature.
Made by schoolchildren in Sunnyside, Darke County, Ohio, dated 1894.
Cottons, 88" x 66.5". 1997.007.0916.

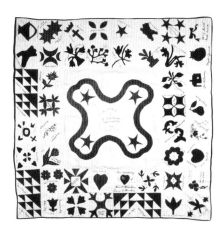

PLATE 7-51. Album, Signature.
Made in Monmouth County, New Jersey, dated 1908–1914.
Cottons, 65.5" x 63.5". 1997.007.0252.

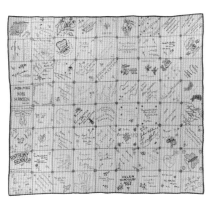

PLATE 7-53. Album, Signature.
Possibly made in Illinois, c. 1941.
Cottons, 79.5" x 91". 1997.007.0574.

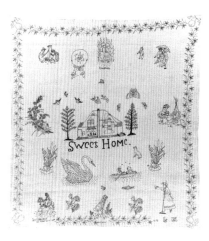

PLATE 7-55. Album.
Possibly made in Massachusetts, dated 1898.
Cottons, 76.5" x 73". 1997.007.0932.

PLATE 7-52. Album.
Probably made by the Peet sisters (Cordelia Peet, Jane Hull, Helen Lind, and Lois Sage), Kent County, Michigan, c. 1908–1909.
Cottons, 67" x 55.5". 1997.007.0265.

PLATE 7-54. Album, Signature.
Made in Beatrice, Nebraska, dated 1890.
Cottons, 69" x 69". 1997.007.0678.

PLATE 7-56. Album.
Possibly made by Raymond D. Fry.
Location unknown, dated 1918.
Cottons, 78.5" x 90". 1997.007.0940.

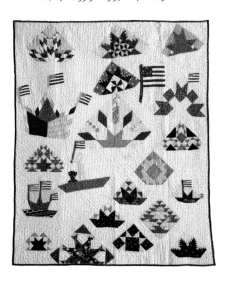

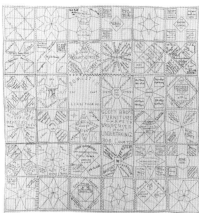

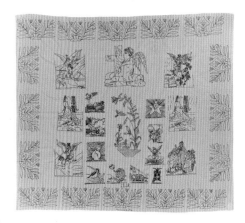

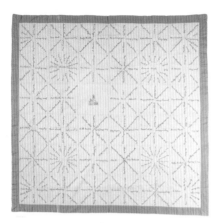

PLATE 7-57. Album, Signature.
Possibly made in New York, c. 1927.
Cottons, 69" x 69.5". 1997.007.0148.

PLATE 7-59. Album, Signature.
Possibly made in Minnesota or New York,
dated 1924.
Cottons, 87.5" x 81". 1997.007.0785.

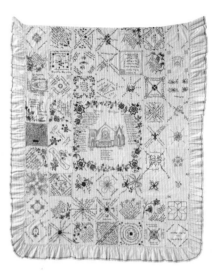

PLATE 7-61. Album, Signature.
Possibly made in Pennsylvania, dated 1916.
Cottons, 76.5" x 65". 1997.007.0880.

PLATE 7-58. Hymns.
Possibly made in Johnstown, Pennsylvania,
c. 1925.
Cottons, 80" x 79". 1997.007.0772.

PLATE 7-60. Album, Signature.
Probably made in York County, Pennsylvania,
dated 1920.
Cottons, 85" x 81.5". 1997.007.0809.

PLATE 7-62. Album, Signature.
Made in Lincoln, Nebraska, c. 1921.
Cottons, 69" x 74.5". 1998.004.0001.
Gift of Mendocino Presbyterian Church.

Pictorial

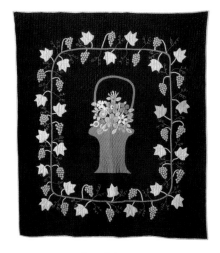

PLATE 7-63. Basket of Flowers.
Possibly made in Berks County,
Pennsylvania, 1920–1940.
Cottons, 77.5" x 69". 1997.007.0652.

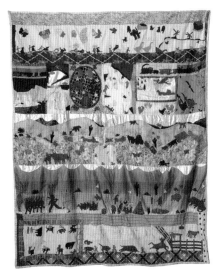

PLATE 7-65. *Uncle Clint's Quilt.*
Made by Clinton R. Hamilton,
Washington DC, c. 1935.
Cottons, 77" x 62.5". 1997.007.0843.

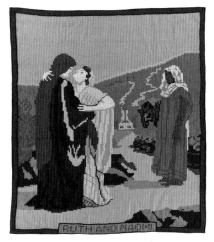

PLATE 7-67. *Ruth and Naomi Quilt.*
Made by Charles Pratt, Philadelphia,
Pennsylvania, 1930–1940.
Silks, 77.5" x 86". 2005.020.0001.
Gift of June McGuyer.

PLATE 7-64. Original, Oddfellows.
Made by Charlotte Gardner. Probably made
in New Jersey or New York, 1885–1890.
Cottons, 97" x 92". 1997.007.0739.

PLATE 7-66. Peacock.
Made by Hannah Haynes Headlee,
Topeka, Kansas, 1930–1940.
Cottons, 91" x 77". 2005.024.0001.
Gift of Hortense Beck.

PLATE 7-68. Hawaiian Flags.
Made in Hawaii, 1890–1910.
Cottons, 86" x 76.5". 2005.050.0001.
*Purchase made possible through James
Foundation Acquisition Fund.*

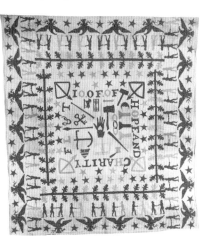

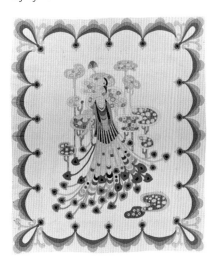

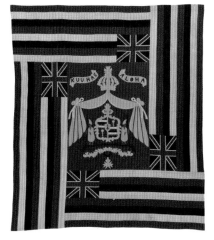

Basic Geometry

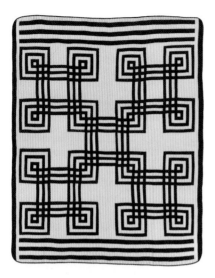

PLATE 7-69. Carpenter's Square.
Possibly made in Indiana, 1880–1900.
Cottons, 77" x 63.5". 1997.007.0203.

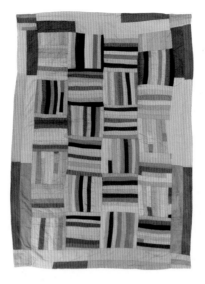

PLATE 7-71. Roman Square.
Possibly made in Vermont, 1930–1950.
Cottons, 86" x 63". 2003.003.0012.

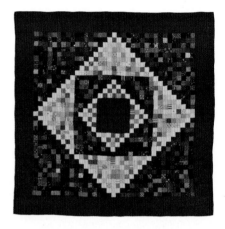

PLATE 7-73. Center Diamond variation.
Probably made in Pennsylvania, 1880–1900.
Cottons, 79" x 78". 2003.003.0132.

PLATE 7-70. Center Diamond.
Possibly made in Indiana or Pennsylvania,
1930–1950.
Cottons, 75.5" x 71.5". 1997.007.0535.

PLATE 7-72. Floral Wreath.
Possibly made in Ohio, 1920–1940.
Cottons, 77.5" x 77.5". 2003.003.0111.

PLATE 7-74. Center Diamond.
Maker/location unknown, 1930–1950.
Cottons, 88.5" x 79.5". 2003.003.0179.

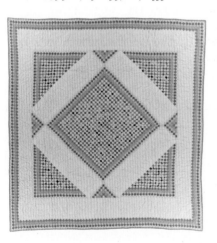

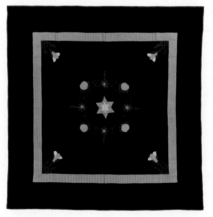

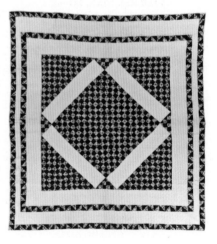

Notes

INTRODUCTION

1 Harvey Green, "Looking Backward to the Future: The Colonial Revival and American Culture," in *Creating a Dignified Past: Museums and the Colonial Revival*, ed. Geoffrey Louis Rossano and Historic Cherry Hill [Corporation] (Savage MD: Rowman and Littlefield, 1991), 5.

2 T. J. Jackson Lears, *No Place of Grace: Antimodernism and the Transformation of American Culture, 1880–1920* (New York: Pantheon, 1981), 175.

3 Lears, *No Place of Grace*, 8.

4 Lynda Jessup, *Antimodernism and Artistic Experience: Policing the Boundaries of Modernity* (Toronto: University of Toronto Press, 2001), 3.

5 Beverly Gordon, "Victorian Fancywork in the American Home: Fantasy and Accommodation," in *Making the American Home: Middle-Class Women and Domestic Material Culture 1840–1940*, ed. Marilyn Ferris Motz and Pat Browne (Bowling Green OH: Bowling Green State University Popular Press, 1988), 64.

6 Virginia Gunn, "Crazy Quilts and Outline Quilts: Popular Responses to the Decorative Art/Art Needlework Movement, 1876–1893," in *Uncoverings 1984*, ed. Sally Garoutte (Mill Valley CA: American Quilt Study Group, 1985), 131–52.

7 Catherine Lynn, "Surface Ornament: Wallpapers, Carpets, Textiles, and Embroidery," in *In Pursuit of Beauty: Americans and the Aesthetic Movement*, ed. Doreen Bolger Burke (New York: Metropolitan Museum of Art, Rizzoli, 1986), 96–97.

8 The author and collector Jonathan Holstein owns a Japanese wood marquetry box from the last quarter of the nineteenth century with designs that are quite similar to the "cracked ice" format of the Crazy quilt.

9 Penny McMorris, *Crazy Quilts* (New York: Dutton, 1984), 12.

10 Cynthia A. Brandimarte, "Japanese Novelty Stores," *Winterthur Portfolio* 26, no. 1 (1991): 10.

11 John Clark Ridpath, *A Popular History of the United States of America* (Cincinnati: Jones Brothers, 1878), 74; Jane Weaver, "Work Bag, in Mosaic Patchwork," *Peterson's Magazine*, November 1870, 384.

12 "'Crazy' Quilts," *The Art Amateur: A Monthly Journal Devoted to Art in the Household* 7, no. 5 (October 1882): 107.

13 L. E. Chittenden, "A Story of a Crazy-Quilt," *Peterson's Magazine*, December 1885, 516.

14 Beverly Gordon, "Crazy Quilts and 'Fairyland,'" *Helen Louise Allen Textile Collection Newsletter* 1 (Fall 2004): 3–5; Mary Warner Blanchard, *Oscar Wilde's America: Counterculture in the Gilded Age* (New Haven CT: Yale University Press, 1998), 118.

15 Susan Hayes Ward, "The Homelike House," *The Chautauquan: A Weekly Newsmagazine* 5, no. 8 (May 1885): 461.

16 John Curtis and Helen Curtis, "Quilts Grandmother Made in the Long Ago, Displayed with Pride Today," *The Modern Priscilla*, February 1925, 422.

17 Dulcie Weir, "The Career of a Crazy Quilt," *Godey's Lady's Book*, July 1884, 77.

18 "The Revival of Patchwork," *The Modern Priscilla*, May 1916, 248.

19 Lewis Edwin Theiss, "Quilts of Long Ago," *Garden & Home Builder*, October 1927, 538.

20 Kenneth L. Ames, introduction to *The Colonial Revival in America*, ed. Alan Axelrod (New York: Norton, 1985), 12.

21 For example, see Susan Prendergast Schoelwer, "Curious Relics and Quaint Scenes: The Colonial Revival at Chicago's Great Fair," in Axelrod, *The Colonial Revival*, 185. Schoelwer notes that twenty-one of the thirty-nine state buildings at the Columbian Exposition were designed in the Colonial style.

22 Green, "Looking Backward," 11.

23 Green, "Looking Backward," 11.

24 "Editorial Chit-Chat," *Peterson's Magazine*, November 1860, 402; "Art at Home," *Arthur's Home Magazine*, July 1884, 487.

25 Mrs. L. N., "Patchwork," *Arthur's Home Magazine* 60 (August 1890): 721.

26 Helen Mar Adams, "Colonial Embroidery Designs," *Ladies' Home Journal*, November 1895, 11.

27 Helen Blair, "A Thing 'of Shreds and Patches,'" *Ladies' Home Journal*, April 1903, 53.

28 Bridget A. May, "Progressivism and the Colonial Revival: The Modern Colonial House, 1900–1920," *Winterthur Portfolio* 26, nos. 2–3 (1991): 122.

29 Jane Benson, "Designs for Patch Work Quilts," *Ladies' Home Journal*, November 1896, 24.

30 "Godey's Arm-Chair," *Godey's Lady's Book and Magazine*, August 1, 1855, 182.

31 "Mother's Needle," *Arthur's Home Magazine*, July 1863, 43.

32 Anne G. Hale, "Domestic Economy; or How to Make Home Pleasant," *New England Farmer*, January 1868, 56.

33 V. M. Johnson, "'The Free' Sewing Machine Idea and How It Worked Out," *Ladies' Home Journal*, December 1909, 76.

34 Advertisement 23, *Ladies' Home Journal*, September 1893, 29.

35 Advertisement, *Ladies' Home Journal*, February 1910, 65.

36 The quilts included in this number comprise actual machine-quilted pieces as well as three Log Cabin quilts that have decorative machine stitching on the surface, despite the fact that it does not go through all layers of the quilt. We counted these quilts because the maker seems to have intended the stitching to look like quilting. Some Log Cabin quilts, on the other hand, have machine stitches visible on their surface but only because the foundation piecing—the attaching of "logs" to a base fabric—is visible.

37 "An Improved Quilter," *Scientific American*, April 26, 1890, 260.

38 Advertisement 66, *Ladies' Home Journal*, December 1892, 48.

39 International Quilt Study Center collections database.

40 In addition, 37 percent of the Log Cabin quilts were completed entirely by hand, including sewing the blocks together and adding sashing, a backing, and binding, if present.

41 Martin Bide, "Secrets of the Printer's Palette: Colors and Dyes in Rhode Island Quilts," in *Down by the Old Mill Stream: Quilts in Rhode Island*, ed. Linda Welters and Margaret T. Ordoñez (Kent OH: The Kent State University Press, 2000), 100–101.

42 Barbara Brackman, *Clues in the Calico: A Guide to Identifying and Dating Antique Quilts* (McLean VA: EPM, 1989), 61.

43 For more information on the lightening of the quilt fabric palette, beginning with chambrays and ginghams shortly after the turn of the twentieth century, see Virginia Gunn, "The Gingham Dog or the Calico Cat: Grassroots Quilts of the Early Twentieth Century," in *Uncoverings 2007*, ed. Joanna E. Evans (Lincoln NE: American Quilt Study Group, 2007).

44 Jacqueline Field, "Dyes, Chemistry and Clothing: The Influence of World War I on Fabrics, Fashions and Silk," *Dress* 28 (2001): 86.

45 Boris Emmet and John E. Jeuck, *Catalogues and Counters: A History of Sears, Roebuck and Company* (Chicago: University of Chicago Press, 1950), 11.

46 Brackman, *Clues in the Calico*, 200.

47 Merikay Waldvogel, *Soft Covers for Hard Times: Quiltmaking and the Great Depression* (Nashville TN: Rutledge Hill, 1990), 12.

1. AMERICAN ADAPTATION

1 Haggard quilt is no. 1983.029 in the collection of the Helen Foresman Spencer Museum of Art at the University of Kansas, Lawrence. For quilts by Grace McCance Snyder and Albert Small with a multitude of pieces, see Mary Leman Austin, *The Twentieth Century's Best American Quilts: Celebrating 100 Years of the Art of Quiltmaking* (Golden CO: Primedia Special Interest Publications, 1999), 36, 61. Snyder, a well-known Nebraska quiltmaker, pieced together 85,875 triangles and squares to create her Flower Basket Petit Point quilt, now in the Collection of Nebraska State Historical Society, Museum of Nebraska History, Lincoln. The quilt with the largest number of pieces is believed to have been made by Albert Small in 1941–44. Mosaic #3, composed of 123,200 hexagons, each a quarter-inch wide, is in the Collection of the Illinois State Museum, Springfield.

2 Nancy Roan and Donald Roan, *Lest I Shall Be Forgotten: Anecdotes and Traditions of Quilts* (Green Lane PA: Goschenhoppen Historians, 1993), 28–30.

3 Julia Hill to Juliette Baker, April 1855, in "Historical Letters 1852–69, Upper Warren County, Warren County, New York, Genealogy and History," available from http://www.rootsweb.ancestry.com/~nywarren/countyhistory/historicalletters.htm (accessed May 29, 2008).

4 W. Emerson Wilson, ed., "Phoebe George Bradford Diaries," in *Delaware History* (Wilmington: Historical Society of Delaware, 1974–75), 16:249.

5 In 2005, the International Quilt Study Center acquired a group of hand-painted quilt and embroidery patterns on paper, the first plate of which reads, "Collection of Paterns [sic] / for Mary Dallarmi / 1861." Mary Dallarmi's paper plates include both appliqué and pieced quilt patterns. IQSC 2005.041.0031, Gift of Joanna S. Rose.

6 See Lynne Z. Bassett and Jack Larkin, *Northern Comfort: New England's Early Quilts, 1780–1850: From the Collection of Old Sturbridge Village* (Nashville TN: Rutledge Hill Press, 1998), 62.

7 See Frank Luther Mott, *A History of American Magazines*, vols. 3 and 4 (Cambridge MA: Belknap Press of Harvard University Press, 1957).

8 Dorothy Steward Sayward, *Comfort Magazine: 1888–*

1942: A History and Critical Study, University of Maine Studies, 2nd Series (Orono: University of Maine, 1960), 75:4, 11.

9 Wilene Smith, "Quilt History in Old Periodicals," in *Uncoverings 1990*, ed. Laurel Horton (San Francisco: American Quilt Study Group, 1991), 194.

10 Jill Sutton Filo, "Ruby Short McKim: The Formative Years," in *Uncoverings 1996*, ed. Virginia Gunn (San Francisco: American Quilt Study Group, 1996), 75–76.

11 Brackman, *Clues in the Calico*, 73.

12 Brackman, *Clues in the Calico*, 73.

13 Calico Carnival newspaper clipping, undated, Chester County Historical Society, West Chester PA; Young Men's Social Club Calico Ball, swatch invitation, 1877, Kansas Museum of History, Topeka; *Atchison Daily Champion*, February 15, 1887, quoted in *Kansas Historical Quarterly*, Spring 1968: 100.

14 Montgomery Ward and Company, *Montgomery Ward and Company Catalog #1* (Chicago: Montgomery Ward and Company, 1872), 1; "Advertisement by Read Brothers," *Coffeyville* [Kansas] *Journal*, October 21, 1875.

15 Bide, "Secrets of the Printer's Palette," 104.

16 Barbara Brackman, *Encyclopedia of Pieced Quilt Patterns* (Paducah KY: American Quilter's Society, 1993), 258.

17 Patty Lee, "Recollections of a Country Life, Chapter V: Caroline Bradley's Quilting," *National Era*, October 7, 1847, 1.

18 Bets Ramsey, Merikay Waldvogel, and David Luttrell, *The Quilts of Tennessee: Images of Domestic Life Prior to 1930* (Nashville TN: Rutledge Hill Press, 1986), 9. Kossuth Feather quilt is in the Collection of the Quilt Restoration Society, Hillsdale NY.

19 Scrapbook clipping, collection of the author.

20 Montgomery Ward and Company, *Catalogue and Buyers' Guide Spring and Summer 1895* (New York: Dover Publications, 1969), 13.

21 "Buy All Your Fall Goods at Garver Brothers," *Sugarcreek Budget*, August 1900, in Eve Wheatcroft Granick, *The Amish Quilt* (Intercourse PA: Good Books, 1989), 61. Louise Fowler Root, "Grandma's Wedding Ring Quilt Goes Modern," *Capper's Weekly*, 1933, scrapbook clipping, collection of the author.

22 According to Edmund Knecht and James Fothergill, *The Principles and Practice of Textile Printing*, 4th ed. (London: Charles Griffin, 1952), 489–90, high-quality oil calicoes remained in production at least into the 1950s. They acknowledged inferior attempts at the Turkey red process by many dye works, but lauded the "magnificent productions of the great firms who make it a specialty." The authors also described developments in the process that yielded equally fast and bright colors in much shorter time. They wrote:

> In most modern processes the frequent and tedious operations of passing the cloth through alternate baths of olive oil emulsions and solutions of sodium carbonate, followed by stoving after each, have been largely replaced by a single run through soluble Turkey-red oils, followed by one stoving or one steaming process. For the fastest reds, however, the oiling and stoving are often repeated four or five times. . . . Oiled cloth, whether steamed or not, possesses the property of attracting and fixing the mordant.

23 Ricky Clark, George W. Knepper, and Ellice Ronsheim, eds., *Quilts in Community: Ohio's Traditions* (Nashville TN: Rutledge Hill Press, 1991), 32–33, 45; Ricky Clark, *Quilts of the Ohio Western Reserve* (Athens: Ohio University Press, 2005), 92.

24 Jeannette Lasansky, *Pieced by Mother: Over 100 Years of Quiltmaking Traditions* (Lewisburg PA: Oral Traditions Project of the Union County Historical Society, 1987), 80.

25 Jeannette Lasansky, *In the Heart of Pennsylvania: 19th and 20th Century Quiltmaking Traditions* (Lewisburg PA: Oral Traditions Project of the Union County Historical Society, 1985), 20.

26 Lasansky, *Pieced by Mother: Over 100 Years*, 75; Nancy Roan, "Quilting in Goschenhoppen," in Lasansky, *In the Heart of Pennsylvania Symposium Papers,* ed. Jeannette Lasansky (Lewisburg PA: Oral Traditions Project of the Union County Historical Society, 1985), 48; Ellice Ronsheim, "From Bolt to Bed: Quilts in Context," in Clark, Knepper, and Ronsheim, *Quilts in Community*.

27 Clark, Knepper, and Ronsheim, *Quilts in Community*, 21, 45.

28 Nancy Roan and Ellen J. Gehret, *Just a Quilt, or, Juscht en Deppich: A Folk Cultural Study and Source Book of Quilting Practices in and around the Goschenhoppen Region, 1840–1940* (Green Lane PA: Goschenhoppen Historians, 1984), 11; Roan and Roan, *Lest I Shall Be Forgotten*, 28–30.

29 Rachel Cochran et al., *New Jersey Quilts 1777 to 1950: Contributions to an American Tradition* (Paducah KY: American Quilter's Society, 1992), 142–43.

30 Cochran et al., *New Jersey Quilts,* 143.

31 John Beardsley, *The Quilts of Gee's Bend* (Atlanta GA: Tinwood Books in association with the Museum of Fine Arts, Houston, 2002), 146.

32 According to the retail catalogs of Montgomery Ward and Company in the 1880s and 1890s, imported indigo prints cost more than domestic prints (e.g., 7 1/2 cents versus 4 1/2 cents). After 1900, the vari-

ety of indigo prints increased and one could buy the cheaper ones for the same price as other staple prints (5 cents).

33 The Society of Dyers and Colourists and American Association of Textile Chemists and Colorists, *Colour Index*, 2nd ed. (Bradford, England: SDC and AATCC, 1956), 2:2419.

34 Bide, "Secrets of the Printer's Palette," 89–101.

35 Harriet H. Robinson, *Loom and Spindle or Life among the Early Mill Girls* (New York: Thomas Y. Crowell, 1898), 212.

36 Jonathan Holstein, *The Pieced Quilt: A North American Design Tradition* (Toronto: McClelland and Stewart, 1973), 57.

37 Merrimack Valley Textile Museum and Peter M. Molloy, *Homespun to Factory Made: Woolen Textiles in America, 1776–1876* (North Andover MA: Merrimack Valley Textile Museum, 1977), 82.

38 Merrimack Valley Textile Museum and Molloy, *Homespun*, 88.

39 Mary Dodge Woodward, diary entry, March 26, 1886, Fargo, Dakota Territory, in Margo Culley, *A Day at a Time: The Diary Literature of American Women from 1764 to the Present* (New York: Feminist Press, 1985), 169.

40 History of the Adams, Abercrombie, Harnan, Gutherless, LeGrand Quilts, undated, IQSC 2004.012.0001 file.

41 Jane S. Smith, *Elsie de Wolfe: A Life in the High Style* (New York: Atheneum, 1982), 139.

42 Colonial Pattern Company, *Prize Winning Designs* (Kansas City MO: Colonial Pattern Company, [1931]), 9. For further information on Rose Marie Lowery and the quilt block contest she entered, see Susan Price Miller, "The Winner of 'Aunt Martha's' 1931 Quilt Block Contest: Rose Marie Lowery and the Modernistic Star Pattern," *Blanket Statements*, Spring 2007, 1, 3–5.

43 Douglas Vermillion to Melissa Slaton, subject: additional info about Vermillion Quilt, personal e-mail, August 2, 2005, IQSC 1997.007.0527 research file.

44 Brackman, *Clues in the Calico*, 62; Alan Mirken, ed., *1927 Edition of the Sears, Roebuck Catalogue* (New York: Bounty Books, 1970), 549.

45 Vermillion to Slaton, subject: Vermillion quilt, personal e-mail, August 2, 2005, IQSC 1997.007.0527 research file.

46 Virginia Gunn, "Template Quilt Construction and Its Offshoots: From Godey's Lady's Book to Mountain Mist," in *Pieced by Mother Symposium Papers*, ed. Jeannette Lasansky (Lewisburg PA: Oral Traditions Project of the Union County Historical Society, 1988), 70.

47 Ruth E. Finley, *Old Patchwork Quilts and the Women Who Made Them* (Philadelphia: J. B. Lippincott, 1929), 62.

48 Brackman, *Encyclopedia*, 190–92.

49 Jonathan Holstein, *American Pieced Quilts* (New York: Viking, 1973), Plate 83. The third quilt is IQSC 2003.003.0324E.

50 Lyle Saxon, *Father Mississippi* (New York: Century, 1927), 30.

51 Wilene Smith, "Quilt Blocks—or Quilt Patterns?," in *Quiltmaking in America: Beyond the Myths*, ed. Laurel Horton (Nashville TN: Rutledge Hill Press, 1994), 32.

52 Finley, *Old Patchwork Quilts*, 196.

53 Brackman, *Encyclopedia*, 118.

2. BUILDING ON A FOUNDATION

1 Bonnie Lehman and Judy Martin, *Log Cabin Quilts* (Wheatridge CO: Moon Over the Mountain Publishing, 1980), 8–9.

2 Terminology for the different Log Cabin configurations has been inconsistent in the past. In this volume, we refer to the most basic construction of the Log Cabin block as the "standard" block, and we call the other constructions, Courthouse Steps and Pineapple, "variations." When referring to the different layouts in which the standard Log Cabin block can be configured, we use the term "setting."

3 Paul E. Rivard, *A New Order of Things: How the Textile Industry Transformed New England* (Hanover NH: University Press of New England, 2002), 71–72, 77.

4 Janet Rae and Dinah Travis, *Making Connections: Around the World with Log Cabin* (Chartham, England: RT Publishing, 2004), 26.

5 Carol Head, *Old Sewing Machines* (Princes Risborough, [England]: Shire, 1982), 15, 26.

6 Judy Schwender completed a technical analysis of the seventy-two Log Cabin quilts in the International Quilt Study Center's collections for her master's exhibition research project in 2006. Her technical analysis included an examination of how each quilt was constructed (foundation-pieced or seamed), number of different prints visible, use of sewing machine, and confirmation of fiber content using fiber microscopy. This information is available in the Log Cabin database at the International Quilt Study Center. In addition, see Judy Schwender, "A Look at Log Cabin Quilts: Research for and Design of an Exhibition" (unpublished thesis project report, 2006, in the International Quilt Study Center & Museum noncirculating library).

7 Margaret T. Ordoñez, "Technology Reflected: Printed Textiles in Rhode Island Quilts," in *Down by the Old Mill Stream: Quilts in Rhode Island*, ed. Linda Welters

and Margaret T. Ordoñez (Kent OH: Kent State University Press, 2000), 148.

8 Virginia Gunn, "Quilts at Nineteenth Century State and County Fairs: An Ohio Study," in *Uncoverings 1988*, ed. Laurel Horton (San Francisco: American Quilt Study Group, 1989), 116–17.

9 Mary Jane Furgason and Patricia Cox Crews, "Prizes from the Plains: Nebraska State Fair Award-Winning Quilts and Quiltmakers," in *Uncoverings 1993*, ed. Laurel Horton (San Francisco: American Quilt Study Group, 1994), 196.

10 Gunn, "Quilts at Nineteenth Century State and County Fairs," 116.

11 Theodore Roosevelt Association, "Timeline: Life of Theodore Roosevelt," 2001, available from http://www.theodoreroosevelt.org/life/timeline.htm (accessed September 13, 2007).

12 Elizabeth V. Warren and Sharon L. Eisenstat, *Glorious American Quilts: The Quilt Collection of the Museum of American Folk Art* (New York: Penguin Studio in association with Museum of American Folk Art, 1996), 72.

13 "Art at Home," 424.

14 Ordoñez, "Technology Reflected," 137–38.

15 The Minnesota Historical Society, St. Paul, owns an inscribed Log Cabin quilt (object call number 8297) embroidered with the initials "L. L. L." for Lucy Lee Lamson, the maker, and "No 352 / Du Quoin / Illinois. / May 1865."

16 Genealogical research completed by Melissa Stewart Jurgena, IQSC research fellow, IQSC 1997.007.0933 research file.

17 In "No Way but Out: German Women in Mecklenburg," in *Peasant Maid—City Women: From the European Countryside to Urban America*, ed. Christiane Harzig (Ithaca NY: Cornell University Press, 1997), 25, 49, Monika Blaschke writes that, prior to emigrating, both male and female peasants led a difficult life; they owned no land, labored on government or manorial estates for meager payments, and were often forbidden to marry by the manor's lord, who wished to control the number of lives his estate was responsible for supporting. Often, emigration was the only option to escape these conditions. One Mecklenburg immigrant to America wrote his German relatives that he had to work harder than in the old country, but he was a free man, and that was "worth a couple of buckets of sweat."

18 "Girl Works Way through Milwaukee Dental School," *Milwaukee Journal*, May 26, 1912, 5.

19 Michelle McClaren James and Patricia Cox Crews, "Continuity and Change in Nebraska Quiltmakers, 1870–1989," *Clothing and Textiles Research Journal* 14, no. 1 (1996): 7–15.

20 Virginia Gunn, "Dress Fabrics of the Late Nineteenth Century: Their Relationship to Period Quilts," in *Bits and Pieces: Textile Traditions*, ed. Jeannette Lasansky (Lewisburg PA: Oral Traditions Project of the Union County Historical Society, 1991), 13–14.

21 Eileen Jahnke Trestain, *Dating Fabrics: A Color Guide, 1800–1960* (Paducah KY: America Quilter's Society, 1998), 162–64.

22 A drawing of a Victorian living room corner, titled "Much in Little Space," by A. Sandier, expresses the aesthetic preference for busy, heavily patterned domestic spaces filled with furniture, collections of objets d'art, and lavish textiles. The illustration appeared in Clarence Cook, *The House Beautiful* (New York: Scribner, Armstong, 1878), 108, and was reproduced in Martha Crabill McClaugherty, "Household Art: Creating the Artistic Home, 1868–1893," *Winterthur Portfolio*, Spring 1983, 14.

3. REGULARLY IRREGULAR

1 "A Crazy Patchwork," *Dorcas Magazine*, October 1884, 263; "The Crazy Quilt," *Good Housekeeping*, October 15, 1890, 310.

2 Janette R. Rets, "Finishing Touches," *Demorest's Monthly Magazine*, November 1882, 27.

3 See Steven M. Gelber, *Hobbies: Leisure and the Culture of Work in America* (New York: Columbia University Press, 1999), 61–64.

4 Montgomery Ward and Company, *Montgomery Ward and Company Catalogue and Buyer's Guide, 1894–1895* (Northfield IL: Gun Digest Co., 1970), 8.

5 Virginia Gunn, "Crazy Memories," in *America's Glorious Quilts*, ed. Dennis Duke and Deborah Harding (New York: Park Lane, 1989), 156.

6 McMorris, *Crazy Quilts*, 88.

7 From the construction details, it seems that Ricard started work on the corner with the photograph and added the central medallion last. This does not necessarily mean that the parts were worked in that order, however, since the quilt was made from separate blocks that have been skillfully joined together.

8 Discussion of the role of the pall as clothing the body in Christ is found in Lee Maxwell, *The Altar Guild Manual: Lutheran Worship Edition* (St. Louis MO: Concordia Publishing House, n.d.), 88. A general history of funeral customs is found in Bertram Puckle, *Funeral Customs: Their Origin and Development* (London: T. Werner Laurie, 1926).

9 Worcester City Museums, "The Collections—Object of the Month—May 2002: The Funeral Pall of the

Worshipfull Company of Weavers," in *Worcester City Museums,* 2002, available from http://www. worcestercitymuseums.org.uk/coll/object/oldobj4/ obmay.htm (accessed November 10, 2007).

10 There were also mourning or "coffin quilts," with coffin shapes appliquéd on them to represent recently deceased individuals, but it is unclear if these were ever draped over coffins. See Carleton L. Safford and Robert Charles Bishop, *America's Quilts and Coverlets* (New York: Dutton, 1980), 100.

11 Betty Pillsbury and Rita Vainius, "The History of Crazy Quilts, Part II," in *The Caron Collection,* 1997, available at http://www.caron-net.com/featurefiles/ featmay2.html (accessed November 10, 2007).

12 Katherine C. Grier, "The Decline of the Memory Palace: The Parlor after 1890," in *American Home Life, 1880–1930,* ed. Jessica H. Foy and Thomas J. Schlereth (Knoxville: University of Tennessee Press, 1992), 62.

13 Concerning different distances, see Beverly Gordon, "Intimacy and Objects: A Proxemic Analysis of Gender-Based Response to the Material World," in *The Material Culture of Gender / The Gender of Material Culture,* ed. Katherine Martinez and Kenneth L. Ames (Winterthur DE: Winterthur Museum with University Press of New England, 1997), 237–52.

14 Genealogical research compiled by Melissa Jurgena, IQSC research fellow, IQSC 1997.007.0802 research file.

15 Weir, "The Career of a Crazy Quilt," 77.

16 Weir, "The Career of a Crazy Quilt," 77.

17 McMorris, *Crazy Quilts,* 64. One other quilt with this image is in the Helen Louise Allen Textile Collection at the University of Wisconsin, Madison, QSUS-36. This woman's facial features do not really match those in other pictures of Anna Held.

18 Advertisements, *Stevens Point (Wisconsin) Journal,* May 24, 1884 and May 31, 1884.

19 Advertisement 6, *Ladies' Home Journal* June 1884, 6.

20 Weir, "The Career of a Crazy Quilt," 77.

21 Brackman, *Clues in the Calico,* 94–95.

22 Penny McMorris includes an image of the fabric in her volume. See McMorris, *Crazy Quilts,* 24.

23 "Fancy Needlework and Home Decoration," *Arthur's Home Magazine* 52, no. 9 (September 1884): 538. Crash is plain weave linen or cotton cloth with a rough texture due to the use of thick and thin, uneven yarns. Oatmeal cloth is a soft, rough-textured fabric intended for household furnishings; it is usually made of cotton or linen and woven of fine warp and coarse filling yarns.

24 Genealogical information compiled by Melissa

Jurgena, IQSC graduate research fellow, IQSC 1997.007.0929 research file.

25 For a more complete discussion of this quilt and the cultural environment in which it was created, see Marin F. Hanson, "The Eva Wight Crazy Quilt: Late-Nineteenth-Century Quiltmaking in Central Kansas," *Kansas History* 26, no. 2 (2003): 78–89.

26 "Work Table," *Godey's Lady's Book* 115, no. 687 (September 1887): 248.

27 Brackman, *Clues in the Calico,* 145.

28 Brackman, *Clues in the Calico,* 145.

29 Sears, Roebuck and Co., *Catalog No. 104, Spring* (Chicago: Sears, Roebuck and Co., 1897); Sears, Roebuck and Co., *Catalog No. 129, Fall* (Chicago: Sears, Roebuck and Co., 1914), 828, 1243; Sears, Roebuck and Co., *Spring Catalog* (Chicago: Sears, Roebuck and Co., 1923), 768; Mirken, *1927 Edition of the Sears, Roebuck Catalogue;* Sears, Roebuck and Co., *Spring and Summer Catalog* (Chicago: Sears, Roebuck and Co., 1931), 327; Stella Blum, ed., *Everyday Fashions of the Thirties: As Pictured in Sears Catalogs* (New York: Dover, 1986), 66.

4. SIMPLE AND COMPLEX

1 Bridget Long, "A Comparative Study of the 1718 Silk Patchwork Coverlet," *Quilt Studies: The Journal of the British Quilt Study Group* 5 (2003): 54–78. The McCord silk patchwork quilt, dated 1726, is in the collection of the McCord Museum of Canadian History in Montreal, Quebec (accession M972.3.1).

2 Gunn, "Template Quilt Construction," 69–70.

3 Virginia Gunn, "Victorian Silk Template Patchwork in American Periodicals," in *Uncoverings 1983,* ed. Sally Garoutte (Mill Valley CA: American Quilt Study Group, 1984), 10–13.

4 Laurel Horton, "An Elegant Geometry: Tradition, Migration, and Variation," in *Mosaic Quilts: Paper Template Piecing in the South Carolina Lowcountry,* exhibition catalog (Greenville NC: Curious Works Press and Charleston Museum, 2002), 10.

5 Jan Hiester, introduction to *Mosaic Quilts,* 6–9; Ruth Haislip Roberson, ed., *North Carolina Quilts* (Chapel Hill: University of North Carolina Press, 1988), 5.

6 Jan Hiester, "Mosaic Patchwork from Charleston and the Lowcountry," in *Mosaic Quilts,* 22.

7 Horton, "An Elegant Geometry," 16.

8 Marin Hanson and Janneken Smucker, "Quilts as Manifestations of Cross-Cultural Contact: East/West and Amish–'English' Examples," in *Uncoverings 2003,* ed. Virginia Gunn (Lincoln NE: American Quilt Study Group, 2003), 100–101.

9 Mary Schoeser, *World Textiles: A Concise History*

(New York: Thames and Hudson, 2003), 78.

10 Suellen Meyer, "Design Characteristics of Missouri-German Quilts," in Garoutte, *Uncoverings 1984*, 106–11.

11 Genealogical research compiled by Melissa Slaton, IQSC graduate research assistant, and Melissa Stewart Jurgena, IQSC graduate research fellow, IQSC 1997.007.0781 research file; "Rites Held for Green's Farms Centenarian," March 31, 1936, newspaper obituary, Westport Historical Society, Westport CT.

12 Brackman, *Clues in the Calico*, 91–92.

13 Genealogical research compiled by Melissa Jurgena, IQSC graduate research fellow, IQSC 1997.007.0907 research file.

14 Mary Ann Grosh Stoner, Anise Barbara Stoner Fox, and Dora Fox McDaniels, Genealogical Records: Descendents of John Valentine Grosh, undated, photocopied manuscript of progressively compiled genealogy and family history from 1706 to 1930s, IQSC 1997.007.0907 research file.

15 Anise Barbara Stoner Fox passed the quilt to her daughter Dora Louine Fox McDaniel, who passed it to her daughter Barbara Jane McDaniel Rafeld. Xenia Cord of Legacy Quilts purchased the quilt from Rafeld and sold it to the collectors Ardis and Robert James. Cord provided the collectors with the quilt's history, which was provided by the family.

16 See Hiester, "Mosaic Patchwork," 26, 30, 41–42, 46, 52.

17 The Church of Jesus Christ of Latter-Day Saints, "Familysearch," available from http://www.family search.org/ (accessed December 1, 2004). See also Melissa Slaton, "Created through the Years: An Analysis of the Diamond Mosaic Quilt by L. Cordelia and Hannah Mallow," unpublished research paper, December 2004, IQSC 2003.003.0292 research file.

18 Brackman, *Encyclopedia*, 30–31, #160m, attributed to the *Kansas City Star*.

19 Hiester, "Mosaic Patchwork," 27, 38–39; Averil Colby, *Patchwork* (London: B. T. Batsford, 1958; reprint, 1978), 156.

20 For other examples, see Patricia Cox Crews and Ronald C. Naugle, *Nebraska Quilts and Quiltmakers* (Lincoln: University of Nebraska Press, 1991), 63; and Colby, *Patchwork*, 156.

21 Another example of letters formed with pieced hexagons is illustrated by Colby in *Patchwork*, 108. A mosaic coverlet of English origin includes "S. E." as well as hearts and other motifs in borders surrounding a framed center. The coverlet is attributed to Sally Eaton, 1811.

22 Slaton, "Created through the Years," 8.

23 Brackman, *Clues in the Calico*, 136–37.

24 Brackman, *Clues in the Calico*, 159.

25 For a study of ginghams and chambrays used in everyday functional clothing and quilts in the early twentieth century, see Gunn, "The Gingham Dog," 1–25.

26 Finley, *Old Patchwork Quilts*, 50, 108–9.

5. PERFECTING THE PAST

1 A. T. Covell, "The Heritage of Historic Style," *Art World and Arts & Decoration*, September 1918, 294.

2 Roy Underhill, "The Colonial Cure," preface to *Early Architecture of Rhode Island*, ed. Lisa C. Mullins (Pittstown NJ: Main Street Press for National Historical Society, 1987), second of two unnumbered pages.

3 See, for example, William B. Rhoads, "Colonial Revival in American Craft: Nationalism and the Opposition to Multicultural and Regional Traditions," in *Revivals! Diverse Traditions 1920–1945: The History of Twentieth-Century American Craft*, ed. Janet Kardon (New York: Harry N. Abrams with the American Craft Museum, 1994), 51–54; Harvey Green, "Culture and Crisis: Americans and the Craft Revival," in Kardon, *Revivals!*, 31–40; and Ames, introduction, 1–14.

4 See Rodris Roth, "The New England, or 'Olde Tyme,' Kitchen Exhibit at Nineteenth-Century Fairs," in Axelrod, *The Colonial Revival*, 159–83. Also see Frank B. Goodrich, *The Tribute Book* (New York: Derby and Miller, 1865).

5 Ridpath, *A Popular History*, 628.

6 James D. McCabe, *The Illustrated History of the Centennial Exhibition* (Philadelphia: National, 1876), 722–23.

7 J. S. Ingram, *The Centennial Exposition* (Philadelphia: Hubbard Bros., 1876), 706–7.

8 *Frank Leslie's Historical Register of the Centennial Exposition* (New York: Frank Leslie, 1876), 87, 90.

9 For further information, see Elizabeth Stillinger, *The Antiquers* (New York: Knopf, 1980).

10 Frances Clary Morse, *Furniture of the Olden Time* (New York: Macmillan, 1902; new edition, 1936), 8.

11 *Demorest's Monthly Magazine*, June 1879, 327.

12 See Jean Dunbar, "The Colonial Revival 'Old Colony Style,'" *Early American Homes*, February 2000, 52–61, 71. Also see Underhill, "The Colonial Cure."

13 Joseph M. Rogers, "Lessons from International Exhibitions," *The Forum*, December 1901, 500–510, especially 509.

14 Tudor Jenks, "Columbian Exposition," in *Johnson's Universal Cyclopedia Vol. II* (New York: A. J. Johnson, 1894), 406–10; G. B. Tobey, *A History of Landscape*

Architecture (New York: American Elsevier, 1973), 181–85.

15 George W. Gay, "The Furniture Trade," in *One Hundred Years of American Commerce*, ed. Chauncy M. Depew (New York: D. O. Haynes, 1895), 631.

16 Weymer Mills, "American Antiques for Americans," *Vogue*, January 1, 1923, 116. Also see Margaret S. Burton, "Old Bed-Spreads, Quilts, and Coverlets—An Alluring Field for the Collector," *Country Life in America*, midmonth, December 1910, 197–98.

17 Edith Wharton and Ogden Codman, *The Decoration of Houses* (New York: Charles Scribner's Sons, 1897; rev. and expanded, New York: Norton, 1998), 2, 172.

18 Robert Shackleton and Elizabeth Shackleton, *The Quest of the Colonial* (New York: Century, 1907), 14.

19 Gay, "The Furniture Trade," 631.

20 C. Matlack Price, "The Georgian Colonial for Country Houses," *Arts & Decoration*, August 1920, 162, 200.

21 For a brief introduction to key women, see Michael Kammen, *Mystic Chords of Memory: The Transformation of Tradition in American Culture* (New York: Knopf, 1991), 148, 266–69.

22 See Fanny D. Bergen, "The Tapestry of the New World," *Scribner's Magazine*, September 1894, 360–70; Ida M. Jackson, "Quaint Old Patchwork Blocks," *McCall's Magazine*, December 1916, 49; "The Old-Fashioned Patchwork Collected by Mrs. Ida M. Jackson," *Woman's Home Companion*, May 1915, 62; and Eliza Calvert Hall, "The Romance of Your Grandmother's Quilt," *McCall's Magazine*, February 1913, 18–20, 67.

23 Finley, *Old Patchwork Quilts*, 22. Also see Ricky Clark, "Ruth Finley and the Colonial Revival Era," in *Uncoverings 1995*, ed. Virginia Gunn (San Francisco: American Quilt Study Group, 1995), 33–65.

24 Sarah M. Lockwood, *Decoration: Past, Present and Future* (Garden City NY: Doubleday, Doran, 1934), 145, 148.

25 Emma S. Tyrrell, "We Copy Grandmother's Quilting," *Successful Farming*, November 1927, 83–84.

26 Benberry's three-part article is one of the earliest contemporary examinations of the quiltmaking phenomenon of the 1890s–1930s. See Cuesta Benberry, "The 20th Century's First Quilt Revival," *Quilter's Newsletter Magazine* Part 1 (July–August 1979): 20–22; Part 2 (September 1979): 25–26, 29; Part 3 (October 1979): 10–11, 37.

27 "The Revival of Patchwork," 3.

28 Finley, *Old Patchwork Quilts*, 8.

29 Curtis and Curtis, "Quilts Grandmother Made," 18.

30 Theiss, "Quilts of Long Ago," 143–45.

31 Marie D. Webster, *Quilts: Their Story and How to Make Them* (New York: Doubleday, Page, 1915; reprint, 1926), xviii.

32 Kammen, *Mystic Chords*, 703.

33 Finley, *Old Patchwork Quilts*, 100–101, plate 43.

34 Webster, *Quilts*, 116, figure 24.

35 *Comfort's Applique and Patchwork Book* (Augusta ME: W. H. Gannet, 1922), 26.

36 Bergen, "The Tapestry of the New World," 362.

37 Mary Harriett Large, "Of Shreds and Patches," *House Beautiful*, November 1905, 41–43; and Charlotte F. Boldtmann, "Patchwork Quilts of a Hundred Years Ago," *Woman's Home Companion*, January 1911, 36–37.

38 Carrie A. Hall and Rose G. Kretsinger, *The Romance of the Patchwork Quilt in America* (Caldwell ID: Caxton, 1935), 159, plate 27.

39 Brackman, *Encyclopedia*, 110–17.

40 Boldtmann, "Patchwork Quilts of a Hundred Years Ago," 36–37.

41 Finley, *Old Patchwork Quilts*, 101.

42 Sybil Lanigan, "Revival of the Patchwork Quilt," *Ladies' Home Journal*, October 1894, 19.

43 Edward W. Bok, "The Story of the Journal," *Ladies' Home Journal*, November 1893, 13.

44 Lanigan, "Revival," 19.

45 Lanigan, "Revival," 19.

46 Genealogical research completed by Melissa Jurgena, IQSC research fellow, and Olds family genealogical records compiled by Richard A. Olds, Portage MI, great-grandson of the maker, both in IQSC 1997.007.0172 research file.

47 Benson, "Designs for Patch Work Quilts," 24.

48 Jane W. Guthrie, "Old Fashioned Counterpanes," *Harper's Bazar*, August 1905, 777.

49 Jean Thompson, "The Passing of the Patchwork Quilt," *The Delineator*, September 1906, 462.

50 Bergen, "The Tapestry of the New World," 363.

51 Hall and Kretsinger, *The Romance*, 94–95.

52 Theiss, "Quilts of Long Ago," 143, 189.

53 Finley, *Old Patchwork Quilts*, 57.

54 Lanigan, "Revival," 19.

55 Bergen, "The Tapestry of the New World," 368.

56 Nancy Roan, "Fabrics Used by Pennsylvania-German Farm Families in Southeastern Pennsylvania," in Lasansky, *Bits and Pieces*, 16–25.

57 Webster, *Quilts*, opposite p. 19.

58 Cyril I. Nelson, *The Quilt Engagement Calendar 1998* (New York: Penguin Studio, 1997), plate 47.

59 See Evening Star quilt from Guernsey County OH in Clark, Knepper, and Ronsheim, *Quilts in Community*, 147; Wild Goose Chase quilt from Champaign

County OH in Jean Ray Laury and California Heritage Quilt Project, *Ho for California! Pioneer Women and Their Quilts* (New York: Dutton, 1990), 34–36; and Fruit and Flowers quilt from Belmont County OH in Mary Bywater Cross, *Treasures in the Trunk: Quilts of the Oregon Trail* (Nashville TN: Rutledge Hill, 1993), 123–24. For a very early Double Nine Patch with sampler quilting, see Lydia Roberts Dunham, "Denver Art Museum Quilt Collection," *Denver Art Museum Winter Quarterly* (1963): 84–85.

60 "A Note on Coverlets," *House Beautiful*, February 1904, 176; Helen Blair, "Dower Chest Treasures," *House Beautiful*, 164–65.

61 These quilts are illustrated in color in Marie D. Webster, *Quilts: Their Story and How to Make Them*, new ed., with notes and a biography of the author by Rosalind Webster Perry (Santa Barbara CA: Practical Patchwork, 1990).

62 The Wilkinson Sisters of Ligonier, Indiana, featured a Rose of Sharon appliquéd quilt that was very similar to Webster's Pink Rose design in their three undated catalogs, ca. 1915–16, 1920s, and 1930s.

63 "The Renaissance of the Four-Poster," *Vogue*, January 1, 1914, 100.

64 Merikay Waldvogel and Barbara Brackman, *Patchwork Souvenirs of the 1933 World's Fair* (Nashville TN: Rutledge Hill, 1993), 43.

65 For a lengthy report of this contest, see the two-part article "The Prize Winners of the Quilt Contest" [illustrations], and "The Quilt Contest at Storrowton" [descriptions], in *Needlecraft—The Home Arts Magazine*, January 1933, 9, 18–19.

66 "The Prize Winners of the Quilt Contest," 9; "The Quilt Contest at Storrowton," 18.

67 "The Quilt Contest at Storrowton," 19.

68 "New Conventional Flower Designs," *Home Needlework Magazine*, August–September 1910, 263.

69 See Virginia Gunn, "Quilts for Milady's Boudoir," in *Uncoverings 1989*, ed. Laurel Horton (San Francisco: American Quilt Study Group, 1990), 81–101.

70 See Helen Grant, "Cross-Stitch Designs," *Needlecraft Magazine*, November 1924, 36; Hugo W. Kirchmaier, *Book of Filet Crochet and Cross-Stitch—Book No.6* (Toledo OH: Cora Kirchmaier, 1919); Sophie T. LaCroix, *Cross Stitch Designs—Book No. 7* (St. Louis MO: St. Louis Fancy Work, [ca. 1915]); Anne Orr, *Filet Crochet (Second Book) and Cross Stitch Designs—Book No. 14* (Nashville TN: Anne Orr, 1918).

71 Sophie T. LaCroix, *Martha Washington Patch Work Quilt Book—Book No. 12* (St. Louis MO: St. Louis Fancy Work, undated); and Anne Orr, *Anne Orr's Tapestries, Quilts, Samplers, Crewel Embroidery and Cross-Stitch Designs* (Nashville TN: Anne Orr Design, Fall 1932).

72 Advertisement for "Wilkinson Art Quilts Hand Made," *Harper's Bazar*, October 1929, 198. Also see the catalog *Added Attractiveness in Your Bedroom* (Ligonier IN: Wilkinson Sisters, [ca. 1930s]), 16.

73 Advertisement for "Eleanor Beard Inc. Kentucky Hand Quilted Things," *House Beautiful*, April 1931, 341.

74 Advertisement for "Anne Orr Quilts," *House Beautiful*, June 1932, 426.

75 Orr, *Anne Orr's Tapestries*, 14. Also see Merikay Waldvogel, "The Marketing of Anne Orr's Quilts," in Horton, *Uncoverings 1990*, 7–28.

76 The kits appeared in various issues of *Home Arts—Needlecraft*, including April 1937, September 1938, May and October 1940, March 1941.

77 *Quilt Patterns: Patchwork and Applique* (St. Louis MO: Ladies Art, 1928).

78 *Hope Winslow's Quilt Book* (Des Moines IA: H. Ver Mehren, distributed by Needleart Department, Chicago, 1933), 8.

79 For an example of a similar quilt, see Safford and Bishop, *America's Quilts*, 117.

80 Finley, *Old Patchwork Quilts*, 92, plate 38.

81 Ruby Short McKim, "Here's How to Make Them," *Better Homes and Gardens*, February 1933, 18.

82 Gertrude Shockey, "A Placid Old Art Invades Our Hurrying Age," *The Modern Priscilla*, February 1928, 9, 55.

83 "A True American Cover," advertisement by Withers of Kirk, Kentucky, *House Beautiful*, April 1928, 398. See Cuesta Benberry, "Quilt Cottage Industries: A Chronicle," in *Uncoverings 1986*, ed. Sally Garoutte (Mill Valley CA: American Quilt Study Group, 1987), 83–100, especially 90.

84 *Hope Winslow's Quilt Book*, 30.

85 Hal L. Cohen, ed., *1922 Montgomery Ward Catalogue*, reprint ed. (New York: Alliograph, 1969), 160.

86 Ethelyn J. Guppy, "Applique Blocks for Quilts and Other Things," *The Modern Priscilla*, January 1923, 35.

87 This quilt was part of the estate of the maker, Cora Arabelle Eckles Dinsmore, which passed to her husband, Marvin Bell Dinsmore, and then to their son, Marvin Eckles Dinsmore, along with four other quilts made by Dinsmore or Eckles ancestors. These quilts and the makers to which they are attributed are 1997.007.0945 made by Rebecca Alford Dinsmore (plate 1-33); 1997.007.0951 attributed to Abbie Bell Dinsmore (plate 5-20); 1997.007.0948 attributed to Mary Anna McConahy Eckles and Cora Arabella Eckles (plate 6-98); and 1997.007.0941 attributed to Mary Anna McConahy Eckles (plate 6-25). All five quilts were sold by Marvin Eckles Dinsmore and his wife,

Joan, to a local dealer after 1984. They presumably were then purchased by Sandra Mitchell of Midwest Quilt Exchange, Columbus, Ohio, from whom collectors Ardis and Robert James purchased them. Genealogical research verifying the attributions to the makers of this group of quilts was compiled by Melissa Jurgena, IQSC research fellow, IQSC 1997.007.0942, 1997.007.0945, 1997.007.0951, 1997.007.0948, and 1997.007.0941 research files.

88 Thompson, "The Passing," 462–63.

89 Boldtmann, "Patchwork Quilts," 37.

90 See, for example, "Patchwork Design, Old and New," *Needlecraft—The Magazine of Home Arts*, June 1931, 18; Webster, *Quilts*, 1926 ed., 96; Finley, *Old Patchwork Quilts*, 42.

91 Family information, including marriage announcements and obituaries, compiled by Melissa Jurgena, IQSC research fellow, IQSC 1997.007.0942 research file.

92 See chapter 5 note 87.

93 Eulalie Osgood Grover, *The Sunbonnet Babies' Primer*, illustrated by Bertha L. Corbett (Chicago: Rand, McNally, 1902); and Eulalie Osgood Grover, *The Overall Boys*, illustrated by Bertha L. Corbett (New York: Rand, McNally, 1905).

94 Francine Kirsch, "Boudoir Dolls," *Antique Trader Weekly*, May 11, 1983, 77–79.

95 Advertisement for "Spring Millinery Number of Vogue," in *Life*, March 23, 1911, 602–3.

96 For example, see *The Modern Priscilla*, May 1914.

97 "The Silver Lining," *The Delineator*, February 1916, 51.

98 *Royal Society Embroidery Package Outfits* (New York: H. E. Verran Co., 1924); *Royal Society Embroidery Package Outfits, Fall and Winter 1927* (Stamford CT: H. E. Verran Co., 1927); *Royal Society Embroidery Package Outfits* (New York: Frampton Co., 1931). All are advertising brochures.

99 Beatrice Ferrell, "Interesting Embroideries for a Colonial Bedroom," *Needlecraft Magazine*, September 1927, 8. See also Ethelyn J. Guppy, "Quaint and Charming Is This Bed-Set," *Needlecraft Magazine*, February 1924, 10; and Bennie Hall, "New and Pretty Togs for Dressing Up the Home," *Needlecraft Magazine*, December 1924, 10.

100 Ruby Short McKim, "Colonial Ideas for Our Little Folks' Embroidery Page," *Woman's World*, February 1926, 52.

101 "Colonial Ladies and Modern Lend Their Charm to Gifts of Fashionable Appeal," *McCall Needlework*, Winter 1926–27, 9.

102 "Make Your Bedroom Smart with Needlework or Paints," *McCall Needlework*, Summer 1925, 34;

"Bright Colors Animate Hand-Worked Linens," *McCall Needlework*, Spring 1928, 32.

103 "Rainbow Applique Quilt-Blocks," *Needlecraft—The Home Arts Magazine*, November 1932, inside cover.

104 "Old Fashioned Lady," in *The Quilt Fair Comes to You* (Cleveland OH: Ohio Farmer, n.d.), 8. This design appears on an Appliqué Album quilt made in Nebraska, dated 1935. See Crews and Naugle, *Nebraska Quilts*, 99.

105 *Virginia Snow Studios Art Needlework Creations* (Elgin IL: Virginia Snow Studios, 1933), 4; *Grandma Dexter New Applique and Patchwork Designs, Book 36B* (Elgin IL: Virginia Snow Studios, n.d.), 8–9. For copy with book, see *Barbara Taylor's Book on Quilting* (Taylor TX: Taylor Bedding, 1961), 12. For copy with parasol, see Scioto Imhoff Danner, *Mrs. Danner's Quilts, Books 3 and 4 Combined*, ed. and rev. Helen M. Ericson (Emporia KS: Helen M. Ericson, 1973), 22.

106 For good cross-stitch examples, see Helen Grant, "Silhouettes in Cross-Stitch," *Needlecraft Magazine*, September 1926, 16.

107 For examples, see Sandi Fox, *For Purpose and Pleasure: Quilting Together in Nineteenth-Century America* (Nashville TN: Rutledge Hill, 1995), 106–9.

108 For example, see also Clark, Knepper, and Ronsheim, *Quilts in Community*, 136–37; and Crews and Naugle, *Nebraska Quilts*, 120–21.

109 Dorothy Cozart, "The Role and Look of Fundraising Quilts, 1850–1930," in Lasansky, *Pieced by Mother. Symposium Papers*, 86–95, especially 90.

110 For further information, see Kathryn Kish Sklar, "The 'Quickened Conscience': Women's Voluntarism and the State, 1890–1920," *Philosophy and Public Policy Quarterly* 18, no. 3 (Summer 1998), available from Institute for Philosophy and Public Policy, http://www.puaf.umd.edu/IPPP/summer98/quckened_conscience.htm (accessed October 29, 2003).

111 Caroline French Benton, *Fairs and Fetes: How to Give Parties for Profit and Amusement, What to Do and What to Sell* (Boston: Dana Estes, 1912), 57.

112 Genealogical research compiled by Melissa Jurgena, IQSC research fellow, IQSC 1997.007.0485 research file.

113 The Wildman quilt is pictured in Patsy Orlofsky and Myron Orlofsky, *Quilts in America* (New York: McGraw-Hill, 1974), 216; the Waldron quilt in Safford and Bishop, *America's Quilts*, 13; the Fitch quilt in Roderick Kiracofe and Mary Elizabeth Johnson, *The American Quilt: A History of Cloth and Comfort, 1750–1950* (New York: Clarkson Potter, 1993), 129; and the Vosburgh quilt in Winifred Reddall, "Pieced Lettering on Seven Quilts Dating from 1833 to 1891,"

in *Uncoverings 1980*, ed. Sally Garoutte (Mill Valley CA: American Quilt Study Group, 1981), 57.

114 Guthrie, "Old Fashioned Counterpanes," 776.

115 The Page quilt is published in *Lady's Circle Patchwork Quilts* 13 (1978): 31; the Kinmore quilt is in Hall and Kretsinger, *The Romance*, 205, plate LXIX.

116 Finley, *Old Patchwork Quilts*, 82, plate 33.

117 *Aunt Jane's Prize Winning Quilt Designs* (Springfield OH: Central Publishing, Household Journal, 1914; reprint, 1981).

118 Alice Beyer, *Quilting* (Chicago: South Park Commissioners, 1934; reprint, Albany CA: East Bay Heritage Quilters, 1978), 16.

119 "From Covered Wagon Days Came This Quilt" [Stearns and Foster advertisement for Mountain Mist batting], in *Needlecraft—The Home Arts Magazine*, March 1933, 23.

120 Pattern No. 530 in *Quilt Patterns: Patchwork and Applique*.

121 Hall and Kretsinger, *The Romance*, 140–41.

122 *Patchwork Quilts: How to Make Them* (Chicago: Needlecraft Supply, 1938), 1.

123 All family information derived from Gladys Sorensen, "The Lone Star Quilt," November 30, 1998, typed narrative, IQSC 1998.005.0001 research file.

124 "Framed Silhouettes and Stamped Linen Samplers," *McCall Needlework and Decorative Arts*, Summer 1930, 42. For an early work on samplers, see Ethel Stanwood Bolton and Eva Johnston Coe, *American Samplers* (Boston: Massachusetts Society of the Colonial Dames of America, 1921).

125 "The Needle Gains Importance In Modern Decoration," *McCall Needlework*, Spring 1930, color insert.

126 Eveline D. Johnson, "Charming Samplers for the Little House," *Needlecraft—The Home Arts Magazine*, January 1933, 7, 19. See also "New Uses of the Sampler," chapter 29 in Georgiana Harbeson, *American Needlework* (New York: Coward–McCann, 1938), 174–82.

127 Johnson, "Charming Samplers," 7.

128 "Linen Sampler," advertisement by Needlecraft Company, Augusta ME, in *Home Arts—Needlecraft*, May 1940, 14. Anne Orr Design Company's Fall 1932 catalog offered a range of stamped samplers costing 75 cents, floss extra.

129 "Linens Cross-Stitched with Silhouettes," *McCall Decorative Arts*, Spring 1931, 44.

130 See Ken Milano, "John Hewson: Kensington's Revolutionary Hero," *Pennsylvania Legacies* 2, no. 2 (November 2002), available at Historical Society of Pennsylvania, http://www.hsp.org/default.aspx?id=497 (accessed November 17, 2005).

131 Susan Burroughs Swan, *A Winterthur Guide to American Needlework* (New York: Crown, 1976), 64–88.

132 See designs in Margery Burnham Howe, *Deerfield Embroidery* (New York: Charles Scribner's Sons, 1976), colored plates between pp. 114 and 115. Also see the excerpted article by Margery Burnham Howe, "The Deerfield Embroidery Story," *Piecework*, March–April 1993, 16–24.

133 Harbeson, *American Needlework*, 31, plates opp. 32, plates opp. 152.

134 Christine Ferry, "Embroidered Upholstery Textiles in the Manner of the English Crewel Needlework of the Jacobean Period," *American Home*, August 1935, 205.

135 *American Quilts from Michigan State University Museum* (East Lansing: Michigan State University Museum, 2003), 102–3. Also see Marsha MacDowell and Ruth D. Fitzgerald, eds., *Michigan Quilts: 150 Years of a Textile Tradition* (East Lansing: Michigan State University Museum, 1987), 102.

136 Florence Peto, "Quilts Then and Now," *McCall's Needlework*, Fall–Winter 1953–54, 87–89. This article has an illustration of her crib-size "Where Liberty Dwells" quilt. Peto's "Calico Garden" quilt, ca. 1950, which was published in the December 1951 of *Woman's Day*, is illustrated in *Quilts from the Shelburne Museum* (Tokyo: Kokusai Art, 1996), 128–29, and in Kiracofe and Johnson, *The American Quilt*, 241.

137 Florence Peto, "Scrap Bag Lore," *McCall Needlework, Knitting, Crocheting*, Summer 1943, 68.

138 Florence Peto, *Historic Quilts* (New York: American Historical, 1939); Florence Peto, *American Quilts and Coverlets* (New York: Chanticleer, 1949).

139 For more information on Peto, see Joyce Gross, ed., *The Quilters' Journal*, Winter 1979, Spring 1980, Summer 1980.

140 Florence Peto, "Chintz 1830 to Today," *McCall Needlework, Knitting, Crocheting*, Winter 1942–43, 71. Peto supplied antique quilt motifs for the article "You Can Make Everything Here!," *American Home*, June 1942, 58–59.

141 For example, see "Restful Beauty for Your Bedroom," *McCall Needlework, Knitting, Crocheting*, Summer 1943, 49.

142 Zelma Bendure and Gladys Pfeiffer, *America's Fabrics* (New York: Macmillan, 1946), 619.

143 "Give Your Bathroom the Charm of Chintz," advertisement for Kleinert's Permasheen, using Clark's "Everglaze" chintz, in *American Home*, June 1942, 51.

144 Sophia Frances Anne Caulfeild and Blanche C. Saward, *The Dictionary of Needlework* (London: L. Upcott Gill, 1882; reprint, New York: Arno, 1972), 10–11.

145 Peto, *Historic Quilts*, xiii.

146 Tanya Wilhelm Maggs, "Olive Emily Mcclure Cook," genealogical narrative, undated, and genealogical information compiled by Melissa Jurgena, IQSC research fellow, IQSC 1997.007.0669 research file.

147 "Patchwork Design, Old and New," 18.

148 Hall and Kretsinger, *The Romance*, 165, plate XXXII.

149 Eleanor Beard's advertisements for quilts appeared regularly in *House Beautiful* from December 1926 through 1936.

150 For an early work on coverlets, see Bolton and Coe, *American Samplers*.

151 Guthrie, "Old Fashioned Counterpanes," 776.

152 Boldtmann, "Patchwork Quilts" 37.

153 Guppy, "Applique Blocks," 35.

154 "Patchwork Design, Old and New," 18.

155 Lanigan, "Revival" 19.

156 Shockey, "A Placid Old Art," 9.

6. REPACKAGING TRADITION

1 "Old-Time Patchwork and Appliqué Quilts," *Ladies' Home Journal*, January 1922.

2 Shockey, "A Placid Old Art," 9.

3 Ruby Short McKim designed quilt patterns that appeared in the *Kansas City Star*, the *Omaha World-Herald*, and many other newspapers. "Nancy Page" was the pen name of Florence LaGanke, who published quilt patterns in newspapers in a syndicated column titled "Nancy Page Quilt Club." Eveline Foland designed quilt blocks for the *Kansas City Star*. "Nancy Cabot" was a fictitious name used by a writer at the *Chicago Tribune*, Loretta Leitner Rising. A company called Needlecraft Service, based in New York City, used the pseudonyms "Laura Wheeler" and "Alice Brooks" for their newspaper columns. Louise Fowler Roote was the women's page editor for *Capper's Weekly*, and she offered quilt patterns to her readers under the pen name "Kate Marchbanks." See Barbara Brackman, *Women of Design: Quilts in the Newspaper* (Kansas City MO: Kansas City Star, 2004), 19–21, 27, 29–31, 71–74, 119–21; Kiracofe and Johnson, *The American Quilt*, 244–47.

4 Anne Orr Design Company, *Anne Orr's Quilts, Quilting Service and Stamped Quilt Tops*, pamphlet (Nashville TN, n.d.), American Quilt Study Group Collection, University of Nebraska Libraries, Lincoln.

5 Advertisement for "Rainbow Quilt Blocks," *Needlecraft Magazine*, n.d., 30, clipping in the collection of Merikay Waldvogel, Knoxville TN; Rainbow Quilt Block, "Showing Eighteen Pretty Ways of Setting Quilt Blocks Together," in the collection of Waldvogel.

6 *Priscilla Needlework*, 1912, catalog, American Quilt Study Group collection, University of Nebraska Libraries, Lincoln.

7 James H. Durham and Company, *Order Solicitor* (New York: James H. Durham, 1916).

8 Mirken, *1927 Edition of the Sears, Roebuck Catalogue*, 244–45.

9 Robert Frank Needlework Supply Co., *Quilts, Patchwork, Appliqué, Needlework That Is Worthy of Your Time*, catalog No. 38 (Kalamazoo MI: Robert Frank Needlework Supply, n.d.), 4.

10 Webster, *Quilts*, 1990 ed., 155–56.

11 See note 3.

12 Similar pieced letter blocks also appeared in the *New England Homestead* magazine in 1898. Ada Stoddard, the household editor of *Hearth & Home* magazine of Augusta ME, published the first letter of her Alphabet series (the Letter S) in the June 1905 *Fireside Visitor*. She published other letter blocks in that magazine's sister publication, *Hearth & Home*, from January 1906 through April 1907.

13 Wilene Smith provided these dates, based on advertisements and other evidence derived from her ongoing research of the Ladies Art Company and its pattern sources. See "Quilt History," 205.

14 Advertisement, *The Modern Priscilla*, November 1907, 34. The author thanks Connie Chunn and Wilene Smith, who provided the information about this advertisement and an earlier (October 1906) advertisement.

15 Webster, *Quilts*, 1915 ed., opposite p. 90.

16 "Directions for Making Wind Blown Tulip Quilt: New Patchwork Quilt Patterns Designed by Marie D. Webster," in the collection of Waldvogel.

17 Marie D. Webster, *Quilts and Spreads: Original Designs* (Marion IN: Marie D. Webster, 1931), 5.

18 Marie D. Webster, "The New Patchwork Quilt," *Ladies' Home Journal*, January 1, 1911.

19 Genealogical information complied by Melissa Jurgena, IQSC research fellow, IQSC 1997.007.0642 research file.

20 The first number in *The Modern Priscilla's* pattern sequence (19-27-62) indicates the design originated in a 1919 issue of the magazine, though it has not been located by the author. The number remained unchanged when it was published later in the 1920 and 1925 editions of *The Priscilla Patchwork Book*. See *The Priscilla Patchwork Book: Appliqué and Pieced Designs Old and New with Patterns for Making* (Boston: Priscilla, 1920); *The Priscilla Patchwork Book: Appliqué and Pieced Designs Old and New with Patterns for Making* (reprint, Augusta ME: Needlecraft, 1925).

21 The 1928 simplified Horn of Plenty design was as-

signed a new pattern number: 28-8-9. The other seven blocks illustrated in the 1928 and 1930 advertisements are all 1928 designs. See "Favorite Old Quilt Blocks," *The Modern Priscilla*, August 1928, 18, 42; see also a reprint of the same blocks: "A Review of Our Favorite Old Quilt Blocks," *The Modern Priscilla*, January 1930, 32.

22 *The Priscilla Patchwork Book*, 1920 ed., 4.

23 The directions for the 1919 version of the design called for sixteen-inch-square blocks. The 1920 redesigned kit was provided on twelve-inch-square blocks. See *The Priscilla Patchwork Book*, 1920 ed., 4; and "A Review of Our Favorite Old Quilt Blocks," 32.

24 *The Priscilla Patchwork Book*, 1920 ed., 4.

25 Ruth A. Bendure and Hannah Waldenmaier, "Six Old-Time Blocks from Our New Quilt Booklet," *Farm & Fireside*, September 1925, 20; Clementine Paddleford, *Patchwork Quilts: A Collection of Thirty-seven Old Time Blocks* (New York: Farm and Fireside, n.d.), in the collection of Waldvogel.

26 Paddleford, *Patchwork Quilts: A Collection of Thirty-Seven*, 16.

27 Paddleford, *Patchwork Quilts: A Collection of Thirty-Seven*, 14.

28 Paddleford, *Patchwork Quilts: A Collection of Thirty-Seven*, 15.

29 For a list of sources of the published pattern, see Brackman, *Encyclopedia*, 456–57.

30 See IQSC 2003.003.0359E research file.

31 *Farm Journal Quilt Patterns Old and New* (Philadelphia: Farm Journal, 1937), n.p., in collection of Waldvogel.

32 Rosalind Perry and Marty Frolli, *A Joy Forever: Marie Webster's Quilt Patterns* (Santa Barbara CA: Practical Patchwork, 1992), 16–20, 30, 35.

33 Marie D. Webster, "The May Tulip Quilt in Appliqué," *Needlecraft Magazine*, May 1931, 6.

34 For more information on the use of exotic names for traditional quilt patterns, see Marin F. Hanson, "Exotic Quilt Patterns and Pattern Names in the 1920s and 1930s," *Textile: The Journal of Cloth and Culture* 4, no. 2 (2006): 138–63.

35 Barbara Brackman, "Who Was Nancy Cabot?," *Quilter's Newsletter Magazine*, January–February 1991, 23.

36 Nancy Cabot, "Adventurer's Coin Forms Inspiration of Unusual Quilt," *Chicago Tribune*, April 7, 1934, 21.

37 Robert Frank Needlework Supply Co., *Quilts*, 4; Mary A. McElwain, *The Romance of the Village Quilts* (Walworth WI: Mary A. McElwain Quilt Shop, 1936), 6; John C. Michael Company, *Quilts, "Mickey" Cut-to-Size Quilt Patches*, catalog no. 5 (Chicago: John C. Michael, n.d.), 34.

38 Brackman, *Clues in the Calico,* 62–71, 81.

39 Family information compiled by Carolyn Ducey, IQSC curator, and Jonathan Gregory, IQSC graduate research assistant, IQSC 1999.007.0001 research file.

40 Garrett Raterink and Gay Bomers, "Quilter's Profile Great Lakes Quilting," *Michigan State University Museum Newsletter* (Winter 2001): 3–4.

41 Lauri Linch, "The Meetin' Place," *Quilter's Newsletter Magazine*, 1984, 65, 77.

42 Needleart Guild, *Heirloom Quilts, for Appliqué, for Patchwork* (Grand Rapids MI: Needleart Guild, n.d.), 3.

43 Merikay Waldvogel, "The Marketing of Anne Orr's Quilts," in Horton, *Uncoverings 1990*, 12.

44 The publication dates of the series in the *Indianapolis Star* are from September 24, 1931, to at least July 28, 1932.

45 Four clippings collected by Leonhard detail her winning quilt entry at the local and national levels with her State Flowers quilt. Other winners at the national level are mentioned by name, but no contest sponsorship is mentioned. One clipping, "Artistry in Quilts," with a photo of "Prize Winner Emma Mae Leonhard," is dated December 15, 1932. See photocopied clippings in the collection of Waldvogel; also see E. Duane Elbert and Rachel Elbert, *History from the Heart: A Two-Century Heritage of Illinois Quilts and Quiltmaking* (Nashville TN: Rutledge Hill, 1993), 152–53.

46 "The Muncie Star's Third Annual Quilt Contest," n.d., photocopy of newspaper article, IQSC 2004.021.0001 research file.

47 The photograph was republished in "Quilt Contest Entries Open," *Indianapolis Star*, November 14, 1976, sect. 6, clipping in IQSC 2004.021.0001 file.

48 "Starts Tomorrow: The Star's Flower Garden Quilt Contest," *Indianapolis Star*, November 10, 1929, clipping in collection of Waldvogel.

49 "Quilt Contest Entries Open."

50 "Quilt Contest Entries Open."

51 Louise Fowler Roote, foreword to *Blue Ribbon Quilts* (New York: Famous Features Syndicate, ca. 1971).

52 "Quilt Pattern," *Capper's Weekly*, August 23, 1977, in the collection of Waldvogel.

53 Merikay Waldvogel, "The Origin of Mountain Mist Patterns," in Gunn, *Uncoverings 1995*, 114.

54 Genealogical information compiled by Melissa Slaton, IQSC graduate research assistant, and Melissa Jurgena, IQSC research fellow, IQSC 1997.007.0681 research file.

55 Merikay Waldvogel, conversation with the author, 2005.

56 Boag Company, *Quilts by Boag, the Most Authentic Quilt Line in America* (Elgin IL: Boag Company, n.d.), 12, in the collection of Waldvogel.

57 Brackman, *Encyclopedia,* 416–19. The earliest reference for the publication of this type of pattern is the 1920s.

58 Nancy Page [Florence LaGanke], Nancy Page Quilt Club Old Almanac Quilt advertisement, *St. Louis Star and Times* [1932], in Mildred Dickerson Pattern Collection, in the collection of Waldvogel.

59 The previous series quilts offered by Nancy Page were Grandmother's Flower Garden, 1929; the Alphabet, October 6, 1929–March 23, 1930; Magic Vine, September 28, 1930–March 15, 1931; Leaf Quilt, March 22, 1931–April 12, 1931; Wreath Series, May 24, 1931–June 14, 1931; Garden Bouquet, October 4, 1931–?; and Snowflake, summer 1932.

60 Nancy Page, "The Old Almanac Quilt, First Block in the Series," *St. Louis Star and Times* [1932], in the collection of Waldvogel.

61 Florence LaGanke, "'Vegetable Cookery' is 13th Book by Press Food Editor," *Cleveland Press,* May 13, 1952, clipping in Florence LaGanke Harris Photographs and Clippings File, Special Collections, Cleveland State University Library.

62 Genealogical and family history compiled by Melissa Jurgena, IQSC research fellow, IQSC 1997.007.0638 research file.

63 Nancy Cabot, "Quilt Attains Beauty through Manipulation of the Patches," *Chicago Tribune,* October 20, 1935.

64 Cabot, "Quilt Attains Beauty."

65 Brackman, "Who Was Nancy Cabot?" 22.

66 Pat L. Nickols, "Mary A. McElwain: Quilter and Quilt Businesswoman," in *Uncoverings 1991,* ed. Laurel Horton (San Francisco: American Quilt Study Group, 1992), 102.

67 McElwain, *The Romance,* 3–4.

68 McElwain, *The Romance,* 34.

69 Nickols, "Mary A. McElwain," 102.

70 McElwain, *The Romance,* 23.

71 Waldvogel, "The Marketing of Anne Orr's Quilts," 12.

72 See two quilts of this type of Orr design in the International Quilt Study Center collections. See plates 6-18 and 6-21.

73 Benberry, "Quilt Cottage Industries," 12.

74 Mountain Mist Quilting Cotton–Form 109 (Cincinnati OH: Stearns and Foster, 1962). Reverse side: The Sunflower—Design "P" copyright 1930, in the collection of Waldvogel.

75 Photocopied correspondence from Stearns and Foster personnel, including F. J. Hooker and Phoebe Edwards, to Margaret Hays, from the private collection of Evelyn Banner, is in the collection of Waldvogel. For a more detailed analysis of the correspondence, see Waldvogel, "The Origin of Mountain Mist Patterns."

76 F. J. Hooker to Margaret Hays, September 22, 1929. Design "P," "Sunflower."

77 F. J. Hooker to Margaret Hays, October 18, 1929. Design "P," "Sunflower."

78 F. J. Hooker to Margaret Hays, November 4, 1929, Design "P," "Sunflower."

79 F. J. Hooker to Margaret Hays, January 30, 1930. Hooker informs Hays that the first shipment of batts with the Mountain Star pattern on the reverse would be in consumer's hands and that he anticipated that it would create a demand for patterns for all the color designs printed on the front of the wrappers.

80 Merikay Waldvogel, "Yes, There Is a Phoebe Edwards," in *Mountain Mist Blue Book of Quilts: Celebrating 150 Years of the Perfect Quilting, 1846–1996,* ed. Vickie Paullus and Linda Pumphrey ([Cincinnati OH: Stearns Technical Textiles], 1996), 28.

81 Phoebe Edwards to Margaret Hays, July 8, 1930.

82 Stephen Mintz, *Huck's Raft: A History of American Childhood* (Cambridge MA: Belknap Press of Harvard University Press, 2004), 3–4.

83 For findings on the sources of Mountain Mist patterns, see Waldvogel, "The Origin of Mountain Mist Patterns," 95–138.

84 *Chicago Tribune,* August 20, 1933, D3.

7. INNOVATION AND IMAGINATION

1 Waldvogel and Brackman, *Patchwork Souvenirs,* 49, 54–55, 59, 61; *Polk's Lexington (Fayette County, Kentucky) City Directory 1933–1934,* s.v. "Caden, Annie M." (Detroit: R. L. Polk, n.d.), 117.

2 In plate 6-87, Grandmother's Fan, the fan shape is also an evocation of a rising sun; plate 6-86, Fan, is a pure Art Deco version also from the 1930s. See also plate 1-41, Sunburst, for a two-color fan variation.

3 *Encyclopædia Britannica Online,* s.v. "clothing and footwear industry," http://0-search.eb.com.library.unl.edu:80/eb/article-66766 (accessed November 21, 2007); s.v. "sewing machine," http://0-search.eb.com.library.unl.edu:80/eb/article-9066989 (accessed November 21, 2007).

4 Suellen Meyer wrote that a man's shirt required fourteen and a half hours to construct by hand, but only slightly more than an hour if constructed with a sewing machine. Suellen Meyer, "The Sewing Machine and Visible Machine Stitching on Nineteenth-Centu-

ry Quilts," in Horton, *Quiltmaking in America,* 112.

5 Barbara Brackman's research revealed a downward trend in the price per yard of American-made cotton calico. The price fell from 37 1/2 cents in 1832 to 12 cents in 1843 to 4 cents in 1872. Brackman, *Clues in the Calico,* 49–50.

6 See, for instance, the early example in the International Quilt Study Center's collections, IQSC 2003.003.0316.

7 See, for instance, Nine Patch and Ohio Star, IQSC 2003.003.0314, in which the pieces were arranged to form a central Variable Star.

8 Genealogical research compiled by Valerie Davis and Jonathan Gregory, IQSC graduate research assistants, IQSC 2003.003.0194 research file.

9 The Quilters' Guild of the British Isles has in its collection a 1718 silk patchwork coverlet that was the subject of a special issue of *Quilt Studies.* For a comparative study of this and other silk patchwork, see Bridget Long, "A Comparative Study of the 1718 Silk Patchwork Coverlet," in *Quilt Studies: The Journal of the British Quilt Study Group,* ed. Dorothy Osler (2004): 54–78. One quilt addressed in Long's article is a silk patchwork quilt, dated 1726, which is in the collection of the McCord Museum of Canadian History in Montreal, Quebec (accession M972.3.1).

10 Carol Williams Gebel, "The Princess Feather: Exploring a Quilt Design," in Evans, *Uncoverings 2007,* 135.

11 See Variable Star, IQSC 1997.007.0087, for a classic example of this pattern used in a quilt.

12 See Ethel Ewert Abrahams and Rachel K. Pannabecker, "'Better Choose Me': Addictions to Tobacco, Collecting, and Quilting, 1880–1920," in *Uncoverings 2000,* ed. Virginia Gunn (Lincoln NE: American Quilt Study Group, 2000), particularly 86–91, 102 note 132.

13 For another example of a tobacco premium quilt arranged in an idiosyncratic manner, see plate 7-32.

14 Gazo Foudji, "A Dragon Bedquilt," *Ladies' Home Journal,* May 1905, 15.

15 Chinese-American Museum of Chicago, "Chinese-Americans and World Fairs," available from http://ccamuseum.org/Fairs.html (accessed November 21, 2007).

16 Chinese-American Museum of Chicago, "Objects/Artifacts," available from http://ccamuseum.org/Object_Photos.html (accessed November 21, 2007).

17 Robert Shaw, *Hawaiian Quilt Masterpieces* (N.p.: Hugh Lauter Levin Associates, 1996), 12.

18 Kiracofe and Johnson, *The American Quilt,* 161.

19 According to information in the research files for this quilt, a Beauty of Hilo Bay pattern was donated by Louise K. Mahelona to the Waianae Public Library, a library noted for its collection of appliqué patterns.

20 According to Barbara Brackman's *Clues in the Calico,* 53, in mainstream American quilts, wool batting is more often found in wool quilts and only occasionally in quilts of other fibers. But according to Loretta Woodard, a Hawaiian quilt researcher, the Hawaiian Quilt Research Project found that cotton and wool battings were used in roughly equivalent amounts up through the 1950s. Loretta Woodard and Sara Dillow, IQSC acquisitions coordinator, personal communication, April 2005, IQSC 2005.015.0001 research file.

21 Bertha Amelia Meckstroth, "The Singing Needle" (Glencoe IL, self-published, n.d.), 2, in Bertha Amelia Meckstroth Papers, 1903–58, Mss 2248, Louisiana and Lower Mississippi Valley Collections, LSU Libraries, Baton Rouge LA. The reference to Wedgewood is likely to china manufactured by the English pottery company founded by Josiah Wedgwood. The name in this resource and in the title of the quilt, however, has a slightly variant spelling that has become part of the quilt's provenance.

22 Allen D. Albert to Bertha Meckstroth, July 24, 1933, Bertha Amelia Meckstroth Papers, 1933, 1940–54, Folder 8.

23 Joyce Gross, "Bertha Meckstroth," *Quilters' Journal,* Fall 1981.

24 Catalogue of Works, 1916–38, Bertha Amelia Meckstroth Papers, Box 3, Folder 9.

25 Helen Young Frost, Pam Knight Stevenson, and Arizona Quilt Project, *Grand Endeavors: Vintage Arizona Quilts and Their Makers* (Flagstaff AZ: Northland Publishing, 1992), 188–93.

26 Sears, Roebuck and Co., "Sears Invites You and Your Friends to Attend Quilt Show and Demonstration" advertising flyer [1933], in collection of Waldvogel; Waldvogel and Brackman, *Patchwork Souvenirs,* 36.

27 Family history provided by the maker's son, H. Lloyd Stow, in February 23, 1994, telephone interview with the author.

28 A carbon copy of Ida Stow's letter to Sears, Roebuck and Co. was sent to Bertha Stenge, another Chicago quiltmaker who made a theme quilt for the contest. See Ida M. Stow to Sears and Roebuck, June 6, 1933, Bertha Stenge Ephemera Collection, Illinois State Museum, Springfield.

29 Emma Leonhard's quilt entry in the 1933 Sears Quilt Contest, plate 7-43, also did not win a prize because it was an original design. See Waldvogel and Brackman, *Patchwork Souvenirs,* 75–78.

30 Kay Vasey, telephone interview with author, August 17, 2003.

31 Sears, Roebuck and Co. to Ethel Mackey, June 16, 1933, prize winner list, IQSC 2004.010.0001 research file. For an in-depth narrative about Margaret Caden and the women who made the winning quilt, see Waldvogel and Brackman, *Patchwork Souvenirs,* 46–61.

32 Nao Nomura and Janneken Smucker, "From Fibers to Fieldwork: A Multifaceted Approach to Re-examining Amish Quilts," in *Uncoverings 2006,* ed. Joanna E. Evans (Lincoln NE: American Quilt Study Group, 2006), 128–29. Nomura and Smucker's paper provides a researched historical review of the development of manufactured regenerated and synthetic fibers in the twentieth century as it relates to fabrics used in quiltmaking. See also C. H. Ward-Jackson, *A History of Courtaulds: An Account of the Origin and Rise of the Industrial Enterprise of Courtaulds Limited and of Its Associate the American Viscose Corporation* (London: Curwen, 1941).

33 Nomura and Smucker, "From Fibers to Fieldwork," 129–30.

34 See Abrahams and Pannabecker, "'Better Choose Me,'" for further information on cigar ribbons and tobacco premiums and their use in quilts.

35 E. McClung Fleming and Jules David Prown each developed an early model for artifact study and have been the most influential figures on the emergence of material culture studies in the late twentieth century. See E. McClung Fleming, "Artifact Study: A Proposed Model," *Winterthur Portfolio* 9 (1974): 153–73; Jules David Prown, "Mind in Matter: An Introduction to Material Culture Theory and Method," *Winterthur Portfolio* 17, no. 1 (1982): 1–19.

36 For more information on the quilt contest, see Waldvogel and Brackman, *Patchwork Souvenirs.*

37 For further information on signature album quilts from the early nineteenth century, see Linda Otto Lipsett, *Remember Me: Women and Their Friendship Quilts* (San Francisco: Quilt Digest, 1985); Pat Ferrero, Elaine Hedges, and Julie Silber, *Hearts and Hands: The Influence of Women and Quilts on American Society* (San Francisco: Quilt Digest, 1987); Jessica Fleming Nicoll, "A Mirror to Show Thy Friends to Thee: Delaware Valley Signature Quilts, 1840–1855," master's thesis, University of Delaware, 1989.

Glossary

album quilt: Contains blocks that are individually designed, appliquéd, pieced, and/or embroidered, some inscribed with signatures, dates, religious passages, or sentimental poetry utilizing ink or embroidery. Quilts in this genre may also be referred to as friendship, signature, or sampler quilts. Album quilts were sometimes made to commemorate people, places, or events and are given away or kept as a reminder of family and friends.

alizarin: The principal coloring agent found in madder root, a natural dye known since antiquity to produce a pleasing range of red colors. It was first synthesized in 1869 in both Great Britain and Germany.

aniline dye: A dyestuff prepared from coal tar derivatives. The term, no longer in use by dye chemists, is sometimes used by writers to broadly refer to all early synthetic dyes. The first aniline dye, mauve or mauevine, was a bright, fugitive violet dye developed by William Henry Perkin in 1856.

appliqué: A quilt style or sewing technique in which pieces of cloth are laid on or applied to a background cloth and secured with blind or buttonhole stitches for decorative purposes. In reverse appliqué, a variety of colored fabrics are layered and then cut, edges turned under, and sewn with a blind stitch to reveal a preplanned decorative design created by exposing the underlayers of fabric. Early twentieth-century descriptive terms for appliqué include sewed on, patched, laid on, and hemmed on.

batting: Sheets of carded cotton, wool, polyester, or other natural or manufactured fibers sandwiched between the quilt top and quilt backing and secured by hand or machine quilting stitches, or tying. Wadding is a British term for batting.

binding: An additional strip of fabric, straight or on the bias, applied to the unfinished edge of a quilt as a way of finishing off the sides. Bindings may also be created from the quilt backing and brought to the front (front binding) or from the front and brought to the back (back binding), or the front and back quilt edges may be sewn together with raw edges tucked in (knife edge).

brocade: Jacquard-woven fabric with a raised figural pattern originally made of silk, but currently from any manufactured fiber, including rayon, nylon, or polyester.

Satin or twill figures on a plain, twill, or satin weave ground can be used.

calico: A lightweight, plain weave cotton fabric with a small-scale printed design.

challis: A soft, plain weave dress-weight fabric of wool, rayon, cotton, or manufactured fiber blends. Supple and lightweight, it is usually printed in small floral designs.

chambray: A plain weave, yarn-dyed fabric, with colored warp and white weft yarns, usually cotton, but can be made from manufactured fibers and blends.

charm quilt: A style of quilt, typically made of single patches, that strives to use the widest variety of printed fabrics, usually calico, with the goal that no two fabric patterns are repeated or that a minimum of 999 different patterns are used. Templates for the patches could be squares, triangles, diamond, hexagons, or other shapes.

cheater cloth: A multicolored cotton fabric printed in such a way as to fool the eye or closely resemble a pieced, appliquéd, or Crazy quilt top.

chintz: The term has come to mean any printed or solid plain weave cotton or cotton blend fabric with a glazed surface used for apparel, decorative household textiles, and quilts. In the eighteenth and nineteenth centuries it referred to a cotton fabric, printed with large-scale figures and sometimes glazed, of suitable weight for both dresses and household textiles. Originally hand-painted or block-printed in India, chintzes were later copied and produced in Europe and America using roller printing technology.

chrome orange: A yellow lead chromate compound treated with an alkali that produces a characteristic yellow-orange color often referred to as cheddar.

chrome yellow: A lead chromate compound that produces an intense yellow color. Invented in 1819, it is one of several so-called mineral dyes produced directly on the fabric by a precipitation reaction.

conversation prints: Roller-printed fabrics containing small nonfloral figures or objects ranging from insects to animals such as horses, dogs, and cats to tools and sporting equipment. Most are printed in monochromatic color schemes. They were often used as shirting fabrics.

cretonne: An unglazed cotton household furnishing fabric in a twill weave with a large-scale pattern. Subjects included large floral designs, commemorative events, and nostalgic scenes. Cretonne was often used as a backing or in scrap quilts.

delaine: A soft, lightweight, plain weave fabric with cotton warp and worsted wool weft. Delaine came in both prints and solids and was produced in many qualities. Also referred to as mousseline delaine, it is found in foundation-pieced and English template-pieced quilts in the late nineteenth and early twentieth century.

dobby weave: Dobby or dobby weave is a general term for a fabric with a small figured design, usually geometric, woven on a loom with a dobby attachment.

double pinks: Printed cotton pattern with several shades of red or pink on a white background produced by printing different concentrations of mordant before dyeing the fabric.

eccentric prints: A term used loosely and vaguely to describe roller-printed, geometric calicoes that have many small stripes broken into sharp angles. They are found in quilts from the second half of the nineteenth century.

foundation patchwork: A method of quilt construction that requires a foundation or background fabric onto which pieces of cloth are attached and built upon to create a design. Examples of this technique are found in Crazy quilts and Log Cabin quilts.

four-block quilts: A design style in which the quilt top is divided into four equal quadrants. Four repetitions of one block design, either pieced or appliquéd, are constructed and placed in each quadrant with identical or rotated orientation to the other blocks. A quilt style prevalent in the second half of the nineteenth century, the blocks featured a wide variety of design elements, including floral motifs, stars, eagles, and geometric designs.

indigo: A blue dyestuff derived from certain plants or made synthetically. Natural indigo is extracted from the leaves of plants via a fermentation process. Synthetic indigo was first synthesized in the 1870s. More than twenty years passed before methods were devised for commercial production at affordable prices.

kit quilt: A quilt that was produced from a kit; a for-purchase, predesigned package of supplies. Supplies in the kits varied. Some kits included die-cut pieces ready to sew together. Others included a full-size fabric background stamped with dotted blue outlines of appliqué motifs, along with smaller pieces of colored fabric, stamped with matching motifs ready to be cut out and sewn in place.

Lancaster blue: Printed cotton pattern with several shades of blue on a white background. The distinctive blue calico was especially admired and used by quiltmakers in Lancaster County, Pennsylvania, so that it became associated with them and called Lancaster blue. They continued to use it in their quilts long after its popularity waned in the rest of the United States at the end of the nineteenth century.

Log Cabin settings: Standard Log Cabin blocks may be arranged in several ways to form different settings, each with its own name, for example Barn Raising setting. Log Cabin quilts are not typically set together with alternating blocks or strips. Courthouse Steps and Pineapple Log Cabin quilts are not additional settings, but are considered variations of the Log Cabin block.

madder: A red dyestuff extracted from the roots of the madder plant of the genus *Rubia tinctorum* or made synthetically. The primary colorant in natural madder is alizarin; it also contains a small quantity of purpurin. Used in conjunction with aluminum, tin, iron, chrome, and iron mordants, madder or alizarin could produce a variety of reds, oranges, browns, blacks, and purples.

madder style: A fashionable color scheme for printed cottons composed of coppery red, purplish brown, and black popular during the middle to late nineteenth century.

mosaic patchwork: See *template piecing*.

mourning prints: Printed cottons that have figures produced using fine black lines or such small figures on a white ground that they appear gray from a distance. Montgomery Ward was one of several catalog companies to designate this style of print as mourning prints.

Nile green: A bluish green pastel color that was popular in quilts between 1925 and 1950. Sears, Roebuck and Co. called the shade Nile green in their 1927 catalog, and it has come to be widely used to designate that distinctive color.

object prints: See *conversation prints*.

oil calico, oil boiled calico: Calicoes in which the cloth was prepared for dyeing and printing by boiling it in oil. The oiling of the cloth produced a brighter color and more colorfast fabric.

patchwork: During the early twentieth-century quilt revival, patchwork referred both to appliqué and pieced patterns. It was a time of transition and development of quiltmaking terminology. Today patchwork is typically used in reference to pieced patterns alone. Quiltmakers of the British Isles have long used the term to denote patterns made by piecing.

Prussian blue: One of the earliest chemical dyes used in America. The bright blue color was produced using

any of a group of powders of ferrocyanides of iron. Discovered in the 1740s, its practical application was delayed until the 1830s, when a method of fixing it on fabrics was developed. Also called Lafayette, Napoleon, or Berlin blue.

red-and-green appliqué: Conventional appliqué quilts in which red and green design motifs, usually floral, are stitched to a white ground. Yellow and blue fabrics are sometimes used for accents. Red-and-green appliqué quilts were made of calicoes or solid cottons or a combination of the two.

redwork: A style of embroidery that uses red floss on a white ground to outline simple line drawings and inscriptions. Frequently, the embroidered blocks or tops were made into fund-raising or commemorative quilts.

robe prints: A roller-printed fabric with a large-scale paisley or floral design, popular from 1875 to about 1915. Robe prints came in the usual colorways of madder-style prints: red, orange, brown, black, and purple. They were used as backing fabrics for quilts of this era, as well as in patchwork tops.

running stitch: The simplest and most basic of stitches. The stitch is simply made by passing the needle over and under the fabric. It is the most common method of piecing a quilt block. The running stitch can be sewn by machine or by hand.

sashing: Strips of fabric sewn between blocks in a quilt top.

sateen: A cotton fabric with a lustrous surface made of spun yarns in an unbalanced weft-faced weave.

satin: A fabric with a lustrous surface made of filament yarns in a highly unbalanced warp-faced weave to produce a smooth surface without apparent pattern. Originally satin was made of filament silk; after the invention of rayon, acetate, and other manufactured fibers, satins were produced from the filament yarns of many manufactured fibers.

set, setting: The way individual quilt blocks are arranged to form the overall layout of the quilt top. A setting also refers to the strips or plain or alternate-patterned blocks included between the quilt blocks to form the overall arrangement of the quilt top. (See also Log Cabin settings.)

set on-point: An arrangement in which the blocks have been rotated so that seam lines are diagonal instead of horizontal or vertical.

strip setting: An arrangement in which blocks are arranged in vertical or horizontal rows that are separated by strips of fabric.

shirting prints: A general term for a printed cotton or cotton blend fabric used for men's shirts. The printed designs are simple, usually geometrics, and the color scheme is monochromatic, typically black or navy on a white ground.

template piecing: A technique of English origin in which pieces of fabric are basted onto paper or cardboard patterns to shape them for a quilt top. Basting stitches and papers are usually removed after the pieces are whipstitched together. Hexagon, diamond, and other geometric shapes were common in America.

Turkey red: Turkey red is a madder or alizarin red, dyed by a special and originally lengthy process, which produced a very bright red that was extremely lightfast, washfast, and resistant to bleeding. Many improvements in the Turkey red dyeing process were devised during the second half of the nineteenth century, one of which shortened the process to days instead of weeks. A distinguishing feature of Turkey red was the preparation of the cloth in oil, usually olive oil or castor oil.

whipstitch: An overcast stitch used in template piecing to join two pieces of fabric.

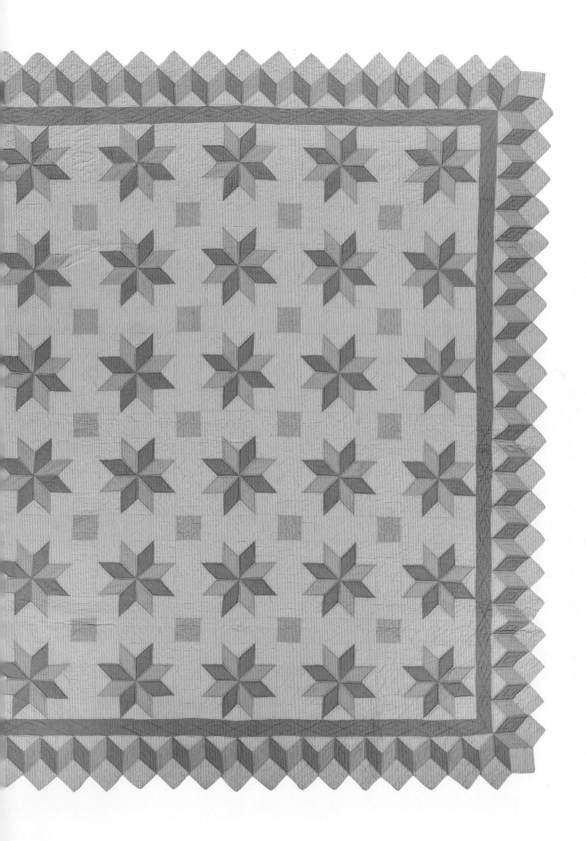

Selected Bibliography

Ames, Kenneth L. Introduction to *The Colonial Revival in America*, edited by Alan Axelrod, 1–14. New York: Norton, 1985.

Bassett, Lynne Z., and Jack Larkin. *Northern Comfort: New England's Early Quilts, 1780–1850: From the Collection of Old Sturbridge Village*. Nashville TN: Rutledge Hill, 1998.

Benberry, Cuesta. "Quilt Cottage Industries: A Chronicle." In *Uncoverings 1986*, edited by Laurel Horton, 91. Mill Valley CA: American Quilt Study Group, 1987.

Brackman, Barbara. *Clues in the Calico: A Guide to Identifying and Dating Antique Quilts*. McLean VA: EPM, 1989.

———. *Encyclopedia of Pieced Quilt Patterns*. Paducah KY: American Quilter's Society, 1993.

Clark, Ricky. *Quilts of the Ohio Western Reserve*. Athens: Ohio University Press, 2005.

Clark, Ricky, George W. Knepper, and Ellice Ronsheim, eds. *Quilts in Community: Ohio's Traditions*. Nashville TN: Rutledge Hill, 1991.

Cochran, Rachel, Rita Erickson, Natalie Hart, et al. *New Jersey Quilts 1777 to 1950: Contributions to an American Tradition*. Paducah KY: American Quilter's Society, 1992.

Crews, Patricia Cox, and Ronald C. Naugle. *Nebraska Quilts and Quiltmakers*. Lincoln: University of Nebraska Press, 1991.

Ferrero, Pat, Elaine Hedges, and Julie Silber. *Hearts and Hands: The Influence of Women and Quilts on American Society*. San Francisco: Quilt Digest, 1987.

Gordon, Beverly. "Victorian Fancywork in the American Home: Fantasy and Accommodation." In *Making the American Home: Middle-Class Women and Domestic Material Culture 1840–1940*, edited by Marilyn Ferris Motz and Pat Browne, 48–68. Bowling Green OH: Bowling Green State University Popular Press, 1988.

Green, Harvey. "Looking Backward to the Future: The Colonial Revival and American Culture." In *Creating a Dignified Past: Museums and the Colonial Revival*, edited by Geoffrey Louis Rossano and Historic Cherry Hill Corporation, 1–16. Savage MD: Rowman and Littlefield, 1991.

Gunn, Virginia. "Crazy Quilts and Outline Quilts: Popular Responses to the Decorative Art/Art Needlework Movement, 1876–1893." In *Uncoverings 1984*, edited by

Sally Garoutte, 131–52. Mill Valley CA: American Quilt Study Group, 1985.

———. "Quilts for Milady's Boudoir." In *Uncoverings 1989*, edited by Laurel Horton, 81–101. San Francisco: American Quilt Study Group, 1990.

———. "Template Quilt Construction and Its Offshoots: From Godey's Lady's Book to Mountain Mist." In *Pieced by Mother Symposium Papers*, edited by Jeannette Lasansky, 69–76. Lewisburg PA: Oral Traditions Project of the Union County Historical Society, 1988.

Holstein, Jonathan. *The Pieced Quilt: A North American Design Tradition*. Toronto: McClelland and Stewart, 1973.

Horton, Laurel. "An Elegant Geometry: Tradition, Migration, and Variation." In *Mosaic Quilts: Paper Template Piecing in the South Carolina Lowcountry*, exhibition catalog, 10–21. Greenville NC: Curious Works Press and the Charleston Museum, 2002.

Jessup, Lynda. *Antimodernism and Artistic Experience: Policing the Boundaries of Modernity*. Toronto: University of Toronto Press, 2001.

Kiracofe, Roderick, and Mary Elizabeth Johnson. *The American Quilt: A History of Cloth and Comfort, 1750–1950*. New York: Clarkson Potter, 1993.

Lasansky, Jeannette. "The Colonial Revival and Quilts, 1864–1976." In *Pieced by Mother Symposium Papers*, edited by Jeannette Lasansky, 96–105. Lewisburg PA: Oral Traditions Project of the Union County Historical Society, 1988.

Lears, T. J. Jackson. *No Place of Grace: Antimodernism and the Transformation of American Culture, 1880–1920*. New York: Pantheon, 1981.

Maines, Rachel. "Paradigms of Scarcity and Abundance: The Quilt as an Artifact of the Industrial Revolution." In *In the Heart of Pennsylvania Symposium Papers*, edited by Jeannette Lasansky, 84–89. Lewisburg PA: Oral Traditions Project of the Union County Historical Society, 1986.

McMorris, Penny. *Crazy Quilts*. New York: Dutton, 1984.

Meyer, Suellen. "The Sewing Machine and Visible Machine Stitching on Nineteenth-Century Quilts." In *Quiltmaking in America: Beyond the Myths*, edited by Laurel Horton, 112–21. Nashville TN: Rutledge Hill, 1994.

Mott, Frank Luther. *A History of American Magazines*. Vols. 3 and 4. Cambridge MA: Belknap Press of Harvard University Press, 1957.

Orlofsky, Patsy, and Myron Orlofsky. *Quilts in America*. New York: McGraw-Hill, 1974.

Rivard, Paul E. *A New Order of Things: How the Textile Industry Transformed New England*. Hanover NH: University Press of New England, 2002.

Roan, Nancy. "Fabrics Used by Pennsylvania-German Farm Families in Southeastern Pennsylvania." In *Bits and Pieces: Textile Traditions*, edited by Jeannette Lasansky, 16–25. Lewisburg PA: Oral Traditions Project of the Union County Historical Society, 1991.

Safford, Carleton L., and Robert Charles Bishop. *America's Quilts and Coverlets*. New York: Dutton, 1980.

Smith, Wilene. "Quilt Blocks—or Quilt Patterns?" In *Quiltmaking in America: Beyond the Myths*, edited by Laurel Horton, 30–39. Nashville TN: Rutledge Hill, 1994.

———. "Quilt History in Old Periodicals." In *Uncoverings 1990*, edited by Laurel Horton, 188–213. San Francisco: American Quilt Study Group, 1990.

Waldvogel, Merikay. *Soft Covers for Hard Times: Quiltmaking and the Great Depression*. Nashville TN: Rutledge Hill, 1990.

Waldvogel, Merikay, and Barbara Brackman. *Patchwork Souvenirs of the 1933 World's Fair*. Nashville TN: Rutledge Hill, 1993.

Warren, Elizabeth V., and Sharon L. Eisenstat. *Glorious American Quilts: The Quilt Collection of the Museum of American Folk Art*. New York: Penguin Studio in association with Museum of American Folk Art, 1996.

Webster, Marie D. *Quilts: Their Story and How to Make Them*. New edition with notes and a biography of the author by Rosalind Webster Perry. Santa Barbara CA: Practical Patchwork, 1990.

Welters, Linda, and Margaret T. Ordoñez, eds. *Down by the Old Mill Stream: Quilts in Rhode Island*. Kent OH: Kent State University Press, 2000.

Wharton, Edith, and Ogden Codman. *The Decoration of Houses*. New York: Charles Scribner's Sons, 1897; rev. and expanded, New York: Norton, 1998.

Contributors

BARBARA BRACKMAN is the author of numerous books about quilt history, including *Encyclopedia of Pieced Quilt Patterns* and *Making History: Quilt and Fabric from 1890–1970*. She is a founding member of the American Quilt Study Group and an honoree in the Quilters' Hall of Fame. She is the honorary quilt curator at the Spencer Museum of Art at the University of Kansas. She also designs reproduction fabric for quilters for United Notions. She lives in Lawrence, Kansas.

PATRICIA COX CREWS is the Willa Cather Professor of Textiles and director of the International Quilt Study Center & Museum at the University of Nebraska–Lincoln. Her publications include *Nebraska Quilts and Quiltmakers*, which won the Smithsonian's Frost Prize for Distinguished Scholarship in American Crafts in 1993, and *Wild by Design: Two Hundred Years of Innovation and Artistry in American Quilts*, which won the 2004 Textile Society of America's R. L. Shep Award for best book in the field.

CAROLYN DUCEY, curator of collections at the International Quilt Study Center & Museum, earned her MA from Indiana University. She is currently completing her PhD in textile history with an emphasis in quilt studies at the University of Nebraska–Lincoln. She has organized numerous exhibitions, including The Collector's Eye: Amish Quilts and African-American Quilts from the Cargo Collection. She is the coauthor of *Masterpiece Quilts from the James Collection* (1998) and a contributing author to *Wild by Design: Two Hundred Years of Innovation and Artistry in American Quilts* (2003).

BEVERLY GORDON, recipient of the 2004 International Quilt Study Center Visiting Scholar Fellowship, is a professor in the Design Studies Department at the University of Wisconsin–Madison. Her most recent published book is *The Saturated World: Aesthetic Meaning, Intimate Objects, Women's Lives, 1890–1940* (2006). She is completing a new manuscript, *The Fiber of Our Lives: Why Textiles Matter*.

JONATHAN GREGORY earned his MA in textile history from the University of Nebraska–Lincoln. His research has explored the personal and social meanings and functions of quilts made during war time in the United States. He is the author of an article on the quiltmaker Rose G. Kretsinger published in *Uncoverings 2007*. Gregory is currently a doctoral student in textile history at UNL, where he also serves as the exhibitions curatorial assistant at the International Quilt Study Center & Museum.

VIRGINIA GUNN is a professor of clothing, textiles, and interiors in the School of Family and Consumer Sciences at the University of Akron in Ohio. She holds a BS in home economics education from Kansas State University, an MS in applied art from Syracuse University, and a PhD in history from the University of Akron. She has contributed numerous foundational articles on American quilt history, as well as publications on coverlets and women's history. Gunn is the 2005 IQSC Visiting Scholar Fellowship recipient. She is a past president (1990–1993) and board member (1984–1994) of the American Quilt Study Group and edited *Uncoverings* from 1994 to 2003.

MARIN F. HANSON is the curator of exhibitions at the International Quilt Study Center & Museum. She holds undergraduate degrees from Grinnell College and Northern Illinois University and earned her MA in textile history with a quilt studies emphasis from the University of Nebraska–Lincoln. She has curated and written catalogs for several exhibitions, including Quilts in Common and Reflections of the Exotic East in American Quilts. Her other publications include articles in the American Quilt Study Group's *Uncoverings* as well as in other textile- and history-related journals.

JONATHAN HOLSTEIN and his wife, GAIL VAN DER HOOF, became interested in the aesthetics of American quilts in the late 1960s and formed a collection from which was drawn the pivotal 1971 Whitney Museum of American Art exhibition, Abstract Design in American Quilts. Many similar exhibitions curated by them in the United States and abroad followed, and Holstein lectured and wrote extensively on the subject. His first quilt book, *The Pieced Quilt: An American Design Tradition*, explored quilts as designed objects. Many other exhibitions, articles, lectures, and other books have followed. Holstein lives in Cazenovia, New York.

LAUREL HORTON is an internationally known quilt researcher. Her MA thesis (Folklore, University of North Carolina, 1979) was one of the earliest regional studies of American quilts, and her award-winning book, *Mary Black's Family Quilts: Memory and Meaning in Everyday Life* (2005), set a new standard for historical quilt research. She is the 2006 recipient of the IQSC Visiting Scholar Fellowship. A member of the American Quilt Study Group since 1982, she edited *Uncoverings* from 1987 to 1993. Her current research interests include early white whole-cloth quilts and embroidered coverlets and international quiltmaking traditions. Horton lives in Seneca, South Carolina.

DEBORAH RAKE received her MA in textile history with a quilt studies emphasis from the University of Nebraska–Lincoln. She curated Modern Marvels: Quilts Made from Kits, 1915–1950, as her thesis exhibition. Rake resides in Homestead, Florida.

MERIKAY WALDVOGEL is a nationally known quilt authority and is best known for her published works on 1930s quiltmaking, including *Soft Covers for Hard Times: Quiltmaking and the Great Depression* and *Patchwork Souvenirs of the 1933 Chicago World's Fair*. She was the 2003 recipient of the IQSC Visiting Scholar Fellowship. She has served as a board member of the American Quilt Study Group and the Alliance for American Quilts. Waldvogel has a BA in French from Monmouth College and an MA in linguistics from the University of Michigan. She lives in Knoxville, Tennessee.

Index

Page numbers in italic refer to illustrations. Every quilt pictured in this work is indexed by name. Specific details of construction—such as backing fabric or binding—discussed in the accompanying text are indexed. Conventional names are referenced to similar names in the text, e.g.: Star quilts. See also Lone Star quilts; quilt names in italics were named by the maker or collector. Quilt names in Roman indicate the conventional name for the pattern. Page numbers in bold refer to glossary entries. For more information about individual quilts, consult the IQSC database at www.quiltstudy.org.

Abercrombie, Mary Adams, 55
A.B.R. (maker of Crazy quilt), 151
acetate fabrics, 432, 434
Aesthetic Movement: as Anti-Modernism, 1–3, 17; and Crazy quilts, 3–4, 6, 131, 149, 168, *168–70*; and madder style colors, 12. *See also* Crazy quilts
African American quilts, 47, 82
Airplanes quilt, 370, *371*
Album, Signature quilts, *13* (detail), *68*, 82, 267, 373, *373*, *385* (detail), *442, 442, 443, 444*
Album quilts, 82, 83, 363, 372, 373, 376, 380, *382–83* (detail), 399, 442, *442, 443*, **463**. *See also* Sampler Album quilts; serial and syndicated quilts; Star and Chintz Album quilt
alizarin, 12, 27, 31, 100, **463**. *See also* madder
allover-style quilts, overview of, 180–83
Alphabet and Eight-Pointed Star quilt, *312, 313* (detail), 313–14
Alphabet quilts, 314, 370, *371, 372*, 458n12; pattern, *315*
American centennial of 1876, 92, 196,

196, 291
An American Home quilt, *394, 395–96, 396–97* (detail)
American Needlework (Harbeson), 279
American Quilts and Coverlets (Peto), 280
American Tobacco Company, 410
American Woman magazine, 306
Amish quilters, 35, 43, 392, 434. *See also* Germanic traditions
aniline dye, **463**
animal motifs, 291
Anne Orr Studio. *See* Orr, Anne
anonymity of quiltmakers, 283
Anti-Modernism, 1–3, 17, 114. *See also* Modernism
Antique Urn quilt, 279, *279*
appliqué, *25*, **463**
appliqué quilts: in Colonial Revival, 9, 260, 267; construction of, 12; Hawaiian quilts as, 421; kits and patterns for, 306, 338; in Sampler Album, 48
Arachne, 32
Around the World quilts, *20* (detail), *80*. *See also* Rainbow Around the World quilt; Trip Around the World quilts
Art Deco design: in allover-style quilts, 223; in block-style quilts, 58; and Colonial Revival, 229, 254, 263, 264, 267, 276, 294; in Crazy quilts, 114; in idiosyncratic layout, 432; kits and patterns for, 325, 363, 374, *379*; Oriental influences on, 329
Arthur's Home Magazine, 7, 10, 96, 155
Art Needlework Creations, 337
Art Nouveau, influence of, 27, 229, 363
Arts and Crafts style, 6, 229, 325
Asian textiles, imitations of, 27. *See also* Orientalist influence

asymmetrical design, 414
Augustyn, Ruth, *367*
Aunt Martha Studios (Colonial Pattern Company), 61, *61*

Baby Bunting pattern, *326*
backing fabrics, 95, *95*, 212, 247
backings: in allover-style, 196, 199, 200, 209; in block-style quilts, 39, 46; Colonial Revival, 273; in Crazy quilts, 96, *102–3, 103*; made of older fabrics, 110, *110*
Baltimore Album quilts, 395
Barn Raising setting, Log Cabin. *See* Log Cabin (Barn Raising setting) quilts
Bars quilts, *224*; pattern, 183, 223
Basket of Flowers quilts, *373, 445*
Basket of Lilies quilt, 257, *257, 258* (detail), 259. *See also* Lily quilt
Baskets quilts, 8, *11* (detail), 42, *42–43, 43* (detail), *76, 77, 87*, 294, *294–95, 295, 301*. *See also* Dutch Baskets quilt; Flowers in Baskets quilt; French Baskets quilt; Fruit Basket quilt
bathing suits, 166, *166* (details)
batting, 421, 461n20, **463**
Beard, Eleanor, 254, 286, 458n149
Beauty of Hilo Bay quilt, *420, 421, 421* (detail)
Beaux Arts movement, 138
Bedtime Quilt (McKim and Burgess), 24
Benson, Jane, 243
Bergen, Fanny D., 233, 246
Beshore, Evangeline, 318
Better Homes and Gardens magazine, 259
bias-cut fabrics in Log Cabin quilts, *11, 11*
bindings, **463**; in allover-style quilts, 200, 207, 209, 212; in block-style quilts, 58; Colonial Revival, 240,

Bindings (*cont.*)

 244, 247, 260, 276, 286; and Germanic aesthetic, 43; in kits and pattern quilts, 338, 341

Bird in Air quilt, 178–79 (detail), 190, 191–92, *191* (detail), *192* (detail), *193* (detail)

Bird of Paradise quilt, 370

Birds in Air quilts, *84, 215*

Birds quilt, *436*

Black, Mattie Clark, 387

Blair, Helen, 250

Blazing Star quilts, 220, 298, 378

block-of-the-month quilts. *See* serial and syndicated quilts

block-style quilts: in allover-style quilt construction, 211–12, *212*; and Crazy quilts, 175, *175–76*; kits and patterns for, 306, 380; and machine sewing, 12; overview of, 20–24

blue: Delft, 243; double blue prints, 39, 100, 247, **464**; Prussian blue, 27, 39, **464–65**. *See also* indigo

blue and white embroidery, 279

Boag Company, 351

Bok, Edward, 317, 325. See also *Ladies' Home Journal* magazine

Boldtmann, Charlotte F., 237, 260, 292

borders: on allover-style quilts, 187, 188, 196, 199; on block-style quilts, 39, 61; Colonial Revival, 237, 244, 248, 253, 259, 267, 273, 276, 291, 294, 294–95; of Crazy quilts, 105, 112, *112*, 140–41, 145, 151; on kit and pattern quilts, 337, 348; and machine sewing, 12; on one-of-a-kind quilts, 391

boudoir dolls, 263

bouquet quilts. *See* Floral Bouquets quilt

Bow Tie quilts, *68, 216*

Brackman, Barbara, 237

Bradley, Lizzie M., *169*

Brick Wall quilt, *221*; pattern for, *221*

brocade, **463**

Brockstedt, H. M., 314. *See also* Ladies Art Company

broderie perse work, 283

Broken Circle quilt, *34, 35, 35* (detail)

Broken Dishes quilts, 32, *32* (detail), *33, 68, 78*; pattern for, *191*

Broken Star quilts, *378*; as kits, 310

Brooks, Alice, 309, 458n3

Bucilla kits, 370

Burdick family, *173*

Burgoyne Surrounded quilts, *8* (detail), 268, *269, 270, 288*; pattern for, *8, 288*

Burmeister, Anna Hazel, 109, *109*

Butterfly quilts, 370, *371, 376, 439*

Cabot, Nancy (pseud. of Loretta Isabel Leitner Rising): kits and patterns, 309, 325, 326, 329, 458n3; Oriental Tulip kit by, *375, 375*; Rose Bower kit by, *356, 356* (detail), *357*

Caden, Annie M., 387

Caden, Margaret Rogers, 387, 428, 431

Calendar quilt, *424, 425, 425* (details)

calico, 28, 207, 212, **463**

Calico Craze, 28–31

California Star quilt, *299*

Campaign Ribbons Crazy quilt, *160, 161–62, 161* (detail), *162* (detail), *163* (details)

Capper's Weekly, 35, 347, 379, 387, 458n3

Carpenter's Square quilts, 300, *392, 392* (detail), *393, 446*

Carpenter's Wheel quilt, *299*

Centennial Commemorative quilt, *440*

Centennial Exposition (Philadelphia, 1876), 3, 4, 131, 229

Center Diamond quilts, *12* (detail), *301, 446*; variation of, *446*. *See also* Diamonds quilt

Century of Progress Exposition (1933), 264, 417. *See also* Sears Century of Progress Quilt Contest

A Century of Progress quilt, *426, 427, 428–29, 429* (detail)

challis, 156, 184, **463**

chambray, 13, 110, 200, **463**

charm quilts, 192, 194, 208–9, **463**

cheater cloth, 152, 155, **463**

Checkerboard quilt, *78*

Chicago. *See* Century of Progress Exposition (1933); Columbian Exposition (1893)

Chicken Ribbons quilt, *385* (detail), *438*

The Chief quilt, *376*; pattern for, *304–5*

children, quilts by, *442*

children, quilts for, 370, *370–71*

China, Qing Dynasty imperial flag, *417*

Chinese Block pattern, 32

Chinese influences. *See* Orientalist influence

Chinese Lantern quilt, *175*

chintz, 247, **463**

chintz appliqué, 280, *282–83, 283*

Christmas Cactus quilt, *296*

chrome orange, 52, **463**

chrome yellow, 39, 42, 100, 105, **463**

church-related albums, *444*

Cigar Ribbons quilt, *439*. *See also* Tobacco Premiums quilts

claret prints, 110

Clark, W. L. M., Company, 310

Clarke, Laura May and Bozena Vilhemina, 279, *279*

Cleveland Herald, 40

clothing scraps and remnants, 47, 128, 145, 200, 273

Cocheco Printworks, 35, 36

Codman, Ogden, Jr., 230

Coffee Cups quilt, *87*

Coffin cover quilt, 138, *139, 139* (details)

coffin quilts (coffin drapes), 138

coffin quilts (coffin shapes on quilts), 452n10

Colonial History quilt, *228* (detail), *367*

Colonial Lady quilt, *16* (detail), *262, 263–64, 265* (detail); as motif, 276

Colonial Needlecraft Heirloom Quilts catalog, 338

Colonial Pattern Company (Aunt Martha Studios), 61, *61*

Colonial Revival movement: as Anti-Modernism, 1–2, 17, 114; background of, 6–9, 229–33; and Colonial Revival interiors, 231; color palette of, 8, 12, 13, *13*, 233, 250, 254, 259, 273, 279, 284, 300, *300–302*; and fanciful quilt stories, 329, 351; kits and patterns, 16, 233, 256, 264, 341; and Marie Webster, 309; role of quilts in, 232, *232–33,* 359

color palettes: and cheaper fabrics, 395; Colonial Revival, 8, 12, 13, 233, 250, 254, 259, 273, 279, 284, 300, *300–302*; Germanic aesthetic, 35, 36, 180; Marie Webster, 251,

253, 307, 325, 368; in 1920s and 1930s, 13, *286*, 333, 338; pinks in, 13, 31, 36–37, 39, *188*, **464**; trends in, 20. *See also* blue; fading; green; orange; pastels; purple; red; two-color quilts; yellow, chrome

Columbian Exposition (1893), 6, 230, *231*, 447n21; Commemorative quilt, *440*

Comfort magazine, 24, 234

commemorative quilts, 406, *440*

Concentric Squares quilt, *219*

Congo red, 12, *13*

construction technique: allover design in block style, 211–12, *212*; and dating of textiles, 27; for the inexperienced quilter, 204, 207; for Sunflower design, 56; yo-yo, 384, 387, 418

contests: Colonial Revival, 253, 279; serial quilt, 309, 342, 345. *See also* Sears Century of Progress Quilt Contest

contrast: between light and dark in Log Cabin, 90, 92; in shading, 22

conversation prints, **463**. *See also* object prints

Cook, Olive Emily, 284, *284*, 286

Corbett, Bertha L., 263

Cornucopia quilt, *321*, *441*. *See also* Horn of Plenty quilts

cotton: in Crazy quilts, 155, 171; prices of, 31, 70, 92, 395, 449n32, 461n5

cotton-wool mix fabrics, 99

counterchange, 47, 74, *74*

country Crazy quilts, 7, 156, 159, 171, *171–72*

County Fair quilt, *85*

Courthouse Steps variation, Log Cabin. *See* Log Cabin (Courthouse Steps variation) quilts

coverlets, woven, and Colonial Revival quilts, 8, 250, 270, 288, *288–89*

Coxcomb and Berries quilt, 260, *261*

Coxcomb quilt, *296*, *297*

crash (fabric), 155, 452n23

Crazy Ann quilt variation, *81*

Crazy cheater cloth quilt, *154*

Crazy cloth. *See* cheater cloth

Crazy/Log Cabin quilt, 4, *4* (detail), *142*, *142* (detail), *143* (detail)

Crazy Quilt pillow sham quilt, *131*

Crazy quilts: cotton, 155, 156, *172*, *174*; definition of, 165, 173; derivation of name of, 131; fan motifs in, 329; and foundation patchwork, 51; high-style, 168, *168–70*; iconography in, 132, 136–37, 141, 145, *145*, 151, 159; influences on, 3–4, 447n4; and Log Cabin, 4; machine stitching in, 11; overview of, 128–32; popularity decline of, 5–6, 156, 238, 306; popularity of, viii; and string quilts, 69; traditional elements in, 175, *175–76*; vernacular in/country style of, 7, 156, 159, 171, *171–72*; wool fabrics in, 156, 165

Crazy Quilts (plates), *3* (detail), *4* (detail), *5* (detail), *6* (detail), 51, *126–27* (detail), *129* (detail), *130* (detail), *131* (detail), *132* (detail), 140, *140–41*, *141* (details), 144, *144–45*, *145* (details), *150*, *150* (detail), 151, *151* (detail), 156, *156* (detail), *157*, *158–59* (detail), 159, *168–76*, *391*, *398*, *399–400*, *400* (detail), *401* (detail); Columbian Exposition Commemorative, *440*; *My Crazy Dream*, *xii* (detail), *134*, 135–37, *135* (detail), *136* (detail), 137, *137* (detail); variation, *164*, 165–66, *165* (detail), *166* (detail)

Crazy Quilt table cover, *14* (detail), *133* (details), 146, *146* (detail), *147*, *148* (detail), *149*, *149* (detail)

Crazy Star quilt, *175*

Crazy Stars quilt, *152*, *152* (detail), *153*, 155, *155* (detail)

cretonne fabric, *188*, *188*, **464**

crewel embroidery, 279

Crossed Ts quilts, *71*, *80*

Crosses quilt, *73*

cross-stitch samplers, 275–76

Crown of Thorns quilt, *78*

the Crusades, 188

Daisy Chain quilts, *366*, *367*

Dallarmi, Mary, 25, 448n5

Dancing Daffodils quilt, 304, 325, *374*, *374*

Dangerfield, Elizabeth, 233

date-inscribed quilts, 100, *100*, 135, *135*, 151, 156, 194, *248*, 267, 336–37, *363*, 451n15

dating of quilts: by campaign ribbons, 162; and fabrics, 27, 52; and fluorescence, 61, 112, 203; and machine stitching, 40–41; Pennsylvania quilts and, 45–46; procedures for, viii–ix

decals for Crazy quilts, *14*, *14*, *130*, *131*, 136, *137*, *146*, *146*

The Decoration of Houses (Wharton and Codman), 230

Deerfield Society of Blue and White Needlework, 279

Deer in Wedgewood quilt, 422–23, *423*, 461n21

delaine, 156, 184, **464**

Delectable Squares quilt, *71*

Delft blue, 243

The Delineator magazine, 260

Demorest's Monthly Magazine, 230, *231*

Depression Era: color palette used during, 13, *286*, 333, 338; and quiltmaking, 337; and thrift, 280, 309, 432. *See also* Sears Century of Progress Quilt Contest

de Wolfe, Elsie, 58

Diamond Field quilts, *197*, 197–99, *198* (detail), *218*; pattern, *199*

Diamond Flower Garden quilt, *218*

Diamonds quilt, *222*. *See also* Center Diamond quilts; Sawtooth Diamond quilts

Dinsmore, Cora, 260, *381*

Dinsmore, Rebecca Alford, 68

dobby weave, 96, 155, **464**

Dogwood Blossom quilt, *379*

Dolly Varden quilt, *367*

Dorcas magazine, 128

double blue prints (Lancaster blue), 39, 100, 247, **464**

Double Irish Chain quilts, 79, 288, *380*; variations of, *79*, *288*. *See also* Irish Chain quilt

Double Nine Patch quilts, *248*, *248* (details), *249*, 250, *289*, 302. *See also* Nine Patch quilts

double pinks, 31, 36, 39, *188*, **464**

Double Wedding Ring quilts, *311* (detail), *377*; as fad, 20. *See also* Pickle Dish quilts

Doyle, Joseph, 24

dragon motif, in Qing Dynasty imperial flag (detail), *414*, *417*

Dragon quilt, 414, 415, 416 (detail), 417
Dresden I quilt, 366
Dresden Plate quilt, 348, 349, 350 (detail), 351
Drunkard's Path quilt, 80; pattern for, 22, 72, 80
Duke, James B., 410
Durham, James H. and Company, 309
Dutch Baskets quilt, 369. See also Baskets quilts
Dutchman's Reel quilt, 36–37, 36 (detail), 37
dyes, synthetic: and Colonial Revival color schemes, 8; and colorfastness, 20; and dyeing and printing processes, 12; invention of, 31, 52–53; and prices of cotton, 70

eagle motifs, 291, 291
Eagle quilt, 7 (detail), 291, 409, 440
Eastern States Exposition (1932), 253
eccentric prints, **464**
Eccentric Star quilt, 72
echo quilting, 421
Eckles, Mary McConahy, 367, 381
Edwards, Phoebe Lloyd, 364
Egyptian motifs, 209
Eight-Pointed Star quilt, 75
elbow quilting, 432
embroidered piqué, 207
Embroidered quilt, 439
embroidery: in "country" Crazy quilts, 159; on Crazy quilts, 4, 128, 135–36, 140–41, 141; Deerfield, 279; as entrée to quiltmaking, 309; on foundation patchwork, 51
Encyclopedia of Pieced Quilt Patterns (Brackman), 237
English Rose quilt: variation, 284, 285, 286, 286 (detail). See also Rose quilts
European fashion, 263
exotic cultures, influences of, 375, 375–76, 417. See also Orientalist influence

fabrics: analysis of, viii; for Crazy quilts, 6; and dating of, 55, 105; in kit quilts, 351; and Log Cabin variation, 92; prices for, 31, 70, 92, 395, 449n32, 461n5; quality of, 48; recycled, 96, 96, 151, 162, 207, 280.

See also cotton; silk; wool fabrics
fading: of greens, 13, 13, 20, 52, 212, 233; of Prussian blue, 39; of purple, 199; of synthetic dyes, 12, 13, 48
fads and fashion cycles, 259, 294, 322
fairs and exhibitions: colonial exhibits at, 229–30, 253; as inspiration, 417; Log Cabin designs in, 92, 95; and women's fundraising, 267
fairyland quality of Crazy quilts, 132
family histories in quilts, 233
fancywork and the ideal Victorian woman, 3
Fan quilt, 379, 391, 460n2. See also Grandmother's Fan quilts
Fans quilt, 326, 327, 328 (detail), 329; as motif, 391
Farm & Fireside magazine, 306, 322, 322, 323
Farm and Home magazine, 80
Farm Journal Quilt Patterns Old and New, 322
Feathered Star quilts, 20 (detail), 75, 242, 243–44, 244 (detail), 298, 301, 302; pattern for, 8
Fence Post quilt, 78
Ferry, Christine, 253
fiber content, ix. See also fabrics
figural designs, 20–21, 87, 395, 409, 445. See also Pictorial Quilts
figure-ground reversal. See counterchange
Finch, Eliza S. and Andrew F., 268
Finley, Ruth E., 36, 80, 223, 233, 234, 259, 270, 370
Fireside Visitor, 458n12
Flags quilt, 441
Fleur-de-lis quilts, 302, 437
Floral Basket quilts, 338, 339, 340–41 (details), 341, 370. See also Baskets quilts; Flowers in Baskets quilt
Floral Bouquets quilt, 254, 255, 256
Floral Wreath quilt, 446. See also Wreath quilt
Flower Garden quilt, 373; as fad, 20. See also Basket of Flowers quilts; Pots of Flowers quilts; State Flowers quilt; Vase of Flowers quilt
flower motifs, 294, 294–95, 370. See also specific flowers, e.g., Rose
Flowers in Baskets quilt, 295. See also

Basket of Flowers quilts
fluorescence, 61, 112, 203
Flyfoot quilt, 81; pattern for, 36
Flying Geese quilt, 70. See also Goose in the Pond quilt; Wild Goose Chase quilts
Foland, Eveline, 309, 458n3
fold-and-cut appliqué, 421, 436, 437
Fordyce, Lillian Smith, 425
Forget-Me-Knot pattern, 254
Foster, Edna, 360
Foth, Wilhelmine Ziemke, 373
foundation patchwork, 51, 69, **464**. See also Log Cabin (quilt pattern)
Four-Block appliqué pattern, 296, 296–97
four-block design, 9, **464**
Four H quilt, 71
Four Patch quilts, 66, 85; pattern for, 66; variation of, 58, 59, 68
Four Swallows quilt, 322, 322 (detail), 323; pattern for, 322
French Baskets quilt, 369
French Wreath quilt, 308 (detail), 367. See also Wreath quilt
friendship quilts, 82, 399. See also Album quilts
Friendship Ring pattern, 351
From 1833 to 1933 quilt, 386 (detail), 387, 387 (detail), 441
Fruit Basket quilt, 308 (detail), 366
Fry, Raymond D., 443
fundraising quilts, 6, 12, 267, 442. See also signature quilts
Furniture of the Olden Time (Morse), 230
"fussy cut" piecing, 184, 187, 350

Garden Maze quilt, 73
Gardner, Charlotte, 445
geometric quilts, 8, 52, 122, 122, 446
Germanic traditions: block-style quilts, 35, 36, 43; Colonial Revival, 260, 296; Crazy quilts, 109, 451n17; fold-and-cut technique, 421, 436; hexagon quilts, 188, 199. See also Pennsylvania quilts
Giddap quilt, 372
Godey's Lady's Book and Magazine, 10, 145, 180
Good Housekeeping magazine, 128, 307, 360

Goose in the Pond quilt, *85. See also* Flying Geese quilt; Wild Goose Chase quilts

Gore, Alice S. Bennett, 28–31, *29*

Grandmother's Fan quilts, *308* (detail), *376, 379, 391,* 460n2. *See also* Fan quilt

Grandmother's Flower Garden quilt, *17* (detail), *334, 335, 336* (detail), 336–37

Grant, Helen, 254

Grape Clusters quilt, *381*

Grapes and Vines quilts, *15* (detail), *368, 368, 369, 374*

green, 12–13, 20, 52, 100, 212. *See also* Nile green; red-and-green appliqué

Greenaway, Kate, *5,* 132, 135, 159, 370

green calico, 40, 52

Gunnerson, Murl "Mabel" Brickner, *370, 380*

Guppy, Ethelyn J., 259, 294

Gutherless, Ruth Harnan, 55

Guthrie, Jane W., 270, 288

Haggard, Martha, 20

Hall, Carrie A., 271, 284, 326

Hall, Eliza Calvert, 233

Hall, Julia, 23

Hamilton, Clinton R., *445*

hand appliqué, 278

hand quilting: of allover-styles, 187, 188, 196, 200, 207, 212; of block-style quilts, 31, 35, 37, 40, 52, 58, 61; Colonial Revival, 237, 240, 243–44, *244,* 247, *248, 248,* 252, 256, 259, 260, 267, 268, 273, 276, 278, 283, 284; of Hawaiian quilts, 421; in Log Cabin style, 105; in one-of-a-kind quilts, 392, 396, 404, 408, 432; and quality of work, 12, 57

hand quilting, professional, 322, 359, 360, 387

hand quilting, stitches per inch: procedures for counting, ix; less than 6 stitches, 38, 54, 111, 140, 185, 205, 208, 274, 331, 346, 395; between 6 and 9 stitches, 34, 49, 91, 93, 153, 189, 239, 266, 349, 407, 411, 414, 433; between 7 and 10 stitches, 46, 59, 60, 186, 201, 210, 245, 255, 281, 316, 334, 362, 423,

424, 430; between 8 and 11 stitches, 26, 42, 94, 271, 285, 320, 324, 341, 403, 420, 427; between 9 and 11 stitches, 41, 181, 195, 197, 235, 242, 269, 323, 326, 353, 393; more than 10 stitches, 104, 249, 251, 257, 261, 278, 339, 357, 358, 390

hand stitching: in allover-style quilts, 211; in block-style quilts, 47, 56; in Colonial Revival quilts, 244; in Log Cabin quilts, 11, 96, 103; in one-of-a-kind quilts, 392

Harbeson, Georgiana Brouwn, 279

Harnan, Ella Abercrombie, 55–57

Harper's Bazar, 58, 243, 254, 270, 288

Harris, Florence LaGanke. *See* LaGanke, Florence (as Nancy Page)

Hawaiian Appliqué quilt, *16* (detail), *404, 436*

Hawaiian Flags quilt, *445*

Hawaiian quilts, 421

Hays, Margaret, 363–64

Headlee, Hannah Haynes, *445*

Hearth & Home magazine, 24, 82, 306, 458n12

Hearts and Gizzards quilts, *50,* 50–51, *51* (detail), *73*

Hedgelands Studio, 254

Held, Anna, image of on ribbons, 149, *149,* 452n17

Heller, Hattie, *441*

Herdrich, Paulina, *291*

Herron, Mrs. Schuyler, 253

Herrschner, Frederick, Inc. *See* Needleart Guild

Hess, Ida, 318

Hexagons quilts, *7* (detail), *17* (detail), *180* (detail), *186, 187, 187* (detail), *188, 188* (detail), *189,* 194, *195,* 196, *196* (detail), *218, 219, 220*

Hexagon Star quilt, *184, 184* (detail), *185*

hexfeiss motifs, 36

Historic Quilts (Peto), 280

Hole in the Barn Door quilt, *71*

Homeneedlecraft Creations kit quilt, *367*

Home Needlework Magazine, 32, 254, 310

Hooker, F. J. "Fritz," 347, 363–64, 460n79. *See also* Stearns and Foster Company

Horn of Plenty quilts, *320, 321, 370;* pattern for, *321. See also* Cornucopia quilt

House Beautiful magazine, 250, 254

Household Art magazine, *380, 418*

Housetops pattern, 47

humility blocks, 32, *32,* 236–37, *237*

Humphreys family, *78*

Hymns quilt, *444*

immigration, Colonial Revival as response to, 229

Indianapolis Star, 342, 345

indigo, 12. *See also* blue

indigo blue: calicoes, 47, 105, 243, 449n32, **464**; embroidery thread, 267

indigo discharge prints, 110, 112

industrialization: and prices of cotton fabric, 31, 70, 92, 395, 449n32, 461n5; responses to, 1, 229; and wool fabrics, 51. *See also* technological change

inscriptions. *See* date-inscribed quilts; signed and dated quilts; signed quilts

International Paris Exposition (1889), 230

International Quilt Study Center & Museum, vii

Irish Chain quilt: pattern for, 8, 288; variation, *79, 83. See also* Double Irish Chain quilts; Double Nine Patch quilts; Triple Irish Chain quilts

Jack in the Pulpit quilt variation, *85*

Jackson, Ida L., 233

Jacob's Ladder quilt, *84*

Japanese influences, *4, 4,* 131–32, *132,* 375, 390–91. See also *Mikado* (Gilbert and Sullivan); Orientalist influence

Jester's Plume quilt, *297*

Johnson, Abba Jane Blackstone, *115*

Justus, Josephine, *320, 321, 368*

Kaleidoscope quilt, *73*

Kansas City Star, 32, 322, 372, 458n3

Kansas Sunflower quilt, *54,* 55–57, *55* (detail), *56* (detail), *57* (detail). *See also* Sunflower quilt

Kashmir shawl motif, 12, 138
King's Crown quilt, 78
Kinmore, Marie, 270
Kirchmaler, Cora and Hugo, 254
kit quilts, **464**
kits and patterns: for block-style quilts, 23, 61; Colonial Revival, 16, 233, 256, 264; history of, 1, 14–15; overview of, 306–11; period of popularity of, viii; prices for, 309, 330, 337, 338, 351, 359; Sears contest winners' use of, 428–29. *See also* quilting designs
Kretsinger, Rose G., 271, 284, 326

LaCroix, Sophie T., 254
Ladies Art Company: alphabet series, 313, *371*; Alphabet and Eight-Pointed Star quilt, *312*, 313–14, *314* (detail); Alphabet pattern by, *315*; Baby Bunting pattern by, 326, *329*; Basket of Lilies patterns by, 257, 259; Dresden Plate pattern, 351; Lone Star pattern, 271; pattern catalog, 14, 24, *25*, 306, 314; pattern names, 32, 51, 80; Rocky Road to Kansas pattern, 69
Ladies Fancy Work Company, 325, 428
Ladies' Home Journal magazine: and Colonial Revival, 8, *231*, 240; dragon motif in, 417; and Marie Webster, 306–7, *317*, 325, 368; patterns in, *25*, *232*, *238*, *241*, *247*, *298*; sewing machine from, 10–11; on washing quilts, 243
LaGanke, Florence (as Nancy Page), 309, 352, 355, 366, 429, 458n3
Lancaster blue (double blue), 39, 100, 247, **464**
Landon/Knox Quilt, 432, *432* (detail), *433, 434*
Langley, Mabel, 253, 428
Lanigan, Sybil, 238, *241*, 247, *298*
Lanvin, Jeanne, 263
Large, Mary Harriett, 237
Larimore, Mrs. D. T., 253
Lattice with Crazy Border quilt, *176*
Laughlin, Sarah, *369*
Laurel Wreath quilt, 366. *See also* Wreath quilt
layouts, idiosyncratic, 413, 417, 432, 461n11

LeGrand, Gayle Gutherless, 55
Leitner, Loretta Isabel (as Nancy Cabot), 356, 458n3. *See also* Cabot, Nancy (pseud. of Loretta Isabel Leitner)
Leitzel, Mrs. G. R., 429
LeMoyne Star quilts, 75, *289*, *380*
Leonhard, Emma Mae, 342, 387, *441*, 459n45, 461n29
light and dark contrast in Log Cabin, 90, 92
Lily quilt, *379*. *See also* Basket of Lilies quilts
linen fabrics, 276, 318
lines and stripes, 221, *221–22*
Linville, Mattie, *169*
Lloyd, Phoebe, 364
Lobster quilt, 437
Lockport Cotton Batting Company, 310, 376
Lockwood, Sarah M., 233
Log Cabin (Barn Raising setting) quilts, 92, *95* (detail), 96, *96* (detail), 97, 114, *114–15*, 122; setting, *95*
Log Cabin (Chevron setting) quilt, *114*
Log Cabin (Chimney and Cornerstone setting) quilts, *11* (detail), 104, 105, *105* (detail), 121, *124*
Log Cabin (Concentric Squares setting) quilt, *120*
Log Cabin (Courthouse Steps variation) quilts, *93* (detail), 100, *100* (detail), *101*, *102* (detail), 103, 106, *106* (detail), 107, 116, *116–17*, 123, *124*; setting, *93*
Log Cabin (figural design). *See* Schoolhouse quilt
Log Cabin (Light and Dark setting) quilts, 120, *123*, 124
Log Cabin (one-of-a-kind setting) quilt, 98, 99, *99* (detail)
Log Cabin (Pineapple variation) quilts, 90, *93* (detail), *94*, 108, 109, 118, *118–19*, 123; setting, *93*
Log Cabin (quilt pattern): and Crazy quilts, 4; foundation patchwork in, 51; layers in, 120, *120–21*; machine quilting in, 448n36; overview of, 90–95; period of popularity of, viii; as political symbol, 86, 92; and secondary designs, 72; settings, 92, 93, 95, **464**; standard

block for, *92*; and string quilts, 69; terminology, 450n2
Log Cabin (Straight Furrow setting) quilts, 121, *122*
Log Cabin (Streak of Lightning setting) quilts, 91, *120*
Log Cabin (Sunshine and Shadow setting) quilts, 110, *110* (detail), 111, 112, *112* (detail), 120
Log Cabin/Crazy quilt, 4, *4* (detail), 142, *142* (detail), *143, 143* (detail)
Lone Star quilts, 271, *271*, *272* (detail), *273*, 430, 431; as kits, 310
Love Apple quilt, *295*
Lowery, Rose Marie, 61

machine appliqué, 11, *43*, 43
machine quilting, 10, *10*, 392, 448n36
machine stitching: of allover-style quilts, 207, 211; of block-style quilts, 40–41, 56; Colonial Revival, 237, 240, 244, 248, 273; and dating of textiles, 27; of Log Cabin quilts, 11, 96; of one-of-a-kind quilts, 392
Mackey, Ethel Ready, 431, *431*
madder, 12, 100, **464**. *See also* alizarin
madder-style prints, 12, 27, 31, 42, **464**
Magpie Rose quilt, *386* (detail), 387, *441*. *See also* Rose quilts
mail-order companies: of Crazy quilt scraps, 14, 17, 24, 128, 145; designers at, 359, 366; fabrics from, 156, 209; kits and patterns from, 24, 32, 306, 310, 313, 338; and technological advances, 9, 14. *See also names of specific companies*, e.g., *Ladies Art Company*
Mallow, L. Cordelia and Hannah, 197, 197–99
manganese-style prints, 194
Mangold, Paulina, 367
many pieces, designs of. *See* small pieces, designs of
Marchbanks, Kate (pseud. of Louise Fowler Roote), 309, 346, 347, 458n3
Martha's Vineyard quilt, 374, *374*
Martha Washington Patchwork Quilt Company, *381*
Maugham, Syrie, 58

Mayborn, Bessie Jackson, *375*

Mayer, Jenney Young Ward, *378*

Mayer-Foeht, Marion, *378*

May Tulips quilt, *324,* 325; pattern for, *325*

McCall Needlework magazine, 263–64, *264*

McElwain, Mary A., 309, 330, 366; Daisy Chain quilt by, *366, 367;* Painted Daisy quilt by, *358,* 359–60, *360–61* (detail)

McKim, Ruby Short, 24, 259, 309, 322, *344,* 366, 458n3; Colonial History quilts by, *228* (detail), *367;* Flower Garden quilt by, *345, 345;* Fruit Basket quilt by, *366;* State Flowers quilt by, *342, 343, 344* (detail), 345

Meckstroth, Bertha, 422–23, *422*

Medallion quilts, *182* (detail), *219, 220*

medallion-style quilts: and allover-style, 219, *219–20;* in Colonial Revival, 238, 279; from kits and patterns, 317, 338, 368, *381;* in Log Cabin, 105

Mennonite quilts, 35. *See also* Germanic traditions

Meyer, Lucille, *295*

Michael, John C., Company, 330

Mickey and Minnie quilt, 370, *372*

Mikado (Gilbert and Sullivan), 5, 145, 163, 390–91. *See also* Japanese influences

Miller, Ellen, 279

Mills, B. I, 370

Mill Wheel quilt, *74*

mistakes in construction (humility blocks), 32, *32,* 236–37, *237*

Mitchell, E and B, *80*

Modern Art Company (New Haven CT), 24

Modernism: in block-style quilts, 61; and Colonial Revival, 229; in Crazy quilts, 173, *173–74;* in one-of-a-kind quilts, 395, 399–400, 432. *See also* Anti-Modernism

Modernistic Star quilt, *60,* 61

The Modern Priscilla magazine: and Colonial Revival, 233, 259, 294; kits and patterns in, 306, 307, *308,* 314, 321, 370, 458nn20–23. *See also* Priscilla Publishing Company

Modjeska, Rose, 356

Montgomery Ward, 31, 35, 128, 209, 259, 449n32

Morning Glories quilt, *367*

Morning Star quilt, *75*

Morris, William, 3

Morse, Frances Clary, 230

mosaic patchwork, 5, 7, *17,* 188, *194.* *See also* Hexagons quilts; template piecing

Mountain Mist patterns: Dancing Daffodils, 325, 374, *374;* Homespun, 270; Martha's Vineyard, 374, *374;* Morning Glories, *367;* Mountain Star, 374, *374,* 460n79; New York Beauty, *347;* by Sears contest winners, *428;* Star of the Bluegrass, 387, 440, *441;* Sunflower, 325, *362,* 363–64, *363* (detail); Wild Ducks, *15* (detail), 374, *374*

Mountain Star quilt, 374, *374,* 460n79

Mounts, Euphemia Medora Anderson, *441*

mourning prints, 27, 110, **464**

Mrs. Danner's Quilts Company, 325

Mueller, Marie, 321, *441*

multifabric quilts. *See* charm quilts

Murray, Mary Spriggs, 368

My Crazy Dream quilt, *xii* (detail), *134,* 135–37, *135* (detail), *136* (detail), *137,* *137* (detail)

naming of quilt patterns. *See* quilt patterns, naming of

Nancy Page Quilt Club. *See* Page, Nancy (pseud. of Florence LaGanke)

National Era (newspaper), 32

nationalism, and Colonial Revival, 229

Native American motifs, *375, 375*

Nebraska Quilt Project, 109

Needleart Guild, 338, *339,* 340–41 (detail), *341*

Needlecraft Company (Augusta ME, 256, 276

Needlecraft Magazine: block-style quilts in, 32; and Colonial Revival, 253, 263, 284, 296; kits and patterns in, 307, 310, 325

Needlecraft Service Company, 458n3

Needlecraft Supply Company (Chicago), 273, 337

New England Farmer magazine, 10

New England Homestead magazine, 458n12

newspapers, patterns in, 309, 356, 458n3

Nicely, Susan and M. Eva, 398, 399–400

niche quilts, 16, 384. *See also* Hawaiian appliqué; Tobacco Premiums quilts; Yo-Yo quilts

Nile green, 13, 62, 273, 333, **464**. *See also* green

Nine Patch quilts, *66,* 216; pattern for, 66, *110,* 288; variations of, *289.* *See also* Double Nine Patch quilts; Split Nine Patch quilts

North Carolina Lily quilt, *76*

nostalgia for the past, 1, 61, 86. *See also* Colonial Revival movement

Oak Leaf quilts, variation of, *436, 437*

Oak Reel quilts, 291, 300, *302*

oatmeal cloth, 155, 452n23

object prints, 192, *192, 193,* 209. *See also* conversation prints

Ocean Waves quilts, 22, 214, *214,* 221; variation of, *79, 222*

Oddfellows quilt, *445*

Ohio Star quilt, *79*

oil calico, 35, 40, 247, 449n22, **464**

Old Almanac Quilt, 352, *353, 354* (detail), 355; advertisement of, *352*

Olds, Mary Caroline Robinson, 242, *242, 243*

O'Neill, Esther (kit seller), *367*

one-of-a-kind quilts: Birds, *436;* Centennial Commemorative, *440;* Chicken Ribbons, *385* (detail), *438;* Embroidered, *439;* Flags, *441;* Flowers in Baskets, *295; From 1833 to 1933, 386* (detail), *387, 387* (detail), *441;* Oddfellows, *445;* overview of, 384, 387; popularity of, 16; unique techniques in, 437

One Patch quilts, 216, *217, 220*

on-point setting, *78,* 248, **465**

optical brighteners (fluorescence), 61, 112, 203

orange, 333

orange, chrome, 52, **463**

Orange Judd Farmer magazine, 43

Orange Peel quilt, *81*

Orientalist influence: and admiration

Orientalist influence (*cont.*)
for non-Western cultures, 1; in allover-style designs, 188; in Crazy quilts, 4, 138, 142, *143*, 145, 148, 149, *163*, 168; kits and patterns having, 329. *See also* exotic cultures, influences of; Japanese influences

Oriental Tulip quilt, 375, *375*

original quilts, 61, 98, 138, 264, 284, *295*, 317, 386, 387, *387*, 395, 402, 403, 406–7, *441*, 425–29, 436–41, *445*

Orr, Anne: as businesswoman, 309, 360; contest judging by, 253; as designer, 325, 366; patterns by, 254, *254*, 256; quilts made from patterns by, *366*, *367*; and Sears contest winners, 428

Paddleford, Clementine, 322

Page, Martha A., 270

Page, Nancy (pseud. of Florence LaGanke), 309, 429, 458n3; quilts made from patterns by, 352, *353*, *354* (detail), 355, *366*

Painted Daisy quilt, 358, 359–60, *361* (detail)

painted images on Crazy quilts, *150*, *151*, 151

painting, influence on quilts, 395, 399

paisley motifs, 138, 184

pastels: in block-style quilts, 20, 58; in Colonial Revival, 259, 284; in Crazy quilts, 110, 114; in kit and pattern quilts, 307, 317, 321, 337, 338; in palette of 1920s and 1930s, 13; and Sears contest, 426

patchwork, **464**

patriotic motifs: in Colonial Revival, 229, 300; eagles as, 7, *291*, 291, 409; in one-of-a-kind quilts, 440, *440*; Pine Tree pattern for, 234. *See also* political motifs

pattern cards, 23

pattern quilts, 82. *See also* Album quilts

patterns: full-size, 24; printed, 32; and sharing among neighbors, 23. *See also* quilting designs

patterns, commercial. *See* kits and patterns

Patterson, Dell, *293*

Peacock quilts, *375*, *384* (detail), *441*, 445

Peet sisters, 443

Pennsylvania quilts: and Colonial Revival, 260, 290; color palettes in, 39, 40, 180; as hexagon quilts, 188, 199; settings in, 44; Split Nine Patch in, 67. *See also* Germanic traditions

Perkin, Mrs. Joseph, *371*

Perkin, William, 52

Peto, Florence, 280

Philadelphia Centennial Exposition (1876), 3, 4, 131, 229

Philadelphia Pavement quilts, *210*, 211–12, *212* (detail), 217

photographs as source of design, 396

photograph transfers, 149

Pickle Dish quilts, *377*. *See also* Double Wedding Ring quilts

pictorial or figural quilts, 20–21, 87, 395, 409, 445

Pictorial Quilts, 388–89, *388* (detail), *389*, 438

Pineapple quilt, *296*

Pineapple variation, Log Cabin. *See* Log Cabin (Pineapple variation) quilts

Pine Tree quilts, 9 (detail), 77, 87, 234, *235*, *236–37* (detail), 237, 290; pattern, 290; variation, 290

Pink Dogwood quilts, 368, *368*, *369*

pinks, 13, 31, 36–37, 39, 188, **464**

Pinwheel quilts, 73, *78*, *81*

pioneer women, 267, 270, 359

Plum Blossoms quilt, 375, *375*

Poiret, Paul, 263

political motifs: "Billy Possum" (William Howard Taft), 95, *95*; and 1884 Republican presidential candidates, *129*; in Landon/Knox campaign, 432; Log Cabin as, 86, 92; in tobacco premium ribbons, 410; Whig Rose as, 292. *See also* patriotic motifs

Poppy quilts, *307* (detail), *316*, 317–18, *318–19* (detail), 368, *368*, *369*, 370, 381

postage stamp quilts: allover-style quilts as, 183; kits and patterns for, 330, 366; as one-of-a-kind quilts, 395. *See also* small pieces, designs of

Postage Stamps quilt, *83*

Postage Stamp Star quilts, *181*, *299*

Pots of Flowers quilts, *294*, *295*, *381*

Practical Patchwork Company, 318. *See also* Webster, Marie

prairie points, 267

Prairie Rose quilt, *292*. *See also* Rose quilts

Pratt, Charles, 445

pre-cut kits. *See* ready-cut kits

"preservation motive," 280

President's Wreath quilt, *10* (detail), *293*. *See also* Wreath quilt

pressed patchwork. *See* foundation patchwork

Prince of Wales, visit to Canada and United States by, 403

Princess Feather quilts, 9 (detail), *296*, *297*, 403; pattern for, *9*, 32; variation in, *ii* (detail), 402, 403–4, *404–5* (detail)

printed images on Crazy quilts, *14*, *146*, *148*, *149*

Priscilla Needlework Company, 309

Priscilla Patchwork Book, *321*

Priscilla Publishing Company, 320, 321. *See also* *The Modern Priscilla*

prize ribbons in Crazy quilts, 128

Progressive Movement, 8, 12

provenance, viii

Prussian blue, 27, 39, **464–65**

puffed shapes technique, 436

Puffed Squares quilt, *418*, *437*

purple, 199, 333

quality of construction. *See* quilt construction quality

The Quest of the Colonial (Shackleton), 230

quilt construction quality: adequate, 48, 276, 396, 406; carefree, 391; in Colonial Revival quilts, 243; by contest winners, 253; in Crazy quilts, 135, 146, 159; and hand quilting, 360; by inexperienced makers, 103, 264; and machine sewing, 12

quilt dealers and provenance, viii

quilt histories, fanciful, 329, 351. *See also* naming of quilt patterns

quilting, hand. *See* hand quilting

quilting, machine, 10, *10*, 392, 448n36

quilting as mirror of history, 388–89

quilting calico, 40

quilting designs: patterns for, 321, 322, 338, 360

quilting parties, 273

quiltmakers, documentation for, viii, ix

quiltmaking aids: as business enterprise, 1; kits and patterns, 309–10; and mail-order companies, 14; Marie Webster templates, 317–18; patterns for Crazy quilts, 152; popularity of, 16. *See also* kits and patterns

quilt patterns, naming of: Basket of Lilies, 257, 259; in Colonial revival period, 270; evolution of, 403; Four Swallows, 322; Ladies Art Company pattern names, 32, 51, 80; Oriental influences on, 329; Pine Tree, 234; and printed patterns, 32; Springtime in the Rockies, 347; Star patterns, 247; symbolism of, 392; Whig Rose, 253

Quilts: Their Story and How to Make Them (Webster), 234, 248, 309, 317, *317*, 368

Qing Dynasty. *See* China, Qing Dynasty imperial flag quilt

Rainbow Around the World quilt, *380*, 418. *See also* Around the World quilts; Trip Around the World quilts

Rainbow Quilt blocks, 309

Rainbow Quilt Company, 264

Rainbow Quilt kit, 310

Rainbow Stripes quilt, *224*

rayon fibers in fabrics, 55, *57*, 165, 432, 434

ready-cut kits, 330

Reconstruction period, 2

recycled clothing (whole pieces), *165, 166*

recycled fabric, 96, *96*, 151, 162, 207, 280

red, 103. *See also* Congo red; madder; Turkey red

red-and-green appliqué, 260, 406–7, **465**; and Colonial Revival, 9; fading of, 13, *13*; and Marie Webster,

368

redwork quilts, 12, *13*, *443*, **465**

regional styles: New Jersey, 44; New York (pieced signatures), 268, 270. *See also* Pennsylvania quilts

Reitz, E. S., *224*

remnants and scraps, 47, 128, 145, 200, 273

repaired quilts, 200, 202, *202*, *203*

reverse appliqué, 404, 422

Reynolds, Mary, 253

Rhorer, Ida Atchison, 387

ribbons in quilts, 128, 149, *149*, 399, 452n17; campaign, *160*, 161–62, *161–63*; Chicken, *438*; and Chicken Ribbons quilt (detail), *385*; and Cigar Ribbons quilt, *439*. *See also* Tobacco Premiums quilts

Ricard, Mary M. Hermandred, 135–37, *135*, 451n7

Richards, Betsey, *175*

Rising, Loretta Leitner. *See* Leitner, Loretta Isabel (as Nancy Cabot)

Rising Sun quilts, *xiv* (detail), *76*, *390*, 390–91, *391* (detail), *466* (detail)

robe prints, **465**

Robert Frank Needlework Supply Company, 310, 330

Roberts, Sue, 431

Rob Peter to Pay Paul quilts, 71, 74, *83*. *See also* Drunkard's Path

Rocky Road to California quilt, *72*

Rocky Road to Kansas quilts, *18–19*, 69, *69*

The Romance of the Patchwork Quilt in America (Hall and Kretsinger), 271, 284, 326

The Romance of the Village Quilts (McElwain), 366

Roman Square quilts, *81*, *446*

Roman Stripe quilt, *215*

Roosevelt Rose quilt, *370*. *See also* Rose quilts

Roote, Louise Fowler (as Kate Marchbanks), 309, 347, 458n3; Springtime in the Rockies quilt by, *346*, 347

Rose appliqué, 292, *292–93*

Rose Bower quilt, 356, *356* (detail), *357*

Rose quilts, *13* (detail), *292*, *293*, *381*. *See also* English Rose quilt; Magpie Rose quilt; Prairie Rose quilt;

Roosevelt Rose quilt; Whig Rose quilt; Wreath of Roses quilts

rotational symmetry in quilt patterns, *81*

Royal School of Art Needlework (South Kensington School), 3

Royal Society patterns, 263

Royal Stars quilt, *301*

running stitch, **465**

Rural New Yorker, 322

rural quilters. *See* country Crazy quilts

Ruth, Caroline, *291*

Ruth and Naomi Quilt quilt, *445*

Sailboat quilt, *81*

Sampler Album quilts, 48, *48* (detail), *49*, 274, 275–76, *277* (detail). *See also* Album quilts

sampler quilts, 82. *See also* Album quilts

samplers, embroidered, 275–76

Sanitary Fairs, 229

sashing, **465**; in allover-style quilts, 211, *212*; in block-style quilts, 43, 76; in Crazy quilt, 151

sateen, 207, 259, 284, 286, *414*, **465**

satin, **465**

Sawtooth Diamond quilts, 238, *239*, 240

Sawtooth quilts, *84*, 219. *See also* Squares, Sawtooth quilt

Sawtooth Star quilts, 75, *77*

Schockey, Gertrude, 259, 300, 306

Schooley, Sarah C., *169*

Schoolhouse quilt, 86, *86*, *87*

Schulte, Carolyn, 426

Scofield, Rachel, *216*

scrapbook, quilt as, *161*

scrapbooks of patterns, 32, 306

scrap quilts: Crazy quilts, 128, 145, 175; during Depression, 309; fabrics in, 13; in kit and pattern quilts, 326; and object prints, 192

Scribner's Magazine, 246

Sears, Roebuck and Co.: "Bathing Apparel of Real Worth," *166* (detail); fabrics from, 45, 209; kits for art needlework, 309–10

Sears Century of Progress Quilt Contest: entrants, 253, 387, 425, 441; judging criteria, 428, 431; and kits and patterns, 310; and marketing

Sears Contest (*cont.*)
of contest, 426; replica of winner of, 440; theme quilts in, 426, 428–29. *See also* Century of Progress Exposition

secondary designs: in allover-style quilts, 217, *217–18*; in block-style quilts, 20–22, 36, 72, *72–73*; in Crazy quilts, 105

serial and syndicated quilts, 309, 342, 352, 363, 366. *See also* Album quilts

settings (set), **465**; and alternate setting block, 76, *77*; in Pennsylvania quilts, 44; on point, 76, *78*; sashing in, 76. *See also* Log Cabin (quilt pattern for)

sewing machines: in Colonial Revival, 233; and decline of hand sewing skills, 48; effect of, 10, 392, 460n4; and Log Cabin, 92

sewing skills, 48, 66

Shackleton, Robert and Elizabeth, 230

shadows in Log Cabin, 120, *120–21*

Shadow Wreath quilt, *367*

Sharpe, Eda R., 342, 345, *345*

Shelton, Elizabeth, 142

shirting prints, **465**; in allover-style quilts, 194, 199, 200, 209; in block-style quilts, 22; in Colonial Revival quilts, 246, *247*; in Crazy quilts, 100, 105

Shoo Fly quilts, *74*; variation in, *77*

Shooting Star quilts, *23* (detail), 74, *379*

show quilts: Colonial Revival, 260, 273; Crazy quilts as, 96, 109, 131, *142*; never washed quilts, 52, 103, 105, 253, 406; one-of-a-kind quilts, 388, 406. *See also* utilitarian quilts

signature quilts and fundraising for women's causes, 267. *See also* Album, Signature quilts

signed and dated quilts: block-style, 52; Colonial Revival, 268, 286, *286*; Crazy, 100, 103, 156, 191; one-of-a-kind, 406. *See also* date-inscribed quilts

signed quilts: Crazy, 135, *135*; one-of-a-kind, *400, 401*

silk fabrics: in allover-style quilts, 184, 187; in block-style quilts, 23, 24; in

Crazy quilts, 5–6, 14, 17, 24, 96, 128, 145; in one-of-a-kind quilts, 399

"silkies." *See* tobacco premiums

Single Irish Chain. *See* Double Nine Patch quilts; Irish Chain quilt

Small, Albert, 448n1

small pieces, designs of, *84–85*, 395; as fad, 20, 448n1; Log Cabin, 123, *123*; Springtime in the Rockies, 347; yo-yo quilt, 418. *See also* charm quilts; postage stamp quilts

Smith, Rachel Achenback, *439*

Snowball quilt, variation on, *68*

Snowflake quilts, *294*

Snyder, Grace McCance, 448n1

Sorensen, Christine Heide, 270, *272*, 273

Southard, Ida L., 234

South Kensington School (Royal School of Art Needlework), 3

souvenirs in Crazy quilts, 128

Spider Web quilts, 38, *39*, *39* (detail), 72, *380*

Split Bars quilts, *183* (detail), *221*, 224

Split Nine Patch quilts, 44–46, *44* (detail), *45*, 67, *67*

Split Patch quilt, *83*

Springtime in the Rockies quilt, *346*, 347; pattern for, *347*

Square in a Square quilts, *vii* (detail), 26, 27, *27* (detail), 40–41, *40* (details), *41*, 46, *47*, *47*, *83*; and pattern and setting blocks, *40*

square patches, 183

squares, 216, *216*

Squares, Sawtooth quilt, *84*. *See also* Sawtooth quilts

Squares quilt, *216*

squares with pieced corners, *68*

Star and Chintz Album quilt, 280, *280* (detail), *281*, *282–83* (detail), *283*. *See also* Album quilts

Star of Bethlehem quilts, 245, *246* (detail), *298*, *299*, *300*, *301*, *378*; pattern for, *8*

Star of the Bluegrass (kit quilt), 387, 440, *441*

Star of the Bluegrass (Sears contest winner), 387. *See also* Caden, Margaret Rogers

Star quilt, 72. *See also* Alphabet and

Eight-Pointed Star quilt; Blazing Star quilts; Broken Star quilts; California Star quilt; Crazy Star quilt; Crazy Stars quilt; Eccentric Star quilt; Eight-Pointed Star quilt; Feathered Star quilts; Hexagon Star quilt; LeMoyne Star quilts; Lone Star quilts; Modernistic Star quilt; Morning Star quilt; Mountain Star quilt; Ohio Star quilt; Postage Stamp Star quilts; Royal Stars quilt; Sawtooth Star quilts; Shooting Star quilts; Star and Chintz Album quilt; Star of Bethlehem quilts; Star of the Bluegrass (kit quilt); Stars quilt; String Star quilts; Touching Stars quilts; Wreath of Stars quilts

Stars quilt, *xiv* (detail), 4, 62, *63*, *64* (detail), *75*; gallery, *378*; pattern for, *298*, *298–99*

State Flowers quilt, 342, *343*, *344* (detail), 345; pattern for, *344*

Stearns and Foster Company, 270, 347, 363–64, 460n75. *See also* Hooker, F. J. "Fritz"; Mountain Mist patterns

Stelzer, Carrie, 334, *334*, 337

Stenge, Bertha, 422, 461n28

St. Louis Star and Times, 352

Stoddard, Ada, 458n12

Stone, Clara, 24

Stoner, Mary Ann Grosh, 194, *194*, 196

Storrow, Mrs. James, 253

Stow, Ida Mae, 426, *428*

Streak of Lightning quilts, *221*. *See also* Log Cabin (Streak of Lightning setting) quilts

string designs, 69

String Squares quilt, *69*

String Star quilts, *69*, 173

strip patterns, 183, 204

strippie patterns, 223, *223–24*

strip setting, **465**

Stuart family, 160

stuffed squares or circles, 418

Stutzman, Mr. and Mrs., *380*

Sugarcreek Budget, 35

Sunbonnet Sue quilts, 371, *372*; pattern for, 263, *370*; variation on, *372*

Sunburst quilts, 70, 85, 391, 460n2

Sunflower quilt, 325, *362, 363–64, 363* (detail); pattern for, *363. See also* Kansas Sunflower quilt
sun motif, 391
swastika motif, 36
Sykes, Mary Eliza, *295*
symmetry in quilt design, 410, 413

Target quilt, *x* (detail), *385* (detail), *438*
Taylor, Allie Price, 387
technological change: effect on quilt-making, 9–16; indigo fabrics, 47; sewing machines, 10; and use of white, 58. *See also* industrialization
Temperance movement, 80
template piecing, 23, 180, *180*, 187, *280*, **465**
templates, mail order, 306, 310
theme quilts. *See* Album quilts; niche quilts
Thompson, Jean, 243, 260
Thonstad, Louise, 348, *348*
Thorpe, Salome, 191
Thousand Pyramids quilts, *180* (detail), *208*, 208–9, *209* (detail), *214*, *215*; pattern for, *183*; variation on, *215*
tied quilts: allover-style, 190, 192; block-style, 50, 51; Crazy style, 144, 150, 164; log cabin style, 103, 105
Tile quilt, *2* (detail), *173*
tobacco premiums, 128
Tobacco Premiums quilts, 410, *410* (details), *411, 412* (detail), 413, *413* (detail), *438, 439,* 461n13. *See also* Cigar Ribbons quilt
Tompkins, Dorothy, 131, *169*
Touching Stars quilts, *75, 299, 302, 380*
transfer patterns, 15, 131
translucence in Log Cabin, 120, *120–21*
Tree Everlasting quilts, *223*; pattern for, *183*, 223
"tree of life" motif, 279
Tree of Paradise quilts, 237
triangle-shaped patches, 183, 209, 214, *214–15*
Triangles quilts, *71, 439*
Trip Around the World quilts, 200, *201, 202* (detail), 203, *203* (detail), *217*, 220, 330, *331, 332–33* (de-

tail), *333*; pattern for, *183. See also* Around the World quilts; Rainbow Around the World quilt
Triple Irish Chain quilts, *8* (detail), *289. See also* Irish Chain quilt
Tulip quilt: Bucilla kit for, *370. See also* May Tulips quilt; Oriental Tulip quilt
Tulips and Hearts quilt, *436*
Tulips quilts, *379, 381*
Tumbling Blocks quilts, *218*
Turkey red, **465**; in block-style quilts, 39, 44–45, 52; in Colonial Revival quilts, 240, 243, 259, 267; fastness of, 12
Turkey Tracks quilt, 70
Twenty-five Patch quilt, *293*
two-color quilts: block-style, 42, 47, 70, 70–71, 72, 74; Colonial Revival, 12, 234, 237, 243, 248, 250, 290; Hawaiian, 404; red and green, 313

Uncle Clint's Quilt, 384 (detail), *445*
unfinished quilts: completed by four generations, 55; completed years later, 27, 46, 61; constructed over fifty years, 110; and Crazy quilt never completed, 135, 451n7; and displayed at fair, 364; hexagon quilts, 196Union Square quilt, *21*
utilitarian quilts: allover-style quilts, 199; block-style quilts, 47, 51; children's quilts, 395; Colonial Revival, 240. *See also* show quilts

Vase of Flowers quilt, 278, *279*
velvets in Crazy quilts, 128
Ver Mehren, Herbert, 259, 428–29
Vermillion, Easter Ann Keicher, 62, *62*
Vermillion, Hattie Ellen Broadbent, 62, 64, *64*
Verren, H. E., Company, 263
Victorian aesthetic: with busy surfaces, 209; with coded messages, 392; dark colors in, 184; and foundation patchwork, 51; and industrialization, 388; in Log Cabin, 123, *123*; and transition to Colonial Revival, 230
Virginia Snow Studios, 337
Vogart needlework products, 276
Vogue magazine, 263

Vosburgh, Cornelia Catharine, 268

Wagon Wheel quilt, 266, 267, *267* (detail)
Walther, E. Heldman, *295*
washing: and fluorescence, 203; fundraising quilts and, 267; and never washed quilts, 52, 103, 105, 253, 406; in 1930s, 58; of rayon fabrics, 434; of two-color quilts, 240, 243. *See also* fading; utilitarian quilts
Washington Tree quilts, 237
Webster, Marie: article in *Ladies' Home Journal* by, 306–7, *317*; on attraction of quiltmaking, 310; *Quilts* book by, 234, 248, 309, *317, 317,* 368; as businesswoman, 309; color palette of, 251, 253, 307, 325, 368; as design innovator, 306–7; and influence on Mountain Mist patterns, 374; on women's history, 233
Webster, Marie, designs of: Colonial Revival, 254; Double Nine Patch, 248; Dutch Baskets, *369*; French Baskets, *369*; Grapes and Vines, *15* (detail), *368, 369,* 374; Magpie Rose, *386* (detail), 387, *441*; May Tulips, *324,* 325, *325*; Pine Tree pattern, 234; Pink Dogwood, *368, 369*; Poppy, *316,* 317–18, *318–19* (detail), *368, 369*; Sunflower quilt design, *363*; Wreath of Roses, *368*
Wharton, Edith, 230
Wheeler, Laura, 309, 458n3
Whig Rose quilt, *2* (detail), *292, 293*; pattern for, *9*; variation, *9* (detail), *251, 251, 252* (detail), 253. *See also* Rose quilts
whipstitch, 105, **465**
whirling cross motifs in Germanic aesthetic, 36
Whiskey and Watermelon quilt, 406, *407, 408* (detail), *409*
White, Mrs. M. W., 429
white, use of as color, 35, 58
white cotton, 52
Whiting, Margaret, 279
Whitney Museum exhibition of Abstract Design in American Quilts, 209
Whole Cloth quilt, *300*

Wild Ducks quilt, *15* (detail), *374, 374*

Wilde, Oscar, 131, *131,* 168

Wild Goose Chase quilts, *22, 52–53, 52* (detail), *53, 76, 79, 204, 205, 206, 206* (detail), *222;* pattern for, *183. See also* Flying Geese quilt; Goose in the Pond quilt

Wildman, Joseph and Deborah, 268

Wilkinson Art Quilts, 254

Willard, Mary T. H., *170*

Wilson, Mrs. B. H., 96

Woman's Day magazine, *381*

Woman's Home Companion magazine, 237, 260, 292

Woman's World, 322

women's history: and Colonial Revival movement, 233; and designers as business women, 309, 360; and fight for suffrage, 292; as fund-raisers, 267; and pioneer women as model, 267, 270, 359; and Victorian ideal of woman, 3

women's magazines: and amateur writers, 23–24; balance between Modernism and traditional, 61; and Colonial Revival, 7–8, 233; and Crazy quilts, 5; during Depression, 309; and European trends, 254; patterns in, 23, 306; and quilting fads, 1. *See also specific magazines, e.g.,* Ladies Home Journal *magazine*

Woodhouse, Addie and Eulalie, 268, *268*

Woodward, Mary Dodge, 51

wool batting, 421, 461n20

wool fabrics: in Crazy quilts, *6,* 156, 165, 171; in mosaic patchwork, 184; in one-of-a-kind quilts, 388; production of, 51

wool foundation patchwork, 51

Work Basket magazine, 273

World War I and rise of dye companies, 13, 47

Wreath of Roses quilts, *292, 368, 368. See also* Rose quilt

Wreath of Stars quilts, 28, *29, 30, 31, 31* (detail)

Wreath quilt, *226–27* (detail), *291. See also* Floral Wreath quilt; French Wreath quilt; Laurel Wreath quilt; President's Wreath quilt; Shadow Wreath quilt, *367*

Wright, Eva, *157*

Wurzburg, F. A., Company, 338. *See also* Needleart Guild

Xs patterns, *79*

Yale Silk Works, 152

yellow, chrome, 39, 42, 100, 105, **463**

Young Indian quilt, *375*

Young Man's Fancy quilt, *85*

Yo-yo quilts, *382–83,* 418, *418* (detail), *419, 437;* techniques in, 436

Zigzag quilt, *175*